*A Companion to the Literature of German Expressionism*

*Studies in German Literature, Linguistics, and Culture*

Edited by James Hardin
(*South Carolina*)

Camden House Companion Volumes

The Camden House Companions provide well-informed and up-to-date critical commentary on the most significant aspects of major works, periods, or literary figures. The Companions may be read profitably by the reader with a general interest in the subject. For the benefit of student and scholar, quotations are provided in the original language.

# A Companion to the Literature of
# German Expressionism

Edited by
Neil H. Donahue

CAMDEN HOUSE

First published 2005
by Camden House

Camden House is an imprint of Boydell & Brewer Inc.
668 Mt. Hope Avenue, Rochester, NY 14620, USA
www.camden-house.com
and of Boydell & Brewer Limited
PO Box 9, Woodbridge, Suffolk IP12 3DF, UK
www.boydellandbrewer.com

ISBN: 1–57113–175–2

**Library of Congress Cataloging-in-Publication Data**

A companion to the literature of German Expressionism / edited by Neil
    H. Donahue
    p. cm. – (Studies in German literature, linguistics, and culture)
    Includes bibliographical references and index.
    ISBN 1–57113–175–2 (hardcover : alk. paper)
    1. German literature – 20th century – History and criticism.
    2. Expressionism.   I. Donahue, Neil H.   II. Title.   III. Series:
Studies in German literature, linguistics, and culture (Unnumbered)

PT405.C686 2005
830.9′115—dc22

                                                              2005009638

A catalogue record for this title is available from the British Library.

This publication is printed on acid-free paper.
Printed in the United States of America.

# Contents

## Philosophical Background

## Prose

## Poetry

# Drama

# Interdisciplinary

# Illustrations

## Plates

## Figures

# Preface and Acknowledgments

THIS VOLUME FOCUSES specifically upon the literature of German Expressionism, rather than the arts of painting, sculpture, music, or even architecture. Especially in the United States, the term German Expressionism first calls to mind those arts, rather than the literature of the period, and that circumstance reflects in a very positive manner the increased general familiarity with the German contribution to artistic modernism in the early twentieth century. This volume relies to some degree, necessarily, upon that familiarity, while trying to underscore the interconnectedness of the arts in this period, their shared intellectual debts and sources, and their shared general aesthetics, as suggested by the introduction. Though that very interconnectedness calls into question the notion of genre, as the one borrows from or emulates the other, genre still remains a useful organizing principle for tracking and understanding that interrelatedness. This volume thus traces a trajectory from the philosophy of Friedrich Nietzsche in its influence upon the Expressionist generation, and as literature itself; through the principal literary genres (in a less common sequence of prose, poetry, and drama), to an interdisciplinary section that first addresses the gender politics of Expressionism, and then the visual genre (of film) that most visibly absorbed the narrative impulses, visual imaginary and experimental spirit from the literature of German Expressionism. The sequence of the essays, arcing from philosophy to film, through the literary genres, would like to suggest both the centrality of the literature — the verbal artifacts related to Expressionism in this period — as well as the constant and necessary dialogue of each art with its others in this period, indeed the migration of elements of each art into the other, either under the Wagnerian rubric of *Gesamtkunstwerk* (total work of art) or more recently, of intermediality.

Throughout the volume, the term Expressionism has been capitalized to indicate the specific historical phenomenon of that "movement" between the years 1905 and 1925, as opposed to any sort of general expressionistic (lower case) tendency in the arts before or after that period.

The movie poster illustrations for *Caligari* (design Ledl Bernhard) and *Genuine* (design Josef Fenneker) appear in this volume courtesy of Deutsche Kinemathek Berlin.

For their generous permission to reprint Edvard Munch's portrait of Friedrich Nietzsche (1906) I would like to thank the Thielska-Galleriet in

Stockholm, Sweden, and Karin Meddings in particular. Many years ago during my first trip to Europe in 1977 with a backpack, I became obsessed the work of Edvard Munch and on my peregrinations followed his work through the museums of Europe up to Scandinavia. Upon my visit to that gallery I recall how startled and awed I was by the portrait of Friedrich Nietzsche, because of both its size and its brilliant colors, so I am now delighted to be able to include it in this volume, where it finds a most appropriate intellectual framework in Richard Gray's essay and the general topic of German Expressionism; however, I would also recommend a trip to see the original in the gallery!

Permission to reprint the woodcuts of Frans Masereel was granted by Artists Rights Society (ARS), New York/VG Bild-Kunst, Bonn.

In addition, I would like to thank the contributors for their hard work, patience, and good spirits in response to my many queries and demands during the preparation of this volume, and of course, I would like to express my gratitude to the Editorial Director, Jim Walker, and all of the staff at Camden House for their continued support of this project over the years.

<div style="text-align: right">

N. H. D.
April 2005

</div>

# Chronology

Franz Werfel, *Der Weltfreund. Gedichte* (The World Friend. Poems)

Carl Sternheim, *Die Hose* (The Bloomers)

Der blaue Reiter exhibit, Munich (1911–12)

Franz Pfemfert, first issue of journal *Die Aktion*

Kurt Hiller, et al., Neopathetisches Cabarett

1912    Carl Einstein, *Bebuquin, oder die Dilettanten des Wunders* (Bebuquin, or the Dilettantes of Miracle; novel, begun 1906)

Jakob van Hoddis, *Weltende* (End of the World; poem)

Franz Marc, *Der blaue Reiter* (The Blue Rider; painting)

Reinhard Sorge, *Der Bettler* (The Beggar; play)

Georg Kaiser, *Von morgens bis mitternachts* (From Morn to Midnight; play)

Georg Heym, *Umbra Vitae* (poetry)

Gottfried Benn, *Morgue* (The Morgue; poetry)

Ludwig Meidner, *Apokalyptische Landschaft* (Apocalyptic Landscape; painting)

Albert Ehrenstein, *Tubutsch: Erzählung* (Tubutsch: A Story)

Wassily Kandinsky, *Über das Geistige in der Kunst* (On the Spiritual in Art; treatise)

1913    Georg Trakl, *Gedichte* (Poems)

Ludwig Meidner, *Brennende Stadt* (Burning City; painting)

1914–18  First World War

1914    Paul Fechter, *Der Expressionismus* (Expressionism; treatise)

Walter Hasenclever, *Der Sohn* (The Sohn; play)

Georg Kaiser, *Die Bürger von Calais* (The Burghers of Calais; play)

Ernst Stadler, *Der Aufbruch* (The Departure; poetry)

August Stramm, *Sancta Susanna* (Saint Susanna; play; first production 1918)

Georg Trakl, "Grodek" (poem)

1915    Carl Einstein, *Negerplastik* (African Sculpture; art-historical treatise)

1916    Hermann Bahr, *Expressionismus* (Expressionism; critical treatise)

Reinhard Goering, *Seeschlacht* (Sea Battle; play)

Albert Ehrenstein, *Der Mensch schreit: Gedichte* (The Human Screams: Poetry)

Gottfried Benn, *Gehirne: Novellen* (Brains: Novellas)

Johannes Becher, *An Europa: Neue Gedichte* (To Europe: New Poems)

| | |
|---|---|
| 1917 | Ludwig Rubiner, *Der Mensch in der Mitte* (The Human in the Middle; essay) |
| 1918 | Heinrich Mann, *Der Untertan* (The Loyal Subject; novel) |
| | Thomas Mann, *Betrachtungen eines Unpolitischen* (Confessions of an Unpolitical Man; treatise) |
| | Ernst Barlach, *Der arme Vetter* (The Poor Relation; play) |
| | Georg Kaiser, *Gas I* (play) |
| | Hans Goltz, *Der expressionistische Holzschnitt* (The Expressionist Woodcut; exhibit catalog) |
| | Claire Goll, *Die Frauen erwachen* (Women awaken; collection of novellas) |
| 1919 | Hans Hildebrandt, *Der Expressionismus in der Malerei* (Expressionism in Painting; critical treatise) |
| | Max von Sydow, *Die deutsche expressionistische Kultur und Malerei* (German Expressionist Culture and Painting; critical treatise) |
| | Kasimir Edschid, *Über den dichterischen Expressionismus* (On the Poetics of Expressionism; critical essay) |
| | Wilhelm Worringer, *Kritische Gedanken zur neuen Kunst* (Critical Thoughts on the New Art; critical essay) |
| 1920 | Kurt Pinthus, ed. *Menschheitsdämmerung* (Dawn of Humanity; poetry anthology; printed and released in autumn 1919 with publ. date 1920; original introduction by Pinthus bears that date) |
| | Robert Wiene, *Das Cabinet des Dr. Caligari* (The Cabinet of Dr. Caligari; film) |
| | Arnolt Bronnen, *Vatermord* (Patricide; play, written 1915) |
| | Ernst Toller, *Masse Mensch* (Masses and Man; play) |
| | Georg Kaiser, *Gas II* (play) |
| 1921 | Wilhelm Worringer, *Künstlerische Zeitfragen* (Questions about Contemporary Art; critical treatise) |
| | Frans Masereel, *Die Passion eines Menschen* (Twenty-Five Images of a Man's Passion; woodcuts / graphic-novel, orig. 1918) |
| | Ernst Toller, *Die Wandlung: Das Ringen eines Menschen* (The Transformation: The Struggle of a Man; play) |
| 1922 | Gottfried Benn, "Das späte Ich" (The Belated I, poem) |
| | Friedrich W. Murnau, *Nosferatu* (film) |
| 1923 | Oswald Spengler, *Der Untergang des Abendlandes* (The Decline of the West; treatise) |
| 1924 | Thomas Mann, *Der Zauberberg* (The Magic Mountain; novel) |

1925    Franz Roh, *Nach-Expressionismus: Magischer Realismus* (Post-Expressionism: Magical Realism; critical treatise)
Rudolf Kurtz, *Expressionismus und Film* (Expressionism and Film; film-theoretical treatise)
Frans Masereel, *La ville* (The City; graphic novel)

1933    Gottfried Benn, *Bekenntnis zum Expressionismus* (Avowal of Expressionism; essay)
National Socialist party holds public bonfires / book burnings

1934    Georg Lukács, *Größe und Verfall des Expressionismus* (Greatness and Decline of Expressionism; essay)

1937    Klaus Mann, *Gottfried Benn: Geschichte einer Verwirrung* (Gottfried Benn: The Story of a Confusion; essay)
National Socialist exhibit *Entartete Kunst* (Degenerate Art)

1947    Thomas Mann, *Doktor Faustus* (Doctor Faustus; novel)
Wolfgang Borchert, *Draußen vor der Tür* (Outside at the Door; play)
Siegfried Kracauer, *From Caligari to Hitler: A Psychological History of German Film* (film criticism)

1952    Lotte Eisner, *The Haunted Screen: Expressionism in the German Cinema and the Influence of Max Reinhardt* (film criticism)

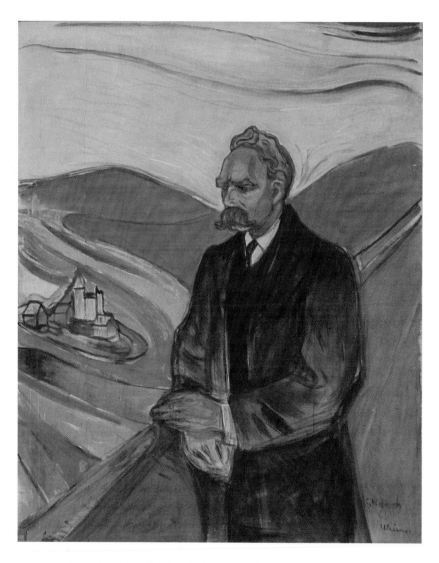

Plate 1. *Edvard Munch,* Portrait of Friedrich Nietzsche,
*Thielska Galleriet, Stockholm.*

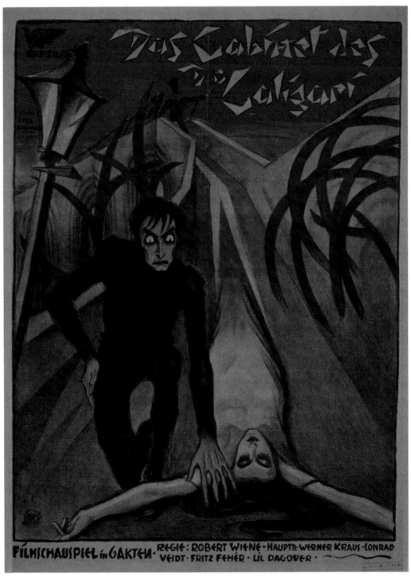

Plate 2. Caligari, *poster design Ledl Bernhard.*
*Courtesy of Deutsche Kinemathek.*

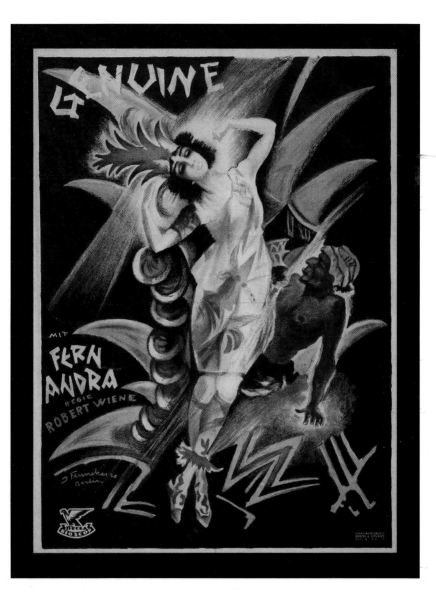

Plate 3. Genuine, *poster design Josef Fenneker.*
*Courtesy of Deutsche Kinemathek.*

# Introduction

*Neil H. Donahue*

WITH THE 2001 OPENING OF Ronald Lauder's Neue Galerie in Manhattan on 86th St. and Fifth Ave., in the middle of Museum Mile, German and Austrian Expressionism has acquired more than a foothold in mainstream American culture. It has been given a permanent, centrally located showcase for German painting and related arts of the late nineteenth and early twentieth century, concentrating on the so-called Expressionist decade from 1910 to 1920. In the wake of the great exhibit of German Expressionist painting at the Guggenheim museum in 1981 (entitled *Expressionism: A German Intuition, 1905–1920*) that introduced the movement and painterly idiom to a general American audience for the first time on a large scale, much as the exhibit "Paris — Berlin" at the Centre Pompidou in Paris had done in France in 1978, or as an exhibit in Marbach had done in Germany in 1960, the Neue Galerie serves as a visible landmark in the steady incorporation of German Expressionism into American culture.[1] In its conception and in its augustly elegant building, the Neue Galerie might have signaled, on the one hand, the confident establishment of German Expressionism in artistic and cultural history from the American perspective. On the other hand, the Neue Galerie might also have appeared as a kind of cultural mausoleum, where Expressionism had been laid to rest in public view, safely inert and therefore a mute object of our curatorial propensities and distant historical curiosity. But neither was the case: the museum opened instead during the period of mourning, disorientation, and heightened security following the destruction of the World Trade Center by terrorists on September 11, 2001. The installation of German Expressionism into the American landscape took place at a time when the financial euphoria and complacency of the boom years of the 1990s had been shattered by a terrorist act and the prospect of war. To underscore that change of mood, in January of 2002 the World Economic Forum, usually held on a "magic mountain" in pretty, placid Davos, Switzerland, convened instead in Manhattan, as a demonstration of moral and economic support for the anxious city. In the climate of immediate fear and uncertainty that surrounded the museum's opening, along with the newly heightened awareness of the far-reaching issues and implications of cultural mediation, the Neue Galerie introduced

Expressionism into an atmosphere that resembled the conditions from which, generations before, it had emerged. This sudden transition from the lucrative insouciance of the 1990s to post-9/11 vulnerability recalls the abrupt disruption of self-congratulatory and suffocating complacency in Wilhelminian Germany by the assassination of Archduke Ferdinand in Sarajevo and the onset of the First World War. That acute disorientation was compounded by the accelerating effects of urbanization and technological modernity, all of which heralded a new sense of shared humanity, of transnational issues, and of what is now called globalization. Thus, instead of confirming the historical distance of early twentieth-century German and Austrian Expressionism from the present age, the Neue Galerie displays its essential proximity to life in early twenty-first-century America. As much as we look at them, the faces of German Expressionism look back at us.[2]

Expressionism emerged as a reaction to the entrenched stolidity of prosperous, pre-war German bourgeois culture as chronicled with ironically doting but critical detachment by Thomas Mann in his *Buddenbrooks, Verfall einer Familie* (Buddenbrooks: The Decline of a Family, 1901). The successive generations of that mercantile family led from robust individualism inspired by the Protestant work ethic to the dispirited sickliness of little Hanno, the sensitive but weak last representative of the family, in a long downward trajectory of familial and cultural enervation. Mann's view of German society always returns, nonetheless, to the inner life and outer ways of the *Bürger*, the prosperous, educated middle-class citizen, in relation to the dictates of art and culture: the tension between the two creates the pervasive irony in his work. In fact, his later novel *Der Zauberberg* (The Magic Mountain, 1924) is a monumental elegy to the "innocence" of that self-absorbed social class, examined clinically in the microcosm of an Alpine sanatorium on the eve of its demise in war.

From the perspective of his fascination with the *Bürger* class in German society, and its realistic depiction and analysis, Thomas Mann expressed great skepticism toward Expressionism, to which he devoted sections of his ranting diatribe *Betrachtungen eines Unpolitischen* (Confessions of an Unpolitical Man, 1918):

> Expressionismus, ganz allgemein und sehr abgekürzt zu sprechen, ist jene Kunstrichtung, welche, in heftigem Gegensatz zu der Passivität, der demütig aufnehmenden und wiedergebenden Art des Impressionismus, die Nachbildung der Wirklichkeit aufs tiefste verachtet, jede Verpflichtung an die Wirklichkeit entschlossen kündigt und an ihre Stelle den souveränen, explosiven, rücksichtslos schöpferischen Erlaß des Geistes setzt. [. . .] Lassen wir aber gelten, daß der expressionistischen Kunsttendenz ein geistigerer Impetus zur Vergewaltigung des Lebens innewohne. . . . (Anz/Stark, 1982, 90–91)

[Expressionism, to give a very brief general explanation, is that artistic direction which, in vigorous contrast to the passivity, the humbly registering and re-presenting manner of Impressionism, most deeply despises the imitation of reality, resolutely dismisses all fidelity to realistic appearances and replaces it with the sovereign, explosive, ruthlessly creative decree of the mind. [. . .] We should recognize however that inherent to the Expressionist tendency in the arts there is an intellectual impetus to do violence to life.]

The verbal violence of Thomas Mann's own defense of representational art against what he sees as the depredations of Expressionismus ("eines absoluten Kunstdämons"; of an absolute artistic demon) frames, however, the challenge posed by Expressionism to artistic conventions, and reveals his devout adherence to that class and that society, despite his subtle criticisms of it. Thomas Mann's venomous outburst was also directed *ad hominem* at his brother's very different attitude toward art and its relation to society.

Thomas Mann's older brother, Heinrich Mann, was less ironic and more openly satirical in his portrayal of the same class and institutions of Wilhelminian society, as in his depiction of a tyrannical pedant in his short novel *Professor Unrat* (1904), which later gained fame as the basis for the film *The Blue Angel* (1930) with Marlene Dietrich as Lola. The professor falls in lust, if not love, with a nightclub torch singer, who comes to dominate, humiliate, and then, predictably, dump him. His fall from the heights of pedantic and imperious self-righteousness to abject self-pity indicts the moral hollowness and hypocrisy of the ruling classes of *Bildungsbürgertum* in Germany before the First World War. Though Heinrich Mann's satires were written in an acerbic but nonetheless conventional style of literary Naturalism, his vehemence, critical acuity, and political convictions (as evidenced also in his essay "Geist und Tat" [Intellect and Action], 1910), made him a model of political engagement for the Expressionist generation in general and its Activist branch in particular.

Heinrich Mann's critique of the ruling classes under Wilhelm II continued through the Expressionist period with his dissection of the authoritarian personality in *Der Untertan* (The Loyal Subject, 1918), the first and most important of his Kaiserreich trilogy (along with *Die Armen* [The Poor, 1917] and *Der Kopf* [The Head, 1925]). In the development of the protagonist of *Der Untertan*, Diederich Heßling, Mann describes the stages of psychological deformation of character by society from early childhood that results in the social type of the domineering egoist and craven subordinate, who lives entirely according to the dictates of the given hierarchy, alternately imperious toward those below, and cowardly, sycophantic to those above. As Roy Allen has noted: "The concept of authority circumscribes in the Expressionist mind the basic orientation of the whole spectrum of Wilhelminian social life, for what this society

demanded of the individual above all else seemed to be total deference to authority" (16). Diederich Hessling is the prototype of the authoritarian philistine, a willing instrument of state power, and is also an expression of the soullessness of the imperial German state under Wilhelm II. As such, he is the very antithesis of the Expressionist.

Both of these broad, panoramic critiques of German society by the Mann brothers, whether respectfully ironic in the case of Thomas or cuttingly satiric in the case of Heinrich, conformed stylistically to the model of nineteenth-century Realist-Naturalist writing, but serve here to frame the social and literary agenda of Expressionism, which was just beginning to emerge. Alfred Döblin's short story "Die Ermordung einer Butterblume" (The Murder of a Buttercup, written 1904, published 1910) likewise takes as its theme the disparity between the outer appearance and inner reality of the bourgeois class, but in more direct anticipation of Expressionism his story begins to trade extensiveness for intensity in the treatment of that theme. Whereas Diedrich Heßling's joyous submission to authority verged on the extinction of individuality, Döblin's protagonist shows clinical symptoms of derangement. Herr Michael Fischer takes a walk outside the provincial city of Freiburg one evening, swinging his cane, with an odd twitch in his gait that suggests something explosive in his personality underneath the uniformity of his bourgeois attire. When his cane gets momentarily caught in the grass, he explodes in a murderous rampage against the buttercups in the field, mowing them down in anger, and spends the rest of the story in delusional re-enactments of that moment or in self-imposed penance for that "crime." For Döblin, who was a psychiatrist, violence and insanity lurk just beneath the surface of middle-class respectability in, to use Sigmund Freud's term from his contemporaneous study, "The Psychopathology of Everyday Life." Like Heinrich Mann, Döblin also shows how precarious that veneer of stability is in the German *Bürger*. Some years later, in his short story "Der Irre" (The Madman, 1913), Georg Heym pushed the theme of individual madness, of violent insanity, so common in Expressionism, to its fictional extreme, before it became a collective reality in the First World War. Together these works show a narrowing and deepening of focus on the principal object of Expressionist scorn and revolt: the stultifying values of middle-class materialism and morality, and its complacent conformity, which serves as the backdrop to the artistic ferment of Expressionism.

That sense of ferment was broadly atmospheric, part reaction to what was, part aspiration to what could be, coursing through German society outside its institutions as an excitement about the possibility of change, of questioning authority or convention, in society and in the arts. As Max Krell says of Expressionism in his memoirs *Das alles gab es einmal* (That's How It All Once Was, 1961): "Es wurde an keinem Ort und überall geboren: sein Kommen lag in der Luft" (It was born in no single location

and everywhere at once: its arrival was in the air; 206). This sort of widespread percolation of ideas and attitudes took place above all in the bohemian ambience of cafés, as has been described by Roy Allen in his study *Literary Life in German Expressionism* (1983) and documented by Paul Raabe in his collection *Expressionismus: Aufzeichnungen und Erinnerungen der Zeitgenossen* (Expressionism: Sketches and Recollections by Contemporaries, 1965). The atmosphere of subversive excitement was not centered in any one city, as was the French avant-garde in Paris (where Expressionists were also active), but rather it spread throughout regional cities of Dresden, Munich, Leipzig, Prague, and Vienna, among others, and of course, most importantly of all, Berlin. Though diffuse in its energies as a counter-cultural movement, Expressionism coalesced in these particular café circles and crystallized in numerous journals devoted to literature and the arts through publication and the sponsorship of readings, exhibits, and other public performances, such as the famous *Sturm*-sponsored reading in Berlin by Filippo Marinetti of the *Futurist Manifesto* in 1913, which sent shock waves through the German art world. Journals such as Herwarth Walden's *Der Sturm* (The Storm), with its very pronounced aesthetic program, and Franz Pfemfert's *Die Aktion* (The Action), with its commitment to political engagement, to name just two, represent concretely the divergent impulses of a very heterogeneous movement. That spirit of collective cultural renewal in aesthetic and political terms reverberates not only through the issues of these journals, but also through the numerous anthologies of the day: both of these forms of publication lent themselves readily to the collective but disparate dimensions of Expressionism.

The unity in diversity of the movement, its sense of heady excitement, also derives from its intellectual origins and forbears. The vibrant but diffuse atmosphere of those cafés, journals, and intellectual circles had very definite roots in the history of ideas. In his essay "The Old Café des Westens," the Expressionist poet Ernst Blass, looking back at the intellectual climate of his generation, asks rhetorically: "Was lag in der Luft?" (What was in the air?) and provides the following answer:

> In der Luft lag vor allem van Gogh, Nietzsche, auch Freud, Wedekind. Gesucht wurde ein postrationaler Dionysos. van Gogh: Das war der Ausdruck und das Erlebnis, dem Impressionismus und Naturalismus entgegengesetzt als flammende Konzentration, als Jünglingsseichtheit, Unmittelbarkeit, Subjektstiefe, als Exhibition und Halluzination . . . der Mut zum eigenen Ausdruck; Nietzsche: Der Mut zum eigenen Selbst und eigenen Erlebnis; Freud: die Tiefe und Problematik des eigenen Selbst; Wedekind: Die zwischenmenschliche Problematik und Explosion [. . .]. Man sprach von Visionen. (As quoted in Raabe, 38)

> [What was in the air? Above all van Gogh, Nietzsche, Freud too, and Wedekind. What was wanted was a post-rational Dionysos. Van Gogh stood for expression and intense experience opposed to Impressionism

and Naturalism as flaming concentration, youthful sincerity, immediacy, depth; exhibition and hallucination. [. . .] the courage of self-expression; Nietzsche: the courage to be oneself; Freud: the hidden depths and problems of the self; Wedekind: the problem of human relationships exploding (in brilliant visions). There was much talk of Visions. (Raabe, 1974, translation by Ritchie, modified by editor, 29)]

The generation of early Expressionists seized on figures from philosophy, psychology, painting, and drama who called into question the practices and conventions of prior generations, and who employed a hermeneutics of suspicion in order to get behind appearances, assumptions, conventions, and preconceptions in order to reach by different means other sources and other levels of expression.

The philosopher Arthur Schopenhauer had called the primary substratum of universal existence the Will, a level of existence that precedes and supersedes individual phenomena or rational cognition, and which could be known only as Idea through irrational intuition, through art that gives form to formlessness, and through the least verbal and representational art, namely music.[3] However, contrary to the passivity inspired by Schopenhauer's pessimistic view of existence (in French Symbolism, for example), but still imbued with the "spirit of music," the artistic agitations of Expressionism received inspiration from Friedrich Nietzsche's analytical sense of critical inquiry, self-creation and dithyrambic overcoming — though Expressionism constituted only one particularly important branch of Nietzsche's complex influences. When Ernst Blass refers to the bohemian search for a "post-rational Dionysos," he alludes to the dithyrambic irrationalism associated with Nietzsche's work, particularly to his *Die Geburt der Tragödie aus dem Geiste der Musik* (The Birth of Tragedy Out of the Spirit of Music, 1872) and its elaboration of an Apollonian-Dionysian dichotomy defining and dividing culture. Yet Nietzsche's writings provoked and inspired responses across the full range of emerging German modernity. Indeed, Steven E. Aschheim's general comment on the breadth of Nietzsche's influence on artistic modernity is acutely revelant to German Expressionism in literature:

> Nietzsche played a definitive role in the agenda of the avant-garde. He provided the basic epistemological tools of its modernist revolution and inspired its elitist, prophetic élan. His exhortation "to *be* something new, to signify something new, to represent new values" was, as Count Kessler perceptively noted, emblematic of this Nietzschean generation. The avant-garde found in Nietzsche sustenance for their alienation from the establishment's high culture and their desire to overcome the nineteenth century. He was a central force in the impulse to radical critique and the revolt against positivism and materialism. He was the major force behind its proclivity for *Lebensphilosophie* and its celebration of post-Enlightenment, irrationalist modalities. (51)

That influence took many forms from, on the one hand, the elevation of vitality to the highest principle, an ecstasy that culminates in madness and violence, in irrationalism and brute force, as forms of regenerative self-over-coming, as in the *Übermensch*; to, on the other hand, the critique of institutions and conventions in society and in language, which leads to a posture and practice of analytical nihilism with a plurality of perspectives, allowing no firm epistemological grounding in a system, no truth. Nietzsche's philosophy provides, in one way or another, a fruitful approach to reading virtually any artist or writer of this period; each can be measured respectively in his or her relation to Nietzsche, in the degree to which they either made productive, original use of ideas they derived from the philosopher (with Gottfried Benn as, perhaps, the best example), or merely succumbed to his influence and got caught, so to speak, in the lava flow that erupted from the Nietzschean volcano onto all paths of German and European modernism. The brooding luminescence of Edvard Munch's 1906 portrait of Nietzsche in a tempestuous, swirlingly colorful Expressionist landscape captures the transitional moment of synthesis from Nietzsche's ideas and inspiration to Expressionist artistic practice (see plate 1). At times, Nietzsche's name enters directly into a work, as in Carl Sternheim's parodic portrayal in *Die Hose* (The Bloomers, 1911), set in 1900, of a Nietzschean acolyte who deploys his arsenal of received ideas to impress and seduce an unlettered married woman, and, in one scene, mockingly asks of the troglodyte husband: "Ist Ihnen der Name Nietzsche zu Ohren gekommen? / [. . .] / Er lehrt das Evangelium der Zeit" (act 3, scene 1; Does the name Nietzsche mean anything to you? // He teaches the gospel of our time; Schürer, 55). Sternheim both acknowledges Nietzsche's profound influence on his own work and his whole generation and creates an ironic distance to it.

In a more serious vein, Thomas Mann's fictional composer Adrian Leverkühn in his *Doktor Faustus* (Doctor Faustus, 1947) is a composite portrait, in retrospect, of the Expressionist artist, based on various composers (Mahler, Webern, Schönberg, Berg), but primarily on Nietzsche, with whom he shares numerous traits, both biographical and intellectual. Indeed, Leverkühn, whose very name is drawn from a Nietzschean aphorism (live boldly!), constitutes a serious synthesis and concentrated representation of Nietzsche's influence on German Modernism and Expressionism, which is also depicted in the lesser luminaries in the novel, the Munich intellectuals surrounding Leverkühn. In a paradoxical fashion typical for Mann, Leverkühn is the quintessential Nietzschean, almost more so than Nietzsche himself for having absorbed his influences. In fact, in his essay "Die Entstehung des Doktor Faustus" (The Genesis of the Novel, 1948), Mann dubbed his work "geradezu ein[en] Nietzsche-Roman" (in point of fact a Nietzsche novel). In retrospect, Thomas Mann's erudite and intricate novel takes stock of the Expressionist generation through its profile of the fictive composer, lending to the Expressionist legacy both sublime grandiosity and

doom-filled pathos, and remaining profoundly ambivalent about its manifestations in art and politics. In this volume, Richard Gray argues that Nietzsche's thought and person(a) constitute the inner "nucleus" of Expressionism, just as Mann's synthesis of Nietzsche into Leverkühn is the nucleus of that late masterpiece. Mann's novel confirms Gray's approach by showing how his fictional composer enacts in his music what Gray has located and felicitously named in Nietzsche's work a "metaphysical mimesis." The allegorical figure of Leverkühn, while evincing a pathos of transcendence in his person and in his music, descends, like Nietzsche himself, into madness.

In the absence of a coherent but confining system to his thought, Nietzsche's influence, both direct and diffuse, knew no bounds (to this day) and it seems rather that the name Nietzsche functioned ultimately in subsequent generations as a cipher for the partial "truth" of how others chose to use or misuse his works for their own ends. But the two principal sides of Nietzsche's multifaceted thought and reception: the vitalistic-barbaric versus the analytical-nihilistic, or the ecstatic life-affirming versus the epistemological-deconstructive, have given rise to two different genealogies. The turn-of-the-century and Expressionist generations favored Nietzsche the *Übermensch* for the revolutionary potential of his views in the more immediate practical context of social institutions in art, religion, and politics. Silvio Vietta notes broadly that "die Motive der Nietzscheanischen Kulturkritik nun in der expressionistischen Literatur gehäuft auftreten, wenn auch unterschiedlich gewichtet, und daß diese kulturkritischen Motive der Moderne insgesamt — wohl durch den entscheidenden Einfluß Nietzsches — an Explizität und Schärfe zunehmen" (elements of Nietzsche's critique of culture now begin to appear more frequently in Expressionist literature, though also with varied emphasis, and that these elements of cultural criticism, running through modernity in its entirety, become — again through the decisive influence of Nietzsche — increasingly explicit and acute; 17). In contrast, Steven Aschheim notes (52) that the later tradition of poststructuralist discourse favors Nietzsche the subtle rhetorician who subverts traditional (Idealist) philosophy by revealing the metaphoric nature of all language (as in his essay "Ueber Wahrheit und Lüge im außermoralischen Sinne" [On Truth and Falsehood in an Extra-Moral Sense]), thereby undermining all positive assertions of truth content, and hence inviting a deconstruction of the very terms of any such discourse. These two genealogies (or two separate, alternate receptions of Nietzsche) predominated, respectively, in the two halves of the last century. Studies of Expressionism have learned from each.

The exact history and semantic shifts of the term *Expressionism* preoccupied and vexed scholars almost from the start,[4] especially when they were trying to isolate specific characteristics of the phenomenon in its artistic or literary forms, and to limit the field, but recent attempts to integrate

Expressionism, in all its turbulent variety, into German modernity now make the question of the specific single origin of the term less urgent. In the last twenty years, German modernism in general and Expressionism in particular have been investigated for the moments and manners in which they anticipated the heterogeneity and pluralism of postmodern thought. In effect, that discussion effaces any distinction between Expressionism (artistic or literary) and Modernism, in order to allow the reciprocal illumination of both (German Expressionism / Modernism) with Postmodernism. Of course, the establishment of such a continuum runs the risk of overlooking specific and lesser known examples in favor of broad synthetic perspectives, but can also in turn allow greater historical differentiation in order to expand the field of historical inquiry anchored in particular texts. In that shift away from the ahistorical "macrotheorizing" (Huyssen/Bathrick, 3) in debates about postmodernism, new research can benefit from poststructuralist awareness of the high-stakes epistemological gambles and gambits of Nietzsche and German Modernism in order to take a fresh look at the particular manifestations of Expressionism in literature and related arts. Such research by Andreas Huyssen and David Bathrick (and the other contributors to their collection *Modernity and the Text: Revisions of German Modernism*, 1989) or by Thomas Anz and Michael Stark in their volume *Die Modernität des Expressionismus* (The Modernity of Expressionism, 1994), has illuminated new aspects of German Expressionism and Modernism with exciting new readings of less known or less studied works outside the canon.[5] Most recently (2002), Rainer Rumold has introduced the notion of an "*agon* of competing discourses" (xii) to characterize the synchronicity of trends and tendencies at the time. Thus, whereas Expressionism had once largely disappeared from such contemporary discussions because of its inherent difficulties of definition, it can now return through that expanded field to the forefront of new historical inquiries into German modernity precisely for its heterogeneity of artistic and stylistic means, its varied intellectual sources, its social and political agendas — all in reaction to the belated onrush of modernity in Germany.[6] What once had made Expressionism so difficult to deal with now accounts for its appeal and the necessity of its continual reexamination: Expressionism figures as the extreme instance of the conceptual and practical dilemmas of German modernity. In other words, our perspective from the present allows new access to both of the Nietzschean sides of Expressionism, the analytical and the emotional, and the philosophical impetus in the early twentieth century to forge new modes of intensity. In general, the central characteristic of Expressionism remains its intensity, noted repeatedly in the scholarship, which can perhaps best be understood as the degree of divergence from, if not antagonism to, prior modes of thinking and of artistic and social practice, also including in literature a tendency to short forms as a way of concentrating and condensing affects.[7]

In the wake of Nietzsche, that desideratum of aesthetic intensity began to take on specific contours through the notion of *Stil* as developed by Wilhelm Worringer in his *Abstraktion und Einfühlung: Ein Beitrag zur Stilpsychologie* (Abstraction and Empathy: A Contribution to the Psychology of Style, 1908). This work gave the nascent and inchoate tendency in the arts, later known as Expressionism, a justification in aesthetic terms, an ally in the academy where it was not otherwise accepted, and a genealogy in Western culture that legitimated its own radical and controversial forms as part of a tradition of abstract or nonrepresentational art. Worringer separated art from its means, from technical knowledge and skill, and posited that all art, in any given period, is the fullest expression of the artist's "artistic volition" or *Kunstwollen*, which derives from a "world-feeling" or *Weltgefühl*, a metaphysical disposition toward the cosmos. Through the "artistic volition" of individual artists, art reflects, in the physical particularities of its form (its *Stil*), the metaphysical disposition of the age. For Worringer, the history of art alternates between the two world-feelings of empathy and abstraction: the former is based on a sense of existential comfort in the world, a confidence in mastering nature (for example, through science and technology), which gives rise to familiar, naturalistic representations, whereas the latter is based on a sort of metaphysical anxiety or "spiritual agoraphobia" (*Platzangst*), a primordial psychic anguish that gives rise to the jarring formations of nonrepresentational or abstract art. By departing from naturalistic representation, abstract art eliminates the implied contingency (and dangers) of the natural world and suggests a higher, irrational permanence behind phenomena, thereby satisfying an urge toward spiritual transcendence, what he later called a "sublime hysteria." Worringer defined a sensibility or a psychology that explained the forms of non-realistic art that had been omitted from the triumphant art-historical narrative of the Greco-Roman Renaissance (that is, the classicist-humanist development of three-dimensional perspective). But his works did not explicitly cite examples, contemporary or historical, though they did implicate African and Egyptian art[8] as well as medieval or Gothic art, which became the topic of Worringer's third book, *Formprobleme der Gotik* (Form Problems of the Gothic, 1911), which in turn was also read by contemporaries as another art-historical manifesto for Expressionism.

In that same crucial year of 1911, the clear distinction or opposition between the new abstract art of Expressionism and traditions of realistic Naturalism burst into the open in Germany, with nationalist overtones, in the "Protest deutscher Künstler" (Protest of German Artists) led by the landscape painter Carl Vinnen, which elicited an overwhelming response entitled *Im Kampf um die Kunst: Die Antwort auf den "Protest deutscher Künstler"* (In the Battle over Art: A Response to the "Protest of German Artists"), also published by Worringer's publisher, R. Piper, in Munich in 1911 (see Manheim 1987). In fact, Worringer contributed his essay

"Entwicklungsgeschichtliches zur modernsten Kunst" (On the Historical Development of the Most Modern Art, 1911), which gave further currency to the term *Expressionists* for the new artists in the process of emancipating art from its tradition-bound "rationalism of sight" (Rationalismus des Sehens," Pörtner, 16), in order to make room for a "simplification of form" in emulation of the austerity of so-called "primitive" art. Likewise, in 1911, in his tract "Über das Geistige in der Kunst" (On the Spiritual in Art, publ. 1911, dated 1912) Wassily Kandinsky noted that — after music — the visual arts provide the best example of a pure art form, divested of representational vestiges. To the consternation and outrage of what Geoffrey Perkins has called the "conservative front" (25) in the German art world, German artists had begun — influenced by post-Impressionist developments in France — to turn away from the notion of aesthetic beauty in harmonious proportions and toward "primitive" art as a model of abstraction, of a non-representational (read: non-academic and non-bourgeois) art of existential immediacy and critical cogency with a new vocabulary of pictorial composition. Critics soon began to reflect upon these developments in painting and in discussions of the new painting, and Worringer's *Formprobleme der Gotik* of 1911 found direct echo in the first single study of the topic by that name, *Der Expressionismus* (1914) by Paul Fechter, and again in Hermann Bahr's *Expressionismus* (1916): these books consolidated and legitimated in the public mind this trend in the visual arts and the name by which it had come to be known.

In painting, post-Impressionist predecessors such as Vincent van Gogh had provided the Expressionist generation with an exemplary, provocative style that used plummeting shifts in perspective, a palette of vivid, even garish colors, and heavy impasto on the canvas to lend to conventional still-life motifs a subjective, swirling intensity, suggestive of visceral anguish. That combination of palpable luminosity and darkness of mood in van Gogh or in the work of the Norwegian Edvard Munch (or others such as Paul Gaugin and the Fauves in France and Paula Modersohn-Becker in Germany), anticipated the characteristic existential chiaroscuro of so much of Expressionist art, which was deeply at odds with reigning orthodoxies of academic art under Wilhelm II, whose tastes for banal, derivative, and didactic classicism in public art filtered through the German Royal Academy of Arts to dominate the art world (and art market). Such was the background against which Expressionist art emerged and forged its revolutionary *Stil*, a concept of artistic style imbued with existential imperatives and urgency, which was in that climate almost automatically offensive and subversive. In his study of the Berlin Secession that prepared the ground for Expressionist art, Peter Paret notes how that group oversaw "the emergence in German art of a sense of the individual and his environment that acknowledged and often emphasized elements of disruption, illness and crisis" (201). But the artists later known as Expressionists soon formed their own groups, such as

"Die Brücke" (The Bridge) in Dresden from 1905–11, which included Ludwig Kirchner and Erich Heckel, Karl Schmidt-Rottluff and Fritz Bleyl, Emil Nolde and Max Pechstein; and in Munich, first the Neue Künstlervereinigung München (New Artists' Association Munich) and then the Blaue Reiter (Blue Rider) group from 1909–12, which included Wassily Kandinsky and Gabriele Münter, Franz Marc and Alexej Jawlensky, among others. Though these two groups shared general features of bright, antinaturalistic coloring and a reduction of the sort of draftsmanship and linear perspective that characterized academic art, the groups also represented in their differences the broad range of Expressionist art once it had been liberated from the constraints of official public taste and expectations. The work of Brücke artists evinces in general a sharp angularity of form, and an edginess of line and brushstroke, especially in the work of Kirchner and Heckel, that shows their interest in and debt to African sculpture and to traditions of the woodcut, which they revived as a prominent art form; that use of line combines with an unnatural luridness of color and tilting perspective to deform people and things, and capture a particularly modern condition of urban anxiety or dis-ease, which seems to pervade and unsettle both the canvas and the viewer. In contrast, the paintings of the Blue Rider group recall less the muscular rawness of the woodcut than the tranquility of stained glass in the composition of bright color fields and sweeping lines into seemingly enchanted and ethereal landscapes that later verged in Kandinsky's work into symphonic abstractions of intermingling colors and geometric forms that he called Improvisations. Expressionist subject matter seems to fluctuate wildly between the antipodes of rural idyll and metropolitan alienation, between tranquility and catastrophe, between Otto Mueller's peaceful reclining nudes in the grass and Kirchner's leering, lascivious prostitutes in the city, between Kandinsky's almost iconic abstractions and Ludwig Meidner's apocalyptic landscapes, between the concentrated energy of Franz Marc's stunning animal images and the scattered tumult of Georg Grosz's and Otto Dix's satiric cityscapes, filled with animalistic humans, between the eloquent poise in the portraiture of Erich Heckel or Alexej Jawlensky, of Oskar Kokoschka or Max Beckman, and the grotesque, anonymous masks of James Ensor and Emil Nolde, among so many other divergent tendencies and highly individual talents. The brilliance and breadth of Expressionist art is regularly on display in museums all over the world, such as the Neue Galerie (see above), and has been described and chronicled by such scholars as Peter Selz, Donald Gordon, Stephanie Barron, Shulamith Behr, and Walter Dube, to name the authors of several now classic texts. Though outside the purview of this volume on the literature of German Expressionism, the visual imagery of Expressionist art forms a necessary backdrop to the literature, not only because the artists shared with the writers the same ideals, obstacles, and themes for their work, as well as their cafés and journals, but also because the painting

recalls what was at stake in the dramatic departure of Expressionists from prior modes of representation. The medium of painting itself took on a new vibrancy and immediacy that all other artistic mediums, whether in image or word, sought to emulate.

Thus, as in painting, a new consciousness of the medium gave rise to the experiments of the Modernist or Expressionist avant-garde in literature. As literary parallel to Ferdinand de Saussure's *Cours de Linguistique* (1902) and Fritz Mauthner's studies of language, the new self-consciousness about the limitations, and conversely, about the expressive potential of language, emerged in Hugo von Hofmannsthal's fictive letter from Lord Chandos (*Ein Brief* [A Letter], 1902), marking an epochal turning point for German literature, from the panoramic breadth of Realist narration to lyrical moments of rhapsodic vision. The *Sprachkrise* or "crisis of language" depicted in the Chandos letter eloquently frames — paradoxically in the ornately complex periods of Renaissance rhetoric — the desire to find a new language capable of expressing essential truths about existence, "eine Sprache, von deren Worte mir auch nicht eines bekannt ist, eine Sprache, in welcher die stummen Dinge zu mir sprechen" (a language of whose words I also know not a one, a language in which mute things speak to me, 22; editor's translation). Simple objects become vessels of revelation for him, but the traditional rhetoric that Chandos employs *and* abjures can only describe the desired affect, but not otherwise communicate the immediacy of his anguish or rapture. In effect, the Chandos letter of 1902 gave poetic license to the Expressionist generation to explore new forms of expression in language, new means of organizing words or verbal particles on the page, in order to explode conventional narration and give fuller expression to spiritual longings. The tightly compressed and complex organization of that letter ultimately issues, in a moment of what might be called "stylistic reve-lation," a moment of paratactic intensity that adumbrates and crosses over into the realm of verbal experimentation explored by the Expressionist gen-eration.[9] Hofmannsthal's letter showed the way and prepared the rationale for what other writers did in the realms of prose, poetry, and drama. As a sharp rejection of social convention and its corresponding rhetorical forms, and as an attempt to inaugurate and embrace a whole new sense of artistic practice or style and get closer to an immediate and unfragmented experi-ence of life, the Chandos letter is, apart from its sixteenth-century English dress-up, imbued with the spirit of early Expressionist primitivism.

Primitivism emerged as a means of calling into question the conven-tions both of pictorial representation and of bourgeois society.[10] Though its roots reach back into the eighteenth century and beyond, primitivism became a dominant force in twentieth-century European art, particularly in German Expressionism, where it came to subsume aesthetic elements as well as a broader critique of culture: it served in short for a sort of decolo-nization of the mind of the German avant-garde from its bourgeois,

imperialist upbringing (while most likely also reinforcing a strain of brutal sexism endemic to the avant-garde and Expressionism). While visibly present in the art of the period in the rejection of verisimilitude, the simple forms and awkward shapes, the heavy lines and disharmonious proportions, the term embraces a broad range of thematic elements in both art and literature: the flight from civilization and a return to nature, the exoticism of locales, the rejection of the forms of technological culture, of rationality or even consciousness, hence a fascination with its opposites, with animals and animality, with will or instinct, violence and sexuality, an exaltation of vitality for its own sake, and further, with insanity, sickness and depravity, alienation and estrangement embodied in outsiders — in short, the term refers to forms of regression away from the inhibiting refinements and constraints of modern culture, founded on assumptions of technical rationality and cultural progress. Primitivism provided a means for critique of society and liberation from convention: as such, primitivism creates both analytical distance and, paradoxically, an emotional, visceral proximity, a felt nearness to experience and heightening of the senses, which emerged also under the alternate rubric of the "New Pathos," which became in turn the name of another leading journal.[11] Primitivism is not nostalgia or flight from reality, but a way of calling into question artistic and social practices and getting under the skin, so to speak, of convention in order to create a space for new thinking. As an expression of critical modernism in the arts and of historical modernity, primitivism lies at the heart of German Expressionism, which thus stands in relation to German colonial practices in Africa and elsewhere. The articulation of that relation constitutes a new dimension in research on Expressionism.

Aside from the painters who drew upon African sources directly (or indirectly through French mediation), the central figure in Germany in the discovery of African art for its aesthetic rather than its ethnological merit was the theorist of Expressionist poetics, experimental prose writer, and art theorist Carl Einstein, who in fact transported Worringer's theory of abstraction directly into his own literary practice and into art criticism. Indeed, Einstein's *Bebuquin, oder die Dilettanten des Wunders* (Bebuquin, or the Dilettantes of Miracle, begun 1906, publication 1912) is an extraordinary work that employs principles of analytical cubism in imaginative prose.[12] Carl Einstein then also introduced African sculpture to a European audience for the first time as a serious art form with his book *Negerplastik* (African Sculpture, 1915), consolidating the Expressionists' conceptual debt to African art.[13] Typically, Einstein was viewed for decades as a minor Expressionist, but further detailed examination of his work and career has since elevated him in stature to a Modernist of the first rank for his analytical depth and theoretical complexity. In that respect, Einstein's works, like the early work of Gottfried Benn, represent what was once the conventional status of Expressionism in discussions of German art and

literature as a kind of sideshow to Modernism, where lesser talents made a lot of light and noise, pubescent sound and fury signifying little, before advancing to more mature, serious, and broadly significant achievements. As documented in Richard Brinkmann's compendious research reports in 1961 and 1980, it took decades for scholarly research to gain perspective on an individual career, or to realize the depth and importance of even just a single work, and then to reassess the status of an artist or a writer such as Carl Einstein. Now the sheer accumulation of such revisions has brought about successive reassessments of Expressionism in relation to Modernism as the site of essential and complex confrontations with modernity.

With the fall of that wall between Expressionism and Modernism, the focus of research has shifted in recent decades to the long-neglected prose of the period in order to examine the disruptive practices of authors from Carl Einstein to Alfred Döblin to Franz Kafka (see Corngold), and to move about more freely within the broad range of prose experiment in the period. Walter Sokel's foundational essay "Die Prosa des Expressionismus" (The Prose of German Expressionism), in this volume in English translation for the first time, assigns to Carl Einstein, as theorist and practitioner, a pivotal place in Expressionist poetics opposite Alfred Döblin; their respective poetics represent two principal but divergent tendencies that embrace the range of experimentation in that genre, which Rhys Williams describes further in his essay. Some of the most intense prose of the Expressionist generation belongs to figures better known as poets, such as Georg Trakl, Georg Heym, and especially Gottfried Benn, whose prose proceeds from and culminates in the sort of rhapsodic moments and "absolute ciphers" (*Chiffren*) that characterize his poetics in general and his own poems. Though the prose of this period has emerged to bridge the former divide between Modernism and Expressionism and to extend the range of the theoretical discussion or debate about Expressionism, the centerpiece of literary Expressionism remains lyric poetry.

The short form of the poem begins at the point of intensity that Expressionist prose seeks to attain. Accordingly, the monumental and representative anthology of German Expressionist poetry *Menschheitsdämmerung* (Dawn of Humanity, 1920), which divides the field of Expressionist poetry thematically into four areas, opens with the short poem "Weltende" (End of the World, 1912) by Jakob van Hoddis, which announced the new style now commonly associated with Expressionist poetry in its staccato rhythms, paratactic construction and portentous imagery.[14] Because of these, his work verges on the satirical, whereas Georg Heym's poems, such as "Umbra Vitae," "Der Gott der Stadt" (The God of the City) and "Die Dämonen der Städte" (The Demons of the Cities) illustrate the mood of apocalyptic modernity in Expressionism. Michael Sharp's essay describes the organization of that all-important collection, the stylistic and topical range of its inclusiveness, and its

shortcomings; he then, as a corrective measure, introduces some of the Expressionist poets *not* included in that epoch-making collection, thus providing an expanded portrait of the epoch in Expressionist poetry, and its immediate influence. Likewise, in her essay, Barbara D. Wright situates the concept of Woman, and real women artists, in the intellectual and literary-historical contexts of Expressionism and then extends the portrait of the epoch and the movement even further by focusing on women poets, adding another important dimension to the revision of the canon set by *Menschheitsdämmerung* and of Expressionism as a whole. Both of these essays give a direction for necessary future archival and historical research.

In *Menschheitsdämmerung* one finds some of the shortest and longest poems in the German language, from August Stramm's telegraphic war poems to Franz Werfel's "O Mensch!" exultations ("Mein einziger Wunsch ist, dir, O Mensch, verwandt zu sein!" *MHD*, 279; My only wish is, O human, to be related to you! *DoH*, 301), as well as some of the most beautifully elegiac, stridently ecstatic and vividly vituperative. In the words of Johannes Becher's "Eroica," the poems of *Menschheitsdämmerung* appear together "Wild wie mild ineinandergefügt / Reihenweise" (*MHD*, 265; Wildly as well as mildly joined together / in rows; *DoH*, 288–89). James Rolleston's essay on "Choric Consciousness," however, demonstrates the significance of Expressionist poetry in intellectual-historical terms, as it articulates, in different forms but in Nietzschean-Dionysian fashion, the crisis and collapse of inherited tenets of perception; he links their shared Expressionist pathos (for example, "ein Weinen in der Welt" [a weeping in the world; Lasker-Schüler, 75]), though this was often laced with intellectuality or cynicism, to the refraction and demise of the autonomous or bourgeois subject. From that perspective, Werfel's "O Mensch!" is no longer an exultation, but rather a lament, an echo from the abyss; that abyss has existential and also stark historical contours, which emerge vividly in Klaus Weissenberger's depiction of the political or activist strain in Expressionist poetry. The art of political engagement and social activism, seen collectively, attempted to inspire and enact a transition from formal autonomy on the page to other forms of social discourse off the page, within a new social collectivity. In this respect the anthology as a genre becomes a blueprint for society as a collection of heterogeneous voices bound together in a common spirit.

Like van Hoddis's famous "Weltende" (End of the World),[15] the less well-known poem "Meine Zeit" (My Age) by Wilhelm Klemm also captures, in starkly representative fashion, essential elements of Expressionism and of the genre of poetry in confrontation with the historical conditions of modernity:

> Gesang und Riesenstädte, Traumlawinen,
> Verblaßte Länder, Pole ohne Ruhm,

Die sündigen Weiber, Not und Heldentum,
Gespensterbrauen, Sturm und Eisenschienen.

In Wolkenfernen trommeln die Propeller.
Völker zerfließen. Bücher werden Hexen.
Die Seele schrumpft zu winzigen Komplexen.
Tot ist die Kunst. Die Stunden kreisen schneller.

O meine Zeit! So namenlos zerrissen,
So ohne Stern, so daseinsarm im Wissen
Wie du, will keine, keine mir erscheinen.

Noch hob ihr Haupt so hoch niemals die Sphinx!
Du aber siehst am Wege rechts und links
Furchtlos vor Qual des Wahnsinns Abgrund weinen! (*MHD*, 40)

[Song and giant cities, dream-avalanches,
Faded lands, poles without glory,
The sinful women, perils and heroism,
Spectral brewings, storm on iron rails.

In cloudy distances the propellers drum.
Nations melt away. Books turn into witches.
The soul shrinks to tiny complexes.
Art is dead. The hours move in swifter circles.

O my age! So indescribably mutilated,
So without star, so existentially poor in knowledge
As you no other age seems to have been.

Never before did the sphinx raise its head so high!
But you see to the right and left of your path,
Dauntless in the face of affliction, insanity's abyss weeping!
(*DoH*, 62–63)]

Like the newspapers that bombard modern consciousness (and later all the more so with, successively, radio, television, and the Internet), the poem presents a catalog of images and phrases that characterize, along lines of dialectical opposition, the extreme situation of mankind in modernity: from harmonious lyricism (*Gesang*) to churning and cacophonous urban life (*Riesenstädte*); from intensely subjective and irrational oneiric interiority (*Traum*) to the impersonal and inexorable violence of nature (*Lawinen*); from the disappointments of nationalism (*Verblaßte Länder*) to those of internationalism (*Pole ohne Ruhm*); from the perceived transgressions of women (*Die sündigen Weiber*) as prostitutes outside bourgeois norms, or as housewives within those norms, to the heroism of those

transgressions against repression in patriarchal society; from the advances of technology, as in aviation, to its misuses in war (*trommeln die Propeller*); from the advances in communication that bring people together to the disintegration of peoples (*Völker zerfließen*); and on to the misuses of reason in the service of unreason, and persecution of authors through censorship (*Bücher werden Hexen*). Science and technology seem either to explain away or militate against mankind's essential humanity, which is threatened, if not quite with extinction, then with deforming reduction to an historical atavism, a mere Id, through systematic explanation (*Die Seele schrumpft zu winzigen Komplexen*). Art too has lost its mystery (*Tot ist die Kunst*) and its ability to resist those historical imperatives, which only allows for the acceleration of the whole process (*Die Stunden kreisen schneller*). As a result, both the individual and the collective are "indescribably mutilated / [. . .] so existentially poor in knowledge," overcome by a feeling of apocalyptic incomprehension. In a variation on Shelley's "Ozymandias" from a century earlier (1817), and more in line with Yeats's "The Second Coming" (1920/21), the sphinx, conventional symbol of the historical mystery of bygone ages, raises its head in perplexity and confusion, now a symbol of the immediate incomprehensibility of the present. Modern mankind stands uneasily at the heights but also precariously on the edge of historical change, overwhelmed and uncertain how to move ("to the right and left [. . .] insanity's abyss").

That precarious historical position of the individual and Western culture emerged most powerfully, in three dimensions, in the theater of Expressionism, as dramatists began to strip away, both literally and figuratively, in the décor and the language, the layers of representation typical of the Naturalist stage that conceal, distort, or distract from essential dilemmas of existence. From Frank Wedekind's *Frühlings Erwachen* (Spring's Awakening, 1891), which anticipates many elements of Expressionist drama, to the work of Bertolt Brecht in the early 1920s, with its roots in Expressionist vitalism, the individual steps forth in agonies of opposition to the reigning order, whether political or existential. The works of Wedekind beginning in the 1890s and of Brecht beginning in 1918, frame, chronologically and conceptually, the development of Expressionist drama as it evolved away from Naturalism to find new technical and rhetorical means of presenting, or rather emoting, the anguish of the individual within bourgeois society. In the work of both dramatists, however, the individual remains enmeshed within the strictures of society, which elicits the audience's critical-analytical engagement, whereas Expressionist drama shifted the emphasis, in varying degrees, to the priority of the individual's vision and emotional outpouring over such confinements, which elicits empathetic involvement. In *Frühlings Erwachen*, Wedekind's depiction of pubescent sexuality offers a critique of bourgeois morality, its institutions of family and school, and its use of language to repress and belie sexuality,

but the play also tries, in its form and rhetoric, to present a new language for emotion in the disjointedly uncertain utterances of confused feelings among the adolescents in the play, leading to what Peter Jelavich calls "the first expressionist scream in modern German literature" (137) in Moritz's monologue:

"Aufschreien! — Aufschreien! — Du sein, Ilse! — Priapial! — Besin-
nungslosigkeit! — Das nimmt die Kraft mir! — Dieses Glückskind, dieses
Sonnenkind — dieses Freudenmädchen auf meinem Jammerweg! — —
O! — — O! — — — — — — — — — — — — — — — — — — — — — / — —
— — — — — — — — — — — — — — — —." (act 2, scene 7)

[Scream! — Scream! — To Be You, Ilse! — Priapal! — Thoughtlessness!
— That robs me of strength! — This child of fortune, this child of the sun
— this maiden of pleasures on my way of woe! — — Oh! — — Oh! — —
— — — — — — — — — — — — — — — — — — — / — — — — — — — —
— — — — — — — — —.]

The scream or Schrei that surpasses speech becomes the signature of Expressionist drama, and Wedekind's play became the prototype for multiple dramas in the next generation about youth in revolt.

Oskar Kokoschka's play *Mörder, Hoffnung der Frauen* (Murderer, The Women's Hope, written 1907, first performed 1909 and first published 1910) cleared the stage of any verbal or decorative vestiges of Naturalism with an extremely reductive and ritualistic portrayal of sexual antagonism and violence, expressed in stark animalistic movements, primary colors, grotesque gestures, and elliptical speech, such as from a bleeding man who utters: "Sinnlose Begehr von Grauen zu Grauen, unstillbares Kreisen im Leeren, Gebären ohne Geburt, Sonnensturz, wankender Raum" (Denkler, 50–51; Senseless craving from horror to horror, unappeasable rotation in the void. Birth pangs without birth, hurtling down of the sun, quaking of space; Schürer, 3). Like so much of Expressionism in general, Kokoschka's play crosses the bounds of established conventions in terms of genre (and morality) as a paradoxical sort of *Gesamtkunstwerk* of aggressive — not soothing — synaesthesia. This primitivist encounter of the sexes exploded the social nuance and delicacies of domestic drama, and of Viennese polite society. Kokoschka's agonistic performance piece was partly modern dance (movement), partly poetry and music (verbal and nonverbal sound), and also partly painting (image) — not least for the play's famous poster and the actors' painted bodies. In that very literal way, Kokoschka tried to render rawly visible the visceral inner life of mankind.

As a result, his play serves as a prototype for three main types of Expressionist drama[16] that overlap but can nevertheless be clearly distinguished. The first type most readily marks the transition from developments in the visual arts: the spiritual drama of heightened formal expression (known under the rubric *Geist*) was influenced before the war

by Maurice Maeterlinck's symbolist drama and by Kandinsky's *Über das Geistige in der Kunst* (1912) and his stage compositions such as *Der gelbe Klang* (The Yellow Clang, 1909); it was characterized by esoteric, mystical, and meditative stage imagery, as an abstract visual composition. In such performances, what would normally be the visual background becomes the foreground action, or at least gains greater prominence to create a synaesthetic *Bühnenkunstwerk* (stage artwork) as advocated and practiced after the war by Lothar Schreyer and the circle around Herwarth Walden's journal *Sturm*, and later represented by Schreyer's *Sturm-Bühne* staging of August Stramm's *Sancta Susanna* (Saint Susanna, 1918) in Berlin in 1918. This form of *Geist* or spiritual drama aims at the formal unification of elements on stage (through rhythms of sound, color, language, movement) in concord with the entranced audience.

The second type is the ecstatic performance of emotional intensity (*Schrei*), as illustrated in Edvard Munch's famous lithograph, which centers less than *Geist* performance on atmospherics and more upon the central figure; it thus depends on the actor's own charismatic range of physical performance and vocal expression. Indeed, the concept of the *Schrei* marks the new poetics of performance that emerged in Expressionism based on the presence of the primal Self on stage, which entailed in turn new registers of voice and what David F. Kuhns calls a new "physical grammar of expression" (50) for the actor. Therefore, actors such as Werner Krauss, Fritz Kortner, and especially Ernst Deutsch became closely associated with Expressionist drama in this vein and famous for the moody and energetic physicality and vocality of their acting. Such intensity on stage no longer seemed like acting in any conventional sense. Like the paintings and woodcuts of Expressionism, this sort of performing aimed not at organically coherent wholeness, but rather, in its volatile, almost spontaneous, abruptness, at an emotional angularity of character, enhanced by grand gestures or "symbolic posturing" (Kuhns, 128), usually emerging in the confrontational dialogues of a small group of central figures. Such plays as Reinhard Sorge's *Der Bettler* (The Beggar, 1912), Paul Kornfeld's *Die Verführung* (The Seduction, 1913), and Walter Hasenclever's *Der Sohn* (The Sohn, 1914) typify this mode of performance. In all three plays, the *Schrei* is the moment when the character enacts, in a situation of rage and revolt against obstacles and constraints, what David Kuhns calls "a breakthrough in cultural consciousness" (132) that reveals on stage the historical dimensions of an existential situation. Such moments also reveal the central Expressionist theme of the reborn "New Man."

The third type of performance is emblematic allegory, also called *Ich*-drama, though that latter term is misleading. *Ich*-drama is not about the individual as much as about the idea mediated by that character. Unlike Schrei performance, the central figure in emblematic allegory does not stand alone but figures as part of an ensemble or opposite a chorus, which

creates a tension between the individual and the group. Through heightened visual scenarios, this tension enacts the idea of the play, which is topical and thus in part depends on the historical circumstances outside the theater. Whereas *Geist* performance attempted a sort of transcendent spiritual communion with the audience in the theater, emblematic performance attempts to forge community beyond the individual in order to address and ultimately change society at large. Georg Kaiser's play *Von morgens bis mitternachts* (From Morn to Midnight, 1912) illustrates this mode in its depiction of the journey of the Bank Cashier, who, once galvanized by a chance contact with a beautiful woman in the bank, overturns his dull life by stealing a huge sum from the bank and going off in search of intense life. The stations of his journey get acted out in seven scenarios, as he moves from the provincial bank to his home, and then to a crowded velodrome, a cabaret, and a Salvation Army hall, where he ends up, disillusioned, shooting himself and dying in an Ecce Homo scene of crucifixion. Ernst Toller's *Die Wandlung* (The Transformation, 1918) likewise follows the journey of a generalized Everyman figure, Friedrich, through the horrors of trench warfare to a revelation, an apotheosis even, of general humanity.

Like other verbal and visual genres, Expressionist drama, in which the visual and verbal dimensions merge on stage, evinced such a turn to abstraction, though again that turn did not necessarily reflect a flight from history — as Lukács would have it in his famous retrospective indictment of Worringer and Expressionism from 1934 — but rather the very historicity of Expressionism's defense of mankind in response to both established tradition and the changed conditions of modernity.[17] In effect, in all three of these dramatic modes of performance, the actors do not represent a character as an individual; rather they present a social type, an idea, or a state of being, — usually in the process of transformation, — whose successful portrayal therefore depends greatly on the circumstances of the specific production and the abilities of the actors: hence the increased emphasis in recent scholarship on aspects of the individual productions and the performance of different plays at different times by different directors and actors. In each case, the actor's body becomes the focal point for and indeed vehicle of historical change: the body as idea, enacted by the drama, in its relation to society.

In these Expressionist allegorical station dramas, such scenes allow for vivid visual stylization that reinforces the play's central idea, emblematically, as a sort of visual oratory. The use of stunning backdrops and stark lighting collapses the three-dimensional space of the stage into a broken sequence (that is, without transitions) of virtually two-dimensional allegorical pictures or emblems. The emergence of the body and the elevation of physical gesture in Expressionist drama resulted from the reduction of stage décor (from the Naturalist stage) and the sparseness of design, as well

as from the reduction of language: instead of staying within the norms of conventional dialogue, the language swings from single explosive words to rhapsodic monologues, both of which can serve to frame a powerful silence that foregrounds the expressive body of the actor in its looming physicality. Walter Sokel calls this alternation of silence and speech, word and pause, in Expressionist drama a "linguistic chiaroscuro" (*Anthology*, xx). In short, the drama of Expressionism is characterized by enunciatory movements and moving utterances, by physical and verbal gestures, by "exclamation and pantomime" (*Anthology*, xx), which anticipated and coincided with developments in the graphic novel and in silent film.

Since the earliest film actors were trained as stage actors, there was an inevitable closeness between the two mediums from the outset, but the developments in the Expressionist stage, as outlined above, provided for an uncommon affinity between Expressionist avant-garde stagecraft and early Expressionist art cinema, best evinced by Robert Wiene's film *Das Kabinett des Dr. Caligari* (The Cabinet of Dr. Caligari, 1920). Like the Expressionist stage from Kokoschka on, film drew heavily upon painting to reduce or abstract the three-dimensional stage space of the acting and transform the actors into pictorial elements, as Lotte Eisner noted in her famous study *The Haunted Screen: Expressionism in the German Cinema and the Influence of Max Reinhardt* (originally published in France as *L'Ecran Démoniaque* in 1952). In this work she draws upon Worringer and Rudolf Kurtz, who himself cites Worringer in his *Expressionismus und Film* (Expressionism and Film, 1925) in order to describe the painterly abstraction of the sets and actors in *Caligari* and the strange effects of their angular "Gothic" distortions.[18] *Caligari*'s three set designers, Herman Warm, Walter Röhrig, and Walter Reimann, were in fact associated with the *Sturm* circle of Berlin Expressionism and set about using "zigzag delineations designed to efface all rules of perspective. Space now dwindled to a flat plane" (Kracauer, 69) against which objects appeared as "emotional ornaments" (Kracauer, 69) to elicit an uncanny mood of disorientation and estrangement. On his murderous outings, dressed all in black, the pallid sleepwalker Cesare (played by Conrad Veidt), under the mind control of his master, Dr. Caligari (played by Werner Krauss), seems to merge with the shadows and lines of the townscape. Though the film image can isolate a powerful gesture, that gesture is inevitably divorced from the voice and presence that forcefully anchored the Schrei performance on stage, yet the graphic image exerts a different, equally powerful, even hypnotic, effect of its own, as thematized by the film itself, which invites the viewer to think through the relations of sight and seduction, vision and violence. In order to contain and mute the potential force of this film's themes and images, the producer Erich Pommer decided to impose on the film a narrative framework that reverses its revolutionary indictment of institutional authority figures as insane, homicidal fanatics who themselves need to be

institutionalized.[19] Sabine Hake's essay in this volume defines the film's "uniquely filmic effects" as well as its "irresolvable tensions" that resist formal closure, while also posing questions whose answers extend well outside the film itself into German society in the Weimar period, including the relation of film in general to Expressionism.[20] As Hake notes, Caligari embodies a crucial "paradigm shift in the conventions of filmic representation" from a medium of spectacle to a medium of "narrative integration" of increasing scope and complexity. In many ways, as first suggested by Kurtz and explained here by Hake, early Weimar or Expressionist film absorbed, revised, refined, and ultimately tamed or domesticated the unruly visions of Expressionism, integrating them fully into society through the new technology of a mass medium, a process which extended also to poster advertisements for Expressionist films.[21]

The tensions between "representational paradigms of showing and telling" (Hake) in Expressionist film and literature, also arise vividly in a genre that has received little attention from scholars, though it combines features from several Expressionist genres. As developed by Frans Masereel, the woodcut or graphic novel uses no words at all to develop its powerful narrative line: instead, the deeply gouged lines of Expressionist woodcuts create images of stark simplicity that isolate in a single moment (as in painting) bold gestures and incidents (as in drama) that follow one another in successive frames (as in film) to create a slow, powerful, strobic effect of declamatory images. Though not a new form of visual technology like film, the woodcut novel offers a vivid counterpoint to both the visual dimension of prose narratives and to the narrative dimension of film in this period. Perry Willett's essay in this volume constitutes a landmark inclusion of the woodcut novel into discussions of Expressionism, where it rightly belongs. The strong lines of plot and picture in the graphic novel reinforce one another in a compact message of social critique and political protest against inequities in post-First-World-War German society.

Of course, the single greatest confrontation with modernity by German artists took the form of the First World War (1914–18), which marked the chronological center of the Expressionist decade (1910–20): some artists had anticipated the war in their apocalyptic visions (Georg Heym), others joined naïvely in the nationalist fervor, while for others it became the focal point of their critique of German society and modern technological capitalism. The war decimated the ranks of Expressionist artists from Alfred Lichtenstein, Georg Trakl, Ernst Stadler, and August Stramm to Franz Marc and August Macke, and to survivors it marked the cataclysmic demise of an obsolete patriarchal and authoritarian society, clearing the ground for a potential renewal of general humanity after the flight from Germany of Kaiser Wilhelm II on November 9, 1918 and the proclamation of a republic with elections to come. Various factions invoked, to varying degrees, the Russian Revolution of 1917 as a model

for German society. The active participation by many artists and intellectuals in the revolution of 1918–19, along with Ernst Toller's position as chair of the First Revolutionary Council in Munich, signaled to many the coming together of radical art and radical politics, its effective union at last in the present, as a step toward a "concrete Utopia" (Ernst Bloch), — but such a hopeful condition did not last. Nonetheless, the fusion, not to say confusion, of art and politics, produced a fascinating imbrication of the two in mediums from poetry to poster art to political discussion: to no small extent, Expressionism had become the common graphic idiom of applied ideology in public pronouncements. The political dimension of Expressionism had begun to emerge in all genres before the war (for example, in Franz Pfemfert's *Die Aktion*), during the war in calls to pacifism and protest, and then most fully in the immediate postwar period of revolution, which in turn marked for many artists and critics either the acme or the end of Expressionism — whether because of its move from art to direct engagement with political life, or because of the failure of direct engagement in that "desperate and euphoric time" (Rigby, 1). The sense of renewal, the hope of Expressionism, then faded fast.

The note of sobriety, even elegiac sadness, that signaled the end of Expressionism was sounded by Wilhelm Worringer in his lecture "Kritische Gedanken zur neuen Kunst" (Critical Thoughts on the New Art, 1919), where he remains deeply sympathetic with the Expressionist attempt to spiritualize expression through art, if only ultimately to no end other than to adorn "jene unsichtbare Kathedrale des Geistes" (that invisible cathedral of the spirit; *Fragen und Gegenfragen*, 102). His disappointment or despair about the failure of the collective Expressionist project of revitalizing art and culture resounds also in commentaries by such contemporaries as Wilhelm Hausenstein and Adolf Behne, among others (Haxthausen 1990, 183–89). In addition to the German defeat in war and the failure of the revolution, these critics were also demoralized by the ubiquitous commercialization of art (under the rubric of Expressionism), which they saw as a sort of decorative decadence, along with the new artistic legitimacy and prestige of film. Of course, their own increasingly tenuous economic status, as examined by Fritz K. Ringer in his study of the German "mandarin" class of this period, helped to shape their views of the long term "Decline of the West."

Yet this sense of an ending helped to pave the way for a "New Sobriety" or "New Objectivity" in the arts based upon social analysis and critical realism during the Weimar period, a trend in which these same critics then participated, thus extending the range of Expressionism — albeit through the dialectical negation of its name and its derivative contemporary manifestations — into different new forms of art and artistic practice (Crockett).[22] Indeed, in his essay "Künstlerische Zeitfragen" (Questions about Contemporary Art, 1921), Worringer argues that the spirit of Expressionism has

migrated from art to scholarship, precisely into such works of intellectual history as Oswald Spengler's *Der Untergang des Abendlandes* (The Decline of the West, 1923), and including his own later works, such as his proto-postmodern reading in 1927 of ancient Egyptian art and culture as a critique of Americanization in Weimar Germany.[23] Yet those works of cultural pessimism begged the question of their own broad political implications, as has been since articulated by Fritz Stern in his *The Politics of Cultural Despair: A Study in the Rise of the Germanic Ideology* (1961).

The critical dimension of Expressionism and post-Expressionism became the central topic in the 1930s with Georg Lukács' essay "Größe und Verfall des Expressionismus" (Greatness and Decline of Expressionism, 1934), with his ad hominem critique of the movement, indicting Expressionism in general and Wilhelm Worringer in particular as representing "eine gedankliche Flucht vor der Wirklichkeit" (a flight in thought from reality; 123) or, in short, a "Fluchtideologie" (an ideology of escape; 123). He defines the flight from reality into art that he finds in Expressionism and in Worringer as "eine typische Verhüllungs- und Vernebelungsideologie der niedergehenden Bourgeoisie" (an ideology of deception and obfuscation typical of the declining bourgeoisie; 125). Lukács cites Worringer's "eulogy" of Expressionism, his so-called funeral speech (*Grabrede*) of the movement from 1919, but in his indictment also goes back to Worringer's *Abstraktion und Einfühlung* (1907) in order to frame his general condemnation of Expressionist writers (whom he quotes) from Ludwig Rubiner to Karl Otten to René Schickele, Franz Werfel, Walter Hasenclever, Albert Ehrenstein, Georg Kaiser, et al. Lukács uses Worringer's work to underscore his thesis that Expressionist authors, — though at times seeming to subscribe to programs (or at least pronouncements) of revolution —, actually translate that concept away from its economic determinants and away from class conflict between the bourgeoisie and the proletariat; instead of espousing social change, they turn away from reality and the possibility of changing it and flee into idealistic abstractions that remain impenetrable to reason and are thus irrational. Such a turn away from reality and reason represents for Lukács not progress but reaction, leading to fascism. He ignores any potential for critique in Expressionism and its forms (verbal, visual, gestural) as well as the totalizing and aesthetically conservative impulse of his own approach.[24]

Lukács's condemnation of Expressionism, from a narrow and doctrinal Marxist/Leninist perspective of social-realism, appeared in the same year as (and hewed closely to) the articulation of the official social-realist aesthetic in the Soviet Union by Andrei Zhdanov at the first All-Union Congress of Soviet Writers, but this was the same year (1934) as Adolf Hitler's denunciation of avant-garde art at the National Socialist Party congress (Reichsparteitag) in Nuremberg (Golomstock, 81–113). Hitler's public denunciation of international modernism in the arts put an end, more or

less, to an internal struggle within the Nazi party (between Josef Goebbels and Alfred Rosenberg) over the relation of National Socialism to avant-garde art, such as that of Expressionism and militaristic Futurism. Josef Goebbels, the minister of propaganda, had once, like Hitler himself, had artistic ambitions (though in literature, not painting) and had even penned a novel, *Michael* (unpublished in Germany; first published in English in 1987): thinking of his Party comrades, his partners in crime, he is purported to have absurdly exclaimed "Wir sind alle Expressionisten!" (We are all Expressionists!). Yet the early possibility, however unlikely, of an integration of the avant-garde into Nazism had seduced figures such as Rudolf Blümner (from the *Sturm* circle), dramatist Arnolt Bronnen, the painter Emil Nolde, and, most infamously, the poet Gottfried Benn. The convergence of Benn's "Bekenntnis zum Expressionismus" (Avowal of Expressionism, 1933), where he tries to defend Expressionism and reconcile it to Nazism through their shared anti-bourgeois posture, with his introduction "Der neue Staat und die Intellektuellen" (The New State and the Intellectuals, 1934), a short historical-metaphysical justification of Nazism, elicited a response from Klaus Mann in his essay "Gottfried Benn: Geschichte einer Verwirrung" (Gottfried Benn: The Story of a Confusion, 1937), which began the now famous "Debate about Expressionism" (Expressionismus Debatte) in the Moscow German exile journal *Das Wort*. That debate, whose starting point was Lukács's indictment of Expressionism and Klaus Mann's indictment of Benn, revolved precisely around the degree of critical potential, or lack thereof, in Expressionism.[25]

Nevertheless, by the time of that debate, however interesting and necessary its examination of German Expressionism from the perspective of exile from Germany, German literary Expressionism had already been subjected to an attempted eradication, both symbolic and very real, by the Nazi book burnings in bonfires across Germany on May 10, 1933, which signaled in a horrific manner the antipathy of Nazi ideology toward experimental, avant-garde literature, and toward any works by socialist, Expressionist, or Jewish authors. In the same vein, the exhibit of so-called "Entartete Kunst" (degenerate art) that opened in Munich in 1937 (and subsequently traveled from city to city), marked the apogee of the impulse in Germany toward virulent anti-modernism as well as the next step in the public institutionalization of that antipathy under National Socialism. The majority of writers of German Expressionism did not try to join the regime, like Benn or Johst, or go into so-called "inner emigration,"[26] but were forced into exile: some, like Walter Hasenclever and Carl Einstein, died by their own hand, in detention or on the run, while others got away to languish in exile, scattered around the world (see Serke). To a large extent, the writers of German Expressionism and their works, literally the copies of their books, along with the audience for those texts, were destroyed by the Nazis. The book burnings, or the fact of missing books, authors, and an

audience, prevented or forestalled for decades further reception and critical, scholarly scrutiny of these works, and thus still determined in large part the reception of that work.[27] Nonetheless, immediately at the end of the Second World War, with the (re)discovery of Franz Kafka, Wolfgang Koeppen's expressionistic (lower case) novels, Alfred Döblin's influence on Günter Grass in prose and the emergence of Wolfgang Borchert's work (*Draußen vor der Tür* [Outside at the Door], 1947) on the stage, and the continuing influence of Gottfried Benn's poetry, to name just a few instances, the styles and vitality of German literary Expressionism reemerged forcefully to help forge the new literature of postwar Germany, often even before the actual works of Expressionist literature had themselves again become available. The recovery and reissue of works of Expressionism has continued to the present, which reflects the fact that the literature of German Expressionism arose from and reflected upon the most critical periods of German cultural history in the twentieth century, before, during, and after the First World War, during the Weimar period, and in the immediate postwar period. In its abundant and manifold manifestations, German literary Expressionism reflects the anguish and intensity, the complexity and convictions, of Germany's sudden and explosive modernity, whose many facets continue to fascinate and influence, and to invite analysis.

# Notes

[1] See Stephanie Barron's essay "The Embrace of Expressionism: The Vagaries of its Reception in America" (1989) for a concise history of the "gradual appreciation of the movement in this country" (131) up to that exhibit. In addition, mass market phenomena, from Madonna's *Express Yourself* video (1989, adapted from Fritz Lang's *Metropolis*) to the film *Bride of the Wind* (2001) about Alma Mahler and her relationships with Gustav Mahler, Oskar Kokoschka, Walter Gropius, and Franz Werfel, demonstrate the increasing familiarity, broad acceptance, and thus popular palatability of the art of this period, at least when viewed as song and dance or costume drama with sensational, if not necessarily dangerous, liaisons.

[2] Indeed, after the 9/11 destruction of the World Trade Center, absence seems to bespeak not at all a semantic or intellectual void in the manner of the now familiar postmodern rhetorical sublime, but rather a palpable emotional content of hurt and mourning; in that regard, the feeling of absence and loss constitutes a bridge (to use an Expressionist metaphor) to the visceral content of Expressionism, its sense of loss and longing, as the urgent attempt, nearly a century ago, to come to terms with its own jarring new reality of modernity on all fronts, and make it productive for the creation of a new sense of social and artistic possibilities.

[3] See the chapter "Music and Existence" in Sokel 1959, 24–54. Also, David Kuhns, 28–31.

[4] The term has a long and problematic history: see Manheim 1986, Werenskiold, D. Gordon, and Perkins. Thomas Anz credits Kurt Hiller, the founder of the

Neopathetisches Cabarett and the Neue Club, with applying the term for the new art to the new literature of the day (2002, 5).

[5] Richard Murphy's study *Theorizing the Avant-Garde: Modernism, Expressionism, and the Problem of Postmodernity* (1999) belongs, despite its later date of publication, to the debates and developments of the mid- to late 1980s in its contestation of Peter Bürger's theory of the avant-garde. His call for "precisely the kind of concrete analysis of individual texts that has become rather rare in the discussion" (4) argues a position that was valid in the 1980s but no longer, and unfortunately he ignores what has been done in the interim. In claiming to "want to explore in particular their creation of various oppositional discourses aimed at the disruption of convention, of form, of mimesis and of representational stability in general" (30) he seems to allude to, but not refer to, my *Forms of Disruption: Abstraction in Modern German Prose* (1993), which does just that with close readings of various authors' poetics and of particular texts, both Modernist and Expressionist, such as Döblin's "Ermordung einer Butterblume" and Benn's *Gehirne*, both of which Murphy then adduces as representative examples of "expressionism's characteristic mode of 'abstraction'" (161). From the same year as my book, Heidemarie Oehm's *Subjektivität und Gattungsform im Expressionismus* (Munich: Wilhelm Fink, 1993) also analyzes "expressionistische Reflexionsprosa" (190–287) with works by some of the same authors as examples (A. Ehrenstein, C. Einstein, G. Benn), along with some others I did not include (G. Sack, P. Adler, R. Goering, and Kafka). Likewise, Augustinus Dierick's *German Expressionist Prose: Theory and Practice* (1987) also provides numerous readings, organized thematically. Murphy simply ignores prior studies with the sort of close textual analysis he then calls for, but he does capably embed these familiar texts in the discursive fields or vocabularies of postmodern theory; what he does not do is open or broaden the field of literary interpretation in this period by introducing new works or authors into the discussion. In a discussion of the Expressionist avant-garde, he addresses only prose and film, omitting all mention of drama or poetry.

[6] Thomas Anz provides in his *Literatur des Expressionismus* (2002) a very thorough and comprehensive introduction to Expressionism, which incorporates primary works and the historical research as well as later theoretical approaches.

[7] Cf. Fritz Martini "An die Stelle der epischen Fülle trat das aesthetische Prinzip der Intensität" (6), echoing for prose a comment by Kurt Pinthus about the poetry of the period that "die Qualität dieser Dichtung in ihrer Intensität beruht" (Menschheitsdämmerung, xv; the quality of this poetry resides in its intensity, trans. Conard et al.).

[8] As the primal scene of his inspiration for this intersection between the forms of modern society and "primitive" art, Worringer later cited his chance encounter with Georg Simmel, the sociologist of German modernity, in the Trocadero Museum in Paris, which housed the ethnological collections of artifacts from Africa, and was also the site of Picasso's encounter with African art.

[9] See my chapter "The Solution to Silence: The Emergence of Abstraction in Hugo von Hofmannsthal's 'Chandos Letter' (1902)" for a detailed analysis of the letter as an anticipation of Modernist and Expressionist experiment; in his book, *The Look of Things: Poetry and Vision around 1900* (2003), Carsten Strathausen very ably

situates Hofmannsthal's text (and *oeuvre*) in the context of aestheticist and modernist epistemology and optics.

[10] But the term *primitivism* thus does not refer to the non-technological or non-western cultures themselves, but rather to the European and American fascination with the forms of those cultures, outside the history of progressively realistic representation in Western art. See the studies by Torgovnick, Rubin, Jill Lloyd, Berman, and Pan.

[11] The term was coined by Stefan Zweig, and early Expressionists went under the name "Neupathetiker." The term "pathos" had many cognates and paraphrases in the journalistic literature of the day, and derives from theories of *Erlebnis* (Dilthey) and *Einfühlung* (Lipps; Riegl), and relates also to primitivism in the period, and to the notion of the Expressionist *Schrei*, leading ultimately to the sound poems of Dada. Its anti-intellectual intonations should not call into question its broad and deep intellectual roots and affinities; pathos marks the desire to overcome and reconfigure traditional modes of expression.

[12] See my essay "Analysis and Construction: The Aesthetics of Carl Einstein" (101–26) in *Forms of Disruption*.

[13] Einstein later also edited a volume entitled *Afrikanische Legenden* (African Legends, Berlin: Rowohlt, 1925) with illustrations by Georg Alexander Mathey.

[14] Kurt Pinthus, ed., *Menschheitsdämmerung: Symphonie jüngster Dichtung* (Berlin: Rowohlt, 1920; Hamburg: Rowohlt Taschenbuch Verlag, 1959, 1976). Unless otherwise indicated, all quotations from this anthology are designated by the abbreviation *MHD* and page number; all English translations are from *Menschheitsdämmerung / Dawn of Humanity: A Document of Expressionism*, trans. Joanna M. Ratych, Ralph Ley, and Robert C. Conard (Columbia, SC: Camden House, 1994) and are designated by the abbreviation *DoH* and page number.

[15] See the readings of that all-important poem by Michael Sharp and Klaus Weissenberger in this volume.

[16] Drawing upon Bernhard Diebold's study *Anarchy in the Drama* (1921), Mel Gordon proposes three basic modes of Expressionist performance: Geist, Schrei and Ich performance. The categories overlap, but the emphasis differs in each. David F. Kuhns likewise works with three categories that he calls Geist, Schrei and the emblematic mode. In my remarks I draw mainly upon Kuhns's excellent study; his description, the most recent, is also the fullest and most detailed, and it incorporates the other two.

[17] David F. Kuhns reviews the contexts of contemporary theorizing of the body in movement in a theatrical space from the writings of Edward Gordon Craig to Emile Jacques Dalcroze and Rudolf von Laban (and their student Mary Wigman), Hans Brandenburg (author of *Der moderne Tanz*, 1917) and Adolphe Appia, among others, to conclude that "All of the pioneering models of performance experimentation I have been considering originated in the desire to liberate contemporary culture from its mimetic bonds and to offer instead a theatre of empowerment in which contemporary history could be symbolically distilled and critiqued in order to become rhetorically reconstituted" (92).

[18] David Kuhns notes rightly (136–37) that the added degree of graphic visualization on stage can also undermine the emotional intensity of Schrei performance.

[19] See my essay "Unjustly Framed: Politics and Art in *Das Cabinet des Dr. Caligari*."

[20] In his lead essay in a new collection on the topic, Dietrich Scheunemann discusses the achievements and limitations of the two studies by Kracauer and Eisner that initially defined and delimited the field of research.

[21] However, Expressionist film, as it developed after the war, extends Expressionist themes in a different direction: for example, the New Man of prewar Expressionism reappears in Expressionist film in various forms as a crisis of masculine subjectivity.

[22] Crockett demonstrates how individual artists and groups of artists located in regional cities worked to overcome, or develop away from, the Expressionist legacy, however differently conceived. Likewise, Sergiusz Michalski's *New Objectivity: Painting, Graphic Art and Photography in Weimar Germany 1919–1933* (Cologne: Taschen, 1994) also emphasizes the dialectical, antithetical differentiation of the New Objectivity from Expressionism while remaining within the same artistic and even biographical lineage: "Against Expressionism's promises of the future were set the banal, small-scale happiness of an unassuming life, against cosmic ecstasy the insight into earthly and social restraints" (16). One would have to call vigorously into question, however, the degree of "happiness" that imbues the New Objectivity.

[23] See my essay "From Worringer to Baudrillard and Back: Ancient Americans and (Post)Modern Culture in Weimar Germany." In *Invisible Cathedrals*, 135–55.

[24] See Charles W. Haxthausen "Modern Art After 'The End of Expressionism': Worringer in the 1920s." Haxthausen remarks pointedly that "it is surprising that until now no one appears to have noticed that he [Lukács] seriously misrepresented the substance of Worringer's text" (119) as he then demonstrates.

[25] Klaus Mann was also responding directly to Benn's essay "An die literarischen Emigranten" (To the Literary Emigrants, 1933) that was his response to an earlier letter from Klaus Mann from his exile in southern France. See Hans-Jürgen Schmitt's collection of essays related to the debate, and David Bathrick's essay for a good summary of the debate.

[26] A figure such as Oskar Loerke reflects the phenomenon of "inner emigration," but unlike Gottfried Benn or a lesser figure such as Karl Krolow, also the anguish of conscience in that impossible position, as well as the fruitful use of the Expressionist legacy (in poetry) to write poetry that is both complex and concrete. For the first full review of the concept of inner emigration in English, along with essays on the circumstances of individual writers, see the collection *Flight of Fantasy: New Perspectives on Inner Emigration in German Literature, 1933–1945*, eds. Neil H. Donahue and Doris Kirchner (New York: Berghahn, 2003).

[27] See the section "Honorable *Menschen*: The Post-World War Two Recovery of Expressionist Prose" (229–37) in my *Forms of Disruption* (1993) for a case study for one genre of this phenomenon that affected all genres.

# Works Cited

Allen, Roy F. *Literary Life in German Expressionism and the Berlin Circles.* Ann Arbor: UMI Research Press, 1972.

Anz, Thomas. *Literatur des Expressionismus.* Stuttgart: Metzler, 2002.

Anz, Thomas, and Michael Stark, eds. *Die Modernität des Expressionismus.* Stuttgart and Weimar: Metzler, 1994.

——, eds. *Expressionismus: Manifeste und Dokumente zur deutschen Literatur, 1910–1920.* Stuttgart: Metzler, 1982.

Aschheim, Steven E. *The Nietzsche Legacy in Germany, 1890–1990.* Berkeley and London: U of California P, 1992.

Barron, Stephanie, ed. *"Degenerate Art": The Fate of the Avant-Garde in Germany.* Los Angeles: The Los Angeles County Museum of Art, 1991.

——. "The Embrace of Expressionism: The Vagaries of its Reception in America." In *German Expressionist Prints and Drawings,* 131–49. Los Angeles: Los Angeles County Museum of Art, and Munich: Prestel, 1989.

Bathrick, David. "Moderne Kunst und Klassenkampf: Die Expressionismus-Debatte in der Exilzeitschrift *Das Wort.*" In *Exil und innere Emigration: The Third Wisconsin Workshop,* ed. Jost Hermand und Reinhold Grimm, 89–109. Frankfurt am Main: Athenäum, 1972.

Benn, Gottfried. "Antwort an die literarischen Emigranten." In *Autobiographische und vermischte Schriften,* vol. 4 of *Gesammelte Werke.* Wiesbaden: Limes, 1961.

——. "Expressionismus" [a.k.a. "Bekenntnis zum Expressionismus"]. In *Essays — Reden — Vorträge,* vol. 1 of Gesammelte Werke, ed. Dieter Wellershoff, 240–56. Wiesbaden: Limes, 1959.

——. "Der neue Staat und die Intellektuellen." In *Autobiographische und vermischte Schriften,* vol. 4 of *Gesammelte Werke,* 393–95. Wiesbaden: Limes, 1961.

Berman, Russell. "German Primitivism / Primitive Germany: The Case of Emil Nolde." In *Fascism, Aesthetics, and Culture,* ed. Richard J. Golsan, 56–66. Hanover and London: The UP of New England, 1992.

Brinkmann, Richard. *Expressionismus: Forschungsprobleme, 1952–1960.* Stuttgart: Metzler, 1961.

——. *Expressionismus: Internationale Forschung zu einem internationalen Phänomen.* Stuttgart: Metzler, 1980.

Corngold, Stanley. "Kafka as Expressionist." In *Franz Kafka: The Necessity of Form,* 250–88. Ithaca and London: Cornell UP, 1988.

Crockett, Dennis. *German Post-Expressionism: The Art of the Great Disorder, 1918–1924.* University Park, PA: The Pennsylvania State UP, 1999.

Denkler, Horst, ed. *Einakter und kleine Dramen des Expressionismus.* Stuttgart: Reclam, 1968.

Diebold, Bernhard. *Anarchie im Drama.* Frankfurt am Main: Frankfurter Verlagsanstalt, 1921.

Dierick, Augustinus P. *German Expressionist Prose: Theory and Practice.* Toronto: U of Toronto P, 1987.

Donahue, Neil H. *Forms of Disruption: Abstraction in Modern German Prose.* Ann Arbor: U of Michigan P, 1993.

———. "From Worringer to Baudrillard and Back: Ancient Americans and (Post)Modern Culture in Weimar Germany." In *Invisible Cathedrals: The Expressionist Art History of Wilhelm Worringer*, ed. Donahue, 135–55.

———. "Unjustly Framed: Politics and Art in *Das Cabinet des Dr. Caligari.*" *German Politics and Society* 32 (1994): 76–88.

———. "The Fall of Wallenstein, or the Collapse of Narration? The Paradox of Epic Intensity in Alfred Döblin's *Wallenstein* (1920)." In *A Companion to the Works of Alfred Döblin*, ed. Roland Dollinger, Wulf Koepke, and Heidi Thomann Tewarson, 75–92. Rochester, NY: Camden House, 2003.

———, ed. *Invisible Cathedrals: The Expressionist Art History of Wilhelm Worringer.* University Park: Penn State Press, 1995.

Donahue, Neil, and Doris Kirchner, eds. *Flight of Fantasy: New Perspectives on Inner Emigration in German Literature, 1933–1945.* New York and London: Berghahn Books, 2003.

Einstein, Carl. *Afrikanische Legenden.* Berlin: Rowohlt, 1925.

———. *Bebuquin, oder die Dilettanten des Wunders.* In *Werke*, 1:73–114.

———. *Negerplastik.* In *Werke*, 1:245–392.

———. *Werke.* Vol. 1, *1908–1918.* Ed. Rolf-Peter Baacke. Berlin: Medusa, 1980.

Eisner, Lotte. *The Haunted Screen: Expressionism in German Cinema and the Influence of Max Reinhardt.* Trans. Roger Greaves. Berkeley, CA: U of California P, 1973. Orig. publ. as *L'Ecran Démoniaque.* Paris: Le Terrain Vague, 1952.

Goebbels, Joseph. *Michael: A Novel.* New York: Amok Press, 1987.

Golomstock, Igor. *Totalitarian Art in the Soviet Union, the Third Reich, Fascist Italy and the People's Republic of China.* New York: Icon Editions / Harper-Collins, 1990.

Golsan, Richard J., ed. *Fascism, Aesthetics, and Culture.* Hanover and London: The UP of New England, 1992.

Gordon, Donald. "On the Origin of the Word 'Expressionism.'" *Journal of the Warburg and Courtauld Institutes* 29 (1966): 368–85.

Haxthausen, Charles W. "A Critical Illusion: 'Expressionism' in the Writings of Wilhelm Hausenstein." In *The Ideological Crisis of Expressionism: The Literary and Artistic German War Colony in Belgium, 1914–1918*, ed. Rainer Rumold and O. K. Werckmeister, 169–91. Columbia, SC: Camden House, 1990.

———. "Modern Art after 'The End of Expressionism': Worringer in the 1920s." In Donahue, *Invisible Cathedrals: The Expressionist Art History of Wilhelm Worringer*, 119–34.

Hofmannsthal, Hugo von. *Gesammelte Werke: Prosa II*. Frankfurt am Main: Fischer, 1951.

Huyssen, Andreas, and David Bathrick, eds. *Modernity and the Text: Revisions of German Modernism*. New York: Columbia UP, 1989.

Jelavich, Peter. "Wedekind's Spring Awakening: The Path to Expressionist Drama." In *Passion and Rebellion: The Expressionist Heritage*, ed. Stephen Eric Bronner and Douglas Kellner, 129–50. South Hadley, MA: Bergin, 1983; New York: Columbia UP, 1988.

Kandinsky, Wassily. *Über das Geistige in der Kunst*. Munich: Piper, 1912. Rpt. Bern: Berteli, 1952.

Kracauer, Siegfried. *From Caligari to Hitler: A Psychological History of German Film*. Princeton: Princeton UP, 1947, 1974.

Kuhns, David F. *German Expressionist Theatre: The Actor and the Stage*. Cambridge: Cambridge UP, 1997.

Kurtz, Rudolf. *Expressionismus und Film*. Berlin: Verlag der Lichtbild-Bühne, 1926.

Lloyd, Jill. *German Expressionism: Primitivism and Modernity*. New Haven and London: Yale UP, 1991.

Lukács, Georg. "'Größe und Verfall' des Expressionismus." (1934). In *4 Essays über den Realismus*, vol. 1 of *Probleme des Realismus*, 109–49. Neuwied & Berlin: Luchterhand, 1971.

Manheim, Ron. "Expressionismus: Zur Entstehung eines kunsthistorischen Stil- und Periodenbegriffes." *Zeitschrift für Kunstgeschichte* 49, 1 (1986): 73–91.

———. *"Im Kampf um die Kunst": Die Diskussion von 1911 über zeitgenössische Kunst in Deutschland*. Hamburg: Sautter & Lackmann, 1987.

Martini, Fritz, ed. Introduction to *Prosa des Expressionismus*. Stuttgart: Reclam, 1970.

Michalski, Sergiusz. *New Objectivity: Painting, Graphic Art and Photography in Weimar Germany, 1919–1933*. Cologne: Taschen, 1994.

Murphy, Richard. *Theorizing the Avant-Garde: Modernism, Expressionism, and the Problem of Postmodernity*. Cambridge, UK: Cambridge UP, 1999.

Oehm, Heidemarie. *Subjektivität und Gattungsform im Expressionismus*. Munich: Wilhelm Fink, 1993.

Pan, David. *Primitive Renaissance: Rethinking German Expressionism*. Lincoln and London: U of Nebraska P, 2001.

Paret, Peter. *The Berlin Secession: Modernism and Its Enemies in Imperial Germany*. Cambridge MA: Belknap P of Harvard U, 1980.

Perkins, Geoffrey. *Contemporary Theory of Expressionism*. Bern and Frankfurt: Herbert Lang, 1974.

Pinthus, Kurt, *Menschheitsdämmerung: Ein Dokument des Expressionismus*. Berlin: Ernst Rowohlt, 1920; Hamburg: Rowohlt Taschenbuch Verlag, 1959, 1976. In English: *Menschheitsdämmerung / Dawn of Humanity:*

*A Document of Expressionism.* Trans. Robert C. Conard, Ralph Ley, and Joanna M. Ratych. Columbia, SC: Camden House, 1994.

Pörtner, Paul. *Literatur-Revolution, 1910–1925: Dokumente, Manifeste, Programme.* Neuwied am Rhein: Luchterhand, 1961.

Raabe, Paul. *Die Autoren und Bücher des literarischen Expressionismus.* Stuttgart: Metzler, 1985.

———, ed. *Expressionismus: Aufzeichnungen und Erinnerungen der Zeitgenossen.* Olten: Walter, 1965. In English: *The Era of German Expressionism.* Trans. J. M. Ritchie. London: Calder & Boyers, 1974; Dallas: Riverrun Press, 1980.

Rigby, Ida Katherine. *An alle Künstler! War-Revolution-Weimar: German Expressionist Prints: Drawings, Posters, and Periodicals from the Robert Gore Rifkind Foundation.* San Diego, CA: San Diego State UP, 1983.

Ringer, Fritz. *Decline of the German Mandarins: The German Academic Community, 1890–1933.* Cambridge, MA: Harvard UP, 1969.

Rubin, William, ed. *"Primitivism" in Twentieth-Century Art: Affinity of the Tribal and Modern.* New York: Museum of Modern Art, 1984.

Rumold, Rainer. *Janus Face of the German Avant-garde: From Expressionism to Postmodernism.* Evanston, IL: Northwestern UP, 2002.

Scheunemann, Dietrich. *Expressionist Film: New Perspectives.* Rochester, NY: Camden House, 2003.

Schmitt, Hans-Jürgen, ed. *Die Expressionismusdebatte: Materialien zu einer marxistischen Realismuskonzeption.* Frankfurt am Main: Suhrkamp, 1973.

Schürer, Ernst, ed. *German Expressionist Plays.* New York: Continuum, 1997.

Serke, Jürgen. *Die verbrannten Dichter: Berichte, Texte, Bilder einer Zeit.* Frankfurt am Main: Fischer, 1980.

Sokel, Walter. "Die Prosa des Expressionismus." In *Expressionismus als Literatur: Gesammelte Studien,* ed. Wolfgang Rothe, 153–70. Bern: Francke, 1969.

———. *The Writer in Extremis: Expressionism in Twentieth-Century German Literature.* Stanford: Stanford UP, 1959.

Sokel, Walter, ed. *Anthology of German Expressionist Drama: A Prelude to the Absurd.* Ithaca and London: Cornell UP, 1963, 1984.

Stern, Fritz. *The Politics of Cultural Despair: A Study in the Rise of the Germanic Ideology.* Berkeley: U of California P, 1961.

Strathausen, Carsten. *The Look of Things: Poetry and Vision around 1900.* Chapel Hill and London: The U of North Carolina P, 2003.

Torgovnick, Marianna. *Gone Primitive: Savage Intellects, Modern Lives.* Chicago and London: The U of Chicago P, 1990.

Vietta, Silvio. "Zweideutigkeit der Moderne: Nietzsches Kulturkritik, Expressionismus und literarische Moderne." In Anz, and Stark, *Die Modernität der Moderne,* 9–20.

Werenskiold, Marit. *The Concept of Expressionism: Origin and Metamorphoses.* Oslo: Universitetsforlaget; New York: Columbia UP, 1984.

Worringer, Wilhelm. *Abstraktion und Einfühlung: Ein Beitrag zur Stilpsychologie*. Munich: Piper, 1908. In English: *Abstraction and Empathy: A Contribution to the Psychology of Style*. Trans. Michael Bullock. New York: International UP, 1953.

―――. *Formprobleme der Gotik*. Munich: Piper, 1911. In English: *Form in Gothic*, later reprinted as *Form Problems of the Gothic*. Trans. Herbert Read. London: Putnam's Sons, 1927.

―――. *Fragen und Gegenfragen: Schriften zum Kunstproblem*. Munich: Piper, 1956.

―――. "Kritische Gedanken zur neuen Kunst." Reprinted in *Fragen und Gegenfragen: Schriften zum Kunstproblem*, 86–105. Munich: Piper, 1956.

―――. *Künstlerische Zeitfragen*. Munich: Lecture (19 October 1920) for the Ortsgruppe München der deutschen Goethe-Gesellschaft. Bruckmann, 1921. Reprinted in *Fragen und Gegenfragen: Schriften zum Kunstproblem*, 106–29. Munich: Piper, 1956.

Zeller, Bernhard, ed. *Expressionismus — Literatur und Kunst, 1910–1923: Eine Ausstellung des deutschen Literaturarchivs im Schiller-Nationalmuseum vom 8. Mai bis 31 Oktober 1960*. Marbach: Deutsches Literaturarchiv, 1960.

# Philosophical Background

# 1: Metaphysical Mimesis: Nietzsche's *Geburt der Tragödie* and the Aesthetics of Literary Expressionism

*Richard T. Gray*

NO SINGLE THINKER had a greater influence on the artists of the Expressionist generation than did Friedrich Nietzsche.[1] Indeed, if one were to mentally subtract Nietzschean ideas and stylistic influences from the intellectual and aesthetic storehouse of Expressionism, what would remain would hardly be recognizable as the artistic and intellectual-historical configuration we know today as literary Expressionism. Will to power; transvaluation of values; a vitalistically defined conception of life; the Zarathustrian *Übermensch* as the new human being; dithyrambic lyric style; the new pathos; immoralism; eternal recurrence; a scathing critique of the world of the Wilhelminian *Bildungsbürgertum* (educated bourgeoisie) — for whom Nietzsche, in the first of his *Unzeitgemäße Betrachtungen* (Unfashionable Observations), coined the derogatory term "Bildungsphilister" ("cultural philistine"; *KSA* 1:165);[2] and finally, the concept of the Dionysian as a glorified irrationalism and an existential will to embrace the horror of existence: Expressionism would lose all its definition and distinctness if we sought to conceive it apart from these notions indebted to Nietzsche. If we accept the testimony of Gottfried Benn, one of the few great Expressionist writers who lived long enough to look back on the era of Expressionism with historical hindsight, then Nietzsche truly was experienced, in Benn's memorable phrase, as "das größte Ausstrahlungsphänomen der Geistesgeschichte" (that phenomenon in intellectual history with the single most irradiative power; 1048), more influential even than Goethe, the Titan of German classicism. Indeed, Benn goes so far as to remark that everything that interested his generation was already articulated in Nietzsche's works, and that what he and his contemporaries produced was merely exegesis of Nietzsche's seminal ideas (1046). Even if we allow for a modicum of rhetorical overstatement in this remark, we cannot help but come away with the view of Nietzsche as an intellectual giant whom the Expressionists adopted as the flag-bearer of their movement. Indeed, as early as 1918 Eckart von Sydow called Nietzsche the "lodestar" of the Expressionist movement (quoted in

Martens, 36). This assertion is confirmed by the formative impact Nietzsche had on the intellectual profiles of most of the leading spokespeople of the Expressionist generation. We need only think here of Nietzsche's significance for Kurt Hiller, Erwin Loewenson, and Jakob van Hoddis, the founding members of the "Neuer Club," which emerged in 1909 as one of the generative cells of German literary Expressionism, along with its outgrowth institution, the "Neopathetisches Cabaret."[3] Indeed, the conception of the "New Pathos" promulgated by Kurt Hiller in the speech given at the opening of the Neopathetisches Cabaret explicitly invokes the definition of pathos Nietzsche gave in *Ecce Homo* (Hiller, 440; cf. *KSA* 6:304), and Stefan Zweig, in an essay that reflects on the phenomenon of the "New Pathos," likewise cites Nietzsche as the source of this new rhetorical style (576–77). Nietzsche also figures prominently in the intellectual biography of Franz Pfemfert, the publisher of the influential Expressionist journal *Die Aktion*, who used this publication to disseminate texts both by and about Nietzsche (Martens, 46–47). Most important, perhaps, is the fact that Nietzsche and his works were heralded by both the vitalistic-Dionysian line of Expressionist thinkers and the politically activist strain of Expressionism. In the multidimensionality of the Expressionist movement, which critics have often broken down into distinct and sometimes contrary facets, such as "naïve" or "rhetorical" versus "activist" (Sokel, 19–20, 166–67), or "Messianic" versus "civilization-critical" (Vietta/Kemper, 14) modes of Expressionism, Nietzsche remains the one prominent common denominator, although the modalities of his reception change in each instance (Martens, 44–45). Thus we might go so far as to claim that to the extent that Expressionism is a unitary phenomenon and has a unified nucleus at all, this nucleus is constituted by the thought and the person of Friedrich Nietzsche.[4]

Despite the prominence of Nietzsche's influence among the Expressionists, Martens's assertion, first made in 1978, that the number of critical examinations of Nietzsche's role in the development of literary Expressionism is surprisingly limited, still largely holds true today. Aside from Seth Taylor's ground-breaking but more narrowly focused examination of Nietzsche's impact on left-wing Expressionists, no book-length study of Nietzsche's reception among the Expressionists exists. In addition to Martens's informative overview, Meyer presents a more extensive chapter on Nietzsche and Expressionism in his book on *Nietzsche und die Kunst* (Nietzsche and Art; 243–321), as does Aschheim in his survey of Nietzsche's legacy in German letters (51–84). Rolleston and Vietta and Kemper develop more focused interpretations of Nietzsche's role in the evolution of specific phenomena, in the former case on the emergence of Expressionist lyric poetry, in the latter on Nietzsche's significance for the Expressionist analysis of historical nihilism (134–39). More specific studies such as those of Taylor, Rolleston, and Vietta and Kemper are sorely

needed.[5] The current essay is conceived as a first attempt to situate the significance of Nietzsche's thought for the aesthetic theory and practice of German Expressionism. For this purpose I have chosen to concentrate on Nietzsche's first published book, his *Geburt der Tragödie aus dem Geiste der Musik* (The Birth of Tragedy from the Spirit of Music), which appeared in 1872 and was republished by Nietzsche in 1886. The reasons for the limitation to this work are manifold: First, Nietzsche himself clearly affirmed the significance this text assumed in his intellectual genesis when he republished it towards the end of his philosophical career, in spite of the sometimes scathing critique to which he subjected this piece of intellectual juvenilia in the foreword to this new edition. This continued significance of *Geburt* is corroborated by the fact that Nietzsche himself came back to this book repeatedly throughout his life, deliberating on its central ideas — especially the dichotomy between the Apollinian and Dionysian approaches to art — and its place in his intellectual development (see especially *Ecce Homo*, KSA 6:309–15).[6] Indeed, in *Götzendämmerung* (Twilight of the Idols) Nietzsche explicitly aligns *Geburt* with his later philosophy by claiming that it was the first in his series of philosophical transvaluations (*KSA* 6:160). Second, and perhaps most important, *Geburt der Tragödie* contains Nietzsche's most detailed and sustained reflection on issues of aesthetics in general, and of literary aesthetics in particular: it represents, in many ways, the paradigmatically modernist transvaluation of classical German aesthetic theory.[7] Third, Nietzsche's inaugural book was, along with *Zarathustra*, *Ecce Homo*, and the posthumously published collection *Der Wille zur Macht* (The Will to Power), one of Nietzsche's most popular works among the Expressionists and their generation (Hillebrand, 50; Martens, 80–81). Many of the central themes the Expressionists pursued and that found sustenance in Nietzsche's thought were articulated in this treatise: the valorization of instinct over reason; the attack on conceptual thought and science; an insistence on the vital importance of art for life; the search for cultural redemption in the realm of aesthetic practice. To be sure, the Expressionists did not read *Geburt der Tragödie* as a strictly philological or historical work about the birth of Greek tragedy — nor, in fact, did Nietzsche conceive it solely, or perhaps even principally, in this way.[8] On the contrary, much more significant for them was Nietzsche's call for a *rebirth* of tragedy as a revolutionary artistic-cultural phenomenon in the Germany of his own day (*Geburt* 103, 129, 132). Indicative of this is the incorrect citing of Nietzsche's title as "Die *Wiedergeburt* der Tragödie aus dem Geiste der Musik" (The *rebirth* of tragedy from the spirit of music) as early as 1877 in a letter addressed to Nietzsche by Heinrich Hart (quoted in Hillebrand, 56; my emphasis). Nietzsche himself confirms the persistence of this Freudian slip when he writes in *Ecce Homo* that he has repeatedly seen his work cited under this skewed title (*KSA* 6:309).

It is no coincidence that Nietzsche begins the very first section of *Geburt der Tragödie* with the assertion that the *science of aesthetics* will make great headway once we recognize the importance of the Apollinian-Dionysian duality: "Wir werden viel für die aesthetische Wissenschaft gewonnen haben, wenn wir nicht nur zur logischen Einsicht, sondern zur unmittelbaren Sicherheit der Anschauung gekommen sind, dass die Fort-entwicklung der Kunst an die Duplicität des *Apollinischen* und des *Diony-sischen* gebunden ist" (We will have made great gains for the science of aesthetics once we have arrived not merely at the logical insight, but rather at the immediate certainty of the view that the continuing development of art is bound up with the duality of the *Apollinian* and the *Dionysian*; 25). Nietzsche's overriding aim in this work is thus stated in terms of a contri-bution to aesthetic theory in general. However, he is not satisfied with sim-ply using abstract logic to demonstrate his claims — as is often the case in philosophical aesthetics — but instead wants to bring this point concretely before the eyes of his readers by presenting them with a historical example. In other words, the examination of Greek tragedy, its emergence and decline, and the role of the Apollinian and Dionysian principles in this his-torical development — the substance, in short, of the first twelve sections of *Geburt* — serve merely as a demonstrative example of this larger argu-ment about the nature of aesthetics as such, which is the true focus of this text.[9] But if *Geburt der Tragödie* is a "hinge," as Henry Staten claims, "between romanticism and all that is post-romantic" (9), then in its aes-thetic theory it is also a hinge between the classical and all that is post-clas-sical, between traditional (that is, eighteenth-century) and modern aesthetic theory.[10] To be a hinge means not only to be a turning point, but also to participate substantially in both formations that are joined together at this hinge. In this sense, the aesthetic theory of *Geburt der Tragödie* constitutes a peculiar hybrid between the classical and the modern. This hybrid character of Nietzsche's text makes itself manifest on the most superficial level in the identification of the classical Attic Tragedy of ancient Greece with the modernism of Wagner's *Gesamtkunstwerk* (total work of art). I will demonstrate that the aesthetics of literary Expressionism exhibits a hybrid character that makes it similar to the hybridity of Niet-zsche's aesthetic theory in *Geburt der Tragödie*. I have given this peculiar hybridity the designation "metaphysical mimesis," as a way of indicating a transitional position between what, for the sake of simplicity, we can call the representational status of classical and the non-representational status of modern art.

If it is true, as Walter Sokel has maintained, that modern art funda-mentally breaks with the Aristotelian principle of mimesis (7) and that the single most prominent feature of modernist aesthetics is the adaptation of musical structures by the other arts (26), then the aesthetics of Nietzsche's *Geburt der Tragödie* is both modernist and anti-modernist: modernist,

because nowhere is the case for the paradigmatic status of music for art in general made more compellingly than here; anti-modernist because Nietzsche, following in this regard the model he adopted and adapted from Schopenhauer, makes the case for the valorization of music and Dionysian aesthetic principles in general on the basis of strict arguments about *mimesis*.[11] Nietzsche's aesthetic theory, then, takes important steps toward the valorization of non-representational artistic forms, but it does so, paradoxically, on the basis of a radically traditionalist notion of mimetic representation. This is the same status, I will argue, that we can accord to the aesthetic practice of literary Expressionism: standing between the scientifically theorized mimesis of Naturalism and the radical non-representationalism of Dada, it represents a transitional aesthetics that does not yet abandon the requirement of representation, but which moves beyond traditional conceptions of mimesis by applying representational techniques not to the *physical* world, but instead to the *metaphysical* domain. Douglas Kellner has given concise expression to the standard — and perhaps overly simplified — view that, following Nietzsche's radical undermining of objectivist epistemological theories, no objective reality remained for artists to imitate, encouraging them to turn to individual expression and subjective creation ("Expressionism and Rebellion" 10). But this assertion ignores precisely the significance of mimetic representation in Nietzsche's aesthetics — mimesis not of the phenomenal world, but of the sub- (or trans-) phenomenal, metaphysical sphere. This metaphysical mimesis is a program, I will claim, that the Expressionists adopt from Nietzsche.

Nietzsche's indebtedness to classical aesthetic theory, especially to the work of Friedrich Schiller, has often been noted (Foster, 44, 61; Rampley, 79, 96; Staten, 9). Many of the themes pursued in *Geburt der Tragödie* explicitly point up the continuity of Nietzsche's thought with fundamental tenets of the German aesthetic tradition. His very valorization of drama, and of tragedy in particular, as the highest literary form takes its cue from the thought of Gotthold Ephraim Lessing, whom Nietzsche greatly admired,[12] and Schiller, who devoted many essays not only to general problems of aesthetics, but specifically to the theater as a social institution. To be sure, Nietzsche explicitly rejects the moralizing component in the dramatic theories of these predecessors, but in so doing he is simply following the lead already inaugurated by Schopenhauer (2:497). Similarly, Lessing and Schiller have already outlined conceptions of drama as the most effective literary form, allowing it to be deployed for the transformation of cultural and political institutions. Nietzsche's call for a reformation of German cultural life based on a rebirth of tragedy harkens back to these classical models. Nietzsche himself, of course, made no secret of the relationship that linked his distinction between Apollinian and Dionysian artistic principles and the Schillerian dichotomy between naïve and sentimentalist modes of literary production: in sections 3 and 19 of *Geburt*,

Nietzsche refers directly to Schiller's concept of the naïve, aligning it with his Apollinian principle (37, 124). Nietzsche's most detailed exploration of this overlap between Schiller's concepts and his own occurs, however, in an unpublished fragment (7 [126]) written in the context of *Geburt der Tragödie* but not integrated into the final manuscript. Here Nietzsche defines the naïve as "rein apollinisch" (purely Apollinian) and as "Schein des Scheins" (semblance of semblance), sentimentalist as "unter dem Kampf der tragischen Erkenntniß und der Mystik geboren" (born from the struggle between tragic knowledge and mysticism; *KSA* 7:184). But Nietzsche goes on to argue that the Schillerian distinction is not broad enough to encompass all the artistic manifestations he has in mind. Hence he asserts that the true opposite of naïve/Apollinian art is not the sentimentalist, but rather the Dionysian:

> Dagegen verstehe ich als den vollen Gegensatz des "Naiven" und des Apollinischen das "Dionysische" d. h. alle Kunst, die nicht "Schein des Scheins," sondern "Schein des Seins" ist, Wiederspiegelung des ewigen Ur-Einen, somit unsere ganze empirische Welt, welche, vom Standpunkte des Ureinen aus, ein dionysisches Kunstwerk ist; oder von unserem Standpunkt aus, die Musik. (*KSA* 7:184)

> [By contrast, I conceive the Dionysian as the complete opposite of the "naïve" and the Apollinian; that is, the Dionysian is all art that is not "semblance of semblance," but rather "semblance of Being," a reflection of the eternal primordial unity, and thus our entire empirical world, which, viewed from the standpoint of the primordial unity, is a Dionysian work of art; or, viewed from our standpoint, music.]

This passage gives us a first indication of how Nietzsche draws his distinction between the Apollinian and the Dionysian not in terms of aesthetic principles as such, since both operate on the basis of semblance and mimesis, but rather in terms of the *object* of this mimetic reflection. Apollinian art is a "semblance of semblance," that is, mimesis of the "primordial unity" twice removed; Dionysian art, by contrast, is immediate mimesis (*Wiederspiegelung*) of this primordial unity at only one remove, and hence more authentic, closer, as it were, to this metaphysically understood primal nature.

When Nietzsche designates Dionysian art as "Schein des Seins," the semblance of Being, and identifies it with the ontic status normally associated with the empirical world of phenomena, he is simply reiterating one of the cardinal principles of Schopenhauer's aesthetics. In *Die Welt als Wille und Vorstellung* (The World as Will and Idea), Schopenhauer developed what we might term an ontic hierarchy among representational forms. For Schopenhauer, the primordial unity is, of course, the "will," and it is telling that in the unpublished fragment cited here Nietzsche carefully avoids the Schopenhauerian term. This is a first indication that Nietzsche, while basing his thoughts on Schopenhauer's aesthetic theories, is simultaneously

struggling to free himself from a strictly Schopenhauerian position.[13] In Schopenhauer's view, at any rate, the "will," as metaphysical ground of all existence, generates out of itself the world of "ideation" (*Vorstellung*), which includes the entire phenomenal world of nature as presented to the senses. This empirical world, for Schopenhauer, is hence a world of semblance, a secondary product of the will. Plato's denigration of art as an imitation of the phenomenal world, as the semblance of semblance, is based, for Schopenhauer, on a fundamental misunderstanding. For Schopenhauer, all art is indeed structured in terms of mimetic representation (*Welt als Wille und Vorstellung* 1:302–3), but the value of this representation depends on the profundity of the "object" it imitates. Schopenhauer thus re-evaluates traditional aesthetic theory, based on the Aristotelian concept of mimesis, by asserting that art is not the mimetic representation of the phenomenal world, but rather of the Platonic ideas that underlie the objects that constitute the sphere of phenomenal appearances (1:250). These ideas themselves are immediate objectifications of the will (1:206, 211), and as representations of these archetypal ideas, art gives a deeper, more authentic picture of the will than if it were a mere mimetic representation of the phenomenal world. However, as we know, Schopenhauer interprets music as an exception even to this general rule governing the arts; music does not copy Platonic ideas, as do the other arts, rather it is a copy of the will itself (1:304) and hence stands on the same level of ontic value as the phenomenal world, which is also a direct copy of the will (1:309). In other words, Schopenhauer differentiates three possible modes of representational mimesis for art that stand in a clear hierarchy. At the very bottom is mimetic representation of the phenomenal world as second-order representation, which for Schopenhauer scarcely deserves the designation "art" at all.[14] Above this stand the visual and literary arts, providing mimetic representations of Platonic ideas, which as eternal forms that exist *prior* to the manifoldness of the phenomenal world are closer to the metaphysical essence (1:277). At the top of this hierarchy stands music, which, as the least mediate form of representation, provides a direct copy of the will itself (1:309).

Nietzsche takes over from Schopenhauer this idea of a hierarchical ordering of mimetic representations valued according to the degree of authenticity with which they portray what he calls the "primordial unity"; but he does not adopt Schopenhauer's model in toto. Above all, nowhere in Nietzsche's aesthetics is there reference to the visual or literary arts as representations of Platonic ideas. Nietzsche either ignores or simply rejects this aspect of Schopenhauer's theory. Hence in the unpublished fragment cited above, the Apollinian is associated with the mimetic representation of the phenomenal world (*Schein des Scheins*), which Schopenhauer would banish from the temple of art completely, while the Dionysian, as the semblance of raw Being (*Schein des Seins*) is placed, as is music for Schopenhauer, on an

ontic level equal to that of the phenomenal world itself. Dionysian artists are thus the most authentic artists in the sense that they imitate in their own creative process that primordial creative act by which the phenomenal world itself is born. This is what Nietzsche means when he writes in *Geburt* that Dionysian artists are no longer merely artists as creators of works of art, but actually become works of art themselves (30), or when he argues that the creative act of the genius must fuse with that primordial act of creativity out of which the world itself originarily issued (47–48).[15]

Keeping in mind this differentiation regarding the relevance and value of distinct ontic levels as the representational objects of art, let us return to questions of Expressionist aesthetic practice, before moving on to a closer examination of the problematic of mimesis in Nietzsche's aesthetics. In one of the first attempts to arrive at a rudimentary definition of literary Expressionism, the literary historian Friedrich Markus Huebner, in his 1920 book *Europas neue Kunst und Dichtung* (Europe's New Art and Literature), juxtaposed it to Naturalism in the following way: "Stand hinter dem Naturalismus als regulierende Norm die Natur in ihrer ganzen Tatsächlichkeit, so steht hinter dem Expressionismus als regelnde Norm die Idee in ihrer ganzen Tatsächlichkeit" (If the regulating norm of Naturalism is nature in all its factuality, then the regulating norm of Expressionism is the idea in all its factuality; Heubner, 5). Huebner's description correctly aligns naturalist works of art with strict imitation of the phenomenal world of nature; but in the context of Schopenhauer's aesthetics, this creative act has been dethroned and exposed as a mere semblance of semblance. For Expressionism, by contrast, Huebner comes up with a formula that sounds on the face of it like a contradiction, or at least like a paradox: the norm of Expressionism is "the idea in all its factuality." What is, we might rightly ask, the "factuality" of an idea? In this formulation Huebner has implicitly elided the basic distinction between idealism and realism. And this, in fact, is the point: for Expressionism — as for Schopenhauer — the realm of ideas has assumed the character of the real, even of the hyperreal. This precisely is the breach that separates naturalism, as the ultimate form of traditional, Aristotelian, "mimetic" art, from Expressionism, as one of the first modes of modern art: the definition and redefinition of what can be considered "real."

It is no coincidence that the debate waged by exiled intellectuals in the 1930s over the heritage of literary Expressionism, which is known in the annals of literary history as *Die Expressionismusdebatte* (The Expressionism Debate), turned precisely on the issue of reality and its role in literary aesthetics. In the memorable words of Georg Lukács, "Es geht um den Realismus" (it is a question of realism; 194). But, the Expressionists might justifiably retort, anticipating a phrase popularized in the United States during the 1960s, What is reality? Lukács's diatribe against Expressionism and all other forms of avant-garde art ultimately comes down to his belief that

they represent an ever greater distancing from the principles of realism, indeed, that they pursue an ideology for the *liquidation* of realism — and hence presumably for the liquidation of the real itself (193). Ernst Bloch offered the only proper retort to Lukács's position, throwing into question Lukács's very concept of reality. "Aber vielleicht ist Lukács' Realität, die des unendlich vermittelten Totalitätszusammenhangs, gar nicht so — objektiv; vielleicht enthält Lukács' Realitätsbegriff selber noch klassisch-systemhafte Züge; vielleicht ist die echte Wirklichkeit auch Unterbrechung" (But perhaps Lukács's notion of reality, a reality bound together as an infinitely mediated totality, is not all that — objective; perhaps Lukács's conception of reality itself still contains classical-systematic features; perhaps genuine reality is also constituted by interruption; 186). Bloch's remark is significant for several reasons. First, it presents an early formulation, from within the camp of Marxist thinkers, of what in the thought of Theodor Adorno will blossom into a full-fledged suspicion of all totalizing worldviews as totalitarian constructions. Second, it calls into question the very objectivity of Lukács's conception of reality and associates it with the worldview of German classicism and emergent capitalism. Third, and most important, perhaps, Bloch articulates the breach between the "classical" and the "modern" epochs in terms of the opposition between a systematic totality and endless fragmentation, "interruption" (*Unterbrechung*). Just as Bloch implies that Lukács's systematic totality, when viewed through a critical prism, will break down into more basic fragmentary components, the Expressionists, in this regard following Schopenhauer and Nietzsche, subscribed to the belief in a *deeper*, more authentic dimension of reality *beyond* (or *below*) the world of empirical phenomena. The basis of the modernist rupture, then, turns initially not so much on style and artistic method, as on worldview and the definition of "reality" as such. In this regard, Nietzsche's metaphysical concept of "life" and his entire *Lebensphilosophie* played a formative role in the thought of the Expressionist generation. Lukács would have had to be a closer reader of Nietzsche in order to understand how the portrayal of sub-phenomenal, or ideational, "reality" could actually proceed according to the mimetic representational principles generally associated with literary "realism."

It should come as no surprise to us that Nietzsche was one of the first people to articulate and analyze the idea of a modernist rupture. In section 18 of *Geburt der Tragödie*, in one of the more declamatory passages of this text, Nietzsche writes:

> Das ist ja das Merkmal jenes "Bruches," von dem Jedermann als von dem Urleiden der modernen Cultur zu reden pflegt, dass der theoretische Mensch vor seinen Consequenzen erschrickt und unbefriedigt es nicht mehr wagt sich dem furchtbaren Eisstrome des Daseins anzuvertrauen: ängstlich läuft er am Ufer auf und ab. Er will nichts mehr ganz haben, ganz auch mit aller der natürlichen Grausamkeit der Dinge. (119)

[The central characteristic of that "rupture," which people have grown accustomed to referring to as the primordial affliction of modern culture, is precisely that the theoretical human being is horrified by his own consequences, and out of dissatisfaction no longer dares to entrust himself to the terrifying ice floe of existence: frightened, he runs back and forth along its edge. He no longer seeks anything in its totality, a totality that also includes all the natural cruelty of things.]

The voice with which Nietzsche speaks in this passage anticipates the voice of cultural critique he will begin to exploit more earnestly in the years immediately following the publication of *Geburt*, a voice intoned most intensely in the essays that appeared as the *Unzeitgemäße Betrachtungen* (Unfashionable Observations). Taking as his point of departure the widespread sense of malaise commonly associated with the advent of modern culture, Nietzsche offers a critical analysis of the causes of this discontent. It stems, he proposes, from an incipient awareness of the limitations of what he calls "Socratic culture": the paradigm of Enlightenment thinking, guided by the principles of rationality, universality, and programmatic optimism. The malaise of modernity is thus symptomatic of the collapse, for Nietzsche, of the scientific worldview: it marks the "dialectic of enlightenment," or the point at which the theoretical human being, the intellectual heir of Socrates, comes to understand that reason does not and cannot provide ultimate salvation. What distinguishes Nietzsche's examination of this problematic is that he diagnoses the ideological double-bind characteristic of this degenerative stage of Socratic culture: no longer unquestioningly trusting its reliance on logic, it is yet unable to abandon the comfort and stability the hyperrational view offers. In other words, Socratic culture has come to the realization that its so-called "science" is little more than an ideological defense mechanism that shields it from accepting the horror of existence, a horror expressed paradigmatically for Nietzsche in the wisdom of Silenus, to wit, that once cursed with the burden of existence, the best one can hope for is death as release from pain and suffering (*Geburt*, 35). Thus in the "Versuch einer Selbstkritik" (Attempt at Self-Criticism) that he appends as an introduction to the 1886 edition of *Geburt*, Nietzsche summarizes the questions posed by this treatise in the following way: "Wie? Ist Wissenschaftlichkeit vielleicht nur eine Furcht und Ausflucht vor dem Pessimismus? Eine feine Notwehr gegen — die *Wahrheit*? Und, moralisch geredet, etwas wie Feig- und Falschheit?" (What? Is reverence for science perhaps nothing but fear of and flight from pessimism? A refined defense mechanism against — *truth*? And, moralistically speaking, something like faintheartedness and falsehood? *Geburt*, 12–13). Science is revealed as a deception on the same order as that pursued by any purely Apollinian art: it seeks to cover over and divert one's gaze from the essential horror of reality — the "ice floe" of existence, to cite Nietzsche's metaphor — by disguising it behind a world of beautiful semblance.[16] Scientific truth is nothing but flight *from* this more fundamental

truth — that is the ultimate transvaluation on which the aesthetic theory of *Geburt der Tragödie* turns. And Nietzsche believes the malaise of modernism derives from the fact that his contemporaries have generally recognized the limits of rational thought but nonetheless refuse to admit or embrace these limits. An art that practices metaphysical mimesis, such as Attic tragedy, becomes an antidote to the deceptions of Apollinian or Socratic culture, a machete that both cuts through the veil of ideological (self-)deception and offers a form of non-deceptive, non-ideological consolation. The Expressionists would embrace this view of art as an instrument of cultural and ideological critique.

Scholars have only recently come to recognize the significant role that arguments about, and metaphors of, representational mimesis play in *Geburt der Tragödie*. For deconstructive critics like Lacoue-Labarthe and de Man, this arouses the suspicion that *Geburt* is still mired in a metaphysics of "presence" that will only be overcome in the works of the later Nietzsche (see Lacoue-Labarthe, 74; de Man, 88).[17] But it is not a metaphysics of *presence* as much as a metaphysics of *mimesis* — or perhaps better, a mimesis of metaphysics — that is Nietzsche's central concern in *Geburt der Tragödie*. As Staten has convincingly demonstrated (20–22), neither Nietzsche nor Schopenhauer, Nietzsche's model, definitively hypostatizes the Dionysian or music as the immediate re-presencing of the will or the metaphysical essence. Both, in fact, are clear in their assertion that the will only appears in diverse — but differentially evaluated — forms of semblance. Nietzsche expresses this most clearly in section 2 of *Geburt*, where he shifts from a discussion of the Apollinian and Dionysian as the fundamental creative principles of nature itself — manifest in Apollo's "die Bilderwelt des Traumes" (imagistic world of dreams), on the one hand, and the "rauschvolle Wirklichkeit" (intoxicating reality) of Dionysus, on the other (*Geburt* 30) — to a treatment of the specifically artistic and aesthetic applications of these two precepts. To be sure, Nietzsche's language when describing these principles as they occur in nature already implies a subtle evaluative distinction: the Apollinian is merely a world of images, that is, from the outset nothing but pure semblance, whereas the Dionysian penetrates deeper to an "intoxicating *reality*." This wording suggests that a dimension of greater authenticity and "realism" inheres in the Dionysian principle as present in nature. At any rate, when he transfers these artistic drives from nature to the mediating function of the artist, Nietzsche leaves no doubt that in both instances the principle of mimesis is at work: he asserts unequivocally, "Diesen unmittelbaren Kunstzuständen der Natur gegenüber ist jeder Künstler 'Nachahmer,' und zwar entweder apollinischer Traumkünstler oder dionysischer Rauschkünstler oder endlich — wie beispielsweise in der griechischen Tragödie — zugleich Rausch- und Traumkünstler" (With regard to these immediate artistic conditions of nature, every artist is an 'imitator,' either an Apollinian dream-artist or a

Dionysian artist of intoxication, or, finally — as is the case, for example, in Greek tragedy — simultaneously an intoxicating dream-artist; 30). Nietzsche thus argues that all art is mimetic, but that one can distinguish three subcategories of mimetic art, one purely Apollinian, one purely Dionysian, and one that melds and intermingles these two, for which Greek tragedy stands as the historical model.

Even at this early stage in his treatise Nietzsche then goes on to provide a first glimpse into how he imagines this interaction occurring in the Attic tragedy he will valorize as the pinnacle of art. We must picture the tragic artist, he writes,

> wie er, in der dionysischen Trunkenheit und mystischen Selbstentäusserung, einsam und abseits von den schwärmenden Chören niedersinkt und wie sich ihm nun, durch apollinische Traumeinwirkung, sein eigener Zustand d. h. seine Einheit mit dem innersten Grunde der Welt *in einem gleichnissartigen Traumbilde* offenbart. (31; Nietzsche's emphasis)

> [as he sinks down, in Dionysian drunkenness and mystical self-forgetfulness, alone and apart from the rapturous chorus, and how at this point, through the influence of the Apollinian dream, his own condition, that is, his oneness with the innermost ground of the world reveals itself to him *in an allegorical dream image.*]

This is a powerfully descriptive passage, rife with implications about Nietzsche's conception of his idealized art form, but a passage that, as far as I can see, has scarcely received attention from critics of this text. Let us try to unpack Nietzsche's densely compressed language here and lay out the stages of the creative process he has in mind. The tragic artist is, first and foremost, a Dionysian artist. That is, "he" — Nietzsche implicitly reserves the masculine gender for the artist throughout this treatise — must first sense his "oneness with the innermost ground of the world." This is the "intoxicating reality" Nietzsche stressed in the passage immediately preceding this description, and it is clearly a metaphysical or, perhaps better, *intra*physical reality, one that lies at the innermost core of the world and existence. We note also, confirming a point made above, how the Dionysian artist himself, in his own being, becomes a mimetic representation of this metaphysical ground: his "own condition" reflects, as it were, his identity with this ground. But after this wholly Dionysian encounter with the world and its deepest reality, something absolutely non-Dionysian must occur: the Dionysian artist stands "alone" and "apart" from the "rapturous chorus," breaking out of the primordial unity and the intoxicated community, and implicitly assuming the individuality of the Apollinian artist. In this withdrawn state, in which the Apollinian dream exerts its influence over him, the tragic artist reflects on his own Dionysian oneness and, in a process of second-order mimesis, creates an "allegorical dream image" that reveals the essence of this Dionysian oneness. This is, of

course, a paradoxical conception — only by stepping out of Dionysian oneness can this oneness be artistically revealed or represented, just as self-reflection always already presupposes distantiation from the self upon which one seeks to reflect. We will need to deliberate subsequently on the relationship between this second-order Apollinian mimesis in Nietzsche's theory of tragic art and the allegorical manner so characteristic of Expressionist literature, especially of its dramatic practice. For the moment, however, it is enough to recognize that Nietzsche presents these arguments about the mimetic quality of art in general, and its specific relation to the fundamental artistic drives he delineates, in an effort, as he expresses it, to understand and *appreciate* (Nietzsche's word is *würdigen*) the Aristotelian principle that all art is an imitation of nature (31). We recognize once more, then, that Nietzsche frames his arguments as a contribution to the much broader context of aesthetic theory in general, specifically as a redefinition of the applicability of mimesis.

When he shifts from the aesthetic to a more psychological or existential explanation of the interaction between the Apollinian and Dionysian principles of art, Nietzsche proposes a relationship of fundamental interdependence between the horror of Dionysian reality and the concomitant necessity for the redemptive semblance invoked by the Apollinian dream world. Commenting on what he perceives as a universal human desire for semblance and for redemption by means of semblance, Nietzsche remarks that he feels himself compelled to formulate the metaphysical hypothesis "dass das Wahrhaft-Seiende und Ur-Eine, als das ewig Leidende und Widerspruchsvolle, zugleich die entzückende Vision, den lustvollen Schein, zu seiner steten Erlösung braucht" (that the truly existent and primordially one, as eternal suffering and as the contradictory, simultaneously requires enrapturing vision, ravishing semblance, for its constant redemption; 38). We understand in this context precisely what Nietzsche means when he claims that the world — that is, empirical reality and existence — is only justified as an aesthetic phenomenon (*Geburt* 17, 47, 152): reality, in all its existential abomination, *requires* semblance as an eternal palliative. Nietzsche's concept of life, then, is not solely the naked reality of Dionysian existence, but also, and above all, the life of semblance, and the semblance of life. Thus in the 1886 self-criticism appended to *Geburt* he unequivocally states: "Alles Leben ruht auf Schein, Kunst, Täuschung, Optik, Nothwendigkeit des Perspektivischen und des Irrthums" (all of life rests on semblance, art, illusion, optics, the necessity of perspectivism and of error; 18). This should not lead one to believe, however, that *all* semblance, *all* illusion is by definition good. On the contrary, the escapism of absolute semblance is precisely what Nietzsche lambastes in Wilhelminian Germany, with its reliance on the deception of science and the fanciful illusionism of its art, represented in *Geburt* by the genre of classical opera (120–28).[18] There is, then, good and bad semblance, and, as a necessary corollary, there is also

good and bad mimesis. Good semblance does not *replace* or *substitute for* insight into the ground of existence, of the "primordial unity"; rather, it *supplements* this profound insight into the core of reality by dressing it up in a palatable form. Thus in the second section of *Geburt der Tragödie*, Nietzsche calls art "die zum Weiterleben verführende Ergänzung und Vollendung des Daseins" (a supplement to and perfection of existence that seduces one to go on living; 36), and he goes on to claim that the very same drive that produces art of this fundamental sort gave birth to the Olympian world of the gods in ancient Greece: in this world of Olympian myth, according to Nietzsche, the Hellenic "will" holds up to itself "einen verklärenden Spiegel" (a transfiguring mirror; 36).

Nietzsche's theme of metaphysical mimesis achieves its exemplary expression in this paradoxical formulation of the "transfiguring mirror." The mirror, of course, is the prototypical emblem of the mimetic capacity of art; and Nietzsche relies throughout *Geburt der Tragödie* on the strategic deployment of this metaphor of art as mirror. Following Schopenhauer, who glorifies music as an immediate copy of the will, Nietzsche calls "wahrhaft dionysische Musik" (true Dionysian music) a "Spiegel des Weltwillens" (mirror of the world will; 112; cf. also 126), appealing to the "higher" or more profound reality it reflects. But in Nietzsche's theory — contrary to a common misunderstanding — the Dionysian itself is not valorized as the pinnacle of art, as music is by Schopenhauer. On the contrary, it is Dionysian mimesis of the existential horror of the will *as filtered through* the transfiguring second-order mimesis of Apollinian image that Nietzsche holds up as the high-water mark of artistic achievement, as exemplified for him in Attic tragedy. That is why he speaks of the "brotherly alliance" into which these two gods enter so as to create the tragic art form (*Geburt* 139–40, 150). But the Dionysian ground that underlies this second-order Apollinian mimesis is the crucial aspect of Nietzsche's theory, and this is also what ultimately segregates his metaphysical mimesis from other, more traditional forms of mimetic representation. These positive and negative forms of mimesis are codified rather carefully in Nietzsche's language. The image of the "mirror" tends to take on positive connotations, especially in the form of the "transfiguring mirror." But even in the vocabulary he employs to articulate the concept of the copy, Nietzsche takes great care in distinguishing between the *Abbild*, the replica, which he evaluates positively (see, for example, *Geburt*, 43–44), and the reproduction, or *Conterfei*, which bears negative connotations (see *Geburt*, 112). Thus in his discussion of the genetic development of tragedy out of the tragic chorus, Nietzsche claims that this heritage alone rescues tragedy from a "painstaking reproduction" of empirical reality.

Die Tragödie ist auf diesem Fundamente [des Chores] emporgewachsen und freilich schon deshalb von Anbeginn an einem peinlichen

Abkonterfeien der Wirklichkeit enthoben gewesen. Dabei ist es doch keine willkürlich zwischen Himmel und Erde hineinphantasirte Welt; vielmehr eine Welt von gleicher Realität und Glaubwürdigkeit wie sie der Olymp sammt seinen Insassen für den gläubigen Hellenen besass. (55)

[Tragedy emerged from this foundation [of the chorus], and for that reason it was relieved, from the very outset, of any painstaking reproduction of reality. And yet in this regard it does not represent a world that is arbitrarily fantasized into the space between heaven and earth; rather, it is a world whose reality and credibility are equal to those that the believing Hellene attributed to Mt. Olympus and all its occupants.]

Verisimilitude in the arts bespeaks mimesis in its debilitating form; hence this comment is immediately preceded by a lilting critique of literary realism and naturalism. Such mechanical mimesis is, once again, merely *Schein des Scheins*, a semblance of semblance, and hence subject to all the vigor of Plato's and Schopenhauer's critique of such second-order semblance (*Geburt*, 93). The world of tragedy, by contrast, is a creative imitation that exists on the same order of ontic reality as does the world of phenomenal existence itself, and once again Nietzsche turns to the metaphor of the Olympian gods to exemplify this concept. A few pages later Nietzsche extends this definition of the chorus, claiming that it copies (*abbildet*) existence in a more truthful, realistic, and complete way "als der gemeinhin sich als einzige Realität achtende Culturmensch" (than the cultural human being who commonly attributes to himself the sole claim to reality; 58). He goes on to extrapolate from this comment a general maxim about the reality and truth of the poetic world.

Die Sphäre der Poesie liegt nicht ausserhalb der Welt, als eine phantastische Unmöglichkeit eines Dichterhirns: sie will das gerade Gegentheil sein, der ungeschminkte Ausdruck der Wahrheit und muss eben deshalb den lügenhaften Aufputz jener vermeinten Wirklichkeit des Culturmenschen von sich werfen. Der Contrast dieser eigentlichen Naturwahrheit und der sich als einzige Realität gebärdenden Culturlüge ist ein ähnlicher wie zwischen dem ewigen Kern der Dinge, dem Ding an sich, und der gesammten Erscheinungswelt. (58–59)

[The sphere of poetry does not lie outside the world, as the fantastic impossibility of a poet's mind: it seeks to be the exact opposite, the unvarnished expression of truth, and this is precisely why it must cast off the mendacious veneer of that ostensible reality of the cultural human being. The contrast between this authentic truth of nature and the cultural mendacity that poses as the sole form of reality is similar to that between the eternal core of things, the thing in itself, and the totality of the phenomenal world.]

This statement could stand as a motto for the literary aesthetics of the Expressionist generation: turning away from the phenomenal reality of the

surrounding *cultural* world does not imply for Expressionist artists, as it does not for Nietzsche, an escape from "reality" into the life of the imagination. On the contrary, it suggests a critical *penetration* of this veneer and a mimetic invocation of the unvarnished truth of existence that lies *below* this sphere of cultural "mendacity." It is no coincidence that in defense of this assertion Nietzsche turns to the Kantian distinction between the phenomenal and the noumenal, the world of appearances and the thing in itself. In other contexts Nietzsche refers to the poetic access to this metaphysical kernel, alluding to the second part of Goethe's *Faust*, as a descent to the realm of the "mothers" (*Geburt*, 103, 132). Thus mimesis in Nietzsche takes on positive connotations when it is related either directly to the representation of this metaphysical core, as in the case of music, or when mimesis functions as a palliative that makes this tragic recognition palatable, rather than providing ideological escape from this ultimate tragic insight. Negative mimesis, imitation as a slave to the world of phenomena (see McGinn, 108), makes its entrance in *Geburt der Tragödie* above all in the form of Euripidean tragedy and the New Attic Dithyramb, for Nietzsche the degenerate forms of classical Attic tragedy, and the Attic Dithyramb, respectively. About Euripides' dramas Nietzsche asserts: "deine [Euripides'] Helden haben nur nachgeahmte maskirte Leidenschaften und sprechen nur nachgeahmte maskirte Reden" (your [Euripides'] heroes only have imitated, masked passions, and they speak only in imitated, masked dialogues; 75). Paper figures with artificial emotions, Euripides' heroes serve only to exemplify the Socratic dialectic and its valorization of conceptual logic and abstract knowledge (see *Geburt*, 80–88). Nietzsche's critique of the New Attic Dithyramb as mere semblance of semblance, and hence as false mimesis, is even more explicit: "Durch jenen neueren Dithyrambus ist die Musik in frevelhafter Weise zum imitatorischen Conterfei der Erscheinung z. B. einer Schlacht, eines Seesturmes gemacht und damit allerdings ihrer mythenschaffenden Kraft gänzlich beraubt worden" (By means of that new dithyramb music is reduced in a blasphemous manner to a mimetic reproduction of phenomenal appearance, for example, of a battle, or of a storm at sea, and thereby wholly robbed of its myth-making power; 112). This new dithyramb represents a kind of program music that alienates musical art from its true mission, the direct mimetic representation of the will, by recasting it as the imitator of the phenomenal world. This limitation to mimesis of the phenomenal world of appearances, to the semblance of semblance is, for Nietzsche, the very definition of degeneracy in art, especially in music.

   It is important to point out, in opposition to the deconstructive critique of *Geburt der Tragödie*, that metaphysical mimesis cannot be equated with a backsliding on Nietzsche's part into a metaphysics of *presence*. Although Nietzsche quotes at great length the passage from Schopenhauer's *Welt als Wille und Vorstellung* in which music is valorized

as the immediate copy of the will (*Geburt*, 104–7), Nietzsche himself is careful to stress that music cannot be conceived as *identical* to the will: "denn die Musik kann, ihrem Wesen nach, unmöglich Wille sein, weil sie als solcher gänzlich aus dem Bereich der Kunst zu bannen wäre — denn der Wille ist das an sich Unaesthetische —; aber sie erscheint als Wille" (for it is impossible for music, according to its very essence, to be will as such, because as such it would have to be banished completely from the realm of art — for the will is the very definition of the non-aesthetic —; however, it appears as the will; 150–51). If the will is the very definition of the non-aesthetic, then music cannot simply "copy" the will; its representation, although at a principal level still mimetic, must also be transformative: music must transport the will into the realm of the aesthetic. Nonetheless, in the published text of *Geburt der Tragödie* Nietzsche perhaps presents this point too succinctly and cryptically, so that it is ultimately dwarfed by the long quotation from Schopenhauer that Nietzsche ultimately revises and corrects. In some of his unpublished notes for *Geburt* Nietzsche is much more lucid on this point. In fragment 12 [1] from spring 1871, for example, he denies, in fundamental opposition to Schopenhauer's position, that even the will itself can be accorded the status of a thing in itself, of being the essential, sub-phenomenal reality: "wir dürfen wohl sagen, daß selbst der 'Wille' Schopenhauers nichts als die allgemeinste Erscheinungsform eines uns übrigens gänzlich Unentzifferbaren ist" (we probably can claim that even Schopenhauer's "will" is nothing but the most general phenomenal form of something that is otherwise entirely indecipherable to us; *KSA* 7:361). Just as all art is mimesis, everything we can humanly perceive and conceive, even the "will," is part of the phenomenal world of appearances. But just as Nietzsche, as we have seen, distinguished different levels of mimetic representation to which he attributed varied values, here he delineates two basic categories of phenomena: sensations of pleasure and displeasure, which he identifies with the representations of the "will" itself, and all other, less universal modes of ideation.

> Müssen wir uns also schon in die starre Nothwendigkeit fügen, nirgends über die Vorstellungen hinaus zu kommen, so können wir doch wieder im Bereich der Vorstellungen zwei Hauptgattungen unterscheiden. Die einen offenbaren sich uns als Lust- und Unlustempfindungen und begleiten als nie fehlender Grundbaß alle übrigen Vorstellungen. Diese allgemeinste Erscheinungsform, aus der und unter der wir alles Werden und alles Wollen einzig verstehen und für die wir den Namen "Wille" festhalten wollen, hat nun auch in der Sprache ihre eigne symbolische Sphaere: und zwar ist diese für die Sprache eben so fundamental, wie jene Erscheinungsform für alle übrigen Vorstellungen. Alle Lust- und Unlustgrade — Äußerungen *eines* uns nicht durchschaubaren Urgrundes — symbolisieren sich im *Tone des Sprechenden*: während sämtliche übrigen Vorstellungen

durch die *Geberdensymbolik* des Sprechenden bezeichnet werden. (*KSA* 7:361; Nietzsche's emphasis)

[Even if we have to yield to the rigid necessity that we never get beyond the realm of ideation, we can yet delineate within the realm of ideation two primary types. One type reveals itself to us in the form of sensations of pleasure and displeasure and accompanies as a never absent thorough-bass all the other ideational expressions. This most general phenomenal form, out of which and under which we alone comprehend all becoming and all willing, and for which we want to retain the name "will," also has its own symbolic sphere in language: and this sphere is just as fundamental for language as is that phenomenal form for all the other ideational expressions. All degrees of pleasure and displeasure — expressions of *one* primal ground that is impenetrable to us — are symbolized in the *speaker's intonation*: whereas all the other ideational forms are denoted by the speaker's *gestural symbolism*.]

As human beings, we are chained, as it were, to the world of phenomena, and we cannot experience the noumenal world, just as in Kant's philosophy. But despite this, we can distinguish different types of ideation (*Vorstellungen*) that display more or less proximity to the sub-phenomenal world of the "will." Nietzsche does not give us much to go on in segregating these two types of ideation, except that he views the more authentic form as more "universal" than the others, and as bound to the unstable world of becoming and desiring. In other words, feelings of pleasure and displeasure are universal sensations, and as such they are those forms of ideation that link us most closely with the pre-individual ground of existence. Universality, in short, becomes the measure of authenticity because it points to that realm of experience — the Dionysian — that antedates the *principium individuationis*, the fragmentation of originary oneness into the manifoldness of distinct individuals. What is perhaps most significant about the cited passage, however, is that immediately after identifying these two genres of ideation, Nietzsche shifts to the manner of their representation, concentrating initially on the way they express themselves in language. Pleasure and displeasure, as the more general manifestations of the "will," are expressed in the *tone* of speech, while all other forms of ideation make themselves evident in gestural symbolism, among which Nietzsche later explicitly includes the consonantal and vocalic articulations by which speech is formed (361–62). Now, when he makes this distinction between more and less "authentic" layers of speech, Nietzsche is clearly relying on a venerable tradition, with roots in the eighteenth century, that valorizes tone of voice as a more "natural" and hence more veracious indicator of thought and feeling. But to identify Nietzsche's emphasis on tone with a metaphysics of voice in the Derridean sense is simply a short circuit of his arguments (De Man, 88; see also Staten's critique 20–22); for the "tone" Nietzsche invokes is not the pneuma of voice, the intangible "spirit" of

breath, but the concrete psychological reality of joy and suffering, pleasure and pain. This constitutes, as it were, the *music* of speech.

Nietzsche's theory has powerful implications for the aesthetic practice of literary Expressionism. His emphasis in the passage cited from his unpublished notes parallels and elucidates passages from the published text of *Geburt der Tragödie* in which he stresses the significance of meter, rhythm, dance, and melody as art's dimension of subliminal expressivity (*Geburt*, 48–50, 62–63). Indeed, what is the "spirit of music" out of which tragedy is born if not this profound level of emotionality expressed in rhythm, meter, and tone? From here it is but a short step to the pathos, attention to rhythm and meter, and emotionality of Expressionist literary language. If the language of Expressionism is no longer oriented toward what is logical and stylistically appropriate, but instead is often agrammatical, broken, turbulent, and exclamatory, as Caesar Flaischlein diagnosed as early as 1895 (Hillebrand, 103), then it found in Nietzsche an advocate — and, in his own writing, a practitioner — of the primal authenticity and mimetic representativity of such "broken" language. The mimetic object of such speech is not the logos, not the conceptual realm of ideation, but the sub-conceptual, psychological domain of primordial emotions. This is what the Expressionists refer to when they invoke Nietzsche's influence as a linguistic model.[19]

This is one side — we can legitimately call it the Dionysian aspect — of Expressionist literary practice; but there is another, equally important, complementary side of Expressionist literary practice that likewise derives its legitimation from Nietzsche: this is the proclivity of Expressionist writers to turn to allegorical modes of representation, and it is related to what Nietzsche conceives as tragic myth, generated by an amalgamation of the Dionysian and the Apollinian. How, we might ask, does Nietzsche specifically theorize the relationship between music, as the "thoroughbass" of authentic Dionysian representation, and other modes of aesthetic representation, especially Apollinian semblance? Or, put another way, why, and in what sense, is music the origin of tragic art and myth? Nietzsche gives an initial answer to this question in section 16 of *Geburt der Tragödie*, when he writes that music, as the immediate mimetic representation of the "will," "excites our imagination [*Phantasie*]," and continues with the claim: "die Musik reizt zum *gleichnissartigen Anschauen* der dionysischen Allgemeinheit, die Musik lässt sodann das gleichnissartige Bild *in höchster Bedeutsamkeit* hervortreten" (music entices us to generate an *allegorical conception* of the Dionysian universality, and hence music allows the allegorical image to emerge *in its most meaningful form*; 107; Nietzsche's emphasis). Music, in short, stimulates our imagination, our Apollinian capacities, to produce *allegorical images* that are coherent with music's Dionysian substrate. Nietzsche goes on to call this "die Befähigung der Musik, *den Mythus* d. h. das bedeutsamste Exempel zu gebären und gerade den *tragischen* Mythus: den Mythus, der von der dionysischen Erkenntniss

in Gleichnissen redet" (music's ability to give birth to *myth*, that is, to the most meaningful example, and in particular to *tragic* myth: that kind of myth that speaks in allegories about Dionysian knowledge; 107; Nietzsche's emphasis). Here we find the metaphor of "birth" contained in Nietzsche's title: the birth of tragedy out of the spirit of music is the birth of Apollinian allegory out of the metaphysical mimesis of Dionysian representation. Only because these allegorical images are born of music itself does their semblance contain a dimension of authenticity: these images, as images, are adequate to the Dionysian element they allegorically represent. Indeed, as Nietzsche explains a few pages later, this allegorical representation itself retains the mimetic capacity inherent in music.

> Denn der Mythus will als ein einziges Exempel einer ins Unendliche hincin starrenden Allgemeinheit und Wahrheit *anschaulich* empfunden werden. Die wahrhaft dionysische Musik tritt uns als ein solcher allgemeiner Spiegel des Weltwillens gegenüber; jenes anschauliche Ereigniss, das sich in diesem Spiegel bricht, erweitert sich sofort für unser Gefühl zum Abbilde einer ewigen Wahrheit. (112; my emphasis)

> [For myth seeks to be sensed *visually* as the singular example of a universality and truth that stares into the face of infinity. Genuinely Dionysian music presents itself to us as just such a universal mirror of the world will; the visual phenomenon refracted in this mirror immediately expands for our emotions into the replica of an eternal truth.]

The universality and truth of Dionysian music must be made visible (*anschaulich*) by means of allegorical representation. If Dionysian music presents itself to us as a mirror that mimetically reflects the "world will" as the metaphysical essence of reality, then, in a second creative phase, this music is transformed into a visual experience as it is refracted in the mirror of music. We should pay particular attention to Nietzsche's metaphors here: music itself is a mimetic mirror, but in this "mirror" a transformative refraction occurs in which the non-visual dimension of Dionysian universality is transmogrified into a visual image. We recall Nietzsche's previous reference to a "transfiguring mirror" (36); in this passage he attempts to detail for us precisely how this process of transfiguration occurs. It is, in essence, a kind of synaesthetic metamorphosis, a transformation of what is manifest in rhythm, meter, and sound into the Apollinian sphere of the visual. It proceeds as an allegorical image-making that reflects/refracts an essential Dionysian truth. The product of this allegorical image-making is what Nietzsche calls "tragic myth": "*Der tragische Mythus* ist nur zu verstehen als eine Verbildlichung dionysischer Weisheit durch apollinische Kunstmittel; er führt die Welt der Erscheinung an die Grenzen, wo sie sich selbst verneint und wieder in den Schoss der wahren und einzigen Realität zurückzuflüchten sucht" (*Tragic myth* can only be understood as a becoming-image of Dionysian truth through the application of Apollinian artistic means; it takes the world of

phenomena to its limits, at which it negates itself and attempts to retreat back into the womb of the true and sole reality; 141; Nietzsche's emphasis).

It is difficult to imagine a more emphatic and powerful defense of the ultimate *reality* of allegorical portrayal. At work in the generation of tragic myth is the same "brotherly alliance" between the Apollinian and the Dionysian that characterizes Attic tragedy for Nietzsche: Apollinian image joins forces with Dionysian truth, individual example merges with universal meaning. The individual, indeed, is forced to speak the language of Dionysian universality, to the point that it "negates" itself and returns, as image, to the "womb of the true and sole reality." Nietzsche's notion of myth, as Henry Staten has correctly claimed, theorizes the image at the absolute limit of its representational capacity, "the determinate particular expanded as far as it will go toward universality" (Staten, 16). But what is this symbolization of particular universality if not allegory? Nietzsche's theory of myth is, in fact, a theory of allegory. Moreover, this theory of allegory had a decisive impact on the generation of Expressionist writers, since it legitimated allegory as a deeper, more profound form of "realism" than the semblance of semblance provided in the literature of Realism and Naturalism. Allegory serves the Expressionist writers, as does myth in Nietzsche's aesthetics, as a mode of representation that permeates the veneer of cultural reality so as to expose universal existential "truths" that lie at the core of human experience. Allegory, when practiced skillfully, makes manifest the ultimate form of metaphysical mimesis, or the mimesis of metaphysical "truths." This is the sense in which we can affirm, with minor revision, Walter Sokel's fundamental insight that Expressionism expresses an intense subjectivism, objectified by means of abstraction (50). Subjectivism is only the proper word here if we identify it with that core level of experience below the sphere of the phenomenal that Nietzsche identifies with the Dionysian; it is, perhaps, subjective, but it is nonetheless, for Nietzsche and the Expressionists, a *shared* subjectivism. The process of "abstraction" by which this "subjective" element is objectified occurs as the image-making of allegory, as the Apollinian transformation of a Dionysian "truth."[20]

We might be tempted today to write off this aesthetics of tragic myth and Dionysian allegory as so much metaphysical hogwash. But the point here is not to deconstruct these notions, as one certainly could do, but merely to highlight certain continuities between Nietzsche's aesthetic theory and the literary practice of the Expressionists. The drive to discover a level of universal truth and reality *below* the everyday dimensions of the phenomenal world was one of the characteristic traits of the Expressionist artists. In a 1915 essay entitled "Die jüngste Dichtung" (The Most Recent Literature) and published in the prominent journal *Die Weißen Blätter*, Kurt Pinthus gave voice to the Expressionist's drive to strip away the veneer of the phenomenal world:

> Die Wirklichkeit vom Umriß ihrer Erscheinungen zu befreien, uns selbst
> von ihr zu befreien, sie zu überwinden nicht mit ihren eigenen Mitteln,
> nicht indem wir ihr entfliehen, sondern, sie um so inbrünstiger
> umfassend, durch des Geistes Bohrkraft, Beweglichkeit, Klärungssucht,
> durch des Gefühls Intensität und Explosivkraft sie besiegen und
> beherrschen, . . . das ist der gemeinsamste Wille der jüngsten Dichtung.
> (1503)

> [To free reality from the contours of its phenomenal appearances, to free
> ourselves from it, to overcome it with its own means, not by running
> away from it, but rather so as to embrace it all the more passionately, to
> come away victorious over and to master it by means of the mind's pene-
> trating power, mobility, drive for clarity, by means of the intensity and
> explosive force of the emotions, . . . that is the common aim of the most
> recent literature.]

Many of the elements of Nietzsche's aesthetics of tragedy are evident in
this passage: self-liberation, self-overcoming, transfiguration, embracing a
reality beyond the world of semblance. Similarly, in his preface to the influ-
ential collection of Expressionist lyric he edited under the title *Menschheits-
dämmerung* (Dawn [Twilight] of Humanity), Pinthus identifies in the
poems he includes "den Beginn eines Kampfes gegen die Zeit und gegen
ihre Realität. Man begann, die Um-Wirklichkeit zur Un-Wirklichkeit
aufzulösen, durch die Erscheinungen zum Wesen vorzudringen" (the
beginning of a struggle against the age and against its reality. One began to
dissolve the surrounding reality into irreality, and to penetrate beyond the
realm of appearances to the essence; 1982, 56). This programmatic state-
ment applies as well to the aesthetics of Nietzsche's *Geburt der Tragödie* as
it does to the unifying thrust of Expressionism. As a final witness let us
bring forward Kasimir Edschmid, whose essay "Expressionismus in der
Dichtung" (Expressionism in Literature) has long been regarded as one of
the most significant manifestos of Expressionistic aesthetics. Claiming that
Expressionist artists present "das tiefere Bild des Gegenstandes" (the more
profound image of the object; 46), Edschmid goes on to demonstrate this
process using the example of a house.

> Ein Haus ist nicht mehr Gegenstand, nicht mehr nur Stein, nur Anblick,
> nur ein Viereck mit Attributen des Schön- oder Häßlichseins. Es steigt
> darüber hinaus. Es wird so lange gesucht in seinem eigentlichsten Wesen,
> bis seine tiefere Form sich ergibt, bis das Haus aufsteht, das befreit ist von
> dem dumpfen Zwang der falschen Wirklichkeit. (47)

> [A house is no longer an object, no longer just stone, just a sight, just a
> rectangle with the attributes of beauty and ugliness. It goes beyond this.
> It is pursued in its most authentic essence until its more profound form
> comes to the fore, until a house emerges that is freed from the dull con-
> straints of false reality.]

What Edschmid describes here bears an uncanny resemblance to the phenomenological method developed by his contemporary, the philosopher Edmund Husserl, at about the same time. The phenomenal world is stripped away so as to reveal the "most authentic essence," the metaphysical core that underlies it. Decades before Husserl, Nietzsche emerged as the philosopher of what we might call a phenomenological aesthetics, an aesthetic theory that exploited the principle of representational mimesis as a revelatory strategy for the essence of existence. The literature of German Expressionism can be viewed as the attempt to transform, by means of specific literary-aesthetic strategies — pathos, rhythm, melody, allegory — Nietzsche's theory of metaphysical mimesis, or the mimesis of metaphysical "reality," into concrete artistic practice. In his "Versuch einer Selbstkritik," Nietzsche calls *Geburt der Tragödie* "ein Buch vielleicht für Künstler mit einem Nebenhange analytischer und retrospektiver Fähigkeiten" (a book perhaps for artists with a secondary inclination toward analytical and retrospective abilities; 13), and a book written for "Blutsverwandte in artibus" (blood relatives in the arts; 14). In the writers of German Expressionism he found these blood relatives, a group of artists with the analytical and retrospective abilities to grasp and apply the metaphysical mimesis he advocated in this first work of modern aesthetic theory.

# Notes

[1] Kellner ("Expressionism and Rebellion" 7) and Taylor (6; 13) make cases for the power of Nietzsche's philosophical impact on the Expressionist generation.

[2] Nietzsche's works are quoted from Colli and Montinari's *Kritische Studienausgabe* and cited as *KSA* with volume and page number; quotations from *Geburt der Tragödie* follow the text in volume one of this edition but will be cited, so as to set them apart from other Nietzsche citations, as *Geburt* followed by the page number. Throughout this essay, translations from the German are my own.

[3] On the role of Nietzsche as intellectual bellwether for the "Neuer Club" see especially Martens, 41–45, but also Ritter, 152; on the "Neopathetisches Cabaret," see Taylor, 41–42.

[4] I am thus inclined to disagree with Meyer, who reduces Nietzsche to just one of many formative influences on the Expressionists (247). To my way of thinking, this conception underestimates the special enchantment Nietzsche held for the Expressionist writers.

[5] The studies by Foster and Rampley, which examine Nietzsche's thought in the broader context of modernist aesthetics, also deserve mention here, although they do not limit themselves either to Nietzsche's reception in Germany or to Expressionism per se.

[6] Rampley goes so far as to regard Nietzsche's subsequent works as simple recastings of the ideas initially expressed in *Geburt der Tragödie* (9).

[7] I am fundamentally in agreement with Henry Staten's insightful and stimulating remark that *Geburt der Tragödie* marks "the hinge between romanticism and everything that is post-romantic" (9).

[8] See in this regard Porter (149), who claims that *Geburt der Tragödie* is not so much about Greek tragedy as it is about the rebirth of German myth.

[9] This focus on larger questions of aesthetics is confirmed by some of Nietzsche's unpublished notes written during the composition of *Geburt der Tragödie*. See, for example, note 12 [1] from spring 1871, in which Nietzsche expresses the hope "einige aufregende Streitfragen der heutigen Ästhetik [. . .] sich ernsthafter vorlegen und tiefer beantworten zu können, als dies gemeinhin zu geschehen pflegt" (that he will be able to outline more seriously and answer more profoundly than has commonly been possible [. . .] some exciting and disputed questions of present-day aesthetics; *KSA* 7:362).

[10] In this regard see Bennett, who makes a case for the relationship between Nietzsche's theory of myth in *Geburt* and the concept of "beautiful semblance" and aesthetic illusion developed in eighteenth-century aesthetics, in particular by Schiller.

[11] Berry takes note of the many references to imitation and mimesis in *Geburt*, but she fails to draw any substantive or critical conclusions from this recognition.

[12] In fact, Nietzsche undertook a detailed study of Lessing's major aesthetic treatise, *Laokoön*, in the late 1860s. See Sweet, 352.

[13] On Nietzsche's attempts to break with or move beyond a rigid Schopenhauerean view of aesthetics, see Nussbaum, 345, 348; Rethy, 3. Cf. also Staten (14), who argues that Nietzsche tried — unsuccessfully — to write Schopenhauer's concept of the "will" as a metaphysical "presence" (in the deconstructive sense) out of *Geburt der Tragödie*.

[14] Thus Schopenhauer valorizes the poet over the historian as someone who gives a more essential depiction of humanity because the poet represents the archetypal idea of the human, whereas the historian merely represents particular phenomenal human beings; see *Welt als Wille und Vorstellung* 1:290–91.

[15] Drost has examined this dimension of the mimesis problematic in *Geburt* most closely (esp. 314–15); but his assumption that this is the only level on which the principle of mimesis operates in Nietzsche's aesthetics is simply incorrect.

[16] Rampley argues that Apollinian art, insofar as it is a representation that refuses to acknowledge its own status *as* representation, is "a metaphor for ideological practice" (99). The same can be said for the scientific or Socratic worldview.

[17] Henry Staten (see esp. 12–13) has given a decisive critique of the deconstructivist position on this text, claiming that Lacoue-Labarthe and de Man must first construct (and hence misrepresent) Nietzsche's position in *Geburt*, and that what they then *de*construct is this artificially constructed or misconstrued text.

[18] McGinn (80–82) has given the most lucid definition of this difference between "authentic" and "inauthentic" cultures for Nietzsche: the former are transparent mediating forms that console, but still focus our attention on the horrors of existence, while the latter are purely opaque forms that serve only to hide, in an act of ideological escapism, the truth of existence.

[19] The praise for Nietzsche as an innovator of language is so universal among the writers of the Expressionist generation that one can cite examples almost at random. For Benn (1047) Nietzsche is the greatest genius of the German language; Frantz Clement calls Nietzsche the first patheticist of modernism (Hillebrand, 182); Richard Dehmel and Heinrich Mann revere him as a linguistic innovator (Hillebrand, 138, 266); and Otto Flake calls him the master of the German language (Hillebrand, 275).

[20] This is also how I would reformulate, in terms of Nietzsche's aesthetics, Douglas Kellner's observation that the Expressionist drive to portray the "essential" human being required abstraction and "symbolism" so as to distinguish it from the fragmentary and contingent. See Kellner's "Expressionist Literature and the Dream of the 'New Man,'" 166–67.

# Works Cited

Anz, Thomas, and Michael Stark, eds. *Expressionismus: Manifeste und Dokumente zur deutschen Literatur, 1910–1920.* Stuttgart: Metzler, 1982.

Aschheim, Steven E. *The Nietzsche Legacy in Germany, 1890–1990.* Berkeley: U of California P, 1992.

Benn, Gottfried. "Nietzsche — nach fünfzig Jahren." In *Gesammelte Werke in acht Bänden*, ed. Dieter Wellershoff, 4:1046–57. Wiesbaden: Limes, 1968.

Bennett, Benjamin. "Nietzsche's Idea of Myth: The Birth of Tragedy from the Spirit of Eighteenth-Century Aesthetics." *PMLA* 94 (1979): 420–33.

Berry, Wanda Warren. "Nietzsche's Dialectical Aesthetic in *The Birth of Tragedy.*" *Studies in the Humanities* 9, 2 (Sept. 1982): 40–46.

Bloch, Ernst. "Diskussion über Expressionismus." In Schmitt, *Die Expressionismusdebatte: Materialien zu einer marxistischen Realismuskonzeption*, 180–91.

Bronner, Stephen Eric, and Douglas Kellner. *Passion and Rebellion: The Expressionist Heritage.* New York: J. F. Bergin, 1983.

De Man, Paul. "Genesis and Genealogy (Nietzsche)." In *Allegories of Reading: Figural Language in Rousseau, Nietzsche, Rilke, and Proust*, 79–102. New Haven: Yale UP, 1979.

Drost, Mark P. "Nietzsche and Mimesis." *Philosophy and Literature* 10 (1986): 309–17.

Edschmid, Kasimir. "Expressionismus in der Dichtung." In Anz and Stark, *Expressionismus: Manifeste und Dokumente zur deutschen Literatur 1910–1920*, 42–55.

Foster, Jr., John Burt. *Heirs to Dionysus: A Nietzschean Current in Literary Modernism.* Princeton: Princeton UP, 1981.

Hillebrand, Bruno, ed. *Forschungsergebnisse: Nietzsche und die deutsche Literatur.* Deutsche Texte 51. Tübingen: Niemeyer/DTV, 1978.

———, ed. *Nietzsche und die deutsche Literatur: Texte zur Nietzsche-Rezeption, 1873–1963.* Deutsche Texte 50. Tübingen: Niemeyer/DTV, 1978.

Hiller, Kurt. "Das Cabaret und die Gehirne Salut: Rede zur Eröffnung des Neopathetischen Cabarets." In Anz and Stark, *Expressionismus: Manifeste und Dokumente zur deutschen Literatur, 1910–1920,* 439–41.

Huebner, Friedrich Markus. "Der Expressionismus in Deutschland." In Anz and Stark, *Expressionismus: Manifeste und Dokumente zur deutschen Literatur, 1910–1920,* 3–13.

Kellner, Douglas. "Expressionism and Rebellion." In Bronner and Kellner, *Passion and Rebellion: The Expressionist Heritage,* 3–39.

———. "Expressionist Literature and the Dream of the 'New Man.'" In Bronner and Kellner, *Passion and Rebellion: The Expressionist Heritage,* 166–200.

Lacoue-Labarthe, Philippe. "Le détour." *Poetique* 5 (1971): 53–76.

Lukács, Georg. "Es geht um den Realismus." In Schmitt, *Die Expressionismusdebatte: Materialien zu einer marxistischen Realismuskonzeption,* 192–230.

Martens, Gunter. "Nietzsches Wirkung im Expressionismus." In Hillebrand, *Forschungsergebnisse: Nietzsche und die deutsche Literatur,* 35–82.

McGinn, Robert E. "Culture as Prophylactic: Nietzsche's *Birth of Tragedy* as Cultural Criticism." *Nietzsche-Studien* 4 (1975): 75–138.

Meyer, Theo. *Nietzsche und die Kunst.* Uni-Taschenbücher 1414. Tübingen: Francke, 1993.

Nietzsche, Friedrich. *Die Geburt der Tragödie.* In *Kritische Studienausgabe,* 1:9–156.

———. *Kritische Studienausgabe.* Ed. Giorgio Colli and Mazzino Montinari. 15 vols. 2nd ed. Munich and Berlin: DTV/De Gruyter, 1988.

Nussbaum, Martha C. "Nietzsche, Schopenhauer, and Dionysus." In *The Cambridge Companion to Schopenhauer,* ed. Christopher Jenaway, 344–74. Cambridge: Cambridge UP, 1999.

Pinthus, Kurt. "Zur jüngsten Dichtung." *Die weißen Blätter* 2 (1915): 1502–10.

Pinthus, Kurt. "Zuvor" [Preface to *Menschheitsdämmerung*]. In Anz and Stark, *Expressionismus: Manifeste und Dokumente zur deutschen Literatur 1910–1920,* 55–60.

Porter, James I. *The Invention of Dionysus: An Essay on "The Birth of Tragedy."* Stanford: Stanford UP, 2000.

Rampley, Matthew. *Nietzsche, Aesthetics and Modernity.* Cambridge: Cambridge UP, 2000.

Rethy, Robert. "The Tragic Affirmation of *The Birth of Tragedy.*" *Nietzsche-Studien* 17 (1988): 1–44.

Ritter, Mark. "The Unfinished Legacy of Early Expressionist Poetry: Benn, Heym, Van Hoddis and Liechtenstein." In Bronner and Kellner, *Passion and Rebellion: The Expressionist Heritage,* 151–65.

Rolleston, James. "Nietzsche, Expressionism and Modern Poetics." *Nietzsche-Studien* 9 (1980): 285–301.

Schmitt, Hans-Jürgen, ed. *Die Expressionismusdebatte: Materialien zu einer marxistischen Realismuskonzeption.* Frankfurt am Main: Suhrkamp, 1973.

Schopenhauer, Arthur. *Die Welt als Wille und Vorstellung.* Vols. 2 and 3 of his *Sämtliche Werke*, ed. Arthur Hübscher. Wiesbaden: Brockhaus, 1961.

Sokel, Walter H. *The Writer in Extremis: Expressionism in Twentieth-Century German Literature.* Stanford: Stanford UP, 1959.

Staten, Henry. "*The Birth of Tragedy* Reconstructed." *Studies in Romanticism* 29 (1990): 9–37.

Sweet, Dennis. "The Birth of *The Birth of Tragedy.*" *Journal of the History of Ideas* 60 (1999): 345–59.

Taylor, Seth. *Left-Wing Nietzscheans: The Politics of German Expressionism, 1910–1920.* Monographien und Texte zur Nietzsche-Forschung, vol. 22. Berlin: De Gruyter, 1990.

Vietta, Sylvio, and Hans-Georg Kemper. *Expressionismus.* Uni-Taschenbücher 362. Munich: Fink, 1975.

Zweig, Stefan. "Das neue Pathos." In Anz and Stark, *Expressionismus: Manifeste und Dokumente zur deutschen Literatur 1910–1920*, 575–81.

# Prose

# 2: The Prose of German Expressionism[1]

*Walter H. Sokel*

IN HIS INTRODUCTION to the catalog to the Marbach Expressionism exhibit in 1960, Bernhard Zeller observed: "Schon die Frage, welche Dichter, welche Werke als expressionistisch anzusehen sind, ist heute wie ehedem nicht immer ganz eindeutig zu beantworten" (Even the question as to which poets, which works are to be considered Expressionist, now as then cannot always receive a completely definitive answer; 5). Indeed, "not always completely definitive" is an exemplary instance of understatement. The question is not only vague and ambiguous, but exceptionally difficult to answer, because we do not have criteria that would provide us with the necessary information to correctly pose the question. Indeed, there exists a general, albeit somewhat tentative, consensus of scholarly opinion that the works of writers published in avant-garde periodicals between 1910 and the early 1920s may be termed Expressionist. Besides these, we should also include works that appeared in a book series such as "Der jüngste Tag" (The Newest Day, published by Kurt Wolff) and anthologies such as Kurt Pinthus's *Menschheitsdämmerung* (Dawn of Humanity, 1920). However, these are purely external and accidental criteria, conveying little about the shared formal, stylistic, and thematic characteristics of these writers. Nevertheless, they do provide a point of departure for subsequent study. Perhaps the question can be posed in this way: What are the inherent or formal characteristics shared by the many writers whose works appeared in avant-garde periodicals, book series, and anthologies between 1910 and 1923 or 1925 that would entitle us to call them Expressionist? Would a characterization that would allow a comparison to Romanticism or Naturalism be preferable? Despite the fact that in these much longer and better-researched literary movements terminological ambiguity still persists (indeed, over-generalization is intrinsic to any definition of genre), the terms Romanticism and Naturalism are nevertheless based upon far more concise and accepted criteria than the constant vacillation found in the term *Expressionism*. In this essay, the question of what criteria would be most suitable to define Expressionism will be addressed, specifically in respect to a single literary genre, namely, narrative prose.

Before we proceed with an analysis of the texts themselves, we must determine whether we can formulate a theory of Expressionism, specifically

a poetics of narration that would enable us to devise a coherent theory of Expressionist prose. Among the writers of Expressionism there was little theoretical reflection. It is therefore much more difficult to assess the theory of Expressionism than that of Romanticism or Naturalism. The well-known commentaries of Kasimir Edschmid, Paul Kornfeld, and Georg Kaiser, among others, have virtually nothing to say about formal, stylistic, and structural aspects of Expressionist literature. Fortunately, this characteristic absence of theory does less harm to a theory of the Expressionist novel than to a theory of Expressionist drama or poetry (Benn's literary theory belongs for the most part to the period subsequent to Expressionism). Alfred Döblin, one of Expressionism's most sophisticated and theoretically well-grounded intellectuals, developed clear and concise theoretical formulations about Expressionism. In the years between 1910 and 1920 he had already contributed many concrete and important ideas about Expressionist prose, so much so that we may use it as the basis for an Expressionist theory of epic prose. Döblin used the term Expressionism in an approving way to describe his own works.

On the other hand, Carl Einstein's theoretical and programmatic remarks on the genre of the novel are far less concrete than Döblin's theories, and despite their elevated philosophical erudition offer little in the way of a theory of Expressionist narrative. Although Einstein and Döblin have much in common, important differences between them make them in many ways diametrically opposed. It is impossible to speak of a single coherent theory of narrative prose in Expressionism. At most, one can speak of differing principles and unique trends, whether one prefers the theories of Döblin or Einstein. In short, we meet with a multiplicity of theoretical points of view, and thus we must investigate further to discover a common denominator shared by the various theories of Expressionist narrative prose.

To begin with, both Döblin and Einstein reject psychology in their theories of narrative prose, but for very different reasons. For Döblin, on the one hand, psychology represented an inappropriate intervention of commentary and analysis by a narrator, a technique that vitiates unmediated representation; Einstein rejects psychology because it compromises the artwork's purity, its autonomy. Neither Döblin nor Einstein attributed great value to the role played by plot in narrative prose, the suspenseful intertwining of the narrated events. However, this also aptly illustrates an important difference in their theories of narrative. Döblin rejects plot because it is essentially not epic in design and is more suitable to drama. Psychological motivation, circumstantial determination, and causality cannot be ascribed to the genre of epic, which is based upon description and naturalistic representation. According to Einstein, however, drama is distinguished from epic by the former's use of gesture, and to the latter he assigns thought and reflection. He conceives of the concrete as a part of

dramatic representation, seeing thought and reflection as belonging exclusively to the novel. In his "Über den Roman: Anmerkungen" (Remarks on the Novel), published in 1912 in *Die Aktion*, Einstein states about the plot that it "kann auch anders endigen" (can also end differently, 128), an idea of arbitrariness in the novel that anticipated by twenty years Musil's fundamental notion of *Parallelaktion* (parallel action). We recall that Döblin defined the epic as the representation of things, of external reality, without commentary, a notion, Muschg has pointed out, that anticipated the *nouveau roman*.[2] Nevertheless, Einstein also insisted that "Dinge haben sich vor dem Schicksal der Menschen zu verkriechen" (objects have to stoop before the fate of humans; 128) an idea that is obviously opposed to the *nouveau roman*. The *nouveau roman* is mentioned in this connection to underscore the fact that the two most prominent Expressionists start out from entirely different theories of prose. In his critique of narrative intervention, his advocacy of autonomous depiction and "scenic" liveliness, as well as his insistent rejection of all rhetorical embellishment, Döblin places himself in a tradition that can be traced back to Gustave Flaubert, Friedrich Spielhagen, and Henry James. This tradition also includes Naturalism and Futurism, as well as Kafka and the *nouveau roman*. One may define this tradition as "objective," for it attempts to eliminate the subjective perspective of the narrator, his personality and mentality, and seeks to describe nothing more than things and events as they are, including the audible and inaudible thinking of characters. In his Expressionist period, Döblin traced his narrative prose style back to Naturalism. He referred to it as "das Sturzbad, das immer wieder über die Kunst hereinbricht und hereinbrechen muß" (the flashflood that breaks again and again over art, as it must do so; 1963, 18). In his opinion, Naturalism employed a very specific narrative technique, namely, the technique of direct or unmediated representation: "Entselbstung, Entäußerung des Autors, Depersonation, [. . .] Tatsachenphantasie!" (De-selfing, externalizing of the author, depersonation, [. . .] factual fantasy! 1963, 18–19). After Naturalism, the history of the novel is the history of the "modern epic." Döblin saw in Futurism (to which Döblin was indebted, as Muschg demonstrates) the final development of Naturalism. In his critique of Marinetti, the founder of Futurism (Döblin 1963, 9–15), Döblin claims that Futurism departed from a rigorous Naturalism by sacrificing naturalistic mimesis to narrative subjectivity, whereas anti-subjectivism and the rejection of plot are inherent to Naturalism. Indeed, Naturalism sets out to abolish the intervention of the narrator situated between external reality and the reader. Accordingly, he exhorts the Expressionist to follow in the footsteps of Realist and Naturalist techniques of narration. Edschmid too viewed Expressionism as a further elaboration of Naturalism, but elevated it to a visionary plane. Kafka, who like Döblin dismissed psychology ("Zum letzten Mal Psychologie!" [For the last time psychology!]; 107), also eliminated the omniscient narrator and

instead sought an unmediated representation of events and actions, as both Beissner and Martin Walser have observed. Nevertheless, we must realize that Kafka's narrative technique differed markedly from that used by the Expressionists.

Unlike Döblin, Einstein had little to say about narrative technique and even less about narrative perspective. He is less concerned with literary technique than he is with conveying a specific worldview. This is an essential difference between the two authors. Unconcerned with techniques of mimetic representation, Einstein's narrative strategy focuses on communication of ideas and a worldview. He opposes form to idea, but form is more than a mere technique, it is the idea of form based on Platonic philosophy, an existential concept and part of his worldview. Whereas Döblin aligns himself with Naturalism, Einstein stresses his absolute difference from it. He dismisses its beauty of style as "vulgar-naturalistic," because it embellishes and conceals reality; instead he asserts that style should seek out the Platonic forms beyond reality. While Einstein prefers *Tristan und Isolde* to *Gulliver's Travels*, he would like to see eroticism eliminated from literature, and in its place inaugurate a "Literatur für differenzierte Junggesellen" (literature for discriminating bachelors; 129). For him, thinking and reflection should be the writer's highest goal and provide the basis for a new literature based upon serious play with ideas. He traces the origins of the new literature back to Romanticism, Nietzsche, and André Gide (to whom he dedicated *Bebuquin*) and finally to Dadaism and to works by Robert Musil and Gottfried Benn. The Expressionists most closely related to him are Musil, Mynona (Salomo Friedlaender), Alfred Lichtenstein, Gustav Meyrink, and Otto Flake; connections can also be made to Franz Kafka, Gustav Sack, Benn, and Hermann Broch. Einstein anticipates Benn's notion of absolute art, and Gide's and Musil's conception of an ironic novel and their experimentation with ethical concepts. Deeply indebted to Nietzsche, his literary theory is ultimately derived from Romanticism and German Idealism. Not only his idealism, but also his style and sentence structure are reminiscent of Friedrich Schlegel. In general he traced the prevalent ideas of his generation back to Nietzsche. Einstein wished to revive free, creative spontaneity, and sovereignty of mind playfully exploring the multifarious possibilities of thought.

For Einstein intellectual reflection should be the theme and object of the modern epic; the narrator is to play a role entirely different from the one assigned to him (or her) by Döblin and other Expressionist partisans of Naturalism. In Döblin the narrator is manifested as the text, everything is unmediated, immediate. In Einstein the narrator is to be present in his reflections and ideas, mediated by a character who constantly ponders and comments upon the narrative. Indeed, reflection replaces depiction. Hence Einstein's preference for first person narration. In Döblin, Heym, Kafka, and Edschmid, among others, scenic representation and gesture

prevail, while in the work of someone like Otto Flake, who followed Einstein, the very opposite is the case. Instead of *Anschaulichkeit* (or three-dimensional plasticity), scenic evocation and images, we are given intellectual discourse. According to Einstein's own formulation: ideas dominate things.

The fundamental difference between these two leading tendencies in Expressionist prose is evident in the use of language: specifically, in the construction of sentences. They both tend towards structural concision, forcefulness, and terseness of expression. This concise use of speech is a unique quality common to the greater part of Expressionist narrative prose and brings us close to a definition of its narrative technique. However, we find evidence of such syntactic terseness and concision expressed in different ways in the two separate groups of Expressionist writers. We shall select Döblin as a representative of the one group and Einstein as representing the other. In the former, syntactic brevity and ellipsis prevail, while in the latter an aphoristic sententiousness predominates. However, this distinction is most tentative and must be examined in the context of narrative perspective and structure.

In the works of Döblin and others following him, we clearly see how a paratactic style directly results from the removal of a commenting narrator. Subordinate clauses explaining or describing motivation are missing, and syntax is reduced to its most basic elements. Döblin referred to this type of narration as "Kinostil" and "Fülle der Gesichte" (cinematic style, fullness of vision; 1963, 17) involving extreme compression and precision, as in his novels and short stories. It combined the imagism that characterized the prose of Expressionists Johannes Becher, Leonhard Frank, and Karl Otten as well as the poetry of Georg Trakl, Georg Heym, Jakob van Hoddis, and Alfred Lichtenstein. Döblin exhorted writers to extract the essence of life and energy from language. This entailed a sparseness of words, the rejection of discursive reasoning, and the avoidance of ornamental figuration. "Man erzählt nicht, sondern baut" (one does not narrate, but rather, constructs; 1963, 17), not explanation, rather presentation is the goal. "Das Ganze darf nicht erscheinen wie gesprochen, sondern wie vorhanden" (The whole should appear not as spoken, but as physically present; 1963, 17). His views on narrative technique are essentially anti-psychological. Döblin rejects psychology, for it seeks to explain, comment, deduce, and argue. However, he embraces psychiatry, since, in his view, it restricts itself to the simple notation of events and actions as such.

The narrative ideal articulated in this opposition between psychology and psychiatry finds clear expression in the sentence structure and language of the short stories and novels in his Expressionist phase; that ideal requires a paratactic style, in which syntactic subordination very nearly ceases to exist. A passage from "Segelfahrt" (Sailing Trip, 1911) illustrates this point:

Dröhnend schlug er seine Zimmertür hinter sich zu, warf sich im finstern Zimmer auf einen Schreibsessel, zerriß die Bilder seiner beiden Kinder, nahm eine Nagelschere, zog seinen edelsteinbesetzten Trauring ab, hing ihn über die Schere, hielt den Ring über die brennende Kerze. Die Steine verkohlten; die Schere wurde heiß; er ließ sie fallen. (1977, 33)

[Thundering he slammed the door to the room behind him, threw himself in the dark room into a writing chair, ripped up pictures of his two children, took a pair of nail scissors, pulled his bejeweled wedding ring off, hung it on the scissors, held the ring above the burning candle. The stones blackened; the scissors got hot; he let them drop.]

Despite its length, the sentence is composed of paratactic simple sentences linked by semicolons. Even though the subject of the sentence is mentioned only once, each clause is an independent sentence, joined to the other not by subordination, but rather coordination. If the subject *er* (he) were repeated, in place of each semicolon we could place a period and this would not impair the syntactic coherence. Therefore, it is not the brevity of the sentences, but their paratactic coordination that constitutes this style. The elimination of syntactic subordination defines the very essence of Expressionist style. Only what actually occurs gets stated. The content is a cinematic succession of events and sensations ("die Schere wurde heiß" [The scissors got hot]). The absence of any sort of commentary, of any narrative intervention, presupposes the paratactic principle of *Kinostil*. In it is contained the vividness, or more exactly, the cinematographic sequence of images on which Döblin insisted.

In naturalistic representation, instead of commentary and intellectual analysis, Döblin conveyed the inner life of characters in two possible ways: first, through their concrete actions and gestures, and, second, through their spoken words and stream of consciousness ("innerer Monolog"). The latter, however, contradicts what Döblin defined as *steinerner Stil* (concrete style, that is, in stone; 1963, 18), his naturalistic style of representation. Apparently, Döblin was unaware of this contradiction. It is impossible to make an absolute distinction between naturalistic representation and the perspectives of the figures or persons in a novel, the latter fully developed in the technique of stream of consciousness. He employs a mixture of the two. Nevertheless, in Döblin's "Segelfahrt," in Edschmid's *Die sechs Mündungen* (The Six Openings, 1915), and in Heym's "Der fünfte Oktober" (The Fifth of October, 1911) naturalistic representation obviously prevails. In these instances, gesture is utilized as an essential compositional technique. It is employed to symbolize the inner life of the character, which conventionally is done by a narrator. Not only do Edschmid's short stories such as "Der aussätzige Wald" (The Leprous Forest, 20–39) and "Maintonis Hochzeit" (Maintoni's Wedding, 40–55) often end with broad, very concretely rendered gestures by the main

characters, but also, on nearly every page of Edschmid's first volume of short stories, gestures serve to underscore the action and express its inner logic. Döblin writes:

> "Zorn," "Liebe," "Verachtung" bezeichnen in die Sinne fallende Erschei-nungskomplexe, darüber hinaus geben diese primitiven und abgeschmack-ten Buchstabenverbindungen nichts . . . sie können nicht zum Leitfaden einer lebennachbildenden Handlung werden. An dieses ursprünglich Gemeinte, dieses Simple muß man sich streng halten, so hat man das Reale getroffen, das Wort entzaubert, die unkünstlerische Abstraktion vermieden. Genau wie der Wortkünstler jeden Augenblick das Wort auf seinen ersten Sinn zurück "sehen" muß, muß der Romanautor von "Zorn" und "Liebe" auf das Konkrete zurückdringen. (1963, 16–17)

> ["Anger," "love," "disdain," denote phenomenal complexes that appear to the senses, beyond that these primitive and tasteless combinations of letters say nothing . . . they cannot become the thread of a mimetic sto-ryline. One must hold strictly to the original intention, the simple mean-ing, thus one captures what's real, demystifies the word, avoids inartistic abstraction. Just as the artist of words sees each word at every moment in its primary meaning, so too must the novelist push back beyond [the words] "anger" and "love" to their concrete significance.]

However, this ideal of a complete depersonalization of narrative is consistently maintained neither by Döblin nor Edschmid, nor anywhere else in Expressionist prose. Abstractions, sentiments, and ideas are not always successfully transformed into concrete imagery and visual represen-tation. This transformation can only occur when dialogue and stream of consciousness usurp the conventional function of narration. Whenever Döblin narrates or reports events using such abstract denominations of feeling as *Zorn* (anger), *Liebe* (love), and *Wut* (rage) for conventional (and not visual) depiction of sentiments, then his above-mentioned *steinerner Stil* is seriously compromised and a back door is opened, so to speak, to authorial commentary upon events.

The works of Georg Heym (1887–1912) suggest a viable alternative to Döblin's ideal of the depersonalized narrator. At first glance, Heym's novella "Der fünfte Oktober" (The Fifth of October, 1911) seems to uti-lize the same principle of depersonalized depiction. However, the generous use of similes in the narrative serves to make the narrative point of view more subjective. By means of similes and metaphor, the narrator's point of view is interjected into the action, thereby forfeiting the *steinerne* (con-crete) objectivity of representations. Döblin would disapprove of Heym's literary style, which teems with metaphors. Döblin rejects similes and metaphors, because he seeks direct "plasticity" in the representation of real-ity, not rhetorical inventiveness on the part of the author. To be sure, Heym never employs rhetorical commentary. Nevertheless, his use of simile

intends to influence the reader, as for example in this novella. The author-ial rhetoric by images finds a clear illustration in the final sentence of the story: "Aber die gewaltigen Pappeln der Straße leuchteten wie große Kan-delaber, jeder Baum eine goldene Flamme, die weite Straße ihres Ruhmes hinab" (But the mighty poplars along the road gleamed like great cande-labras, each tree a golden flame, down the broad street of their glory; 18). The simile and metaphor of this passage give evidence of the participation of the narrator, who with the word "glory" rhetorically praises the revolu-tion, whose history he conjures up in images of relentless immediacy.

Leonhard Frank (1882–1961) makes more extreme and direct use of rhetorical figures in his prose works. In the collection of novellas *Der Mensch ist gut* (Man is Good, 1919) the narrator's participation and inter-ference is undisguised, expressed not only in vocabulary and simile but also through direct commentary. The narrator judges the action and characters, didactically attempting to influence the reader: "Die Abzementierung des Gefühls, des Schmerzes war undurchdringlich; so undurchdringlich war die einzementierte Wortplatte — von den noch im dunkelsten Geiste alter Jahrhunderte Stehenden einzementiert in das empfängliche, gedankenlos-gläubige Gehirn des Volkes — daß der noch undurchlittene Schmerz nicht eine Sekunde lang in ihr Herz vordringen konnte" (The cementing of feel-ing, of pain was impenetrable; so impenetrable was the cemented plate of words — set by those stuck in the darkest spirit of ancient centuries like poured cement into the receptive, thoughtlessly gullible brain of the people — that the still unfelt pain could not for a second penetrate to the heart; 24). Here he employs the technique of "psychologization" repudi-ated by Döblin, namely the attempt to explain and interpret the feelings of the characters, embellishing it with phrases such as "Abzementierung des Gefühls" (cementing of feeling) or clichés such as *Schmerz* and *Herz* all of which refer to "unkünstlerische Abstraktion" (inartistic abstraction). Moreover, the interjection of opinions into the narrative invokes general-izations surpassing the limits of the text. The narrator seeks to persuade the reader by a particular choice of words. The interjection of such authorial phrases such as "in the darkest spirit of ancient centuries" and "thought-less-gullible brain of the people" render them illustrative of the opinions and views of the narrator. Thus the narrative depicts a worldview and seeks to demonstrate a truth that the author wants to propagate. This narrative technique is the very opposite of what Döblin called the *steinerner Stil* (concrete style; 1963, 18) and represents a group of Expressionist writers who sought to spread ideas and present a worldview. We shall refer to this technique, employed by many important prose writers in Expressionism, as parabolic narrative. The distinction between parables told in the first and in the third person is of little relevance here.

Chronologically, Else Lasker-Schüler's *Peter-Hille-Book* (1906) is the first in a series of Expressionist parables.[3] Deeply indebted to the Bible, it

describes various encounters between the first person narrator and a holy figure, and it belongs to the genre of hagiography, exhibiting the exemplary behavior of the master in various life situations. The paratactic style is also indebted to the bible. Sentences often begin with *Und*, a common feature of exemplary prose, and the succession of events and statements suggests a life of wandering on earth, expressing edifying views of the holy figure from the point of view of a devout and loving disciple.

Albert Ehrenstein's *Tubutsch* (1911), a work composed of episodes and narrated in the first person, is a parable expressing a worldview very different from that of Lasker-Schüler. Borrowing from Schopenhauer and materialism, Ehrenstein seeks to demonstrate the senselessness and absurdity of existence. One might say that each episode is "assembled" in a specific way that serves to emphasize the pessimistic view of life communicated by the narrator.

It is above all Mynona (1871–1946) who made the most extensive use of the parabolic form. Unlike Lasker-Schüler and Ehrenstein, he employed third person narrative, but the personality and ideas of the narrator dominate the story. For example, in his most well-known tale, "Rosa, die schöne Schutzmannsfrau" (Rosa, the Beautiful Policeman's Wife) the reader is directly addressed: the narrator interrupts and discusses the story through commentary and reflection. Mynona's narrator plays a role quite different from that of the narrator in Döblin's works. Like Leonhard Frank, Mynona addresses topics beyond the story, and the interjections of the narrator determine the meaning of the tale. According to Döblin, the sense of the story is embedded in the text itself. In parabolic narrative the sense of the story derives from extra-narrative references, which in Mynona's case convey an idealistic view of life that sees material reality overwhelmed by the spiritual and in which the universal represents the sole authentic reality. However, unlike Frank's moral-political reflections, Mynona's works are not didactic but rather ironic and inconclusive.

In sharp contrast to Frank's messianism and explicit activism, Mynona employed the Romantic device of an ironic narrator. The narrator himself is marked through the use of grotesque irony. His madness is shown from a critical and sovereign point of view. The narrator refers to himself as a "grotesker Humorist" (grotesque humorist) who creates a caricature of the earthly corruption of the divine archetype of authentic life. It is a negativity that leads to the spiritual essence of being. Without a doubt, Mynona's stories are guided by didactic intentions. His sketches are ironic-grotesque parables, illustrations of nonsense, beyond which lies a deeper spiritual meaning. Here the reemergence of authorial intention is deemed necessary. As is the case in the works of Jean Paul, E. T. A. Hoffmann, Raabe, and later Musil, authorial intentionality prevails. However, unlike Döblin's type of naturalism, Mynona's grotesque humor denies the

narrator absolute status, denies him absolute reality. The use of irony transforms the narrative into a "sign" that refers to ideas beyond the text.

The same idea of narrative emerged in Carl Einstein's novel *Bebuquin, oder die Dilettanten des Wunders* (Bebuquin or the Dilettantes of Miracle, 1912) and later in Otto Flake's *Stadt des Hirns* (The City of the Brain, 1919) and Robert Musil's *Mann ohne Eigenschaften* (Man without Qualities, 1930). They all reject the narrative technique of representation, that is, of *Bauen* as a goal in itself. Instead they ponder philosophical and moral issues, which to them are the very *raison d'être* of writing. Einstein's abstract intellectualism and grotesque irony belongs in the category of parabolic Expressionism. It clarifies the discrepancy between the ideal of spiritual control over external reality and the futile attempt, indeed, "dilettante" quest, to represent it. As for Mynona, parable is effective in two ways, namely, through philosophical dialogue, and grotesque fantasy. These two components characterize the dialogue as well as the circumstances, situations, and figures in the novel. The dialogue contains opinions and points of view that constitute the content of the novel. Consisting mostly of discourses of a kind we also find in Flake's *Stadt des Hirns* and Musil's *Mann ohne Eigenschaften*, these meditations illustrate the intellectual and experimental nature of Expressionist prose. The narrative is not objective; it is subjective, intellectual and amorphous, a merely thematic aspect of the narrative structure. Ideas appear and find formulation in the text. This predominance of intellectual rumination in the dialogue characterizes Einstein's, and later Flake's, theory of literature. In contrast to Döblin's concrete description of external reality, Einstein aimed for an afigural idealism. Above all, he saw dialogue and conversation as very important, but even such a work of classical Realism as Fontane's *Der Stechlin* has been characterized as a conversational novel. Thus it is less a question of the predominance of dialogue and more a question of the kind, content, and manner of dialogue that fundamentally distinguishes Einstein's novel from the earlier conversational novels of European Realism. Einstein's dialogues do not merely represent characters and situations, but make the characters convey ideas. In *Bebuquin*, character development is secondary to the ideas, which are what interested Einstein.

The main character's reflections form the other narrative technique of importance. These cogitations are formulated as aphorisms and accompanied by astonishing, absurd, and fantastic events. One example taken from *Bebuquin* illustrates the interweaving of these aspects in this first Expressionist novel:

> . . . Er sagte sich, daß der Wert etwas Alogisches sei, und er wollte damit nicht Logik machen. Er spürte in diesem Widerspruch keine Belebung, sondern Auflösung, Ruhe. Nicht die Verneinung machte ihm Vergnügen. Er verachtete diese prätentiösen Nörgler. Er verachtete diese Unreinlichkeit des

dramatischen Menschen. Er sagte sich, vielleicht nötige ihn nur seine Faulheit zu dieser Betrachtung. Doch die Gründe waren ihm nebensächlich. Es handelte sich um den Gedanken, der logisch war, woher auch seine Ursachen kamen. Böhm begrüßte ihn leise und freundlich. Er wollte sich nach seinem Tode etwas schonen, da er noch nichts Sicheres über die Unsterblichkeit wußte.

"Es ist anständig und läßt Sie in gutem Licht erscheinen, wie Sie sich mit Todesverachtung um das Logische bemühen. Aber leider dürften Sie keinen Erfolg haben, da Sie nur eine Logik und ein Nichtlogisches annehmen. Es gibt viele Logiken, mein Lieber, in uns, welche sich bekämpfen, und aus deren Kampf das Alogische hervorgeht. Lassen Sie sich nicht von einigen mangelhaften Philosophen täuschen, die fortwährend von der Einheit schwatzen und den Beziehungen aller Teile aufeinander, ihrem Verknüpftsein zu einem Ganzen. Wir sind nicht mehr so phantasielos, das Dasein eines Gottes zu behaupten. Alles unverschämte Einbiegen auf eine Einheit appeliert nur an die Faulheit der Mitmenschen. Bebuquin, sehen Sie einmal. . . ." (1980, 80–81)

[He said to himself that value was something alogical and he wanted thereby to make no logic. He felt in this contradiction no animation, but rather release, repose. It was not negation that was fun. He despised these pretentious grumblers. He despised this uncleanliness of dramatic man. He said to himself, maybe it's only laziness that led him to this observation. Yet the reasons were secondary. It was the thought that mattered, which was logical, whatever its origins. Böhm greeted it softly and in a friendly manner. He wanted to take it a little easy after his death, since he did not yet know anything for sure about immortality.

"It is decent and puts you in a good light, the way you are exerting yourself in defiance of death over what is logical. But unfortunately you will probably have no success since you assume only a logical and a non-logical. There are many types of logic, my friend, at war within us and the alogical derives from that battle. Don't let yourself be misled by a few deficient philosophers, who rant all the time about a unity and the relations of all parts to each other, their ties to the whole. We are no longer so lacking in imagination as to claim the existence of a God. All shameless capitulation to the concept of unity speaks only to the laziness of your fellow humans. Bebuquin, take a look . . ."]

From the point of view of perspective, the narrator looks, so to speak, over the shoulder of the main character and reports his thoughts. However, he does not provide guidance or an interpretation, as is often the case in Mynona. Moreover, the fantastic is treated as self-evident; as in this instance, in which the narrator Nebukadnezar Böhm is actually dead. That clearly represents an instance of allegorical and parabolic language. This dialogue is composed of clearly contoured rhetoric, transforming philosophical ideas into generalizations and formulating them as

epigrams. Einstein's epoch-making novel combines four types of narrative technique that often appear separately in other Expressionist writers, namely, monologic reflection, fantastic allegory, aphoristic irony, and sermonizing rhetoric. Though seldom in the same way as in Einstein's works, they often appear also in writers using Döblin's technique of naturalistic representation.

The self-reflections of the main character — in part or totally identified with the narrator — spontaneously transform external events into intellectual or cognitive experience and transmute every action of the plot into stream of consciousness. This narrative technique is employed by Gustav Sack in *Ein verbummelter Student* (An Idle Student, written 1910–13, published 1917), by Gottfried Benn in his collection of stories *Gehirne* (Brains, 1916), and by Flake in *Stadt des Hirns* (City of the Brain; in Flake the title itself clearly expresses this intellectualization of narrative). With some important reservations, the same can be said for the works of Musil and obviously for Benn's late novel *Der Ptolemäer* (1949). We also find fantastic allegories in the works of Mynona and Lichtenstein, and in Max Brod's novella *Die erste Stunde nach dem Tode* (The First Hour after Death, 1916), as well as in Kubin's novel *Die andere Seite* (The Other Side, 1909), in Meyrink's novels and in the late works of Kafka. Aphorism, the third distinct element of this type of narrative, constitutes the essential stylistic and structural device in the sketches and tales of Alfred Lichtenstein, in Klabund's parabolic novel about Eulenspiegel, *Bracke* (1918), and with significant modification in the prose of Carl Sternheim. Sermonizing rhetoric is employed in Klabund's *Bracke*, but above all it suffuses Leonhard Frank's volume of novellas *Der Mensch ist gut*. Philosophical and proto-existentialist ideas appear in Einstein's prose, and in the hands of Klabund become moralizing-epigrammatic, but in the works of Frank they are flattened into semi-political propaganda (in the etymological and literal sense of the word).

We now turn to the use of allegory in Expressionist narrative prose, which is closely associated with the use of fantasy. In *Bebuquin* the silver skull of the deceased, but speaking, Nebukadnezar Böhm may serve as an example. In this skull things appear silver-plated and wonderfully polished (an image obviously symbolizing the intellect). The especially fantastic nature of the image provides a vehicle to convey ideas. With writers who employ allegory, such as Kubin, Meyrink, and Kafka, two fundamental tendencies of epic (or prose) Expressionism come together: namely, naturalistic, scenic, concrete representation and intellectual parables. In Kafka, however, the central idea, as expressed through images or material objects, ultimately remains unknown, and his allegories therefore permit an infinite number of interpretations. In Einstein, Meyrink, and Kubin, the meaning of the allegory is more accessible. Nebukadnezar Böhm's silver skull in *Bebuquin* conveys a very specific meaning: the image is a sign. Likewise,

the doorless room communicates an unambiguous meaning in *Der Golem* (1915) by Gustav Meyrink (1868–1932). The story's setting makes clear that the Golem's doorless room serves as a sign for the hidden human self. More ambiguous is Alfred Kubin's dream allegory in *Die andere Seite* (The Other Side, 1909),[4] one of the earliest examples of an Expressionist or quasi-Expressionist novel. The title and subject matter suggest a subtle and carefully crafted allegory about the "other side" of human experience, the dream self and the oneiric realm presented with visionary power. Related to it is the idea of the dual nature of God, specifically about the nature of Patera, borrowed from ancient Gnosis, and more directly from Jakob Böhme. In the novel that idea manifests itself in the mysterious founder of a utopian/dystopian dream colony, who struggles against a satanic opponent, but who carries within his own soul a diabolical component as well. With allegorical clarity, these linked ideas appear as the visionary content of the narrated sequence of events.

If we look briefly at the novels *Der Prozeß* (The Trial, 1925) and *Das Schloß* (The Castle, 1926) by Franz Kafka (1883–1924), an essential distinction becomes evident that makes it questionable whether we can speak of allegory at all in the same way as we can in Kubin's *Andere Seite*, Meyrink's *Golem*, or Robert Müller's *Tropen* (The Tropics, 1915). We sense that the "trial" and "castle" have transcendent meaning and that they are in some way parables, but at the same time we are aware that any single, direct, or exclusive correspondence between images and ideas remains impossible in Kafka. The meaning of the bureaucracies appearing in these works is so multivalent that it remains inseparable from the representation in the work and remains irreducible to any simple equation with specific ideas.

Linguistically speaking, we cannot define any of the Austrian writers using allegory, whether they are from Prague or from Vienna, as Expressionists. The general stylistic features of Expressionist prose (parataxis, ellipsis, syntactic distortion) do not apply to the narrative styles of Kafka, Meyrink, Kubin, or Musil. Here, syntactic complexity and subordination still remain the rule. Nor do any of these stylistic features predominate in the works of Heinrich Mann or of Robert Müller. Therefore, those authors cannot be included among the Expressionists.

While the aforementioned features cannot be applied to that group of authors, the Expressionist use of narrative perspective, form, and structure certainly can. We have already drawn attention to stylistic parallels and relations between Musil and Einstein. Kafka plays a special role in the development of narrative technique in Expressionism, evident in the way he intensifies the ambiguity of the parabolic-allegorical forms of narration, widely used by Expressionists. At the same time he combines those with Döblin's elimination of authorial commentary.

In regard to narrative perspective, Kafka develops to an extreme the exclusion of the omniscient narrator. We find in his texts what, borrowing

the term from Franz Stanzel, we can call "figural perspective." The narrated events are consistently experienced from the single perspective of the main character. Developed between 1910 and 1912, this technique emerged simultaneously in Döblin's *Ermordung einer Butterblume* (The Murder of a Buttercup), Heym's novellas "Der Irre" (The Madman) and "Der Dieb" (The Thief), and Kafka's short stories *Das Urteil* (The Judgment) and *Die Verwandlung* (Metamorphosis, 1915). In that company belongs also Paul Adler's novel *Nämlich* (Namely, 1913), which uses a first-person perspective. These prose works, among the most interesting and finest narrative works produced by Expressionism, all convey a distorted view of the world narrated from the very personal viewpoint of the main character, who in three of these works is insane. Döblin's *Ermordung einer Butterblume*, perhaps indebted to Heinrich Mann's *Professor Unrat* [aka *The Blue Angel*, 1905], unleashes a latent demonic cruelty hidden in the seemingly respectable petty bourgeois. The petty bourgeois is revealed as a fantastically macabre and grotesque menace. In that same vein, Heinrich Mann began working on his satire *Der Untertan* (The Loyal Subject, 1918) in 1911, a year after Döblin's novella. Mann maintained the same grotesque intensity of narrator perspective through large sections of the book. Döblin's petty bourgeois, wildly beheading buttercups, is a prophetic anticipation of the political reality that was to come in central Europe (Adolf Hitler was twenty-one years of age when Döblin composed *Ermordung einer Butterblume*).

Nonetheless, there exists between Kafka and the other Expressionists an essential distinction in regard to the use of figural perspective. In Döblin, Heym, and Adler, the character from whose perspective the events are narrated is represented as insane, but this is not the case in Kafka. The internal point of view, the point of orientation for narrated events, is entirely coherent in Kafka, untouched by any reference to an external reality. Kafka uniquely depicts a closed world governed only by the interior of the perspectival mind, that is, a world exclusively seen from a single character's point of view. Lacking reference to external reality, the distorted world of Kafka (a distortion present in all his works) envelops the reader so perfectly that he or she is unable to determine the perspectival figure's sanity or lack thereof. Similar to allegory, Kafka's consistent use of figural perspective developed one aspect of Expressionist narrative to its logical extreme. However, from a linguistic point of view, we cannot consider him a true Expressionist. This example shows us that we must proceed with nuanced care when seeking to define Expressionist prose.

After this discussion of narrative perspectivism, let us now again turn to linguistic features of Expressionism in order to reiterate that the two fundamental features of its prose were the pursuit of the utmost compression of language and syntactic distortion. As in *Bebuquin*, the trend towards brevity and pithiness is not only a result of syntax, enumeration, and ellipsis

but also derives from succinct aphoristic generalization. The use of aphorism in the works of Einstein, Mynona, and Lichtenstein, as well as in Klabund and Sternheim, illustrates merely *one* tendency towards brevity, which, unfortunately, Kurt Pinthus in "Glosse, Aphorismus, Anekdote" (Gloss, Aphorism, Anekdote) mistakenly identified as Expressionism's sole tendency towards terseness. We observe that aphorisms predominate whenever naturalistic representation yields to the expression of ideas. Aphorisms deal with generalizations and as such refer to ideas beyond the text, to a region shared by reader and narrator. Events and characters assume secondary importance; the identical relationship of the narrated events to reality external to the narrative is of primary importance. Aphorisms disturb the autonomy of the fictional world represented in the narrative.

Aphorism is linked to irony. The irony of Einstein and Mynona rests upon the keen awareness of the abyss that separates the world of ideas from empirical reality. In the works of Alfred Lichtenstein (1889–1914), which depict the milieu of the Berlin artistic community, ironic anecdotes, composed of aphorisms, are the most prominent feature of the narrative. Irony is above all evident in the pointed closures of the stories and in the meandering observations of the first-person narrator or in the character of Kuno Kohn, who functions as the writer's alter ego. Even Kohn's inner monologue abounds in aphorisms: "Er dachte: Nur keine Sentimentalitäten . . . Um anständig leben zu können, muß man ein Schuft sein" (He thought: absolutely no sentimentalities . . . In order to live decently, one has to be a scoundrel; 49). The character's outlook on life, his worldview, is summarized in witty paradoxes.

Aphorisms convey a philosophy or a truth about life in concise wording of universal applicability. The escalation of the aphorism from a sentence into a scene, anecdote, or even story by necessity leads to parable. One anecdote by Lichtenstein about a poet's self-mutilation with a salad knife is essentially a parable. The situation, its staging — "[dann] erstach sich der Dichter Schulz endgültig mit einem Salatmesser" (then the poet Schulz stabbed himself definitively with a salad knife; 60) — presents the grotesque combination of triviality and tragedy, the very essence of the absurd. The same applies to Ehrenstein's *Tubutsch.* Two flies are drowned in an inkpot, and in this grotesque and trivial event the narrator finds an illustration of the tragic meaninglessness of existence. The distinction between the parables of Lichtenstein and Ehrenstein and those of Mynona is that the latter, despite his use of irony and relativity, permits the Platonic idea to shine through, as the eternal possibility of intellectual freedom. In contrast, the former two writers demonstrate the absurdity of life by grotesquely combining the trite and ridiculous with sorrow and tragedy. However, in Kafka, the incomprehensible defeats all attempts at interpretation.

In his *Chronik aus des zwanzigsten Jahrhunderts Beginn* (Chronicle of the Twentieth-Century's Beginning, 1918), Carl Sternheim (1878–1942)

employed parables. The sentence structure and linguistic aberrations transform his stories into ironic, or rather, burlesque parables. Although Sternheim's sentence structure uses subordination rather than coordination in syntax, it is nevertheless distorted and alienating. According to Carlo Mierendorff's analysis of Expressionist narrative prose (he made many worthwhile contributions), "die Verspannung des Satzgefüges" (the tension of the syntactic structure; 196) is an essential part of avant-garde narrative prose. This tension reflects "die Verspannung der Dinge [. . .], die so gewaltig sein kann, daß sich die Diktion bis zu skurrilen Verschränkungen schrauben muß" (the tension among things, which can be so powerful that the diction twists itself into scurrilous contortions; 196). It is just this sort of syntactic tension that engenders parables in Sternheim's works. It is a pompous and "classicist" affectation of style, used to describe the modern petty and grand bourgeoisie, which lends to the narrative a sense of travesty, as is also the case in Heinrich Mann's *Professor Unrat* and, above all, in the *Untertan*. The typical peculiarities of Sternheim's style are his use of antiquated pronouns, such as "jenem" in the petty-bourgeois setting of the character Constable Busekow, where the employment of a noun would seem more natural; the application of the absolute genitive borrowed from translations of classical languages (for instance, "geschlossenen Auges lächelte sie"; 18); and his disregard for articles, or the "bureaucratese" postponement of the subject ("Bedenken gegen seine Kurzsichtigkeit zerstreute er auf die geschilderte Art"; reservations about his short-sightedness he put off in the described manner; 15). The disconcerting opposition of formal, classicist, elevated, and official style to modern-bourgeois life and states of mind generates travesty and burlesque comedy (Wendler's analysis of Sternheim shows this very well). The distortion of syntax as derived from German classicism, as well as from professional bombast and bureaucratese, is precisely what elevates the twentieth-century *Bürger* into the ranks of heroic activism, rendering policemen and restaurateurs into mock heroic figures. The typological character of Sternheim's figures finds a linguistic correlative in his elimination of the definite article. This widespread tendency toward ellipsis in Expressionist prose has however also an entirely different cause that the admirer of Sternheim, Gottfried Benn, formulates as follows:

> . . . nicht da stand vor ihm die Olive, nicht: da fiel sein Blick auf eine Olive, sondern: da geschah sie ihm, wobei allerdings der Artikel noch besser unterbliebe. Also, da geschah ihm "Olive" und hinströmt die in Frage stehende Struktur über der Früchte Silber, ihre leisen Wälder, ihre Ernte und ihr Kelterfest. (188)

> [. . . not the olive stood before him, not: his gaze fell upon an olive, but rather: it happened to him then, whereby however it would be better to drop the article. Thus, "olive" happens to him and the structure here in

question floods over the silver of the fruits, their quiet forests, their harvest, and the festive pressing.]

Let us now turn to the anti-psychology stance in Expressionist narrative. We have already seen that anti-psychology underlies both Döblin's descriptive naturalism and Einstein's parabolic-aphoristic prose. Döblin's naturalistic constructivism rests upon the omission of a narrator who destroys the illusion of fiction, whereas in Einstein it follows from the rejection of mimesis, specifically, the rejection of the mimetic ideal of probability and logical consistency. However, beneath those differences lies a deeper affinity uniting these authors in their shared antipathy toward psychology, namely, the rejection of causality as a sufficient explanation of human behavior and of the world. In the eyes of those two theorists of Expressionist narrative prose, reasoning from causes constricts, misconstrues, and even distorts life (in Döblin), and the intellect (in Einstein). As we saw in the above passage from Benn's "Schöpferische Konfessionen" (Creative Confessions, 188–89) there exists a similarity between Döblin's "steinerner Stil" (concrete style) and Einstein's capricious play with aphorisms. It is the disavowal of the subject, the transformation of self from a merely deduced, defined, and isolated entity into one of infinite potential and experience — indeed, vital and surging primal energy in Döblin und Benn, creative freedom and boundlessness of the mind in Einstein, Mynona, Meyrink, and Adler. In both of these currents of Expressionism, the writers are bent on eliminating the opposition between the self and external reality, between subject and object, between inside and outside.

In a formal and linguistic respect, inner monologue achieves the elimination of the subject-object opposition. Inner monologue, the final narrative technique to be examined, is the most often employed, most avant-garde, and most promising for the future, as seen in the prose works of James Joyce, Virginia Woolf, and William Faulkner, not to mention the late Döblin, Hanns Henny Jahnn, and Hermann Broch, among other writers of the 1920s through 1940s. Inner monologue frequently occurs in Heym's novellas, in the first-person perspective of "Der Irre" and "Der Dieb" (both composed in 1911), as well as in Döblin's novel *Die drei Sprünge des Wang-lun* (The Three Leaps of Wang-Lun, 1915); it also dominates the prose narratives of Gustav Sack, Johannes Becher, Gottfried Benn, Leonhard Frank, Fritz von Unruh, Herwarth Walden, Franz Jung, Paul Zech, and the Moravian writer Ernst Weiß. In these writers, the distinction between inner and external reality ceases to exist. The common stylistic technique employed to break through the conventional barriers between subject and object is the omission of the "er dachte" (he thought) or "er sagte sich" (he said to himself) and quotation marks, which earlier distinguished the character's inner monologue from the description of external events. Later, the transition from one character's inner monologue

to another's is unanticipated and abrupt. Everything flows together. This blurring of transitions, however, elicits confusion and difficulty, and it creates in the reader's mind a state of alienation. A narrative structure of shifting perspectives and absence of narrative orientation makes the reader feel everywhere and nowhere at all.

Moreover, such a narrative technique is the ultimate triumph of literary Naturalism; for the narrator by relinquishing the role of reporter allows the characters an unmediated expression of fictional reality. The elimination of quotation marks and marks of punctuation is the realization of Döblin's insistence that the conventional form of the narrator must be done away with in the modern novel. Annulling the distinction between dialogue and narrative achieves complete autonomy of the text. This is effectively demonstrated in Herwarth Walden's *Das Buch der Menschenliebe* (The Book of Brotherly Love, 1916). This form of inner monologue is more radical than anything encountered in Naturalism. It deconstructs syntax (by means of radical ellipsis) and destroys the mimetic representation of reality. It undermines the coherent narrative logic presupposed in Naturalism, that is, causality, argument, and order. The erosion of syntax gives way to association, which replaces the mimetic principle of representation: many post-Expressionist writers, such as James Joyce, William Faulkner, Alfred Döblin in *Berlin Alexanderplatz* (1929), Hans Henny Jahnn, and Hermann Broch, employed verbal association in a masterly way. As Gottfried Benn described it in the Expressionist period: "'groß glühte heran der Hafenkomplex,' nicht: da schritt er an den Hafen, nicht: da dachte er an einen Hafen, sondern: groß glühte er als Motiv heran, mit den Kuttern, mit den Strandbordellen, der Meere uferlos, der Wüste Glanz" ("great glowed toward him the port complex," not: he approached the port, not: he thought of a port, but rather: great it glowed toward him as a motif, with cutters, with beach bordellos, oceans boundless, the desert's splendor; 188).

Developing out of Naturalism, the narrative technique of inner monologue became a normative form and visionary experience in Expressionism, composed of musical leitmotifs. Gustav Sack's *Ein verbummelter Student*, Franz Jung's novels *Opferung* (Sacrifice, 1916) and *Der Sprung aus der Welt* (The Leap out of the World, 1918), and, above all, Ernst Weiß's *Tiere in Ketten* (Animals in Chains, 1918) — the latter renowned as one of the most stylistically ambitious novels of Expressionism — exemplify this process of linguistic decomposition and transformation. These authors demonstrate a masterful command of the stream-of-consciousness technique, which was subsequently to culminate in Joyce's *Ulysses* and *Finnegan's Wake*, in Döblin's *Berlin Alexanderplatz*, and in Broch's *Tod des Vergil* (Death of Virgil, 1945). In Broch the first-person inner monologue of Naturalism expands into visionary grandeur, dissolving sentences into musical rather than grammatical structures, unleashing a stream of

musical themes. Instead of sentences expressing a logically coherent world, Broch utilizes sequences of associative appositions. That omission of predicates and the liquefying of sentences into a stream of language suggests a reaching out toward infinity. The way condensation undermines conventional sentence structure in Expressionism makes us anticipate the timeless and subjectless stream of musical language found in Broch's *Tod des Vergil*, composed a generation later.

*Translated by Gregory Kershner*

# Notes

[1] The original version of this essay appeared in the volume *Expressionismus als Literatur: Gesammelte Studien* (Bern and Munich: Francke, 1969) edited by Wolfgang Rothe. The essays in that volume all followed the same format, with no notes and no page numbers for citations. The current translation now provides page numbers to the most recent available editions, rather than to the edition available when the article was first published. Additional notes are thus from the editor, not the author, as are all English translations.

[2] The French *nouveau roman* is associated with the works of authors Alain Robbe-Grillet and Nathalie Sarraute, Michel Butor and Margarite Duras, along with several others and the publishing house Les Editions de Minuit, and denotes a new trend in novel-writing from 1953 through the 1950s that negated the anthropocentrism of the nineteenth-century Realist novel and of the wave of existentialist novels (Camus and Sartre, Beauvoir and Sagan, for example), in favor of strict camera-eye observation of mundane, inanimate and even trivial external reality that to large extent evacuated the human presence and psychology, as well as plot, from the text and emphasized the text's own constructedness. While Döblin certainly anticipated the anti-psychology of the *nouveau roman*, the naturalistic dynamism and raw and abundant lexicality of his works would be at odds with those sparse, quiet fictions. See Gerald Prince's article on the Nouveau Roman in Denis Hollier's collection.

[3] Else Lasker-Schüler, 1869–1945.

[4] Alfred Kubin, 1877–1959.

# Works Cited

Beissner, Friedrich. *Der Erzähler Franz Kafka: Ein Vortrag.* Stuttgart: W. Kohlhammer, 1952.

Benn, Gottfried. "Schöpferische Konfession." In *Gesammelte Werke: Autobiographische und vermischte Schriften*, ed. Dieter Wellershoff, 188–89. Wiesbaden: Limes, 1961.

Döblin, Alfred. *Aufsätze zur Literatur.* Ed. Walter Muschg. Olten and Freiburg im Breisgau: Walter-Verlag, 1963.

Döblin, Alfred. *Erzählungen aus fünf Jahrzehnten.* Ed. Edgar Pässler. Olten and Freiburg im Breisgau: Walter, 1977.

Edschmid, Kasimir. *Die sechs Mündungen.* Leipzig: Kurt Wolff, 1915; Stuttgart: Reclam, 1965.

Ehrenstein, Albert. "Tubutsch." In *Prosa des Expressionismus,* ed. Fritz Martini, 72–102. Stuttgart: Reclam, 1970.

Einstein, Carl. *Werke: Band 1, 1908–1918.* Ed. Rolf-Peter Baacke, with assistance from Jens Kwasny. Berlin: Medusa, 1980.

Frank, Leonhard. *Der Mensch ist gut.* Potsdam: Kiepenheuer, 1919; repr. Würzburg: Arena, 1983.

Heym, Georg. *Prosa und Dramen.* Vol. 2 of *Dichtungen und Schriften.* Ed. Karl Ludwig Schneider. Hamburg und Munich: Heinrich Ellermann, 1962.

Hollier, Denis. *A New History of French Literature.* Cambridge, MA and London: Harvard UP, 1989.

Kafka, Franz. *Hochzeitsvorbereitungen auf dem Lande und andere Prosa aus dem Nachlass.* Ed. Max Brod. New York: Schocken Books, 1953.

Lichtenstein, Alfred. *Gesammelte Prosa.* Ed. Klaus Kanzog. Zurich: Arche, 1966.

Mierendorff, Carlo. "Wortkunst / Von der Novelle zum Roman." In *Theorie des Expressionismus,* ed. Otto Best, 194–97. Stuttgart: Reclam, 1976.

Mynona (Salomo Friedlaender). *Rosa, die schöne Schutzmannsfrau.* Leipzig: Verlag der Weissen Bücher, 1913.

Prince, Gerald. "The Nouveau Roman." In Hollier, *A New History of French Literature,* 988–93. Cambridge, MA and London: Harvard UP, 1989.

Sack, Gustav. *Prosa, Briefe, Verse.* Munich and Vienna: Langen/Müller, 1962.

Sternheim, Carl. *Erzählungen.* Vol. 3 of *Werkauswahl,* ed. Wilhelm Emrich and Manfred Linke. Darmstadt and Neuwied: Luchterhand, 1973.

Walser, Martin. *Beschreibung einer Form.* Munich: C. Hanser, 1961.

Weiß, Ernst. *Tiere in Ketten.* Berlin: Fischer, 1918; Frankfurt am Main: Suhrkamp, 1982.

Wendler, Wolfgang. *Carl Sternheim: Weltvorstellung und Kunstprinzipien.* Frankfurt am Main and Bonn: Athenäum, 1966.

Zeller, Bernhard. *Expressionismus — Literatur und Kunst, 1910–1923: Eine Ausstellung des deutschen Literaturarchivs im Schiller-Nationalmuseum vom 8. Mai bis 31. Oktober 1960.* Marbach: Deutsches Literaturarchiv, 1960.

# 3: Prosaic Intensities: The Short Prose of German Expressionism

*Rhys W. Williams*

THE INTENSITY OF EXPRESSIONIST PROSE, its linguistic dislocation and abstraction, rendered it thoroughly unsuited to the long form and measured pace of the novel.[1] As Albert Soergel noted already in his monumental study *Dichtung und Dichter der Zeit: Im Banne des Expressionismus* (Poetry and Poets of the Age: In Thrall of Expressionism, 1925): Expressionism is "lyrischer Zwang, dramatischer Drang, nicht epischer Gang" (lyrical stress, dramatic duress, not epic progress; 796). The drama of Expressionism with its incantations and bombast also seems uncongenial to audiences in the twenty-first century. Yet the lyric poetry and short prose of Expressionism retains a capacity to shock, to unnerve, and to shatter habitual modes of perception: the Expressionist period abounds in short works of intense narrative experimentation, some successful, some less so, but which all put on display the energy and ambitions of the day to reform the genre. Such texts exhibit, despite the time that has now elapsed since their composition, remarkable virtuosity and freshness. Indeed, the formal and linguistic experimentation by the authors I shall discuss in this chapter makes their work not only challenging but also of enormous literary-historical significance.

As a literary movement Expressionism is conventionally dated between 1910 and 1925. It is characterized as sharing with other movements around the turn of the century, variously categorized as neo-Romanticism, Symbolism, Impressionism or *Jugendstil*, a rejection of scientific positivism and its artistic counterpart of Naturalism in literature and painting. Expressionism proper seeks to take that opposition to Naturalism to a new formal extreme, insisting that its aim is not a naturalistic depiction of the external world, nor even an impressionistic capturing of the shifting patterns of light on the surface of that reality, but an intuitive grasp of essence. Expressionist "vision" cuts through surface appearances to reveal that hidden essence. The theoretical underpinning of Expressionist writing suggests an eclectic appropriation of ideas current in art history and philosophy. One of the key influences is Wilhelm Worringer's *Abstraktion und Einfühlung* (Abstraction and Empathy, 1908). Worringer's thesis is that Greco-Roman art, together with Western art since the Renaissance, is an art of empathy,

an art that sets out to maximize the identity or sense of recognition between the spectator and the work of art. Its precondition is a confident relationship between man and nature, which produces an art of immanence. But Worringer considers that much of the history of art falls outside this canon, and he postulates a diametrically opposed tendency, namely an urge to abstraction, which in turn produces an art of transcendence. This art springs from a spiritual unrest, a disturbed relationship with nature, which is manifest, in different ways, in primitive man, in Egyptian art, in Gothic art, but also characterizes modern civilization and its discontents. Worringer's impact on the Expressionist generation is as immense as it is difficult to demonstrate. But in bringing together primitivism, transcendence, and abstraction, Worringer lays the foundation for much of the thinking about both art and literature in the Expressionist period. His reflections on art supply the Expressionists with a rationale for formal distortion and linguistic dislocation.

Developments in philosophy around and immediately after the turn of the century offer interesting parallels to Expressionist theory. In one or two incidences one may speak of influence, but the process of reception is usually far less precise. Heinrich Rickert, a Neo-Kantian philosopher of the Baden school, published in 1902 a work entitled *Die Grenzen der naturwissenschaftlichen Begriffsbildung* (The Limits of Conceptualization in the Natural Sciences, 1902), a landmark in the rejection of scientific positivism. As Jost Hermand has pointed out, the impact of this work was felt far beyond the realm of philosophy in art history and literary criticism (1–6). Rickert distinguishes sharply between the methods of the *Geisteswissenschaften* (or the "historical sciences," as he prefers to call them) and those of the natural sciences. Rickert's thesis runs as follows: the empirical world consists of an infinite variety of things, both quantitatively and qualitatively; all knowledge depends on man's capacity to overcome this manifold variety ("Überwindung der Mannigfaltigkeit"). While the natural scientist seeks to distill universally applicable laws from this *Mannigfaltigkeit* (or multifariousness), the historian seeks to arrive at historical concepts that, though not obtained by the same process as scientific concepts, have equal status with them. The historian, and by extension the artist, concentrates on features that are unique to objects, rather than on general laws; this uniqueness, what Rickert calls "the particular" (*das Besondere*), constitutes the value of an object. Rickert's ideas had a direct impact, as has been documented, on Carl Sternheim, who attended his lectures in Freiburg in 1906, but the wider implications of Rickert's philosophy cannot be ignored. The aim of the artist is now to provide knowledge of the world by a process of conceptualization that runs counter to scientific positivism; artistic and cultural value lie not in a mimetic reproduction of the empirical world but in a process by which the particularity of an object may be distilled.

If art history and philosophy offered a theoretical framework in which Expressionist writing could position itself, political pressures also played a part. The outbreak of the First World War shattered the bourgeois complacency of Wilhelminian society, and both the disastrous course of the war and the Bolshevik revolution further polarized political opinion. While some intellectuals, like Kaiser and Sternheim, were attracted by the anarcho-socialism of Gustav Landauer, others, particularly the circle of writers associated with Franz Pfemfert's periodical *Die Aktion*, moved after 1916 into line with the USPD, the more radical Independent Social Democratic Party, which split from the SPD, opposed the war and supported the socialist values of Rosa Luxemburg and Karl Liebknecht. What is striking is the fact that writers on both sides of this political spectrum, the anarchists and the communists, asserted the revolutionary nature of their artistic enterprise, arguing that the new modes of perception, the new ways of seeing, represented a radical break with what was deemed bourgeois conventionality.

One of the earliest examples of the Expressionist revolution in imaginative prose is Carl Einstein's *Bebuquin oder die Dilettanten des Wunders* (Bebuquin, or the Dilettantes of Miracle, 1912), published in installments in the periodical *Die Aktion*; it was probably conceived and written in 1906 or 1907, for a short piece, entitled "Herr Giorgio Bebuquin," appeared in a journal edited by Franz Blei, *Die Opale*, in 1907. Both the early version and the final publication, which bears the note that it was "written for André Gide 1906/1909," display an intense involvement with the interest in scientific, philosophical, and aesthetic issues that was stimulated by Carl Einstein's academic studies. Indeed, the final text reflects Einstein's extraordinary capacity to grasp complex arguments and apply them to literature. His "anti-novel" implies rejection both of the notion of nature as an objective reality and of the perceiving subject as an adequate means of gaining access to that reality. Influenced by the physicist Ernst Mach and the art historian Conrad Fiedler, as well as by contemporary writers like Paul Scheerbart, Einstein produced a novel that eschewed psychological verisimilitude in the interest of constituting a metaphysical, quasi-religious reality. Perhaps the clearest indication of Einstein's project emerges in a group of essays entitled "Totalität" (Totality, 1914): here he argues, as Worringer had of Gothic art, that art is not mimetic; its objects do not exist in the empirical world, but are constituted in the act of seeing. Art is concerned not with the depiction of objects but with the structuring of a way of seeing. Art thus frees objects from the web of causal connections into which scientific rationality would enclose them and constitutes them as "absolute" objects, objects in their own right. The totality that thus comes into being is transcendent. Art embodies a mode of perception in which the traditional distinction between the perceiving subject and the object perceived is broken down; the art object is not a paraphrase,

a metaphor, or an example of something else, but constitutes a reality in its own right.

The epistemological implications of Einstein's theory suggest strong parallels with the process of phenomenological reduction advocated by the philosopher Edmund Husserl in his *Ideen* (Ideas, 1913). Husserl's cognitive procedure is based on intuition, which requires a three-fold reduction, or "bracketing out": first, of all subjectivity, so that the mind is concentrated solely on the object; second, of all theoretical knowledge, such as hypotheses or proofs derived from other sources; and third, of all tradition, all that has been previously taught about the object. If one ignores questions about the existence of the object and disregards everything contingent, one arrives at the essence (*das Wesentliche*), a recurrent term in the theoretical writings of the Expressionists. Husserl's intentional theory of consciousness suggests that there is no subject without an object, no object without a subject. In a society in which objects appear alienated, cut off from human purposes, phenomenological reduction appeared, particularly, one suspects, to non-philosophers, to offer a new opportunity to repair the subject-object dichotomy, and, by bridging the gap between man and things in themselves, to heal the sense of alienation that afflicts modern man.

Carl Einstein, as a theorist of modern art, supplies much of the terminology found in the theoretical statements of the Expressionist generation. His mode of seeing, which he terms variously *Vision, Wunder, Totalität, das Absolute* (vision, miracle, totality, the absolute), or any tautological combination of these, is intuitive and transcendent, and hence is offered as an alternative to the rationalism that is perceived as having dominated Western culture since the Renaissance. Reacting to the overweening claims of scientific positivism in the late nineteenth century, the art theory of the early twentieth century offers an antidote to overly civilized and overly cerebral society, celebrating instead both the primitive and the medieval. Carl Einstein's *Negerplastik* (African Sculpture, 1915), offers simultaneously an analysis of African (and Polynesian) art and a theoretical justification for cubism. The language of Expressionist theory, of which Einstein's terms may serve as an illustration, tends to bring together a disparate set of assumptions related to a new mode of perception: the intuitive grasp of essences is at once quasi-religious in its intensity and revolutionary in casting doubt on previous rationalist modes of perception; "hallucinatory" in that it represents an ecstatic vision that transcends mere rational understanding; or "absolute" in that the merely contingent is stripped away; and "primitive" in that a grasp of what is essentially human will inevitably involve the peeling away of the bourgeois accretions of an over-civilized, over-cerebral existence in a European society that has lost touch with humanity's essence. While individual Expressionist prose writers approach their formal task in different ways, their theoretical assumptions draw on

this same complex of associations. Some Expressionists, like Carl Einstein, emphasize that art has all too little to do with mimesis; others, like Sternheim, insist that formal distortion is necessary only because art must reveal an underlying reality and that, despite (or rather because of) the distortion, the artist remains a realist; a third possibility embodies an oscillation between these two approaches, exemplified by Gottfried Benn's prose. Carl Sternheim's conviction that Expressionist distortion should serve a broadly mimetic purpose seems to conflict with Einstein's views, but the differences between them were merely superficial. Both were convinced that formal distortion reflected a new way of seeing, a revolutionary act of perception, though Sternheim, as an opponent of the war, was increasingly keen to assert analogies between his literary strategy and that of the French Realist tradition.

His five most successful short stories were published before he adopted in 1918 the overall title "Chronik von des zwanzigsten Jahrhunderts Beginn" (Chronicle of the Twentieth-Century's Beginning; 1976). It was only around 1916, after his conversion to the belief that all literature was broadly political in nature, that he sought to present all his prose works, even those written earlier, as depicting underlying social realities. The notion of the artist as the chronicler of his age accompanies Sternheim's opposition to the war and his championing of the French Realist tradition of the nineteenth century. From 1916 onwards Sternheim began to justify his own literary production as realism, as the distillation of prevailing values, as a chronicle of contemporary attitudes and assumptions. Before 1916 an ambivalence characterizes his stories, positive and negative elements are fused, and his heroes seem capable of fulfilling themselves within society. After 1916, his stories become more overtly critical and his heroes seem capable of realizing their individuality only outside a corrosive European mentality. After 1916 the stories reveal his overt intention of diagnosing what Sternheim sees as contemporary evils, of exploring collisions between radical individualism and social conformism. Sternheim, who is better known as dramatist for his prewar comedies such as *Die Hose* (The Bloomers, 1913), turned to prose for two reasons: his move to Belgium in 1912 made it more difficult for him to remain in touch with theatrical circles in Berlin, and once war was declared, his drama was effectively banned from the German stage.

*Busekow* (begun in November 1912 and completed in January 1913) presents an eponymous hero with no conventionally heroic qualities. Puny, myopic, and pusillanimous, Busekow enters police service because he is prevented from fulfilling his royalist enthusiasm in the army. As his colleagues condescendingly observe, he is a born policeman. His life of service to the Prussian state compensates him for a childless, loveless marriage. Then, through his encounter with the prostitute Gesine, he gains a sense of his own human worth. His newfound self-confidence results in his promotion

to sergeant, significantly on the Kaiser's birthday, and coincides with Gesine's pregnancy. Busekow's private idyll is a mixture of eroticism and religious ecstasy, but it coincides with his public role, as he picks out the notes of the Prussian national anthem, "Heil dir im Siegerkranz" (incidentally, the same tune as "God save the Queen"), on the piano in Gesine's room.[2] The manner of his death, too, is apposite: he is knocked down and killed by the royal car as it arrives at the theater. His duties as a traffic policeman, through which his ambition, then his fulfillment, are signaled, are instrumental in his death. Even at the last his obsessive *Königstreue* (loyalty to the king) is satisfied.

Initially, it might appear that Sternheim is ridiculing Busekow's archetypal Prussian mentality. With his unmistakably Prussian name, he is on the lowest rung of the ladder that constitutes the authoritarian state. He is a typical underling, sublimating his personal inadequacy in royal devotion. Sternheim's use of religious motifs also seems satirical: it is Epiphany when he first encounters Gesine, and his first name, Christoph (the patron saint of travelers) predestines him to the role of a traffic policeman. Busekow's Lutheran Protestantism is matched by Gesine's Catholicism, which prompts her to invoke biblical heroes at moments of sexual passion: "Moses David Jesus und alle Helden des Buches war Christoph in dieser Nacht. Es strömte heroische Männlichkeit von Jahrtausenden aus ihm" (Moses David Jesus and all the heroes of the good book was Christopher in this night. The heroic manliness of the ages streamed forth from him; 1963, 4:25). It would be a mistake to interpret Sternheim's intention as wholly satirical, for Busekow does indeed attain genuine fulfillment. Sternheim, as he does with his prewar comedies, depicts the least heroic of individuals and seems to invite the reader to adopt a comfortably superior position and to view Busekow as a caricature of servility. But the reader's expectations are disappointed: Busekow achieves heroic stature in and through the very royalism that seemed to preclude it. The story does not demonstrate that individual fulfillment is achieved in the teeth of social conformism; on the contrary, Busekow's conformism supplies the means by which his fulfillment is achieved. The subtlety of *Busekow* seems to derive from its intriguing combination of critical and affirmative elements of social commentary.

In a second of his stories, *Napoleon*, written early in 1915, Sternheim picks on another unlikely candidate for heroic stature. Born in, of all places, Waterloo, in 1820, Napoleon starts out as a cook and then becomes a waiter in Paris. His life is divided into four phases, each marked by a changed attitude to food. In his early days in Paris he is obsessed with nutritional value, scorning both the undernourished and the obese customer, and he becomes interested in the opposite sex only when he chances upon a mother breast-feeding. He is attracted to Susanne only because of her powerful build. A new encounter marks a new stage in his development: the

graceful and delicate ballet dancer Valentine requires nutritious but light and exquisitely prepared delicacies, and therefore Napoleon makes the transition from "gutbürgerliche Küche" (hearty bourgeois fare) to "haute cuisine." He gains an international reputation and is vouchsafed glimpses of the world of politics and diplomacy. Political developments then intervene: during the Paris Commune Valentine is shot and Napoleon imprisoned. On his release he reverts to a materialist theory of calorific value, despising the *nouveau riche* and hankering after the departed aristocracy. He becomes sardonic, embittered, and cynical, and eventually runs away from Paris, renounces acquisitive materialism and returns to his Belgian roots. Now, as a waiter, he regains self-respect and is appreciated by his customers. He comes to accept the world as it, repudiating ambition and the desire to influence others. His death, which closes this period of contentment, completes the cycle of his life.

The reader may anticipate a comic or satirical discrepancy between Napoleon's banal life and the grand historical associations evoked by his name. But in the event, he lives up to his name, scaling the culinary heights of Paris and even outdoing his illustrious namesake by taking Russia by storm. Sternheim uses his hero to register the changing values of Europe after 1871 and to explore alternative attitudes to life, alternative ways of seeing the world. The epistemological dimension in Sternheim's prose works has not been given its due by critics. In exploring Napoleon's attitude to food, Sternheim is dealing, by analogy, with a writer's attitude to both his material and his readers. Napoleon oscillates between a desire to influence his public (both positively and negatively) and a kind of aesthetic detachment, an acceptance of the world as it is. These extremes embody the two artistic possibilities between which Sternheim himself fluctuates. *Napoleon*, which appeared in the Expressionist periodical *Die Weißen Blätter* in July 1915, was written well before Sternheim developed his theory of radical individualism as an antidote to a conformist and decadent European culture, though a number of critics have sought to apply this theory retrospectively (and erroneously) to all Sternheim's work.[3] In fact, it is not until 1916, when Sternheim becomes convinced of the futility of war, that his central characters begin to find fulfillment only in radical opposition to European values.

*Meta*, written in early 1916, is the first of Sternheim's stories to contain an overt proclamation of individualism. Meta is a figure whose mundane life is consecrated to domestic service. Hard-working, deferential, and unassuming, she develops into a passionate woman, her imagination fired by the popular romances that constitute her staple reading. Her sexual fulfillment is postponed because of her lover's idealized view of female purity, but Franz overcomes his inhibitions just once, the night before he leaves for the war and an inglorious death. Thus Meta's passions are aroused but left unsatisfied, and she focuses these pent-up emotions on the

dead Franz, distorting her relationship with the world around her. She is transformed into a powerful figure who exploits her position in the household to seduce her employer, embroil her mistress in an adulterous affair, and dominate the family through blackmail. This phase ends abruptly when Meta is confronted and dismissed. Driven by her isolation to reflect on her innermost needs, she reverts to her role as a "subservient spirit," creating in the almshouse a true sense of community. Sternheim takes pains to emphasize that Meta's sense of service is neither born of Christian self-abnegation nor the result of resignation: "schönste irdische Wirklichkeit bin ich mir selbst" (most exquisite earthly reality am I to me myself; 4:112). Oneness with the natural world, a kind of secularized *unio mystica*, is conveyed in the language of a German mystical tradition, but Sternheim, who affirms its intuitive grasp of ultimate truths, would undoubtedly have dissociated himself from its otherworldliness.

In *Ulrike* Sternheim creates a character who is the epitome of Prussian values. Ulrike is brought up to accept the Lutheranism, patriotism and stern sense of duty conventionally associated with Prussia. While she remains in seclusion on the family estate, Ulrike's values survive; only when she is confronted with the repulsive realities of an army hospital is she assailed by doubts. An encounter with a cynical ex-convict, the grotesquely crippled Bäslack, and a chauvinistic letter from a clergyman friend undermine Ulrike's Prussian certainties. She becomes aware that her own Prussian values are responsible for the carnage she witnesses. Her response is a flight into exoticism: in the company of Posinsky, a Jewish painter, who enthuses about African art, she begins to regress into a primitive idyll of uninhibited sexuality, culminating in her death in childbirth. There is more than circumstantial evidence that Sternheim was embroidering material here about the relationship between Countess Aga von Hagen, the embodiment for him of Prussian values, and Carl Einstein, author of *Negerplastik*, who was working for the German military government in Belgium. In a letter to Franz Blei on 31 October 1916, just as he was embarking on *Ulrike*, Sternheim gave a clue to his intentions: "Überliefern Sie Späteren doch einmal die Mark Brandenburg begrifflich! Sie brauchen bloß Sand, Kartoffeln und Luther ausdrücken zu können" (Pass along to those who come later a concept of the Mark Brandenburg region! You only need sand, potatoes, and Luther to capture the essence; 1971, 38).

*Ulrike* has generally been regarded as depicting the heroine's self-realization. But the story is more complex than simply a depiction of individual fulfillment. Sternheim is, as in the other stories examined above, concerned to present the embodiment of a set of values, in this case Prussian values (which Sternheim, among others, came to regard as responsible for the war), and then to supply a massive dose of primitivism as an antidote. The reader is confronted with his or her sympathies for the values of order and discipline and is shocked to perceive Ulrike's transformation,

only to be made aware of the connection between the constraints of civilized society and the inhumane war that it has unleashed. In affronting the sensibilities of his readers, Sternheim challenges their social and political values, and he cannot have been surprised that his story was banned. Posinsky paints Ulrike as a tattooed native and calls his work "Nevermore." Here Sternheim alludes, of course, to Gauguin's painting of the reclining nude entitled "Nevermore, o Tahiti!," clearly enjoying the joke that the model for Gauguin's painting might have been a Prussian aristocrat in disguise.[4] Gauguin's flight from European civilization to an exotic pre-civilization idyll constitutes one pole of Sternheim's alternative to an over-civilized European society. But the other pole is a phenomenological acceptance of the world as it is, epitomized for him in the painter van Gogh. The debate between these respective positions is explored at length in his *Gauguin und van Gogh* (1924).

Faced with the problem of capturing in literary language the sharp contrasts, hard outlines, and clear definition he admired in van Gogh, Sternheim was convinced that he had to evolve a style that had little enough in common with conventional prose: "Ich bin nur gegen einen Impressionismus der Sprache, der 'das Leben nachahmen soll' und bin für Form. [. . .] Nicht für die Syntax aber für eine Syntax" (I am only against an impressionism in language that is supposed to "imitate life," and for form. [. . .] Not for the syntax but for a syntax; 1971, 45). Stylistic virtuosity is not an end, but a means to an end; that end is maximum expressive force. The formal and technical features of van Gogh's paintings: the juxtaposition of heightened colors, the distortion of natural shapes, the use of rhythmic contours suggesting intense energy radiating from inanimate objects, the use of short adjacent brushstrokes, all these features find analogies in Sternheim's prose style. In his essay *Guter Prosastil* (Good Prose Style, 1921) he defines, albeit retrospectively, his method: having distilled the most concise formulation, the writer gives "des Mitzuteilenden Kern" (the core of the message) the most prominent position in the sentence. He wants to shock readers out of their habitual expectations. A comparison of his earlier and later versions of the stories is revealing.[5] In keeping with his phenomenological theory, Sternheim deletes adjectives and adverbs that imply narrative involvement or moral judgment; he deletes especially adverbs of time, thus blurring the distinction between a single and a repeated action. Definite and indefinite articles are excised, again removing distinctions between the general and the particular. His narrator simply chronicles events that are essential to the character depicted, eschewing psychological differentiation, to produce a single definitive statement, once and for all. His prose, in subsequent editions, becomes more intensely concentrated, more dislocated, more absolute. That it also becomes less accessible and less readable is an inevitable consequence.

Some of Sternheim's later stylistic idiosyncrasies he attributes to Gottfried Benn, whose acquaintance he made in Brussels in 1916. Sternheim credits Benn with the sage advice of stripping out adjectives from his prose. Benn's own prose collection *Gehirne* (Brains, 1916) consists of six prose pieces, four of which appeared in the periodical *Die Weißen Blätter* in 1915 and 1916. There has been a tendency to interpret Benn's prose in the light of his much later statements about experimental prose fiction, notably in his autobiographical *Ein Doppelleben* (A Double Life, 1949), but it is perhaps more helpful here to examine it in the context of contemporary Expressionist thinking. Benn always regarded his experience as an army medical officer in Belgium during the war as the most stimulating and productive phase of his career, retaining an affection for Brussels that lasted throughout what became a long life (see Grimm). That affection derived not only from his contacts with Carl and Thea Sternheim, Otto Flake, Carl Einstein, and Wilhelm Hausenstein, which Benn recalls in his "Epilog" of 1921, but also from the curious sense of both involvement and detachment in the great events of the war. The Brussels colony could hear the sound of the gunfire at the front, but they lived an almost timeless civilian existence. Moreover, Benn's personal sense of being torn between his medical and professional life on the one hand and his literary experience on the other finds expression in the *Gehirne* volume. The first story, which gave its name to the volume, supplies the narrative impetus for the whole collection.[6] Rönne, a young doctor who has carried out many postmortems and is clearly suffering from both overwork and a dissociation of sensibility brought on by daily preoccupation with corpses, is traveling northwards to take up a new post in North Germany. His crisis, his inability to form a coherent whole of his impressions, is reflected in the train journey itself; features of the landscape flit before his eyes, but remain disconnected, failing to coalesce into a meaningful whole. Two further features of the story make it unusual: the description of the journey as "er sah in die Fahrt" (he looked into the journey) has already been remarked upon (Donahue 1993, 169). But this brief remark on forgetfulness does not do justice to the overwhelming prompt that Benn gives the reader: "Es geht also durch Weinland, besprach er sich, ziemlich flaches, vorbei an Scharlachfeldern, die rauchen von Mohn" (thus it goes through vineyards, he said to himself, pretty flat, past fields of scarlet that reek of poppy; 3:29). There is here, I believe, an unambiguous suggestion of intoxication, of both wine and poppy (and in Benn's case perhaps more powerful drugs), which serves as a trigger to the release of subliminal thoughts. Benn, the embodiment of scientific precision, relaxes his iron self-control and imagines Rönne doing the same.

Benn's prose at this time offers, more even than his poetry (which was becoming decidedly clinical and cynical), a means of mediating between nineteenth-century scientific positivism, in which he was trained, and a

residue of spiritual experience. Henri Bergson, Rickert, and many others, offered writers of Benn's generation a new challenge: they were uniquely placed to counterbalance an increasingly scientific notion of perception. Rönne embodies a consciousness that shifts, sometimes bewilderingly, between a scientific detachment, cynical, harsh and much in keeping with the Prussian mentality that many intellectuals held responsible for the war, and what one might perceive as a non-Enlightenment, Romantic, or spiritual alternative. Kurt Hiller's imprecation "Geist werde Herr" (Let Spirit / Intellect become Lord) must be understood in context: *Geist* now stands for all that is left after scientific rationality has completed its task. In Benn's writing there is a religious and Romantic residue that is the other pole of Rönne's experience. Donahue comments perceptively (*Forms of Disruption*, 169) that Rönne's decision to buy a notebook and write down his experiences, "damit nicht alles so herunterfließt" (so that not everything slips away, 3:29), is the only reference to a potentially literary formulation. But coming, as it does, in the first fifteen lines of his story, it seems to offer the reader a way of reading the subsequent text (and the volume of which it became an introduction) as both a detached account of a crisis of sensibility and the literary expression of the actual experience of undergoing just such a crisis. The text itself oscillates between factual account and imaginative flow, between scientific precision and intuitive perception, requiring of the reader precisely the same ambivalence that Rönne embodies. Rönne, when he does his rounds in the wards, is both "wahrgenommen und bedacht" (perceived and contemplated, 3:31), he is perceived both sensuously and intellectually. The narrative shifts between the first person and the third, just to reinforce Rönne's sense that he is both subject and object. He sees himself both as a product of past memories, some personal, some atavistic, and as a project of intense immediacy, aware of the sheer quiddity of life. He is both rationally controlled and subordinate to immediate impressions. He has acquired the gesture of holding a brain (all too obviously a symbol of cerebral consciousness) and breaking it in half, a gesture that makes no sense to the nurses at the clinic until they observe Rönne breaking in two the brain of a slaughtered animal. The gesture prefigures and offers a peculiar resonance to what appears later in "Die Reise" (The Trip) to be an avocado pear. The implication is that the brain has a dual function: it represents both hypertrophied scientific rationality and its opposite of a primal collective subconscious. The structure and the theme of *Gehirne* embody this dichotomy: for Rönne, periods of scientific rationality give way to trancelike moments of deeper, intuitive awareness; similarly, the reader of the story is confronted with passages that reflect conventional narrative and consecutive time, as well as with passages that stand outside that framework.[7]

Stimulated by the intoxicating perception of the poppy field, Rönne notes: "ein Blau flutet durch den Himmel, feucht und aufgeweht von

Ufern: an Rosen ist jedes Haus gelehnt, und manches ganz versunken" (a blue floods through the sky, moist and blown upward from the banks: each house leans upon roses, and some have sunk in completely; 3:29). Blue is, as Benn later notes, "das Südwort schlechthin" (the most apt word to evoke the South), that trigger of a subconscious, atavistic vision; it indicates a mode of perception that transcends rationality. Benn resurrects a basic Romantic notion of a heightened state of consciousness and underpins it with the latest medical discoveries about the function of the brain. Rönne, having held many brains in his hands, now suggests that he is holding his own brain thus and "muß immer darnach forschen, was mit mir möglich sei" (must always explore what is possible with me; 3:34). Even as he is present in the hospital routine, he is aware of a deeper structure within himself, evoked not only by a cluster of images, but also by the breakdown in the sentence of normal punctuation and syntax: "Aber nun geben Sie mir bitte den Weg frei, ich schwinge wieder — ich war so müde — auf Flügel geht dieser Gang — mit meinem blauen Anemonenschwert — in Mittagsturz des Lichts — in Trümmern des Südens — in zerfallendem Gewölk — Zerstäubungen der Stirne — Entschweifungen der Schläfe" (But please now clear the way for me, I'm swinging upward again — I was so tired — this way goes on wings — with my blue sword of anemone — in the midday rush of light — in the ruins of the South — in scattering clouds — pulverization of foreheads — a slipping away at the temples; 3:34). The Brussels experience was so significant for Benn, since he manages there to discover the subliminal imagery that will become such an integral part of his poetic imagination (*blau, Süden, Mittag, Anemone*) and form a complex of images that reappear in a Mediterranean or South Sea Island setting; this cluster of images involves a breakdown (*zerfallen, Zerstäubungen, Entschweifungen*) of cerebral consciousness (represented by *Stirne, Schläfe*). For Benn, the rejection of cerebral consciousness will from now on find expression in a *Südkomplex* of images and associations, in which a single term can conjure up a wealth of references. These abbreviated signs or ciphers — Benn will later call them *Chiffren* — may be decoded only when they are related to the whole complex for which they stand. The title story of the volume *Gehirne* introduces this complex.

In "Die Eroberung" (The Conquest) Benn juggles two quite different meanings suggested by the title: the military conquest of Belgium by the German High Command (in which Benn himself took part, albeit as a medical officer), and a personal quest to overcome the multiplicity of impressions and truly comprehend the city. The narrator's sense of being an outsider, of not belonging to this community, is reflected in his plea: "Liebe Stadt, laß dich doch besetzen! Beheimate mich!" (Dear City, allow your occupation! Make me at home! 3:35). The military victory precludes the second sort of acceptance, and the central figure (not explicitly named as Rönne) embarks on a quest, which will prove elusive, for *Gemeinschaft*

or community in a city, presumably Brussels. The final lines of the story suggest instead a regression into a primitive, exotic world, a compensation for *der Einsame* (the loner), who will remain excluded, whether as a German outsider in a Belgian city or as someone whose heightened cerebral consciousness reinforces a sense of alienation and detachment. The activity of his quest gives way to passivity and, by implication, openness to the poetic imagery of a *Südseetraum*: "Ich wollte eine Stadt erobern, nun streicht ein Palmenblatt über mich hin" (I wanted to conquer a city; now a palm leaf brushes across me; 3:41). A similar process occurs in "Die Reise," the title of which evokes both a brief trip to Antwerp and a journey away from his doomed efforts to give rational shape to both his world and his own individuality and escape into a trancelike condition that suspends Rönne's epistemological dilemma. He sets out on his journey with the express desire to impose order on his perceptions: "Aufzunehmen gilt es, rief er sich zu, einzuordnen oder prüfend zu übergehen. Aus dem Einstrom der Dinge, dem Rauschen der Klänge, dem Fluten des Lichts die stille Ebene herzustellen, die er bedeutete" (What counts is to absorb, he cried out to himself, to put into order or to pass over discerningly. To produce the still surface that he [Rönne] signified from the flux of things, the rush of sounds, the flood of light; 3:46). This quest for context (*Zusammenhang*), to create coherent order from the plethora of impressions, eludes him; his only recourse is to induce for himself, through a kind of imaginative vision, an alternative timeless consciousness, ecstatic and transcendent at once, that echoes Worringer's notion of abstraction and bears similarity to Carl Einstein's primitivist vision — though Benn's image of the South has classical associations that are entirely absent from Worringer and Einstein.

As Donahue has pointed out (*Forms of Disruption*, 181), the task that Rönne sets himself in "Die Insel" is paralleled by Benn's own: "Rönne lebt einsam seiner Entwicklung hingegeben und arbeitete viel. Seine Studien galten der Schaffung der neuen Syntax. Die Weltanschauung, die die Arbeit des vergangenen Jahrhunderts erschaffen hatte, sie galt es zu vollenden. Den Du-Charakter des Grammatischen auszuschalten, schien ihm ehrlicherweise notwendig, denn die Anrede war mythisch geworden" (Rönne lived in isolation . . . and worked a lot. His studies dealt with the creation of the new syntax. The worldview that the work of the previous century had achieved, that had to be completed. To eliminate the familiar address [du] in grammar seemed to him honestly necessary, for the form of address had become mythic; 3:65). Rönne's quest to find a linguistic correlative for his heightened perceptions of a collective unconscious that transcends his individual psychology — "Er fühlte sich seiner Entwicklung verpflichtet und die ging auf Jahrtausende zurück" (He felt himself bound to his evolution and that went back thousands of years; 3:65) — corresponds to Benn's own efforts to dislocate and disrupt normal syntax.

Given the assumption that "was war und wird, ist längst geschehen" (what was and is to be, is already long past; 3:67), it follows that the conventional syntax of everyday routine cannot do justice to what is called "der psychische Komplex" (the psychic complex; 3:67). Normal social intercourse — "Geschehnis zwischen Individualitäten" (a event between individualities; 3:68) — is complicated by the knowledge that part of the brain responds at a primal, atavistic level, undermining or vitiating individual psychology. The language of everyday life provides only inadequate expression for that psychic experience. The "psychic complex" requires an absolute language, timeless and transcendental. Here Benn is approaching, by a biomedical route, what Worringer defines as "abstraction" and what Carl Einstein calls *Totalität*. Rönne's insight runs counter to his scientific training: namely, that the psychic complex is qualitative, not quantitative (as Heinrich Rickert had argued) and may be grasped only creatively: "Schöpferischer Mensch! Neuformung des Entwicklungsgedankens aus dem Mathematischen ins Intuitive" (Creative mankind! Reformation of evolutionary thought from the mathematical into the intuitive; 3:70). For Rönne, epiphanic moments of significant or heightened perception remove an object from its web of causal connections, render it absolute, transform it into a Kantian "thing in itself." For both Benn and Sternheim, the visual arts epitomize that process and afford writers of the Expressionist period new creative possibilities. Distortion of the surface appearance of objects in the interest of revealing a hidden essence, or in Benn's case a substratum of primal experience, finds its parallel in disrupted syntax. Donahue has captured the discontinuities of *Gehirne* succinctly: "the stories fluctuate between descriptions of Rönne in the world, in his attempts at reconciliation with a community through a public identity, his paralyzing consciousness of existence, and its opposite of transcendence through imaginative associations" (1993, 179).

One final example of that latter complex will suffice to indicate the challenge posed for the reader:

> Einen Augenblick streift es ihn am Haupt: eine Lockerung, ein leises Klirren der Zersprengung, und in sein Auge fuhr ein Bild; klares Land, schwingend in Bläue und Glut und zerklüftet von den Rosen, in der Ferne eine Säule, umwuchert am Fuß; darin er und die Frau, tierisch und verloren, still vergießend Säfte und Hauch. (III, 71)

> [One moment it brushes him on the head: a loosening, a soft shimmering of explosion, and into his eye flashes an image: clear land, swinging into blueness and fiery heat, and cleft with roses, in the distance a pillar, overgrown at the base; within, he and the woman, animalistic and lost, silently spilling fluids and breath.]

Depicted is a moment of transcendence, a significant moment (*Augenblick*), when normal time seems suspended and the scientific and intellectual

(*am Haupt*) grasp on reality loosened (*eine Lockerung*) or even burst (*Zersprengung*); what follows is a vision, a static picture (*ein Bild*), an absolute embodiment of primal experience, this time erotic. All the characteristic attributes appear: blueness, heat, the scent of roses, the fragment of what appears to be a Classical Greek pillar, and there Rönne and the woman, timeless symbols of sexuality, captured in an archetypal moment of animal ("tierisch") and silent, non-verbal ("still") regression. The last association of the exchange of bodily fluids suggests a curious amalgam of Benn's medical detachment and Nietzsche's Dionysian dream, together with echoes of Sternheim's primitive erotic idyll in *Ulrike*.

While Sternheim, Einstein, and Benn drew the logical linguistic and formal conclusions of their theoretical insights, another disparate group of Expressionist prose writers was less formally experimental but no less typical of the quest to seek an essential reality beneath the surface of experience.[8] One of the most frequently cited Expressionist prose works is Albert Ehrenstein's *Tubutsch* (1911), the first edition of which contained twelve illustrations by Oskar Kokoschka. It shares with other Expressionist pieces a sense of crisis, a profound disillusionment with bourgeois values and conventional ways of seeing the world. Ehrenstein's central character, like Benn's Rönne, remains detached from everyday reality, incapable of making sense of the experiences he undergoes, aware that the present is shot through with archetypal situations: he experiences "Tage, die ineinander stürzen, die ich nicht durch irgendein Erlebnis aufzuhalten vermag. Ergebnislos lebe ich Jahrhunderte" (days that collapse into one another, that I cannot stop with any sort of experience. Fruitlessly I live centuries; 278). But there the similarity ends, for Ehrenstein's vision is by turns whimsical and grotesque, a catalogue of everyday experiences that trigger in the narrator bizarre (and often humorous) inventions and stories of oddly named friends in a recognizable Viennese milieu.[9] The alienation from mundane realities, usually represented by figures of authority (policemen, headmasters) is expressed through a series of loosely connected anecdotes. But an irony, a playfulness, belies the oppressiveness of Tubutsch's "tiefe Apathie und Gleichgültigkeit" (deep apathy and indifference; 310). Formal experimentation is hardly in evidence. Indeed, the narrative returns to its point of departure, the statement "mein Name ist Tubutsch" (my name is Tubutsch) signaling formally Tubutsch's inability to break out of the solipsism of his own experience. The fundamentally Schopenhauerian pessimism is held in balance by a curiously affirmative humor.[10] But while Gottfried Benn invents a transcendent vision and gives it form, Ehrenstein remains trapped in the circularity of his text. Even when he tries to conjure up an ancient Egyptian poet, he is forced to admit defeat: "bin aber leider so außer aller Form, daß ich durch keine Vision oder Halluzination den Wackern vor mich zwingen kann" (am however unfortunately so out of sorts that I cannot compel, through any sort of vision or hallucination that hardy soul before me; 286).

The Expressionist predilection for heightened consciousness is nowhere better exemplified than in Georg Heym's story "Der Irre" (The Madman, 1911; published in the prose collection *Der Dieb* [The Thief] in 1913). Released from a lunatic asylum as cured, the madman in the title sets out to return home, seeking to exact revenge on his wife; after first murdering two children and hiding their bodies, then assaulting and killing a woman, he smashes his way into his abandoned apartment. Fleeing the neighbors who are alerted by the noise, he wanders through the city, finally entering a department store, where he is finally shot after another attack. The plot itself is far less interesting than the narrative technique: the third-person narrator presents events from the madman's perspective, entering wholly into his consciousness. As a result the reader is never entirely sure whether he is confronting external reality or merely the projection of the madman's inner visions. Moreover, the horror of the murders is curiously heightened by the matter-of-fact way in which they are narrated, almost as if they were the logical outcome of the madman's inner experience. The story presents no moral dimension: instead, the inner visions seem to signal escape from the pressures of everyday urban reality into an idyllic, timeless landscape: "Er war ein großer weißer Vogel über einem großen einsamen Meer, gewiegt von einer ewigen Helle, hoch im Blauen. [. . .] unten tief in der Flut schienen purpurne Inseln zu schwimmen, großen rosigen Muscheln gleich. Ein unendlicher Friede, eine ewige Ruhe zitterte unter diesem ewigen Himmel" (He was a great white bird above a great lonely sea, rocked by an eternal lucidity, high up in the blue [. . .] purple islands seemed to swim deep below in the swells like great, rosy shells. An endless peacefulness, an eternal calm trembled beneath this timeless sky; 2:32–33). This ecstatic vision marks the characteristic Expressionist attempt to express an inner reality, though the tell-tale presence of the simile indicates that Heym has not wholly broken with traditional narrative techniques. The Expressionist rejection of an urban-technological landscape in favor of a primal vision of a pre-industrial, timeless nature turns the madman into a potent symbol of the need to disrupt normal rational processes. In a society increasingly populated by signs of consumer fetishism — the department store strikes the madman as being "a fine church" (31) — the madman perversely becomes a positive alternative.[11]

Alfred Döblin's early text, "Die Ermordung einer Butterblume" (The Murder of a Buttercup; written in 1904, though not published until 1910) similarly prefigures Expressionist experimentation. Approaching the quest for an underlying essence from the starting point of what appears to be Freudian psychology, Döblin depicts a pedantic, obsessively punctilious petit-bourgeois figure whose suppressed anger prompts him to an act of violence against a buttercup, which he beheads with his walking stick. The incident, trivial as it may seem, prompts a breakdown in his normal routine. Internalizing the crime as murder, Michael Fischer finds his relationship with

his social milieu radically altered. He becomes obsessive about atoning for his crime, opening a bank account for the murdered flower and having his housekeeper lay a place for the flower at table. Eventually, he acquires a replacement for Ellen (the name he gives to the dead buttercup), and lavishes his attention on it, only for his housekeeper to break the spell by knocking over the flowerpot and discarding the remnants of the substitute flower to which he has transferred his guilt. His exculpation complete, he returns to the spot where the murder took place, intent on further slaughter. Döblin's interest lies less in social satire of the bourgeois than in the ways inner obsessions are projected onto the social world as a symptom of pathological obsession. The reader gains only the deeply disturbed protagonist's perspective on events and never quite attains the ironic detachment needed to feel superior, much less to laugh at, the central character. Thus, his disturbing transformation proves as unnerving to the reader as to the character himself. This shock of recognition lies at the heart of Expressionist prose.

Kasimir Edschmid is probably as well known for his theoretical championing of Expressionism as for his own creative contribution to it. In his essay "Über den dichterischen Expressionismus" (On Literary Expressionism, 1918), he is at pains to distinguish the Expressionist from the Impressionist artist: the former

> sieht nicht, er schaut. Er schildert nicht, er erlebt. Er gibt nicht wieder, er gestaltet. Er nimmt nicht, er sucht . . . . Er gibt das tiefe Bild des Gegenstands, die Landschaft seiner Kunst ist die große paradiesische, die Gott ursprünglich schuf, die herrlicher ist, bunter und unendlicher als jene, die unsere Blicke nur in empirischer Blindheit wahrzunehmen vermögen. . . . Der Kranke ist nicht nur der Krüppel, der leidet. Er wird die Krankheit selbst, das Leid der ganzen Kreatur scheint aus seinem Leib. (Best, 57; Anz/Stark, 46)

> [does not see, he envisions. He does not describe, he animates. He does not represent, he shapes. He does not take, he seeks [. . .] He presents the deep image of the object, the landscape of his art is the great paradisiacal one that God originally created, that is more glorious, colorful and more infinite than the one our sight in mere empirical blindness is capable of perceiving. [. . .] The sick are not just the cripples who suffer, but rather they become the sickness itself; the suffering of all creation radiates from each body.]

This theoretical observation could serve admirably as an account of Edschmid's own story "Der tödliche Mai" (The Deadly May, 1915) one of the two short stories that appeared under the title *Das rasende Leben* (Frantic Life, 1915). The story depicts a young army officer's battle for survival after being severely wounded. Although he makes a gradual recovery, his memories of an earlier ecstatic scene of the sheer intensity of life begin to dim; only when the fragments of that memory come to the surface again

does he awaken to both an intense sense of life and a renewed fear of death. The intensity of the language, as well as the vivid and painterly eye for landscape — the officer is also a painter — confirm Edschmid's insight that the landscapes are those of the inner eye and seem to have a dynamic that echoes the officer's innermost feelings. Much to Edschmid's own irritation (Edschmid, 43–44), critics have drawn parallels between his work and Sternheim's, but readers familiar with Georg Büchner's *Lenz* (to which tribute is paid in the dedication of *Das rasende Leben*) will spot some striking similarities. Edschmid's prose certainly displays expressive qualities, but it is by no means as stylized, as compressed, as Sternheim's.

In his story "Café Klößchen" (1919), Alfred Lichtenstein displays a tendency to veer off into the grotesque, like Ehrenstein or Mynona, yet the ironic tone, the humorous names of the characters, and the satire of contemporary notions of art suggest a more cynical perspective. The eponymous café, a version of the Romanisches Café in Berlin, is the setting for a battle between two writers for the love of a star-struck would-be actress from the provinces, Lisel Liblichlein. Her cousin, Gottschalk Schulz, takes her under his wing, introducing her to city life, before making a crude attempt to seduce her. Her horrified response provides just the pretext for unhappiness that the budding writer Schulz needs; he now has his unrequited love and his muse and disappears into the Café to celebrate. Lisel's next encounter is with another habitué of the Café, Kuno Kohn, a humpbacked poet, an Expressionist counterpart to Schulz's neo-Romanticism. Lisel falls for this curiously misshapen figure, whose characteristically Expressionist intention is made abundantly clear: "Ich will aus Lisel Liblichlein ihr höheres Wesen herausbilden" (I want to create out of Lisel Liblichlein her higher essence; Martini, 296). In the last section of the story the seduction takes place. Lisel, moved to tears by her happiness, is given a piece of Expressionist advice: "Der einzige Trost ist: traurig sein. Wenn die Traurigkeit in Verzweiflung ausartet, soll man grotesk werden" (The only comfort is: to be sad. If sadness turns to desperation, one becomes grotesque; Martini, 298), a sentiment that could well stand as a motto for Lichtenstein's writing. This is the last time that the lovers will meet and Kohn remains a lonely figure in the Café Klößchen, the very embodiment of expressive suffering: "Der ganze Körper schrie lautlos" (His whole body screamed silently; Martini, 299).

What most of these writers have in common is a rejection of psychology (or, in Benn's case, a powerful awareness of its limitations). They share, too, a cubist or constructivist view of spatial relations, refusing to situate objects within their milieu, but rather making them stand out from their milieu as "things in themselves." The methods that they adopt vary, but formal distortion and linguistic dislocation are their stock-in-trade. Expressionists themselves tend to argue that distortion is merely a means to an end, a method of revealing a hidden essence, of presenting the world

afresh, as it really is. Particularly under the impact of the First World War, Expressionist theorists began to emphasize the political implications of this way of seeing, claiming that customary type of perception was bourgeois and that the Expressionist grasp of essences was, by implication at least, a revolutionary act. But therein lies the paradox and the problem of Expressionist writing, for what guarantees that formal distortion serves a new epistemology, and not merely a willful aesthetic self-indulgence?

One of the clearest statements of this dilemma appears in Carl Sternheim's story *Gauguin und van Gogh* (1924), in which van Gogh's phenomenological search for the essence underlying the chaotic and confusing phenomena of the empirical world is contrasted with Gauguin's flight from reality. The story reflects the powerful appeal van Gogh held for the Expressionist generation, for Sternheim's van Gogh is also presented as a socially committed painter in direct contrast to the escapist and self-indulgent Gauguin. Gottfried Benn also found in van Gogh a confirmation of his own advocacy of absolute art as well as of his suspicion of cerebral consciousness: "Durchbruch aus der Zone des Gedankens in die des Seins, letzte Dränge des Zeitlich-Gültigen in das Unendlich-Zeitlose, fiebernde Jaktationen des Individuums in das Unbedingte" (Breakthrough out of the zone of thought into that of being, ultimate impulses of historical boundedness into infinite historical unboundedness, feverish jactitations of the individual into the absolute; Der Garten von Arles, 3:114). Carl Einstein places more emphasis on van Gogh's social commitment: "Nicht mehr Malerei um des Malens, sondern der menschlichen Leidenschaft, einer Gesinnung willen" (No longer painting for painting's sake, but rather for the sake of human passion, a way of thinking; 24). But Sternheim, in dignifying Gauguin as a worthy opponent of van Gogh, seems to be aware that the charge of pure aestheticism, of distortion for its own sake, could be leveled at the Expressionists as well. It was this charge of escapism that accounted for Georg Lukács's famous condemnation of Expressionism, in which he characterized it as "eine gedankliche Flucht vor der Wirklichkeit" (A flight in thought from reality). He argued, from a realist standpoint, that the Expressionists had sought to alter the way in which the world is perceived, rather than attempt to alter the world itself through revolution. Certainly, while the Expressionists saw themselves as revolutionary, their revolution was artistic, or at most epistemological, but in light of the extraordinarily fresh prose that they produced, it was no less valuable for that.

# Notes

Unless otherwise noted, literary works discussed in this chapter may be found in the editions of collected works listed for the respective author in the Works Cited list.

[1] Later exceptions to this rule such as Döblin's *Berlin Alexanderplatz* (1929) or Hans Henny Jahnn's *Perrudja* (1929) only confirm the rule, as do the mixed results of Döblin's successive but unsuccessful earlier long prose experiments in the Expressionist vein. See Donahue on *Wallenstein* (1920).

[2] This incident echoes what is an overtly satirical episode in Heinrich Mann's novel *Im Schlaraffenland* (1900), where the social climber Andreas Zumsee visits his mistress, who likewise picks out the tune. See H. Mann, *Gesammelte Werke* (Berlin and Weimar), 1:275.

[3] Notably, Wolfgang Wendler, *Carl Sternheim: Weltvorstellung und Kunstprinzipien* (Frankfurt am Main and Bonn: Athenäum, 1966), 84–118.

[4] Carl Einstein clearly regarded Posinsky, with some justification, as a portrait of himself and complained that Sternheim was making capital out of his relationship with Countess Aga von Hagen. See Sternheim, *Gesammelte Werke*, 10:1020 and Sybille Penkert, *Carl Einstein: Beiträge zu einer Monographie* (Göttingen: Vandenhoeck & Ruprecht, 1969), 80–81.

[5] See my article "From Painting into Literature: Carl Sternheim's Prose Style," *Oxford German Studies* 12 (1981): 139–57.

[6] For one of the earliest and clearest analyses of Benn's stories, see Buddeberg, 1–27.

[7] There are parallels here with the ways in which Robert Musil operates in *Die Verwirrungen des Zöglings Törleß* (The Confusions of Young Törless, 1906).

[8] For ease of access, I have selected a number of texts from those reproduced in Fritz Martini, ed. *Prosa des Expressionismus*. Page numbers refer to this volume.

[9] Even more whimsical are the works of Mynona, the pseudonym of Salomo Friedländer, whose *Grotesken* are largely humorous in tone and make little claim to reveal a hidden "essence."

[10] For a salutary discrimination between Tubutsch and his creator Ehrenstein see Alfred D. White, "Albert Ehrenstein's Short Stories: Are They Autobiographical?" *German Life and Letters* 42 (1989): 362–76.

[11] It is not difficult to understand why van Gogh's madness, as well as his visionary qualities, should have held such appeal for this generation of writers.

# Works Cited

Anz, Thomas, and Michael Stark, eds. *Expressionismus: Manifeste und Dokumente zur deutschen Literatur, 1910–1920.* Stuttgart: Metzler, 1982.

Benn, Gottfried. *Sämtliche Werke.* Ed. Gerhard Schuster. Stuttgart: Klett-Cotta, 1986–2003.

Best, Otto F., ed. *Theorie des Expressionismus.* Stuttgart: Reclam, 1976.

Buddeberg, Else. *Gottfried Benn.* Stuttgart: Metzler, 1961.

Donahue, Neil H. "The Fall of Wallenstein, or the Collapse of Narration: The Parodox of Epic Intensity in Alfred Döblin's *Wallenstein* (1920)." In *A*

*Companion to the Works of Alfred Döblin*, 75–92. Rochester, NY: Camden House, 2003.

———. *Forms of Disruption: Abstraction in German Expressionist Prose.* Ann Arbor: U of Michigan P, 1993.

Edschmid, Kasimir. *Lebendiger Expressionismus: Auseinandersetzungen, Gestalten, Erinnerungen.* Frankfurt am Main and Berlin: Ullstein, 1964. Orig. Munich: Kurt Desch, 1964.

Ehrenstein, Albert. *Gedichte und Prosa*, ed. Karl Otten. Neuwied: Luchterhand, 1961.

Einstein, Carl. *Die Kunst des 20. Jahrhunderts.* 3rd ed. Berlin: Propyläen, 1931.

———. *Gesammelte Werke.* Ed. Ernst Nef. Wiesbaden: Limes, 1962.

Grimm, Reinhold. "Brussels 1916: Gottfried Benn's *Urerlebnis.*" In *The Ideological Crisis of Expressionsim: The Literary and Artistic German War Colony in Belgium, 1914–1918*, ed. Rainer Rumold and O. K. Werckmeister, 133–49. Columbia, SC: Camden House, 1990.

Hermand, Jost. *Literaturwissenschaft und Kunstwissenschaft.* Stuttgart: Metzler, 1965.

Heym, Georg. *Dichtungen und Schriften.* Ed. Karl Ludwig Schneider. Hamburg and Munich: Heinrich Ellermann, 1962–68.

Lukács, Georg. "'Größe und Verfall' des Expressionismus." In *Probleme des Realismus*, 146–83. Berlin: Luchterhand, 1955.

Mann, Heinrich. *Gesammelte Werke.* Vol. 1. Berlin and Weimar: Aufbau, 1968.

Martini, Fritz. *Prosa des Expressionismus.* Stuttgart: Reclam, 1970.

Penkert, Sybille. *Carl Einstein: Beiträge zu einer Monographie.* Göttingen: Vandenhoeck & Ruprecht, 1969.

Soergel, Albert. *Dichtung und Dichter der Zeit: Im Banne des Expressionismus.* 1925.

Sternheim, Carl. "Carl Sternheim: Briefe an Blei." Ed. Rudolf Billetta. *Neue Deutsche Hefte*, 18, 3 (1971): 36–69.

———. *Gesamtwerk.* Ed. Wilhelm Emrich and Manfred Linke. 10 vols. Neuwied: Luchterhand, 1963–76.

Wendler, Wolfgang. *Carl Sternheim: Weltvorstellung und Kunstprinzipien.* Frankfurt am Main and Bonn: Athenäum, 1966.

White, Alfred D. "Albert Ehrenstein's Short Stories: Are They Autobiographical?" *German Life and Letters* 42 (1989): 362–76.

Williams, Rhys. W. "From Painting into Literature: Carl Sternheim's Prose Style." *Oxford German Studies* 12 (1981): 139–57.

Worringer, Wilhelm. *Abstraktion und Einfühlung: Ein Beitrag zur Stilpsychologie.* Munich: Piper, 1908. *Abstraction and Empathy: A Contribution to the Psychology of Style.* Trans. Michael Bullock. New York: International UP, 1953.

# 4: The Cutting Edge of German Expressionism: The Woodcut Novel of Frans Masereel and Its Influences

*Perry Willett*

IN THE EARLY TWENTIETH CENTURY, several artists in Europe and the United States developed a unique Expressionist aesthetic in the graphic arts while exploring *Aufbruch* (departure, break-up, revolution) and revolt, in a genre they named the "novel in woodcuts." These works consist of a series of illustrations, sometimes numbering over one hundred, that narrate a story without any words at all. The idea of telling a story using only pictures is a simple one and common to children's picture books, but these woodcut novels are complex and moving, using only woodcuts, wood engravings, lithographs, or other forms of graphic art. They were published in book format with bound pages and a cover, usually the same size as novels, and drew on several artistic and political currents of the early twentieth century, particularly Expressionism. In the late twentieth century, these works continue to influence comic books, graphic novels, and the work of Art Spiegelman and other contemporary graphic artists.[1] The genre's aesthetic explores the importance of language in both the expression and control of subversive ideas, and is expressionistic in theme and style. The irony at the center of these narratives lies in their exploration, entirely without words, of the power of language and the language of power.

The originator of the woodcut novel was Frans Masereel, the Belgian graphic artist.[2] Before the First World War, Masereel illustrated editions of works by such Belgian writers as Emile Verhaeren, Pierre Jean Jouve, and Charles-Louis Phillipe and made a reputation as a highly skilled woodcut artist. He opposed the war and avoided active duty by serving as a translator for the Red Cross in Geneva, where he befriended other pacifists such as writers Romain Rolland and Stefan Zweig. Together they worked on pacifist journals such as *La feuille* and *Les tablettes*. Masereel provided crude, satiric woodcuts for these journals, and in them he would typically juxtapose the pronouncement of a politician or industrialist with a scene of battlefield carnage, and in doing so showed the vast gulf between the official rhetoric of the war and the reality.

As a Belgian, Masereel straddled both French and German cultures, yet his work clearly exhibits a German aesthetic. His woodcuts exhibit the same formal features present in the work of Ernst Barlach, Erich Heckel, and other German Expressionist graphic artists and the same kinetic urgency as the films of such post-Expressionist directors as Walter Ruttmann or Dziga Vertov, and they deal with the themes of *Aufbruch*, war, and life in the industrial metropolis common to Expressionist art in all genres and media, especially the theater of Ernst Toller. Although Masereel lived in Geneva and Paris during and after the war, he found his greatest success in Germany through the editions of his works published by Kurt Wolff, which sold hundreds of thousands of copies in the 1920s. Masereel both draws upon the gestural language of Expressionist theater and film and influences those genres in turn.

In 1918, Masereel produced his first woodcut novel entitled *25 images de la passion d'un homme* (Twenty-Five Images of a Man's Passion, 1918). This work, with the religious implications of the title, shows the martyrdom of a man for his beliefs. It was first published by Éditions du Sablier, a publisher sponsored by Masereel, René Arcos, and others in Geneva. In 1921, his novel was published in Germany by Kurt Wolff, a leading publisher of Expressionist authors, with the title *Die Passion eines Menschen*. As with many of his later woodcut novels, the first printing of this edition was a numbered collector's edition, with subsequent trade printings. Since the illustrations did not require translation, it was relatively simple to create a new edition in a different country with a new title page. His works achieved their greatest popularity in Germany, and the Kurt Wolff edition had several printings through the 1920s.[3] Thomas Mann, Hermann Hesse, and Max Brod wrote introductions to different editions.

With this first woodcut novel, Masereel created the archetype that most of the other works in this genre follow. The narrative concerns a sympathetic main character and his martyrdom to the powerful representatives of capitalism. He is born to an unmarried mother and faces every disadvantage: eviction, poverty, hard labor, and juvenile detention. After his release from jail, he strolls the metropolis, among the well-to-do. He notices the social and economic inequalities in life, and begins to read and think. He leads a strike, for which he is arrested and sentenced, with the final scene showing him standing against a wall, awaiting execution. His defiant, impassive stare toward his executioners reveals his willingness to give his life for the cause of freedom and justice (figure 1).

Masereel draws religious parallels throughout, starting with the title. The popular German edition published by Kurt Wolff has a Christ figure on the cover, carrying a cross. The protagonist has only words to threaten the power structure of society. He rouses the crowd with words; he confronts the armed guards with words; and for his words he is

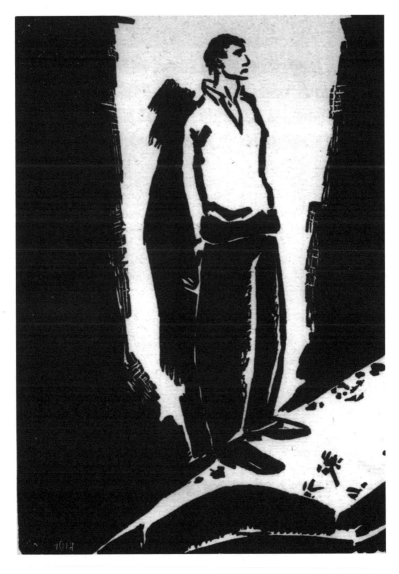

Figure 1. From Frans Masereel, *Die Passion eines Menschen:*
*25 Holzschnitten* (Munich: Kurt Wolff, 1927). 23 cm.
© 2005 Artists Rights Society (ARS), New York / VG Bild-Kunst, Bonn.

silenced. In a key illustration, during his trial, a figure of Christ on the cross shines beams of redemption on him. The judges mediate this redemption, sitting between the cross and the prisoner, and yet the beams fall on them and the guards as well. This illustration echoes an earlier one, in which the protagonist stands beneath a smokestack, reading a book. The smokestack glows, with the rays radiating on him as he reads, as he achieves a different kind of redemption. These themes of injustice and martyrdom, told as a kind of socialist melodrama, are common to many other woodcut novels, and serve as a unifying element of the genre's aesthetic (figure 2).

The narrative arc of *25 Images of a Man's Passion* resembles that of Ernst Toller's drama *Die Wandlung* (The Transformation, 1919), first performed in 1919, in which the main character becomes disillusioned and speaks out in the hopes of starting a mass uprising, and indeed both works arise from the social unrest in Germany following the First World War. However, Toller's character strives for a transformation that is more personal than political, and wishes to change the hearts of the masses, while Masereel's main character in this early woodcut novel strives for a solely political revolution. Masereel remained much more committed to socialism than Toller, who expressed his distrust of mass movements in *Die Wandlung* and his later play, *Masse-Mensch* (Man and the Masses, 1921). The central conflict of Toller's dramas finds expression in the contradictory, even antithetical, concerns of the protagonist for both the individual and the mass of society. Masereel's characters remain wordless and can only demonstrate their inner turmoil through action and silent exhortation. We only view the characters' actions without hearing their thoughts, making the action seem inevitable and tragic.

Masereel's second woodcut novel, *Mon livre d'heures* (My Book of Hours, 1919) also published as *Mein Stundenbuch: 165 Holzschnitte* (1920) and *My Book of Hours* (1922) (and later published in the United States as *Passionate Journey*) is also his longest, most personal, and most popular. With 167 illustrations, this novel, with elements that are clearly autobiographical, relates the joy, sorrow, contentment, boredom, and anger experienced by a common man after his arrival in the metropolis. The woodcut novel found a large audience and was also a critical success. Thomas Mann wrote in the introduction to the first German popular edition:

> Laßt seine kräftig schwarz-weißen, licht-und schattenbewegten Gesichte ablaufen, vom ersten angefangen, von dem im Qualme schief dahinbrausenden Eisenbahnwagen, der den Helden ins Leben trägt, bis zu dem Sternenbummel eines Entfleischten zu guter Letzt; wo seid ihr? Von welcher allbeliebten Unterhaltung glaubt ihr euch hingenommen, wenn auch auf unvergleichlich innigere und reinere Weise hingenommen, als es euch dort denn doch wohl je zuteil geworden? (18–19)

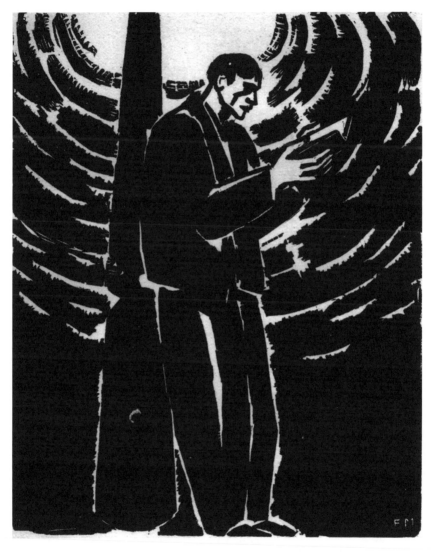

Figure 2. From Masereel, *Die Passion eines Menschen.* 23 cm.
© 2005 Artists Rights Society (ARS), New York / VG Bild-Kunst, Bonn.

[Look at these powerful black-and-white figures, their features etched in light and shadow. You will be captivated from beginning to end: from the first picture showing the train plunging through the dense smoke and bearing the hero toward life, to the very last picture showing the skeleton-faced figure wandering among the stars. And where are you? Has not this passionate journey had an incomparably deeper and purer impact on you than you have ever felt before?[4]

The German edition went through several printings, with sales in Europe totaling over 100,000 copies through the 1920s. This wide distribution, a milestone achievement for the genre, caught the interest of artists and encouraged other publishers to sponsor editions of new woodcut novels.

The narrative follows a young man as he arrives at the railway terminus of a metropolis, hatless, curious, open to experience. The character embraces all that the city has to offer him. In one sequence, early in the narrative, Masereel seems to comment on his earlier woodcut novel — the character speaks out at a rally and leads a group of men in a strike, but walks away in the next illustration, disgusted by the endless political discussion. He experiences rapturous love. After the young man's tryst with his lover, Masereel gives him a glowing halo, as he becomes both redeemed and redeemer. He finds deep sorrow, too, after being spurned. He then saves a small girl from a beating by her father, and takes on her upbringing. She soon dies, however, and his sorrow deepens. He leaves the metropolis and travels the world. When he returns, his rage for life is even more acute, and he does whatever he pleases regardless of others' reactions. He is chased from the city by a horde of outraged citizens and returns to the country, where he dies. He does not find peace, but instead continues to rage even in death, raising lightning bolts and striding across the galaxy. The novel's exploration of themes of wandering and isolation, its attempts to portray a larger urban experience, its calls for universal brotherhood, and its insistent individualism using a somewhat allegorical main character yearning for *Aufbruch* all link this woodcut novel with Expressionist painting, theater, and film (figure 3).

Masereel's most widely reprinted and most popular woodcut novel, this is also his most personal and exuberant. Masereel later stated in an interview that he would return again and again to this work as a source of inspiration:

> Ich glaube, daß darin das Wesentliche von dem liegt, was ich sagen wollte; ich drückte darin ein wenig meine Philosophie aus, und vielleicht enthält "Mein Stundenbuch" mit seinen 167 Holzschnitten potentiell alles das, was ich danach geschaffen habe, denn ich habe wo anders und später eine ganze Anzahl von Themen daraus entwickelt. (Vorms, 44)

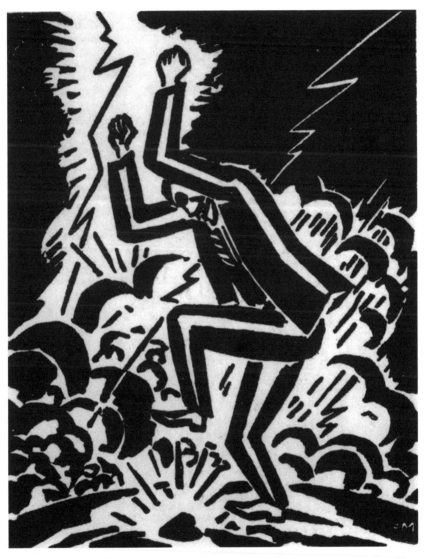

Figure 3. From Masereel, *My Book of Hours*
(N.p.: Se trouve chez l'auteur, 1922). 18 cm.
© 2005 Artists Rights Society (ARS), New York / VG Bild-Kunst, Bonn.

[I believe that it contained the essence of what I wanted to say; I expressed my philosophy, and perhaps "My Book of Hours" with its 167 woodcuts contains everything that I have created since, because I have developed a number of themes from it in my later work.]

According to John Willett, the French edition was published on credit, and "so impressed the German publisher Kurt Wolff that he sent Hans Mardersteig to see Masereel and arranged those popular editions which ran into six figures and made the artist's reputation throughout central Europe in the 1920s" (1968, 989). Wolff continued to publish Masereel's novels even after Wolff emigrated to the United States, and he published *Danse Macabre*, Masereel's woodcut novel depicting his flight from war-torn France in 1941, at his new publishing house, Pantheon. The reviews in Germany were all positive, and it seems to have been well known in the United States even though it was only published in a limited edition of 600 copies.[5] According to the standard Masereel bibliography,[6] it was even published in China in popular editions, first in 1933 and again in 1957.

Masereel's success can be traced to his mastery of the genre, combining allegory and satire into narratives critical of society with an immediate emotional impact, a technique characteristic of Expressionism. Between 1918 and 1920, he published three other woodcut novels: *Le soleil* (The Sun, 1919) later published as *Die Sonne* (The Sun, 1920); *Histoire sans paroles* (Story without Words, 1920) later published as *Geschichte ohne Worte* (Story without Words, 1922); and *Idée* (The Idea, 1920), later published as *Die Idee* (1924), all employing the same Expressionistic visual idiom first explored in *25 images de la passion d'un homme*, and exploring modern society with the same themes of alienation, revolution, love, and redemption contained in his first woodcut novel. The gestures he used in his woodcuts are understated, not overblown, even as he illustrates a full range of emotion. Most characters in the novels appear impassive, with the crude woodcuts only outlining their expressions, while characters in despair generally hide their faces. This makes the apocalyptic ecstasy at the conclusion of *Mon livre d'heures* all the more emphatic and effective. Lotte Eisner noted that "the brusque, exaggerated gestures of actors in an Expressionist film frequently make modern audiences laugh" (140), yet Masereel's art remains vital because the central characters achieve expressive emotion without exaggeration.

*Idée*, like *Mon livre d'heures* and *Le soleil*, was extremely popular and went through several printings in Germany in the 1920s, and continued to gain new editions in the decades after the First World War, and even to the present.[7] In it Masereel tells the story of artistic creation and of the power of ideas to elude and survive all attempts at suppression. This allegorical tale shows the artist (who greatly resembles Masereel) creating a small figure of a nude woman, placing her regretfully in an envelope and mailing

her to an unsuspecting and uncomprehending public that tries to arrest her, clothe her, and deny her all expression. She transcends all suppression and flaunts her nudity to society at large, causing great shock and consternation. She finds the new mass media of photography, telephone, radio, and film to provide even greater opportunities for expression, so that crude attempts at book burning and other forms of suppression are in vain. She even uses music, automobiles, electricity, modernity itself, as vehicles of expression (figure 4).

This short, effective narrative shows Masereel at his confident best. The woodcuts savage bourgeois culture with wild exaggeration and satire. Masereel is clearly in control of the medium and the genre, and he makes a powerful statement on the importance of the artist. He predicts the potential of new media for greater expression and foretells attempts at suppression, although the ease with which he believed truth could triumph now seems overly optimistic.

As in his other works, Masereel portrays society as extremely threatened by this free speech, and its members seek to prevent or suppress any attempt at creative expression. In *Le soleil*, the mere desire to touch the sun stirs crowds of people from all classes to chase down the hapless dreamer, yet he breaks free to fly with the birds and later come crashing back to earth. In *Mon livre d'heures*, the protagonist easily provokes an all-too-willing society to outrage with a few well-aimed taunts. In *Idée*, the figure of free expression is confronted by frenzied crowds of men in top hats, the very icon of bourgeois culture, seeking to chase her down and suppress her, yet she eludes them with her appearance in each new medium. The artist or individual acts as if gripped by compulsion to defy the escalating acts of social repression performed by mass culture.

*La ville* (The City, 1925) must be considered Masereel's masterpiece woodcut novel, and is without a plot, a "lyric documentary,"[8] a succession of views of the city whose protagonist is the city itself, observed during one typical day. In most other woodcut novels, as in most narrative film, the requirements of plot at times interfere with the aesthetic desires of the artist or director. However, in *La ville*, freed from the constraint of narration by focusing on the experience of the city, each woodcut is striking and deserves detailed examination. Masereel shared the Expressionist and Modernist fascination with the city; its features, the brothel, the factory, the street, the restaurant, the music-hall, constitute at once the backdrop and the subject of the novel: in one scene, a well-dressed, well-fed man strolls past an ill-dressed, ill-fed one; in the next, a man peers at the sun from a prison cell; the next shows a man writing in a study crammed to the ceiling with books. Much like Ludwig Meidner's painting, *Ich und die Stadt* (Self and the City, 1914) or Jakob Steinhardt's *Die Stadt* (The City, 1913),[9] his focus is at once a close-up and a panorama. The one hundred woodcuts show the physical city and the individual emotions: the crowds

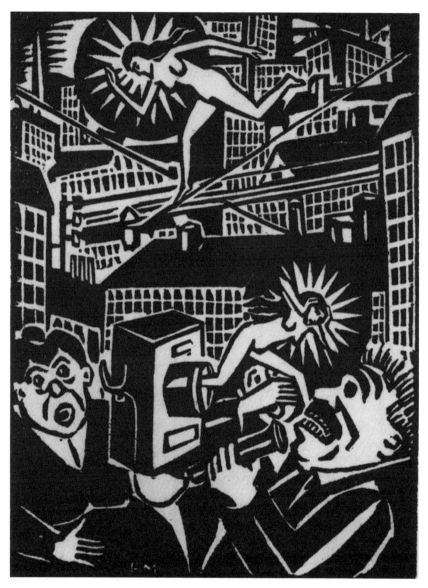

Figure 4. From Masereel, *Die Idee* (Munich: Kurt Wolff, 1927). 16 cm.
© 2005 Artists Rights Society (ARS), New York / VG Bild-Kunst, Bonn.

and the empty street as well as the rage, the love, the boredom, the fatigue, the violence, and the excitement, all to capture the vitality of the metropolis. The woodcuts are sharp and candid, and they display an acute understanding of and passion for city life. The effect is a montage, as the scenes shift between utterly depopulated rooftops, to mass, impersonal crowds, to intimate views of personal life, to voyeuristic peerings into others' lives. Unlike some other works in this genre, the woodcuts are consistently engaging and to be lingered over, as each illustration expresses a complex view of the city and its inhabitants and, taken together, they encompass the full range of urban experience.

As with *Mon livre d'heures*, the scene opens with a solitary figure outside the city, from a vantage point overlooking the countless factories and buildings crowding the landscape in front of him. The scene quickly moves from the train station and is thrown immediately into the bustling street, where countless people rush past. One remarkable aspect is the lack of interaction; the figures largely stare forward, or gaze on the anonymous lives of others. In most of the illustrations, a crowd gathers just to watch, and they see it all: birth, death, love, commerce, motion, art, sport, public spectacle, and private moments, with spectatorship providing an incidental diversion of city life. Unrealistically large masses congregate at the slightest activity. In several of the illustrations, a figure stares out from the page, including and implicating the reader in this gaze. In his 1917 lecture, "Über den dichterischen Expressionismus" (On Literary Expressionism), Kasimir Edschmid said:

> So wird der ganze Raum des expressionistischen Künstlers Vision. Er sieht nicht, er schaut. Er schildert nicht, er erlebt. Er gibt nicht wieder, er gestaltet. Er nimmt nicht, er sucht. Nun gibt es nicht mehr die Kette der Tatsachen: Fabriken, Häuser, Krankheit, Huren, Geschrei und Hunger. Nun gibt es ihre Vision. (Edschmid 1919, 54)

> [So the entire expanse becomes the vision of the Expressionist artist. He does not see; he perceives. He does not describe; he experiences. He does not repeat; he shapes. He does not take; he seeks. There is no longer a chain of facts: factories, houses, illness, whores, outcry, and hunger. Now there is their vision.]

In *La ville*, we have the "chain of facts," but also a vision of humanity. The intensity of his other novels is focused through a single main character, culminating in rage, suppression, and death; this intensity becomes white-hot at the end of *Mon livre d'heures*, where the protagonist calls forth lightning and dances across the cosmos. As Edschmid wrote in an introduction to a collection of Masereel's political drawings (Frans Masereel, *Politische Zeichnungen*, 1924): "Aus biblischem Furor, nicht aus der Begeisterung der Linie kommt seine Graphik. In ekstatischem Zorn

macht er seine Manifeste, nicht aus Groteske oder Liebe zur Kunst" (His graphic art originates in a biblical fury, not from an infatuation with formal concerns. His manifesto comes from an ecstatic wrath, not from the grotesque, or a love of art; 8). In *La ville*, Masereel constructs a novel without narrative, and expresses his vision of modern life in the interplay of the illustrations, with as many points of view as individuals in a metropolis. Without a main figure, the characters seem solitary, even in large crowds. What little interaction occurs is furtive, illicit, even violent: a boy picks the pocket of a mourner at a public funeral; an older man chooses a prostitute at a brothel; a man murders his lover. Only a few woodcuts hint at comfort and reassurance: a family at dinner; a woman giving birth; lovers embracing. However, the final image shows a single man, gazing at the stars from his garret window. He is framed entirely by the window of the small top-story room he occupies, but at the edge of the illustration. The city is silent and dark, yet the factories and buildings still push up, in the background, toward a skyline dominated by the stars and moon. For the first time since the first illustration of the novel, nature interposes itself, while the man gazes upward with hope and rapture. Although Masereel's vision of the city is bleak, there is vibrancy and excitement in the crowds, and the man in the final illustration awaits the new day with anticipation. In this novel, the climax is muted, as Masereel finds a quieter solace amid the chaos and frenzy (figures 5, 6, and 7).

This novel is closely akin to the films *Berlin, die Symphonie einer Groß-stadt* (Berlin: the Symphony of a Metropolis, 1927) by Walter Ruttmann and *The Man with the Movie Camera* (1929) by Dziga Vertov, both of which express the experience of urban life through candid shots of the city and its residents in a single typical day. Masereel combines the elements of hope and passion that Siegfried Kracauer finds in Vertov's film with the anarchy and meaninglessness Kracauer finds in Ruttmann's. Kracauer points out the contrasts in Ruttman's film, where "one picture unit connects a cavalcade in the Tiergarten with a group of women beating carpets; another juxtaposes hungry children in the street and opulent dishes in some restaurant. Yet these contrasts are not so much social protests as formal expedients" (185). Masereel's juxtapositions are designed entirely as social and political criticism: a military parade is followed by a scene at a stock market; a birth is followed by a worker's death. Both Masereel's *La ville* and these films attempt to find overall meaning in the details of everyday life, yet Masereel captures better the claustrophobic crush of the crowds and the solitary emptiness that coexist in the metropolis, while avoiding dehumanizing entirely his scenes into mere formal abstractions. While Masereel did not invent the aesthetic interest in urban life, and it is not known if Ruttmann or Vertov knew of Masereel's work, the woodcut novel anticipates both films and captures the essence of the metropolis as a filmic concept.[10]

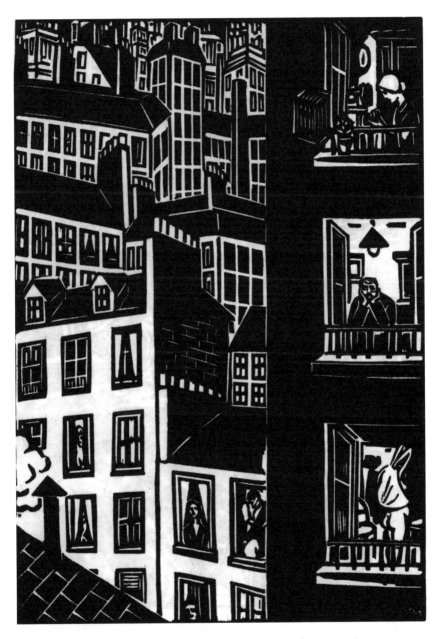

Figure 5. From Masereel, *Die Stadt* (Frankfurt am Main:
Büchergild Gutenberg, 1961). 29 cm.
© 2005 Artists Rights Society (ARS), New York / VG Bild-Kunst, Bonn.

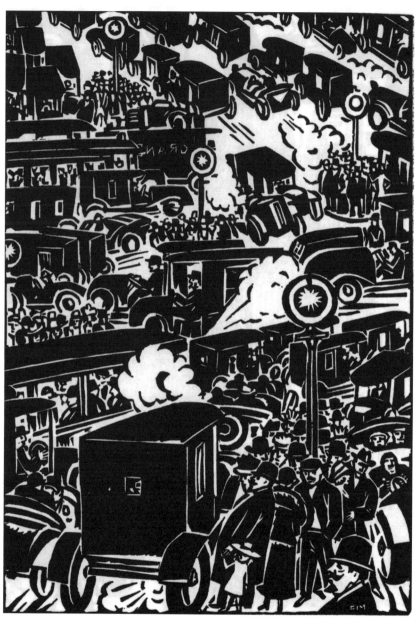

Figure 6. From Masereel, *Die Stadt*. 29 cm.
© 2005 Artists Rights Society (ARS), New York / VG Bild-Kunst, Bonn.

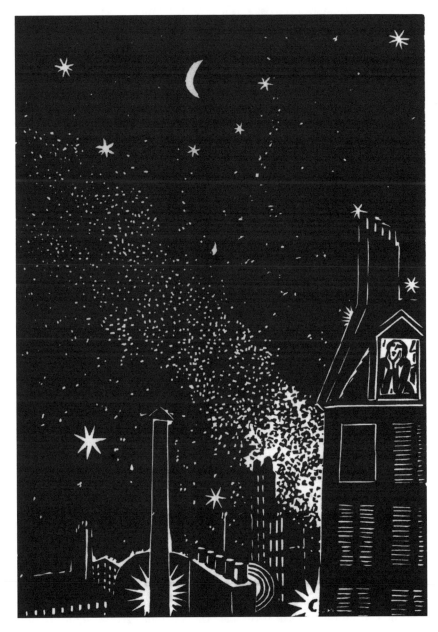

Figure 7. From Masereel, *Die Stadt*.
© 2005 Artists Rights Society (ARS), New York / VG Bild-Kunst, Bonn.

Many other artists created woodcut novels in the 1920s and 1930s, including the American artist, Lynd Ward.[11] Ward, better remembered today as a children's book illustrator, created 6 woodcut novels in the 1920s and 1930s. His most popular was his first, *Gods' Man*, published in 1929, a retelling of the Faust myth. Others who created woodcut narratives at this time include the Germans Clément Moreau and Otto Nückel, the American Giacomo Patri, and the Hungarian Szegedi Szuts,[12] although none achieved the same success in the genre as Masereel. With the woodcut novel, these artists combined the pictorial elements and aesthetic of Expressionist graphic art, the gestural and moral elements of Expressionist art and theater, and the kinetic elements of film. The idea of combining illustration and narrative is not new, but these artists' attempt at a purely illustrated narrative differed in more than just style from previous periods.

The roots of this genre extend in three directions. First, the early twentieth century witnessed a general revival of interest in medieval art forms in theater and the pictorial arts. German Expressionist dramatists such as Ernst Toller and Georg Kaiser, and, in the United States, Elmer Rice and others, drew on the dramatic structures and moral concerns of medieval drama, and coupled it with their indignation at war and modern capitalist society. Graphic artists such as Otto Dix, Max Beckmann, Karl Schmidt-Rottluff, and Käthe Kollwitz found inspiration in the German Biblical woodcuts of the Middle Ages such as the *Biblia Pauperum*, realizing the immediate visual impact that such works produce. In his catalogue for the 1918 exhibition of woodcuts, *Der expressionistische Holzschnitt* (The Expressionist Woodcut, 1918), Hans Goltz notes the lineage of contemporary artists from the Middle Ages. Many artists of the early twentieth century, in a move away from realistic representation toward more primal forms of expression, used, paradoxically, the awkwardness and roughness of the medieval woodcut to represent the anguish of modern experience. Masereel and the other woodcut novelists enlisted these medieval elements as a means of expressing their political ideas, in much the same way as Ernst Toller used the form of the medieval station drama for his complex views on revolution and social and personal change. Masereel's emblematic use of the crude woodcut over the more refined wood engraving, which allows for more exact lines, is a constant reminder of both medieval art and early film.

The critic Lothar Lang believes Masereel's illustrations to be only formally expressionistic. He finds many similarities and influences, but thinks that the revolutionary ideal at the core of Masereel's art distinguishes him from the Expressionists:

> Trotz mancherlei formaler Gemeinsamkeiten stand[en. . .] besonders Masereel dem Expressionismus aus ideologischen Motiven fern. Ihre

Souveränität in allen künstlischen Strömungen ihrer Zeit ist eine kunsthistorisch unumstößliche Tatsache. Expressionistische Elemente in ihren Arbeiten bei Barlach, und Masereel weit auffälliger als bei Kubin, weisen lediglich auf das Fließende, Offene ihres weltanschaulichen und künstlerischen Bewußtseins, das Anregungen kritisch aufzunehmen, zu überprüfen und zu verwerten wußte, in sich aber festgefügt genug war, um den einmal gefundenen und beschrittenen Weg künstlerischer Wirksamkeit unbeirrt fortzusetzen. So gibt es zwischen Kubin, Barlach, Masereel und dem Expressionismus lediglich Berührungspunkte. (Lang, 68)

[Despite several formal features in common, ideological motives kept Kubin, Barlach, and especially Masereel far removed from Expressionism. No art historian would deny that they remained independent of all the artistic movements of their time. Expressionist elements in their works, far more pronounced in that of Barlach and Masereel than in that of Kubin, indicate merely that their philosophical and artistic consciousness was fluid and open, was prepared to respond critically to suggestions, to test and evaluate them, but was secure enough in itself to pursue a line of artistic activity, once found and adopted, without deviating. Thus, though there were points of contact between Kubin, Barlach, Masereel, and Expressionism, they remained tangential.]

However, Edschmid's contemporary description of Masereel's "biblical fury" and "ecstatic wrath" (quoted earlier in this chapter) places him squarely within Lang's own opening definition of Expressionism as an "art of protest [Aufschrei] and anger against bourgeois reality" (Lang, 9). Paul Raabe, a well-known scholar of literary Expressionism, believes Masereel to be the "most successful Expressionist book artist" (Raabe, 121).

Religious illustrations were popular in the 1920s and 1930s — there were countless illustrated versions of the life of Christ, illustrated chapters of the Bible, and illustrated prayer books published, all using woodcuts to recreate the style of books from an earlier age of faith. But Masereel's interests were not religious. Instead, he chose to retell not religious but socialist myths. His novels, in using the anachronistic medium of the woodcut, also appropriate the religious apparatus associated with it, just like the other illustrated religious books of the period. Masereel's first works invite this comparison because of their titles, such as *25 Images of a Man's Passion* and *My Book of Hours*. Yet, as his first woodcut novel showed, the passion shown was the martyrdom not of Christ but of the common man, on the cross of capitalism.

The second root for this art is found in the short pictorial narratives produced around the turn of the century, such as Käthe Kollwitz's series of six lithographs entitled *Weberaufstand* (Weavers' Revolt) in 1897 and her seven etchings entitled *Bauernkrieg* (Peasants' War) in 1908. These portfolios consist of works that are linked thematically and are highly political in their depiction of injustice and social strife. Max Klinger

produced several short dream-like narrative sequences, such as *Der Hand-schuh* (The Glove), around the same time. Klinger juxtaposes highly real-istic yet symbolic drawings with Freudian narratives of subconscious desires. Kollwitz's and Klinger's narratives intend to provoke with their depictions of disturbing political or psychological uprisings and repres-sions, and they succinctly express the frustration that was building in Ger-man and Austrian society. After the First World War, several artists, including Karl Schmidt-Rottluff and Max Pechstein, produced small port-folios of woodcuts to be displayed and viewed together. These portfolios, comprising perhaps eight to ten woodcuts, relate the artist's war experi-ences in a realistic or allegorical manner. Other artists in the early 1920s, including Otto Dix, Georg Grosz, and Kollwitz, also produced series of woodcuts to be viewed in sequence.[13] As Robin Reisenfeld notes, these portfolios "constituted a semi-private sphere for its liberal bourgeois audi-ence" (31). While they were created in a reproducible medium, most of these portfolios were produced in limited editions, meant for collectors. They are a middle ground between a unique work of art and the longer, mass-reproduced woodcut novels, and perhaps prepared the public for the idea of an extended illustrated narrative. Woodcut novels were published as books, the same size as novels, in much larger editions, and generally aimed at a more popular audience. Woodcut novels are also considerably longer, and achieve a wider sweep and more complex narratives. Yet they share the same desire as these print portfolios to extend the expressive possibilities of graphic art, and to provoke their audience through their style and political stance.

Third, the novel in woodcuts draws on silent film. The idea of an extended narrative without words reached all levels of the culture in this period through film. Dziga Vertov begins his film *The Man with the Movie Camera* (1929) with this pronouncement:

> For the viewers' attention:
> This film presents an experiment in the cinematic communication of visible events
>
> Without the aid of intertitles (A film without intertitles)
> Without the aid of theater (A film without sets, actors, etc.)

This experimental work aims at creating a truly international absolute language of cinema based on its total separation from the language of the-ater and literature.

Vertov intends this language to be silent and entirely visual.[14] In sev-eral respects, this international language had already emerged in the wood-cut novel, and Masereel was able to reach a mass audience with his wordless narratives.

Without question, Masereel drew inspiration from silent film. The filmic qualities of woodcut novels resonate upon first viewing. Artists require a filmic imagination to realize a woodcut novel successfully, and Thomas Mann, in his introduction to Masereel's *Mein Stundenbuch*, reports being asked to name the movie that had stirred him the most, and replied, "Masereels *Stundenbuch*" (Masereel, 1928, 19). The American Lynd Ward, later in his career, described the process of creating a novel in woodcuts as similar to producing a silent film that he could first see in his mind, and he also mentioned in an interview that Emil Janning's silent film *Der letzte Mann* (The Last Laugh, 1924) was an inspiration to him (McCullough, 7). Ward had several offers to create film versions of *Gods' Man*, some as late as the 1960s, although none of these projects was ever completed. Masereel mimics the rhythm of film in his novels, as when, for instance, he zooms in and out in *La ville* to capture the mass movement and individual pathos of the city. The wild satire of *L'idée* and *Le soleil* uses slapstick and low comedy as the characters romp madly through the city, one jump cut after another. His illustrations are alive with movement, and his point of view, framing, sequencing, and choice of locale all achieve a mesmerizing impact, as immediate and powerful as film.

In 1930, Masereel met the Hungarian graphic artist Berthold Bartosch in Berlin, and they agreed to collaborate on a film version of *Idée*. Masereel withdrew from the project before its completion, and Bartosch finished the film on his own in 1932. The film attempts to create the illusion of three dimensions through multiple layers of animated cells, and is something of a disappointment.[15] The action is unclear in parts, and ends with the defeat of the idea rather than its triumph, which perhaps explains Masereel's decision to pull out. The desire to tell these stories through the medium of film was very strong, but its promise remains unfulfilled. Yet even this unsuccessful attempt underscores the proximity of the woodcut novel to early silent cinema.

Most reviewers of the time understood the connection between woodcut novels and film, and drew attention to the similarities between the two genres in their reviews. One feature common to both is the lack of definite demarcations in the dramatic action. Generally, while there may be section titles, the woodcut novel has no numbered pages. Alfred Kazin noted this in his review of *Vertigo*, when he tried with some exasperation and humor to refer to a specific passage: "There is a lovely sequence (though I can't tell you where, for nobody remembered to paginate the cuts. Is this a novel or isn't it?)"(Kazin, 6). Kazin finds himself caught in the fertile dilemma of the genre: between the sequential impulse of dramatic narrative and the static force of powerful imagery.

The genre reached the height of its popularity between 1929 and 1931, just as silent movies were replaced by sound. While the film version of *Idée* confirms the affinity between woodcut novels and film, viewing it also

makes clear the important contrasts between the two very different media. The film *Idée* is at points unclear, and because of the steady pace imposed by the incessant scrolling of the reel, any attempt at clarification becomes unwieldy. With the book format of the woodcut novel, the pace is determined by the reader and can vary both within and between readings. Should a narrative passage seem unclear, the reader can easily review the illustrations or skip over sections in subsequent readings. Thus, the reader of a woodcut novel retains control over pace, much as a reader of a conventional novel would, and the woodcut novel is truly a hybrid of film and book.

These narratives explore a wide range of artistic concerns and themes, but those produced in the late 1920s and early 1930s embody artistic concerns common in this period: the juxtaposition of the individual and the city, showing both the dangers and attractions of the metropolis; the recognition and fear of powerful forces in capitalist society and the sense of outrage and powerlessness in the face of them; and, finally, the place of the artist in modern society. In many cases, the protagonist of these novels is a young artist, emblematic both of the artist's importance in society and of a social class or generation. After observing and suffering privation and injustice, the protagonist finds that he can no longer be silent and must speak out. It is at this point that the narratives differ — the protagonist dies a meaningless death at the hands of hired thugs, as in Lynd Ward's *Wild Pilgrimage*; a man is martyred for political beliefs, as in Masereel's *25 images de la passion d'un homme*; a man is executed for his beliefs but his message lives on as an idea, as in Masereel's *Idée*; the protagonist is blackballed for union activities but achieves class unity as in *White Collar* by Giacomo Patri; the soldier in *My War* by Szegedi Szuts loses everything — health, family, self-esteem — until he finally must speak out, resulting in his arrest and execution. These characters find speech to be an empowering reflex, for they feel that they can no longer keep silent, but it inevitably leads to dire consequences. The narratives tell the silent aftermath. Silent defiance is the only remaining form of rebellion available to the characters — and to the artist. Not all the narratives in this genre are based upon the class struggle, but most woodcut novels in pictures make use of the silent medium to explore the power of language.

Peter Brooks's ideas on silence in melodrama provide some insight into this aspect of the woodcut novel:

> Melodrama appears as a medium in which repression has been pierced to allow thorough articulation, to make available the expression of pure moral and psychological integers. Yet here we encounter the apparent paradox that melodrama so often, particularly in climactic moments and in extreme situations, has recourse to non-verbal means of expressing its meanings. Words, however unrepressed and pure . . . appear not to be wholly adequate to the representation of meanings . . . The mute role is remarkably prevalent in melodrama. (36)

The characters in woodcut novels are mute, having been silenced by social, political, or economic forces, and the narratives exist in silence. The narratives are certainly melodramatic in their use of stock characters and familiar plots and with their high level of moral indignation. The portly capitalist in vest and top hat is a common character in many woodcut novels. Also, prostitutes often figure in these works, just as they do in the paintings of artists George Grosz and Otto Dix from the same period. These women are often not the odalisque fantasies of previous centuries, but rather representations of the basic ingredients of the capitalist transaction: buyer, seller, and desire. They also represent a certain uneasiness about sexuality common to the genre. A typical narrative sequence shows the main character visiting a prostitute, then suffering from remorse afterwards. The main characters in most woodcut novels are drawn with compassion, while other characters such as the man in the top hat and the prostitute return as stock characters in the political melodrama.

The question is still open as to what influence these works from the 1920s, 1930s, and 1940s exerted on later artists. Most of these artists produced only one woodcut novel. Masereel and Ward, the two artists most devoted to the genre, largely gave it up by the 1940s and moved on to other projects, other media. Masereel retained some attention through the 1960s, with John Willett's articles in the *Times Literary Supplement* still the best English language introduction to his life and work, but Masereel's obituary in the *New York Times* did not even mention his woodcut novels (Willett 1960, 1968, and 1972). Meanwhile, the other artists dropped from sight. The sudden loss of interest in this highly political, highly polemic art form resembles other shifts in the arts, such as in musical theater, which saw movement away from the political musical theater of Brecht and Weill, Marc Blitzstein, and others to the popular musical theater of Rodgers and Hammerstein, and Lerner and Loewe.

However, the reemergence of comic books and graphic novels has revived interest in Masereel's work. While most of these new works use words, dialogue, and captions, many of the artists demonstrate their awareness of Masereel and others. Eric Drooker, in particular with his award-winning work *Flood!*, has recast Masereel's themes and style for the 1990s while exploring personal alienation, social unrest, and the urban experience,[16] and has shown that these works retain their importance and vibrancy.

# Notes

Translations are by the author unless otherwise noted.

[1] Art Spiegelman demonstrates his familiarity with the genre and artists in his review in the *New York Times Book Review* (27 December 1992: 9) of Eric Drooker's *Flood!*

[2] Masereel was born in Blankenberghe, Belgium, near Ghent, and lived in a solid bourgeois family. He later reported that he and his family spoke French to one another and Flemish to the maids. He attended the Art Academy in Ghent; one account has it that he left because an instructor told him "he had nothing left to learn"; another account states that he was an indifferent student. He went to Paris in 1910, where he began his career as an illustrator and woodcut artist. For more on Masereel's life, see Joris van Parys, *Masereel: eine Biografie* (Zurich: edition 8, 1999) and Pierre Vorms, *Gespräche mit Frans Masereel* (Zurich: Limmat-Verlag, 1967).

[3] As a convention, I will use the first published title of a woodcut novel, unless I am referring to a specific edition.

[4] From the translation, *Passionate Journey*, trans. Joseph Bernstein, 10–11.

[5] Several woodcut novels were published in the United States in 1929 and 1930, and the genre was seen as a trend. See Hellmut Lehmann-Haupt, "The Picture-Novel Arrives in America." *Publisher's Weekly*, 1 Feb. 1930: 609–12.

[6] Roger Avermaete, *Frans Masereel* (Antwerp: Fonds Mercator; New York: Rizolli International, 1977). See also Paul Ritter, ed., *Frans Masereel: Eine annotierte Bibliographie des druckgraphischen Werkes* (Munich: K. G. Saur, 1992).

[7] Most recently, published by Shambhala Redstone Editions in Boston and London in 2000. Interestingly, Masereel's novels were not published in England until the 1980s, but many of his novels have seen multiple British editions since then.

[8] Kracauer coined this phrase to describe Dziga Vertov's *The Man with a Movie Camera*. Siegfried Kracauer, *From Caligari to Hitler: A Psychological History of German Film* (Princeton: Princeton UP, 1947), 185.

[9] Both paintings are reprinted in Carol Eliel's book *The Apocalyptic Landscapes of Ludwig Meidner* (Los Angeles: Los Angeles County Museum of Art; Munich: Prestel, 1989).

[10] Ruttman's associate Paul Rotha reports that "In 1925, standing amid the whirling traffic of the Ufa Palast am Zoo, he conceived the idea of a City Symphony. He saw 'a melody of pictures' and began to write a treatment of *Berlin*" (quoted in Kracauer, 182). It is perhaps only coincidence that Masereel's *La ville* was published in 1925.

[11] Ward studied in Germany in 1926, where he reported later that he saw one of Masereel's woodcut novels, which inspired him to create *Gods' Man*. For more on Ward, see *Storyteller Without Words: The Wood Engravings of Lynd Ward* (New York: Abrams, 1974).

[12] For a more comprehensive list of artists and works in this genre, see Perry Willett, *The Silent Shout: Frans Masereel, Lynd Ward and the Novel in Woodcuts.* (Bloomington, IN: Indiana U Libraries, 1997).

[13] See Robin Reisenfeld, *The German Print Portfolio, 1890–1930: Serials for a Private Sphere* (New York: Rizzoli, 1992) for a thorough discussion.

[14] At this same time, Otto Neurath was developing an international pictorial language he called "Isotype." See Michael North, *Reading 1922: A Return to the Scene of the Modern.* (New York: Oxford UP, 1999) 107–10.

[15] Arthur Honegger wrote a musical score that used a new type of electrical instrument he called "Les ondes musicales," and the music was added in 1934. This is

perhaps the first electronic musical film score. For more information on the film version of *Idée*, see: *Circulating Film Library Catalog* (New York: The Museum of Modern Art, 1984) 172–73.

[16] For more on Drooker's imaginative reuse of Masereel's art, see David Beronä, "Picture Stories: Eric Drooker and the Tradition of the Woodcut Novels." *INKS: Cartoon and Comic Studies* 2.1 (Feb. 1995): 2–11. See also Scott McCloud, *Understanding Comics* (New York: HarperPerennial, 1994): 18–19; and David Beronä, "Pictures Speak in Comics Without Words: Pictorial Principles in the Work of Milt Gross, Hendrik Dorgathen, Eric Drooker, and Peter Kuper," in *The Language of Comics: Word and Image*, ed. Robin Varnum and Christina T. Gibbons (Jackson: U of Mississippi P, 2001).

# Works Cited

Avermaete, Roger. *Frans Masereel*. Antwerp: Fonds Mercator; New York: Rizzoli International, 1977.

Beronä, David. "Pictures Speak in Comics Without Words: Pictorial Principles in the Work of Milt Gross, Hendrik Dorgathen, Eric Drooker, and Peter Kuper." In *The Language of Comics: Word and Image*, ed. Robin Varnum and Christina T. Gibbons, 19–39. Jackson: U of Mississippi P, 2001.

———. "Picture Stories: Eric Drooker and the Tradition of the Woodcut Novels." *INKS: Cartoon and Comic Studies* 2, 1 (Feb. 1995): 2–11.

Brooks, Peter. *The Melodramatic Imagination: Balzac, Henry James, Melodrama, and the Mode of Excess*. New Haven: Yale UP, 1976.

Drooker, Eric. *Flood! A Novel in Pictures*. New York: Four Walls Eight Windows, 1994.

Edschmid, Kasimir. "Frans Masereel," in: Frans Masereel, *Politische Zeichnungen*. Berlin: Erich Reiß, 1924. 7–13.

———. "Über den dichterischen Expressionismus." In *Über den Expressionismus in der Literatur und die neue Dichtung*. Berlin: Erich Reiß, 1919.

Eisner, Lotte. *The Haunted Screen: Expressionism in the German Cinema and the Influence of Max Reinhardt*. Berkeley: University of California Press, 1973.

Eliel, Carol. *The Apocalyptic Landscapes of Ludwig Meidner*. Los Angeles: Los Angeles County Museum of Art; Munich: Prestel, 1989.

Kazin, Alfred. "Boy, Girl and Old Man in Woodcuts." *New York Herald Tribune Books* (19 December 1937): 6.

Kracauer, Siegfried. *From Caligari to Hitler: A Psychological History of German Film*. Princeton: Princeton UP, 1947.

Lang, Lothar. *Expressionismus und Buchkunst in Deutschland, 1907–1927*. 2nd edition. Leipzig: Edition Leipzig, 1993.

Lehmann-Haupt, Hellmut. "The Picture-Novel Arrives in America." *Publisher's Weekly* (February 1, 1930): 609–12.

Masereel, Frans. *Die Idee*. Munich: Kurt Wolff, 1927.

———. *La ville*. Paris: A. Morencé, 1925.

———. *Mein Stundenbuch: 165 Holzschnitte*. Munich: Kurt Wolff, 1928. In English: *Passionate Journey*. Trans. Joseph M. Bernstein. San Francisco: City Lights, 1988.

———. *Politische Zeichnungen*. Berlin: Erich Reiß, 1924.

McCloud, Scott. *Understanding Comics*. New York: HarperPerennial, 1994, 18–19.

McCullough, David. "Eye on Books." *Book of the Month Club News* (October 1974): 7.

North, Michael. *Reading 1922: A Return to the Scene of the Modern*. New York: Oxford UP, 1999.

Raabe, Paul. "Illustrated Books and Periodicals." In *German Expressionist Prints and Drawings: The Robert Gore Rifkind Center for German Expressionist Studies*, vol. 1. Los Angeles: Los Angeles County Museum of Art, 1989. 115–29.

Reisenfeld, Robin. *The German Print Portfolio, 1890–1930: Serials for a Private Sphere*. New York: Rizzoli, 1992.

Ritter, Paul, ed. *Frans Masereel: Eine annotierte Bibliographie des druckgraphischen Werkes*. Munich: K. G. Saur, 1992.

Spiegelman, Art. Review of Eric Drooker. *New York Times Book Review* (27 December 1992): 9.

Van Parys, Joris. *Masereel: eine Biografie*. Zürich: edition 8, 1999.

Vorms, Pierre. *Gespräche mit Frans Masereel*. Zürich: Limmat, 1967.

Willett, John. "Artist against War." *Times Literary Supplement* (July 29, 1960): 473.

———. Obituary of Frans Masereel. *New York Times* (January 5, 1972): A40: 2.

———. Review of "Antwerpen / Couples / Les mains / Route des hommes / Mon livre d'heures." *Times Literary Supplement* (September 12, 1968): 989.

Willett, Perry. *The Silent Shout: Frans Masereel, Lynd Ward and the Novel in Woodcuts*. Bloomington, IN: Indiana U Libraries, 1997.

# Poetry

# 5: *Menschheitsdämmerung:* The Aging of a Canon

*Francis Michael Sharp*

THE ORIGINAL EDITION OF Kurt Pinthus's acclaimed anthology of Expressionist poetry, *Menschheitsdämmerung: Symphonie jüngster Dichtung* (Dawn of Humanity: Symphony of New Poetry), has a publication date of 1920 but actually appeared in November 1919.[1] It quickly became the first bestseller of a publishing house newly founded by Ernst Rowohlt after the end of the First World War. In 1922 a second edition appeared that was essentially unchanged in content but included in Pinthus's afterword a melancholy farewell to the exuberant humanism and emotionally charged idealism that characterize a large number of the collected poems. Pinthus's farewell echoes the widespread resignation and disappointment in Expressionist circles at the political turn of events. The success of his *Menschheitsdämmerung* has endured well beyond the initial sales and rave reviews given it by most contemporaries and has continued over the years playing an important role in the general reception of Expressionism. *Menschheitsdämmerung* has become, in fact, the single most celebrated and often cited document not only of Expressionist poetry, but of German literary Expressionism in general.[2]

In 1959, forty years after the collection's first publication, Rowohlt decided to republish it in paperback. All but three of the original twenty-three poets had died, but for this "Dokument des Expressionismus" (Document of Expressionism) — Pinthus's new choice of subtitle — the timing was propitious. After being attacked in the thirties by the Nazis as degenerate — both Pinthus and his anthology fell under a Nazi ban in 1933 — and by some Marxists as an intellectual precursor of fascism, Expressionism was well on its way to rediscovery and rehabilitation in the Federal Republic of the fifties and sixties. The first significant exhibit of Expressionist works took place in Marbach in 1960. Eight years later, an East German publisher brought out an edition of *Menschheitsdämmerung* with a critically sympathetic introduction from a Marxist perspective, a measure of Expressionism's political recuperation as well (Mittenzwei, 5–26). More recently, the complete translation into English of all the poems in the anthology as well as Pinthus's various introductions testifies to its perceived significance in representing the literary activity of the Expressionist

years. It has long since been treated as canonical by literary scholars of the era.

As Pinthus recounted many years later, the idea for the anthology occurred to him "blitzartig" (like a bolt of lightning) in the spring of 1919 (Denkler, xiv). He created his lyrical composition with selections from the numerous manuscripts of poetry he had read and edited earlier in the decade for the Kurt Wolff publishing house. In its four movements — "Sturz und Schrei" (Crash and Cry), "Erweckung des Herzens" (Awakening of the Heart), "Aufruf und Empörung" (Call-to-Action and Revolt) and "Liebe den Menschen" (Love to Human Beings) — he sought to bridge the emotional depths and peaks that characterize these poems and their time as a whole. These emotions ranged from a sense of impending doom reflecting the collapsing metaphysical, social, and political orders to a secularized religiosity that trumpeted a radical transformation in humankind, a transformation that would bring about a new age of community and solidarity. This almost bipolar range of mood is captured by the title itself and the ambiguous notion of "twilight," which can suggest both dawn and dusk, and by extension, both apocalypse as cataclysmic ending and chance of renewal, as death or rebirth. Yet in his original preface Pinthus warns his reader not to look for historical development in the underlying structure of his collection, but rather to listen for the "Symphonie" of voices simultaneously expressing their triumphs and defeat (*MHD*, 23).[3] With his intentions clearly aesthetic in nature, Pinthus sought to compose and orchestrate the metapoem of Expressionism, to dissolve the individuality of the 273 poems into a larger symphonic whole.

Yet even for those readers on the margins of Expressionist circles, many of the individual poems and poets in *Menschheitsdämmerung* must have already been quite familiar and therefore would have resisted this loss of identity. This is certainly the case for Jakob van Hoddis's poem "Weltende" (End of the World) — first published in 1911 — with which Pinthus chose to open his anthology, as well as for the poet Franz Werfel, whose contributions outnumber any of the others. On the metaphorical downbeat at the very beginning of this metaphorical symphony, van Hoddis's poem sets the course for the collection's first section, "Sturz und Schrei" (Crash and Cry):

> Dem Bürger fliegt vom spitzen Kopf der Hut,
> In allen Lüften hallt es wie Geschrei.
> Dachdecker stürzen ab und gehn entzwei,
> Und an den Küsten — liest man — steigt die Flut.
>
> Der Sturm ist da, die wilden Meere hupfen
> An Land, um dicke Dämme zu zerdrücken.
> Die meisten Menschen haben einen Schnupfen.
> Die Eisenbahnen fallen von den Brücken. (*MHD*, 39)

[The burgher's hat flies off his pointed head,
Everywhere the air reverberates with what sounds like screams.
Roofers are falling off and breaking in two,
And, along the coasts — the paper says — the tide is rising.

The storm is here, the wild seas are hopping
Ashore to squash thick dikes.
Most people have a cold.
The trains are dropping off the bridges. (*DoH*, 61)]

These curious and apparently unremarkable eight lines of verse have gained legendary status in the history of German Expressionist poetry. Gottfried Benn termed their publication — along with the appearance of Alfred Lichtenstein's "Dämmerung" (*MHD*, 47; Dusk, *DoH*, 70) — the beginning of Expressionist poetry. Johannes R. Becher wrote glowingly of their transforming impact on a young generation of artists alienated from the middle-class values of their parents (Vietta, 30). Although the poem's individual images forebode disasters of varying degrees of seriousness, together they portend the imminent collapse of this system of values. From the burgher's loss of his badge of honor and respectability and the rising tide in the first stanza to the threatening storm and falling trains in the second, the images speak consistently in apocalyptic terms. As the detested old world fell apart in the poem's images, the alienated young generation must have gleefully taken heart in van Hoddis's ironically superior vantage point.

Constructed in collage-like fashion, with each line (except 5 and 6) presenting a new threat, "Weltende" also typifies a stylistic innovation — the so-called *Reihungsstil* (paratactical style) or *Simultangedicht* (simultaneous poem) — commonly found in other early Expressionist poems (Vietta, 31). As the "first emphatically urban verse" in German, this poetry reflects the explosive growth of metropolitan areas at the time and the new demands imposed on the perceptual capacities of the city dweller. With increasingly more people crowding around him, and technology accelerating the pace of his life, this urban resident felt inundated by the rapid barrage of images impinging on his senses (Vietta, 34). By stringing separate and distinct poetic images one after the other in consecutive lines, the poets attempted to convey in the structure of their poems the simultaneity of this barrage of perceptions. They are the snapshots of a moment of ostensibly unconnected events although, as in "Weltende," the events often converge in the theme suggested by the title.

Poems by Franz Werfel stand at the end of each of the four sections of *Menschheitsdämmerung.* When this was pointed out to Pinthus by a student many years later, he claimed to have been unaware of the fact, but found in

the placement of these four poems the "gewollte Steigerung von dem Verzweiflungsschrei [. . .] bis zu dem triumphalen Finale" (desired escalation from a cry of desperation up to triumphant finale; Denkler, xvii). If van Hoddis's poem represents the musical downbeat in *Menschheitsdämmerung* or the strong current of anomie in the Expressionists' perception of reality, then Werfel's poetry represents the upbeat movement that reaches its crescendo in a vision and proclamation of a collective humanity. In the final two lines of the anthology, Werfel ecstatically proclaims in his "Ein Lebens-Lied" (A Song of Life): "Doch über allen Worten / Verkünd' ich, Mensch, *wir sind!!*" (*MHD*, 329; But beyond all words / I proclaim, human being, we are! *DoH*, 355). These two starkly contrasting modes frame the multifarious poems within. In the ultimate confirming moment of brotherhood Werfel envisions the unity of the one and the many as "Mensch" — the individual and the species. These contrasting opening and closing poems by van Hoddis and Werfel marked for Pinthus the depths and heights of lyrical Expressionism and established the emotional register for the poems included in his anthology.

A Werfel poem, "An den Leser" (To the Reader) also opens the final movement of Pinthus's lyrical symphony. This "classic of Expressionism" (McClintick, 147) begins with the Whitmanesque desire of the poem's speaker to be counted among the human collective: "Mein einziger Wunsch ist, dir, o Mensch verwandt zu sein!" (*MHD*, 279; "My only wish is to be related to you, O human being!" *DoH*, 301). Addressing one after the other in the following lines, Werfel fervently courts exemplars of the multitudinous variants of the human species, claiming that he has shared each of their "destinies": "ich habe alle Schicksale durchgemacht." In the final four lines, he declares his common humanity with the multitudes and pleads with them not to resist his advances:

> So gehöre ich dir und Allen!
> Wolle mir, bitte, nicht widerstehen!
> O, könnte es einmal geschehen,
> Daß wir uns, Bruder, in die Arme fallen! (*MHD*, 279)

> [Therefore I belong to you and to everyone!
> Do not, please, do not resist me!
> Oh, if one day it could be
> That we, brother, would fall into each other's arms! (*DoH*, 301)]

The pathos of such poetry, its exuberance and trademark exclamation "O, Mensch!" (Oh, Fellow Human!) represented for Pinthus the heart of the poetry collected in *Menschheitsdämmerung* and thus for Expressionist poetry as a whole. Fifty years after its first publication, he still considered Werfel the key figure in the innovative new tone that German poetry

sounded in the aftermath of the aestheticism of Stefan George, Rainer Maria Rilke, and Hugo von Hofmannsthal (Denkler, xvii).

By rendering *Menschheitsdämmerung* as *Dawn of Humanity* in the English title, the translators voided the inherent ambiguity of the German title that conjures up the "twilight of humanity" at once as "dusk" as well as "dawn." This translation privileges the "O, Mensch!" poetry of Werfel and others such as Johannes R. Becher and Kurt Heynicke, a choice Pinthus himself would surely have approved of. The meanings in the original German, however, oscillate between semantic poles, reflecting both the strident visions of decline and downfall of poets like Georg Trakl and Georg Heym and the secularized messianic impulse. Pinthus wrote enthusiastically in his original preface to *Menschheitsdämmerung* of the central role that humanity itself played in the poetry of his anthology, humanity in the process of its demise and renewal (25). In hindsight, however, political events — the failed revolution in Germany, the rise and catastrophic success of National Socialism, and the Second World War — drastically undercut the credibility of messianic Expressionism. Instead, posterity has assigned the greater significance to the poetry of Trakl and Heym, as well as to that of Gottfried Benn and Ernst Stadler.[4]

The nineteenth-century French poets Baudelaire and Rimbaud left a recognizable imprint on much of Expressionist verse that is nowhere more apparent than in the works of Trakl and Heym. Temperamental idiosyncrasies, life experience, and the differing national literary traditions of these two German-speaking poets, however, shaped this legacy in distinctive ways. Trakl's imagery, for example, is more pronounced in its dream-like or hallucinatory quality. It resides at a further remove from empirical reality than that of Heym, who locates his fantastic images in morgues, in city streets, or on bloody battlefields. In Heym's poem "Die Morgue" (*MHD*, 97–99; "The Morgue"; *DoH*, 119–22), corpses ponder their ignominious return journey to dust after the Icarian flights of their mortal existence:

> Wir, Ikariden, die mit weißer Schwinge
> Im blauen Sturm des Lichtes einst gebraust,
> Wir hörten noch der großen Türmen Singen,
> Da rücklings wir in schwarzen Tod gesaust.

> Im fernen Plan verlorner Himmelslande,
> Im Meere weit, wo fern die Woge flog,
> Wir flogen stolz in Abendrotes Brande
> Mit Segeln groß, die Sturm und Wetter bog.

> Was fanden wir im Glanz der Himmelsenden?
> Ein leeres Nichts. Nun schlappt uns das Gebein,
> Wie einen Pfennig in den leeren Händen

Ein Bettler klappern läßt am Straßenrain.
[. . . . . . . . . . . . . . . . . . . . . . . . . . . . . . .] (*MHD*, 99)

[We Icarians who on white pinions
Once raced in the storm's blue light,
We still heard the huge towers' singing
As we zoomed backwards into black death.

On the faraway plane [*sic*] of lost celestial realms,
Over the wide seas where faraway the waves flew,
We flew proudly in the sunset's conflagration
With huge sails that storm and weather bent.

What did we find in the gleaming of the celestial limits?
An empty nothing. Now our bones dangle,
The way a beggar by the side of the road
Makes a penny flap in his empty hands.
[. . . . . . . . . . . . . . . . . . . . . . . . . . . . . .] (*DoH*, 122)]

In contrast to that stark sense of grotesque deflation and disillusionment, the Austrian Georg Trakl blends an acute awareness of decay and dissolution of the natural world with a profound sense of the beauty accompanying these processes.

That sense of beauty relates him to the *fin de siècle* aestheticism of Rainer Maria Rilke, Hugo von Hofmannsthal, and Stefan George, poets emphatically rejected by Heym and Gottfried Benn, another Expressionist poet from Berlin. Trakl's imagery lacks the sense of concrete location and contour of Heym or Benn and is often more richly evocative. Ghostly and animate images intermingle in the lines of a poem, apparently obliterating the impermeable boundaries between life and death, being and non-being. Like Elis in Trakl's poem "An den Knaben Elis" (To the Boy Elis) the figures in his poetry embark on a downward course and often descend at a gently precipitous angle, falling tranquilly toward a goal that signals transition (*Übergang*) more clearly than destruction (*Untergang*):

Elis, wenn die Amsel im schwarzen Wald ruft,
Dieses ist dein Untergang.
Deine Lippen trinken die Kühle des blauen Felsenquells.

Laß, wenn deine Stirne leise blutet,
Uralte Legenden
Und dunkle Deutung des Vogelflugs.
[. . . . . . . . . . . . . . . . . . . . . . . . . . . . .]

Ein Dornenbusch tönt,
Wo deine mondenen Augen sind.
O, wie lange bist, Elis, du verstorben.
[. . . . . . . . . . . . . . . . . . . . . . . . . . . . .] (*MHD*, 100)

[Elis, when the blackbird calls in the black forest,
This is your decline.
Your lips drink the coolness of the blue rock-spring.

Forgo, when your brow bleeds quietly,
Ancient legends
And the dark interpretations of birds in flight.
[. . . . . . . . . . . . . . . . . . . . . . . . . . . . . . .]

A thornbush sounds
Where your moon eyes are.
Oh, how long, Elis, since you passed away.
[. . . . . . . . . . . . . . . . . . .] (*DoH*, 123)]

The eerie beauty of Elis's gentle descent contrasts starkly with the abrupt fall backwards of Heym's corpses from life's heights into "black death," his resonating "moon eyes" with the rattling skeleton and clattering penny.

Together with the Alsatian poet Ernst Stadler, Trakl and Heym have often been grouped as "early" Expressionists, partly because of their untimely deaths at a young age. Stadler died in battle in Belgium in October 1914, a casualty of the First World War in its early days, while the unstable Trakl succumbed to a drug overdose on the eastern front a few days later. Heym had drowned in a lake in a skating accident two years prior to the war, though his apocalyptic and intensely visual images anticipate the battlefield experience of so many of his generation. Characteristic of Heym's verse as well as Stadler's is a dissatisfaction and impatience with the staleness, the unheroic quality, and the lack of vitality in his times, a widely shared attitude that found popular expression in the enthusiasm that greeted the outbreak of the First World War. In the long lines typical of his poetry in "Der Aufbruch" (*MHD*, 80; Setting Out, *DoH*, 100–101), Stadler employs militaristic images — trumpet blasts, a hail of bullets, and a charge into battle — to externalize the desire for escape from the tepid spirit of his age. Several of Stadler's other poems in *Menschheitsdämmerung* also capture the sense of a seething yet constricted vitality straining to burst free of restraints. In the programmatic "Form ist Wollust" (Form is Ecstasy) he writes: "Form will mich verschnüren und verengen, / Doch ich will mein Sein in alle Weiten drängen" (*MHD*, 312; Form wants to lace and constrict me, / But I want to force my being into all distances; *DoH*, 336).

In another of his famous poems "Fahrt über die Kölner Rheinbrücke bei Nacht" (*MHD*, 179; Ride across the Cologne Rhine Bridge at Night, *DoH*, 202–3), as the express train races over the bridge it challenges the force of gravity holding it earthbound. In the final lines the concrete imagery dissolves into an ecstatic but abstract vision of decline and renewal, of death and rebirth.

The physician and poet Gottfried Benn, who survived all the political and military upheavals of the first half of the twentieth century, began publishing early on in Expressionist journals. By the time he died in 1956, he had become the most celebrated voice of modernism in all of twentieth-century German poetry. Of those poets whose personal reputations have eclipsed the fame of *Menschheitsdämmerung*, Benn is furthest removed from the "Humanitäts-Melodie" (*MHD*, 14; Humanity Melody, *DoH*, 18) that Pinthus considered the core of his anthology. Several of his eight poems in the collection reflect the clinical perspective of not only an observer acquainted with the bodily frailty of the human animal, but one grown cynical about its self-exaltation. In "Kleine Aster" (*MHD*, 52–53; Little Aster, *DoH*, 75) an autopsy is performed on a drowned beer-truck driver; a physically graphic tour of a cancer ward is at the center of the poem "Mann und Frau gehen durch die Krebsbaracke" (*MHD*, 96; Man and Woman Walk through the Cancer Ward, *DoH*, 118). The atavistic wish for evolutionary regression in Benn's "Gesänge" (Songs) locates this poem at the furthest possible remove from the humanistic idealism that resonates in poems by Werfel, Becher, and others: "O daß wir unsere Urahnen wären. / Ein Klümpchen Schleim in einem warmen Moor" (*MHD*, 186; Oh, that we were our primal ancestors / A clump of slime in a warm bog; *DoH*, 210).

The farther that Expressionism recedes into history, the easier it becomes to lose sight of the much larger context from which Pinthus made his selection. In the last sentence of his introduction to the 1959 edition, he reminds the reader that the poets included in *Menschheitsdämmerung* represent only a small fraction of the hundreds of poets writing at the time (21). Ludwig Dietz's review in 1960 of its republication in 1959 highlights the editor's narrowly subjective selection — 18 of the 23 poets had published volumes in the press for which Pinthus had previously worked — while recognizing its documentary value. Ironically, its canonization has probably slowed down the process of rediscovery and reexamination of the large numbers of poets outside its scope, a process still in motion.

In his 1980 update of his own earlier research report on literary Expressionism from 1961, Richard Brinkmann begins the section on "Lyrik" (Poetry) with reference to the revised and expanded edition of *Menschheits-dämmerung* published in 1959. He reports on the debut of Pinthus's collection in East Germany in the late sixties as well as on two scholarly studies devoted exclusively to the anthology, one containing interpretations of

selected poems (Denkler) and another dealing with the general problem of form (Newton) (Brinkmann, 224–25). Wolfgang Paulsen's study (1983) alludes to *Menschheitsdämmerung* in its opening sentence, underscoring its centrality to the historical reception of Expressionism as a whole (9). He later writes of its "decisive" influence on this reception of Expressionism but in the same sentence suggests its limitations as well, terming it a "very personal" selection of the poetry written at the time (76). As scholars and editors during the past fifty years have rediscovered and made available some of the marginalized Expressionist poetry, poetry published originally by small presses or in short-lived journals or series, the specific nature of some of the anthology's limitations and inadequacies have become clearer.

Between 1912 and 1924 *Menschheitsdämmerung* was only one of about twenty such published collections, yet the reputation it has acquired over the years has left all the others in its shadow (Denkler, 271–72). Its translation into English in 1994 represents the final stage of its canonization. As recent academic controversy involving minority literature illustrates, however, canons present a large target, particularly when they appear to be exclusionary. McClintick has taken the translators of *Menschheitsdämmerung* to task for uncritically supporting and continuing "the long history of simply accepting the exemplary status of the anthology," and, in particular, for contributing "to the marginalization of female Expressionist poets" (154). Archival scholarship on Expressionism since the sixties has brought the generational as well as the gender deficiencies of *Menschheitsdämmerung* into increasingly sharper focus. Since Paul Raabe's pioneering work on documenting literary Expressionism during the years from 1918 to 1922, it has been customary to date the final stage of the epoch into the early twenties, a stage with a second generation of writers entirely unrepresented in *Menschheitsdämmerung* (Raabe 1966; Göbel, 542). More recently, a considerable number of "sisters" have begun to stake an equally valid claim alongside what Raabe calls the Expressionists' "younger brothers" for inclusion in a more comprehensive account of Expressionist poetry (1966).

When *Menschheitsdämmerung* appeared in 1919, almost all of the poets represented — if they had survived the war years — had reached their thirtieth birthday. Of the total of 23, only six had birthdates in the last decade of the nineteenth century and none later than 1891. One of the oldest was Else Lasker-Schüler, the single woman poet included. Representation of the second generation of poets — male or female — born nearer the century's end, those who began publishing at the midpoint or late in the second decade of the new century, is entirely missing. In 1922, when the second edition of *Menschheitsdämmerung* came out, Pinthus considered Expressionism a closed chapter in literary history and decided against any new additions. From the vantage point that more than eighty years provides, his consignment of Expressionism to the past appears to

have been precipitous, for even while he was composing the first edition three years earlier the final sub-chapter was still being written.

In Brinkmann's authoritative report on research published in 1980, he points out the absence of general and historical accounts of Expressionist poetry (227). He suggests that some anthologies of a more recent vintage than *Menschheitsdämmerung* might serve as drafts for a potential remedy to this lacuna in literary history (227). He singles out for particular recognition an anthology published in East Germany in 1969 as the most representative of the epoch (226). Adding 38 individual poets to those 23 already represented in *Menschheitsdämmerung*, its editors use Pinthus's familiar motifs as basic building blocks while superimposing the historical framework that Pinthus had rejected (Reso, 659). An introductory section subdivided chronologically into three periods — 1910 to 1914, 1914 to 1918, and 1918 to 1923 — includes poems alluding to poetic, mythological, and historical precursors. Each of the following main three sections corresponds to one of these chronological periods and within that period is organized according to motifs that recall those of its forerunner: the rebellion of Expressionist youth, its apocalyptic visions, its enthusiastic and then its pacifistic reaction to the war, its activism, revolutionary fervor, and finally its disappointment and disillusionment.

In the extension of its historical coverage, the East German anthology does greater justice than *Menschheitsdämmerung* to the "flood" of new Expressionist publications that followed the end of the war and censorship (Raabe 1964, 19). The number of journals alone rose from 7 at the beginning of 1917 to 44 by the end of 1919. Then in the early twenties, the flood began to ebb rapidly until there were only 8 remaining by the end of 1922 (16–21). Oskar Loerke surmised at the time that there had perhaps never been so many poems written, published, and, he adds with some astonishment, "sogar gelesen" (even read; 1964, 35). Expressionism in general celebrated its growth during the postwar years from a cultural phenomenon on the edges of society into a mass movement touching the broader public consciousness. In addition to its broader historical view, the East German anthology is far more inclusive in the number of individual poets represented. However, the gains in representation by younger generation as well as by women poets remain minimal. Any future history of Expressionist poetry — as Brinkmann described it — in which this neglected segment of poets is given its due will have to include a number of second generation poets brought back to light by scholarship since the end of the Second World War.

Among the most important rediscovered younger male poets with roots in Expressionism are Hermann Kasack (1896–1966), Edlef Koeppen (1893–1939), Hans Schiebelhuth (1895–1944), and Anton Schnack (1892–1972). Kasack in particular had been well represented on the pages of late Expressionist publications. His earliest collection of poems (*Der*

*Mensch;* the Fellow Human) was the first number in the late Expressionist series *Die neue Reihe,* which published twenty-five volumes between 1918 and 1921. Although Kasack's title seems to imply a simple echo of the sometimes emotionally strained "O Mensch!" melody at the heart of Pinthus's symphony, Loerke pointed to these poems as proof that "Expressionismus ohne hektisches Rot, ohne Schweiß und Krampf möglich ist" (Expressionism is possible without hectic red, without sweat and cramps; 1918, 106). Loerke named Kasack along with Georg Kulka (1897–1929) and Friedrich Schnack (1888–1977) as the most promising of the postwar lyrical talents in an inventory of German poetry written in the seven years preceding 1921 (1964, 337). Although long nearly forgotten except for his public quarrel with Karl Kraus, Kulka was also a familiar name in several publications in that flood of late Expressionist publications. Scholarly excavations in search of this Viennese Expressionist culminated in an expanded edition of a selection of his poetry in 1985 in the series "*Vergessene Autoren der Moderne*" (Forgotten Authors of Modernism) and the appearance of his collected works in 1987.

Posterity acted more quickly to recover the poetry of Hans Schiebelhuth from oblivion. Various editions of selections from his poetry preceded the two volumes of his collected works published in 1966–67. In 1915 Schiebelhuth had become involved with a circle of artists and writers in Darmstadt who founded a journal and publishing enterprise called *Die Dachstube* (The Garret). As was the case in cities like Dresden, the activities of the circle included various publications and the initiation of a secessionist movement in art, the *Darmstädter Sezession,* in 1919. A partial list of its first members — Schiebelhuth, the theorists of Expressionist prose Kasimir Edschmid and Carlo Mierendorff, Wilhelm Michel and Theodor Haubach, the Expressionist painters Max Beckmann and Ludwig Meidner — reflects the attempt at blending art and politics, an attempt that occurred in numerous late Expressionist circles across the German-speaking landscape. This intermingling did not take place without collective misgivings and reservations. In the editorial by Joseph Würth on the title page announcing its own demise in November 1918, *Die Dachstube* proclaimed the new pressures of a politicized consciousness: "Now to jump into the stream of history, to be active to the extreme" while it clung to a primary allegiance to art: "Not that art would cease to exist as our ultimate, most arduously desired goal."

*Das Tribunal,* the successor to *Die Dachstube,* was an avowedly polemical journal of socialist persuasion modeled on Franz Pfemfert's *Die Aktion.* In its first year of publication, however, *Das Tribunal* featured major poems by the essentially apolitical Schiebelhuth in six of its ten issues, with his grandly conceived "Hymne des Maropampa" staking claim to the title page of the June 1919 issue. From an all-embracing perspective similar to the lyrical voice in Werfel's early poetry, this paean to adventure

and exotic climes strives for mythical proportions. Yet Schiebelhuth's hymn directs its grand gestures toward Eros rather than a vision of collective humanity. For Fritz Usinger, the most well-versed and most adept reader of his poetry, Schiebelhuth distinguished himself by refusing to join the chorus of "O Mensch!" poets. While his contemporaries sang the praises of an idealized humanity in the face of reality's shortcomings, Schiebelhuth affirmed and embraced these shortcomings (1967, 10). In point of fact, the long serene lines of "Hymne des Maropampa" with its indulgence in fantasy and the fantastic are more strongly reminiscent of George than Werfel. With only minor exceptions in hybrid forms, Schiebelhuth's poem is free of the four words that Pinthus considered most characteristic of Expressionist poetry: "Mensch, Welt, Bruder, Gott" (fellow human, world, brother, God; *MHD*, 29; *DoH*, 34).

As for many of the poets only recently brought back to light through new editions of their works or scholarly studies, Expressionism was only a way station for Edlef Köppen. A close friend of Kasack, Köppen first published his poetry, a pacifist poetry about the suffering caused by the war, in *Die Aktion*. From 1919 on his poems found an outlet in such late Expressionist journals as *Menschen* (People), *Kündung* (Announcement), and *Die rote Erde* (The Red Earth). The monthly publication *Menschen*, only one of several ventures of the *Dresdner Verlag von 1917*, claimed to represent the "aufsteigende jüngste Generation geistig tätiger Menschen" (the rising youngest generation of intellectually active individuals; Raabe 1964, 71). This journal was edited for a time by yet another prolific but forgotten poet, Walter Rheiner (1895–1925) whose works began to find their way back into circulation in the 1980s. Heinar Schilling (1894–1955), the founder and financial power behind the *Dresdner Verlag von 1917* (Dresden Press of 1917) published numerous collections of his own poetry and prose between 1915 and 1921. Among those with the most telling titles were: *Du Bruder Mensch* (You, Brother Human) and *Mensch, Mond, Sterne* (Human, Moon, Stars). As the inspiration of the latter, Klabund (Alfred Henschke) diagnosed a certain "Werfelseligkeit," a kind of bliss-pathology or rampant outpouring of Werfel-inspired bliss (*Seligkeit*) widespread at the time but certainly not universal (8). Kasack, Schiebelhuth, and a number of the women poets had either partial or total immunity.

In the surge of Expressionist publications after the First World War, several more of the younger generation poets found places in collections that have fallen into oblivion beside Pinthus's anthology. The two volumes of the yearbook *Die Erhebung* (The Elevation) have poems by Kasack and Kulka as well as Martin Gumpert (1897–1955), Adolf von Hatzfeld (1892–1957), Oskar Schürer (1892–1949), and Henriette Hardenberg (1894–1993). Although their poems had appeared scattered in the pages of the important Expressionist journals *Die Aktion* and *Die Weißen Blätter* prior to the end of the war, the major outlets for their works were the new

publishing ventures founded after the war. In his essay published in 1954 on German poetry in the twentieth century, Clemens Heselhaus added a third collection to what he called "die großen expressionistischen Anthologien" (the great Expressionist anthologies; Heselhaus, 31). This addition was Wolfgang Kayser's *Verkündigung* (Annunciation) published in 1921. Nearly all the poets chosen by Pinthus were included here, yet almost half the additional ones had birth dates in the 1890s. Among the latter are most of those already mentioned as well as Alfred Vagts (1892–1986), Johannes Urzidil (1896–1970), and Claire Studer (1891–1977).

Claire Studer (later Claire Goll), Emmy Hennings, and Berta Lask are the only additions to Else Lasker-Schüler that the East German anthology makes in its representation of women poets. Goll, who published in *Der Sturm* and *Die Aktion* and whose works appeared in several of the journals, anthologies, and series after the war, has enjoyed something of a posthumous renaissance of her work and reputation in the last fifteen years. The same can be said of Henriette Hardenberg and Paula Ludwig (1900–1974), poets whose lives and republished works have recently attracted scholarly attention.

But the appearance in 1993 of Hartmut Vollmer's anthology, *"In roten Schuhen tanzt die Sonne sich zu Tod": Lyrik expressionistischer Dichterinnen* ("In Red Shoes the Sun Dances Itself to Death": Poetry of Female Expressionist Poets) marks the real entry of women's voices into all future renegotiations for a more inclusive and historically accurate image of Expressionist poetry. Moreover, fully one third of the thirty-nine individuals represented belong to those who arrived late on the Expressionist scene. By opening his anthology with Else-Lasker Schüler's "Weltende" (End of the World), a poem written in 1905, several years before the more famous "Weltende" by Jakob van Hoddis that introduces *Menschheitsdämmerung*, Vollmer makes pointed reference to his influential predecessor (29). In his preface to the anthology, Paul Raabe draws the readers' attention to this reference: "It was precisely this important book that long blocked our view of the large number of authors who also took part in Expressionism. It is particularly, however, the women poets of the movement who fell into oblivion" (11). While the English translation of *Menschheitsdämmerung* may signify its canonization, its position is far from sacrosanct. Yet another of its vulnerabilities is underscored by the emergence of a substantial female dimension to Expressionist lyric in Vollmer's anthology. Added to the historical and generational shortcomings that have become apparent in Pinthus's symphony is its increasingly apparent gender inequity.

Vollmer's thematic division of the anthologized poems into five groups — "Krieg, Großstadt, Traum, Schmerz, Liebe" (War, Metropolis, Dream, Pain, Love) — seems at first to resonate with the same themes and motifs sounded in Pinthus's symphony. At least the first four *are* quite

familiar. Yet the poems in Pinthus's final movement ("Liebe den Menschen" Love for Fellow Humans) are suffused with that spirit of *agape* or brotherly love that so often marks Werfel's poetry. Some of the love poetry in Vollmer's anthology, on the other hand, has a distinctly erotic spirit. A poem by Ingeborg Lacour-Turrup, a minor member of the *Sturmkreis* (the circle of poets around the journal *Der Sturm*) closes the volume:

> Unsere Hände krampfen umeinander
> Unsere Lippen brennen ineinander
> Unsere Leiber suchen sehnen suchen
> Krampfen
> Brennen
> Sehnen
> Suchen
> Sehnen
> Stummen sterben
> Und Verstummen
> Oh das Weinen ohne Tränen
> Leiser immer leiser
> Leise                                    (220)

> [Our hands clenched together
> Our lips locked in glowing embrace
> Our bodies search hunger search
> Clenching
> Glowing
> Longing
> Searching
> Longing
> Mutely ceasing
> Dying away
> O weeping without tears
> Quieter and quieter
> Quietly]

In both its vocabulary and rhythm this poem traces the contours of the act of love in its rising and falling tensions. This and other poems from the final section belie Wolfgang Paulsen's sweeping declaration in 1983: "Es ist hinreichend bekannt, daß es im Expressionismus so gut wie keine Liebeslyrik gibt" (It is known well enough that in Expressionism there is as good as no love poetry at all to speak of; 25).

In an Expressionist poetry that declared in unison with Franz Werfel, "Wir sind" (We Are), there was little inclination to reflect on the intimacy between an "I" and a "You." Vollmer notes in the introduction to

his collection, however, that even though his collected poems also often manifest an arching solidarity, an inwardly turned perspective predominates (23). A poem by Claire Studer (Goll), "Erneuerung" (Renewal) published in *Neue Blätter für Kunst und Dichtung* in 1919 combines the by then well worn Expressionist themes of renewal, the "godless city," and anti-materialism with an expressed desire for this less encompassing, narrowed perspective. It ends with the line: "Gefühl von mir zu dir, das ist allein" (The feeling from me to you, that's all that matters). Firmly grounded in the private sphere, her poetry as well as that of Hardenberg and Ludwig had little place for the loud rhetoric or forced emotional outbursts of Werfel, Becher, or Heynicke. Macrocosmic dreams declaring the brotherhood of man gave way to poems focused on the narrowest of human relationships. The "I" in Ludwig's collection *Die selige Spur* (The Sacred Trace, 1919) is in constant search of its counterpart. The first strophe of the final poem ("Psalm," 28–29) reflects her exasperation with the louder voices of the day:

> Wir Menschen.
> Wir.
> Daß unsere Hände doch behutsamer
> ineinandergriffen, sich zum Troste!
> Aber der Tag ist laut von den schreienden Stimmen.
>
> (*Gesamtausgabe* 28)

> [We humans.
> We.
> Would that our hands more gently would
> interlock in solace!
> But the day is loud with shouting voices.]

Together with its expanded historical, generational, and gender coverage, Brinkmann's hypothetical future history of Expressionist poetry will have to take account of the co-existence of this first-person perspective alongside the collective "we." It seems particularly essential to any undiscovered Expressionist love poetry that Paulsen so totally dismisses. Finally, as Vollmer stresses, and as the sheer number of poets actively publishing after the First World War suggests, the age of discovery has not yet passed in research on Expressionism: "Trotz aller Forschungsvielfalt, die beim Versuch, ein umfassendes und genaues Bild der expressionistischen Bewegung darzubieten . . . kann jedoch nicht davon gesprochen werden, daß ein Abschluß der Entdeckungen und Analysen erreicht ist" (In spite of the great variety of research that has gone into the construction of a comprehensive and accurate depiction of the Expressionist movement, one can by no means assert that an end has been reached in discoveries and analyses; 15). Such

basic scholarship, which excavates and examines the lyrical finds with an intensity already brought to bear on many of the individual talents of Expressionism, will doubtless bring with it an enlarged understanding of Expressionist poetry. It will grant appropriate historical significance to the *Menscheitsdämmerung* as the symphonic metapoem of the era, without diminishing the significance of some of the individual voices at its very heart. While poets like Trakl, Benn, Heym, and Stadler seem securely in place at the lyrical apex of Expressionism, others chosen by Pinthus for structural reasons alone will fade even further and give way to stronger lyrical talents, unheralded at that point in time, but enduring over — and in spite of the *flow* of — time.

# Notes

<sup> </sup>

1 Kurt Pinthus, ed., *Menschheitsdämmerung: Symphonie jüngster Dichtung.* (Berlin: Rowohlt, 1920; Hamburg: Rowohlt Taschenbuch Verlag, 1959, 1976). All parenthetical references to *Menschheitsdämmerung* in German are to the 1959 edition. All quotations from this anthology are designated by the abbreviation *MHD* and the page number, and all English translations are from *Menschheitsdämmerung / Dawn of Humanity: A Document of Expressionism*, trans. Joanna M. Ratych, Ralph Ley, and Robert C. Conard (Camden House, 1994) and are designated by the abbreviation *DoH* and the page number. All other translations into English are my own.

2 In his introduction to the 1959 edition ("Nach 40 Jahren"), Pinthus alludes to the significant effect that his anthology had on shaping the reception of Expressionist poetry (7-8). He quotes an East German critic in his introduction to Denkler's collection of interpretations of individual poems from *Menschheitsdämmerung*: "Ruhm und Wirkung dieser literarischen Bewegung gründeten sich nicht zuletzt auf die *Menschheitsdämmerung*, ja es mag ernsthaft bezweifelt werden, ob der Expressionismus ohne diese Anthologie das wäre, als was er sich im Bewußtsein der Nachgeborenen darstellt" (The renown and influence of this literary movement are grounded to a not insignificant degree in *Menschheitsdämmerung*. One can seriously doubt that Expressionism would represent to us today what it does without this anthology; xxviii). See also Newton, 70; Raabe 1976, 203; the "Vorbemerkung des Herausgebers" (Editor's Preface) of Vietta's anthology *Lyrik des Expressionismus*, and the "Translators' Introduction" to *Menschheitsdämmerung / Dawn of Humanity*.

3 And one of his most perceptive contemporaries, the poet Oskar Loerke, agreed that he had done just that: "Kurt Pinthus ist etwas Wundersames geraten: er hat die Gedichte für die Dauer unserer Versenkung in seine Sammlung namenlos gemacht" (Kurt Pinthus has done something remarkable: for the time that we are wrapped up in his collection the poems become anonymous); "Gerichtstage," 144.

4 Wolfgang Paulsen wrote in 1983: "In der Lyrik liegen die großen Leistungen, chronologisch gesehen, im ganzen sicher sehr früh und decken sich mit dem,

was man gemeinhin meint, wenn man vom 'Frühexpressionismus' spricht"
(Chronologically, the great achievements in lyric poetry happened very early and
coincide with what one generally means when speaking of "early Expressionism";
70). Vietta and Kemper characterize the fundamental tension underlying Expres-
sionist literature as the " 'Dialektik' von Ichdissoziation und Menschheits-
erneuerung, von Entfremdungserfahrungen und dem Aufruf zur Wandlung des
Menschen" (the "dialectic" of self-dissociation and the renewal of man, of experi-
ences of alienation and the call for the transformation of humankind; 22). They
find the innovative forces of Expressionism in the ideological and cultural con-
frontation with the modern age inherent in the first part of the dialectic while the
latter appears increasingly naïve. In his more recent overview of research Hermann
Korte agrees and judges the devaluation of messianic Expressionism to be consis-
tent with "der allgemeinen Forschungstendenz seit 1945" (the general tendency of
research since 1945; 229).

# Works Cited

Brinkmann, Richard. *Expressionismus: Forschungsprobleme 1952–1960.* Stuttgart:
Metzler, 1961.

———. *Expressionismus: Internationale Forschung zu einem internationalen
Phänomen.* Stuttgart: Metzler, 1980.

Denkler, Horst, ed. *Gedichte der "Menschheitsdämmerung": Interpretationen
expressionistischer Lyrik.* Munich: Fink, 1971.

Dietz, Ludwig. Review of *Menschheitsdämmerung: ein Dokument des Expres-
sionismus,* ed. Kurt Pinthus. *Germanistik* 1 (1960): 111.

Göbel, Wolfram. "Der Kurt Wolff Verlag 1913–1930: Expressionismus als ver-
legerische Aufgabe." *Archiv für Geschichte des Buchwesens* 15 (1975):
521–962.

Goll, Claire. "Erneuerung." *Neue Blätter für Kunst und Dichtung* 2 (October
1919): 141.

———. *Ein Mensch ertrinkt: Roman.* Berlin: Argon, 1988.

———. *Werke in Einzelbänden.* Ed. Barbara Glauert-Hesse. 1 vol. to date.
Berlin: Argon, 1989–.

Hardenberg, Henriette. *Dichtungen.* Ed. Hartmut Vollmer. Zurich: Arche,
1988.

———. *Südliches Herz: Nachgelassene Dichtungen.* Ed. Hartmut Vollmer.
Zurich: Arche, 1994.

Heselhaus, Clemens. "Die deutsche Lyrik des 20. Jahrhunderts." In *Deutsche
Literatur im 20. Jahrhundert: Strukturen und Gestalten,* ed. Otto Mann and
Wolfgang Rothe, 1:11–44. Bern: Francke, 1954.

Kasack, Hermann. *Der Mensch: Verse.* Munich: Roland, 1918.

Kayser, Rudolf, ed. *Verkündigung: Anthologie junger Lyrik.* Munich: Roland,
1921.

Klabund. "Aus neuer Lyrik." *Die neue Bücherschau* 1 (1919): 8.

Kulka, Georg. *Aufzeichnung und Lyrik*. Ed. Hermann Kasack and Helmut Kreuzer. Siegen: n.p., 1985.

————. *Werke*. Ed. Gerhard Sauder. Munich: edition text + kritik, 1987.

Loerke, Oskar. "Die sieben jüngsten Jahre der deutschen Lyrik." Ed. Reinhard Tgahrt. *Jahrbuch der Schillergesellschaft*, 8 (1964): 33–40. Repr. in: *Literarische Aufsätze*, 333–37.

————. "Vielerei Zungen." Review of *Der Mensch*, by Hermann Kasack. *Die neue Rundschau* 2 (1918): 1228–40. Repr. in: *Literarische Aufsätze*, 101–15.

Ludwig, Paula. *Gedichte: Gesamtausgabe*. Ed. Kristian Wachinger and Christiane Peter. Ebenhausen: Langewiesche-Brandt, 1986.

McClintick, Christopher. "The Anthologist Function: *Menschheitsdämmerung* from 1919 to 1994." *Michigan Germanic Studies*. 19 (1993): 141–58.

Mittenzwei, Werner. Introduction to *Menschheitsdämmerung: Ein Dokument des Expressionismus*. Leipzig: Reclam, 1968.

Newton, Robert P. *Form in the "Menschheitsdämmerung": A Study of Prosodic Elements and Style in German Expressionist Poetry*. The Hague, Paris: Mouton, 1971.

Paulsen, Wolfgang. *Deutsche Literatur des Expressionismus*. Bern: Peter Lang, 1983.

Pinthus, Kurt, ed. *Menschheitsdämmerung: ein Dokument des Expressionismus*. Hamburg: Rowohlt, 1959. Hamburg: Rowohlt Taschenbuch Verlag, 1959, 1976. In English: *Menschheitsdämmerung / Dawn of Humanity: A Document of Expressionism*. Trans. Joanna M. Ratych, Ralph Ley, and Robert C. Conard. Columbia, SC: Camden House, 1994.

————. *Menschheitsdämmerung: Symphonie jüngster Dichtung*. Berlin: Ernst Rowohlt, 1920.

Raabe, Paul. *Der Ausgang des Expressionismus*. Biberach an der Riss: n.p., 1966.

————. "On the Rediscovery of Expressionism as a European Movement." *Michigan Germanic Studies* 2 (1976): 196–210.

————, ed. *Die Zeitschriften und Sammlungen des literarischen Expressionismus: Repertorium der Zeitschriften, Jahrbücher, Anthologien, Sammelwerke, Schriftenreihen und Almanache 1910–1921*. Stuttgart: Metzler, 1964.

Reso, Martin, Silvia Schlenstedt, and Manfred Wolter, eds. *Expressionismus: Lyrik*. Berlin: Aufbau, 1969.

Rheiner, Walter. *Ich bin ein Mensch, ich fürchte mich: Vergessene Verse und Prosaversuche*. Ed. Thomas Rietzschel. Assenheim, Germany: Brennglas, 1986.

————. *Kokain: Lyrik, Prosa, Briefe*. Ed. Thomas Rietzschel. Leipzig: Reclam, 1985.

Schiebelhuth, Hans. *Hans Schiebelhuth: Eine Einfuhrung in sein Werk und eine Auswahl.* Ed. Fritz Usinger. Wiesbaden: Steiner, 1967.

————. *In Memoriam Hans Schiebelhuth: Gedichte.* Darmstadt: Darmstädter Verlag, 1949.

————. *Lyrisches Vermächtnis.* Ed. Fritz Usinger. Heidelberg: Schneider, 1957.

————. *Werke.* Ed. Manfred Schlösser. 2 vols. Darmstadt: Agora, 1966–67.

————. *Wir sind nicht des Ufers: Gedichte aus dem Nachlaß.* Ed. Fritz Usinger. Darmstadt: J. V. Liebig, 1957.

Schilling, Heinar. *Du Bruder Mensch: (Opus 37) Gedichte 1918.* Dresden: Dresdner Verlag von 1917, 1918.

————. *Mensch, Mond, Sterne: Gedicht.* Dresden: Dresdner Verlag von 1917, 1918.

Vietta, Silvio, ed. *Lyrik des Expressionismus.* Tübingen: Niemeyer, 1976.

Vietta, Silvio, and Hans-Georg Kemper. *Expressionismus.* Munich: Fink, 1975.

Vollmer, Hartmut, ed. *In roten Schuhen tanzt die Sonne sich zu Tod: Lyrik expressionistischer Dichterinnen.* Zürich: Arche, 1993.

Wolfenstein, Alfred, ed. *Die Erhebung: Jahrbuch für neue Dichtung und Wertung.* 2 vols. Berlin: S. Fischer, 1919 and 1920.

Würth, Joseph. Editorial in *Die Dachstube* 4, 65 (November 1918).

# 6: Choric Consciousness in Expressionist Poetry: Ernst Stadler, Else Lasker-Schüler, Georg Heym, Georg Trakl, Gottfried Benn

*James Rolleston*

MICHEL FOUCAULT CONCLUDES *The Order of Things* (1966) with the suggestion that man, as the revolutionary/organic carrier of histori- cal modernity, could dissolve into the sea of time, "be erased, like a face drawn in sand at the edge of the sea" (387). The major Expressionist poets experienced this moment in advance, as a premonition of an apocalyptic event far transcending the decay of the bourgeois ethos as depicted in Thomas Mann's broadly naturalistic *Buddenbrooks* (1901). Nineteenth- century epistemology had fused the categories of the Enlightenment into seemingly irrefutable coherence. The individual self claimed moral and emotional autonomy; the social and natural sciences appeared to guarantee historical progress; even the ideology of imperial expansion could be justi- fied by an appeal to democratic civilization. The interlocking quality of these assumptions meant that there was no outside, no language of critique available other than that of the "self"-centered universe. Indeed, a power- ful trend within modernism sought to radicalize the language of enlight- ened progressivism, transforming its temporality into sheer intensity (Futurism) and its self-centeredness into a world drenched in subjective emotional energy. For Theodor Däubler, writing in 1916 in *Die neue Rundschau*, the new temporality is "Simultanität"; the new sense of space requires objects to be "ichbegabt" (endowed with self), indeed "Der Mit- telpunkt der Welt ist in jedem Ich" (The center of the world is in every self; Däubler, 51–53). However, such a program perpetuates, problematically, a discourse of agency, claiming the potential to reform or revolutionize the world one more time. But Expressionist poets knew an underlying truth: that the situation entailed a collapse of inherited perceptual categories, and that it was their task to give voice to this imminent event.

In his 1999 book *Poetisches Pathos*, Peter Stücheli argues for the grounding of the Expressionist moment in Nietzsche's category of pathos, "Anschauung und Entzücken zugleich" (contemplation and ecstasy at the same time; 79). While Nietzsche's role as Expressionist inspiration is

well known, the norm has been to stress his later "Lebensphilosophie" (vitalism), as in the study by Günter Martens. Stücheli returns to the primal antitheses of *Die Geburt der Tragödie* (The Birth of Tragedy), "Individuation und Vernichtung" (individuation and destruction), "Sprache und Musik" (language and music; 80), insisting that "Begreifen des Pathos" (grasping/comprehending pathos) is only imaginable as "Ergriffenwerden dadurch" (being grasped/gripped by it; 84). To understand poetry's special role as the medium for *Das neue Pathos* (the title of Paul Zech's journal, 1913–18), one must return to the original image of *The Birth of Tragedy*. Nietzsche cites Schopenhauer: " 'Wie auf dem tobenden Meere, das, nach allen Seiten unbegrenzt, heulend Wasserberge erhebt und senkt, auf einem Kahn ein Schiffer sitzt, dem schwachen Fahrzeug vertrauend; so sitzt mitten in einer Welt von Qualen, ruhig der einzelne Mensch, gestützt und vertrauend auf das principium individuationis.' " (22; "Just as in a stormy sea that, unbounded in all directions, raises and drops mountainous waves, howling, a sailor sits in a boat and trusts in his frail bark: so in the midst of a world of torments the individual human being sits quietly, supported by and trusting in the *principium individuationis*" [translator's italics]; Kaufmann, 35–36). Nietzsche locates this "Apollonian" consciousness of self, to be invaded and fused with the Dionysian, at the "birth" of Western tragic civilization. But at what now seems to be its end, after millennia of the cult of Socratic rationality, the modern self is imprisoned by individuation; the stormy sea, the excluded world, is ever more tangibly present in its alien indifference, though perhaps in different, urban-industrial, and technological forms. In the beginning the Apolline lyricist dreams individuality into existence; at the end of time once again the poet, but this time the Expressionist poet of pathos, must be central, recording the dissolution of the dreamed self.

Nietzsche's own early warnings of the civilizational crisis involved versions of a collective project, however rarefied: Wagnerian aesthetic ritual, willed "evolution," a re-imagining of History through the Eternal Return. But his core thesis of "perspectivism," his contention that "thinking" designates "bestimmte Fixpunkte" (specific fixed points; Martens, 42) in the stream of becoming, precludes any truly synthesizing perspective. A major group of Expressionist poets imagined no new transformation, nothing but an intensification of the crisis, the ever increasing force of the cosmic sea crashing in upon their fragile psychic boats. This Nietzschean image helps demonstrate how and why pathos emerges as a central feature in Expressionist poems. The title of Ernst Stadler's groundbreaking collection *Der Aufbruch* (1913) suggests what is involved: "to break out" of the constraints of bourgeois individualism requires letting the sea "break in," letting it flood the Apolline dreamer's boat. Essentially Stadler invokes Nietzsche's original dynamics of the "break-in" of the Dionysian onto a purely lyrical Greek culture, but now, as in Stadler's poem "Fahrt über die

Kölner Rheinbrücke bei Nacht" (Ride Across the Cologne Rhine Bridge at Night), that sea of collective ecstasy breaks in upon industrial German modernity.[1]

Der Schnellzug tastet sich und stößt die Dunkelheit entlang.
Kein Stern will vor. Die ganze Welt ist nur ein enger,
    nachtumschienter Minengang,
Darein zuweilen Förderstellen blauen Lichtes jähe Horizonte
    reißen: Feuerkreis
Von Kugellampen, Dächern, Schloten, dampfend, strömend . . .
    nur sekundenweis . . .
Und wieder alles schwarz. Als führen wir ins Eingeweid der
    Nacht zur Schicht.
Nun taumeln Lichter her . . . verirrt, trostlos vereinsamt . .
    mehr . . . und sammeln sich . . . und werden dicht.
Gerippe grauer Häuserfronten liegen bloß im Zwielicht bleichend,
    tot — etwas muß kommen . . . o, ich fühl es schwer
Im Hirn. Eine Beklemmung singt im Blut. Dann dröhnt der
    Boden plötzlich wie ein Meer:
Wir fliegen, aufgehoben, königlich durch nachtentrissne Luft,
    hoch übern Strom. O Biegung der Millionen Lichter,
    stumme Wacht,
Vor deren blitzender Parade schwer die Wasser abwärts
    rollen. Endloses Spalier, zum Gruß gestellt bei Nacht!
Wie Fackeln stürmend! Freudiges! Salut von Schiffen über
    Blauer See! Bestirntes Fest!
Wimmelnd, mit hellen Augen hingedrängt! Bis wo die Stadt
    mit letzten Häusern ihren Gast entlässt,
Und dann die langen Einsamkeiten. Nackte Ufer. Stille. Nacht.
    Besinnung. Einkehr. Kommunion. Und Glut and Drang
Zum Letzten, Segnenden. Zum Zeugungsfest. Zur Wollust.
    Zum Gebet. Zum Meer. Zum Untergang. (*MHD*, 179)

[The express train feels and jerks its way through the darkness.
No star dares appear. The entire world is but a narrow mine-gallery
    railed round by night,
Into which now and then haulage stations of blue light tear abrupt
    horizons: fiery circle
Of arc-lamps, roofs, smokestacks, steaming, streaming . . . only for
    seconds . . .
And all is black again. As if we were descending into the bowels of
    the night to work our shift.
Now lights stagger by . . . lost, wretchedly forlorn . . .
    more . . . and join together . . . and grow dense.

Skeletons of gray housefronts lie bare, bleaching in the half-light,
    dead— something has to happen . . . oh, I feel its weight
On my brain. An apprehension sings in the blood. Then suddenly
    the ground roars like an ocean:
We are flying, suspended, majestically through air wrested from the
    night, high above the river. O bend of millions of lights, silent
    sentinels
Before whose glittering array the waters slowly roll downward.
    Endless guard of honor saluting in the night!
Storming like torches! Joyous sight! Salvoes of ships across a blue
    sea! Star-studded festival!
Swarming, pushed onwards with bright eyes! Up to where the city
    with last houses bids its guest farewell.
And then the long lonelinesses. Banks. Silence. Night.
    Reflection, Contemplation. Communion. And ardor and the
    urge
To the ultimate, to what blesses. To the feast of procreation. To
    ecstasy. To prayer. To the sea. To extinction. (*DoH*, 202–3)]

The train effectively embodies the "sea" surrounding the modern self,
the independent technological power originally produced by that self's pri-
mal ingenuity — but now experienced as "other," as enclosing the self in a
network of alien forces. In fact the first line humanizes this other, confining
the speaker's role to observation; the confinement is of course dialectical,
as the speaker "borrows" the train's power, becoming decentered in the
process. "Kein Stern will vor": just before the Dionysian moment a defa-
miliarized cosmos asserts itself, blocked and controlled by the train's
autonomy — and thrusting the observer into the opposite extreme, equally
black and confining, the mineshaft. The dynamism of the extended lines
undermines this stasis even as it is being asserted: lights flash momentarily
into existence, destabilizing all function, intensifying the blackness. Impor-
tant though Walt Whitman was to this "liberation" of Expressionist verse,
his hymnic accumulation has little in common with Stadler's precision and
extremes (Thomke, 120). "Als führen wir . . .": the speaker "knows" in
some sense that he is not alone and is constructing a metaphor, but this
knowledge is itself obliterated as the lights impose themselves on his senses,
entirely alien and unsentimental, culminating in a half-light, a deathworld,
an image of the social ("Häuserfronten," house fronts) as remote as possi-
ble from the network of social relations associated with trains.

At this precise center of the poem the "ich" (the "I") declares itself,
though subordinated to the longed-for change ("etwas muß kommen,"
something has to happen) that might lend shape to the Dionysian break-
in; moreover the self is a set of receptors — brain, blood — without
controlling perspective. The world is indeed transformed: its "ground" is

suddenly a sea — and (as the train enters the bridge over the actual water of the Rhine) this metaphysical sea generates, expressly in the word choice, an "overcoming" of the primal sea through the new "collective" experience of the train: "Wir fliegen, aufgehoben, königlich durch nachtentrissne Luft" (We are flying, suspended, majestically through air). Suddenly all the chaotic motifs of the opening lines crystallize into order, the lights into a "blitzender Parade" (glittering array [parade]); the water's flow can be specified, the lights from boats can be designated as "Salut." Even the stars participate in this "bestirntes Fest." All is now describable: the journey itself, the city and its reborn houses, the self/train as the city's guest. And yet the self has formally entered the scene as sheerly physical, not at all in control: "ich fühl es schwer im Hirn" (I feel its weight / on my brain). The self has not "returned" to identity but has, in the mode of pathos, been seized ("ergriffen") by its own image-making. Dissolved affirmatively into the repetitions of the train's motion, the speaker is now free to fill them with all of humanity's sacred thoughts, the vocabularies of religion and love. History is exiled, there is no temporal sequencing of birth and death; and the final opening towards "Meer" (sea) and "Untergang" (extinction) crystallizes an Expressionist vision. Absorption into the moment, however ecstatic, must culminate in radical self-dissolution: the poem's driving energy propels the reader towards some new configuration of life, but it cannot be a recovery of individual stability.

Stadler's poem enacts the Dionysian festival, assaulting the self's autonomy, then opening onto a collective ecstasy. But of course no authentic collectivity could be realized in the 1900s: to think of Stadler's fellow train-passengers as the "wir" underlines the point. The choric speaking and the invocation of mighty rituals draw attention to the closure of the self within the train; in its very thrust toward dissolution the helplessly individualized self remains obstinately intact, all the more exposed to the crisis of history because of its momentary overcoming. Nietzsche's choric ritual cannot simply be reenacted. It must be grounded in the negative immensity of the historical moment, and, in a truly modern aesthetics, a post-mimetic production of the world as "aesthetic phenomenon" (Nietzsche, 52).

Else Lasker-Schüler, writing before Stadler, appears mesmerized by the crisis, while taking evasive action, shaping laconic language that postulates an imagined place not yet condemned by the implosion of modernity. Yet this place of love, like love itself, is conditioned in every detail by the temporality of the end, as in her poem "Weltende" (End of the World, 1903):

> Es ist ein Weinen in der Welt,
> Als ob der liebe Gott gestorben wär,
> Und der bleierne Schatten, der niederfällt,
> Lastet grabesschwer.

Komm, wir wollen uns näher verbergen . . .
Das Leben liegt in aller Herzen
Wie in Särgen.

Du! Wir wollen uns tief küssen —
Es pocht eine Sehnsucht an die Welt,
An der wir sterben müssen. (1996, 75)

[There is a weeping in the world,
As if our dear lord had died,
And the leaden shadow, pressing down,
Weighs upon us like the grave.

Come, hold tightly as we hide . . .
Life lies heavy in the hearts of all,
As if they were coffins.

You! Let us kiss intensely —
A longing beats against the world,
From which we will surely die.]

The opening lines convey dislocation with terrifying intensity: the collective tears that humanity has kept bottled up as a species, defending itself against the certainties of suffering and mortality, erupt into the open, rending apart the dream of individuality. Nothing can be commensurable with this image, so Lasker-Schüler shifts to a citational mode, translating God into a kind of memory: what is dying, or has died, is "der liebe Gott," the God of our childhood, the very orderliness of the inherited world. The speaker can only continue by aligning her language with the catastrophe while observing her own creative act. As Lasker-Schüler phrased this poetics in 1911: "Ich sehe also aus dem Bilde das Leben an; was nehm ich ernster von beiden? Beides. Ich sterbe am Leben und atme im Bilde wieder auf" (Thus I gaze at life from within the picture; which of the two do I take more seriously? Both. I die of life and live again in the picture; 1962, 357). This formulation goes to the heart of Nietzsche's choric consciousness, of the suspension of categories within the world "justified" as an "*ästhetisches Phänomen*" (Nietzsche's italics; aesthetic phenomenon; 41): "Unser Bewußtsein über diese unsre Bedeutung [ist] kaum ein Andres . . ., als es die auf Leinwand gemalten Krieger von der auf ihr dargestellten Schlacht haben" (41; our consciousness of our own significance hardly differs from that which the soldiers painted on canvas have of the battle represented on it; 52). Indeed the "leaden shadow, pressing down" recalls another primal experience of urban modernity, Baudelaire's nightmares in the Paris of the 1860s:

When skies are low and heavy as a lid
over the mind tormented by disgust. . . .
and silent hordes of obscene spiders spin
their webs across the basements of our brains. . . .
and giant hearses, without dirge or drums,
parade at half-step in my soul, where Hope,
defeated, weeps, and the oppressor Dread
plants his black flag on my assenting skull.

(From "Spleen IV," translated by Richard Howard, 76–77)

Baudelaire's allegory of the porous brain is consonant with Lasker-Schüler's alignment of the space of the heart with that of the coffin. Klaus Weissenberger writes: "Als Paria, 'am Leben sterbend,' wird der Künstler in einer zweiten Geburt wieder zum ursprünglichen Leben erweckt, analog dem Einhauchen des göttlichen Pneumas in die Form aus Erde und Lehm bei der Schöpfung des Menschen" (As a pariah, "dying in life," the artist awakens again in a second birth to primal life, analogous to the inspiration of divine breath into the forms of earth and clay at the creation of mankind; 99). Baudelaire's proto-modernism and Lasker-Schüler's actualized Expressionism have in common an apocalyptic faith in language: in the dying of civilization the text of creation will again be legible.

With the caveat that imagery of creation is necessarily "analogous" (there are only analogies), the sudden shift to dialogue in stanza two thus signifies the paradoxical freedom of the voice that has affirmed its location at the end of time. Politzer writes of the topos of "flight" in Lasker-Schüler that it leads "in eine Welt, die zugleich innerhalb und außerhalb, vor und hinter der Flüchtenden liegt" (into a world that lies at once inside and outside, before and behind the one fleeing; 219). Here the quest is for a way of actually living the end-time. The poem shifts from unbearable weight to joyous weightlessness. The moment of love and intimacy fills the entire "canvas" of finality in which the lovers embrace. The apocalypse requires aesthetic consciousness in order to frame that trans-historical event. Thus Lasker-Schüler fuses deathly certitude with erotic exhilaration to define the event. Citation is again in play: "Sehnsucht" (desire) is a powerful Romantic term, translated into a longing for death in Wagner's *Tristan und Isolde* (1865), a work universally known at this time (and of course decisive for the conception of Nietzsche's *Birth of Tragedy*). Lasker-Schüler displaces the longing: it is now *outside* the lovers, an irresistible, alien force to which their kiss is nothing but a momentary response. But moments are all they have.

In the eight years separating Lasker-Schüler's text from the major poems of Georg Heym, the experience of "Weltende" became aesthetically

familiar, commonplace, as the basis for fantasy and irony as well as apocalyptic terror. By the time of Heym's early death in a skating accident (January 1912), he had generated the fullest imaginable versions of disintegration's grim ecstasy. His most famous poems, "Der Krieg" (War) and "Der Gott der Stadt" (The God of the City), do more than "anticipate" the First World War: they speak the mythological language of destruction, evoking the enormity of war in a way later to be inaccessible to most participants, condemned as they were to "translate" the experience of the trenches into the normative discourse of the bourgeois self. Paul Fussell describes that latter phenomenon in the English context and speaks both of "an attempt to make some sense of the war in relation to inherited tradition" (57) and of "a ghastly pretence of normality" (64). Heym's poetry is a stark departure from that convention- and tradition-bound response. His vision appears inseparable from the metric strictness of his verse: poetry is an institution of the self, a communicative technology enabling him to map the catastrophe of the self-centered world with paradoxical impersonality. The speaking voice is usually identified as "wir": as the singular self drowns in the Dionysian sea, the plural self speaks from a perspective both inside and outside the events. The word "perspective" is itself misleading: Heym takes us very far from the experiential premises of either Stadler or Lasker-Schüler, compressing his intensity into a rigid duality of horror and detachment. Thus "Der Krieg" drives the reader vertiginously up into the ambience of the God of destruction, annotating the indifferent hurling of the fire; yet the expressive language ("furchtbar," "brausend") is the language of the victims far below, whose fate the speaker does not share in this one final moment, so that the event may exist in language:

> In die Nacht er jagt das Feuer querfeldein
> Einen roten Hund mit wilder Mäuler Schrein.
> Aus dem Dunkel springt der Nächte schwarze Welt,
> Von Vulkanen furchtbar ist ihr Rand erhellt. (*MHD*, 79)

> [Into the night he drives the fire across country,
> A red hound with the screaming of wild mouths.
> Out of the darkness springs the black domain of nights,
> Edges sinisterly lit up by volcanic lights.]

> (Translated by Patrick Bridgwater, 214; also in *DoH*, 100)

Whereas Lasker-Schüler stages values of love and closeness inside their ruined time, Heym eviscerates the human, capturing the final terrors with the impassive detachment of a camera at the apocalypse. For he knew that his language was charged with the ubiquity of death; as "traditional," theological awareness of mortality receded behind the repressive rationality

of modernity in the cities, death became grotesquely actual and immediate: "Man könnte vielleicht sagen, daß meine Dichtung der beste Beweis eines metaphysischen Landes ist, das seine schwarzen Halbinseln weit herein in unsere flüchtigen Tage streckt" (One could perhaps say that my poetry is the best proof of a metaphysical land that extends its black peninsulas far into our fleeting days; quoted in Rölleke, 367.) The voice of this metaphysical land cannot be individual, since individuality is the core illusion of classical aesthetics and bourgeois sensibilities. The doubleness of Heym's language registers the stark contrasts: the terror and tedium, selfhood and its negation, myth and demystified banality.

Central to Nietzsche's imagining of Greek tragedy — as the inaugural achievement of Western civilization — is the chorus: if the Apolline self is by definition alone, the cultural gesture embracing the Dionysian is by definition collective. The God (Dionysos) is not the source but the symbol of the ecstatic event: Nietzsche stresses that the "characters" of the early Greek plays were masks for the single character, Dionysos, who is bodied forth by the chorus. In "Die Morgue" (*MHD*, 97–99; The Morgue; *DoH*, 119–22), one of his longest poems, Heym stages an imagined conclusion to this macro-drama. The principle of Christianity has become universal rationality. Death has always threatened that rationality; if God is silent at the moment of death, the world's framework of meaning disintegrates. Heym's "black peninsulas" represent that disintegration.

> Die Wärter schleichen auf den Sohlen leise,
> Wo durch das Tuch es weiß von Schädeln blinkt.
> Wir, Tote, sammeln uns zur letzten Reise
> Durch Wüsten weit und Meer und Winterwind. (*MHD*, 97)

> [The attendants creep softly on their soles
> Where through the sheets there is a white glittering of skulls.
> We who are dead gather for the final journey
> Through deserts wide and sea and winter wind.]

For the first two lines the reporter speaks, confirming the reader's "normal" view of death as both factual and somehow other, its defining whiteness something to be glimpsed; then the apocalyptic camera is wrenched into the perspective of the dead themselves, and initially the imagery is conventional, even expansive, incorporating liturgical elements like the desert and final journey.

> Wir thronen hoch auf kahlen Katafalken,
> Mit schwarzen Lappen garstig überdeckt.
> Der Mörtel fällt. Und aus der Decke Balken
> Auf uns ein Christus große Hände streckt.

Vorbei ist unsre Zeit. Es ist vollbracht.
Wir sind herunter. Seht, wir sind nun tot.
In weißen Augen wohnt uns schon die Nacht,
Wir schauen nimmermehr ein Morgenrot.

[We are enthroned high up on bare catafalques,
Hideously covered with black rags.
The plaster falls. And from the ceiling's beam
A Christ stretches large hands toward us.

Our time is over. It is consummated.
We are finished. See, we are now dead.
The night already dwells in our white eyes,
Never again will we look upon a sunrise.]

These stanzas set the "tone" for the rest of the poem, postulating the dignity of the dead ("Wir thronen . . .") in order to deconstruct it: the elevation enables this chorus to "see" a picture of Christ that, in the very gesture of stretching out hands, seems to mock their rigid helplessness. Then religious terms are invoked, even the famous phrase of St. Matthew, "Es ist vollbracht" — only to thrust the dead back down into banality and empty facticity: "wir sind nun tot." The "camera" then turns inwards, as if seeking the dynamism found by Stadler in psychic dissolving; but within there is only blankness, absence of interiority. Heym has established a vast linguistic space for the dead, at once exalted and decomposing, biblical and clinical. This chorus can "speak" all the invocations of Western civilization, but it cannot fill any of them with meaning. Heym's stress on the single line enables him to conjure up and cancel meaning in one gesture. The next two stanzas open and close with assaults on the living:

Tretet zurück von unserer Majestät.
Befaßt uns nicht, die schon das Land erschaun . . .

Wir wuchsen über euch wie Berge weit
In Ewige Todes-Nacht, wie Götter groß.

[Step back from our majesty.
Do not touch us who already behold [the land] . . .

We grew over you like broad mountains
Into eternal death-night, like great gods.]

Language cannot but overreach itself, Heym suggests: the similes inflate the dead beyond the mountain, only to be punctured by the contemptuous precision that opens the next stanza: "Mit Kerzen sind wir

lächerlich umsteckt" (With candles we are ludicrously encircled). The cho-
rus of the dead can invoke the grandeur of religion and mountainous land-
scapes, but only on condition that it is anchored in the fact of the morgue;
its immobility is what enables its exclusively verbal fecundity. The twelfth
stanza turns the poem's forward movement against itself. "Werden wir
sein, wie ein Wort von niemand gehört?" (will we be like a word heard by
no one?). The word "sein" itself is at issue, embedded in temporality
("werden") and communication ("Wort"). The more language seeks to
express nothingness, the more it conjures up something in time and space.
At this limit of fertile impossibility, Heym locates the center of the poem,
collapsing the dactylic rhythm for a single extended stanza, and posing the
ultimate annihilating question:

> Oder — wird niemand kommen?
> Und werden wir langsam zerfallen,
> In dem Gelächter des Monds,
> Der hoch über Wolken saust,
>
> Zerbröckeln in Nichts,
> — Daß ein Kind kann zerballen
> Unsere Größe dereinst
> In der dürftigen Faust?[2]
>
> [Or — will nobody come?
> And will we slowly decompose
> In the laughter of the moon
> That dashes high above the clouds,
>
> Crumble away to nothing
> So that some day a child
> Can squeeze and crush our greatness
> In its paltry fist?]

Western civilization, in its death-throes, is utterly dependent on the
advent, the "speaking" of the God; we are T. S. Eliot's "hollow men,"
finding solidarity only in death, where the "higher" language of religion is
supposed to begin flowing. Since it does not, the poem's center becomes
the "Nichts" of dust in a child's hand. Heym's rhetorical doubleness gives
rise to contrary readings; accordingly, critics differ on the significance of
this verbally "free" stanza at the limit of interpretation. Martens (223) and
Bridgwater (234–35) see it as a kind of release, an ecstasy of a poet who
fundamentally valued life, which seems counter-intuitive, whereas Heinz
Rölleke speaks persuasively of a strictly verbal ecstasy: "Es bedurfte der
Mächtigkeit des Themas, um diese Formzertrümmerung im Rahmen eines
Heymschen Gedichts zu bewirken . . . Das Leben wird von der Grenze der

Existenz her betrachtet und als hohl und leer entlarvt" (The grandeur of the theme is necessary to effect the disintegration of form in the framework of a poem by Heym . . . Life is considered from limits of existence and revealed as empty and hollow; 371).

The ecstasy of unmasking is in principle self-perpetuating. If Stadler can conclude his dissolving moment with "Untergang," the word "Nichts" eschews all organic overtones, all possibilities of change. There is always nothing, yet never a void: the agony of the ending is unending. The long second part opens with the disturbance of a visit from the living. As if in defiance, the dead claim community: "Was stört Ihr unser frohes Stelldichein?" (Why are you disturbing our tryst?) But this is quickly reduced to the bareness of the reportorial voice: the speaker has the options of evoking the other dead, who are however decomposing rapidly ("Riecht doch, wie er stinkt.") — and of registering the time passing before redemption ("Was kommt er nicht?"). This second linguistic mode permits expansion of the imagery ("In welche Dämmerung geht unser Flug?"), but only so that it can deflate back into brute facticity:

> Eine Ratte hopst auf nacktem Zehenbein.
> Komm nur, wir stören deinen Hunger nicht.

> [A rat hops about on bare toe-bones
> Just come, we will not disturb your hunger.]

Desperately the speaker turns back to the past — but only to evoke its pretentious, generic emptiness: ("Wir zogen aus . . . Wir Ikariden . . ." (We moved out . . . We Icarians. . ). The text enacts this ever-narrowing oscillation between memory and hope, each eating away at the other like the varied creatures eating the corpses. The empty present is inescapable, precisely because it can never convert into the promised stasis. Time continues its nibbling, bells ring, the poem just stops.

Georg Heym and Georg Trakl often figure together as two of Expressionism's major lyrical voices. On the surface they appear very different: Heym's rigorous reductionism contrasts with Trakl's seemingly infinite verbal shadings and dream-play. Heym is always concluding, Trakl barely starting. That is to say, Heym's poems, his poetic lines, evince thunderous and frightening finality, whereas Trakl's elicit a brooding, atmospherically suggestive richness of mood. Yet they have in common the intense registering of civilization's Dionysian endgame, as it was felt in the years before and during the First World War. Heym's posture is rapid oscillation between agonized experience and ruthlessly detached reportage of the death throes. Trakl wanders as if in the eye of the hurricane, Western culture's mythology swirling about him in enigmatic fragments. I have chosen to discuss two poems that are slightly atypical in

that they adapt familiar narratives. But Trakl always conveys the feeling that his dreams are eternally recurrent, barely recognizable manifestations of a once vibrant story. In this sense he shares with Heym the poetics of the chorus: "Dieser Prozeß des Tragödienchors ist das *dramatische* Urphänomen: sich selbst vor sich verwandelt zu sehen und jetzt zu handeln, als ob man wirklich in einen andern Leib, in einen andern Charakter eingegangen ware" (Nietzsche, 55; This process of the tragic chorus is the *dramatic* proto-phenomenon: to see oneself transformed before one's own eyes and to begin to act as if one had already entered into another body, another character; 64). For Nietzsche this imaginative event launches the Western cultural project, the ongoing struggle between tragic vision and rational individualism; the Expressionists, convulsed by what Vietta calls "Ichdissoziation" (dissociation of self; 22), are the chorus enacting the project's dissolution through an aesthetics of deindividuation.

Heym's world is consumed by death's presence. Trakl, in his "Kaspar Hauser Lied" (Song of Kaspar Hauser), evokes a world luminous with beauty even as death suffuses every image. He evokes the natural world through a well-known story from the early nineteenth century. Kaspar Hauser, a young man, emerged from the forest able to speak but one sentence: "Ich will ein Reiter werden" (I want to become a rider). Both studied and cared for by the local people, he was later murdered under mysterious circumstances. The story, with its fusion of innocence and death, its enigmatic beginning and end, has often been viewed as an allegory of modernity, of the intricate involvement of Reason and Progress with their longed-for Other, organic harmony. Trakl articulates this by drawing Kaspar into near-fusion with nature while maintaining his cognitive identity.

> Er wahrlich liebte die Sonne, die purpurn den Hügel hinabstieg,
> Die Wege des Walds, den singenden Schwarzvogel
> Und die Freude des Grüns.
>
> Ernsthaft war sein Wohnen im Schatten des Baums
> Und rein sein Antlitz.
> Gott sprach eine sanfte Flamme zu seinem Herzen:
> O Mensch!
>
> Stille fand sein Schritt die Stadt am Abend;
> Die dunkle Klage seines Munds:
> Ich will ein Reiter werden.
>
> Ihm aber folgte Busch und Tier,
> Haus und Dämmergarten weißer Menschen
> Und sein Mörder suchte nach ihm.

Frühling und Sommer und schön der Herbst
Des Gerechten, sein leiser Schritt
An den dunklen Zimmern Träumender hin.
Nachts blieb er mit seinem Stern allein;

Sah, daß Schnee fiel in kahles Gezweig
Und im dämmernden Hausflur den Schatten des Mörders.
Silbern sank des Ungebornen Haupt hin.

[He verily loved the sun which, purple, descended the hill,
The paths of the wood, the singing blackbird
And the joy of the green.

Earnestly he lived in the shadow of the tree
And his countenance was pure.
God spoke a soft flame to his heart:
O Man!

Silently, his step found the city in the evening.
The dark lament of his mouth:
I want to become a rider.

But bush and animal followed him,
House and dusky garden of white men
And his murderer sought him out.
Nights he remained with his star alone;

Saw, that snow fell into bare branches
And in the hall's half-light, the shadow of the murderer.
Silver, the head of the unborn one sank away.

                (Trans. Francis Michael Sharp, 126)]

    As with Heym, the structuring of perspective is problematic, but for the opposite reason: where Heym cuts abruptly from one point of view to another, Trakl seeks a continuum that dissolves categories. We move through the world with Kaspar, but with no sense of his strangeness; indeed the speaker has "entered into another body," so that his purity becomes a kind of agency that dissolves civilization, not as corrupt but as superseded. The stressed "wahrlich" in the opening line activates the process: a conversational term, it puts Kaspar on stage, while its root meaning, "truth," foregrounds what is at stake in the simplicity of his "loving." Corruption and decay are hallmarks of Trakl's dream imagery, so the unambiguous "rein sein Antlitz" calls attention to the poem's specific project: the story's anthropological strangeness is to be actualized through the perspective, not of "ordinary people" but of its

"outsider," the figure of Kaspar, whose unchallengeable oneness with the world identifies him as a Messiah. Of course he is also Adam, always already juxtaposed with Paradise's dangerous trees: "Kaspar never escaped the 'shadow of the tree,' whose latent menace is transformed with each quiet step he takes toward the city and society, into 'the shadow of the killer.'" (Williams, 238). Civilization's constructions and destructions are one.

The Messiah's role is embodied in his two-word assignment: "O Mensch!" (Oh, Fellow Human!) God "speaks" the phrase, turning assertion into destiny: Kaspar "is" a human (he had not known it) and must enter the human world. Why is his one enigmatic sentence a "Klage" (lament)? Because he has entered the town where speech occurs; because the trope of the future ("werden") intervenes upon a consciousness where only the temporality of the seasons counts; above all because speech must supersede the primal senses as the focal point of identity. The story's doubleness, its staging of modernity's yearnings, becomes inescapable: "Ihm aber folgte Busch und Tier, / Haus und Dämmergarten weißer Menschen." The town-world *can* glimpse his importance, longs to follow its Messiah: but the moment in which he becomes a center, an identity, is also the moment he becomes a story, a story of (self)-destruction as the bearer of an impossible innocence.

The fifth stanza is extended by a line, evoking the dream of unity enveloping Kaspar's world during his last days. The Messiah's role fits comfortably ("sein leiser Schritt . . ."), indeed the horror of identity is held at bay: he is "Nachts . . . mit seinem Stern allein," alone yet still whole. But we know the story: the tranquillity is premised on its coming end. "Des Ungebornen Haupt": Kaspar is of course the unborn, the emblematic figure who is in the world but not of it, a "human" living before / outside the psychology of individualized time. But the phrase is also inescapably linear, denoting a "future" where murder does not need to justify itself, but is simply the norm. Walter Sokel finds that violence at the core of Trakl's "identity": "stressing the violent and cruel passion in himself, he calls himself not 'I' but 'the murderer.' The metaphor abstracts the person from the feelings . . ." (50). Trakl's expression of choric consciousness resembles Lasker-Schüler's. He both creates a "picture" and lives intensely within it. Since the murder of Kaspar frames his story, brings it into being, Trakl cannot but identify with the murderer. The apocalyptic culmination of modern civilization compels a rewriting of the past, a terrible validation of Kaspar's murder.

Trakl's very last poem, "Grodek," emerging from the actual self-destruction of his world in the Great War, explores the fusion of nature, dying, and the "unborn" as a monstrous ritual without spectators, without the possibility of non-participation:

Am Abend tönen die herbstlichen Wälder
Von tödlichen Waffen, die goldnen Ebenen
Und blauen Seen, darüber die Sonne
Düstrer hinrollt; umfängt die Nacht
Sterbende Krieger, die wilde Klage
Ihrer zerbrochenen Münder.
Doch stille sammelt im Weidengrund
Rotes Gewölk, darin ein zürnender Gott wohnt,
Das vergossne Blut sich, mondne Kühle
Alle Straßen münden in schwarze Verwesung.
Unter goldnem Gezweig der Nacht und Sternen
Es schwankt der Schwester Schatten durch den schweigenden Hain,
Zu grüßen die Geister der Helden, die blutenden Häupter;
Und leise tönen im Rohr die dunklen Flöten des Herbstes.
O stolzere Trauer! Ihr ehernen Altäre,
Die heiße Flamme des Geistes nährt heute ein gewaltiger Schmerz,
Die ungebornen Enkel.

[In the evening the autumn woods resound
With deadly weapons, the golden plains
And blue lakes; the sun rolls
More gloomily over them; the night embraces
Dying warriors, the wild lament
Of their shattered mouths.
Yet quietly in the pasture's hollow,
Red clouds, the spent blood gathers —
There a wrathful god lives, lunar coolness;
All roads empty into black decay.
Under golden branches of the night and stars
The sister's shade sways through the silent grove,
To greet the spirits of the heroes, the bleeding heads;
And softly the dark flutes of autumn resound in the reed.
O prouder grief! You bronze altars,
A powerful pain nourishes today the hot flame of the spirit,
The unborn grandsons. (Trans. Francis Michael Sharp, 188)]

Trakl wrote his final poem before dying, by his own hand, after a bat-
tle (Grodek) on the Eastern front in the fall of 1914. Since he thus actually
did enter the inferno that consumed the bourgeois world, it is important
to register the continuities between "Grodek" and the "Kaspar Hauser
Lied": organic nature, strongly color-coded, on which a human event
intervenes; the conflict between singular sound and enigmatic silence, and
of course the "unborn." Here, too, the poem opens unobtrusively, seem-
ingly "inside" nature: "tönen" could well suggest birdsong, even

"tödlichen Waffen" (deadly weapons) evoke the stylization of ancient heroes (echoed later in the poem) acting within a permanent landscape. Only in line four does this seeming stability shift, as the comparative "Düstrer" (more gloomily) sets nature itself in motion: this ultimate Dionysian upheaval fuses humans with the cosmos in willed destruction. Mythologies and images from all of Western history are activated as the night "embraces" the warriors, echoing the singular, irreducible cry from their collapsing mouths. By line seven the unique/universal story is fully underway: the text has moved rapidly from evening to night, momentarily allowing "Rotes Gewölk" (red clouds) to evoke sunset as well as battle. But the apocalypse overrides the cycle: the sky has absorbed all the blood into itself and the (angry) divinity becomes tangible once more. In the earliest stagings of Greek tragedy, according to Nietzsche (66), Dionysos appears only in masked form — now the God needs no mask; he is at one with the sheer outpouring of blood. The blood is "collected," withdrawn from the world: "schwarze Verwesung" (black decay) is another name for this withdrawal, this instant, accelerated decay.

Williams (306–7) stresses the importance of line ten in modulating the text from the "loud" sound-frame initiated by *tönen* (resound) in the opening line to the "quiet" *tönen* of the dark flutes in line 14. The finality of "Alle Straßen . . ." (All roads . . .) is the finality of a historical process; after it the battlefield reopens onto myth. The figure of the sister refers to Trakl's own sister, to whom he was close, or to a field-nurse: in context, however, she is a female "principle" (Williams calls her a "vestige of a feminine ground," [290] and Francis Michael Sharp sees in her "quasi-religious significance"; 190), evoking beauty, gentleness, the longings known to all the dying soldiers. Nature's tranquillity accompanies her in the new tonality of myth ("den schweigenden Hain . . ., die dunklen Flöten des Herbstes"). Then the scene fades into the austerity of tribal ritual: whatever "Geist" may be, it is by definition nourished by this seemingly definitive historical conflagration. As the human disaster dissolves physically into "decay" or putrefaction, it is spiritually distilled and this spirit lives as the horrified mourning of those left alive. As with the sister, "die ungeborenen Enkel" (the unborn grandsons) mandate a reading on more than one level: they are the descendants the dead will never have. But they are perhaps also the human future as such, a normality no longer conceivable. The poet can visualize the rivers of blood and their counterpoint, the female principle; at the end he can distill it all into the modality of spirit, but the "violent pain" denotes imaginative closure. "Heute" is the last day, Grodek no longer a place. Theo Buck summarizes this extreme dialectic, fusing the text's modernist autonomy with the unstoppable persistence of the Utopian imagery: "Trakls Gedicht lebt letzten Endes von seinem operationellen Aspekt. Die in ihm enthaltene 'negative Dialektik' kommt an ihr Ende, indem sie den 'objektiven Wahrnehmungszusammenhang' (Theodor W. Adorno), gegen

den sie angeht, durchschaut. Der katastrophale Endpunkt wird dann zum Ansatzpunkt eines neuen Anfangs. Die Dichtung Trakls gilt den 'ungebornen Enkeln'; sie ist negative Utopie" (Trakl's poem lives ultimately on its operational impact. The "negative dialectic" contained within it reaches its conclusion by penetrating the "objective perceptual context" against which it rises up. The catastrophic end then becomes provocation for a new beginning. Trakl's poetry is addressed to the "unborn posterity"; it is negative utopia; 77). "Grodek" embodies with precision the mission of "nonidentity" Adorno saw as integral to modernism: translating the entirety of the social-empirical world (its beauty as well as its destruction) into a linguistic artefact, the poem maintains, simply by its indestructible being, the possibility of a different world.

Nietzsche's Dionysian "birth" of tragedy as a cultural thesis enabled these poets of the next generations to express the end of that same Greek-based civilization, suddenly experienced as a collapsing "whole," as the disintegration of long-established categories and assumptions. At the macro level, three qualities of this event need stressing. First, as all studies of Expressionism emphasize, the initially liberating shape of modernity had congealed: the self as epistemological center, voicing both nourishing Nature and threatening City, had become totally sterile; "Ichdissoziation" (dissociation of self; Vietta) is the primal moment of Expressionism. Second, no "new" version of the world is imaginable — Vietta labels the topos of "der neue Mensch" (the New Man) as "bereits eine Regressionsform" (already a form of regression; 22). The very emancipatory drive of modernity has, in the process, generated new barriers and limits, most recently and threateningly the determinist categories of Social Darwinism. Nietzsche's inspiration for *The Birth of Tragedy* was Wagner's *Tristan und Isolde*, first produced in 1865; the immensity of Tristan's and Isolde's love is consciously and unavoidably "todgeweiht" (consecrated to death): only through a shattering of life itself can life actually be lived. The third core event is the shift in the status of language at the outset of the twentieth century. Nineteenth-century language presupposes a certain transparency, required for its role as medium between expressive subject and scientifically described object. The twentieth-century shift is signaled by Hofmannsthal's "Ein Brief," known as the Chandos Letter (1902), by Saussurean linguistics, and, eventually, by Russian formalism: words become dense, "signifiers" within self-contained language systems; they are autonomous, bearers of historical experience in their very being. Foucault's essay "Nietzsche, Genealogy, History" articulates the seismic scope of this cultural event.

The collapsing self, the disintegration of social meaning into barriers and limits, the new centrality of "thick" language, language emancipated from instrumental uses: these categories of crisis, of stasis experienced as intolerable and inescapable, have shaped this discussion of the major Expressionist poets. One might think that the silence of linguistic impossibility, such as

Adorno was to prescribe after Auschwitz, would follow the horror of "Grodek." But there is never silence. Articulation of the crisis presupposed what I have termed a "choric" consciousness, the ability to speak the unlivable truth in a range of disparate, in principle deindividuated, voices. At the "birth" of tragic culture, Dionysos is imagined onto the stage as a singularity; at its death the crowded stage must be emptied; only choric language can survive. This dense, collective speaking was central to Expressionism. The experimental poet August Stramm, who died early in the First World War, condensed sentences into single words, often inventing new ones for the purpose: sheer intensity of language is to generate momentum for a post-bourgeois world.

The practicing physician Gottfried Benn achieves this vision in some of his poems: he began publishing in 1912, the year of Heym's death, and even then his texts were suffused with a sense of "lateness," of the story being over and a radically fragmented cultural landscape newly opened to its first explorers. This lateness is devoid of Rilkean melancholy; indeed it is expressed through the sheer "presentness" of the twentieth-century urban and technological world. Benn's first collection *Morgue* (1912) has the same title as Heym's contemporaneous poem, but this is the physician's morgue, structured and confined. The poem "Mann und Frau gehn durch die Krebsbaracke" (Man and Woman Go through the Cancer Ward) begins and ends as follows:

> Der Mann:
> Hier diese Reihe sind zerfallene Schöße
> und diese Reihe ist zerfallene Brust.
> Bett stinkt bei Bett. Die Schwestern wechseln stündlich.
> [. . .]
> Hier schwillt der Acker schon um jedes Bett.
> Fleisch ebnet sich zu Land. Glut gibt sich fort.
> Saft schickt sich an zu rinnen. Erde ruft. (*MHD*, 96)

> [The man:
> Here in this row are wombs that have decayed,
> and in this row are breasts that have decayed.
> Bed beside stinking bed. Hourly the sisters change.
> [. . .]
> Here the grave rises up about each bed.
> And flesh is leveled down to earth. The fire
> burns out. And sap prepares to flow. Earth calls. —
> (Benn 1987, 187; trans. Babette Deutsch; also, *DoH*, 118)]

Even as the first-person voice speaks it is bracketed, that is, re-embodied in the expertise of the doctor viewing the cancer patients. After the

expulsion of feeling, the rigor of diagnostic description and the literal draining of human dignity, inherited organic imagery forces its way back in, as the only possible synthesis. Who utters the final two words? The poem itself does, in its bleakness and its truth. The primal dream of "the earth" becomes reality in the devouring presence of cancer.

Benn speaks with an authentically choric, deindividualized consciousness, inspecting the still-smouldering ruins, but his tone is fundamentally ironic: the third key element of the crisis, the shift of language towards density and autonomy, conditions Benn's speaking. Indeed, after 1945, Benn became the strongest advocate for modernism in German culture, for a language (under the rubric of *Artistik*) that is consciously hermetic. The adjective seems more appropriate to Trakl, whose work has drawn ongoing hermeneutic attention. But hermeticism is Benn's actual theme and language is the only authentic survivor of the crisis; Benn's poems, such as "Das späte Ich" (The Belated I, 1922), strive to embody what such survival might mean.

# I

O du, sieh an: Levkoienwelle,
der schon das Auge übergeht,
Abgänger, Eigen-Immortelle,
es ist schon spät.

Bei Rosenletztem, da die Fabel
des Sommers längst die Flur verließ —
moi haïssable,
noch so mänadisch analys.

# II

Im Anfang war die Flut. Ein Floß Lemuren
schiebt Elch, das Vieh, ihn schwängerte ein Stein
Aus Totenreich, Erinnern, Tiertorturen
steigt Gott hinein.

Alle die Großen Tiere: Adler der Kohorten,
Tauben aus Golgathal —
alle die großen Städte: Palm- und Purpurborden —
Blumen der Wüste, Traum des Baal.

Ost-Gerölle, Marmara-Fähre,
Rom, gib die Pferde des Lysippus her —
letztes Blut des weißen Stiers über die schweigenden Altäre
Und der Amphitrite letztes Meer —

Schutt. Bacchanalien. Propheturen
Barkarolen. Schweinerein.
Im Anfang war die Flut. Ein Floß Lemuren
schiebt in die letzten Meere ein.

## III

O Seele, um und um verweste,
kaum lebst du noch und noch zuviel,
da doch kein Staub aus keinen Feldern,
da doch kein Laub aus keinen Wäldern
nicht schwer durch deine Schatten fiel.

Die Felsen glühn, der Tartarus ist blau,
der Hades steigt in Oleanderfarben
dem Schlaf ins Lid und brennt zu Garben
mythischen Glücks die Totenschau.

Der Gummibaum, der Bambusquoll,
der See verwäscht die Inkaplatten,
das Mondchateau: Geröll und Schatten
uralte blaue Mauern voll.

Welch Bruderglück um Kain und Abel,
für die Gott durch die Wolken strich —
kausalgenetisch, haïssable:
das späte Ich.

## I

[Oh there, just look: that bed of stock that swells,
Its eye already filled with tears,
Leave-taker, its own immortelle,
Late is the year.

Last roses here, where summer's fable
Has left the fields and fallen mute —
Moi haïssable,
Maenadic still, and dissolute.

## II

In the beginning was the Flood. A raft of lemurs
Shoves Elk, the Beast. (A stone got him with child).

From Realm of Death, from Memory, from tortured beasts
God enters in.

All the great animals: eagles of the legions,
Doves from Golgotha —
All the great cities: galooned with palms and purple —
Flowers of the desert, dreamt of by Baal.

The East and its scree, Bosphorus ferry,
Rome, give the stallions of Lysippus back —
White steer's blood over altars dead silent
And Amphitrite's last sea.

Rubble. Bacchanals. Prophecies.
Barcaroles. Cochonneries.
In the beginning was the Flood. A raft of lemurs
Puts out for the last seas.

# III

My soul, oh rotten to the core,
Hardly alive and yet too much,
Each grain of sand blown from the fields,
Each single leaf the woodland yields
Falls through your shadow at the touch.

The cliffs are glowing, Tartarus is blue,
Into sleep's eyelid Hades rises, burning
To sheaves that still a mythic yearning
The spirit ranks, all oleander-hued.

The rubber tree, the bamboo sprout,
Lake licking Incan pedigree,
The moon chateau: dark shade and scree
Fill ancient walls and blue redoubt.

Fraternal bliss of Cain and Abel
Who still in clouds could God espy —
Causally-minded, haïssable:
The Belated I.

         (Benn 1987, 274–75; trans. Robert M. Browning)]

Sharp shifts of perspective define Benn's writing, including movement from perception to reflection, and an ongoing sense of citation. Thus the opening "O du" echoes Lasker-Schüler's attempts to rescue a version of the self. But Benn's self is not at all dialogic: he talks to himself, as it were,

in order to monitor the self's withdrawal from nature's potential nourishment. As the speaker stands by the late roses, he fills with self-hatred and with his own version of the Dionysian "maenads," the torture of unceasing self-analysis.

Strong rhyme, a constant feature in Benn's work, controls the rapid shifts in focus; at the same time the strangeness of the rhymes in the second stanza intensifies the isolation of each phrase. Language is rendered prominent, not in order to reinforce convention but rather to disrupt it, to turn the phrases into fragments held together solely by their structural function in the poem. The text enacts fragmentation, simultaneously overcoming it on a "choric" level. Citation has this effect also: the Biblical opening of section two offers an ironic re-creation of time's entirety. The cosmic events occur suddenly, but in the eternal present of the language that records them. Each stanza of the second part evokes a distinct moment in universal history. The flood is both productive and violent, compelling life into existence as random excess. God's late arrival into the flooded world confirms the Nietzschean frame: the "Totenreich" of tormented animals must exist for aeons before God and meaning and memory can even enter the picture.

The Expressionists, especially Trakl, gesture at an Apolline dream world, a "picture" of harmony, in order to situate the implosion of all sustaining order. Benn's "Alle die großen Tiere" alludes to the order that God has immediately wrought: the categorizing of birds and animals, their emblematic fractions in the human world, the differentiation of fertility from its opposite ("Blumen der Wüste") and of course the rise of explanatory cults: "Traum des Baal." The repeated "alle" projects the text through millennia, stopping almost at random for birds and colors. Human history has begun — and instantly aged. The third stanza pauses in Rome, but the "letztes" of the sacrifice and the silence of the altars speak of how late things already are. The names of Gods and heroes, religious gestures and geography all remain only in isolated phrases: the human world deconstructs even as it is being reconstructed by rhyme and verbal memory. The last stanza of the section accelerates even more, collapsing all singular events into generic markers, words summoning whole epochs into momentary being, what Benn calls *Chiffren* (ciphers). The Nietzschean "intoxication" of the Bacchanales supplants historical movement as such, perceptible only against the background of "Schutt." We are inside Schopenhauer's version of history as sheer repetition, inherited by Nietzsche and compressed into a formula by Benn: "Barkarolen. Schweinerein." The words as ciphers in Benn's *Chiffrenkunst* (art of ciphers) evoke the centuries of Venetian hegemony, pulverized by mordant irony. The section then closes with the symmetry of recurrence: the flood returns, the human story rewinds to the lemurs. Benn moves associatively, via Rome, to its residual altars to its panoply of Gods; via Venice to its precarious beauty to

the primal flood it symbolically resists. The associations are not profound (Trakl's extreme moment is past); they enact both the banality of the failed human story and the persistent "presence" of the words that absorb, transform, and randomly cite that story.

The tone changes completely in the third section. Benn's "self" is left washed up on the shores of time, and he now has the repertoire (history as such) with which to address that self, hence he can put his restless ironic detachment on hold. The elaborately rhymed five-line stanza presents the self as wholly atrophied, yet functioning as a kind of perceiving machine. One thinks of Borges's "Funes the Memorious" — and of the "Tiertorturen" in Benn's original flood: there is no pleasure in this perceiving, but the perceptions keep generating complex, insistently autonomous verbal structures (such as the double negatives cancelled in this translation). The next stanza, "Die Felsen glühn . . .," is such a structure, sustained, coherent, refusing the hope of "life": it is Hades that lives, rising into the sleep of everything living and consuming all ritual distance in its indifferent flames. In the next stanza the fire recedes, replaced by equally obliterating water; Benn reopens the texture to individual glimpses, but they no longer seem random — the debris consumes history's markers, however longlived, but, implicitly, they live on in the purely verbal beauty of "uralte blaue Mauern."

The final stanza draws back, sarcastically summarizing the human story once more, this time locating God at the very moment when history's infinite, "hateful" repetitions began. "Kausalgenetisch" situates Benn's poetic self as a twentieth-century scientist, a figure who can produce the words we have just read but has no other claims to value or survival. The determinisms of genetics offer new linguistic turns — but in their content they reinforce the desolation of all history, now irrevocably "late." Such lateness, this poem has been repeating, is a kind of eternal return, a looping back to the universe's primal violence. No story of emancipation can include such violence, present in all five of the poets discussed; the shift of aesthetic language into abstract formations of verbal density and autonomy conveys the conflicts of the Expressionist poem, its ceaseless, painful, infinitely self-conscious dissolving of Western civilization in and through its language in order to create the possibility of rebirth.

Nearly twenty years separate Lasker-Schüler's "Weltende" from Benn's "Das späte Ich," yet it would be misleading to characterize the one poem as anticipatory or the other as retrospective, in relation to Expressionism. Lasker-Schüler's title announces the entire event, and Benn's "lateness" is experienced by all these poets. But while such lateness signifies the exhaustion of the self, it also opens onto Western history as a totality of disintegrating stories. Choric consciousness registers this totality.

# Notes

[1] Kurt Pinthus, ed., *Menschheitsdämmerung: Symphonie jüngster Dichtung* (Berlin: Rowohlt, 1920; Hamburg: Rowohlt Taschenbuch Verlag, 1959, 1976). Unless otherwise indicated, all quotations are from this anthology and designated by the abbreviation *MHD* and page number; English translations from *Menschheitsdämmerung / Dawn of Humanity: A Document of Expressionism*, trans. Joanna M. Ratych, Ralph Ley, and Robert C. Conard (Camden House, 1994) are designated by the abbreviation *DoH* and page number.

[2] In the original edition of *Menschheitsdämmerung* these two stanzas form a single strophe.

# Works Cited

Baudelaire, Charles. *Les Fleurs du Mal.* In English: *The Flowers of Evil.* Trans. Richard Howard. Boston: David R. Godine, 1983.

Benn, Gottfried. *Gesammelte Werke 1: Gedichte.* Wiesbaden: Limes Verlag, 1960.

———. *Prose, Essays, Poems.* Ed. Volkmar Sander. New York: Continuum, 1987.

Bridgwater, Patrick. *Poet of Expressionist Berlin: The Life and Work of Georg Heym.* London: Libris, 1991.

Buck, Theo. "Negative Utopie: Zu Georg Trakls Gedicht 'Grodek.' " In *Frühling der Seele*, ed. Rémy Colombat and Gerald Stieg, 171–80. Innsbruck: Haymon-Verlag, 1995.

Däubler, Theodor. "Expressionismus" and "Simultanität." In *Theorie des Expressionismus*, ed. Otto F. Best, 51–55. Stuttgart: Reclam, 1976.

Foucault, Michel. "Nietzsche, Genealogy, History." In *Language, Counter-Memory, Practice*, ed. Donald Bouchard, 139–64. Ithaca: Cornell UP, 1977.

———. *The Order of Things: An Archaeology of the Human Sciences.* New York: Vintage, 1973.

Fussell, Paul. *The Great War and Modern Memory.* New York and Oxford: Oxford UP, 1975.

Heym, Georg. *Dichtungen und Schriften 1: Lyrik.* Ed. Karl Ludwig Schneider. Hamburg: Heinrich Ellermann, 1964.

———. *Gedichte, 1910–1912: Historisch-kritische Ausgabe aller Texte in genetischer Darstellung.* Ed. Günter Dammann, Gunter Martens, and Karl Ludwig Schneider. Tübingen: Max Niemeyer, 1993. (Philological edition, includes all variants: "Die Morgue" is on pp. 928–56.)

Lasker-Schüler, Else. *Prosa und Schauspiele.* Ed. Friedhelm Kemp. Munich: Kösel-Verlag, 1962.

———. *Werke und Briefe 1: Gedichte.* Kritische Ausgabe. Ed. Karl Jürgen Skrodzki. Frankfurt am Main: Jüdischer Verlag, 1996.

Martens, Gunter. *Vitalismus und Expressionismus.* Stuttgart: Kohlhammer, 1971.

Nietzsche, Friedrich. *Die Geburt der Tragödie aus dem Geiste der Musik.* Orig. 1872; Stuttgart: Reclam, 1979. In English: *The Birth of Tragedy.* Trans. Walter Kaufman. New York: Vintage, 1967.

Pinthus, Kurt, ed. *Menschheitsdämmerung: Symphonie jüngster Dichtung.* Berlin: Rowohlt, 1920; Hamburg: Rowohlt Taschenbuch Verlag, 1959, 1976. In English: *Menschheitsdämmerung / Dawn of Humanity: A Document of Expressionism.* Trans. J. M. Ratych, R. Ley, and R. C. Conard. Columbia, SC: Camden House, 1994.

Politzer, Heinz. "Else Lasker-Schüler." In Rothe, *Expressionismus als Literatur,* 215–31.

Röllecke, Heinz. "Georg Heym." In Rothe, *Expressionismus als Literatur,* 354–73.

Rothe, Wolfgang, ed. *Expressionismus als Literatur.* Bern and Munich: Francke, 1969.

Sharp, Francis Michael. *The Poet's Madness: A Reading of Georg Trakl.* Ithaca: Cornell UP, 1981.

Sokel, Walter H. *The Writer in Extremis: Expressionism in Twentieth-Century German Literature.* Stanford: Stanford UP, 1959.

Stadler, Ernst. *Dichtungen, Schriften, Briefe.* Kritische Ausgabe. Ed. Klaus Hurlebusch and Karl Ludwig Schneider. Munich: Beck, 1983.

Stücheli, Peter. *Poetisches Pathos: Eine Idee bei Friedrich Nietzsche und im deutschen Expressionismus.* Bern: Peter Lang, 1999.

Thomke, Hellmut. *Hymnische Dichtung im Expressionismus.* Bern, Munich: Francke, 1972.

Trakl, Georg. *Dichtungen und Briefe.* Historisch-Kritische Ausgabe. Ed. Walther Killy and Hans Szklenar. Salzburg: Otto Müller, 1969.

Vietta, Silvio, and Hans-Georg Kemper. *Expressionismus.* Munich: Fink, 1975.

Weissenberger, Klaus. "'Ein Mensch der Liebe kann nur auferstehen!' Else Lasker-Schülers Lyrik im Kontext von Liebesthematik und deren poetischer Konkretisation." In *Else Lasker-Schüler,* ed. Ernst Schürer and Sonja Hedgepeth, 91–117. Tübingen: Francke, 1999.

Williams, Eric B. *The Mirror and the Word: Modernism, Literary Theory and Georg Trakl.* Lincoln: U of Nebraska P, 1993.

## The Poets' Published Collections

Ernst Stadler (1883–1914)
*Präludien*. Strasbourg, 1905.
*Der Aufbruch*. Leipzig, 1914.
Else Lasker-Schüler (1869–1945)
*Styx*. Berlin, 1902.
*Der siebente Tag*. Berlin, 1905.
*Meine Wunder*. Karlsruhe, 1911.
*Hebräische Balladen*. Berlin, 1913.
*Die Kuppel*. Berlin, 1920.
*Theben*. Frankfurt am Main, 1923.
*Mein blaues Klavier*. Jerusalem, 1943.
Georg Heym (1887–1912)
*Der ewige Tag*. Leipzig, 1911.
*Umbra Vitae: Nachgelassene Gedichte*. Leipzig, 1912.
Georg Trakl (1887–1914)
*Gedichte*. Leipzig, 1913.
*Sebastian im Traum*. Leipzig, 1915.
*Die Dichtungen: Erste Gesamtausgabe*. Leipzig, 1917.
Gottfried Benn (1886–1956)
*Morgue und andere Gedichte*. Berlin, 1912.
*Söhne: Neue Gedichte*. Berlin, 1913.
*Fleisch: Gesammelte Lyrik*. Berlin, 1917.
*Schutt*. Berlin, 1925.
*Betäubung*. Berlin, 1925.
*Spaltung*. Berlin, 1925.
*Zweiundzwanzig Gedichte, 1936–1943*. Private printing, 1943.
*Statische Gedichte*. Zürich, 1948.
*Trunkene Flut: Ausgewählte Gedichte*. Wiesbaden, 1949.
*Fragmente*. Wiesbaden, 1951.
*Destillationen*. Wiesbaden, 1953.
*Aprèslude*. Wiesbaden, 1955.
*Gesammelte Gedichte*. Wiesbaden, Zürich, 1956.
*Primäre Tage: Gedichte und Fragmente aus dem Nachlass*. Wiesbaden, 1958.

# 7: Performing the Poem: Rituals of Activism in Expressionist Poetry

*Klaus Weissenberger*

OF THE TWENTY-THREE POETS Kurt Pinthus included in his anthology *Menschheitsdämmerung* (Dawn of Humanity, 1920),[1] only Benn, Lasker-Schüler, Heym, Stadler, and Trakl belong to the canon of German lyric poetry. According to general opinion, only these poets transcend the level of autoreferentiality; the others are sometimes labeled minor to the point of "iconoclastic barbarians" (Waller, 2) or their expressionistic beginnings deemed unpalatable for the present literary taste, as in the case of Franz Werfel. Their poetry seemed without the formal complexity, significance, and integrity attributed to those others in the canon, and instead seemed merely expressions of political activism or overweening pathos. In order to do justice to these poets, however, one must understand the complexity of the socio-political and literary situation in Germany between 1900 and 1910. Expressionists decried not only the bourgeois society, but also the contemporary art of Impressionism, *l'art pour l'art* or aestheticism, for avoiding social relevance by way of aesthetic forms that had become empty clichés. Accordingly, Pinthus characterizes the unifying stylistic traits as follows: "Niemals war das Ästhetische und das L'art pour l'art-Prinzip so mißachtet wie in dieser Dichtung, die man die 'jüngste' oder 'expressionistische' nennt, weil sie ganz Eruption, Explosion, Intensität ist — sein muß, um jene feindliche Kruste zu sprengen" (*MHD*, 29; Never before were aesthetics and the principle of *l'art pour l'art* as disdained as in this poetry, which is called the "newest" or "expressionist" because it is eruption, explosion, intensity — has to be in order to burst that hostile crust"; *DoH*, 35). With the title *Menschheitsdämmerung* ("Dawn of Humanity," or, more exactly, "Twilight of Humanity"), Pinthus consciously refers to the correlation of apocalypse and renewal as the principle tenor of the Expressionist movement (30), but he does not distinguish between the religious concept of the apocalypse as the end of history and just punishment for humanity's sins, on the one hand, and political revolution for the sake of social progress, on the other. Gerhard Kaiser maintains that the Expressionists as a whole belong to the former camp (509). But he also shies away from an exhaustive investigation of the period of Expressionism as such (880). In contrast, however, some poet-activists indeed had intended to revolutionize society,

though not necessarily along the lines of Marxist ideology; however, their proposed renewal was not simply spiritual.

In their revolt against the bourgeoisie, Expressionism and its offspring Dada represent the end of a sequence of social and literary movements that started in the late 1800s and that all criticized the bourgeoisie for its lack of values, double standards, hypocrisy, and complacency in the era of morals, education, and aesthetics. Friedrich Nietzsche served as the philosophical point of reference for disparate artistic developments (Naturalism, Symbolism or fin-de-siècle decadence, and Expressionism) in their shared criticism of bourgeois values and mentality. According to Ernst Blass's recollection, at the beginning of the Expressionist decade Nietzsche had been "in the air" at the gatherings at the Café des Westens in Berlin (Raabe, 29). Similarly, Gottfried Benn attests to the fact that all the ideas discussed *ad nauseam* by his generation derived from Nietzsche (1:482). They all identified with Nietzsche's concept of nihilism, the multi-facetedness of the "I," the doctrine of "superman," the "will to power" and the "artist-metaphysics," by which "the genius in the act of artistic production [. . .] is now at once subject and object, at once poet, actor, and spectator" (Nietzsche, 50). While their poetic responses varied, they all suffered from a dissociation of the self as a result of a dysfunctional community created by the social changes in Germany of the *Gründerzeit* after the founding of the empire in 1871.[2]

The previous predominantly agrarian society had been based on strong family ties, and life in the small and medium size towns was structured by church and the guilds, thus establishing a strong social net that provided a sense of belonging. These traditional social structures lost their exclusive status due to the rise of technology, industry, and high finance around the turn of the twentieth century and Berlin's resulting emergence as a metropolis; they were replaced by anonymous economic, financial, and bureaucratic organizations, which instilled in the individuals a feeling of isolation, uprootedness, and lack of self-esteem. In addition, the pace with which this change took place in Germany as a result of the victory over France did not allow for gradual adjustment and the development of countermeasures or institutions to mitigate its effects. The disintegration of the individual identity was mirrored by the demonic anonymity of the city, which became the predominant symbol of the malaise of the time, being in turn held responsible for the loss of self-esteem and dignity. At first, the degrading transformation of individuals to objects became most apparent in the factory workplace and thereafter in the war. The seeming lack of redeeming aspects in modernity led some poets to proclaim the imminent apocalypse or to repeat Nietzsche's denial of God's existence.

Only against this bleak view of the human condition at the time can one comprehend the Expressionists' ambivalence towards nature, their outcry for a messianic renewal of mankind, or their radical experiments with

language. These poets constantly experimented with images, forms, and themes, and influenced one another in the process. Especially the prewar phase, early Expressionism, was marked by that sort of dynamic interaction and reciprocal influence to such a degree that the lines between the various groups became blurred and even unrecognizable.

Ideologically, they were all indebted to Nietzsche for the fervor, energy, and dynamism of his vitalistic *Lebensphilosophie*. A well-defined poetic mission was absent in early Expressionist poetry, which was marked by two different concepts of activism: on the one hand, as criticism of society, and on the other, as affirmation of life and the fraternization of all mankind. Georg Heym is the most prominent representative of the former and Franz Werfel of the latter. The balance between these extremes characterizes poets of a less pronounced activist stance as well as poets like Georg Trakl, Ernst Stadler, Else Lasker-Schüler, Gottfried Benn, and Oskar Loerke, who integrated activist tension into poetic form. The First World War brought about the middle phase of Expressionism and forced poets to develop a more distinctive profile than before: abstract criticism of society led to the antiwar movement and calls for revolution, as in the case of Johannes R. Becher, or invested experiments with language as such with Utopian aspirations, as in the case of August Stramm. In Dada, which marks the late phase of Expressionist poetry, the revolution of poetic language has reached the level of anarchy.

In 1911, Kurt Hiller, the leader of the Neue Club in Berlin, proclaimed: "We are Expressionists. We are preoccupied again with content, volition, and ethos" (Hiller, 34) and outlined his anti-bourgeois program. In January of the same year, Jakob van Hoddis's poem "Weltende" (End of the World) appeared as the prototype for all subsequent apocalyptic renditions. Consequently, Pinthus opened his anthology with this poem.

> Dem Bürger fliegt vom spitzen Kopf der Hut,
> In allen Lüften hallt es wie Geschrei.
> Dachdecker stürzen ab und gehn entzwei,
> Und an den Küsten — liest man — steigt die Flut.
>
> Der Sturm ist da, die wilden Meere hupfen
> An Land, um dicke Dämme zu zerdrücken.
> Die meisten Menschen haben einen Schnupfen.
> Die Eisenbahnen fallen von den Brücken. (*MHD*, 39)

> [The burgher's hat flies off his pointed head,
> Everywhere the air reverberates with what sounds like screams.
> Roofers are falling off and breaking in two,
> And along the coasts — the paper says — the tide is rising.

> The storm is here, the wild seas are hopping
> Ashore to squash thick dikes.
> Most people have a cold.
> The trains are dropping off the bridges. (*DoH*, 61)]

At first glance, the poem is very unassuming and does not reflect the title's implication of ensuing doom. The two stanzas of four lines each have a regular iambic meter and rhyme scheme and, with the exception of the 5th line, the end of the sentence coincides with the rhyme. However, the sentences are not interconnected at all, but rather represent statements reported by an uninvolved observer, not unlike the assembly of different articles on a newspaper page, the primary medium of impersonal information about catastrophic events. In 1910, the return of Haley's Comet had prompted newspapers to publish numerous predictions of the world's end. The poem conflates the cosmic event and the apocalyptic predictions in almost comic personification of nature and objectification of humanity, and breathtakingly apodictic brevity. This perspective in turn underscores loss of control over the world, which relegates mankind to the role of passive bystander or helpless object. The bourgeois even loses his status symbol, the top hat, and the only response to all events, whether apocalyptic or ludic, is to catch a cold. With the world thus destabilized, the apocalypse seems imminent, a sense produced by alliterations and assonances, which connect the lines in vertical columns (*Bürger-Lüfte-stürzen-Küste*; *spitz-wie-liest-wild*; *Geschrei-entzwei-steigt*) to reinforce the paratactic style of the poem with its abrupt non sequiturs.

Most other poems by van Hoddis confine themselves either to man's recognition of the metaphysical abyss or, conversely, to the dissociation of self in bourgeois society and its ramifications. In the case of the former, van Hoddis divests sun, moon, and stars of their traditional Romantic values, demystifying with ridicule: the sun is dangling from a "Leiterwagen" (ladder-wagon; 144) or he calls it "fette Feuerglatze" (fat fire baldhead; 34); the "moons" are producing "Tollkirschen" (deadly nightshade cherries; 144) or the poet calls the moon provocatively "meine Tante" (my aunt; 49).[3] The poem "Morgens" (*MHD*, 121–22; In the Morning; *DoH*, 191–92) transfers this celestial devaluation to society; the qualities of renewal and a fresh start normally associated with the morning are replaced by "die Morgensonne rußig" (*MHD*, 121; sooty the morning sun; *DoH*, 191), "mürrisches Mühn" (sullen toil) and a "schmutzig fließender Strom" (foully flowing river; *DoH*, 191). In van Hoddis's poem "Die Himmelsschlange" (The Celestial Snake; 46), the reverse transfer of society's festive high life to heaven produces, on the occasion of Lucifer's visit, a grotesque travesty of the heavenly host. In the illusion of transcending time and space, the new medium of film symbolizes chaotic simultaneity: "Und in den dunklen Raum — mir ins Gesicht — / Flirrt das hinein, entsetzlich! nach der

Reihe!" (all that is flocking into the dark room — into my face — how terrible! one after the other; 25).

Alfred Lichtenstein consciously adopts this style of apocalyptic understatement by creating a state of apparent normalcy in the poem "Dämmerung" (Dusk, 1911):

> Ein dicker Junge spielt mit einem Teich.
> Der Wind hat sich in einem Baum gefangen.
> Der Himmel sieht verbummelt aus und bleich,
> Als wäre ihm die Schminke ausgegangen.
>
> Auf langen Krücken schief herabgebückt
> Und schwatzend kriechen auf dem Feld zwei Lahme.
> Ein blonder Dichter wird vielleicht verrückt.
> Ein Pferdchen stolpert über eine Dame.
>
> An einem Fenster klebt ein fetter Mann.
> Ein Jüngling will ein weiches Weib besuchen.
> Ein grauer Clown zieht sich die Stiefel an.
> Ein Kinderwagen schreit und Hunde fluchen. (*MHD*, 47)
>
> [A plump kid is playing with a pond.
> The wind has gotten caught in a tree.
> The sky looks hung over and pale,
> As though it had run out of makeup.
>
> Stooped down crookedly on long crutches
> And chattering two cripples creep across the field.
> A blond poet may well be going crazy.
> A little horse is tripping over a lady.
>
> A fat man is glued to a window.
> A youth wants to visit a soft woman.
> A gray clown is pulling on his boots.
> A baby-carriage screams and dogs curse. (*DoH*, 70)]

By lining up random subjects — boy, wind, sky, lame ones, poet, little horse, man adolescent, clown, buggy, and dogs — and presenting them from different perspectives, Lichtenstein creates a collage of images artificially joined together by their setting at dusk. This manipulation of the various agents renders them into objects; their incongruous juxtaposition creates a disorientation, which increases to the level of the grotesque: the line "Ein Pferdchen stolpert über eine Dame" (A little horse is tripping over a lady) would rather apply in German to an accident between the knight and the queen on a chess board (see Kaiser, 517). The fat man sticks like a fly to the window glass, a buggy shouts and, in a reversal of the

common curse "Du Hund!" (You dog!) dogs themselves curse, most likely: "Du Mensch!" (You human!). The "blond poet" on the verge of madness offers a glimpse of the lyrical self. Gerhard Kaiser suggests (519) that the majority of these images are distorted allusions to works of art: most prominently, the pond might allude to the lake poems of Klopstock and Goethe; the little horse and the lady to Pegasus and the Muse, the clown to Picasso's harlequins, etc. The title could even allude to Hofmannsthal's poem "Ballade des äußeren Lebens" (Ballad of External Life), which also connects images of decay from the perspective of an uninvolved observer. Hofmannsthal's poem, however, ends with the word "Abend" (evening) to symbolize closure and fulfillment, thus allowing for "Tiefsinn und Trauer" (deep thought and mourning), whereas Lichtenstein's poem does just the opposite by deconstructing art and poetry, and culminating in the dog's imprecation "You human!" as disdainfully demonstrative as Pontius Pilate's "Ecce Homo" (Behold the man!).

Of special interest in this poem is the stylistic device of stringing along the impressions line by line connecting them only by the steady rhythm and rhyme. After van Hoddis's "Weltende," Lichtenstein intensified this cutting technique from film, which introduced to poetry the notion of simultaneity, a new concept as a result of consistent poetic parataxis. Georg Heym had made the following entry in his diary: "Ich glaube, daß meine Größe darin liegt, daß ich erkannt habe, es gibt wenig Nacheinander. Das Meiste liegt in einer Ebene. Es ist alles ein Nebeneinander" (I believe that my greatness lies in my recognition that there is little sequence. Most things lie on a flat plane. Everything is in juxtaposition; 1960, 140). Ultimately, this concept led to the "simultaneous poem" of the Dadaists. Like van Hoddis, Lichtenstein viewed film as symbolic of the reversal of subject-object relations in modern society, whereby man has fallen under the spell and the control of the material world of objects and of anonymous forces. Likewise, in its early stages film consisted of disconnected scenes, shown in courtyards or at carnivals, as in the poem "Kientoppbildchen" (Little Scenes from the Flicks). In addition, the outdoor setting after dark creates a ghost-like atmosphere that blurs the difference between film and reality: "Der Abend bringt den Zeitvertreib, / Laternen, Mond, Gespenster. / Recht häufig hängt ein altes Weib / In einem kleinen Fenster" (The evening provides pastimes, / lanterns, moon, ghosts. / Rather often an old woman is hanging / in a small window; 37).[4]

This microcosmic reduction of life to trivialities and banalities has of course its macrocosmic equivalent: "Die Sonne, eine Butterblume, wiegt sich / Auf einem Schornstein, ihrem schlanken Stiele" (The sun, a buttercup, is rocking on a chimney, its narrow stem, 78); sky and heaven appear as "ein alter Lappen [. . .] heidenhaft und ohne Sinn" (an old rag [. . .] heathenous and without meaning, 46) or even grotesquely as "ein graues Packpapier, / Auf dem die Sonne klebt — ein Butterfleck" (The sky is gray

wrapping paper, to which the sun is glued — a butter smudge; 72). The only answer to prayers appears in the reflection of "ein Fetzen Mondlicht [. . .] in Kloaken" (a scrap of moon light in the sewage; 66). Lichtenstein is fascinated by the nightlife of Berlin — "So taumelnd wird man von den Augenspielen. / Den Himmel süßt der kleine Mondbonbon" (One gets dizzy from the play of the eyes. The little moon candy sweetens the sky; 110), but daily routine turns mankind into animals under a stampede: "Viel Tage stampfen über Menschentiere" (a herd of days trample over human animals; 66). Ultimately, city life immobilizes the individual, robbing the senses one by one: the streets run through the "erloschenen Kopf" (the burned-out head), the flesh gets punctured by "Dornrosen" (briar roses), further, "das Herz ist wie ein Sack. Das Blut erfriert" (the heart is like a sack. Blood freezes) until the collapse of the world coincides with the demise of the individual: "Die Welt fällt um. Die Augen stürzen ein" (The world collapses. The eyes cave in; 80).

In this context, Lichtenstein's poem "Die Operation" (54) deserves special attention, because, on one hand, it represents the poetic potential of ugliness as an extension of the big city theme; the early Expressionists developed a regular cult of the ugly by making hitherto unacceptable subject matters their special concern — like the morgue, the surgery room, suicide, mental illness, and prostitutes. However, after having sketched in a few bold strokes the operation as not unlike the scene of a sacrifice — "Im Sonnenlicht zerreißen Ärzte eine Frau. / Hier klafft der offne rote Leib. Und schweres Blut / Fließt, dunkler Wein, in einen weißen Napf" (The doctors tear up a woman in sunlight. Here the open red body is split up. And heavy blood flows, dark wine, into a white bowl; 54) — Lichtenstein contrasts the intensity of the "eucharistic" event with the lack of participation of the "congregation": "Eine Pflegerin / Genießt sehr innig sehr viel Wurst im Hintergrund" (A nurse / very much enjoys very much sausage in the background).[5] The clinic becomes a metaphor for the modern stage of social interaction, where rational arguments of purported benefit justify the objectives.

With the advent of leisure time after work, even the escape mechanisms of excursions ("Ausflug" [57] or "Sommerfrische" [77]) only unveil their deceptive function to cover up the tedium and meaninglessness of life: "Die Erde ist ein fetter Sonntagsbraten, / Hübsch eingetunkt in süße Sonnensauce" (Earth is a fat Sunday roast, nicely dipped in the sun's sweet gravy; 77). Recognizing the futility of protesting against the cosmos — "Gegen den unsinnig großen, / Tödlich blauen, blanken Himmel" (Against the crazily big, deadly blue, bare sky; 57) — Lichtenstein places all his hopes on a social upheaval: "Wär doch ein Sturm . . . der müßt den schönen blauen / Ewigen Himmel tausendfach zerfetzen" (If only there were a storm . . . that would have to shred the beautiful blue eternal sky [heaven] into a thousand pieces; 77). In the battles of the war, however,

Lichtenstein's cathartic enthusiasm gives way to somber assessment: "Ich stemme mich steil in das Graue / Und biete dem Tode die Stirn" (I brace myself steeply into the gray and defy death; 123). He died from a gunshot wound on September 25, 1914.

With Georg Heym and van Hoddis, Ernst Blass was one of three poets among the students who founded the Neue Club in 1909 in Berlin. The title of his first volume of poetry, *Die Straßen komme ich entlanggeweht* (Blown Down the Streets I Come) of 1912, is symptomatic of the countercultural thrust of the new movement. His preface to this volume is a manifesto legitimizing the everydayness of the new poetic sound, which consists of "das Wissen um das Flache des Lebens, das Klebrige, das Alltägliche, das Stimmungslose, das Idiotische, die Schmach, die Mießheit" (the knowledge of life's flatness, the stickiness, the triteness, the boredom, the idiocy, the humiliation, the morose; Blass 1912, 5–6). It will be uplifting for the poet to admit "daß man noch in der Erhebung weiß, daß man nicht immer erhoben ist" (that one knows even in elevation that one is not uplifted all the time; 6). Accordingly, he attacked Romantic imagery (comparing, for example, moonlight to slime) and in the poem "Der Nervenschwache" (The Neurotic; 29) portrays this generation in its irritable sensitivity, fearing "Darmverschlingung, Schmerzen, Sterben, Zuhältermesser und die großen Hunde" (stoppage of the bowels, pain, dying, pimps' knives and the big dogs; 29). Conversely, the bourgeois suppresses any such notions by seeking the company of prostitutes and frequenting bars: "In der Bar / Verrät der Mixer den geheimsten Tip. / Und überirdisch, himmlisch steht dein Haar / Zur Rötlichkeit des Cherry-Brandy-flip" (The barmixer is revealing the most secret tip. And out of this world, divinely your hair complements the redness of the Cherry-Brandy-flip; 12). But Blass is also fascinated by the hustle and bustle of Berlin nightlife, for which he even forsakes sentimental and erotic love: "Fort mit dem süßen Blick! Fort mit dem Kusse! / Hörst du die roten Nacht- und Not-Alarme? / Die heißen, blassen Träume sind verstreut" (Let go the sweet glance! Away with the kiss! Aren't you hearing the red night- and emergency alarms? The hot, pale dreams are gone; 25). Likewise, a car ride becomes like a roller coaster, paling at its conclusion the sky and moon over Berlin: "Rechts steigt der Himmel dunstig schief empor, / Wo klein der Mond, ein weißer Tropfen, hängt" (To the right, the sky is rising mistily and awkwardly, where small the moon, a white drop, is hanging; 42). In poem after poem, Blass overstates and thereby undermines late Romantic diction to twist the poetic line and image into new, grotesque, and startling combinations.

Among the early Expressionist proponents of apocalyptic prophecy, Paul Zech adds a special note. Out of idealistic solidarity with the proletariat, he had worked from 1902 to 1903 in the coal mining area, where the borders of Germany, France, and Belgium form a triangle. For that reason,

his poems about industrial cities, coal mines, and forges reflect real life experiences, unlike other Expressionist poets, who employed such images in order to express their anti-bourgeois convictions. Likewise, the composition of Zech's poems is extremely coherent, almost to the point of being naturalistic, if it were not for an underlying tendency towards symbolism, which closes most of his poems with thundering finality. The poem "Fabrikstraße tags" (Factory Street by Day) dates from 1911:

> Nichts als Mauern. Ohne Gras und Glas
> zieht die Straße den gescheckten Gurt
> der Fassaden. Keine Bahnspur surrt.
> Immer glänzt das Pflaster wassernaß.
>
> Streift ein Mensch dich, trifft sein Blick dich kalt
> bis ins Mark; die harten Schritte haun
> Feuer aus dem turmhoch steilen Zaun,
> noch sein kurzes Atmen wolkt geballt.
>
> Keine Zuchthauszelle klemmt
> so in Eis das Denken wie dies Gehn
> zwischen Mauern, die nur sich besehn.
>
> Trägst du Purpur oder Büßerhemd —:
> immer drückt mit riesigem Gewicht
> Gottes Bannfluch: u h r e n l o s e   S c h i c h t. (*MHD*, 55)

> [Nothing but walls. Without grass and glass
> the street moves down the motley belt
> of façades. No trolley track hums.
> always the pavement glistens water-wet.
>
> If someone brushes against you, his gaze coldly cuts you
> to the quick, his hard steps hew
> fire from the steep fence, tower-high,
> even his short breathing makes clenched clouds.
>
> No penitentiary cell clamps
> in ice all thinking as firmly as this walking
> between walls that look only at each other.
>
> Whether you wear royal purple or hairshirt —:
> always pressing down with gigantic heaviness
> is God's anathema: *clockless shift*. (*DoH*, 77)]

At first glance, the sonnet form appears to be out of place with this material; however, Zech defended its use (see Newton, 27). Traditionally the sonnet represents the conflict between reality and art and its resolution, so

Zech's use of this form for such a topic is provocative in itself. The tension of the quasi-Petrarchan form brings the weight of tradition to bear upon the anonymous self, like the burden of God's curse or of godless capitalism. The deadening monotony exists in its own right and swallows up even the encounter of another person — the echo of the footsteps and the breath from hurrying confirm the inhumanness of the street that the people have internalized beyond seeking an escape. Correspondingly, the finite term of the prison sentence offers more hope. By making universal this prison-like condition, the final tercet offers a religious reason for this misery (Gen. 3:19; God's banishment of man from the Garden of Eden). The monotony of an endless factory shift becomes a metaphor for God's irrevocable curse. The finality of this verdict stands in stark contrast to Schiller's maxim: "Arbeit ist des Bürgers Zierde, Segen ist der Mühe Preis" (Work is the citizen's pride, blessing is for effort the prize). Modern capitalism destroys the humanist ideal of German classicism.

In the poem "Sortiermädchen" (Sorting Girls; *MHD*, 55–56; *DoH*, 78–79) in the lyrical form of the terza rima, associated with Dante's *Divine Comedy*, Zech presents the fate of the young female employees whose job it is to sort out metal pieces in a metal shop. The meter of the 13 verses is very regular, as is the rhyme scheme, which alternates between one- and two-syllable rhymes of the first and third line, reinforcing the permanence of the girls' fate in a deadening industrial job. Zech, however, does not describe the actual work, but rather the enervating environment that turns the young workers into parts of a mechanical process that operates like clockwork and thwarts any fulfillment of their dreams as young women: "Eingesponnen in des Uhrwerks engen Ring: / O was nützen Gifte ausge-laugt aus Fetzen / einer Jugend, die unfruchtbar verging!" (*MHD*, 56; Cocooned into the clockwork's narrow ring: / oh, of what use are poisons leached from shreds / of a youth that went by fruitlessly! *DoH*, 79). In contrast to the young men, who either turn their frustrations into revolu-tionary actions, or the young women on the other side of the canal, who go dancing, their thoughts are reduced to one thing: "metals." Although the last stanza appears to offer hope, their kiss loses its fervor when incor-porated into the ritual kiss of the priest's soutane. The ceremonial mechan-ics of religious ritual rob the kiss of passion and correspond to the routine of work: the two become interchangeable in their reduction of humans to objects.

Zech exemplifies this subjugation of man to object most convincingly in the sonnet "Fräser" (Milling Cutters):

> Gebietend blecken weiße Hartstahl-Zähne
> aus dem Gewirr der Räder. Mühlen gehn profund,
> sie schütten auf den Ziegelgrund
> die Wolkenbrüche krauser Kupferspäne.

Die Gletscherkühle riesenhafter Birnen
beglänzt Fleischnackte, die von Öl umtropft
die Kämme rühren; während automatenhaft gestopft
die Scheren das Gestänge dünn zerzwirnen.

Ein Fäusteballen hin und wieder und ein Fluch,
Werkmeisterpfiffe, widerlicher Brandgeruch
an Muskeln jäh empor geleckt: zu töten!

Und es geschieht, daß sich die bärtigen Gesichter röten,
daß Augen wie geschliffene Gläser stehn
und scharf, gespannt nach innen sehn. (*MHD*, 59)

[White hard-steel teeth flash imperiously
from the maze of wheels. Mills operate profoundly,
they pour onto the brick-paved ground
the cloudbursts of curled copper shavings.

The glacial coolness of gigantic bulbs
illumines flesh-naked beings who, drenched in oil drops,
work the combs; while the shears, automatically stuffed,
thinly twine the bars.

The clenching of a fist now and then and a curse,
foreman's whistles, disgusting stench of burning
abruptly licking upward along muscles: to kill!

And it happens that the bearded faces turn red,
that eyes become like cut glass
and sharply, intently gaze inward. (*DoH*, 80)]

Although the title refers to one or several metal millers, the first stanza is devoted entirely to the depiction of the milling machine, which assumes monstrous qualities in appearance and effectiveness: the teeth of the gears take on the aggressive posture of a giant dog, the grinding plates spew out clouds of curly copper shavings. The bizarre entanglement of the gears is reinforced by technical terms with surprisingly familiar names like combs, shears, bars. Those who work the machine turn into machine parts themselves, their bodies covered with oil and shining under the artificial light; the neologism *Fleischnackte* for "flesh-naked beings" strips them down to the level of functioning parts. After the caesura the focus shifts to humans, but not as persons, rather only in the form of metonymic body parts — fists, muscles, bearded faces, eyes — or spontaneous reactions to the functioning or malfunctioning of the machine: making a fist, cursing, the whistling of the foreman, the burning of skin, and the murderous "intent" of the machine. The workers are left to the mercy of the machine — "And

it happens" — their eyes have become precision instruments like gauges registering the impact of the accident. Then the gaze turns inward, though not to imply a potential for spiritual response: the last words "turned inward" imply a total emptiness as the corresponding psychological reaction to the subjugation by the machine, bringing to closure man's progressive reduction to a tool in inverse relation to the machine's feral vitality. Rather than using the plight of the workers for social protest, the sonnet form intensifies their isolation as "exotic creatures" in a cage, thus exposing the inhumanity of industrial work even more poignantly.

Behind this dismal assessment of labor stand Zech's firm convictions about the religious basis of life, which in modern times has lost the communal experience and thus requires the individual to compensate for that loss with the creative act: as he notes in "Die Grundbedingungen der modernen Lyrik" (The Basic Tenets of Modern Poetry): "Die metaphysische Glut der sehnsüchtigen, auf das Ewige gerichteten Einzelseele, die soviel wirrer, beladener verlassener vor dem Ewigen steht, als die von einem gemeinsamen Glauben und Geist getragene, lebt in dieser Religiösität, die nicht mehr in der Religion sich erlösen kann und mündet in die Gestaltung" (The metaphysical heat of those isolated souls looking longingly at the Eternal, those who stand so much more confused, burdened and abandoned before the eternal than those who are sustained by a common belief and spirit, draws upon their religiosity that cannot be redeemed by a religion and [instead] issues in artistic activity; 247). The sonnet "Die Häuser haben Augen aufgetan" (The Houses Have Opened Their Eyes) illustrates this claim:

> Am Abend stehn die Dinge nicht mehr blind
> und mauerhart in dem Vorüberspülen
> gehetzter Stunden; Wind bringt von den Mühlen
> gekühlten Tau und geisterhaftes Blau.
>
> Die Häuser haben Augen aufgetan,
> Stern unter Sternen ist die Erde wieder,
> die Brücken tauchen in das Flußbett nieder
> und schwimmen in der Tiefe Kahn an Kahn.
>
> Gestalten wachsen groß aus jedem Strauch,
> die Wipfel wehen fort wie träger Rauch
> und Täler werfen Berge ab, die lange drückten.
>
> Die Menschen aber staunen mit entrückten
> Gesichtern in der Sterne Silberschwall
> und sind wie Früchte reif und süß zum Fall. (*MHD*, 170)
>
> [In the evening things are no longer blind
> and hard as mortar in the surging-by

of hounded hours; wind carries from the mills
cooled dew and incorporeal blue.

The houses have opened their eyes,
the earth is again star among stars,
the bridges dive down into the riverbed
and swim there in the depths, boat next to boat.

Shapes grow massively from every bush,
the treetops waft away like lazy smoke,
and valleys throw off mountains that long oppressed them.

But human beings marvel with ecstatic
faces in the silver torrent of stars
and are like fruit ripe and sweet for falling. (*DoH*, 194)]

The poem presupposes that industrialization has transformed all workers into objects and objects into the mere material presence of their instrumental function, as suggested by the first lines, but also suggests that objects might come to life at night. In contrast to the demonization of the object world by day in the poem "Fabrikstraße tags," this poem suggests that in the evening all objects are inspired by communal spirit. Accordingly, the entire landscape becomes a sacred environment for Zech, reestablishing mythical time and space in union with the cosmos. But unlike the once unconscious belonging to the cosmic order, mythical time and space can now only be regained by a conscious process, the first stage of which is the recognition of the inherent unity between earth and cosmos, expressed by the anthropomorphosis of the landscape: objects lose their blindness, the houses open their eyes. Again the earth can resume its star-like activity of glowing in self-sufficiency without a superimposed utilitarian function.

Correspondingly, in addition to the houses, all the other structures like bridges give up their pragmatic use and become part of nature; rather than spanning the river, the bridges merge with it and float on it. This process leads to a liberation of nature with the landscape casting off all signs of oppression; in the case of the mountains, this amounts to a peaceful revolution by the valleys. Not until the last three lines, after this grand anthropomorphosis of nature has taken place, does the poem turn to the humans, whose role in this process is subordinate, because they have interfered with the earth's self-regenerating power and have to give up their control. For that reason, as admiring observers, they lose themselves into the stars. In that stage of sublime transport, death takes on the quality of ultimate fulfillment, expressed in the metaphor: "like fruit ripe and sweet for falling." As optimistic as this spectacular vision of the earth's restoration may be, Zech is very much aware of its tentativeness: not only does the sonnet form put this vision expressly and emphatically into the realm of art, but this vision requires a complete reversal

of mankind's behavior from dominance over nature to subordination under the cosmic law "vereinigt in der Trilogie der Leidenschaft, in die Reihe der großen geistig schöpferischen Mächte: Erkennen, Anschauen, Liebe" (in the sequence of the great spiritually creative powers: recognition, observation, and love; Pörtner, 1: 247).

At the opposite poles of Expressionist activism, Heym contributed demonizing metaphors of civilization and Werfel a sense of fraternal humanity with his "O Mensch-Pathos." Pinthus had included in his anthology twelve poems by Heym and twenty-seven by Werfel — the most of any poet — indicating the great popularity of his friend's poetry at that time, but that popularity has disappeared since then, whereas Heym's has continued to grow. During the short time between the founding of the Neue Club in March of 1909 and his death by drowning in a skating accident on January 16, 1912 at the age of twenty-five, Heym became identified almost immediately with a demonic, apocalyptic vision due to his ability to figure it metaphorically. Characteristic of his metaphors is their rich variation. Like many other Expressionists, he dismantles the traditional connotations of the "Mond" (moon) with an unusual metaphor: "In roter Tracht / Steht er, ein Henker, vor der Wolken Block" (in a red garb he stands there, an executioner, before the block of clouds; Heym, 1:243). However, in his poem "Den blutrot dort der Horizont gebiert" (He to whom, blood-red, the horizon there gives birth), the anti-bourgeois tenet is encompassed by the personification of the moon as a cosmic giant stepping across the globe at the time of the Babylonians who, by observing the orbits of the celestial bodies, still remained bound to the mythic foundation of their culture. In contrast to these prehistoric cultures, modern society has become void of any sustaining cultural memory linking it to cosmogonic and heroic origins. For that reason, Heym does not even have to employ traditional apocalyptic imagery to express the end of the world in his poem "Mitte des Winters" (Middle of Winter, 1:438). With the exception of the opening line "Das Jahr geht zornig aus" (The year ends in anger), no event prompts strong emotional reaction. The days are uneventful, the nights are likewise uninterrupted by cosmic signs and the "gray morning" promises only uncertainty. Correspondingly, the seasons pass monotonously, with all the fruit rotting on the vine, because modern society has eliminated the holiday in its original function: to reestablish magical or mythic time and to reaffirm communal identity, to provide structure, meaning, and a mythic sense of belonging (see Assmann/Sundermeier, 14–17). From this perspective, the apocalyptic implications of Heym's poem become apparent when he refers to the absence of the holy days in modern society. For Heym, this phenomenon is not restricted to German society; other cultures have also turned into, so to speak, "cold stars," having lost their original function.

Heym's extreme sensitivity to the implications and ramifications of the social and cultural malaise of his time reaches a peak in poems about the

modern city and war. "Der Gott der Stadt" (The God of the City), illustrates his remarkable demonization of the city in the mythic figure of Baal.

Auf einem Häuserblocke sitzt er breit.
Die Winde lagern schwarz um seine Stirn.
Er schaut voll Wut, wo fern in Einsamkeit
Die letzten Häuser in das Land verirrn.

Vom Abend glänzt der rote Bauch dem Baal,
Die großen Städte knieen um ihn her.
Der Kirchenglocken ungeheure Zahl
Wogt auf zu ihm aus schwarzer Türme Meer.

Wie Korybanten-Tanz dröhnt die Musik
Der Millionen durch die Straßen laut.
Der Schlote Rauch, die Wolken der Fabrik
Ziehn auf zu ihm, wie Duft von Weihrauch blaut.

Das Wetter schwält in seinen Augenbrauen.
Der dunkle Abend wird in Nacht betäubt.
Die Stürme flattern, die wie Geier schauen
Von seinem Haupthaar, das im Zorne sträubt.

Er streckt ins Dunkel seine Fleischerfaust.
Er schüttelt sie. Ein Meer von Feuer jagt
Durch eine Straße. Und der Glutqualm braust
Und frißt sie auf, bis spät der Morgen tagt. (*MHD*, 42–43)

[On a row of houses he sits squarely.
The winds camp blackly about his brow.
He gazes full of rage to where in distant loneliness
The last houses stray into the countryside.

Eventide makes Baal's red belly shine,
The big cities kneel around him.
Tremendous numbers of churchbells
Well up to him from a sea of black steeples.

Like a dance of Corybantes the music of millions
Thunders noisily through the streets.
The chimneys' smoke, the clouds from factories
Waft up to him like scent of incense turning blue.

The tempest smolders in his eyebrows.
The dark evening is stunned into night.
The storms flap their wings, gazing like vultures
From his head's hair which stands on end in anger.

He thrusts his butcher's fist into the darkness.
He shakes it. A sea of fire races
Through a street. And the fiery smoke roars
And consumes it, till late the morrow dawns. (*DoH*, 65–66)]

For Heym, the city serves as a throne to the god who rules it and embodies it at the same time. For that reason, his rule extends beyond the one city to include all the cities of the world in the original meaning of "catholic" as "all-encompassing": the cities have come to worship him with their noise of millions serving as corybantic music and the smoke from industrial smokestacks as incense, while the god's belly glowing red from the sunset completes the liturgical ritual for human sacrifices. However, this god cannot be satisfied by any sacrifice. Instead of justice, he represents naked brutality in the form of destructive thunderstorms and fire emanating from his "Fleischerfaust" (butcher's fist), a fire storm that consumes the city ("sie" in the last line can refer to city or people); the Baal-like god transforms into a Chronos-like Moloch devouring its own children and ultimately itself. All lines except one end in one-syllable rhymes, which produce a forceful hammering rhythm and lend monumental proportions to the mythical figure of this god.

In contrast to the allegorical personification of malign historical forces in a monstrous god, "Umbra Vitae" represents the collective human correlative in paradigmatic patterns of behavior. Accordingly, the rhythm is much more fluid, allowing for subtle shifts of meaning in this otherwise bleak enumeration of horror, doom, and anxiety:

Die Menschen stehen vorwärts in den Straßen
Und sehen auf die großen Himmelszeichen,
Wo die Kometen mit den Feuernasen
Um die gezackten Türme drohend schleichen.

Und alle Dächer sind voll Sternedeuter,
Die in den Himmel stecken große Röhren,
Und Zauberer, wachsend aus den Bodenlöchern,
Im Dunkel schräg, die ein Gestirn beschwören.

Selbstmörder gehen nachts in großen Horden,
Die suchen vor sich ihr verlornes Wesen,
Gebückt in Süd und West, und Ost und Norden,
Den Staub zerfegend mit den Armen-Besen.

Sie sind wie Staub, der hält noch eine Weile.
Die Haare fallen schon auf ihren Wegen.
Sie springen, daß sie sterben, und in Eile,
Und sind mit totem Haupt im Feld gelegen,

Noch manchmal zappelnd. Und der Felder Tiere
Stehn um sie blind und stoßen mit dem Horne
In ihren Bauch. Sie strecken alle Viere,
Begraben unter Salbei und dem Dorne.

Die Meere aber stocken. In den Wogen
Die Schiffe hängen modernd und verdrossen,
Zerstreut, und keine Strömung wird gezogen,
Und aller Himmel Höfe sind verschlossen.

Die Bäume wechseln nicht die Zeiten
Und bleiben ewig tot in ihrem Ende,
Und über die verfallnen Wege spreiten
Sie hölzern ihre langen Finger-Hände.

Wer stirbt, der setzt sich auf, sich zu erheben,
Und eben hat er noch ein Wort gesprochen,
Auf einmal ist er fort. Wo ist sein Leben?
Und seine Augen sind wie Glas zerbrochen.

Schatten sind viele. Trübe und verborgen.
Und Träume, die an stummen Türen schleifen,
Und der erwacht, bedrückt vom Licht der Morgen,
Muß schweren Schlaf von grauen Lidern streifen. (*MHD*, 39–40)

[People are standing forward in the streets
And gazing at the huge portents in the sky,
Where the comets with fiery noses
Sneak menacingly around the pointed towers.

And every roof is crowded with star-gazers
Who thrust enormous tubes into the sky,
And magicians growing out of attic holes,
Aslant in darkness conjuring a heavenly body.

Suicides walk about at night in great hordes,
Looking for their lost selves just ahead of them,
Stooping south and west and east and north,
Sweeping the dust with their arm-brooms.

They are like dust, it keeps for yet a while.
Their hair is already falling on the paths they tread.
They run so they can die, and die fast,
And are lying in the fields with their dead heads,

Still twitching sometimes. And the animals of the fields
Stand around them blindly and butt their horns

Into their bellies. They turn up their toes,
Buried beneath sage-brush and the briar.

The seas however stagnate. The ships
Hang in the waves, rotting and morose,
Scattered about, and no current is moved.
and all the courtyards of the skies are sealed off.

The trees do not change seasons
And stay eternally dead in their finality.
And across the decaying paths they spread
Their long finger-hands woodenly.

Whoever dies sits up straight trying to get up
And just as he has uttered one more word,
All at once he is gone. Where is his life?
And his eyes are shattered like glass.

Shadows are many. Cheerless and hidden.
And dreams that drag past silent doors.
And whoever wakes up, depressed by the light of morning,
Must rub heavy sleep from gray eyelids. (*DoH*, 61–62)]

The opening line sets the tone of nervous anticipation and utter helpless-
ness created by cosmic events. The poem consists of four parts, each one con-
taining two stanzas, except for the second part, which contains three. The
beginning portrays all of mankind being mesmerized by the unusual appear-
ance of comets, which "sneak" like wild animals around the city's towers,
against a night sky strongly reminiscent of van Gogh's paintings (see Salter).
Astrologers and sorcerers desperately try to glean the correct meaning of the
portentous celestial signs with the tools and practices of their dubious profes-
sion. The next sequence of three or four stanzas (depending on the version;
1:440–42) presents a picture of sickness, deformity, and suicide. Everyone
anticipates death or is driven by the desire to die; for that reason, they carry
their own deathbeds or gather in hordes like lemmings for their death-bound
migrations. Accordingly, their deaths lack any mythic qualities of dignity and
veneration. After this preoccupation with decay, the next two stanzas turn to
nature. The oceans curdle like milk, suspending the ships on the waves; all
celestial courts are closed for appeal, a metaphor made possible in German due
to the double meaning of *Hof* as court and celestial halo. Likewise, the seasons
have been suspended. Just as arms figure as lifeless brooms, tree branches
become skeletal "finger-hands," equally lifeless. Similarly, the common
metaphor in German "seine Augen brechen" (his eyes break, that is, glaze
over in death) for the moment of departure in death changes to the concrete
simile "seine Augen sind wie Glas zerbrochen" (his eyes are shattered like
glass) which reduces man's soul to an object, albeit fragile, void of redemptive

qualities. After the sullen registration of events, the question "Where is his life?" appears both naïve and eschatological. Life takes place in the shadow of death: the editor entitled the poem and the posthumously published volume of Heym's poems "Umbra Vitae." Whereas holidays in prehistoric cultures celebrate order and fecundity and serve to restore knowledge of the cosmic order in its beauty and mystery, in Heym's vision they signify the exact opposite: the disorder and barrenness in modern society. Jaded *ennui* turns into a thirst for a meaning, into mass hysteria, which replaces the ritualistic holi-day with war and rituals of destruction. Before the First World War many intellectuals longed for a war, like Heym in his prophetic poem "Der Krieg" (The War). Unlike van Hoddis's and Lichtenstein's mere reference to apocalypse, Heym's apocalypse is both prophecy and realization of the nightmare.

In his diary, Heym had been complaining about melancholy since 1909 and called it his "Krankheit" (illness; 3:128) to which he also referred as "inhaltsloses Dasein" (life without any content; 131), "Ereignislosigkeit des Lebens" (life in which nothing happens; 135), "Hunger nach einer Tat" (hunger for action; 135), "Fader Geschmack von Alltäglichkeit" (taste of commonness; 138). As a cure for this condition, he proposed "eine große Revolution" (a great revolution; 128), "eine Durchquerung Afrikas" (a crossing of Africa; 128) or "einen Krieg" (a war; 139). The most telling entry in this respect dates from Sept. 15, 1911 and reads:

> Mein Gott — ich ersticke noch mit meinem brachliegenden Enthousiasmus in dieser banalen Zeit. Denn ich bedarf gewaltiger Emotionen, um glücklich zu sein. Ich sehe mich in meinen wachen Phantasien, immer als einen Danton, oder einen Mann auf der Barrikade, ohne meine Jacobinermütze kann ich mich eigentlich garnicht denken. Ich hoffte jetzt wenigstens auf einen Krieg. Auch das ist nichts. (3:164)

> [My God — I am going to suffocate with my unutilized enthusiasm in these banal times. For I need forceful emotions in order to be happy. In my dreams, I see myself always as a Danton, or as a man on the barricades; I cannot conceive of myself any longer without a Jacobin cap. Now I had hoped at least for a war. That too comes to nothing.][6]

In a letter to a friend dating from the end of July 1911, Heym attributed his sickness to a "Mangel an Emotion, keine große Tätigkeit. Wäre ich doch in der französischen Revolution geboren. Heute gibt es nichts, für das man sich begeistern könnte, nichts, das man zu seiner Lebensaufgabe machen möchte, schlimmer als Pest und Cholera" (lack of emotion, no great activity. If only I had been born during the French Revolution. Today nothing exists one could get enthusiastic about, nothing that one would turn into one's life-work, worse than plague and cholera; Schneider, 75). However, instead of engaging in concrete socio-political activities, Heym sought refuge in the realm of his poetic imagination through

"befreiende Bilder erregender Ereignisse und großer Emotionen" (liberating images of exciting events and great emotions; 75).

Heym's war poem (*MHD*, 79–80; *DoH*, 99–100) demonizes war into a monstrous god-like figure, terrorizing society with his war dance. The rhymed couplets are like building blocks that form the giant figure from the bottom up. The poem begins with the dramatic anaphora "aufgestanden" (risen), partially in reference to the long peacetime since 1871, but partially also in reference to the dulling complacency to which war appeared the only remedy. Not only do ritual and its realization become one, but also war and holiday, in so far as war takes the place of holi-day. The giant crushes the moon, the Romantic symbol of harmony, and replaces it with his own destructive power, putting the citizens in awe, because it replaces their lost "sacred time." Consequently, all that "sacred time" stands for is being destroyed in a counter ritual: instead of effervescence, there is gloom; instead of opulence, want; instead of order, destruction. In modern society, individuals have lost their sense of community; they have been relegated to anonymity and passivity, controlled by the likewise anonymous force of war that runs its own course. The initial paralysis is shown rhythmically in the division of line 8 into three staccato parts: "Es wird still. Sie sehn sich um. Und keiner weiß" (It grows still. They look around. And no one knows). Line 10 responds to that with: "Eine Frage. Keine Antwort. Ein Gesicht erbleicht" (A question. No answer. A face goes pale). Such a community no longer draws upon the power of myth to provide a sense and meaning to life (see Assmann, 142). And, subsequently, a society that lacks cultural memory falls into disharmony and disintegration, as in line 14: "Und er schreit: Ihr Krieger alle, auf und an!" (And he cries: All you warriors, up and at 'em!). But there is no depiction of a specific battle; the god simply rules the people and they worship him and follow like cattle, their only act of volition being the self-sacrifice of a large city, which "warf sich lautlos in des Abgrunds Bauch" (threw itself without sound into the belly of the abyss). The god himself defies concrete characterization and is only defined by his activities and their effects. He takes on the qualities of the sacred in the *mysterium tremendum, numinosum et fascinosum* (see Otto), because Heym has replaced the aesthetics of beauty with those of unending ugliness. The monster's powers are self-regenerating, because they originate from the collective replacement of holi-day with the ritual of war. The poem cannot provide any of the cathartic effects of war, because unlike the rituals of "sacred time," from which the participants return "reborn" or "regenerated," there is no return from this perversion of ritual, which nonetheless reveals the social dimension behind the ritualistic *mysterium fascinosum* of power.[7]

In direct contrast to Heym, Franz Werfel is the most prolific representative of the Expressionist "O-Mensch-Pathos"; the titles of his early volumes of poetry speak for themselves: *Der Menschenfreund* (The World

Lover, 1911), *Wir sind* (We Are, 1913), *Einander* (Each Other, 1915). In these volumes he addressed in particular the alienation of man from any communal structure as a result of the particularism and anonymity of modern society. With messianic pathos Werfel proclaimed the brotherhood of mankind as the only way to overcome the existential loneliness and isolation of man. The way to this salvation is love in all its manifestations from intimate sexuality to universal love of mankind, implicating, however, the father figure as the prime culprit for the dysfunctional modern society. This mission necessitates the poet's willingness and ability to reach all of society; to this end, the poet has to eliminate the distance between himself and the reader and create the immediacy of the staged event. Yvan Goll's "Appell an die Kunst" (Appeal to Art) from 1917 proclaims in this respect:

> Wer ein Herz hat, der stellt sich vor die Menschen hin, der reißt sich auf und sagt den Schmerz der Millionen, die um ihn herum leiden.
>
> Der baut Tempel, weite Hallen, unendliche Gärten, zwitschernde Paradiese, die runden Gewölbe des Volkshauses, wo Brudermenschen zusammenstehen und zusammen leiden; Tribünen, von denen die rote Wahrheit erbarmungslos in die schwarze Welt geschüttet wird, Wahrheit, eine ätzende Helligkeit, schwerer zu ertragen für Menschenaugen als die Flüssigkeit der Sonne.
>
> [. . .] Und du Dichter, schäme dich nicht, in die verlachte Tuba zu stoßen. Kommt [*sic*] mit Sturm. (Pörtner, 144–45)
>
> [Whoever has a heart stands in front of the people, pulls himself together, and speaks the pain of millions who suffer around him.
>
> He builds temples, wide halls, unending gardens, twittering paradises, the round rotundas of the public congregation hall, where people stand together as brothers and suffer together; tribunes, from where the red truth is dumped mercilessly into the black world, from where truth, an acidic brightness, is more difficult to bear for human eyes than the liquid of the sun.
>
> (. . .) And you, poet, don't be ashamed to blow into the ridiculed tuba. Come storming.]

For Werfel, such an interaction with a reading audience must have taken place immediately after *Der Weltfreund* hit the stands; according to Otto Pick's recollection, when the literary circle in Prague's Café Arco came face to face with Werfel's poems:

> Belesenheit und philosophischer Ehrgeiz schwanden dahin. Schülerhaftes Geplänkel, Wettlauf der Talente, Überhebung des wühlenden Geistes, grotesker Indifferentismus und beharrliche Anrufung von Gazettengrößen — wie fortgeweht waren die abendlichen Spukgeister

unseres Kreises. Und dann begann — wir kannten und kannten sie nicht
— diese und jene Strophen, gesprochen-gedichtet vom Dichter,
aufzusteigen in das Stimmengewirr, in das bläuliche Grau des Zigaretten-
rauchs, zu übertönen die Cafégeräusche . . . Und Werfel sprach, Werfel
sang, Werfel wogte, Werfel wurde, nachdem er geworden . . . (quoted in
Soergel, 128).

[Education and philosophical ambition vanished. Pupil-like competi-
tion, butting heads of talents, hubris of the probing mind, grotesque indif-
ference, and stubborn support of tabloid greats — the nightly ghosts of our
circle were blown away. And then began — we knew and did not know
them — this and that stanza to emerge, written as spoken by the poet, into
the din of voices, into the blue grayness of the cigarette smoke to rise above
the noise of the café . . . And Werfel spoke, Werfel sang, Werfel floated,
Werfel became real, after he had arrived on the scene.]

The final poem "An den Leser" (To the Reader) illustrates Werfel's
messianic mission and its poetic implementation. By addressing the reader
as the *prima facie* representative of mankind, the poet proves he is worthy
of acceptance. The poet claims association with the underprivileged class
and confirms his messianic calling to establish "world brotherhood":

So gehöre ich dir und Allen!
Wolle mir, bitte, nicht widerstehn!
O, könnte es einmal geschehn,
Daß wir uns, Bruder, in die Arme fallen! (*MHD*, 279)

[Therefore I belong to you and to everyone!
Do not, please, do not resist me!
Oh, if one day it could be
That we, brother, would fall into each other's arms! (*DoH*, 301)]

Werfel substantiates his claim for solidarity with the reader most effec-
tively in specific genre-scenes, for which he used the sonnet form, quite
often with a grotesque effect. The poem "Konzert einer Klavierlehrerin"
(Concert of a Piano Teacher; Werfel 1967, 39–40) is written from the per-
spective of the young piano pupils attending the concert of their aging
teacher, who is wearing an attire far too revealing for the occasion and her
age. Likewise, the sonnet "Pompe funèbre" (40) unmasks the extravagant
orchestration of an important person's funeral as a meaningless masquer-
ade. The insistence on the funeral protocol exposes the empty mannerism
that turns the scene into a grotesquely disjointed performance, symbolic of
bourgeois society and art. The only persons specifically mentioned are
twenty orphans at the head of the procession, who, just like the "loose
roses" that they are carrying, are unconnected to the event. Werfel is also
able to use the same performative device to present his concept of a
*Gesamtkunstwerk* (total work of art), exemplified in his depiction of the

"grand opera," for which he had a life-long predilection. As a member of the audience, he longs to take over the role of the conductor in order to fully experience the multidimensionality of this art form, theater as music and music as theater, which was intended by its originators, the members of the Florentine Camerata, to provide the audience with the experience of a spiritual rebirth. Consequently, the lyrical "I" sacrifices himself, by throwing himself down from the "sky-high trampoline" into the finale in order to be met and uplifted by the uproar of the applause:

> Wie wunderbar! Mein weicher Sitz entschwand.
> Emporgehoben leicht verließ ich ihn,
> Und jetzo, wie durchschauert's meine Nerven . . .,
>
> Steh' ich aufschaukelnd, Arme ausgespannt,
> Bereit, vom himmelhohen Trampolin
> In das Finale mich hinabzuwerfen. (38)
>
> [How wonderful! My soft seat disappeared.
> Lifted lightly upward I left it behind,
> And now, my nerves are all a-quiver . . .,
>
> I stand, swinging upward, arms outstretched,
> Ready to throw myself from the sky-high trampoline
> Downward, into the finale.]

This vision avoids ridicule, because it exaggerates, in implicit self-irony, the spectator's self-centeredness as a grotesque distortion of the operatic intent.

Werfel is even able to introduce humor into the father-son conflict, in contrast to the melodramatic patricide of Hasenclever's drama *Der Sohn*. In the earlier sonnets "Gespräch" (Conversation; 1967, 40) and "Variation" (41) from the volume *Der Weltfreund* (The World Lover), old and young are pitted against each other in a combative dialogue; in the first instance, "Gesetz des Wachstums plötzlich aufgehoben [. . .] Allein der Kleine in Triumph und Hohn" (the law of maturity is suddenly suspended [. . .] the small one in triumph and defiance); in the second one, however, the tables are turned, and all the carefully constructed rhetorical finesse, presumably of the young one, is toppled by the final word "Nein!" Conversely, the later poem "Vater und Sohn" (Father and Son) is based on the generational conflict symptomatic of the time, and its metaphysical correlative. Werfel views the father-son conflict as emblematic for the cosmogonic process by which the original union is split up and ends in mortal combat.

> Wie wir einst im grenzenlosen Lieben
> Späße der Unendlichkeit getrieben

Zu der Seligen Lust —
Uranos erschloß des Busens Bläue,
Und vereint in lustiger Kindertreue
Schaukelten wir durch seine Brust.

Aber weh! Der Äther ging verloren,
Welt erbraust und Körper ward geboren,
Nun sind wir entzweit.
Düster von erbosten Mittagsmählern
Treffen sich die Blicke stählern,
Feindlich und bereit.

Und in seinem schwarzen Mantelschwunge
Trägt der Alte wie der Junge
Eisen hassenswert.
Die sie reden, Worte, sind von kalter
Feindschaft der geschiedenen Lebensalter,
Fahl und aufgezehrt.

Und der Sohn harrt, daß der Alte sterbe
Und der Greis verhöhnt mich jauchzend: Erbe!
Daß der Orkus widerhallt.
Und schon klirrt in unseren wilden Händen
Jener Waffen — kaum noch abzuwenden —
Höllische Gewalt.

Doch auch uns sind Abende beschieden
An des Tisches hauserhabenem Frieden,
Wo das Wirre schweigt,
Wo wirs nicht verwehren trauten Mutes,
Daß, gedrängt von Wallung gleichen Blutes,
Träne auf- und niedersteigt.

Wie wir einst in grenzenlosem Lieben
Späße der Unendlichkeit getrieben,
Ahnen wir im Traum.
Und die leichte Hand zuckt nach der greisen
Und in einer wunderbaren, leisen
Rührung stürzt der Raum. (*MHD*, 247)

[As once with boundless love we
Indulged in the fun and games of eternity
For the pleasure of the blessed —
Uranos opened up the blueness of his bosom,
And united in happy childlike loyalty
We rocked our way through his breast.

But woe! The ether got lost,
World roared and body was born,
Now we are estranged.
Somber from quarrelsome noonday repasts
Glances meet like steel,
Hostile and ready.

And in the sweep of his black cape
The old man, like the young, carries
Odious iron.
The words they speak reflect the cold
Animosity of their separated ages,
Livid and emaciated.

And the son waits for the old man to die
And the aged man laughs at me triumphantly: heir!
So that the underworld reverberates.
And already in our wild hands
The hellish violence — practically unavoidable —
Of those weapons clashes.

But even we are granted evenings
At the table's sublime household peace,
Where confusion is silent,
Where in our warm-heartedness we do not prevent
Tears agitated by the surging of the selfsame blood
From welling up and falling.

How once with boundless love we
Indulged in the fun and games of eternity
We surmise in a dream.
And the nimble hand moves tremulously toward the aged hand,
And in a wonderful, quiet
Stirring of the heart the cosmos falls. (*DoH*, 303–4)]

The poem sets out with the cosmic harmony between Uranos and Chronos, bonding on a celestial swing — an audacious transfer of bourgeois idyll onto the cosmos. This idyll, however, ends in the father-son catastrophe, as the name of Uranos reminds the reader. The expansion of the worldly conflict to its original state of harmony is counterbalanced by the reverse lowering of the mythical duel onto "the family dining table at noon as the battleground for family tragedies" (Kaiser, 2:566). The defiant father's challenge: "Erbe!" (Inherit!),[8] which rhymes with "sterbe" (die), combines the father's pretense of immortality with the tragic inevitability of the murderer-victim relation, a configuration that repeats itself from generation to generation. Against this background, the family dinners,

where peace could allow family bonds to prevail and tears — as in the case of Saul and David — express compassion and guarantee safety for all, appear to be only a postponement of the inevitable. Ultimately, this uncovering of metaphysical conflict allows the memory of the primordial state to take hold and the human conflict to be resolved in the course of time. The final tableau "And in a wonderful, quiet stirring of the heart the cosmos falls" signifies the restoration of primordial bliss in its timeless sanctity; for one brief moment, macrocosm and microcosm are in congruence.

This poem illustrates Werfel's definition of poetry: "Das ewige unerbittliche Bewußtsein vom Schöpfungsfehler, die lebendige Erkenntnis vom obersten Mißlungenheitskoeffizienten und seine Korrektur zu sein, . . . [. . .] Alle Poesie stellt eine Verwandlung dar, die Verwandlung der Wirklichkeit in die Richtigkeit, die Verwandlung der Sündhaftigkeit in die Erlöstheit, die Verwandlung der Welt in die Vorwelt (ins Paradies)" (the eternal unmitigated awareness of the flaw of creation, the living recognition of the supreme coefficient of failure and its correction. All poetry represents a metamorphosis, the metamorphosis of reality into trueness, of sinfulness into salvation, the metamorphosis of the world into the preworld [into paradise]; Werfel, 1992, 25). This metamorphosis should have a paradoxical but cathartic effect "das Leben unerträglich und heilig zu machen, und dich, oh Leser, bis zu den Schatten zu verfolgen!" (to make life unbearable and sacred and persecute you, oh reader, all the way to the grave; 25). Only a few of Werfel's Expressionist poems live up to this high level of poetic ethos (or ethical pathos). For that reason, some critics lump him together with the political activists of the time and call him "das klassische Beispiel für den Salonsozialismus der Generation" (the classical example of salon-socialism of this generation) and deem his poetry not free of "kitsch" (Muschg, 38). Whereas the criticism of his sort of "socialism" is an oversimplification of his call for "world brotherhood," the risk of kitsch in Werfel's Expressionist poetry is great, and can be attributed to the dimension of performance in his poetry; his poetry tries to return in the first instance to oral presentation and immediate audience engagement. The simplicity of language goes hand in hand with emphatic exaggeration in its articulation, a combination intended to bridge the gap between author as performer and the audience, in order to create a moment of "mythic time"; however, any failure to accomplish this at once reduces the poem to an array of sentimental emotions and overwrought verbal gestures: in other words, to kitsch.

In contrast to Werfel's sentimental "world brotherhood," Johannes R. Becher eventually proclaimed a socialistic one. In this development he followed Kurt Hiller's call for activism in response to the prolonged war. Hiller had amended his idealistic program to elevate the "deed" over pure ideology. He still believed, however, in the spiritual principle of this process and maintained that volition could assure him "Wir wollen, bei

lebendigem Leibe, ins Paradies" (to enter Paradise as a living being; Hiller, 401). But Becher went even further und placed his poetry in the service of concrete social change, as a comparison of two poems from 1914 and 1916 will demonstrate. The earlier poem "Der Wald" (The Forest; *MHD*, 155–56; *DoH*, 177–79) reflects the strong influence of Heym's poetic demonization of modern society. Here Becher identifies himself with the forest as the primeval state of the earth in contrast to the open plain, representing society. The forest poses a threat to the people from the plain, who have lost contact with its creative forces that then decay and expire.[9] The waning, or rather decaying, moon suggests the ultimate demise of the plain: "Hoch schwanket die Zitrone verfallenden Mondes über deinem Scheitel grad" (the lemon / Of the waning moon swings high above your head). Not only will those who enter the forest succumb to its intrinsic powers, but apocalyptic forces of destruction will also emerge and consume the lands "in meines letzten Brandes blutigem Höllenschein" (in the bloody hellish glow of my last conflagration), rushing "durch abendliche Welt" (through the evening [occidental] world), and culminating in a union between the forest and the plain, which is fatal for the latter. The death of society is necessary to atone for "Lästerung und Raub und Mord" (slander, robbery, and murder) and to prepare for the rebirth of mankind, a vision that the poem does not further define; the primeval forest implies, however, a pre-feudal and pre-capitalistic society. This ambiguity nonetheless changed for Becher because of the war and the increased momentum of the socialist movement in Germany, as exemplified by the poem "Der Dichter meidet strahlende Akkorde" (Becher, 1):

> Der Dichter meidet strahlende Akkorde.
> Er stößt durch Tuben, peitscht die Trommel schrill.
> Er reißt das Volk auf mit gehackten Sätzen.
> [ . . . ]
> O Trinität des Werks; Erlebnis, Formulierung, Tat.
> Ich lerne. Bereite vor. Ich übe mich.
>
> . . . bald werden sich die Sturzwellen meiner Sätze zu einer
> unerhörten Figur verfügen.
> Reden. Manifeste. Parlament. Der Experimentalroman.
> Gesänge von Tribünen herab vorzutragen.
>
> Der neue, heilige Staat
> Sei gepredigt, dem Blut der Völker, Blut von ihrem Blut,
> eingeimpft.
> Restlos sei er gestaltet.
> Paradies setzt ein.
> — Laßt uns die Schlagwetter-Atmosphäre verbreiten! —
> Lernt! Vorbereitet! Übt euch!

[The poet avoids radiant chords.
He blows through tubas, whips the drum to a shrill crescendo.
He incites the people with chopped sentences.
(. . .)
O trinity of the work: experience, formulation, deed.
I learn. I prepare. I train.

    . . . soon the gushing waves of my sentences will form an
           unprecedented figure.
Speeches. Manifestos. Parliament. The experimental novel.
Songs to be delivered from tribunes.

The new, holy state
be preached, injected into the blood of nations, blood of their blood.
Totally be it built.
Paradise commences.
— Let us spread the firedamp atmosphere! —
Learn! Prepare! Train!]

Becher came to see himself in the role of tribune and to believe at this stage that the function of poetry is to instigate the masses (Das Volk) to follow the poet's call. For Becher at this stage poetry has become an instrument to address the masses. The poem decries the poetic tradition of glorifying the existing state of affairs and exhorts the poet to adopt the role of demagogue. Accordingly, the poem progresses from a programmatic depiction of a demagogic style in explosive sentence fragments to the vision of paradisiacal conditions in a "new holy state" as a result of a total revolution, with predictable references to the Holy Roman Empire and the millennium. In order to realize this vision, the masses only have to emulate the poet's activities of education, preparation, and practice ("I learn. I prepare. I train"). The poet's account is altered, not unlike Christ's mandate to his disciples, to the command "Learn! Prepare! Train!" The rhetorical engagement of this command suggests the poet's abdication of traditional lyrical autonomy and self-referentiality, whereas the opposite is true of the most drastic experiments of Expressionist poetics, such as August Stramm's *Wortkunst* (Word Art) and eventually Dada.

In his manifesto "Die futuristische Literatur: Technisches Manifest" (Futurist Literature: Technical Manifesto), published in the 1912/13 issue of *Der Sturm*, Marinetti proclaimed the need to abolish "die lächerliche Leere der alten, von Homer ererbten Grammatik" (the ridiculous emptiness of the old grammar inherited from Homer; Anz/Stark, 604) and to create a new one by using only the verb infinitives, nouns in clusters without particles (wie, gleich, ebenso wie, ähnlich [as, like, so, as or similar to]) and by eliminating adjectives and adverbs: "Nur der unsyntaktische Dichter, der sich losgelöster Wörter bedient, wird in die Substanz der

Materie eindringen können und die dumpfe Feindlichkeit, die sie von uns trennt, zerstören" (Only the asyntactic poet, making use of unfettered words, will enter into the essence of matter and will be able to destroy the "deep" animosity that separates us from it; 608). With the help of an "eng-maschiges Netz von Analogien [. . .], das man in das Meer der Erschein-ungen versenken wird" (tightly woven net of analogies, which will be thrown into the sea of phenomena), all that exists "an Flüchtigem und Unfaßbarem in der Materie" (as an elusive intangible form in matter; 606) can be gathered and apprehended.

Although August Stramm was a personal friend of Herwarth Walden, the editor of *Der Sturm*, and had read Marinetti's "Futurist Manifesto," one should be careful not to identify his poetry exclusively with the mani-festo: rather, that document confirms Stramm's poetic concept, which per-haps became more radical after his encounter with Marinetti. As an employee of the German postal service, Stramm fittingly developed a laconic *Telegrammstil* to uncover the original semantic layer of words. Contrary to Marinetti's unconditional embrace of technological advances, Stramm's poetic innovations are based on a critique of language itself, which was a sign of the time.[10] Among the Expressionist poets from Pinthus's anthology, Stramm is the only one who has challenged the tradi-tional balance between phanopoia, melopoia, and logopoia, that is, the integration of the visual, acoustic, and semantic dimensions into an aes-thetic whole based on their reciprocal functionality (Pound, 26). However, Pinthus' assessment that Stramm had done so by simply granting melopoia superiority — supposedly he "ballte reines Gefühl zu donnernden Ein-Worten, gewitternden Ein-Schlägen" (pressed pure feeling into booming one-syllable words, thundering single blasts; *MHD*, 27) — does not do jus-tice to Stramm's visual reduction of the lyrical line or to the semantic devel-opment in each poem. Stramm's poetry is a disharmonious manifestation of the principal lyric constituents of phanopoia, melopoia, and logopoia.

The poem "Untreu" (Unfaithful) is from April or May 1914, when Stramm had not yet fully completed his transition to an abstract *Wortkunst* along the lines of Walden's art theory.[11] In a letter to Walden, Stramm explained his poetic rationale:

> "Welkes Laub" klingt zwar weicher, aber meinem Empfinden nach auch unbestimmter, während "Laubwelk" mehr den Begriff des Duftes enthält, auf den es mir ankommt. Auch fällt dadurch der doppelte, aufeinanderfolgende Wortanfang mit "W" fort, den ich gerade deshalb vermeiden möchte, weil ich die Vorsilbe "ver" als Gefühlswecker des Vergehens, des Verlassens absichtlich gehäuft habe. Endlich erweckt in mir die Häufung des "T" mit nachfolgendem "L" auch eine Vorstellung des Gleitens, des Vorbeiwehens des Atems!
>
> (Pörtner, 1:45)

["Wilted leaves" may sound softer, but according to my perception also less defined, whereas "foliage-decay" contains more the concept of the odor, which matters to me. By that also the two word beginnings with "w," which are repeated in rapid succession, are eliminated, which I want to avoid, because I intentionally increased the use of the prefix "ver" as emotional stimulus of transitoriness, of departure. Finally, the accumulation of the "T" with a subsequent "L" invokes in me also the concept of the gliding, the passing-by of the breath!]

This careful and meticulous weighing of denotative and connotative semantics against each other in a lengthy process of chiseling away at the conventional use of language dispels any notion of spontaneous outburst; in the case of this poem, 24 versions exist (see Stramm, 459):

> Dein Lächeln weint in meiner Brust
> Die glutverbissenen Lippen eisen
> Im Atem wittert Laubwelk!
> Dein Blick versargt
> Und
> Hastet polternd Worte drauf.
> Vergessen
> Bröckeln nach die Hände!
> Frei
> Buhlt dein Kleidsaum
> Schlenkrig
> Drüber rüber! (*MHD*, 61)

> [Your smile weeps in my breast
> The bitten-to-pieces-in-ardor lips chill
> On the breath foliage-decay odors!
> Your gaze encoffins
> And
> Hastens thumping words on top.
> Forgetting
> The hands then crumble!
> Openly
> Your dress-hem woos
> Flapping
> Thither hither above! (*DoH*, 83)]

The poem treats the age-old lament about a lover's unfaithfulness by referring to autumn as traditionally symbolizing the "wilting" of love as opposed to its blossoming in spring. However, the triviality of topic and reference serves as a contrast to the innovative linguistic rendering of deceit by way of the oxymoron "your smile weeps," the full meaning of which becomes only apparent by the transfer from "*your* smile" to "*my*

RITUALS OF ACTIVISM IN EXPRESSIONIST POETRY ♦ 215

breast." Similarly, the second and third lines are also based on oxymoronic tensions, the second between *glutverbissen* and *eisen*, the third between *Atem* and *welk*, all contributing to the semantic notion of incompatibility. The verb *wittern* (sniff, scent) also connotes a heightened olfactory awareness, letting the deceit radiate from the breath, followed by the gaze that seals the finality of the suspicion, so that the words, hastily spoken as a cover-up, sound like the shovels of dirt falling on the coffin, as part of the burial ritual, and just as automatically — actually almost unintention-ally — the hand gestures reinforce such a ritualistic ending of a relation-ship. After all the body parts of communication have acted out their role in this two-faced charade, the feeling of liberation breaks through and allows the lover's true frivolous nature to reveal itself with self-assured coquetry, in which the hem, in anticipation of a new relationship, takes on the role of revealing and covering up, playing the game of enticing and rejecting, a game which the former partner can only painfully watch from the side lines. Behind the common situation of a love relationship that has gone sour, Stramm reveals the fundamental dynamics of the relations between man and woman and how they play out as dramatically as in an opera, in which the reader participates with eyes and ears.

All of Stramm's poems center upon the relationship between man and woman, the "I" and the "You," and make readers part of this process of semantic "rebirth." This is even true of Stramm's war poems, which he wrote at the front, where he died on September 1, 1915. Although out-wardly these poems are not critical of war, they present war as the ultimate testing ground for Stramm's vitalistic philosophy of life and thus imply that at any moment death could prove his philosophy wrong. As a soldier, Stramm views himself, more than ever before, totally unaccountable to any spiritual authority at all: "Es gibt nichts über ihm [dem Soldaten] und er erkennt nichts über sich an. Er tritt die Erde und schießt den Himmel tot. Und Grausen ist in ihm, um ihn, er selbst ist Grausen. Aber stolzes göttliches Grausen. Alles ist ihm Spiel und er selbst wirft sich als Würfel. So kenne ichs und ich weiß so ists" (Nothing exists above him [the soldier] and he does not recognize anything above him. He tramples the earth and shoots the sky [heaven] dead. And horror is within him, around him, he himself is horror. But proud divine horror. Everything is a game and he casts himself as a die. Such I know and know that it is such; Pörtner, 1:49). Among these war poems, "Patrouille" (Patrol) best captures the Expressionist features of per-sonification and reduction in order to intensify the expression, here, of fear, anguish, and death in war:

> Die Steine feinden
> Fenster grinst Verrat
> Äste würgen
> Berge Sträucher blättern raschlig

Gellen
Tod. (*MHD*, 87)

[The stones are hostile
Window grins treachery
Branches strangle
Mountains bushes leaf swishy
Shriek
Death. (*DoH*, 108)]

Though there is no narrative context, the soldier on patrol is in danger, which increases with each line as with each step or each turn in another direction. The forceful brevity becomes so concentrated with pent-up tension that deceptive nature "screams" its true nature — death. Each individual object is stripped of poetic connotation — stones, window, branches, mountains, bushes — because all could serve here as places of concealment, as extensions of the enemy. Nature conceals menace. Sentimentality about nature has been banished by fearful alertness. Against the tide of sentimental usage in poetry, Stramm considered himself to be

ein Schwimmer, der immer wieder hochtaucht und staunend in die Sonne blinzelt und den Abgrund unter sich fühlt, den Abgrund in sich trägt. [. . .] Schlacht und Not und Tod und Nachtigall, alles ist eins! Es gibt keine Trennung! Es geht alles in eins und verschwimmt und erschimmert wie Sonne und Abgrund. Nur mal herrscht das vor, mal das. So kämpfen, hungern, sterben, singen wir. Alle! Soldat und Führer! Nacht und Tag. Leichen und Blüten. Und über mir scheint eine Hand! Ich schwimme durch alles! Bin alles! Ich!

[a swimmer who always emerges again and blinks his eyes in the sunlight surprised and feels the abyss below himself, bears the abyss in himself. [. . .] Battle and peril and death and nightingale, all are one! There is no such thing as division! Everything merges and blends together and shimmers like sun and abyss. Only sometimes this dominates, sometimes that. Thus we fight, starve, die, sing. All! Soldier and leader. Day and night. Corpses and blossoms. And above me shines a hand. I swim through everything! Am everything! Me! (56)]

Stramm is convinced that this mental state of fluidity is keeping him alive and accordingly, he establishes a correlation between himself as someone who is "ein Werder" (in a state of becoming, 54), and his yet to be written poetry, which is in the state of inception. Therefore he expects this poetry of the emergent "I" to protect him: "Ich stehe kalt und trotze allem. Und wenn mich das Mißtrauen überfällt und würgen will, dann wappne ich mich mit meinen ungeborenen, doch schon gezeugten

Werken!" (I stand coldly and defy everything. And if suspicion overcomes me and wants to strangle me, then I arm myself with my unborn, but already begotten, works! 54). Ultimately, for Stramm the poem gives birth to the self and the other, the "I" and "Thou" as the keystone to the founding of a new humanity, of mankind reborn.

Stramm's reduction of language to single words that concentrate in themselves a much larger mood and context provides a transitional step to the verbal experimentation of Dadaist poetry. The Dada movement was started in Zürich by an international group of artists of very different temperaments who were united by one common goal: to end the carnage of the First World War by deconstructing the cultural systems that generated it. To that end they founded the Cabaret Voltaire in Zurich in February 1916, and the movement received the name "Dada" without anyone able to attest to its exact origin (Richter, 31–32). The Rumanian Tristan Tzara proclaimed in his Dada-manifestos total anarchy from any and all systems and programs. For Hugo Ball, the initial leader of the Cabaret Voltaire, "Dada ist das Herz der Wörter" (1986, 156; Dada is the heart of words; 221);[12] with that he probably referred to magic spells and the power of primeval, adamic language (see Kuenzli, 69). On June 23, 1916 Ball introduced in a reading his new genre of poetry, "Poems Without Words":

> Man verzichte mit dieser Art Klanggedichte in Bausch und Bogen auf die durch den Journalismus verdorbene und unmöglich gewordene Sprache. Man ziehe sich in die innerste Alchemie des Wortes zurück, man gebe auch das Wort noch preis, und bewahre so der Dichtung ihren letzten heiligsten Bezirk. Man verzichte darauf, aus zweiter Hand zu dichten: nämlich Worte zu übernehmen (von Sätzen ganz zu schweigen), die man nicht funkelnagelneu für den eigenen Gebrauch erfunden habe. (Ball 1992, 106)

> [In these phonetic poems we totally renounce the language that journalism has abused and corrupted. We must return to the innermost alchemy of the word, we must even give up the word too, to keep for poetry its last and holiest refuge. We must give up writing secondhand: that is, accepting words (to say nothing of sentences) that are not newly invented for our own use. (Ball, 1996, 71)]

In a special costume, in which Ball resembled an obelisk, he recited his poems slowly and majestically. In order to overcome the initial tumultuous response to the apparent nonsensical lallolalia, he subconsciously reverted to "die uralte Kadenz der priesterlichen Lamentation [. . .], jenen Stil des Meßgesangs, wie er durch die katholischen Kirchen des Morgen- und Abendlandes wehklagt" (106; the ancient cadence of priestly lamentation, that style of liturgical singing that wails in all the Catholic churches of East and West; 71). The effect was in accordance with the intended staging:

"Ich wurde vom Podium herab schweißbedeckt als ein magischer Bischof in die Versenkung getragen" (106; I was carried down off the stage, covered in sweat, like a magical bishop in rapture; 71). One poem he recited was "Karawane" (The Elephant Caravan):

> jjolifanto bambla ô falli bambla
> grossiga m'pfa habla horem
> égoga goramen
> higo bloiko russula huju
> hollaka hollala
> anlogo bung
> blago bung
> blago bung
> bosso fataka
> ü üü ü
> schampa wulla wussa ólobo
> hej tatta gôrem
> eschige zunbada
> wulubu ssubudu uluw ssubudu
> tumba ba- umf
> kusagauma
> ba- umf                    (Schifferli, 65)

Scholars have a difficult time evaluating Ball's "phonetic poems," and refer to his preoccupation with the language mysticism of the Gnostics, especially Dionysios Areopagita and Hermes Trismegistos: "Der gesamte Gottesdienst ist Magie [. . .] Die eigentliche Mysterienfeier besteht in einer Abfolge unerklärlich erhebender Prozeduren. [. . .] Laternen und Lichter in leuchtender Symmetrie; ein primitives Gemisch von Tier- und Kinderlauten; eine Musik, die in längst verschollenen Kadenzen schwingt: all dies erschüttert die Seele und erinnert sie an ihre Urheimat" (The entire religious service is magic [. . .] The actual mystery celebration consists of a sequence of inexplicably uplifting rituals. [. . .] Lanterns and lights in illuminating symmetry; a primitive mélange of animal and children's sounds; a music that resonates in cadences which have been long lost: all this deeply moves the soul and harks back to its original home; Ball 1955, 48). In a similar vein, Ball refers to

Glauben an eine Ur-Erinnerung, an eine bis zur Unkenntlichkeit verdrängte und verschüttete Welt, die in der Kunst durch den hemmungslosen Enthusiasmus [. . .] befreit wird. [. . .] Im unbedacht Infantilen, im Irrsinn, wo die Hemmungen zerstört sind, treten die von der Logik und vom Apparatus unberührten, unerreichten Ur-Schichten hervor, eine Welt mit eigenen Gesetzen und eigener Figur, die neue Rätsel und neue Aufgaben stellt, ebenso wie ein neuentdeckter Weltteil. (Ball 1992, 110)

[. . . the belief in a primeval memory, in a world that has been supplanted and buried beyond recognition, a world that is liberated in art by unrestrained enthusiasm.[. . .] The primeval strata, untouched and unreached by logic and by the social apparatus, emerge in the unconsciously infantile [. . .], when the barriers are down; that is a world with its own laws and its own form; it poses new problems and new tasks, just like a newly discovered continent. (Ball, 1996, 73–74)]

Apparent in Ball's "phonetic poems" are reminiscences of word stems from various languages, animal sounds, and sounds created by movements. He also used a different font for each line of the "Caravan" poem. Despite Ball's intentions and poetic devices, the reader is hard pressed to accept them as poetry. The other members of the Zurich Dada movement, Richard Huelsenbeck, Hans Arp, Marcel Janko, and Tristan Tzara, went even further than Ball and created the "poème simultané," which Ball characterizes as follows:

Das ist ein kontrapunktliches Rezitativ, in dem drei oder mehrere Stimmen gleichzeitig sprechen, singen, pfeifen oder dergleichen, so zwar, daß ihre Begegnungen den elegischen, lustigen oder bizarren Gehalt der Sache ausmachen. [. . .] Das "Poème simultan" handelt vom Wert der Stimme. Das menschliche Organ vertritt die Seele, die Individualität in ihrer Irrfahrt zwischen dämonischen Begleitern. Die Geräusche stellen den Hintergrund dar; das Unartikulierte, Fatale, Bestimmende. Das Gedicht will die Verschlungenheit des Menschen in den mechanistischen Prozeß verdeutlichen. In typischer Verkürzung zeigt es den Widerstreit der vox humana mit einer sie bedrohenden, verstrickenden und zerstörenden Welt, deren Takt und Geräuschablauf unentrinnbar sind.

(Schifferli, 21–22)

[This is a contrapuntal recitative in which three or more voices speak, sing, whistle, etc. simultaneously, in such a way that the resulting combinations account for the total effect of the work, elegiac, funny or bizarre. [. . .]The subject of the poème simultané is the value of the human voice. The vocal organ represents the individual soul, as it wanders, flanked by supernatural companions. The noises represent the inarticulate, inexorable and ultimately decisive forces, which constitute the background. The poem carries the message that mankind is swallowed up in a mechanistic process. In a generalized and compressed form, it represents the battle of the human voice against a world which menaces, ensnares and finally destroys it, a world whose rhythm and whose din are inescapable. (Richter, 30–31)]

These happenings created a strong sense of community; yet in contrast to the communal recitals of "primitive" cultures, these Dada happenings were anarchic in nature, with no enduring or binding significance to the larger community; as early as July 1916 Ball broke with the group,

rejoined it in March 1917 and left it for good in June 1917. In contrast, Kurt Schwitter's poetry preserved some degree of visual, acoustic, and semantic coherence and thus only implied their total abolition. For that reason, his criticism of society was much more poignant and effective.

Schwitters's poetry between 1918 and 1922 appears to bear the direct influence of Stramm's *Wortkunst*. In 1918 he had come into direct contact with the *Sturm-Kreis* in Berlin and Stramm's poetry, which was congruous to his own collage technique. However, in his reduction of language to individual words, Stramm uses that process to arrive at a new level of semantic concentration; Schwitters, in contrast, is playing with parts of language in order to reveal their existing semantic potential derived from the arrangement of a poem. He defines the difference between the use of words in poetry and everyday language as follows:

> Worte und Sätze sind in der Dichtung weiter nichts als Teile. Ihre Beziehung untereinander ist nicht die der üblichen Umgangssprache, die ja einen anderen Zweck hat: etwas auszudrücken. In der Dichtung werden die Worte aus ihrem alten Zusammenhang gerissen, entformelt und in einen neuen, künstlerischen Zusammenhang gebracht, sie werden Form-Teile der Dichtung, weiter nichts. (Schwitters, 5:134)

> [In poetry, words and sentences are nothing more than parts. Their relation to one another is not the customary one of everyday speech, which after all has a different purpose: to express something. In poetry, words are torn from their former context, dissociated, and brought into a new artistic context; they become formal parts of the poem, nothing more.]

This concept allows Schwitters to liberate the poetic language from the restrictions of meaning:

> Elemente der Dichtkunst sind Buchstaben, Silben, Worte, Sätze. Durch Werten der Elemente gegeneinander entsteht die Poesie. Der Sinn ist nur wesentlich, wenn er auch als Faktor gewertet wird. Ich werte Sinn gegen Unsinn. Den Unsinn bevorzuge ich, aber das ist eine rein persönliche Angelegenheit. Mir tut der Unsinn leid, daß er bislang so selten künstlerisch geformt wurde, deshalb liebe ich den Unsinn. (Schwitters, 5:77)

> [Elements of poetry are letters, syllables, words, sentences. By evaluating the elements in their relation to each other, poetry is created. Meaning is only essential if it is also evaluated as a factor. I am pitting meaning against nonsense. I prefer nonsense, but this is purely a personal matter. I feel sorry for nonsense because up to now it so rarely was an object of the artistic process; for that reason, I love nonsense.]

However attenuated, Stramm has maintained the coherency of sense through a binding context that links the words together, despite the absence of syntax. Schwitters takes the next step toward breaking down words, language, into particles.

Schwitters calls his poetry *Merzdichtung*; a detached syllable from the word *Kommerz* (commerce), *Merz* designates his own concept of art in response to his exclusion from the Berlin Dada circle in 1919. His definition of *Merzdichtung* in his essay "Selbstbestimmungsrecht der Künstler" (The Artists' Right to Self-Determination) of 1919 is directed primarily against the bourgeois concept of art and poetry, but also against the Berlin Dada — circle, and distances him from the Expressionist *Sturm-Kreis*. The dangling adverbs in the statements — "Die Verdienste des Sturm um das Bekanntwerden Stramms sind sehr. Stramms Verdienste um die Dichtung sind sehr" (The merits of Sturm for making known Stramm are very. Stramm's merits regarding poetry are very; 5:38) — leave open the question whether these merits are negligible or great, and likewise, the question of Schwitter's own indebtedness to Stramm and the *Sturm-Kreis*. His definition of *Merzdichtung* exactly fits Dada, and Schwitters interjects critical comments not only on bourgeois society, but also on Berlin Dada:

> Die Merzdichtung ist abstrakt. Sie verwendet analog der Merzmalerei als gegebene Teile fertige Sätze aus Zeitungen, Plakaten, Katalogen, Gesprächen usw., mit und ohne Abänderungen. (Das ist furchtbar.) Diese Teile brauchen nicht zum Sinn zu passen, denn es gibt keinen Sinn mehr. (Das ist auch furchtbar.) Es gibt auch keinen Elefanten mehr, es gibt nur noch Teile des Gedichtes. (Das ist schrecklich.) Und Ihr? (Zeichnet Kriegsanleihe!) Bestimmt es selbst, was Gedicht, und was Rahmen ist. (5:38)

> [Merz poetry is abstract. Analogous to Merz painting, it uses as given parts whole sentences from newspapers, posters, catalogues, conversations, etc. with and without alterations. (That is terrible.) These parts do not have to fit the meaning, for meaning does not exist any more. (Also that is terrible.) Also, there is no elephant any more, there are only parts of the poem. (That is horrible.) And You! (Do sign war bonds!) You determine yourself what is poem, and what is frame.]

In this highly charged atmosphere, *Sturm* published Schwitter's poem "An Anna Blume" in August 1919, and its immediate success not only sealed the rift with the Berlin Dadaists forever but also established Schwitters as an artist to be reckoned with:

> Oh Du, Geliebte meiner 27 Sinne, ich liebe Dir!
> Du, Deiner, Dich Dir, ich Dir, Du mir, — — wir?
> Das gehört beiläufig nicht hierher!

> Wer bist Du, ungezähltes Frauenzimmer, Du bist, bist Du?
> Die Leute sagen, Du wärest.
> Laß sie sagen, sie wissen nicht, wie der Kirchturm steht.

Du trägst den Hut auf Deinen Füßen und wanderst auf die Hände,
Auf den Händen wanderst Du.

Halloh, Deine roten Kleider, in weiße Falten zersägt,
Rot liebe ich Anna Blume, rot liebe ich Dir.
Du, Deiner, Dich Dir, ich Dir, Du mir, — — wir?
Das gehört beiläufig in die kalte Glut!
Anna Blume, rote Anna Blume, wie sagen die Leute?

*Preisfrage*:

    1.) Anna Blume hat ein Vogel,
    2.) Anna Blume ist rot.
    3.) Welche Farbe hat der Vogel.

Blau ist die Farbe Deines gelben Haares,
Rot ist die Farbe Deines grünen Vogels.
Du schlichtes Mädchen im Alltagskleid,
Du liebes grünes Tier, ich liebe Dir!
Du Deiner Dich Dir, ich Dir, Du mir, — — wir!
Das gehört beiläufig in die — — Glutenkiste.

Anna Blume, Anna, A — — N — — N — — A!
Ich träufle Deinen Namen.
Dein Name tropft wie weiches Rindertalg.
Weißt Du es Anna, weißt Du es schon,
Man kann Dich auch von hinten lesen.
Und Du, Du Herrlichste von allen,
Du bist von hinten, wie von vorne:
A — — N — — N — — A.
Rindertalg träufelt STREICHELN über meinen Rücken.
Anna Blume,
Du tropfes Tier,
Ich — — — liebe — — — Dir!
                    (1:58–59)

[O beloved of my twenty-seven senses, I
love your! — you ye you your, I your, you my.
— We?
This belongs (by the way) elsewhere.

Who are you, uncounted female? You are
— are you? People say, you are, — let
them say on, they don't know a hawk from a handsaw.

You wear your hat upon your feet and walk round
on your hands, upon your hands you walk.

Halloo, your red dress, sawn up in white pleats.
Red I love Anna Blume, red I love your! — You
ye you your, I your, you my. — We?

This belongs (by the way) in icy fire.
Red bloom, red Anna Blume, what do people say?

Prize question: 1.) Anna Blume has a bird.

          2.) Anna Blume is red.

          3.) What color is the bird?

Blue is the color of your yellow hair.
Red is the color of your green bird.
You simple girl in a simple dress, you dear
green beast, I love your! You ye you your,
I your, you my. — We?
This belongs (by the way) in the chest of fires.
Anna Blume! Anna, a–n–n–a, I trickle your
name. Your name drips like softest tallow.
Do you know, Anna, do you know already?

you can also be read from behind, and you, you
the loveliest of all, are from behind, as you are from
before: "a–n–n–a".
Tallow trickles caressingly down my back.
Anna Blume, you trickle beast, I love your! (Richter, 141)]

The poem consists of a collage of petit-bourgeois sentimental love rhetoric, intermixed with the sociolect of the Berlin lower classes, references to Stramm's personal pronoun declinations in his poems, literary images and symbols of the Romantic period, segments of proverbs or idiomatic expressions, and a syllogistic quiz question. The collage nature of this love declaration establishes itself in various ways. The expansion of the normal five senses to twenty-seven right at the start ridicules hyperbolic language as such; it is complemented in German by the emphatic declaration of love in the incorrect grammatical case ("Ich liebe Dir!"). As if to confirm the incorrect use of grammar, it triggers the case paradigm of "Du," but in the incorrect order — "Du deiner dich dir, ich dir, du mir, — wir?" and thus alludes to Stramm in his probing the potential of the "I-You" relationship to reach the level of "We." But this higher level of poetic discourse is discarded immediately. This incorrect paradigm is rehearsed all together three times and thus serves to divide the poem into three segments. The first segment expands the trivial question "Who are you?" to its ontological dimension, but lets that one collapse by way of a nonsensical description of behavior followed up by a petty correction of grammar. The

second segment creates analogies to the family name "Blume" (Flower) and its color. The color of the red dress is transferred to the person in such a way that the "rote Anna Blume" refers more to a flower than to a person. That leaves the door open for exploring the application of the primary colors blue, yellow, red, and green, briefly alluding to the "blue flower" of the German Romantics and finally answering the syllogistic question "What color is the bird?" in the nonsensical way: "Red is the color of your green bird." The last segment, at which point the lover has changed to an animal, is devoted to the lover's qualities associated with her first name and pronounces the palindromic characteristics as if they were physical ones. Of course, lovers in Germany may use animal names as terms of endearment, but this sort of dripping sentimentality is carried out in the poem to an extreme: The palindromic pronouncement of the name takes on the quality of a caress, which literally drips tallow onto the speaker's back, culminating in the association of "tropfen" (drip) with "Tropf" as in "armer Tropf" (poor wretch), the ultimate juxtaposition of banality and creative playfulness, as also validated in the final line by the magic spell of the rhyme "Tier — Dir." But this magic quality of rhyme necessitates also the final use of incorrect grammar and thus preserves the absolute autonomy of this poem as art up to the very end. The grammatical dislocation conveys in conjunction with the rhyme a force of emotion beyond rational comprehension, a sort of transcendent loving nonsense. Despite the continuing popularity of this poem, it subverts, unrecognized by most readers, traditional concepts and values of love, language and poetry, and represents as such an unusual form of activism.

In this vein, Schwitters went on to write the "Nießscherzo. Das Ganze niesen" (1:244) and "Husten Scherzo. Das Ganze husten" (1:244–47) and the "Ursonate" ("Primeval Sonata"). The last consists only of vowels and syllables arranged in the form of a sonata 28 pages in length (1:214–42). These poems have rightfully been designated "performance scores" (Froehlich, 15) because only then do they come alive. Reactions from the audience to the "Ursonate" confirm the ultimate purpose intended by Schwitters of leading the "audience by way of confusion, boredom, tension, annoyance, and laughter to discover beauty, where they expected it the least" (28) and arriving at the conclusion that appears to have been to a greater or lesser degree the principal goal of all Expressionist poetry: "I felt as if we all had participated in a religious ritual" (25).

This investigation of activist Expressionist poets, who by and large have been forgotten, serves several purposes. For one, it should have become clear that the literary revolution prompted by their critique of bourgeois society and impressionist art characterizes all of Expressionist poetry. At its time, the activist camp of the Expressionist revolution was the most representative of the movement. As shown by the analysis of the various activist poets, they did not form a homogenous group. The period of strongest

cohesion was in the beginning, during the prewar years, when the demonization of industrial society and the city, and of traditional poetic images, prevailed. These poets even welcomed the war as a means to transform bourgeois complacency and chauvinism. The death of the majority of these poets very early in the war brought this phase to an abrupt halt. The antiwar movement changed the focus of the literary movement to a direct attack on society by social activism, on the one hand, and to an indirect subversion of society by Dada, on the other. Against the background of the multifaceted poetic accomplishments of the so-called activist poets of Expressionism, the specific contributions of the better known Modernist / Expressionist poets can be accurately assessed. The variety of their poetic innovations attests to the deep sense of crisis in this generation, the dissociation of the self in a rapidly changing society, to which the Expressionist movement was responding. Furthermore, although the conscious assimilation of cultic paradigms conveyed a new community, it was unable to consolidate itself in those utopian terms (and later took on more severely ideological forms in Fascism and Communism); that failure should not discredit the idealistic sense of mission itself. Those totalitarian regimes represented a political misappropriation of that mission, whose poetic legacy, albeit without the pathos and linguistic anarchy, endured through the twentieth century.

# Notes

[1] Kurt Pinthus, ed., *Menschheitsdämmerung: Symphonie jüngster Dichtung* (Berlin: Rowohlt, 1920; Hamburg: Rowohlt Taschenbuch Verlag, 1959, 1976). Unless otherwise indicated, all quotations from this anthology are designated by the abbreviation *MHD* and page number; all English translations are from *Menschheitsdämmerung / Dawn of Humanity: A Document of Expressionism*, trans. Joanna M. Ratych, Ralph Ley, and Robert C. Conard (Camden House, 1994) and are designated by the abbreviation *DoH* and page number.

[2] For a more detailed analysis of Expressionism from a perspective of "Geistesgeschichte" see S. Vietta/H.-G. Kemper, *Expressionismus* (Munich: Fink, 1975).

[3] Except for those poems from *Menschheitsdämmerung* (indicated *MHD* and *DoH*), page numbers refer to Jakob van Hoddis, *Dichtungen und Briefe*, ed. Regina Nortemann. Zürich: Arche, 1987.

[4] Except for those poems from *Menschheitsdämmerung* (indicated *MHD* and *DoH*), page numbers refer to Alfred Lichtenstein, *Dichtungen*, ed. Klaus Kanzog and Henrich Vollmer. Zürich: Arche, 1989.

[5] N.B. The repetition of "sehr" in this context indicates the trivialization of the original meaning of the verb stem "sehr-" in German, which means to harm.

[6] The latter remark is in reference to the so-called Moroccan Crisis, at the end of which war had been averted.

[7] G. Kaiser does not recognize this dimension of Heym's poem and therefore denies that it presents any "criticism of modern society in its historically specific traits [. . .] The poem is lyrical theater of cruelty; certainly readable as a symptom of the time, but without any diagnostic impulse" (G. Kaiser, 2:542–43).

[8] The translators did not recognize the imperative in the challenge "Erbe!"; the noun "Erbe" is much less dynamic in this case (303–4).

[9] Becher draws upon Droste-Hülshoff's imagery of "Der Knabe im Moor" (The Boy on the Moor).

[10] With regard to philosophy, one has to mention Wittgenstein, Husserl, Cassirer, Mach, and Mauthner, with regard to poetry, Hofmannsthal, Kraus, and Rilke.

[11] Walden demands that *Wortkunst* emancipate itself from the personality of the poet: "Was geht das Wort die Persönlichkeit an. Die Persönlichkeit bedient sich des Wortes. Das Wort wehrt sich, indem es der Persönlichkeit nicht dient. Das Wort herrscht, das Wort beherrscht die Dichter. Und weil die Dichter herrschen wollen, machen sie gleich einen Satz über das Wort hinweg. Aber das Wort herrscht. Das Wort zerreißt den Satz, und die Dichtung ist Stückwerk. Nur Wörter binden. Sätze sind stets aufgelesen" (What concern does the word have for the personality? The personality is making use of the word. The word is resisting by not serving the personality. The word is dominating, the word dominates the poets. And because the poets want to dominate, they immediately make a sentence by going beyond the word. But the word dominates. The word tears up the sentence, and the poetry is piece meal. Only words bind. Sentences are always picked up [leftovers]; Pörtner, 1:410).

[12] In citations of Ball's work "Das dadaistische Manifest," the first page number given refers to the German original, and that given after the translation refers to the Elderfield translation, "Dada Manifesto."

# Works Cited

Anz, Thomas, and Michael Stark, eds. *Expressionismus: Manifeste und Dokumente zur deutschen Literatur, 1910–1920.* Stuttgart: Metzler, 1982.

Assmann, Jan. *Das kulturelle Gedächtnis: Schrift, Erinnerung und politische Identität in frühen Hochkulturen.* Munich: Beck, 1997.

Assmann, Jan, and T. Sundermeier. *Das Fest und das Heilige: Religiöse Kontrapunkte zur Alltagswelt.* Gütersloh: Gerd Mohn, 1991.

Ball, Hugo. "Dada Manifesto." In *Flight Out of Time — A Dada Diary.* 219–21.

———. "Das dadaistische Manifest." Ausstellungskatalog, in *Hugo Ball (1886–1986): Leben und Werk,* ed. Ernst Teubner, 155–56. Berlin: publica, 1986.

———. *Flight Out of Time — A Dada Diary.* Ed. John Elderfield. Berkeley: U of California P, 1996.

———. *Die Flucht aus der Zeit.* Ed. Bernhard Echte. Zürich: Limmat. 1992.

————. Introduction to *Dionysios Areopagita: Die Hierarchien der Engel und der Kirche*. Munich: O. W. Barth, 1955. 19–95.

Becher, Johannes R. *An Europa: Neue Gedichte*. Leipzig: Kurt Wolff, 1916.

Benn, Gottfried. *Gesammelte Werke, vol. 1*. Wiesbaden: Limes, 1965.

Blass, Ernst. "The Old Café des Westens." In Raabe, *The Era of German Expressionism*, 27–33.

————. "Vor-Worte." In *Die Straßen komme ich entlanggeweht*. Heidelberg: Weißbach, 1912. Kraus Reprint, 1973.

Froehlich, A. J. P. "Reaktionen des Publikums auf Vorführungen nach abstrakten Vorlagen." In Wolfgang Paulsen and H. G. Hermann. *Sinn aus Unsinn: Dada International*, ed. Wolfgang Paulsen and H. G. Hermann, 15–28. Bern: Francke, 1982.

Heym, Georg. *Lyrik*. Vol. 1 of *Dichtungen und Schriften*, ed. Karl Ludwig Schneider. Hamburg: Ellermann, 1960.

————. *Tagebücher — Träume — Briefe*. Vol. 3 of *Dichtungen und Schriften*, ed. Karl Ludwig Schneider. Hamburg: Ellermann, 1960.

Hiller, Kurt. "Die Jüngst-Berliner." In Anz and Stark, *Expressionismus: Manifeste und Dokumente zur deutschen Literatur 1910–1920*, 34–36.

Kaiser, Gerhard. *Geschichte der deutschen Lyrik von Goethe bis zur Gegenwart*. Vol. 2. Frankfurt am Main: Insel, 1996.

Kuenzli, Rudolf. "The Semiotics of Dada Poetry." In *Dada Spectrum: The Dialectics of Revolt*, ed. Kuenzli and Foster. Iowa City: Coda Press, 1979.

Lichtenstein, Alfred. *Dichtungen*. Ed. Klaus Kanzog and Heinrich Vollmer. Zurich: Arche, 1989.

Muschg, Walter. *Von Trakl zu Brecht: Dichter des Expressionismus*. Munich: Piper, 1961.

Newton, Robert P. *Form in the Menschheitsdämmerung*. The Hague: Mouton, 1971.

Nietzsche, Friedrich. *Die Geburt der Tragödie aus dem Geist der Musik,* 1871. In English: *The Birth of Tragedy: The Complete Works*. Trans. William A. Haussmann. New York: Gordon, 1974.

Otto, Rudolf. *Das Heilige: Über das Irrationale in der Idee des Göttlichen und sein Verhältnis zum Rationalen*. Breslau: Trewendt and Granier, 1917.

Pinthus, Kurt, ed. *Menschheitsdämmerung: Symphonie jüngster Dichtung*. Berlin: Rowohlt, 1920; Hamburg: Rowohlt Taschenbuch Verlag, 1959, 1976. In English: *Menschheitsdämmerung / Dawn of Humanity: A Document of Expressionism*. Trans. J. M. Ratych, R. Ley, and R. C. Conard. Columbia, SC: Camden House, 1994.

Pörtner, Paul, ed. *Literatur-Revolution, 1910–1925: Dokumente, Manifeste, Programme*. Vol. 1. Darmstadt: Luchterhand, 1960.

Pound, Ezra. *The Literary Essays*. London: Faber & Faber, 1954.

Raabe, Paul, ed. *The Era of German Expressionism*. Trans. J. M. Ritchie. New York: Overlook Press, 1974.

Richter, Hans. *Dada — Art and Anti-Art*. New York and Toronto: Oxford UP, 1965.

Salter, Ronald. *Georg Heyms Lyrik: Ein Vergleich von Wortkunst und Bildkunst*. Munich: Fink, 1972.

Schifferli, Peter, ed. *Das war Dada: Dichtungen und Dokumente*. Munich: dtv, 1963.

Schneider, Karl Ludwig. *Zerbrochene Formen: Wort und Bild im Expressionismus*. Hamburg: Hoffmann und Campe, 1967.

Schwitters, Kurt. *Die Lyrik*. Vol. 1 of *Das literarische Werk*, ed. Friedhelm Lach. Cologne: DuMont, 1973.

———. *Manifeste und kritische Prosa*. Vol. 5 of *Das literarische Werk*, ed. Friedhelm Lach. Cologne: DuMont, 1981.

Soergel, Albert, and Curt Hohoff. *Dichtung und Dichter der Zeit*. Vol. 2. Düsseldorf: Bagel, 1963.

Stramm, August. *Das Werk*. Ed. R. Radrizzani. Wiesbaden: Limes, 1963.

van Hoddis, Jakob. *Dichtungen und Briefe*. Ed. Regina Nörtemann. Zürich: Arche, 1987.

Vietta, Silvio, and Hans-Georg Kemper. *Expressionismus*. Munich: Fink, 1975.

Waller, Christopher. *Expressionist Poetry and its Critics*. Leeds: W. S. Maney, 1986.

Werfel, Franz. "Brief an einen Staatsmann." In *"Leben heißt sich mitteilen": Betrachtungen; Reden; Aphorismen*. Frankfurt am Main: Fischer, 1992. 19–25.

———. *Das lyrische Werk*. Ed. Adolf Klarmann. Frankfurt am Main: Fischer, 1967.

Zech, Paul. "Die Grundbedingung der modernen Lyrik." In Pörtner, *Literatur-Revolution, 1910–1925: Dokumente, Manifeste, Programme*. 245–47.

# Drama

# 8: Provocation and Proclamation, Vision and Imagery: Expressionist Drama between German Idealism and Modernity

*Ernst Schürer*

WHEN WE THINK OF THE LITERATURE OF EXPRESSIONISM (1910–1923), its lyrical poetry and dramatic works immediately come to mind. The two genres are indicative of the two poles of the literary movement: its subjectivity and private nature on the one hand, and its desire for human interaction and public appeal on the other. In Expressionist drama alone both poles are also represented, the private and the public, the subjective and the objective world. This two-pronged approach appealed to contemporary audiences, with both its concern for the personal problems of the individual and its engagement of social and political issues. It also caused problems for the playwrights, who had to resort to new forms and high pathos to effect this symbiosis, which in turn brought an immediacy and vibrancy to Expressionist drama. The overall impression of a new movement with new structures and modes of expression, however, belies its historical embeddedness and dialectical indebtedness. To discuss the roots of Expressionist drama in German literature and thought, we have to step back and take a look at the historical development of drama in Germany.

The first section of this article explores the affinity of Expressionist drama to the plays of the *Sturm and Drang* as well as to the period of Weimar classicism and its intellectual legacy. The fact that the Expressionists explicitly rejected the classical heritage does not disprove their indebtedness in terms of language and topics. The second section addresses the birth of the Expressionist drama "from the spirit of the modern"; in spite of its classical literary lineage, Expressionist drama was part of aesthetic modernity. Its call for a regeneration of the individual will be examined and analyzed in specific types of Expressionist plays. The third section explores the imagery of Expressionist drama and its sources, since metaphor, allegory, and symbolism in general play a crucial role in conveying the meaning of the text. The concluding remarks in the final section make it clear that the new element in Expressionist drama is not its language but rather its forms and content, which reflect modern society. Although the

playwrights criticized the symptoms of modern development, they were not political revolutionaries but rather radical *Bürger* and *citoyens* who wanted to recapture for themselves and all humanity the ideals of the Enlightenment and the French Revolution of 1789, namely *liberté*, *égalité*, and *fraternité*, in order to create the foundation for a better society.

In the history of modern German literature, the dramatic genre has played an important, if not the most important, role, especially in the eyes of the public, and its function and significance in German cultural and social life have remained a topic of discussion continuously since at least the days of Johann Christoph Gottsched (1700–1766). Audiences and critics have based the status and rank of this genre not only on the literary quality of the dramatic canon but also on the production of the plays on stage and their reception, which ultimately determine the stature of a drama. In contrast to a poem or a novel, which appeals to the individual reader, drama needs stage production and addresses a theater audience and, at least in theory, the general public. In the tradition of Horace's *prodesse et delectare*, German playwrights have endeavored not only to entertain but also to enlighten their audiences about social and political problems. Expressionist drama, with its critique of its times and society, its calls for change, and its search for a better world, very much conforms to this prominent aspect of the genre.

German drama has blossomed in times of crisis, as during the eighteenth century, when it was adopted by the politically disenfranchised middle class. Gotthold Ephraim Lessing led the attack against courtly tyranny with *Miss Sara Sampson* (1755) and especially with *Emilia Galotti* (1772). Although they rejected Lessing's enlightened rationality, the youthful and rebellious authors of the *Sturm und Drang* (Storm and Stress, 1765–85) took up his cry for social justice and his advice to look to Shakespeare for dramatic inspiration. Aspiring authors such as Johann Wolfgang Goethe, with his *Götz von Berlichingen* (1773) and *Urfaust* (1773/75), and Friedrich Schiller, with his *Die Räuber* (The Brigands, 1781), and *Kabale und Liebe* (Cabals and Love, 1784), revolutionized the dramatic literature of their times. Together with other young rebels, such as Jakob Michael Reinhold Lenz, Friedrich Maximilian Klinger, and Heinrich Leopold Wagner, in their plays they exposed the conventions of polite society and the tyranny of the upper class, especially the despotism of the nobility and the strict fundamentalism of the state church. They saw their parents as representatives of a rigidly stratified society, which they rejected. They championed the oppressed people, the *Volk*, and called for a return to nature by espousing a new primitivism. The passionate protagonists of their plays, such as Götz and Karl, are *Kraftkerle*, men of genius who fight for their personal freedom and attack corrupt society at all levels and in all social institutions. In his essay on "Die Schaubühne als moralische Anstalt" (The Stage as Moral Institution, 1785), Schiller calls the theater a moral institution that allows politically impotent subjects to criticize their autocratic rulers and

educate their fellow citizens ethically and aesthetically. In 1909, Ferdinand Hardekopf was harking back to Schiller's essay when he demanded a more relevant theater: "Man gründe in Berlin ein Thesenstück-Theater, eine propagandistische Bühne, eine moralische Anstalt —: das wären endlich Bretter, die die Welt bedeuten, in der man sich nicht langweilte" (One should found a theater in Berlin for programmatic dramas, a propagandistic stage, a moral institution — that would be, finally, a platform that signifies a world in which one is not bored; Pörtner 1:335). In Walter Hasenclever's *Der Sohn* (The Son, 1914), which revolves around generational conflict, the friend of the protagonist refers to Schiller and *Storm and Stress* authors while trying to incite the son to rebellion against his father:

> Denn bedenke, daß der Kampf gegen den Vater das gleiche ist, was vor hundert Jahren die Rache an den Fürsten war. Heute sind wir im Recht! Damals haben gekrönte Häupter ihre Untertanen geschunden und geknechtet, ihr Geld gestohlen, ihren Geist in Kerker gesperrt. Heute singen wir die Marseillaise! Noch kann jeder Vater ungestraft seinen Sohn hungern und schuften lassen und ihn hindern, große Werke zu vollenden. Es ist nur das alte Lied gegen Unrecht und Grausamkeit. Sie pochen auf die Privilegien des Staates und der Natur. Fort mit ihnen beiden! Seit hundert Jahren ist die Tyrannis verschwunden — helfen wir dem Wachsen einer neuen Natur! (Act 4, scene 2; 86–87)

> [Then ponder that the fight against the father is the same as the revenge against the princes one hundred years ago. Today we are right! Then crowned heads oppressed and enslaved their subjects, stole their money and imprisoned their spirits. Today we are singing the Marseillaise! Every father may still let his son go hungry and enslaved without being punished, and prevent him from doing great things. It is only the same old song against injustice and cruelty. They stand on the privileges of the state and nature. Away with both of them! For one hundred years now tyranny has been gone — let us help a new nature to grow! (Act 4, scene 2; Schürer 1996, 129)]

As it turns out, Expressionism and *Storm and Stress* share many thematic and formal characteristics. Without drawing attention to this fact in his study *Drama of the Storm and Stress*, Mark O. Kistler summarizes some of these similarities when he writes:

> One began to glorify the irrational aspect of man with particular emphasis on the development of the emotional, imaginative, mysterious, and occult faculties. Philosophical thought and elaborate systems of rules were relegated to a position of obscurity in favor of man's reliance on his feelings, desires, and natural urges — in short, his genius. No longer did "polite society," in which the aristocracy was dominant, determine the cultural tone; on the contrary, the "Storm and Stress" sought its destiny in the primitive, in the origins of civilization, among the simple, innocent people who lived in harmony with nature. (11)

Both movements were carried by young artists who formed friendships and literary, philosophical, and to a certain degree, political circles for discussion, especially in Berlin, which they experienced as the quintessential modern metropolis. Just like the characters in Hasenclever's play, the Expressionists considered themselves a "League of the Young against the World!" (Hasenclever, act 2, scene 5; Schürer, 122). In his *Drama des Sturm und Drang: Kommentar zu einer Epoche* (The Drama of Storm and Stress: Commentary on an Epoch, 1980) Andreas Huyssen points to the continuing influence of the movement on German literature:

> Der Sturm und Drang war eine vorwiegend literarische und weltanschauliche Bewegung, die allerdings nur als Ausdruck eines durchdringend und umfassend neuen Lebensgefühls adäquat zu verstehen ist. Obwohl folgenreiche ästhetische Konzepte wie geniales Schöpfertum und Autonomie der Kunst in dieser Periode erstmals ausformuliert wurden, blieb der Sturm und Drang der Wirklichkeit und dem Alltag der Zeit eng verhaftet. Bürgerliche Kunst und bürgerliches Leben traten hier in ein qualitativ neues Verhältnis ein, das bis ins 20. Jahrhundert weiterwirken sollte. (13)

> [The Storm and Stress was mainly a literary and philosophical movement that can however only be adequately understood as the expression of a pervasive and comprehensive new feeling about life in general. Although influential aesthetic concepts such as creative genius and artistic autonomy were first formulated in this period, Storm and Stress remained closely attached to the historical reality and everyday life of the period. Bourgeois art and bourgeois life entered here into a qualitatively new relationship that would carry into the twentieth century.[1]

Indeed, many of Huyssen's introductory comments on the Storm and Stress movement apply as well to Expressionist drama (13–84). Just as the Storm and Stress authors had rebelled against the Enlightenment, the Expressionists rebelled against scientific naturalism. The Naturalist playwrights had reproduced the world around them in an almost photographic manner, as Gerhart Hauptmann did in his play *Die Weber* (The Weavers, 1892). Their plays, however, stayed on the surface and lacked pathos.

The young Expressionist dramatists came from a middle-class background and were born into upwardly mobile bourgeois families. In school they studied the works of the German literary canon, including the early plays of Goethe and Schiller as well as their later dramas from the classical period (after they had outgrown their rebellious youth), such as *Iphigenie auf Tauris* (Iphigenia on Tauris, 1787) and *Maria Stuart* (1810), which are representative of German idealism and Weimar classicism. When as students the generation of Expressionist dramatists started attending the Gymnasium, the university-track high school, their knowledge of these

works was further enhanced through regular visits to the city theater with its repertoire of mostly classical plays. No wonder that they internalized the ideas and vocabulary and that both exerted a powerful influence on their own literary attempts, especially in the beginning. This does not mean, however, that new books, new ideas, and new plays held no interest for them. On the contrary, they were fascinated by contemporary authors, foremost among them the philosopher Friedrich Nietzsche. He was their secular prophet, who proclaimed the death of God and with it the loss of all metaphysical certainties. Nietzsche's prime call was for an "Umwertung aller Werte" (re-evaluation or transvaluation of all values); his condemnation of contemporary German society, especially the *Bildungsbürger*, the educated middle-class philistine, and his stress on individualism appealed greatly to them (Vietta/Kemper, 134–43). It was especially the imagery of his work that influenced their language.

Reinhard Sorge's *Der Bettler* (The Beggar, 1912), one of the earliest Expressionist plays, provides a good example of the tendency to resort to classical language when the protagonist attempts to sketch his own new drama and verbalize his vision. At the beginning of the play he heaps scorn upon the Neo-Romantic playwrights, who live in a world of medieval knights and damsels, while he expresses his longing for an exalted spiritual existence through the figures of modern pilots who mourn a comrade killed while flying. He evokes further symptoms of modernity with newspaper readers and prostitutes. In the end, however, when he visualizes the action of his supposedly revolutionary play he falls back on a sentimental love story and tries in vain "*Durch Symbole der Ewigkeit zu reden*" (To speak through symbols of eternity; 83). His alternation between prose and verse, especially free verse, in an attempt to express his inner being, his soul, also shows the link to classical German drama. Therefore, it comes as no surprise to learn that Sorge was reading Goethe's *Wilhelm Meister's theatralische Sendung* (Wilhelm Meister's Theatrical Calling) while working on his drama (Ritchie, 64). The attempt to go beyond the worldly concerns of the individual, to go beyond feeling and rational discourse and describe a state of almost religious rapture, is manifested in Sorge's play by a linguistic paralysis, a lack of words to express this visionary state of being. He can remain silent or fall back on the language of his home and education, of the educated bourgeoisie (or *Bildungsbürgertum*) steeped in Goethe and Schiller. Storm and Stress and Classicism provided the Expressionists with literary tools and ideas, but it was their rejection of modern society that spurred them to set pen to paper.

In the context of revolt against literary Naturalism and modern society, Expressionism emerged around 1910 as the last art movement in Germany to try with missionary zeal to change the *status quo* in life and art. It was a grandiose attempt to combine literature, philosophy, and, to a certain extent, politics. Although the term was first used in the fine arts,

especially painting, to denote a movement in opposition to Naturalism and Impressionism, it soon encompassed other cultural manifestations, including literature. The artists tried to capture the essence (*das Wesen*) of their subject matter as revealed to them in a vision. Intuition, imagination, and dreams inspired this vision, which to them was more meaningful than experience and reality. They discussed the aesthetics and the ethical and social mission of art in a world that they saw as morally decadent and shallow in the extreme. In their view modern society was ruled by soulless, rationalistic, and dangerous technological progress, crass and superficial materialism, greedy and corrupt capitalism, and saber-rattling, chauvinistic nationalism. The Expressionists looked upon educational institutions and state churches as servants of the dominant ideology, more interested in maintaining the *status quo* than in helping the downtrodden and disadvantaged, the tragic victims of industrialization and so-called progress. Because of its critical attitude and its ambivalent or oppositional stance against modern social developments since the Enlightenment, the beginning of the modern age, Expressionist drama constitutes part of "aesthetic modernity" as defined by Thomas Anz; he lists as typical manifestations of this development:

> Prozesse der Rationalisierung, Technisierung, Industrialisierung und Urbanisierung, die Zunahme sozialer Mobilität, die Expansion massenkommunikativer Prozesse und die Bürokratisierung, die Ausdifferenzierung eines immer komplexeren gesellschaftlichen Systems, die Entzauberung tradierter Mythen und die kritische Überprüfung metaphysischer Gewißheiten, die fortschrittsgläubige Ausweitung der rationalen Verfügungsgewalt über die äußere Natur und, im sozialpsychologischen Bereich, den von Norbert Elias beschriebenen Zwang des zivilisierten Subjekts zur Disziplinierung der eigenen Natur, des Körpers und der Affekte. (1)

> [Processes of rationalization, technicalization, industrialization, and urbanization, the increase in social mobility, the expansion of mass communication and bureaucratization, the differentiation of more and more complex social systems, the demystification of inherited myths and the critical examination of metaphysical certitudes, the melioristic expansion of rational domination over physical nature, and, in the realm of the social-psychological, the coercion of the civilized subject to discipline his or her individual nature, the body and the affects, as described by Norbert Elias.]

Georg Kaiser addresses the processes of this modernity in many of his plays, such as *Von morgens bis mitternachts* (From Morn to Midnight, 1916), the *Gas*-Trilogy (1917–20), *Kanzlist Krehler* (Chancellor Krehler, 1922), *Nebeneinander* (1923), and *Gats* (1925), as does Ernst Toller also in his plays. When Anz writes "Mit der Verstädterung, der Technisierung

und der Expansion der Massenmedien verbindet die Expressionisten eine eigentümliche Haßliebe" (Expressionists viewed the expansion of cities and technology and the mass media with a peculiar love-hate relation; 3), he seems to allude particularly to Sorge's *Der Bettler*. These topics also played a large role in Sorge's own biography. Aesthetic modernity as it figures in Expressionism anticipates many characteristics of postmodernism; some major problems and key concepts (such as rationality and autonomy) that figure prominently in the postmodern debate appeared first in Expressionist literature (see Anz, 3). Manifestations of these personal and philosophical developments abound in Expressionist drama. Vietta shows the "dissociation of self" (Ichdissoziation) in Kaiser's plays, Toller's *Die Wandlung* (The Transformation, 1919), and Hasenclever's *Die Menschen* (The People, 1920). Yet, while aesthetic modernity rejects modernization, postmodern thinking welcomes it.

Following the perceived loss of all transcendental values in the wake of modern science, the Expressionist artists were searching for a new meaning and new values in life. They were filled with a sense of mission and saw themselves as prophets of a new spirituality and a new ethos. Such a prophet is the youthful protagonist of Sorge's *Der Bettler*. A budding playwright in search of direction and meaning for his life, he stands in contrast to his mad scientist father who harasses the family and wants to subjugate nature. The father dreams of saving humanity by technological progress and envisions space travel. In contrast, his son is engaged in a spiritual quest for the essence (*das Wesen*) of life and love. However, this quest is not purely subjective, since he also desires to redeem the masses of exploited and exhausted workers and city dwellers. A disciple of Nietzsche and supremely confident of himself and his mission, the Beggar envisions a new theater, a temple of art where only his own plays will be staged and where the people will find the solace and salvation their ancestors had looked for in church. They must be purified, a process demonstrated in the so-called *Läuterungsdramen* or plays of purification, such as Kaisers *Die Bürger von Calais* (The Burghers of Calais, 1914). Human beings are basically good, the Expressionists agreed; they only need to overcome the restrictions and negative influences of society in order to realize their true potential. If revolution and war were necessary to achieve this goal, then the Expressionists were ready to go along.

In accordance with their positive view of human nature, the Expressionists saw as their primary mission the creation of a new individual (*der neue Mensch*). As Vietta points out, the call for this new human being is a reaction to the alienation and dissociation modern man experiences (Vietta/Kemper, 187). Once this new human being came into being, he or she would transform society. While Marxism called for a revolution to establish a new society, which would then allow each individual to reach his or her full potential, the Expressionists began with the reform of the

individual. Their key concept, *der neue Mensch*, male or female, is on the one hand modeled on the ideas of the German classical tradition, but, in contrast to the individualism and quietism of the idealistic model, the Expressionists demanded the renewal of every human being in order to create a society of such new individuals. Anz's statement about Expressionism in general holds true to a great extent for drama:

> Mit der ihn leitenden Idee des "Neuen Menschen" oder des "Neuen Lebens" er [der Expressionismus] knüpft weiterhin an klassisch-idealistische Traditionen an, die ihrerseits über den Pietismus des 18. Jahrhunderts religiös vermittelt waren. Hatte indes der auf die Synthese von Gegensätzen ausgerichtete Diskurs um 1800 im Kontext der Französischen Revolution antirevolutionäre, reformerische Implikationen, so radikalisierte sich demgegenüber das expressionistische Erneuerungspathos zu revolutionärem Anspruch. (48)

> [With its lead ideas of the "New Man" or of "New Life," [Expressionism] links itself to traditions of [German-Romantic] Classicism-Idealism, which in turn were mediated by religious currents of eighteenth-century Pietism. Just as the discourse around 1800, in the context of the French Revolution, aimed with antirevolutionary, reformist implications at the synthesis of opposites, so too did the pathos of renewal in Expressionism become, in contrast, increasingly radical in its revolutionary claims.]

The exact nature of this new human being is never clearly specified, but the concept seems, on the one hand, to owe much to the ideas of the Enlightenment and German idealism, as evoked by the often quoted lines of Goethe's poem "The Divine" (Das Göttliche), "Noble is mankind / helpful and good" (Edel sei der Mensch, / Hilfreich und gut!); but on the other hand the "New Man" reflects more directly and immediately the influence of Nietzsche and his notion of the *Übermensch*.

The ambiguity in the definition of the *essence* of man is caused by the Expressionist author, who does not define it rationally but takes recourse in his vision. Kaiser expressed it in his essay "Vision und Figur" (Vision and Figure): "Von welcher Art ist die Vision? Es gibt nur eine: die von der Erneuerung des Menschen" (Of what type is this vision? There is only one: that of the renewal of mankind" 4:549). *Vision* is also the key concept in Kasimir Edschmid's famous manifesto "Über den dichterischen Expressionismus" (On Literary Expressionism):

> So wird der ganze Raum des expressionistischen Künstlers Vision. Er sieht nicht, er schaut. Er schildert nicht, er erlebt. Er gibt nicht wieder, er gestaltet. Er nimmt nicht, er sucht. [. . .] Jeder Mensch ist nicht mehr Individuum, gebunden an Pflicht, Moral, Gesellschaft, Familie. Er wird in dieser Kunst nichts als das Erhebendste und Kläglichste: *er wird Mensch*. (Edschmid, 32–34)

[Thus the entire space of the Expressionist artist becomes a vision. He does not see, he envisions. He does not describe, he experiences. He does not represent, he gives shape. He does not take, he seeks. [. . .] Each person is no longer just an individual, bound to obligations, morals, society, family. In this art, he is nothing other than the most uplifting and the most pitiable: he realizes his humanity.]

Kaiser's vision of the regeneration of the individual, the "Erneuerung des Menschen" (renewal of mankind), finds its dramatic expression in his play *Die Bürger von Calais* (1914). At the time of its publication it did not attract much attention, but after three years of a savage and never before experienced modern war, it was hailed as a call for peace and the renewal of man. It has been called a *Verkündigungsdrama* or drama of proclamation (Vietta/Kemper, 195). Its protagonist, Eustache de Saint-Pierre, is the new man who changes the six volunteers through his example. They will go back into the community and act as catalysts for further transformations. Kaiser spoke of drama as a school that transforms the author and the audience: "was mir geschieht in dieser Zeit, kann von derselben Kraft jedem anderen neben mir geschehen. Dann wird aus Einem: zehn, aus zehn: Zehntausend und schließlich eine unendliche Versammlung von Kreaturen im Geiste. Ich glaube: was Einer kann, das können alle" (whatever happens to me in this time can happen with the same force to each and every other beside me. Then out of one, comes: ten, from ten: ten thousand, and ultimately, an infinite assembly of spiritual beings. I believe that whatever one can do, so can all others; 4:599). Kaiser's play constitutes an expression of a collective desire for spiritual renewal (Vietta/ Kemper, 198) that would later be exploited by totalitarian regimes, especially fascism.[2]

Playwrights inspired by their social mission considered the message the most important part of the drama. Experimentation with modern artistic forms interested others, but for most, aesthetic and social questions and intentions were intertwined and cannot be separated. The majority of the Expressionists agreed that art and life must form a whole — they believed neither in *l'art pour l'art*, art for art's sake, nor in withdrawing into an ivory tower. In his typological study from 1935 entitled *Aktivismus und Expressionismus* (Activism and Expressionism), Wolfgang Paulsen maintains that these terms should not be considered as two opposing poles but rather as complementary developments within the art movement. The political events during the Expressionist period from 1910 to 1923 and their impact on the social and economic conditions of German citizens strongly influenced and often changed the philosophical and political orientation of playwrights. History also played a part in the importance of the literary genres. Before the First World War, most Expressionists found an outlet for their feelings and sentiments, their vision, in the fine arts and in

poetry. During and after the war, drama came into its own as the dominant genre. Initially most Expressionists, among them dramatists such as Kaiser, Toller, and Fritz von Unruh, were carried along by the fever of patriotism that swept across Europe and had welcomed the war. However, the savagery and brutality of modern mechanized warfare and the mass slaughter at all fronts turned them into pacifists who began to protest vehemently against the regression of supposedly civilized nations into barbarism (Vietta/Kemper, 14–15).

Aesthetically, the Expressionist playwrights rejected the conventions and principles of Naturalist drama. They were not interested in the psychology of their *dramatis personae* but saw them as essential human beings solely defined by their family relationships or professions. Therefore, they appear only as "The Father," "The Mother," "The Daughter," "The Son," "The Cashier," "The Billionaire Worker," or "The Chief Engineer." They are not fully developed personalities or characters but rather types or figures. In *Gas II* (1920) Kaiser carries this classification to its extreme when he designates the opposing camps simply as Yellow Figures and Blue Figures. These flat characters are media for thoughts and ideas, figures who according to Walter H. Sokel "die Funktion von Spruchträgern haben" (function as vehicles for a message; 1968, 61–62). Ludwig Rubiner appends the following footnote to the list of characters of his drama *Die Gewaltlosen* (The Powerless, 1918), "Die Personen des Dramas sind die Vertreter von Ideen. Ein Ideenwerk hilft der Zeit, zu ihrem Ziel zu gelangen, indem es über die Zeit hinweg das letzte Ziel selbst als Wirklichkeit aufstellt" (The characters of a drama are representatives of ideas. A work of ideas helps the age reach its goal by setting the ultimate goal beyond historical time as its reality; Otten, 304). Kaiser states about drama in general: "Die Idee ist ihre Form. Jeder Gedanke drängt nach der Prägnanz seines Ausdrucks. Die letzte Form der Darstellung von Denken ist seine Überleitung in die Figur. Das Drama entsteht" (The idea is [in] its form. Each thought presses toward poignancy of expression. The last form of representation of thought is its transposition into a character. The drama comes into being; 4:590). Since the figures of the play are only media for a message, dialogue in Expressionist drama serves mainly as a means for expressing the sentiments of the protagonist, as Sokel has demonstrated convincingly (1968, 59–84). Therefore, monologues delivered with great pathos are an essential feature of Expressionist drama, which follows in the footsteps of classical authors but contrasts sharply to Naturalist plays, in which monologue is outlawed in favor of exposition, characterization, and description of the milieu. Nevertheless, Expressionist drama shares with Naturalist drama relatively sparse, plot-centered dialogue that advances the action.

The speech of the characters in Expressionist plays also becomes more and more abstract: from the colloquial dialect-filled conversation

(*Sekundenstil*) in Naturalist drama it slowly develops into a diction stripped down to its bare essentials, the so-called telegraphic style (*Telegrammstil*) in which adjectives are used sparingly and verbs and articles are often omitted. Carl Sternheim develops this language as a powerful weapon in his famous comedies "aus dem bürgerlichen Heldenleben" (of the heroic life of the middle-class) among them *Die Hose* (The Bloomers, 1911), *Bürger Schippel* (Citizen Schippel, 1913), and *Der Snob* (The Snob, 1913). In his desire for linguistic cleansing he cuts down the language, under the rubric "Kampf der Metapher!" (Fight against Metaphor!), to its essentials, omitting articles, adjectives, and adverbs. Evocative nouns, newly coined verbs, and autonomous metaphors create a new reality of art that aims at a strong emotional impact and the evocation of cultural, mythological, and literary associations. Generalization and, especially, literary rhetoric serve to illustrate sentiments and conviction through dialogue, which according to Sokel achieves its purpose through "Bildhaftigkeit, metaphorische Personifizierung, und damit Dynamisierung abstrakter Begriffe, plötzlichen Übergang von alltäglicher Prosa zu rhythmisch gebundener und gehobener Sprache" (concrete imagery, metaphoric personification, and dynamic rendering of abstract concepts, the sudden transition from common prose to rhythmically concentrated and elevated language; 1968, 75–76). To confront the problem of transmitting abstract ideas, since in many cases the visionary rhetoric is incomprehensible to the uninitiated, the dramatist had to take recourse to imagery. The ultimate reduction of language results in *der Schrei* (the Scream) as the pure expression of intense feeling. Reinhard Goering's vitalistic play *Seeschlacht* (Sea Battle, 1916) begins with just such a scream. Thus the language of Expressionist drama is difficult to understand and even harder to translate, since it does not primarily serve rational discourse, but rather provocation and proclamation.

In his "Versuch eines zukünftigen Dramas" (Draft for a Future Drama), Kurt Pinthus defines Hasenclever's *Der Sohn* as a drama not of action but of emotions: "Denn der Inhalt des Stückes ist nicht das Handeln, sondern das Fühlen des Sohnes" (since the content of the play is not the action, but the feeling of the son; Pörtner, 1:344). Pinthus argues that purely subjective emotions determine the actions of the son, because his strong feelings rather than real injustices cause his revolt against paternal authority and render his language highly emotional. The same applies to all plays about the conflict of the generations, the uprising of the sons against their fathers, such as Sorge's *Der Bettler*, or Arnolt Bronnen's *Vatermord* (Patricide, 1920), among others. As Pinthus states in his summary: "Nochmals: die Kunst eines solchen Dramas besteht nicht in der Handlungs-Linie, nicht in der Bewegung ausgeführter Charaktere, sondern in der eindringlichsten Formung der Expression einer tragisch-geschwollenen Seele, nicht in der Intensität der Impression, sondern in der Intensität der

Expression" (Once again: the artistry of such a drama consists not in the plotline, not in the movements of the characters, but rather in the most penetrating formulation of a tragically swollen soul, not in the intensity of impression, but rather the intensity of expression; Pörtner, 1:346). The favored vehicle of dramatic intensity in Expressionism is, therefore, the rhetorically high-pitched monologue.

Most Expressionists rejected the traditional structure of the well-made play in five acts that the literary Naturalist Gustav Freytag had expounded in his *Technik des Dramas* (Dramatic Technique, 1863). They themselves experimented with new forms, as the subtitles of their plays indicate. The most radical of these theatrical experiments were Alfred Döblin's early play *Lydia und Mäxchen: Tiefe Verbeugung in einem Akt* (Lydia and Little Max: A Deep Bow in One Act, 1906), Oskar Kokoschka's *Mörder, Hoffnung der Frauen* (Murder, Hope of Women, 1910), and Wassily Kandinsky's *Der gelbe Klang: Eine Bühnenkomposition* (The Yellow Clang: A Stage Composition, 1912).[3] Later, Kokoschka and Kandinsky achieved fame as painters, and their plays were practically forgotten. Nevertheless, Albert Ehrenstein comments on the genesis of Expressionist drama: "Im Anfang war Kokoschka. Es ist, als sollte sie der Bildner schreiben lehren" (In the beginning was Kokoschka. It is as if the painter had taught them to write; 1911). Kandinsky contributed an essay "Über Bühnenkomposition" (On Composition for the Stage) along with his play *Der gelbe Klang* to an anthology of essays on art, music, and the theater published in 1912 by the painter Franz Marc under the title *Der blaue Reiter* (The Blue Rider). He presents his aesthetic ideas concerning a total theater, which he sees as a synthesis of all the arts, as well as an example of this new type of theater. In an analysis of the theatrical innovations of Kokoschka and Kandinsky, Charles Swoope writes, "Indeed, the basic technique of Expressionism was visual rather than verbal: the projection of inner states of mind onto the stage by means of symbolic images and episodes. And in its earliest manifestations Expressionism was a complete rethinking of the theatrical event, not merely a new use of the resources of modern staging and scenery but an attempt (and one of the first) at the sort of total theater that Richard Wagner had called for in his essays on the *Gesamtkunstwerk*" (Total Work of Art; Swoope, 11). However, these radical theatrical experiments by Kokoschka and Kandinsky were later forgotten — although resurrected to a certain extent by the Dadaists — and during the heyday of Expressionism in the theater from 1917 through 1923 "most of the stage works [. . .] remain in essence poetic dramas, predominantly verbal and very much in the tradition of drama as dialogue" (Swoope, 11).

For this type of drama as dialogue the influence of two authors, Frank Wedekind and especially August Strindberg, was of greater importance. Their dramas reveal the frustrated and isolated individual on his way through a hostile world. They developed the so-called "station play"

(*Stationendrama*), which shows the protagonist, often a thinly disguised self-representation of the author, his ego, on his way, in distinct episodes, through a world viewed only through the eyes of the main character. In consequence, it is a highly subjective portrayal. Because of its concentration on the central character, Horst Denkler calls this major type of Expressionist drama an *einpoliges Wandlungsdrama* or unipolar drama of transfiguration. Denkler looks at Expressionist drama as theater performance rather than as literature.[4]

The best known example of the "unipolar drama of transfiguration" in the form of a so-called "station play" is Kaiser's *Von morgens bis mitternachts* (From Morn to Midnight, 1916). Its protagonist — through whose eyes the audience perceives the world — is a bank cashier at work behind the teller's window. Through the sensual allure of a beautiful Italian lady, something is triggered in him (*Anstoß*), causing an awakening and his departure (*Aufbruch*) from his conventional boring marriage and his monotonous job, which could just as well be done by a machine. He absconds from the bank with a substantial sum of money and abandons his family. He rejects his previous existence and at the same time looks for more meaningful, exciting experiences. He leaves his small provincial hometown W[eimar] and takes the train to the big city B[erlin], where he hopes to encounter life in peaks of vital intensity and ecstatic passion. In Berlin he experiences different aspects of a modern metropolis such as a sporting event, a cabaret and dance hall, and finally a meeting of the Salvation Army, without, however, achieving his goal of an inner rebirth or spiritual regeneration. Although usually classified as a "drama of transfiguration," no actual transformation of the Cashier takes place. He remains imprisoned in his past and finally commits suicide. Actually the drama portrays more about the modern city than about the Cashier's inner self. Peter Szondi's observation concerning the "station play" fits Kaiser's play perfectly: "Die Ich-Dramatik des Expressionismus gipfelt paradoxerweise nicht in der Gestaltung des vereinsamten Menschen, sondern in der schockartigen Enthüllung vor allem der Großstadt und deren Vergnügungsstätten" (The drama of Self in Expressionism achieves its peak paradoxically not in the figure of the isolated individual, but in the shocking revelation of the metropolis and its pleasure quarters; 107). In all its manifestations, especially its technology and industry as the focus of Expressionist criticism of the modern world, the metropolis occupies a central position in the discourse of Expressionist writers.

Besides the station play, Denkler lists three other types of Expressionist drama. They are the "well-staged plot drama" (*bühnengerechtes Handlungsdrama*) that exhibits the regular five-act structure and a traditional development, such as Kaiser's *Gas*; the "filmic drama of transfiguration" (*filmverwandtes Wandlungsdrama*), heavily influenced by the film medium, such as Ludwig Rubiner's *Die Gewaltlosen*. In these plays, as in

silent film, dialogue is reduced to an absolute minimum. Finally Denkler analyses the "operatic drama of transfiguration" (*opernnahes Wandlungsdrama*), influenced by the opera, especially Wagner's works. Examples are Paul Kornfeld's *Himmel and Hölle* (Heaven and Hell, 1919), or Kaiser's *Die Bürger von Calais*. The operatic qualities of the latter play are most obvious in the final scene when blaring trumpets announce the arrival of the English king, surrounded by colorful lancers, while tubas sound in the cathedral and the air is filled with the ringing of bells. Denkler's classification calls attention to the diverse influences on Expressionist drama from the other arts. However, when these plays were first produced, audiences and reviewer found it hard to understand and appreciate them since their structure diverged considerably from the traditional model. In his study of the reception of Expressionist drama, Rüdiger Steinlein notes that the majority of critics initially reacted negatively to Expressionist plays because their expectations in regard to a traditional plot line were disappointed. They found it impossible to deal with the new structures developed from new aesthetic presuppositions.

The innovations of Adolphe Appia and Gordon Craig in stage design, their use of lighting devices, new developments in opera production (especially for the works of Richard Wagner and his concept of *Gesamtkunstwerk*), as well as the new medium of film, all influenced the often revolutionary productions of Expressionist plays in Berlin and in the provinces. The most important stage for the success of Expressionist drama was the Frankfurt Neues Theater, under its director Arthur Hellmer, who ushered in a new epoch in the history of German theater with the premiere of Kaiser's *Die Bürger von Calais* on January 27, 1917. Other important stages were the Munich Kammerspiele under director Otto Falckenberg, the Düsseldorf Schauspielhaus, and especially the experimental stage of the Reinhardt Theater in Berlin, called appropriately *Das junge Deutschland* (Young Germany). Between 1917 and 1920 it presented to the public no fewer than twelve of the best-known Expressionist plays, which invited comparison to *Die Freie Bühne* (The Free Stage); what *Die Freie Bühne* had done for Naturalist drama, *Das junge Deutschland* did for Expressionism, as demonstrated by Stephen Shearier. In these productions, visual imagery in stage design contributed significantly to the symbolism of the play. At the same time, literary imagery played an even greater role in conveying the message of the dramatist.

Expressionism tries to express an essence, a feeling, "den inneren Klang der Seele" (the inner reverberation of the soul) as Kandinsky called it in his pioneering *Über das Geistige in der Kunst* (On the Spiritual in Art, 1912); the use of imagery in Expressionist literature recalls the theory of the symbol espoused by the young Gottfried Herder during his Storm and Stress days. According to Herder, nature has a symbolic character because "alle äußere Form der Natur ist Darstellung ihres innern Werks" (all

external forms of nature are a representation of its inner workings; Sorensen, 56). Sorensen interprets Herder's theory as follows: "Das Wesen der Kunst wird nicht mehr wie noch bei Mendelssohn und Lessing als imitativ, sondern als expressiv aufgefaßt. In diesem Sinne soll die Kunst nach Herder 'symbolisch' sein, denn sie ist das Symbol des Gefühls, dem sie entspringt" (The essence of art is no longer conceived as mimetic as with Mendelssohn and Lessing, but rather as expressive. In this regard, art is, according to Herder, symbolic, since it represents the feeling from which it derives; 55). This definition anticipates and resembles that of Kandinsky, since both artists view art as a symbolic expression of inner feelings and ideas, as *Vision*, rather than as mimesis; indeed, this resemblance underscores the rootedness of Expressionism in Romanticism.

Kasimir Edschmid's programmatic essay "Über den dichterischen Expressionismus" (On Literary Expressionism) states in the same vein:

> Niemand zweifelt, daß das Echte nicht sein kann, was uns als äußere Realität erscheint. Die Realität muß von uns geschaffen werden. Der Sinn des Gegenstands muß erwühlt sein. Begnügt darf sich nicht werden mit der geglaubten, gewähnten, notierten Tatsache, es muß das Bild der Welt rein und unverfälscht gespiegelt werden. Das aber ist nur in uns selbst. So wird der ganze Raum des expressionistischen Künstlers Vision. [. . .] Die Tatsachen haben Bedeutung nur so weit, als durch sie hindurchgreifend die Hand des Künstlers nach dem faßt, was hinter ihnen steht. (32–33)

> [No one doubts that what appears to us as external reality cannot be what is genuine. Reality has to be created by us. The sense of an object must be fathomed. The commonly believed, imagined, noted fact must not be taken for granted; the image of the world must be reflected purely and without distortion. That, however, is only within us. Thus the entire space of the Expressionist artist becomes a Vision. External facts only have significance in so far as the hand of the artist reaches through them to grasp what stands behind them.]

If the artist negates "external reality" and disregards mimesis, and if he (or she) presents the "meaning of a thing" in a totally subjective manner through his vision, then literature becomes accordingly more symbolic. Walter Rheiner takes note of the trend in Expressionist drama to confession and prophecy rather than to action; in "Expressionismus und Schauspiel" (Expressionism and the Theater), he writes:

> Denn es sei gleich vorausgeschickt: Das Drama im streng Lessingschen Sinne wird niemals expressionistisch sein; will sagen: es gibt kein expressionistisches Drama, sondern nur ein expressionistisches Schauspiel, d.h. eine Bühnenhandlung, an der die transzendentale Idee durch die auftretenden Objekte (Personen und andere Objekte) zu realisieren versucht wird.

[Let it be then here noted in advance: Drama in the strict sense of [Gotthold Ephraim] Lessing will never be expressionistic, which means: there is no Expressionist drama, but rather an Expressionist play of vision, that is, a staged plot in which the objects that step forward (characters and other objects) attempt to make real a transcendental idea. (Pörtner 2:279)].[5]

In a drama of ideas (*Ideendrama*) as defined by Rheiner, the figures, the dialogue, the properties, and the stage itself assume a symbolic meaning. They all contribute to and underline the message of the play.

Therefore, one of the most striking characteristics of Expressionist plays is their classical and religious symbolism, in which allegory also plays a role. However, the reader should not equate "the poetic images from mythology" of modern poets with genuine, believed religious mythology. As Karl S. Guthke writes, these images

sind poetische Chiffren einer Interpretation des Inkommensurablen, Chiffren einer verzweifelten Orientierung in einer Welt, die dem erwarteten Sinn nicht mehr entspricht.[. . .] Diese mythischen Bilder haben also einen zugleich scheinhaften und zeichenhaften Realitätsmodus, der dem Wesen der Dichtung durchaus nicht unangemessen ist. (25)

[are poetic ciphers of an interpretation of the incommensurable, ciphers of a despairing orientation in a world that no longer makes sense by corresponding to expectations [. . .] The mythic images have thus at one and the same time an apparent and an encoded status that corresponds to the essence of poetry.]

In 1955, Gottfried Benn praised Expressionism for its opposition to sociocultural modernism and its search for a new human being. He describes its attempt to return to more primitive, mythical times, which had in his case led to a short and misguided flirtation with fascism. In the works of the Expressionists, primitivism led to the use of archetypal symbolism that Benn himself employed in his poetry and his early play *Ithaka* (Ithaca, 1914), which he explains as follows:

Aber diese Fragestellung war echte Bereitschaft, echtes Erleben eines neuen Seins, radikal und tief, und sie führte ja auch im Expressionismus die einzige geistige Leistung herbei, die diesen kläglich gewordenen Kreis liberalistischen Opportunismus' verließ, die reine Verwertungswelt der Wissenschaft hinter sich brachte, die analytische Konzernatmosphäre durchbrach und jenen dunklen Weg nach innen zu den Schöpfungsschichten, zu den Urbildern, zu den Mythen, und inmitten dieses grauenvollen Chaos von Realitätszerfall und Wertverkehrung, zwanghaft, gesetzlich und mit ernsten Mitteln um ein neues Bild des Menschen rang. (1962, 13)

[But the question was genuine readiness, genuine experience of a new [form of] being, radical and profound, and it also led in Expressionism to

the sole intellectual achievement that got beyond this pitiable circle of liberalistic opportunism, that put behind itself the pure instrumentality of science, that broke through the analytical corporate atmosphere, and struggled on the dark path inward to the layers of creativity, to the primal images, to myths, and in the midst of this horror-full chaos of disintegration and inversion of values, to arrive, by force, by law, by serious means, at a new image of mankind.]

The imagery of the literary works of the Expressionists thus reflects their vision, their spiritual position and their message. Karl Ludwig Schneider states unequivocally, "In jeder Metapher steckt tatsächlich schon ein Stück Weltdeutung des Dichters. Seine Weltauffassung schlägt sich in seiner Metaphorik nieder und zwar zuverlässiger als in allgemeinen oder programmatischen Äußerungen" (In each and every metaphor lies in fact already a piece of the poet's interpretation of the world. His conception of the world leaves its imprint in his use of metaphor and, to be sure, more reliably than in any general or programmatic statements; 15). One only has to think of early plays such as Kokoschka's *Mörder, Hoffnung der Frauen*, Kandinsky's *Der gelbe Klang*, Kaiser's *Die Bürger von Calais*, or his later *Gas*-Trilogy to recognize the central importance of imagery. In Expressionism, writers did not focus on the realistic portrayal of external reality but rather wanted to express a subjective, quasi-religious, mystical experience. Expressionist drama reflects this subjective position of the author; abstraction and stylization, the main characteristics of Expressionist drama, result from the attempt to describe the essence of things as seen in a vision, an insight into essential being (*Wesensschau*).

Gunter Martens lists "typische, stets wiederkehrende Bildbereiche" (typical, constantly recurring realms of imagery, 51) that link Nietzsche's *Zarathustra*, for example, to Expressionist drama, and notes about that work that "Die gedankliche Aussage tritt in den Hintergrund und wird überdeckt von einer üppigen Symbolik und Metaphorik, die in den Einlagen der lyrisch-dithyrambischen Zarathustralieder ihre letzte Aufgipfelung findet" (The intellectual content recedes into the background and is overshadowed by the exuberant proliferation of symbols and metaphors that reach their peak in the lyrical-dithyrambic song of Zarathustra; 47). Nietzsche's imagery abounds in metaphors of imprisonment and the innumerable images of winter, of cold, and of ice that symbolize paralysis, immobility, and infertility; in contrast to this negative imagery one finds metaphors of vital life, of streaming fluidity and of flames, of dance, and of the sun and the sea (Martens, 51). Either a mild spring breeze must loosen the rigid forms or they must be shattered with a hammer. Nietzsche was a favorite author of Kaiser, who borrowed his imagery in abundance in *Von morgens bis mitternachts* as well as in his other plays. Besides this nature symbolism Nietzsche also supplied the imagery for Expressionist fantasies

of destruction and annihilation of the old world, especially in metaphors of war (Martens, 51).

With their proclivity for graphic imagery, the Expressionists gravitated to allegory, and, in their adoption of this literary device, borrowed from yet another period of German literature, namely the Baroque. As Walter Benjamin has pointed out, allegory during the Middle Ages had a primarily didactic function and a Christian background, while during the Baroque era it harks back to classical antiquity with roots in mythical thinking and natural history. Benjamin draws parallels between Baroque and Expressionist writing. Anz lists some of these affinities: "Im Umgang mit tragischer Schuld, mit der Figur des Märtyrers und dem Motiv des Opfertodes stehen etliche tragische Dramen des Expressionismus dem barocken Trauerspiel in der Tat nahe, näher jedenfalls als der Tragödie aus dem Umkreis der klassischen Ästhetik" (In its association with tragic guilt, with the figure of the martyr and the motif of sacrificial death, a number of the tragic dramas of Expressionism come close to the baroque play of mourning, closer in any case than any tragedy from the realm of German classical aesthetics; 191). The quasi-religious mission of the Expressionists resulted in a rehabilitation of the allegory. Wilhelmina Stuyver writes:

> Ebenso wie in der zerrissenen Zeit des Barock, wütet im Expressionismus ein heftiger Kampf zwischen Intellektualismus und Gefühlsüberschwang, der sich häufig in der Allegorienbildung austrägt. Außerdem liegt die Personifikation, dieser Grund- und Eckstein allegorischen Gestaltens, schon in der anthropozentrischen Haltung des Ausdruckskünstlers, der den Reichtum Natur nur als menschliche Innerlichkeit zu erschauen vermag. Die allegorische Bildlichkeit ist eine der wichtigsten expressionistischen Stilmittel, das Wesen der Dinge durch die Mittel der Wortkunst unmittelbar ästhetisch zugänglich zu machen, wobei aber die anschaulich-sinnliche Ausschmückung der barocken Allegorie vollkommen fehlt. (42)

> [Just as in the strife-ridden time of the Baroque, there rages in Expressionism a lively battle between intellectualism and extreme emotionalism, which is born out often in the formation of allegories. In addition, personification, the foundational cornerstone of allegoresis, manifests itself in the attitude of the Expressionist, who views the realm of nature's wealth as human interiority. Allegorical pictoriality is one of the most important stylistic means of Expressionism to make the essence of things aesthetically accessible by means of verbal artistry, whereby the sensuous-visual ornamentation of Baroque allegory is completely absent.]

The Marxist critic Georg Lukács, however, places allegory squarely in the sphere of theology and religious life and rejects its use in modern literature. Therefore he considers it an expression of nothingness. It is small wonder, therefore, that he rejects Expressionist literature as conservative and accuses it of having prepared the way for fascism (12:772). If, however,

allegory represents abstract concepts that do not necessarily originate in the sphere of religion, it can still play an important role in modern art in spite of all changes in culture and in religious beliefs. Many critics also have asked the question whether the Expressionist *dramatis personae* can be called allegories in view of the fact that for the playwrights they embody an idea. In his interpretation of Kaiser's *Die Bürger von Calais* Eberhard Lämmert suggests: "Man sollte hier also eher von Personifikation als von Abstraktion reden oder den schon zu lange abgewerteten Begriff der Allegorie wieder in sein Recht setzen" (One should rather speak here of personification than of abstraction, or once again give the long-devalued concept of allegory its due; 320). The replacement of the play of action with its individualistic characters by the drama of ideas with its figures acting as mouthpieces creates a fertile field for the use of allegory in modernity.

In conclusion, we have to consider the place of Expressionist drama between German idealism and modernity, as well as its ideological foundation. During the last three decades the scholarly discussion has been fueled as much by historical events and the ideological position of the critics as by the literary evidence. In his "Remarks on the Place of Expressionism in Literary History," Bernd Hüppauf argues that the movement has elicited diametrically opposed classifications and evaluations centered upon the "grundsätzliche Frage" (fundamental question; 55) of whether it constitutes something original or a continuation of older traditions, and to what degree. In other words, is Expressionism solely part of German classical literature, its last hurrah, or is it the beginning of something totally new?

The preceding sections have shown that Expressionist drama is at least partly heir to the German classical tradition and idealistic philosophy, but that it also rebelled against the perversion of these same ideals in modern society, and is, therefore, an expression of aesthetic modernity. On the basis of the plays' programmatic manifestations, Paul Pörtner even calls the movement a *Literatur-Revolution 1910–1925* (Literature Revolution 1910–1925), the title of his anthology. The revolutionary element of Expressionism is not so much of a linguistic nature, but is found in its critical presentation of modern man and modern society. Jan Knopf asserts that

> Der Expressionismus ist die erste Literatur, die auf die moderne Massengesellschaft und Massenkultur reagiert und die die literarischen Möglichkeiten dadurch verändert und erweitert hat, weil sie — wie bewußt angewendet auch immer — die neuen technischen Produktionsbedingungen und die neuen, damit verbundenen Rezeptionshaltungen (der Filmsehende liest Literatur anders) in der Literatur realisiert hat und sie damit auch selbst eingreifend verändert hat. (50)

> [Expressionism is the first literature that reacts to a modern mass society and culture of the masses and that thereby has altered and expanded the

literary possibilities, because it — how consciously is uncertain — realized in literary terms the new technical conditions of production and the new, related conditions of reception (the viewer of film reads literature differently), and in turn, altered those conditions as well.]

Horst Meixner refers especially to the dramatic genre and asserts from the perspective of collective psychology: "Der Zugriff auf Wirklichkeit erfolgt über die Entdeckung und Darstellung des Symptomatischen. Die expressionistischen Dramatiker haben wesentliche Symptome auf die Bühne gebracht, szenisch realisiert [. . .] Sie entdecken diese Wahrheit des Wirklichen in der Verdinglichung, Entfremdung und Vermassung" (The grasp on reality follows from the discovery and depiction of the symptomatic. Expressionist dramatists brought essential symptoms onto the stage, realized in scenes [. . .] They discover this truth of the real in objectification, estrangement and creation of masses; "Drama im technischen Zeitalter," 35). Meixner uses Kaiser's *Gas* Trilogy to analyze the effects of our technological age on the individual. His alienation and objectification are manifestations of modern mass culture, the results of the industrial revolution and technological advances, of urbanization and the rise in population. They led to a disintegration of social relations within the capitalist system and to the power politics of the large industrial and imperialistic states. The individual became a cog in the wheel of industry and the state and lost his or her uniqueness in a mass culture. The Expressionist playwrights were deeply disturbed by these modern developments, but ideologically they were neither socialists nor political revolutionaries; rather they wanted to regain for the individual the position he had occupied in German idealism. Bernd Hüppauf defines the Expressionistic political stance as cultural radicalism (*Kulturradikalismus*). In contrast to many of the critics of Expressionism, who locate the movement within the context of an ideologically determined social and political progress of German history and thus deny it its own identity, he sees it not as a revolutionary or political movement per se, but as an attempt by the young German intellectual elite to reestablish the values of the bourgeois (*bürgerliche*) revolution that had culminated in the American War of Independence in 1775 and the French Revolution of 1789. Hüppauf explains:

> Ihr Angriff auf die bürgerliche Gesellschaft bezieht seine Kraft nicht aus dem Entwurf einer sozialistischen Gegenwelt, sondern aus einem bürgerlichen Radikalismus. Er [der Expressionismus] nimmt die Werte der eigenen bürgerlichen Kultur und die Versprechungen der bürgerlichen Revolution beim Wort, mißt die tatsächliche Lebenswelt an ihnen und verwirft sie auf dieser Grundlage. Die Antworten, die die Expressionisten auf die vom Kapitalismus produzierten Probleme ihrer Zeit versuchen, entwickeln sie aus dem Rückgriff auf das Bild der Menschlichkeit

und Brüderlichkeit, das der revolutionären Konstituierung der bürger-
lichen Gesellschaft zugrundelag. In seiner radikalen Wiederaufnahme mit
dem Ziel der Legitimierung einer *neuen* bürgerlichen Welt und eines
neuen Menschen ist die kulturelle Leistung der expressionistischen
Epoche zu sehen. (78–79)

[Its attack on bourgeois society draws its force not from a blueprint
for an alternate socialist society, but rather from its bourgeois radicalism.
It [Expressionism] takes at its word the values of its own bourgeois cul-
ture and the promises of the bourgeois revolution, measures actual condi-
tions of life against them and condemns them on that basis. The
Expressionist responses to the problems produced by capitalism in their
day derive from their return to the image of humanity and brotherliness
that comprised the revolutionary constitution of bourgeois society. The
cultural achievement of Expressionism is its radical recourse [to these rev-
olutionary ideals] for the purpose of legitimizing a *new* bourgeois world
and a new man[kind].]

The literary output of the Expressionists must be interpreted against
this background. In the words of Hüppauf: "In ihren Utopien, der
Konzeption vom 'neuen Menschen,' von Gemeinschaft und Brüderlichkeit
findet die expressionistische Epoche ihre Identität" (In its utopias, in the
concepts of the "New Man," of community and brotherliness, the Expres-
sionist epoch finds its identity; 78).

Expressionist drama played an important role in this process, by trying
to reassert the values of German idealist philosophy in a modern, highly
politicized world and by attempting to influence and shape the cultural
perceptions of its audience in order to change the social and political
spheres. Although its success during the Expressionist decade was limited,
its influence up to the present time has been considerable, especially in the
field of modern mass media in the service of business and politics. Sokel
writes:

Die syntaktische Aussparung der Rede und ihre Reduktion auf das eine
Einzelwort, das stichwortartig den Sinn enhält, ist rhetorisches Mittel
ersten Ranges. Im Drama des Expressionismus nimmt es vorweg, womit
auf wirtschaftlichem Gebiet die Reklame und auf politischen Gebiet die
Propaganda das Leben in den auf den Expressionismus folgenden
Jahrzehnten beherrscht haben und noch heute beherrschen — das Bom-
bardement unserer Sinne durch Aufruf und Klischee. (1963, 75)

[The syntactical parsing of speech, and its reduction to single words that,
slogan-like, capture the meaning, is a rhetorical trope of the first order.
The drama of Expressionism anticipates the means by which advertise-
ment dominated life in the economic realm, and as did propaganda in the
realm of politics, in the decades after Expressionism: the bombardment of
the senses by exclamation and cliché.]

Unfortunately, the linguistic and dramatic innovations of Expressionism have been put to use not for the purpose that the Expressionists intended, namely for the good of the individual citizen and of society at large, but rather in the interest of economic exploitation and political indoctrination. The reform of bourgeois society the Expressionists envisioned is still outstanding. It is, however, more necessary than ever before, now that the socialist utopia has been discredited by historical events.

# Notes

[1] All translations are by the editor of this volume, Neil H. Donahue, unless otherwise noted.

[2] In his discussion of the drama Eberhard Lämmert has criticized the idea of self-sacrifice for its own sake without regard for the purpose of this sacrifice: "Menschen, denen man anstelle der Sache die Intensität der Opferbereitschaft zum Maßstab des Handelns setzt [. . .] verbluten hingegeben für die Idee der Menschheit, des Proletariats, der Nation — für den, der ihnen die Parole gibt"; 323).

[3] Included in Horst Denkler, *Einakter*, 22–64.

[4] See his pioneering study *Drama des Expressionismus. Programm-Spieltext-Theater.*

[5] Rheiner plays on the words *Drama* and *Schauspiel*, which are normally synonymous for a work of the theater, or a play, but rather than an action to be looked at, *Schauspiel* becomes for him in Expressionism the "play of vision."

# Works Cited

Anz, Thomas. *Literatur des Expressionismus.* Stuttgart and Weimar: Metzler, 2002.

———, and Michael Stark, eds. *Die Modernität des Expressionismus.* Stuttgart and Weimar: Metzler, 1994.

Benn, Gottfried. Introduction to *Lyrik des expressionistischen Jahrzehnts: Von den Wegbereitern bis zum Dada.* Munich: dtv, 1962.

Denkler, Horst. *Drama des Expressionismus: Programm — Spieltext — Theater.* Munich: Fink, 1967.

———, ed. *Einakter und kleine Dramen des Expressionismus.* Stuttgart: Reclam, 1968.

Edschmid, Kasimir. *Frühe Manifeste: Epochen des Expressionismus.* Darmstadt / Neuwied am Rhein / Berlin-Spandau: Luchterhand, 1960.

Ehrenstein, Albert. "Junges Drama." *Die neue Rundschau,* 1916.

Guthke, Karl S. *Die Mythologie der entgötterten Welt.* Göttingen: Vandenhoeck & Ruprecht, 1971.

Hasenclever, Walter. *Der Sohn: Ein Drama in fünf Akten*. Stuttgart: Reclam, 1994.

Huyssen, Andreas. *Drama des Sturm und Drang: Kommentar zu einer Epoche*. Munich: Winkler, 1980.

Hüppauf, Bernd. "Zwischen revolutionärer Epoche und sozialem Prozeß: Bemerkungen über den Ort des Expressionismus in der Literaturgeschichte." In *Expressionismus und Kulturkrise*, ed. Hüppauf, 55–83.

——, ed. *Expressionismus und Kulturkrise*. Heidelberg: Winter, 1983.

Just, Roland, and Hansgeorg Schmidt-Bergmann, eds. *Im Dialog mit der Moderne: Zur deutschsprachigen Literatur von der Gründerzeit bis zur Gegenwart*. Frankfurt am Main: Athenäum, 1986.

Kaiser, Georg. *Werke*. Ed. Walther Huder. Frankfurt am Main and Vienna: Propyläen, 1970–72.

Kistler, Mark O. *Drama of the Storm and Stress*. New York: Twayne, 1969.

Knopf, Jan. " 'Expressionismus': Kritische Marginalien zur neueren Forschung." In *Expressionismus und Kulturkrise*, ed. Hüppauf, 15–53.

Lämmert, Eberhard. "Kaiser: *Die Bürger von Calais*." In *Das deutsche Drama*, ed. Benno von Wiese. Düsseldorf: Bagel, 1958.

Lukacs, Georg. *Werke*. Neuwied and Berlin: Luchterhand, 1960–86.

Martens, Gunter. *Vitalismus und Expressionismus: Ein Beitrag zur Genese und Deutung expressionistischer Stilstrukturen und Motive*. Stuttgart: Kohlhammer, 1971.

Meixner, Horst. "Drama im technischen Zeitalter — Die expressionistische Innovation." In Meixner and Vietta, *Expressionismus: Sozialer Wandel und künstlerische Erfahrung*.

Meixner, Horst, and Silvio Vietta, eds. *Expressionismus: Sozialer Wandel und künstlerische Erfahrung*. Munich: Fink, 1982.

Otten, Karl, ed. *Schrei und Bekenntnis: Expressionistisches Theater*. Neuwied am Rhein and Berlin: Luchterhand, 1959.

Paulsen, Wolfgang. *Expressionismus und Aktivismus: Eine typologische Untersuchung*. Bern: Gotthelf, 1935.

Pörtner, Paul. *Literatur-Revolution, 1910–1925: Dokumente, Manifeste, Programme*. 2 vols. Darmstadt: Luchterhand, 1960–61.

Ritchie, J. M. (James MacPherson). *German Expressionist Drama*. Boston: Twayne, 1976.

Schneider, Karl Ludwig. *Der bildhafte Ausdruck in den Dichtungen Georg Heyms, Georg Trakls und Ernst Stadlers*. Probleme der Dichtung 2. 3rd ed. Heidelberg: Winter, 1954.

Schürer, Ernst. *Georg Kaiser*. New York, Twayne, 1971.

——. "Überlegungen zur Bildsprache im Drama des Expressionismus: Herkunft — Funktion —Wirkung." In Just and Schmidt-Bergmann, *Im Dialog mit der Moderne: Zur deutschsprachigen Literatur von der Gründerzeit bis zur Gegenwart*, 221–45.

Schürer, Ernst. ed. Introduction to *German Expressionist Plays*. New York: Continuum, 1996.

Shearier, Stephen. *Das junge Deutschland, 1917–1920: Expressionist Theater in Berlin*. Bern: Peter Lang, 1988.

Sokel, Walter H. "Dialogführung und Dialog im expressionistischen Drama: Ein Beitrag zur Bestimmung des Begriffs 'expressionistisch' im deutschen Drama." In *Aspekte des Expressionismus: Periodisierung — Stil — Gedankenwelt*, ed. Wolfgang Paulsen, 59–84. Heidelberg: Stiehm, 1968.

———, ed. *Anthology of German Expressionist Drama: A Prelude to the Absurd*. Ithaca and London: Cornell UP, 1963, 1984.

Sorensen, Bengt Algot. *Symbol und Symbolismus in den ästhetischen Theorien des 18. Jahrhunderts und der deutschen Romantik*. Copenhagen: Munksgaard, 1963.

Sorge, Reinhard. *Der Bettler: Eine dramatische Sendung*. Ed. Ernst Schürer. Stuttgart: Reclam, 1985.

Steinlein, Rüdiger. *Theaterkritische Rezeption des expressionistischen Dramas: Ästhetische und politische Grundpositionen*. Kronberg an der Taunus: Scriptor, 1974.

Stuyver, Wilhelmina. "Deutsche expressionistische Dichtung im Lichte der Philosophie der Gegenwart." Diss. Amsterdam: H. J. Paris, 1939.

Swoope, Charles. "Kandinsky and Kokoschka: Two Episodes in the Genesis of Total Theater." y*ale/theater* 3,1 (Fall 1970): 10–18.

Szondi, Peter. *Theorie des modernen Dramas*. Frankfurt am Main: Suhrkamp, 1963.

Vietta, Silvio, and Hans-Georg Kemper. *Expressionismus*. Munich: Fink, 1975.

# 9: The Spirit of Expressionism *ex machina*: The Staging of Technology in Expressionist Drama

*Christa Spreizer*

GERMAN EXPRESSIONISM WAS A REVOLUTION IN ART, philosophy, litera-
ture, and spirit to regenerate the cultural, political, and social spheres
stagnating beneath nationalist and authoritarian institutions and their rep-
resentatives. Immanent, transformative energies and the future-directed
spirit of man, according to Kurt Pinthus in "Rede für die Zukunft"
(Speech for the Future, 1918), would reshape the world, for "die Wirk-
lichkeit ist nicht außer uns, sondern in uns" (reality is not outside us, but
rather within us; in Rothe, 126)[1] Such calls for renewal and salvation were
common within German political, social, artistic, and scientific circles,
which were acutely aware of the unresolved existential, social, and political
problems caused by Germany's accelerating industrialization in the late
Wilhelminian period. Debates concerning "wholeness" and "spirit" preoc-
cupied a society obsessed with the power and reach of scientific and capi-
talist enterprise, especially after 1914.[2] The confrontation of "machine"
and the "soul" resonated widely and encompassed a range of cultural
meanings: For some it promised salvation and the transformation of the
self that humanistic discourse had failed to provide; for others it became
the source of human damnation. As the complete penetration of technol-
ogy in modern life entered general consciousness, nineteenth-century faith
in the progressive promise of technology, the supremacy of traditional
elites, and the spiritual autonomy of the subject came under scrutiny and
the metaphorical function of the machine in culture and society
expanded.[3]

Although many artists embraced technology as a revolutionizing tool
for the stage, and as a symbol of freedom of movement in their private lives
as avid car and airplane enthusiasts, especially in the prewar era (see
Loquai, 76–94), the depiction of technology in modernist literature exhib-
ited more generally the "schizophrene Haltung des modernen Menschen
zur Technik überhaupt" (schizophrenic posture of modern man to tech-
nology in general; Daniels, 177) as artists struggled to come to terms with
the contrary senses of liberation and subjugation by the machine on the

one hand, and on the other the mastery it afforded while it threatened the mechanization of the human spirit.[4] As Karlheinz Daniels shows, prewar poems such as René Schickele's "Großstadtvolk" (Big City People), Ernst Stadler's "Bahnhöfe" (Train Stations), Alfred Wolfenstein's "Fahrt" (Trip), Gottfried Benn's "D-Zug" (Express Train), and Gerrit Engelke's "Lokomotive" (Locomotive) depict industrialism and technology as the site of energy and as tools to serve the self on a journey of self-discovery and brotherhood. In these poems technology confirms the individual's new potential, while Paul Zech's "Fabrikstraße tags" (Factory Street by Day) highlights the unavoidable psychological, philosophical, and physical displacements of nineteenth-century industrialism. The caesura of the First World War changed attitudes towards technology radically, as, for example, a comparison of the pre- and postwar versions of Iwan Goll's poems "Der Panama-Kanal" (1912–1918) and "Der Panamakanal" (1918) will demonstrate.[5] Throughout Expressionist literature, treatments of the New Man revealed the precarious position of the artist as cultural leader in the modern age; Expressionist drama was one cultural movement that produced some of the most vivid and influential experiments in stagecraft of the early twentieth century in an attempt to salvage an autonomous vision of the self within an increasingly mechanized society.

In prewar drama, highly abstracted and stylized language and settings, characters as social types, ecstatic monologues, and other rhetorical strategies sought to explode the physical and mental limitations of the alienated hero as he "became" rather than "mimicked" the ecstatic gestures of the soul freed from all constraints. The station drama, evoking Christ's journey to Calvary through a series of interrelated episodes, highlighted the hero's mission to recapture the authenticity of life and the energies quashed beneath the realism and mechanized industrialization of Wilhelminian society. Nonverbal elements such as light, color, spontaneous gesture, music, and silence combined with a tendency towards irrationality, spirituality, mysticism, and esoteric religions to present vision-like and distorted settings that evoked the spiritual transformation of the hero against society. Literary and artistic works demonstrate a fascination for humankind's primitivist beginnings as an antidote to the father-generation's mechanistic thinking and blind faith in industrial progress, which had its basis in rationalism and the Enlightenment. Rather than advocate concrete, sociopolitical goals to combat the dislocations of the industrial age, Expressionists sought through an abstract and antimimetic style of provocation to (re)locate primeval origins within the individual through the (re)creation of feelings that would unify mankind in "brotherhood."

The most important precursors to Expressionist drama include the works of the *Sturm und Drang*, such as Friedrich Maximilian Klinger's *Die Soldaten* (The Soldiers, 1776), *Sturm und Drang* (Storm and Stress, 1777), and Friedrich Schiller's *Die Räuber* (The Brigands, 1781). Georg

Büchner's *Woyzeck* (Woyzeck, 1836/37) and August Strindberg's taut early Naturalist plays such as *The Father* (1887) and *Miss Julie* (1888), as well as his vision-like station dramas *To Damaskus* (1897–1904), *Dreamplay* (1902), and *Ghost Sonata* (1907), also proved influential. For inspiration Expressionists looked to the penetrating dialogues of Henrik Ibsen's *Peer Gynt* (1867), the advocacy of social issues by the Naturalists, and the frank language of sexuality in Frank Wedekind's *Lulu* plays and *Frühlings Erwachen* (Spring Awakening, 1891). The analyses of man's darkest psychological recesses in the novels of Fyodor Dostoyevsky and Leo Tolstoy also served as models for art set against artistic traditions in the Wilhelminian era. Dramatic experiments sought to evoke a frenetic emotionalism and dialectical intellectualism to challenge all bourgeois norms and values and lead Germany to a more egalitarian and transnational society. Leading journals such as Franz Pfemfert's *Die Aktion*, Herwarth Walden's *Der Sturm*, and René Schickele's *Die Weißen Blätter* were deeply involved in delineating the relationships between art and society, and art and politics. The theater would influence performatively the development of German society and become the center of revolutionary change.[6]

In Expressionist drama the individual's subjective vision rather than the dialectical development of objective and subjective realities predominated on stage. Expressionist drama made explicit the internal structures of subjectivity and its strategies to overcome a world dominated by scientific-technological advances. Subjectivity was a given, and free will, autonomous agency, and the right of the subject to possess himself were all part of the New Man. The antinomy of human subjectivity and the mechanized world, rather than the entwining of humans and machines in modern society, was the focus of the Nietzschean evocation of man's overcoming of his environment.[7] This overarching suspicion of the machine in German artistic circles stands in contrast to Italian Futurism and its enthusiasm for technology to revolutionize society and accelerate the transformation of bodies and psyches, although as Frank Trommler points out, Futurism's "hymns to technology are too aggressively attuned to the emotion of anxiety not to be read also as an outgrowth of it" (Trommler, 1995, 405). Introduced to Germany through a series of exhibitions and readings at the Sturm Gallery in Berlin under Herwarth Walden's sponsorship in 1912, Futurist language experiments became models for the development of the reductive language style or *Telegrammstil* (telegraph style) of Expressionist works such as August Stramm's *Sancta Susanna* (1914). With the exception of Walden's *Sturm* circle, however, Expressionists in general did not subscribe to the vision of the Futurist leader Tomasso Marinetti, who embraced technology's connotations of aggression, masculinity, and warfare, and who advocated the dissolution of the human subject in his "Technical Manifesto of Futurist Literature" (1912).

A true multimedia phenomenon combining poetry, drama, cinema, music, and architecture arose when Expressionist directors and actors alike experimented furiously to try to evoke a new mode of artistic and political expression. In terms of acting, they looked to the world of German body culture such as cabaret, the eurhythmy of Rudolf Steiner and Émile Jaques-Dalcroze, and the eukinetics of Rudolf von Laban, as well as such German dramatic traditions as Naturalist experiments in voice and gesture for models. Prolific, "ecstatic" actors such as Ernst Deutsch, Fritz Kortner, and Werner Krauß went beyond mere presentation of the central figure to evoke a mode of performance that would break through physical and mental limitations in order to become "spirit" and "soul," a "psychic totality." Directors such as Richard Weichert, Max Reinhardt, and Jürgen Fehling became as important as the dramatists and actors themselves in bringing this new style to the theater. They now had the directorial authority (via the English theorist Gordon Craig) and technical know-how to create and control a fully integrated theatrical production or *Gesamtkunstwerk*. Innovations in lighting technology such as tungsten filament and gas lamps allowed for the spatialization of light and *mise-en-scène* necessary to shape the body and its movement within a disembodied and absolute world that highlighted the deep and "infinite" energies of the New Man (See Schivelbusch 1988). Lighting could finally realize the Swiss designer Adolphe Appia's insight that "light is to production what music is to the score; the expressive element in opposition to literal signs; and, like music, light can express only what belongs to the 'inner essence of all vision'" (Appia, 72). As David Kuhns notes, Expressionist dramatic space developed into a "sequence of continually transforming spatial images, or tableaux" (Kuhns, 97) that revealed the psychic landscape of the individual in his attempts to change the world. Premieres of Expressionist dramas in Frankfurt, Düsseldorf, Leipzig, and Munich proved influential in setting the tone through advances in lighting and stagecraft, while Berlin, still under the sway of Max Reinhardt's realist productions, came to such innovations primarily in the postwar period.[8] In the 1920s and beyond, Bertolt Brecht extended the innovations of Expressionist stagecraft in his development of epic theater and in the role he envisioned for it as a vehicle of social change. Directors such as Erwin Piscator and Leopold Jeßner employed even more elaborate stage mechanisms: Jeßner's *Treppenbühne* (Step-Stage) used multiple levels to allow elaborate stage action to flow more freely; Piscator integrated film, slide montage, reportage, and segmented staging to produce provocative and contradictory effects for his proletarian theater, which he details in *Das politische Theater* (Political Theater, 1929).

The sculptor Ernst Barlach and the painters Wassily Kandinsky and Oskar Kokoschka wrote some of the most innovative and challenging works, seeking to evoke dimensions of the nonrational and primitive, the mythic and exotic by building the theater as essentially a visual medium.

The return to the essential and primitive and the rejection of Western paradigms of progressive history illuminate the widespread desire of primitivists and Futurists alike to rediscover man's original relation to the world. Ernst Barlach brought the plasticity and haunting depth of his sculptures to his explorations of the human condition in *Der arme Vetter* (The Poor Relation, 1918), *Die echten Sedemunds* (The Genuine Sedemunds, 1920), *Die Sündflut* (The Flood, 1924), and *Der blaue Boll* (Blue Boll, 1926). Kandinsky outlined in "Über das Geistige in der Kunst" (Concerning the Spiritual in Art, 1914) how the spiritual theater of the future would be composed of sound, color, and mobile forms, which were all of equal value. His short stage work *Der gelbe Klang* (Yellow Sound, 1912) emphasizes synaesthetic experience to portray this new mode of being. Kokoschka's use of performing objects, in this case the use of automata or "self-actuating things" in *Sphinx und Strohmann* (Sphinx and the Strawman, 1909), challenged the precepts of Cartesian consciousness, positivism, and realism, a strategy pioneered by Alfred Jarry in *Ubu Roi* (King Ubu, 1896). *Ubu Roi* made clear that the world was no longer transcendent and guided by organic concepts, as objects became as important as the human actors, which in effect undermined systematically the perceived domination of human consciousness. The Bauhaus theater workshop in the 1920s, under the direction of Oskar Schlemmer, would later explore the synthesis of man and machine in such works as Schlemmer's "Bauhaus Dances."

Theoretical works of Wassily Kandinsky and Wilhelm Worringer's *Abstraktion und Einfühlung* (Abstraction and Empathy, 1908) helped legitimize the correlation between abstraction and expression in drama and the arts through a reevaluation of the role of volition in art. By "subsuming the differences between artistic media to a single psychological imperative manifested in art that alternates in broad swings between the categories of time and space in different historical epochs" (Donahue, 16), Worringer showed that artists and their cultures react against a hostile, threatening environment by seeking harmony and order in the geometrical and abstract, thus lending theoretical legitimacy to the Expressionist art of *Die Brücke* (The Bridge) in Dresden, *Der blaue Reiter* (The Blue Rider) in Munich, and the *Neue Sezession* (New Secession) in Berlin, who looked to the painters van Gogh, Cézanne, and Matisse for metaphysical and primitivist inspiration. Sigmund Freud's development of psychoanalysis, Friedrich Nietzsche's treatments of the Apollonian and the Dionysian, and Henri Bergson's life affirming *élan vital* debated the distinctions between reason and instinct, between civilization and primitive nature, which in turn revealed the tenuous balance between a liberating, transrational spirituality and the anarchic wishes of Expressionists to revolutionize society. Nietzsche's philosophy especially became a model for young artists, who viewed bourgeois realism and the tenets of Naturalism, with its emphasis

on social determinism and mimetic reality, as incapable of addressing the concerns of a younger generation faced with the fragmentation of the world. The antithetic juxtapositions of *Gemeinschaft* (community) versus *Gesellschaft* (society), *Kultur* versus *Zivilisation*, the "Soul" versus "Reason," "Man" versus the "Machine" mirrored wider cultural debates on the proper role of man in a mechanized world.

Kokoschka's primitivist prewar dramatic tetralogy *Sphinx und Strohmann*, *Mörder, Hoffnung der Frauen* (Murderer, the Women's Hope, 1909), *Der brennende Dornbusch* (The Burning Bush, 1911) and *Hiob* (Job, 1917), a later version of *Sphinx und Strohmann*, are far removed from the dreamy exoticism and archetypal elements of his earlier lithographs for *Die träumenden Knaben* (The Dreaming Youths, 1908). Not only do these early plays present a "visual and pantomimic liberation from the confining fetters of realism and propriety" in their "dreamlike, magical, and surrealistic poetry of Expressionist theater and its peculiarly subjective use of myth and biblical and literary allusions" (Sokel, xvii, xxxi), they also show the complex relationship between sexuality and the aesthetic sensibilities of modernity. The frank portrayal of sexual conflict and destruction of mythic unity in Kokoschka's episodic and visual work *Mörder, Hoffnung der Frauen* (Murderer, the Women's Hope, 1909) points to Kokoschka's ongoing preoccupation with the fragmentary experiences of modernity and its challenges to masculinity. The Cartesian consciousness of the rational and mechanistic world vanishes; preconceptions of the physical world, time and space, are subverted. Arguably the first Expressionist drama with its starkly episodic structure, lack of clear narrative, and violent, visual imagery, *Mörder, Hoffnung der Frauen* also shows Kokoschka's belief that the power of theater lies in its visual elements rather than spoken language.

The play, with its abstract settings and primitive, archetypal figures locked in a violent confrontation of the sexes, had its premiere in the summer of 1909 at the Vienna Kunstschau garden (which had just enjoyed a performance of Oscar Wilde's *Birthday of the Infanta*), and, as Carl Schorske reports, the differences between the two could not have been more provocative (Schorske, 335). Kokoschka even painted musculature and nerves onto the actors' bodies, which exposed the primitive and anatomical animality of the characters. The actors' bodies are no longer secured possessions — the body becomes an intertwining of vision and movement rather than an object displacing space at the command of a human presence. Language is also no longer a known quantity used to share an impression of the outside world, but rather a reservoir of energy released by the artist. Although the play is barely five pages long, its dialogue or utterances are unintelligible without Kokoschka's stage directions, which call for the evocative use of symbolic colors, lighting, noise, and gestures.

The influence of Otto Weininger's *Geschlecht und Charakter* (Sex and Character, 1903) and Heinrich von Kleist's tragedy *Penthesilea* (1808) emerge in the actions of the archetypal figures of Man and Woman, who appear in glaring, primary colors. Today Weininger's theories on the polarization of sex and gender may seem to amount, as John Toews notes, to "a cartoonishly hyperbolic, pretentiously philosophical, maniacally simplifying book, throbbing with uncontrolled misogynist and anti-Semitic feelings" (Toews, 31), but upon its publication it had enormous influence on the avant-garde and spoke to its preoccupations with sexuality and threatened masculinity. Likewise, the play compresses the events of Kleist's *Penthesilea*, where the love of the Amazon princess Penthesilea for Achilles and her quest for a true identity between the worlds of nature and civilization lead to tragedy and death, into a violent conflict and brutal mythical horror without any hint of resolution (Schorske, 338). Only through the murder of the Woman is the Man able to break out of the vicious cycle of attraction and destruction, love and hate, which binds them. Kokoschka's presentation of savage primitivism and violent emancipation betrays the crisis of human subjectivity in the modern age, where human consciousness is subverted and a clearly delineated and predictable outside world simply vanishes.

Kokoschka employed the power of the visual to rebel against the repression and stagnation of Viennese culture and the industrial mechanization of the human spirit; that impulse was then taken up on German provincial stages by a younger generation of dramatists. Even if they had not seen his plays performed, they were certainly aware of the primal quality of his 1910 illustrations in *Sturm* for his play, and of his attempts to revolutionize the theater through a greater awareness of the plasticity of performance space around the protagonist. Early Expressionist station dramas such as Reinhard Johannes Sorge's *Der Bettler: Eine dramatische Sendung* (The Beggar: A Dramatic Mission, written 1912), Walter Hasenclever's *Der Sohn* (The Son, written 1913/1914), and Georg Kaiser's *Von morgens bis mitternachts* (From Morn to Midnight, written 1912) express their outrage at materialist bourgeois society through the visceral emotional scream or *Schrei*. Both the portrayal of the dreams of the eponymous hero of *Der Bettler* and the world as subjective vision of the twenty-year-old Son in Hasenclever's work illustrate their attempts to overcome the authoritarian, militarist, and mechanistic traditions of the father generation of the prewar period. The Cashier's failed attempts at regeneration and transfiguration within capitalist social and psychic structures in *Von morgens bis mitternachts* nonetheless reveal those impulses as social critique.

In Sorge's five-act play *Der Bettler* (1912), prewar lyrical and neo-Romantic traditions mix with Expressionist characteristics such as the use of figures as social types, an episodic structure, and revolutionary staging directions. Sorge subverts the predictable transitions of the well-made play

through an eclectic mix of lyrical reveries and ecstatic monologues, in order to convey the visions of the eponymous hero. His "essentially vertical grammar of expression" (Kuhns, 129) calls for coordinating revolutionary lighting effects, such as spotlighting the Poet from steep angles to show the soaring aspirations of the Poet, and then contrasts this with the flat and undifferentiated representations of the figures around him. Sectional lighting, similar to jump cuts in film, stressed the episodic structure of the Poet's journey to found a new theater and thereby fulfill the wishes of the public for a Prophet for the new generation, as the Third Critic states in the first act: "Wir warten auf einen, der uns unser Schicksal neu deutet, den nenne ich dann Dramatiker und stark [. . .] einer muß einmal wieder für uns alle nachsinnen" (We're waiting for someone who will give new meaning to our fate; him I would call a dramatist and strong [. . .] someone must once again think for us all; 12). The play opens in prewar Berlin with the Poet (variously labeled as the Young One [Jüngling] and the Son) aspiring to found his own theater and realize his vision. Other figures act as either barriers or facilitators for the Poet's transformation: An overbearing Patron tempts him with a fixed income for ten years to allow his brash visions to adjust to the limits of possibility; a thoughtless Friend misunderstands his poetic vision; a Girl marvels at this wondrous stranger and pledges to follow the Poet to a great and vague beyond, giving up her own child when she learns she is carrying his. The grand possibilities of the New Man are further tied to the inventions of the second wave of industrialization and its promise of accelerated social and physical mobility, suggested by the six Flyers of the first act. But the Son's real challenge to Wilhelminian Germany's assault on the subject focuses on his mentally deranged Father, who is obsessed with his own supernatural, mystic, and often violent vision of an engineering breakthrough to new horizons. The perception of technology is clearly shaped by imperial Germany's vocabulary of authoritarian militarism. The objectivity and self-restraint of the engineer type of the nineteenth century, trained to eliminate unruly, natural phenomena through the imposition of human design, gives way to an unstable, destructive presence bent on conquering the natural world and destroying his own autonomy and identity in the process. In the third act, after the Father completes his engineering plans with the blood of a baby bird fallen from its nest, the Son fulfills his Father's wishes by killing him to alleviate his own sufferings, and also to facilitate his own strivings to "create anew."

Breaking with his heritage and risking the journey into the unknown, the Son confronts his alienation from his self and the material world. Yet his strivings to become the New Man fall short — the unity of art and life fails him and he must fall back into his theatrical role to speak "through symbols of eternity" at the end of the work. Unlike his father, however, he is able to return from the boundaries of human consciousness and remain

fascinated by life, rather than be drawn into his father's (and society's) yearning for death. Sorge links the deterioration of nineteenth-century notions of empirical objectivity, self-abnegation, and restraint to historical shifts in the early twentieth century in moral, familial, and political spheres. But he sees at least a possible resolution of the tension between art and technology, which so dominate prewar European discourse (see Trommler, 1995, 407–13), in the Six Flyers, who transcend rationalist and mechanistic society and offer a more optimistic collaboration between man and machine. The stage becomes a holy site where the Son accepts his fate as a beggar and social outcast in an indictment of the social order, and embraces a new vision of man in order to renew himself and the world. Reminiscent of Hasenclever's *Der Sohn*, but without the self-consciously ambivalent construction of the Son's transfiguration in that work, *Der Bettler* opened the possibilities of Expressionist staging before Sorge could see his vision realized. He received the Kleist prize for his work in 1912 but was killed during the war in 1916.

The Son's vitalist and ultimately immoral behavior and *Sturm und Drang* struggles with familial and authoritarian structures in Sorge's play also constitute the basis for Hasenclever's five-act drama *Der Sohn*, written between summer 1913 and early 1914, which is less episodic in form than *Der Bettler* and follows generally a linear plot development. Its performance during the war amplified the social and political connotations of the play, characterized by Hasenclever in the playbill to the closed 1916 German premiere at the Albert Theater Dresden as "der Umweg des Geschöpfes, sein Urbild zu erreichen; das Spiel des Sohnes zum Vater, das Vorspiel des Bürgers zum Staat" (the circuitous route of creation to reach its primal image; the play of the son toward the father, the play of the citizen toward the state; Hasenclever, 1916). Postwar performances in Mannheim proved a sensation, thanks to the director Richard Weichert and stage designer Ludwig Sievert, who highlighted the psychic development of the Son through more abstract and symbolic staging. Fewer props were used, characters appeared and disappeared in shadow, and the centering of a cone of light on the Son accentuated that one was viewing a fragmented reality through the prism of his subjective vision, reflected also in the eclectic mix of verse, prose, monologue, and hymnic reveries. This accentuated the deep energies of the protagonist, despite the ambivalence of the hero's successes in overcoming personal and societal obstacles to his mission.[9] *Der Sohn* became the model for activist political revolt, and Hasenclever the prototype of the political poet, although political references remain quite vague. Hasenclever himself renounced any wish for a political role within Germany after the failures of the postwar revolutions, a decision he brought to the stage in *Die Entscheidung* (Decision, 1919).

In act 1 the Son, distracted by neo-Romantic longings, has just failed his high school examination despite the best efforts of his tutor. Among

other things, he laments a technological age where he is asked to surrender his individuality and autonomy, where self-creation and community are mediated more and more by technological processes that threaten the clear contours of the autonomous self. Rather than accept his material mastery over society (via new developments in manufacture and travel), the Son's alienation focuses instead on the threat to unmediated human communication and transrational spirituality in the age of math, science, and wire and radio communication: "Ich bin gedemütigt durch jede Existenz, die meine Sehnsucht nach ihr verringert. Ich finde es empörend, daß ein Gebäude entsteht, aus dem man vermittels elektrischer Wellen die Lüfte ruiniert. Wie hasse ich dies Communiqué zwischen Kaiser und Kommis. Der Teufel hat dafür gesorgt, daß sich jede Braut und jeder Sterbende noch um die Erde drahtet!" (Hasenclever 236; I am humbled by each existence which diminished my desire for it. I am revolted by the fact that a building is constructed from which the air is ruined by electric waves. How I hate all the communiqués between Emperor and soldier. [The devil has seen to it that each bride and every dying man wires around the world.]; Schürer's translation with author's addition of omitted sentence in brackets, 84). Although the locus of selfhood is questioned and the fragility of consciousness is exposed, his monologue in the second scene again confirms his sense of self. He later embraces the help of the mysterious Friend to escape the wrath of his Father, who has refused his claims to social freedom and his desire to become the Prophet of a new generation by imprisoning him in his own household.

Pledging him hatred unto death, the Son escapes with the help of his governess and a band of armed compatriots sent by the mysterious Friend, and later incites the "Klub zur Erhaltung der Freude" (Club for the Preservation of Joy) to revolution while in a somnambulistic state under the spell of the Friend. He then finds his own sexual liberation at the hands of the prostitute Adrienne. But despite his rejection of his Father's world, his apparent successes as a Leader at the Club, his journey into manhood, and his triumph over the nihilistic decadence that leads to the demise of the Friend, the Son is still bound to the world of the Father since he has failed, as he states in act 4, "nach soviel Stationen, endlich eine Sache ganz tun" (Hasenclever 299; after so many stations, to do something completely; Schürer, 128). He owes his role as leader at the mysterious club to the hypnotic powers of the Friend; he steels himself to confront and kill his Father, but he is denied this revolutionary act when the Father dies on the spot of a stroke. This simultaneous activity and passivity throughout the play calls into question the traditional autonomy of the subject and hints at an underlying yearning for submission. But his attempt at a unity of art and life ignores the integration of technology in this process. The Son embraces his transcendence over technology rather than through technology as he pursues complete autonomy. Yet overcoming his origins remains

problematic, and as he prepares to explore new horizons and fight for "freedom," his cliché-ridden rhetoric qualifies and undermines his quest for authentic truth and brotherhood, as does his anticipatory optimism, which dismisses socioeconomic circumstance and the dwindling influence of his culturally elite audience. Despite the ecstatic emotional embrace of revolution, the final scene sooner points to the troubles to come for self-proclaimed prophets unprepared for Germany's postwar period: "Denn dem Lebendigen mich zu verbünden, / hab ich die Macht des Todes nicht gescheut. / Jetzt höchste Kraft in Menschen zu verkünden, / zur höchsten Freiheit, ist mein Herz erneut!" (Hasenclever, 322; To ally myself with what is vital / I have not shunned Death's eternal might. / Now man's greatest power to proclaim / Toward freedom, is my heart's new aim! Schürer, 144).

Sorge's and Hasenclever's desire for the eternal beyond the familial, political, and economic restraints of prewar society contrasts with the wickedly funny social satires of the comfortable middle class in Carl Sternheim's *Die Hose* (The Bloomers, 1911), *Der Snob* (1914), *1913* (1915), and *Das Fossil* (1923), the most important works of the cycle *Aus dem bürgerlichen Heldenleben* (From the Lives of Bourgeois Heroes, 1911–23). Unlike the anxiety of the intellectual and elitist characters in Sorge's and Hasenclever's prewar works, Sternheim's social strivers do not even mention the privileges of technological innovations that afford mastery over their surroundings, but take everything available to the aspiring middle classes for granted. Likewise, Sternheim does not harbor any illusions that Wilhelminian society can be transfigured through the energies of the artist and the power of his rhetoric. On the contrary, the highly expressionistic and stylized language of his plays, which he addresses in his essay "Kampf der Metapher" (Fight against the Metaphor, 1918), exposes the empty and ridiculous propriety of common turns of speech, which inhibit authentic thought and feeling and therefore the possibility of personal and social transformation in capitalist society. To illustrate this, Sternheim leaves out articles and conjunctions, he embeds dependent clauses within (rather than at the end of) main clauses, and in general subverts linguistic constructions to concentrate the focus on basic noun and verb forms and therefore the basic expressive power of language.[10] But although Sternheim subtitles *Die Hose* "ein bürgerliches Lustspiel" (a bourgeois comedy), he never offers an antidote to the failings of Wilhelminian society, and the protagonists are not brought to justice at the end, as is the case, for example, in Heinrich von Kleist's classic *Der zerbrochene Krug* (The Broken Jug, 1808). Rather, Sternheim reduces and flattens the metaphysical longings of the Expressionist hero by exalting the Darwinian survival of the anti-hero, Theobald Maske, who seems immune to any sort of higher impulse other than self-satisfaction. In *Der Snob*, Sternheim presents the development of the liberal humanist subject in the age of capitalism as a brutal egoist and

materialist, thus reducing the modern self exclusively to the acquisition of material wealth and property. As Silvio Vietta points out: "Sternheim zeichnet in Christian Maske mit Witz und Ironie ein Subjekt, das die abendländische Sebstbegründung des Subjekts, wie sie in der neuzeitlichen Philosophie von Descartes über Fichte bis Hegel als Denkprozeß vollzogen wird, als materiellen Kaufakt vollzieht" (Sternheim portrays, with wit and irony, in Christian Maske a subject who brings to conclusion the occidental self-legitimation of the subject, as conceived in modern philosophy from Descartes through Fichte to Hegel as a process of cognition, as [instead] an act of purchasing; Vietta/Kemper, 104). The productive imagination has deteriorated to posturings for self-advancement and has lost any aspiration to higher ideals.

The four act comedy *Die Hose* (The Bloomers, 1911) was first performed under the name *Der Riese* (The Giant) on 15 February 1911 at the Kammerspiele des Deutschen Theaters in Berlin, because Berlin censors had struck the original title on the grounds of gross immorality. True to the forthrightness of the title, Luise Maske loses her bloomers during a royal parade just as the Kaiser and his entourage pass by, which leads her husband, the philistine Theobald Maske, to wage damage control to protect his family's reputation and economic standing at all costs, whereas his wife Luise views the entire situation as a welcome relief from a mundane existence. The sudden popularity of Herr Maske's residence results in two new subletters, each with an eye on Frau Maske, albeit for different reasons. The ridiculously cultured Herr Frank Scarron is obsessed with the high ideals of German *Kultur* and his lust for Frau Maske. The hypochondriac barber Mandelstam sees through Scarron's intentions and vies for her attentions as well. Yet for Mandelstam it may not be a mere affair he is after, but a maternal figure who can offer him the security and stability he never had during his own upbringing. Luise's maternal instincts and desires are awakened in her dealings with both. Their neighbor Gertrud Deuter cannot be persuaded that Luise Maske's little spectacle was all an accident. Thus she offers to pimp for Luise so that she can liberate her urges, which is also an excuse to flirt with Luise whenever she tires of her two suitors. The satire reaches its high point in the third act when Herr Maske unwittingly undermines Scarron's philosophical musings on Nietzsche's Superman theory, whose aspects of social Darwinism Mandelstam enthusiastically embraces. Each is presented as more laughable than the next in an ultimately downward spiraling dialectic. The stolid philistine Maske ultimately triumphs over both, and proves himself sovereign over all: although he seems the cuckold of the entire affair, Frau Maske's suitors ultimately fail in their quest, and, in the end, Herr Maske benefits materially, sexually, and socially from his wife's accident by raising the rent on his rooms, engaging in a discreet fling with Fräulein Deuter, and planning a proper family life, as he promises Luise in act five: "Jetzt kann ich es, dir ein Kind zu machen, ver-

antworten" (Sternheim, 133; Now I can take on the responsibility of starting a family; Schürer, 80). His masked true nature allows him to indulge in all manner of excesses, just as he had bragged to Scarron in the third act: "Meine Unscheinbarkeit ist eine Tarnkappe, unter der ich meinen Neigungen, meiner innersten Natur ungehindert frönen darf" (Sternheim, 96; My insignificance is the cloak of invisibility under which I can indulge my inclinations, my innermost nature unhindered; Schürer, 60).

Urges and drives certainly play a central role in Sternheim's dramas, and philosophical systems are again distorted in *Der Snob* (1914), this time by the son Christian Maske's capitalist machinations for material power, an echo of Friedrich Nietzsche's "will to power." In this comedy, which premiered 2 February 1914 at the Deutsches Theater, the son rises through a series of self-serving machinations to the post of General Director and husband of a countess. His parents are among the first he jettisons as he pursues his goals by sending them off to a retirement home. Yet later, in the comfort of his new wealth and security, he again takes up contact and learns from his father of his mother's death. Thus he is now free to use his mother's infamous reputation to feign lineage as an illegitimate son of an aristocrat and solidify his position in the upper aristocracy. The play *1913* (1915) follows the lives of Christian Maske's three children, Philipp Ernst, Ottilie, and Sofie, now the Countess of Beeskow. Maske finds himself locked in intrigue against his conniving daughter Sophie, who has signed a military contract without his knowledge during his illness. Her vision of industrial mass production, now dangerously associated with the destructive power of the military, threatens Maske's nineteenth-century paternalism and individualism, where "der massenweise Verschleiß aller Lebensutensilien" (Sternheim, 284; the mass consumption of all of life's implements) has inculcated in the user "auf das einzelne nicht mehr zu achten und er Gefühle, Urteile und sich selbst hinwirft und verbraucht wie das Übrige und ihnen keine Qualität mehr geben kann" (Sternheim, 284; not to be concerned with the individual, who throws away and uses up feelings, judgments, and himself like any other object to which he can no longer give a value). The persona of the nineteenth-century manufacturer shifts to the industrialists and experts of Bismarck's Germany, who readily conflate military and industrial interests. Although he is able to cancel the war contract before his death, the power struggles of the Maske family prefigure the national crises on the European stage as the self becomes trapped within the debilitating rationalizations and commodifications of the era.

The Expressionist critique of Wilhelminian familial and political institutions and society's blind faith in the power of capitalist and technological enterprise shifted to a general rebellion against violence and technology in all its forms after 1914 as the war claimed the lives of Ernst Stadler, August Stramm, Reinhard Johannes Sorge, Georg Trakl, Franz Marc, and August Macke, among countless others. The sociologist Max Weber's view in his

Munich lecture "Wissenschaft als Beruf" (Science as a Vocation, 1918) that the world was now bereft of transcendent principles and prophets was echoed by Rudolf Paulsen in "Das Tempo unserer Zeit und der Expressionismus" (The Tempo of Contemporary Times and Expressionism, 1918) where he viewed technology as facilitating society's acceleration towards death. In drama, the figure of the artist-superman, the self-proclaimed slayer of fathers and the liberator of youth, shifted to the urgent and sometimes shrill posturings of the martyr and activist political poet attempting a spiritualized and communal transformation of society against overwhelming military and industrial forces, where "victory [was] no longer decided by the spiritual and mental resistance of men, but by the predominance of mechanical instruments of power . . . Things had come to rule over men" as the socialist analyst Erich Wittenberg observed (235–36; quoted in Harrington, 30–31). Fritz von Unruh's lyrical antiwar play *Ein Geschlecht* (One Race, 1917) served as a prelude for a new and aggressive pacifism to battle against militarism and entrenched nationalist prejudices. In Reinhard Goering's one act play *Seeschlacht* (Sea Battle, 1917), class and political differences collapse as sailors, referred to only by their number, lose their identity and humanity as they submit to the mechanization of war. Hasenclever's antiwar play *Antigone* (1917) highlights humanist, mystic, Judeo-Christian, and pacifist messages, replacing the aggressive, anticipatory optimism of *Der Sohn*. Metaphorical allusions to technology now allude less to manufacture and Wilhelminian political and social processes and more to destructive forces beyond imagination. Whereas in France and Russia technology suggested revolutionary potential (Trommler, 1995, 399), in Germany it was closely associated with military defeat and political anarchy.

Ernst Toller wrote his semi-autobiographical plays *Masse Mensch* (Masses and Man, 1920), *Die Maschinenstürmer* (The Machine Wreckers, 1922), and *Hinkemann* (1923) while in prison for his role in the revolutionary events of 1918–19; they highlight how the lone individual perishes as he or she strives to communicate a spiritual concept of personal and political life in the overwhelmingly industrialized and violent world of the postwar period. Here, the revolution for idealistic ethical and humane values meets the revolution of the factory and the suppression of all individuality in the masses, but a reconciliation of art and technology fails. Toller's theatrical deliberations on the ethical and moral dilemmas of the pacifist revolutionary and the possibility of personal and political regeneration following the events of 1919 contrast with the optimistic anti-war fervor that preceded defeat and revolution in *Die Wandlung: Das Ringen eines Menschen* (Transformation: The Struggle of a Man, 1918).

*Die Wandlung* is in verse and comprises a prologue (which can also be regarded as an epilogue) and six alternately realistic and dreamlike sequences focusing on anti-war agitation. Religious ecstasy and oratorical

pathos mark the journey of the patriotic Jewish sculptor Friedrich, as he is transformed in six stations from a loyal war volunteer to an anti-war hero advocating peace and brotherhood. In the first and second stations Friedrich's patriotism and idealism come up against the prejudices of his comrades and the horrors of war. The only member of his unit found alive after a suicidal mission, through his inadvertent heroism he finally earns the respect of his anti-Semitic commanding officer — but at the cost of ten thousand lives. His inner journey continues as he convalesces in a hospital in the third station and seven horribly deformed cripples are marched before a group of medical students, one with Friedrich's features. He faints during the lectures of the death-like Professor, who praises the ability of medical science to treat the ghastliest wounds, though with even more grotesque and disfiguring results. In the fourth station Friedrich works on a statue celebrating the triumphs of German militarism, with his patriotism outwardly intact, but the appearance of one of his physically and emotionally crippled comrades and his syphilitic wife serves as the final catalyst to his awakening: he destroys his statue and announces ecstatically that he will fight to free humanity and create man in a new image. His mission lies not in his artistic development but in awakening humankind through his revolutionary fervor. In the sixth station of *Die Wandlung,* others take up his call for brotherhood and revolution as Friedrich becomes a public figure proclaiming love and social renewal: "Brüder recket zermarterte Hand, / Flammender freudiger Ton! / Schreite durch unser freies Land / Revolution! Revolution!" (Brothers! Stretch out your beseeching hands, burning joyful sound! March through our free country. Revolution! Revolution!; Toller, 285)

In contrast to the anti-war stance of the hero and the open anticipation of revolution, in *Masse Mensch* (Masses and Man) and *Die Maschinenstürmer* the figures of the social activists Sonja Irene L. and Jimmy Cobbett give new value to the actions of revolutionaries in the immediate postwar period during Germany's transition to parliamentary democracy, when the actions of the revolutionaries themselves were still open to much debate. As Frank Trommler notes, these plays illuminate the defiance of Toller himself in the face of the revolution's failures, and "offer paradigmatic structures on the stage whose tragic dynamics are intended to locate the author's experience within the public perception of revolution" (Trommler 1992, 65). Toller explains in his 1921 foreword to the second edition of *Masse Mensch*, entitled "Brief an einen schöpferischen Mittler" (Letter to a Creative Mediator), that of the seven scenes written in verse and dedicated to the proletariat, scenes 2, 4, and 6 are *Traumbilder* (dream images) that convey Sonja's internal ethical struggles with her individual and social responsibilities, while scenes 1, 3, 5, and 7 are *reale Bilder,* meant as visionary abstracts of reality. These abstracts of reality, however, do not merely convey external reality, as Toller makes clear: "Was kann in

einem Drama wie *Masse Mensch* real sein? Nur der seelische, der geistige Atem" (What can be real in a drama like *Masse Mensch?* Only spiritual, mental breathing; Toller, 293), just as real world actions of 1919 do not merely convey Naturalist milieu scenes, but "schauerliche Marionetten, von ahnungsvoll erfühltem Zwang schicksalhaft getrieben" (horrific marionettes fatefully pursued by a prefigured compulsion; Toller, 293).

In *Masse Mensch* the factory is a site of inhumane suffering; the first scene and the macabre *Traumbild* that follows stress the State's manipulation of capitalism and technology to subjugate the proletariat. But Sonja's goal to lead the masses to humanity and community through a peaceful strike fails as they turn against her and demand revolution. She is the only one aware of the need for the integration of human and machine: "Fabriken dürfen nicht mehr Herr, / Und Menschen Mittel sein. / Fabrik sei Diener würdigen Lebens!" (Toller, 306; Factories may no longer be the masters / And men the means. / Let factories be servants / Of decent living; Schürer, 212). The *Traumbild* of the fourth scene reveals her inner transformation and impending martyrdom as she renounces all violence and offers herself up when faced with the vision of her husband's execution. In the fifth scene she is arrested as the ringleader after the failed revolution, and in the next *Traumbild* acknowledges her guilt in keeping silent when she should have prevented the deaths of the victims whose shadows now accuse her. Refusing to sacrifice the life of a warden to save herself, she rebuffs the efforts of the Nameless One to break her out of prison in the seventh scene: "Ich verriete die Massen, / Forderte ich Leben eines Menschen. / Nur selbst sich opfern darf der Täter" (Toller, 328; If I took but one human life, / I should betray the Masses. / He who acts may only sacrifice himself; Schürer, 239). She is executed with her social commitment intact. Later two prisoners rifle through her belongings and pause just long enough to consider their actions, in Toller's only concession to the self-determination of the masses.

*Die Maschinenstürmer* (The Machine Wreckers), set during the Luddite revolt of the early nineteenth century, highlights more directly the complicity of the State and industry to break the will of the people, as well as the inability of the masses to attain any measure of self-knowledge and self-determination. The masses associate freedom exclusively with pre-industrial beliefs and values, refusing to acknowledge any collaboration of nature and civilization. Fear, rather than hope, guides them in their ideas of history and nature. Before the hero Jimmy Cobbett is stoned to death by the mob, having failed to convert them to his vision that "die Arbeiter werden die Maschinen erobern!" (the workers will conquer the machines!; Toller, 348), he prophesies their doom: "Dann, Brüder, bleibt ihr Knechte bis ans Ende aller Tage!" (Then, brothers, you will remain slaves to the end of your days!; Toller, 387). The emotional turmoil of the masses stands in stark relief to the regularity and rationality of the machines. In *Masse Mensch* and

*Maschinenstürmer* the active self is dismissed, and indeed has become a source of despair in the clash between the realism of sociopolitical circumstance and the idealism of the revolutionary. Although both Sonja and Cobbett keep their revolutionary commitment intact, thus retaining some degree of defiance, both fall victim to intractable circumstances that have their roots in the concurrent rise of modern science and industry in the nineteenth century. The interdependence of man and machine is so woven into society that forced disengagement, which the masses crave, can lead only to catastrophe. Toller's tragedy *Hinkemann* (1923) resigns itself to the fact that all are exposed to a chaotic and unchanging inhumane world. In *Hoppla, wir leben!* (Hurray, We're Alive, 1927) the revolutionary hero, now released from prison, is unable to deal with the empty technological trappings and mistaken assumptions of a society that views his calls for humanity and brotherhood as the rantings of a psychopath, and commits suicide in a tragic premonition of Toller's own death in 1939.

Georg Kaiser's prewar and postwar works reveal with merciless precision the dangers of conflating technical, ideological, and philosophical paradigms in modernizing society. One of the movement's most prolific authors, Georg Kaiser, in his search for the *Synthese Mensch,* for a synthesis of Nietzschean vision and humanitarian and social engagement, uses a wide range of settings, from biblical times in *Die jüdische Witwe* (Jewish Widow, 1904–21), to classical antiquity in *Europa* (1914) and *Der gerettete Alkibiades* (Alkibiades Saved, 1917–19), to medieval France in *Die Bürger von Calais* (Citizens of Calais, 1914), to contemporary Germany in *Von morgens bis mitternachts,* and, finally, to the dystopian future worlds of the *Gas* trilogy (1916–19), where he demonstrates the mechanization and commodification of the human during the emergence of mass manufacturing and the development of a modern military. In the *Gas* trilogy, Kaiser's critique of technology is inextricably tied to a critique of Western metaphysics, presaging Heidegger's article "The Question Concerning Technology" (1953).[11]

Georg Kaiser's two-part station drama *Von morgens bis mitternachts* premiered in 1917 and plays between "die kleine Stadt W. und die große Stadt B" (the small town W. and the big city B). Here Kaiser exposes the disintegration of the Wilhelminian middle classes within a spiritless society through the portrayal of the tragic Cashier, who attempts to "buy" his way to regeneration and spiritual salvation by embezzling sixty thousand marks, thus sealing his circuitous and ultimately fatal journey trapped within rather than transcending capitalist society. In the opening scene the routine actions of the bank cashier suggest his reduction to a function in the bureaucracy of capitalism as he sits at his teller window. This scene prefigures the tempo and trajectory of the play as a whole as he ultimately fails to break out and overcome his deeply ingrained habits of body and mind. After being sexually aroused by a mysterious lady from Florence, who

attempts to withdraw a large sum, he steals the money for her, but rather than devote himself to any altruistic, utopian ideas about society as portrayed in Sorge's and Hasenclever's plays, he chooses to abandon his career and family to begin an ecstatic life with her. He soon learns, however, that she was merely interested in purchasing a painting for her son's studies. After this first rejection, he flees in the last vision-like, expressionistic scene of part 1 across a snow-covered field with money stuffed into his shirt, believing that he is on the brink of momentous discoveries.

In part 2, this expressionistic ecstasy is quashed after he returns to his family, who offer him no solace in the naturalistic setting of their home. His insight that "so ein Leben lang schaufelt mächtig. Berge sind auf einen getürmt. Schutt, Müll — es ist ein riesiger Abladeplatz. Die Gestorbenen liegen ihre drei Meter abgezählt unter der Oberfläche — die Lebenden verschüttet es immer tiefer" (Kaiser, 73; Life keeps dumping loads of rubbish on you. Mountains of it are piled on top of you. Heaps of rubbish — till you're a giant rubbish tip. The dead lie the regulation six feet beneath the surface — the living are buried far, far deeper; Schürer, 167) is met with incomprehension, and he again disappears before the Bank Manager arrives to confront him. Yet even in the era of amusement and entertainment he finds no release: In the next scene at the races in B[erlin], he puts up outrageous sums of money for the winners at the bicycle races in order to manipulate the onlookers into a frenzy and experience the delirium of the masses — "Menschheit. Freie Menschheit. Hoch und tief — Mensch. Keine Ringe — keine Schichten — keine Klassen. Ins Unendliche schweifende Entlassenheit aus Fron und Lohn in Leidenschaft. Rein nicht — doch frei! — Das wird der Erlös für meine Keckheit" (Kaiser, 86; Humanity. Free humanity. High or low — just man. No different levels, no social strata — no classes. Release from class and wage-slavery in passion sweeping to eternity. Not pure, but free! That will be the reward for my boldness; Schürer, 179) — but the world of sport does not offer the ecstatic life he craves. The liberating jubilation of the crowd changes to the groveling silence of national subjugation at the appearance of the Crown Prince, who has come to watch the last race. Money is powerless in the face of nationalist and authoritarian traditions, and the cashier leaves in disgust: "Sind Sie toll, mich für so verrückt zu halten, daß ich zehn Pfennig vor Hundeschnauzen werfe? Auch das wäre noch zu viel. Ein Fußtritt gegen den eingeklemmten Schweif, das ist die gebotene Stiftung!" (Kaiser, 86; You must be mad, to think I'm crazy enough to throw sixpence to these dogs. Even that would be too much. A boot where the dog takes its tail between its legs, that's the prize offered; Schürer, 179). At a dance hall, his much anticipated "explosion" while viewing voluptuous masked dancers fails to satisfy after they remove their masks to reveal their horrific features. Later he tosses the remaining money on the floor of the Salvation Army Hall to be trampled under the feet of the righteous in a desperate act of

confession and atonement, but instead the scene degenerates into a greed-induced frenzy. Even the Girl turns him in to the police for the reward money, dealing him the final blow. He realizes that his life is a circuitous series of gross miscalculations and false beginnings: "Zuerst sitzt er da — knochennackt! Zuletzt sitzt er da — knochennackt! Von morgens bis mit-ternachts rase ich im Kreise — nun zeigt sein fingerhergewinktes Zeichen den Ausweg — — — wohin?!!" (Kaiser, 105–106; At the start he is sitting there — stark naked! At the end he is sitting there — stark naked! From morning to midnight I chase round in a frenzied circle — his beckoning finger shows the way out — where to? Schürer, 197). His dying utterance of "Ecce Homo" as he shoots himself and falls against the backdrop of a cross sewn onto the curtain is not jubilation at his Christ-like martyrdom and anticipation of a new world to arise after a series of transfiguring events, but a tired resignation that "man kauft immer weniger, als man bezahlt" (Kaiser, 104; The more you pay, the less you get; Schürer, 195). Kaiser offers no remedy to the cashier's misguided attempt to overthrow a mechanistic and capitalist world by purchasing his way to the regeneration borne of a Nietzschean-like Dionysian ecstasy.

According to Kaiser in "Die Zukunft der deutschen Bühne" (The Future of the German Stage, 1917), the theater is not a place for an artifi-cial, synthetic resolution of social, philosophical, or existential problems, nor is it a moral institution as Schiller had envisioned. Rather, the stage is "ein Kampfplatz" (an arena) where ideas are pitted one against another to reveal the "truth" beneath the veil of civilized society. In "Formung von Drama" (The Formation of Drama, 1922), he writes that the goal of the dramatist is to make the energy of humankind visible and palpable to the audience in order to begin the transformative process:

> Wirkung schießt nur auf aus Wundern von Darstellung von Energie. Der *Held* tut eine Leistung von Energie (und vergeht selbstverständlich mit seinem Rekord) — das überwältigt, das demoliert den Zuschauer. Diese Sichtbarmachung vom Zweck des Seins, der ist: Energie sichtbar zu machen. Vollkommen erfüllt diesen Vorsatz das Drama. Der schöpferische Mensch — kann zusehen und zuhören und im Gleichnis des *Helden* den Dichter — und sich selbst am stärksten erleben. Das Vor-bild: sich zu gebrauchen — wird unverwickelt gegeben. Man geht aus dem Theater — und weiß mehr von der Möglichkeit des Menschen — von Energie. (686)

> [The desired effect arises only by marveling at the portrayal of energy. The Hero achieves energy (and of course dies with his achieve-ment) — that overpowers, that demolishes the spectator. Making visible the purpose of being — which is to make energy visible. Drama fulfills this intention without a doubt. The creative person — can look on and listen and, like the hero, experience the poet and oneself most powerfully. The model: to use oneself — is presented in an uncomplicated way. One

leaves the theater — and knows more of the possibility of humankind — of energy.]

In this work, Kaiser widens and deepens the context of society's enthusiasm for technological progress during a time when the new sciences of quantum physics and relativity sought all-encompassing knowledge and insight beyond rational and causal frameworks. These scientific discoveries reforming the social landscape of twentieth century culture exposed the inadequacies of social and cultural paradigms, while pointing out the dangers of technology's ability to manipulate humanity under capitalism.

In *Von morgens bis mitternachts* the Cashier's attempts to enact his transformation into the New Man are doomed from the start, but it remains his individual decision and lone journey within the relatively static setting of late nineteenth-century capitalism. However, the mass distribution of electricity and gas fundamentally altered society's path to the future. The suicide of the cashier in *Von morgens bis mitternachts* degenerates into the Billionaire's killing of another human being, his Doppelgänger or double, in *Die Koralle*, which leads to a deadly and unavoidable catastrophe in *Gas I*, leveling the proletariat's workplace, and finally to the destruction of all nature and civilization by the end of *Gas II*. The abstracted characters and architectonic structures marking the tripartitions of *Gas I* and *Gas II* demonstrate the dangers of capitalist society's collective weaknesses and blind faith in technological progress in an era of accelerating production.

In the five-act prose drama *Die Koralle* (The Coral, 1916/17) technology appears in prewar terms, as primarily an instrument of capitalism. The tensions between the reduction of the individual via the machine and the harnessing of the machine to create individual wealth and opportunity are highlighted through the Billionaire industrialist's incessant "rastloser Fleiß — rastlose Flucht" (Kaiser 1, 663; tireless work — ceaseless flight). He tries to shield his son and daughter from his bleak childhood experiences of industrialization ("Da stehen Maschinen, die haben meinen Vater ausgesaugt — die haben meine Mutter an der Türhaken geschnürt — die werden mich zermalmen, wenn ich sie nicht unter mich zwinge" (Kaiser 1, 663; there were machines, they sucked the life out of my father, they hung my mother on the door peg. They will crush me if I don't force them to my will), but instead his children proclaim solidarity with the industrial proletariat: the son works as a stoker on a coal steamer rather than idle away his days on his father's yacht; the daughter works as a nurse in her father's factory. For himself he employs a *Doppelgänger* (double) for his public duties, differing from him only by a coral pendant, which evokes the exotic and idyllic world the Billionaire craves. Haunted by his deprived childhood, jealous of the Secretary's seemingly carefree personal history, and hounded by the specter of a nonsensical and illogical Schopenhauerian

universe motivated by the Will, he kills the Secretary in order to retrieve his consoling reality for himself; in effect, to lose himself in the object and become the "*pure knowing subject.*"[12] But this thirst for a luminous reality betrays how insubstantial and unreal the Billionaire's carefully constructed life has become, and after he takes on his employee's identity and memories, he is tried and convicted (as the Secretary) for the Billionaire's murder. The Billionaire's thirst for the Doppelgänger's effortless life by killing him is doomed to failure; he cannot become, in Schopenhauerian terms, the "*pure* will-less, painless, timeless *subject of knowledge*," the complete suppression of the self that Schopenhauer considered the precondition for knowledge itself. The regularity of industrial production and self-abnegation of the individual, seen as positive virtues in the nineteenth century, offer no way to quiet the Will even of its most successful practitioners, or to enable self knowledge. Thus he views his impending execution as a neo-Romantic escape into an idyll beyond the inescapably harsh realities of the modern world — a Schopenhauerian pessimism of frustration and pain overshadows all attempts to break free of his alienation and isolation, as he states to the priest before his execution: "Aber die tiefste Wahrheit wird nicht von Ihnen und den Tausenden Ihresgleichen verkündet — die findet immer nur ein einzelner. Dann ist sie so ungeheuer, daß sie ohnmächtig zu jeder Wirkung wird!" (Kaiser 1, 710; But the deepest truth is not proclaimed by you and the thousands like you — truth is only ever found by a single person. And then it is so monstrous that it makes one powerless!).

This tragic insight of *Die Koralle* also becomes the preface to Kaiser's five-act play *Gas I* (1918), which refers to the military buildup leading to the explosion of the Great War, as an overwhelming industrial reality becomes entrenched within the terms of its deterministic logic. Increasingly mechanized human forms and highly abstracted settings cancel out any hint of individual consciousness and thus the possibility of regeneration: humans act and react progressively as machines to their workplace. The powerful Will created by German Idealist epistemology, bound up with the idea of the active self, folds in upon itself as mathematical formulas now promote a transfer of nature into knowledge. A constructive resolution of technical and industrial processes is impossible; its "truth" remains a mystery.

In *Gas I* the Billionaire's Son has created a socialist worker's utopia where all share equitably in the company's successes. In act 1, however, despite the accurate computations of the Engineer, the perfectly calculated formula spins out its own destructive logic and levels the factory: "Stimmt — und stimmt nicht! An die Grenze sind wir gestoßen. Stimmt — und stimmt nicht! Dahinter dringt kein Exempel. Stimmt — und stimmt nicht! Das rechnet sich selbst weiter und stülpt sich gegen uns. Stimmt — und stimmt nicht!" (Kaiser, 179; It checks out — yet doesn't add up! We have reached the limit. Checks out — yet doesn't! We are beyond the formula.

Checks out — yet doesn't! It calculates itself and turns against us. Checks out — yet doesn't!). The Billionaire Son's failures to persuade his workers to join an agrarian utopia after the initial factory explosion reveal the impossibility of humankind dictating the terms of existence, as well as the shortcomings of alternative social utopias.

The stylized language of the workers during a strike assembly in act 4 illustrates their deformed and mechanistic reduction to automata: their mothers and wives deplore their dehumanization in a choral outcry, while the severe tripartite structure places in stark relief the struggle between the Billionaire's Son and the engineer for the hearts of the workers and highlights the failures of the Hegelian dialectic and Romantic individualism and meliorism to arrive at the longed-for synthesis of humanitarian ideals and technical mastery. The Billionaire Son reveals himself among the crowd and takes the platform: "Zieht aus der Vernichtung zur Vollendung — zu Menschen!!" (Kaiser, 213; Walk away from destruction to fulfillment — to humankind!) but they are oblivious to their own indoctrination and unable to fathom the synthesis of the New Man as they ultimately accept the arguments of the Engineer and return to their old ways, working from explosion to explosion. In act 5 the workers stream through the factory gates, and the national army occupies the gas works. Despite his claim that "Ich habe den Menschen gesehen — ich muß ihn vor sich selbst schützen!" (Kaiser, 214; I have seen humankind — I must save it from itself!), the Billionaire's Son has failed to show them the way to themselves, in contrast to the apparent successes of Eustache de Saint-Pierre in Kaiser's prewar work *Die Bürger von Calais* in leading the townsmen to the New Man. Yet there is a sliver of hope for humanity in the concluding scene as the Daughter announces that she will give birth to the New Man.

The architectonic and cubistic elements in *Gas I* become more extreme in *Gas II* (1920) as centralized power sources, and worker/soldier discipline shows how deeply linked science, industry, and the military have become. The absence of natural settings stresses the transition of humankind from *homo sapiens* to *homo faber*, whose environment is constructed purely through technical discoveries that continue to reduce individual features while achieving a perverse quiescence of the Will via factory discipline. Mathematical formulations become regulative processes of transformation, which proceed by their own logic and then are carried forward by society. Energy production appears as a manifestation of society's fanatical attachment to the forces and objects of modern culture, thus connecting society's fascination with technology to the para-scientific practice of alchemy, rather than to the progressive promise of humanity. Highly abstracted settings and robot-like humans show how capitalism and militarism have conjoined powerfully to subject society, industry, and the worker's body and psyche to the machine, as Marx had envisioned in *Das Kapital* (Capital, 1867). In contrast to nineteenth and early

twentieth-century treatises praising the moral virtues of self-abnegation in the manufacturing process, for example Andrew Ure's *The Philosophy of Manufactures* (1835), Kaiser shows the destructive application of productive energy forms leading to the extermination of human civilization. The dangers are palpable from the start: whereas in *Die Koralle,* factory production was represented by smokestacks spewing thick volumes of smoke, "dicht und steil wie erstarrte Lavasäulen, Rauchwolkengebirge stützend" (Kaiser 1, 680; thick and steep like solid lava flows supported by a mountain of smoke) by *Gas I* natural energy is a vertical and dynamic force "in geraden Strahlen Feuer und Rauch vorstoßend" (Kaiser, 173; in straight shafts spewing fire and smoke). In *Gas II* this highly unstable energy, represented by its incessant red glow, becomes omnipresent and is then converted to poison gas.

In act 1, highly mechanized workers and their stylized interactions fill the stage, which is dominated by concrete, glass, metal, wires, and lighted switchboards. The way in which workers use their bodies and experience time and space is now inseparable from that of the machine. Abstracted Blue Figures occupy the now nationalized factory and are barely able to maintain the line against the technologically inferior Yellow Figures. Past miscalculations and now militarized technologies set the stage for a catastrophic military stalemate, while the rigid identities of Yellow and Blue figures assure that any confrontation will lead to comprehensive destruction. Despite profit-sharing incentives and the threat of national defeat, production levels continue to decrease due to the workers' reduction to mechanistic principles. The Chief Engineer explains to the First Figure in Blue: "Planlos schafft der Mann am Werkzeug — das Werk entzog sich der Übersicht, wie der Mann durch Tag und Tag tiefer ins gleichförmige Einerlei glitt" (Kaiser, 227; Planless the man at his tool — the work withdrew ever farther out of sight as the man slipped day by day ever deeper into sameness and monotony; Schürer, 296). The Billionaire Worker, the son whose birth was prophesied at the end of *Gas I*, is ordered to whip up the workers in one last push to increase production, but instead he invokes the memory of his grandfather and refuses. In act 2 he beseeches his fellow workers to stop production and recognize their humanity, convincing them to let down their guard and roll the dome clear to proclaim a truce with the Yellow Army. But the Yellow Army seizes the opportunity to occupy the factory. In act 3 the Yellow Figures order the Blue Figures to continue production under horrendous conditions, but production levels continue to sink. The Chief Engineer calls on them to reject the exhortations of the Billionaire Worker to accept their lot and a life of serfdom, and instead vanquish their enemy by unleashing the limitless power of poison gas to annihilate both sides in one glorious Armageddon: "Haß und Scham formten die Formel, die endlich ergab, was befreit. Jetzt triumphiert ein Häutchen von Dünnglas, das ausbläst

und ätzt gleich das Fleisch vom Gebein und bleicht starre Knochen!" (Kaiser, 247–48; Hatred and shame were its ingredients. In a skin-thin glass — victory, that swells and eats away flesh from legs, bleaches stiff bones; Schürer, 312). The workers vie among themselves to throw the poison gas, but in the end the Billionaire Worker takes his role as their leader and avenges the loss of their humanity by throwing the poison gas himself: "Meines Blutes Blut schlug nach Verwandlung von uns!! Mein Eifer tränkte sich mit Eifer von Mutter und Muttervater!! Unsre Stimme konnte die Wüste wecken — der Mensch ertaubte vor ihr!! Ich bin gerechtfertigt!! Ich kann vollenden!!" (Kaiser, 253; My blood's blood beat for our conversion. My thirst slaked itself at the thirst of mother and mother's father. Our voice might have waked the wilderness — men's ears are deaf. I am vindicated! I can fulfill! Schürer, 216). Rather than step aside and allow his workers to reject him yet again and cast him into the isolation and alienation seen in *Die Koralle* and *Gas I*, the New Man achieves a destructive union with them, underscoring the utter failure of the Expressionist prophet and the dangers inherent in the ultimately unfathomable potential of technology and humanity.

In his considerations of the dialectical underpinnings of Western political, economic, and social structures, the Expressionist artist sought to position himself in a world transforming and being transformed by technology. These meetings between the world of art and technology, man and machine, were resolved in different ways. The dramas of Kokoschka sought to wake the nonrational and the primitive and break with rationalist traditions by developing theater as a visual medium through which to rediscover humankind's fundamental energies. In prewar dramas such as Sorge's *Der Bettler*, engineering paradigms of the nineteenth century are met by the potential of twentieth-century inventions and a new world of energy and movement; the road to renewal lay in a new language for the theater and a new world that will overcome the psychopathologies wrought by mechanistic science. The anticipation of revolution in Hasenclever's *Der Sohn* sidesteps the implications of innovations that would fundamentally alter the unmediated communication so crucial to the Savior's image, as the Son embraces his transcendence over rather than through social and technological changes. Amid the shock and dislocations of the First World War, the rebellion against the prewar mechanization of the spirit shifted to an indictment of the war machine and its deformations of body and mind, seen in Reinhard Goering's *Seeschlacht* and Ernst Toller's *Die Wandlung*. The ensuing postwar chaos was tied to intractable socioeconomic and ideological forces beyond the control of the failed revolutionary in Toller's dramas, whose reconciliations with the machine were lost within the personal and collective failings of the masses. In Kaiser's dystopian *Gas* trilogy, the possibility of "freedom" would require a fundamental epistemological critique of how "knowledge" and "progress" were

defined — coupled with the realization that the inadequacies of conventional social, economic, and scientific paradigms remained beyond the capacity of the owners of production, their scientists, and factory workers.

The ideal of the New Man was but one manifestation of both the hope and the fear of scientific, economic, and social changes. By cultivating the internal structures of subjectivity against the rationalist and mimetic conventions seen as "mechanizing" the human spirit, experiments in language, staging, embodiment, and incorporating practices posited the great transgressive and transformative energy of the New Man against the relentless era of the machine. Yet although Expressionists ultimately mourned the loss of the active subject and the synthesis of ethical humanist philosophies with social activism, neither could they conceptualize a viable alternative to the objectification and domination of the human spirit in their works. Conversely, Futurism sought to free the human body from its physical constraints and celebrate the destruction of the subject, but wanted to reconstitute it as a technologized object still under human control.[13] As Expressionism was one of the artistic spheres where the confrontation between humanity and the machine was being explored in the early part of the twentieth century, a return to its varied framings of man and machine can help inform present discussions on the concept of the human as the boundaries between the human and the machine continue to evolve (see Hayles, 1999). As mechanical technologies recede in importance and the immaterial control of the environment continues via the digital revolution, such works allow us to rethink the varied experiences of an important cultural and social transition.

# Notes

[1] Unless otherwise noted, all translations are my own.

[2] For an overview of the expanding associations of the Machine and the cultural meaning of science in prewar Germany, see Anne Harrington, *Reenchanted Science*.

[3] Harrington notes that in prewar Germany "Bismarck [. . .] was only one face of a Machine whose meanings were multiplying. The Machine was also the 'war engine' of the Prussian army: pitiless, efficient, impersonal. The Machine was the coke furnaces and iron and steel factories of the Ruhr Valley, the ugly result of a process of extraordinarily rapid industrialization at the end of the nineteenth century that had left many feeling uprooted and aesthetically revolted" (20).

[4] As Gustave Claudin pointed out in his 1867 work *Paris*, new technologies such as the railroad "bend our senses and our organs in a way that causes us to believe that our physical and moral constitution is no longer in rapport with them. Science, as it were, proposes that we should enter a new world that has not been made for us. We would like to venture into it; but it does not take us long to recognize that it requires a constitution we lack and organs we do not have" (71–72,

quoted in Schivelbusch, *Railway*, 159). For an overview of the manner in which European literature confronted the issues of man and machine, see Keith Bullivant, 11–22.

[5] These and other poems are analyzed in Karlheinz Daniels, "Expressionismus und Technik" in Rothe, *Expressionismus als Literatur*, 171–93. See Wolfgang Schivelbusch, *The Railway Journey* on the phenomenon of the railway journey, which "produced novel experiences — of self, of fellow-travelers, of landscape (now seen as swiftly passing panorama), of space and time" (xiv).

[6] See David F. Kuhns's book on expressionist theatrical productions, *German Expressionist Theatre. The Actor and the Stage*, for an analysis of "the formative connections between a mode of dramatic art and its cultural moment" (2).

[7] See Steven Aschheim, "The Not-So-Discrete Nietzscheanism of the Avantgarde," in Ascheim, *The Nietzsche Legacy in Germany 1890–1990*, 51–84.

[8] For a discussion of early stage Expressionism and theatrical innovation see David Kuhns's chapter "Schrei ecstatic performance" in *German Expressionist Theater*, 94–138.

[9] Hasenclever acceded to the wishes of his publisher Kurt Wolff and toned down the play, allowing the Father to die of natural causes: "Nehmen Sie es nicht so [. . .], Kurt August, was geht uns vorläufig der 5. Akt an, wo wir kaum am 2. sind! Ich mache Ihnen aber gern Konzessionen, und der Papa soll am Herzschlag sterben. Sterben muß er." Letter to Kurt Wolff, 13 August 1913, reprinted in Kasties, *Briefe* 1:96–97, here 97.

[10] See Neil H. Donahue's discussion of Sternheim's prose experiments in *Forms of Disruption*, 139–45.

[11] For a discussion of Heidegger's interpretation and evaluation of modern technology, see Michael E. Zimmerman's *Heidegger's Confrontation with Modernity*, especially 205–21.

[12] Schopenhauer writes in *Die Welt als Wille und Vorstellung* (The World as Will and Idea, 1819): "We lose ourselves entirely in this object . . . in other words, we forget our individuality, our will, and continue to exist only as pure subject, as clear mirror of the object, so that it is as though the object alone existed without anyone to perceive it, and thus we are no longer able to separate the perceiver from the perception, but the two have become one" (178–79).

[13] Hal Foster notes in his article "Prosthetic Gods" that such neoclassical and machinic modernisms "tended to treat the body as if it were already dead, an uncanny statue in the first instance, an uncanny mechanism in the second — that is, *as if the only way for the body to survive in the military industrial epoch of capitalism was for it to be already dead, in fact deader than dead*" (7).

# Works Cited

Anz, Thomas, and Michael Stark, eds. *Die Modernität des Expressionismus.* Stuttgart: Metzler, 1994.

Appia, Adolphe. *La musique et la mise en scène.* Bern: Theaterkultur, 1963. In English: *Music and the Art of the Theatre.* Trans. Robert W. Corrigan and Mary Douglas Dirks. Ed. Barnard Hewitt. Florida: U of Miami P, 1962.

Aschheim, Steven. *The Nietzsche Legacy in Germany, 1890–1990.* Berkeley: U of California P, 1992.

Bullivant, Keith. "Literatur und Technik: Ein Überblick." In Schütz, *Willkommen und Abschied der Maschinen,* 11–21.

Claudin, G. *Paris.* Paris: A. Fauve, 1867.

Daniels, Karlheinz. "Expressionismus und Technik." In Rothe, *Expressionismus als Literatur,* 171–93.

Donahue, Neil. *Forms of Disruption: Abstraction in Modern German Prose.* Ann Arbor: U of Michigan P, 1993.

Foster, Hal. "Prosthetic Gods." *Modernism/Modernity* 4, 2 (1997): 5–38.

Harrington, Anne. *Reenchanted Science: Holism in German Culture from Wilhelm II to Hitler.* Princeton: Princeton UP, 1996.

Hasenclever, Walter. *Der Sohn: Drama von Walter Hasenclever.* Albert-Theater Dresden 8. Oktober 1916 (playbill).

———. *Der Sohn.* In *Walter Hasenclever. Sämtliche Werke,* eds. Dieter Breuer and Bernd Witte, Vol. II.1. Mainz: v. Hase & Koehler, 1990.

Hayles, N. Katherine. *How We Became Posthuman: Virtual Bodies in Cybernetics, Literature, and Informatics.* Chicago: U of Chicago P, 1999.

Heidegger, Martin. *The Question Concerning Technology, and other Essays.* Trans. William Lovitt. New York: Harper & Row, 1977.

Kaiser, Georg. *Stücke Erzählungen Autsütze Gedichte.* Ed. Walther Huder. Cologne, Berlin: Kiepenheuer & Witsch, 1996.

———. *Von morgens bis mitternachts, Die Koralle, Gas, Gas Zweiter Teil.* In *Georg Kaiser: Werke,* ed. Walther Huder. Vol. 1 (*Von morgens bis mitternachts, Die Koralle*), Frankfurt am Main: Ullstein, 1971.

Kasties, Bert, ed. *Walter Hasenclever: Briefe in zwei Bänden, 1907–1940.* Mainz: v. Hase & Koehler, 1994.

Kuhns, David F. *German Expressionist Theatre: The Actor and the Stage.* Cambridge: Cambridge UP, 1997.

Loquai, Franz. "Geschwindigkeitsphantasien im Futurismus und im Expressionismus." In Anz/Stark, *Die Modernität des Expressionismus,* 76–94.

Marinetti, F. T. *Let's Murder the Moonshine: Selected Writings.* Trans. R. W. Flint and Arthur A. Coppotelli. Ed. R. W. Flint. Los Angeles: Sun & Moon Classics, 1971.

Pinthus, Kurt. "Rede für die Zukunft." (1918) In *Der Aktivismus 1915–1920*, ed. Wolfgang Rothe, 116–33. Munich: dtv, 1969.

Rothe, Wolfgang. *Expressionismus als Literatur: Gesammelte Studien*. Bern and Munich: Francke, 1969.

Schivelbusch, Wolfgang. *Geschichte der Eisenbahnreise: Zur Industrialisierung von Raum und Zeit im 19. Jahrhundert*. Munich: Hanser, 1977. In English: *The Railway Journey: The Industrialization of Time and Space in the 19th Century*. Berkeley: U of California P, 1986.

———. *Lichtblicke: Zur Geschichte der künstlichen Helligkeit im 19. Jahrhundert*. Frankfurt am Main: Fischer, 1986. In English: *Disenchanted Night: The Industrialization of Light in the Nineteenth Century*. Trans. Angela Davies. Berkeley: U of California P, 1988.

Schopenhauer, Arthur. *Die Welt als Wille und Vorstellung* (1818, rev. ed., 1844). *Sämtliche Werke in zwölf Bänden*, vols. 2–3, ed. Arthur Hübscher. Wiesbaden: E. Brockhaus, 1946–50. In English: *The World as Will and Representation*. Trans. E. F. J. Payne, Vol. 1. New York: Dover, 1969.

Schorske, Carl E. "Explosion in the Garden: Kokoschka and Schoenberg." In *Fin-de-Siecle Vienna: Politics and Culture*, 322–66. New York: Vintage, 1981.

Schürer, Ernst, ed. *German Expressionist Plays*. New York: Continuum, 1997.

Schütz, Erhard, ed. *Willkommen und Abschied der Maschinen: Literatur und Technik — Bestandsaufnahme eines Themas*. Essen: Klartext, 1988.

Sokel, Walter, ed. *Anthology of German Expressionist Drama: A Prelude to the Absurd*. New York: Doubleday, 1963.

Sorge, Reinhard, *Der Bettler: Eine Dramatische Sendung*. Ed. Ernst Schürer. Stuttgart: Reclam, 1985.

Sternheim, Carl. *Gesamtwerk* (Vol. 1: Dramen 1). Ed. Wilhilen Emrich. Neuwied am Rhein, Berlin: Luchterhand, 1983.

Toews, John E. "Refashioning the Masculine Subject in Early Modernism: Narratives of Self-Dissolution and Self-Construction in Psychoanalysis and Literature, 1900–1914." *Modernism/Modernity* 4.1 (1997): 31–67.

Toller, Ernst. *Prosa-Briefe-Dramen-Gedichte*. Hamburg: Rowohlt, 1979.

Trommler, Frank. "The Avant-Garde and Technology: Toward Technological Fundamentalism in Turn-of-the-Century Europe." *Science in Context: Technology: Culture, Politics, Aesthetics* 8, 2 (1995): 397–416.

———. "The Redemptive Power of the Failed Revolutionary." In *German Writers and Politics, 1918–1939*, ed. Richard Dove and Stephen Lamb, 60–75. London: Macmillan, 1992.

Ure, Andrew. *The Philosophy Of Manufactures: Or, An Exposition Of The Scientific, Moral, And Commercial Economy Of The Factory System Of Great Britain*. London: C. Knight, 1835.

Vietta, Silvio, and Hans-Georg Kemper. *Expressionismus*. Munich: Wilhelm Fink, 1983.

Werkner, Patrick. *Physis und Psyche: Der Österreichische Frühexpressionismus.* Vienna: Herold, 1986. In English: *Austrian Expressionism: The Formative Years.* Trans. Nicholas T. Parsons. Palo Alto, CA: Society for the Promotion of Science and Scholarship, 1993.

Wittenberg, Erich. "Die Wissenschaftskrisis in Deutschland im Jahr 1919: Ein Beitrag zur Wissenschaftsgeschichte." *Theorie: A Swedish Journal of Philosophy and Psychology* 4 (1938): 235–64.

Worringer, Wilhelm. *Abstraktion und Einfühlung: Ein Beitrag zur Stilpsychologie.* Munich: Piper, 1908. In English: *Abstraction and Empathy: A Contribution to the Psychology of Style.* Trans. Michael Bullock. London: Routledge and Kegan Paul, 1968.

Zimmerman, Michael E. *Heidegger's Confrontation with Modernity: Technology, Politics, and Art.* Bloomington, IN: Indiana UP, 1990.

# Interdisciplinary

# 10: Intimate Strangers: Women in German Expressionism

*Barbara D. Wright*

WOMEN IN GERMAN EXPRESSIONISM have been the intimate strangers of the movement in more senses than one. As literary artists and participants in that avant-garde explosion of creativity and innovation at the beginning of the twentieth century, they remained largely unacknowledged by male leaders of the movement, their works and perspectives for the most part invisible, both to the movement and to the wider public. Later, when literary critics and academics rediscovered Expressionism in the 1950s and 1960s, following decades of eclipse and then violent suppression, it was male exponents of the movement who were reprinted, providing the foundation for scholarly work and the canonical examples of Expressionist literature that have since shaped our definitions and understandings of the movement. The manifestos and other documents of Expressionism selected for reprinting have compounded the problem.[1] Even feminist literary scholarship, which began to thrive in the 1970s and 1980s, has mostly overlooked the women of German Expressionism.

The topic of women and Expressionism has several separate but related facets. Traditionally in feminist research on women in literature, there has been first the question of how women are portrayed. The emphasis in such analysis is primarily but not exclusively on the canonical male authors of a movement and their treatment of women characters or women's issues. Second, there is "recovery": the task of discovering the works of women authors, researching their biographies and reconstructing their bibliographies. In particular, the scholarship of recovery focuses on determining the extent to which women authors participated in or influenced the literary movements they are associated with, and identifying the ways in which their writings resemble or differ from those of male authors, whose works in reality set the standards. Finally, on the conceptual or theoretical level, the key question becomes: What do comparisons of the writings of male and female authors tell us about a particular literary movement, and how does the inclusion of works by women force us to significantly redefine, for example, such concepts as period, style, genre, aesthetic intent, characteristic themes and issues, or even "greatness"?

The bulk of scholarly work on women in Expressionism has confined itself to the first category, that is, the portrayal of female figures in Expressionist works largely by men. Christiane Schönfeld's research, for example, focuses on the figure of the prostitute in Expressionist literature, while that of Jean Wotschke analyzes the prostitute's obligatory complement in Expressionist thinking, the mother. My own previous work has concentrated on non-fiction discussions that appeared in Expressionist "little magazines" on the nature and appropriate role of women, and on the transformation of the Expressionist *Weib* (woman) into the New Woman of the twenties in dramas by erstwhile Expressionists Ernst Toller and Carl Zuckmayer. Maria Tatar's groundbreaking study *Lustmord: Sexual Murder in Weimar Germany* (1995) focuses on the extreme violence toward women portrayed in Alfred Döblin's *Berlin Alexanderplatz* as well as in the visual art of Otto Dix and George Grosz. All three of these creative artists are popularly associated with the Weimar Republic, but each of them has roots in Expressionism and produced significant early works in the period from the First World War through the early twenties. Tatar argues that mutilation of the female body becomes a strategy used by male artists to manage social, political, and sexual anxieties. Similarly, art historian Beth Irwin Lewis refuses to view the portrayal of violated and dismembered women victims of sexual murder merely in aesthetic terms as experiments in imagery or composition, as other art historians traditionally have done. Instead, she insists on addressing misogyny directly, connecting it to the deep-seated anxiety about the role of women that male artists and intellectuals, despite their understanding of themselves as an enlightened avant-garde, shared with conservative and mainstream bourgeois contemporaries.[2] An outstanding essay by German art historian Kathrin Hoffmann-Curtius, "Frauenbilder Oskar Kokoschkas" (Oskar Kokoschka's Images of Women), published in 1987, makes numerous connections among Kokoschka's bloody visual images of women, his equally bloody Expressionist dramas, and his obsession with the battle between the sexes. But Hoffmann-Curtius's essay has not inspired parallel efforts in literary scholarship.

The scholarship of recovery, that is, of finding and publishing the works of women authors, has lagged behind, and because of this the opportunities to compare portrayals of women by male and female writers — for differences in perspective, for differing aesthetic sensibilities, for alternative visions of the Expressionist utopia — have necessarily lagged, as well. One happy exception to the rule is the work of Helmut Vollmer, editor of a volume of poetry by Henriette von Hardenberg (1991), an anthology of lyric poetry by thirty-nine Expressionist women poets (1993), and another anthology of Expressionist women's prose (1996).[3] In the foreword to his 1993 collection, *"In roten Schuhen tanzt die Sonne sich zu Tod": Lyrik expressionistischer Dichterinnen* (In Red Shoes the Sun Dances Itself to Death": The Poetry of Female Expressionist Poets), Vollmer observes

that Expressionism today is one of the most frequently and most thoroughly researched movements in German-language literature (15). Yet despite all the effort that has gone into the reprinting and interpretation of Expressionist literature, much remains to be done. Most notably, in Vollmer's view, there has been scarcely any attempt to collect and publish the works of *women* Expressionists; lacking that foundation, scholarly investigation into the light those works might shed on the movement as a whole has been inhibited.

Vollmer suggests that this lacuna may be the result of an impression that women writers of the movement were rare and anomalous phenomena (as, for example, Else Lasker-Schüler is often represented), or that they were merely the coffeehouse companions and lovers of male Expressionists. The neglect of women writers may well also be the result of the aggressively masculinist stance of the movement, a stance expressed not only in poetry, drama, and prose but also, and perhaps even more strongly, in the theoretical and social-critical writings of the movement (see Wright 1987). Since the inception of feminist literary scholarship in the 1970s, it has been primarily women in German Studies who have labored to recover the female presence in German literary history, and Expressionism has given the impression of being particularly barren and unwelcoming terrain for such endeavors. Thus for example Gisela Brinker-Gabler's acclaimed two-volume collection of essays, *Deutsche Literatur von Frauen* (German Literature by Women), contains several essays on women at the turn of the century and others on women writers of the Weimar period and beyond, but makes no mention of women Expressionists. Vollmer's publication of the collected works of poet Henriette Hardenberg in 1988 served to add her name to the short list of relatively well-known authors, such as Else Lasker-Schüler, Claire Goll, and Emmy Hennings,[4] who are readily associated with Expressionism. But at the same time, Hardenberg was received as an exception that proved the rule. In her review of the book, a critic from the *Neue Zürcher Zeitung*, Beatrice Eichmann-Leutenegger, writes that with this publication, Expressionism — "so arm an Vertreterinnen" (so poor in female representatives) has finally gained "eine neue eigenwillige Nuance," "eine neue, eine weibliche Dimension" (a new original nuance . . . a new female dimension; quoted in Vollmer, 15).[5]

Yet Paul Raabe's *Index Expressionismus* (Index of Expressionism), that extraordinary compilation of bibliographic information on the little magazines of the movement, lists the names of over *three hundred* women contributors. Many of them are represented by only a handful of entries; others such as Bertha Lask, Mechtilde Lichnowsky, Ruth Schaumann, and Martina Wied pursued successful writing careers long after the end of the movement and are not identified primarily as Expressionists. Still others expressed their artistic creativity in a variety of media beyond poetry, working as dancers, singers, actresses, or artists and thus elude neat categorization. Like a

number of their male counterparts, some also were politically active on behalf of the revolutionary workers' movement (Vollmer, 16). The editors of the two most influential Expressionist magazines, *Die Aktion* and *Der Sturm*, were both assisted by talented women, yet today we have no detailed picture of the influence that Alexandra Pfemfert or Nell Walden exerted on the movement.[6] Obviously, the raw material for extensive scholarship on women's contributions to literary Expressionist is present, but the research itself remains to be done.

Given the meager amount of work that has been devoted to the recovery of women Expressionists, the scholarship of German Expressionism clearly lacks the texts necessary for a thorough comparison of male and female writers. Even more clearly, we lack the basis for the third and potentially most far-reaching facet of literary scholarship noted above, namely the task of reexamining our fundamental understanding of Expressionism in light of new information provided by research into women authors. This essay will suggest the dimensions of the challenge and provide a concrete example of what we might learn from a comparison of literature by male and female Expressionists. In the following section, the backgrounds for Expressionist thinking about women and portrayal of women will be sketched. A pivotal question, for a movement dedicated to the renewal of *die Menschheit* (humankind), is the extent to which men and women writers regard women as *Menschen* (human beings), as full participants in and contributors to the human community. This is contested ground, and the sources that Expressionists draw on — politically progressive Neo-Kantianism, but also the thinking of Johann Jakob Bachofen, Friedrich Nietzsche, and Otto Weininger — are ambiguous in their assessments, leaving the door open to divergent interpretations by male and female writers.

In the third section of this essay, discussion will turn to a comparison of the poetry of male and female Expressionists as it appears in Kurt Pinthus's *Menschheitsdämmerung* (Dawn of Humanity) and Vollmer's *In roten Schuhen tanzt die Sonne sich zu Tod*, a comparison made possible by the publication in 1993 of Vollmer's anthology. The comparison only begins to tap into the possibilities for this kind of exercise, focusing as it does on fairly superficial characteristics of the poetry. Even so, the discrepancy between male and female Expressionists' views of women is striking and anticipates the gender conflicts of the 1920s between the New Woman and the "lost generation" of men. The "New Man" of Expressionism projects a vision of a "New Woman" — *das Weib* (the female) — who differs significantly from what women wish for themselves. These projections continue into the twenties, when a liberated, independent New Woman does emerge as a social and literary phenomenon, a woman who shares some but by no means all of the characteristics of the New Man's female ideal.

The concluding section of this essay will argue, finally, that in terms of portrayals of women and women's perspectives, the results of even this superficial comparison are suggestive and should inspire more extensive efforts: first in the recovery of women's work particularly in drama and prose, where social conflicts are likely to be more vividly portrayed than in lyric poetry; and second in the re-examination of our assumptions about German Expressionism as a literary and artistic movement. Many if not all Expressionists saw themselves not only as artistic revolutionaries but also as shapers of politics and social policy — and, indeed, of a utopian new reality — which raises the central question of the extent to which the views of male and female Expressionists are congruent or divergent, particularly in gender-related areas.

With a few notable exceptions, male Expressionists, despite their artistic innovativeness and infatuation with modernism, remain caught in traditional, stereotypical categories of binary thinking about the nature of masculinity and femininity, and this in turn colors both their representations of male and female figures and their views on social and political structures. Women Expressionists do not see themselves confined in those traditional categories; they blur boundaries and suggest tantalizing alternatives. By exploiting the vast potential for feminist scholarship on literary Expressionism, we can move those women's voices to the center of the conversation and help to keep Expressionism, its legacy and its lessons, a vital part of intellectual discourse.[7]

To achieve this, we must go back to the sources that shaped the Expressionist representation of women. German Expressionism shares in a modernist mission to strip off surface phenomena and distill things down to their abstract core elements, to express not outer appearance but inmost being. In so doing, paradoxically, it draws on a long cultural tradition for its understanding of women and their nature, purpose, and role in human society. Because of this fundamental tension between modernity and tradition, Expressionism runs the risk of arriving not only at new and essential truths but also at hoary stereotypes, of not only blurring traditional boundaries but also of setting them back into place in a new guise.

Expressionist literature is strongly influenced by a range of late nineteenth- and early twentieth-century philosophical currents. Foremost among them is Neo-Kantianism, which shapes notions of the Expressionist "New Man" and by implication sets him apart from traditional men and women alike. Neo-Kantianism anticipates the Expressionist insistence that human *Geist* (spirit / intellect) and *Wille* (will) can transform empirical reality and social relations in ethically desirable ways. Expressionists, who view themselves not only as artistic but also to a large extent as social and political revolutionaries, take this position to an idealist extreme, however, scorning the controlling effects of feedback from empirical reality. The authors of Expressionist political manifestos and essays on social or political

reform argue that if human consciousness — or *Geist* — confines itself to the highest and purest levels of reason and will, then the ensuing changes will necessarily be supremely ethical and desirable. But true, powerful *Geist* is possessed by only an elite few; it is embodied in *der neue Mensch* (The New Man; Wright 1987, 584–87).

The New Man of Expressionism is a contradictory and ambivalent creature, revolutionary yet caught up in a series of traditional dichotomies. He rejects "civilization" while embracing "culture" and thus becomes part of a longstanding and rather conservatively colored debate over Germany's cultural status vis à vis other major European powers such as Britain and France. He rejects *Gesellschaft* (society) while embracing a *Gemeinschaft des Geistes* (spiritual-intellectual community), providing a variation on Ferdinand Tönnies's analysis of modernity and joining the national nostalgia for lost community, yet he is irresistibly drawn to the iconic site of the *Gesellschaft*, to the modern metropolis, with all its freedom as well as ugliness, alienation, and human misery. He bitterly rejects the dominance of the bourgeois father while celebrating his own masculinity and power. He opposes religious orthodoxy and the authoritarianism of the state while embracing elitism and an aesthetic dogmatism. Not least of all, the extreme dualism that Expressionists derive from Neo-Kantianism leads to a starkly binary — and very traditional — construction of the relationship between man and woman. Although Expressionists otherwise reject positivism and the empiricism of modern scientific research, they accept a form of biological determinism at least with regard to women, who become the receptacle for the physical and sexual qualities that the New Man rejects as determinative in himself. The foundation of the Kantian ethical system is the imperative to treat the individual not as means but as his or her own end. However, its claims to a higher ethics notwithstanding, key documents of Expressionism repeatedly present woman as a means to the New Man's end, namely his development as an artist and/or social revolutionary.

Both in their understanding of women's nature and in their views of the German women's movement of the day, Expressionists thus stake out a basically traditional position; their innovation lies in reversing the values they attach to those quintessential female roles, mother and lover/prostitute, as set forth most clearly in the theoretical literature. Whereas the New Man is the bearer of *Geist* and *Wille*, women (with few exceptions, for instance Ernst Toller's female protagonists) are the embodiment of earth, nature, physicality, and carnality. In other words, women represent precisely the forces that the New Man must conquer if he is to create a new reality. While the New Man is in search of the essential, the core of truth and being, women specialize in illusion. Man is dynamic, conscious, fully human, charged with *Geist* and *Wille*; woman is static, unchanging, and unchangeable. The two forms of creation — female procreation, male creation — are in competition, but the male artist as creator trumps the

woman as mother. In positioning themselves within the aesthetic context of their day, male Expressionists thus provide a highly gendered definition of their movement. They repeatedly assert the manliness, activism, and focus on essence or *das Wesen* that characterize Expressionism, in opposition to the alleged passivity and ornamental superficiality of art nouveau or impressionism. The aggressive *Schrei* (scream) of the Expressionist protagonist confronts the effeminate sentimentality of philistines.[8] In sum, the task of imposing Expressionist *Geist* on raw matter is a titanic and ongoing struggle, a relationship of eternal opposition that finds a ready metaphor in the struggle of men to exercise control over women (Wright 1987, 594–95).

The dualism that flows from Neo-Kantianism reveals something about the Expressionist New Man, but woman remains elusive, a negation, not man, not *Geist*. To complete the Expressionist image of woman, other philosophical sources come into play. If the Expressionist construct of the New Man is largely inspired by Neo-Kantianism, the understanding of woman is conditioned by other philosophical sources that include Johann Jakob Bachofen (1815–87), Friedrich Nietzsche (1844–1900), and Otto Weininger (1880–1903). These influences further support a view of woman that is dualistic, built on traditional binary oppositions between male and female, and biologically determined. In this "eternal" view of woman, she is characterized largely through her carnality, sexuality, reproduction, and association with natural forces, in contrast to the New Man, who is identified through the force of his *Geist* and *Wille* and may engage in sexuality but never succumbs to the merely carnal.

Admittedly, Expressionist acceptance of these ideas is not complete or consistent. Opposition to bourgeois subjugation of women (a companion phenomenon to the oppression of the son by the father), to the bourgeois double standard of sexual morality, to bourgeois rigidity and intolerance — these positions also characterize German Expressionism. In their writings on society, male Expressionists support abortion, contraception, divorce, and sexual fulfillment for women. One finds as well male criticism of women who as mothers support the patriarchal leaders of Germany, push their sons into battle (Wotschke) and espouse an unthinking nationalism. One finds a fascination with the prostitute as the physical manifestation of something authentic and primitive that contemporary society has lost; her attractiveness functions as a threat to bourgeois society, and as an outcast she represents something wild and untamed in the artificial urban space (Schönfeld, 1996, 1997). One finds further Ernst Toller's courageous female protagonists and, in the little magazines of the movement, male champions of the women's movement such as Franz Pfemfert, Erich Mühsam, and Alfred Kerr (Wright 1987, 591–94). But ultimately, more conventional convictions outweigh the progressive aspects in mainstream Expressionist thinking about women.

One of the most important influences on perceptions of women and notions of gender relations in Wilhelminian Germany was Johann Jakob Bachofen (1815–87), the Swiss professor of Roman law, scholar of Greco-Roman antiquity, and historian of culture. Bachofen's most significant work is *Das Mutterrecht* (Matriarchal Law, 1861); he achieved his greatest impact posthumously, however, in the 1910s and again in the 1920s, when *Mutterrecht und Urreligion* (Matriarchal Law and Primal Religion), a selection of his writings, was edited and published by Rudolf Marx in 1926. Bachofen was rediscovered, as Joseph Campbell points out, not by historians or anthropologists, who had come to reject his theories, but by a circle of creative artists and literary people in the group around the poet Stefan George (Bachofen, xxv).[9]

Bachofen postulated two orders of matriarchal law: first the hetaerist-aphroditic, which he associated with a primitive, nomadic existence based on hunting and gathering; and the later matrimonial-demetrian form, associated with early agriculture. In the first or "tellurian" stage, mother-hood exists without marriage, without agriculture, and with nothing resembling a state; then in the "lunar" stage conjugal motherhood and legitimate birth appear within settled communities; in the "solar" period, finally, there emerges the patriarchal law or privilege of the conjugal father, a division of labor, and individual ownership. Bachofen reflects a Hegelian belief in progress and evolution as he traces an ascent from the crudely sensuous — that is, tellurian matriarchy — to spiritually pure and elevated Apollonian patriarchy. Social and cultural progress requires the male to triumph over matriarchy, but Bachofen also acknowledges the generative power of the female, the civilizing influence of marriage, and the importance of the nurturing and protective qualities of the mother as precursors of justice and civil rights.

Bachofen's theories anticipate much of German Expressionism's view of women and of gender relations, which are centered upon an acknowl-edgment of the female's awesome power and, at the same time, the male's need to triumph over her. His theories foreshadow Expressionism's fasci-nation with the hetaera or prostitute and the compulsion to overcome her and the physical world, the world of sex, lust, and matter, if the New Man is to fulfill his cultural mission. In this context the Expressionist response to women and the "woman question" appears as a kind of telescoping and replaying of 5000 years of male/female relations, as described by Bachofen, into a few short years of artistic and literary ferment, character-ized by a defiant return to the hetaera and sexual promiscuity, a celebration of the mother — in her primordial, not her bourgeois role — and a reduc-tion of women to these two basic roles, accompanied by awe at the power of sexual desire and of mother love, but also by violent reassertion of male dominance, this time in a "new world" of *Geist* and *Wille* over mundane political or economic reality.[10]

In the view of legal historian Roy Garré, Bachofen's work can be viewed as a contribution to conservative thinking of the time. But Bachofen also sees cultural history as progress to ever higher levels of development. It is in this sense, in his *Origins of the Family*, that Friedrich Engels uses Bachofen's work on maternal rights in early human societies for revolutionary purposes. Expressionism, too, attracts adherents who subsequently move to the political right as well as left. Bachofen advocates a return to ancient simplicity and spiritual health that seems almost to prefigure Expressionist painters' search for simplicity and renewal, a search they enact in their outings to the beach or lakeside and in paintings of naked figures frolicking in natural landscapes. Most importantly, however, Bachofen's thinking gives a radically new perspective on the sexual and marital relations of the late nineteenth and early twentieth century. By presenting these relations as historically determined and variable rather than divinely ordained and immutable, Bachofen's work invites an interrogation of Wilhelminian mores, the double standard, and alternative sexual relations.

Friedrich Nietzsche became a frequent guest in the Bachofen home upon his arrival in Basel in 1869 as a newly appointed professor of classical philology. Like Bachofen, Nietzsche saw history as a dialectical progression. In his view, the key conflict lay between the forces of disease, weakness, and life-resentment versus manly courage and affirmation of life. Bachofen had written that the physical aspect of human existence, enacted in maternity, is the only thing man shares with the animals; the paternal-spiritual principle belongs to him alone. Nietzsche subsequently often equates women with animals, describes male/female relations almost exclusively in terms of a struggle for dominance, and regards the fulfillment of masculine potential as requiring liberation from the pull of women, along with the pull of conventional piety and the community, or in his phrase "the herd." In his writings Nietzsche, like many later Expressionists, emphasizes the central importance of the individual, the need for rebellion against society, the imperative to exercise will, and the importance of myth, embodied in poetry, as a means to capture the deepest truths of human existence.

Nietzsche's writings are rife with mocking references to women not only as animals but also as dangerous playthings, born slaves, purveyors of illusion, religious fanatics, and representatives of a realm of darkness against which he contrasts the masculine world of daylight and rationality. Like Bachofen, Nietzsche sees two roles for women: either as mother bearing robust offspring or the hetaera of Greek antiquity.[11] But in contrast to Bachofen, Nietzsche values both roles negatively: the mother becomes identified with the hated bourgeoisie and Christianity, while the hetaera is ambiguous. She presents both the weakness of male sexual desire and the opportunity for agon, for reassertion of male dominance against all the

seductiveness of the feminine. Woman, who is identified with the life force and viewed positively by Bachofen as a creator of culture and thus a worthy partner/antagonist of man, becomes for Nietzsche the quintessential herd animal, the simultaneously fearsome and unworthy antagonist. This is a core component of Nietzsche's transvaluation of values.

Several similarities with dominant Expressionist views of women emerge here, along with differences. Like Nietzsche, Expressionists are fascinated by the feminine and acknowledge the feminine, whether for good or ill, as a source of enormous power. They feel the need to assert themselves in relation to this power, toward which they, like Nietzsche, feel great ambivalence: both attraction and repulsion. Raised in a household of, as he saw it, repressively pious women, Nietzsche blames women for much of what he hates in German bourgeois society; Expressionists reject the institution of the bourgeois family but direct their overt anger at the father, generally viewing the mother as at best a helpmate and at times even as a fellow victim of the father. For Nietzsche, the attack on women is merely part of a larger attack on all things sacred or canonical, including God, absolute truth, conventional morality, German nationalism, democracy, and a host of other values. Nietzsche's "herd animal," the individual who has no higher ambitions and seeks above all security and the comfort of conformity, sounds much like the bourgeois philistine Expressionists love to pillory. Like Nietzsche before them, the Expressionists are deeply dissatisfied with modern European culture, decry the positivist privileging of science, empiricism and theory over art or myth, the reduction of the human being to a biological creature, and the loss of a higher, truer calling in life. Like Bachofen before him, Nietzsche calls contemporary sexual mores and gender relations into question, arguing that the prevailing situation inhibits cultural progress. For Nietzsche and even more for mainstream Expressionism, the relationship with women is a primary locus for the inevitable conflict and struggle for dominance that characterize the (male) human life of higher purpose and the evolution of culture to a higher level. Nietzsche's extremes of femininity (*das Weib*, the female) and masculinity (*der Übermensch*, superman) reappear in Expressionism as *das Weib* and *der Mensch*. Expressionism's contribution lies in the aesthetic novelty of its formulation of these views.

Otto Weininger, the son of an assimilated middle-class Jewish family, was born in Vienna in 1880 and took his own life there in 1903, only months after completing his doctoral dissertation, which was revised and published the same year under the title *Geschlecht und Charakter* (Sex and Character). The dissertation perplexed and alienated his advisors; his suicide, however, sensationalized the work, which subsequently was discussed at length in bourgeois as well as avantgarde and Expressionist publications and had gone through 28 editions by the end of the 1920s (Heckmann, 114). He received a letter of thanks from August Strindberg for solving the

"problem of the sexes," was later described by Adolf Hitler as "the only honorable Jew" he'd ever known (Anderson, 433), and Ursula Heckmann argues persuasively that he was a major influence on the poet Georg Trakl. It seems reasonable to assume that Weininger influenced other Expressionists beyond Trakl, and that his ideas were an integral part of the cultural context, well known during the period from about 1910 to 1930 even to those who had never actually read *Geschlecht und Charakter*. Though Weininger's ideas appear outrageous today, in his own day he fascinated "so feine Geister wie Karl Kraus, Ludwig Wittgenstein, Hermann Broch, Heimito von Doderer e tutti quanti" (such fine minds as . . .; quoted in Anderson, 433). Others attracted to his work included Ludwig von Ficker, editor of the influential *Brenner*, Adolf Loos, Arnold Schönberg, and Alban Berg (Heckmann, 121). Carl Dallago pronounced Weininger's work "das tiefste philosophische Werk . . . das je über das Weib geschrieben wurde" (the most profound philosophical work [. . .] ever written about the female; Heckmann, 132).

Born, like the majority of Expressionists, in the decade of the 1880s, Weininger believes the turmoil of his age is rooted in the relationship between the sexes. Like the Expressionists in search of artistic or literary basics, he seeks philosophical fundamentals and finds them in a theory of the sexes that is strongly essentialist and dualistic. He posits two absolute or ideal types, Male and Female, ascribing spiritual and ethical qualities to maleness while arguing that femaleness is entirely dominated by the sex drive and thus incapable of intellectual activity, morality, or creative endeavor. If sexuality is the whole reason for woman's being and the erotic power of women seduces and thereby degrades men, it follows that man is locked in an eternal struggle with sexuality and therefore with woman. To remain true to his higher calling, man must defend himself, and the inevitable result is emphatic assertion of male claims to dominance and patriarchal relations. Whether the seductress is a hetaera or a (potential) mother is secondary; both are exponents of the W principle, Woman.

By extending Nietzsche's thinking and linking motherhood with sexuality in this way, Weininger undermines the tradition that reveres the mother while reviling the sexually active woman; instead of polar opposites, Weininger sees no fundamental difference: " 'Die Eignung und der Hang zum Dirnentum ebenso wie die Anlage zur Mutterschaft' (ist) in jeder Frau 'organisch, von der Geburt an vorhanden . . . Es gibt sicherlich kein Weib ohne alle Dirneninstinkte,' ebenso wie sich keine Frau finden lasse, die 'aller mütterlichen Regungen bar wäre' " (The aptitude and inclination to prostitution, like the disposition to motherhood [is] organically present within each woman from birth on. . . . There is most certainly no woman entirely without whoring instincts, just as no woman can be found who entirely lacks all maternal impulses; quoted in Heckmann, 76). Indeed, in a reversal of conventional moral judgment that anticipates

Expressionism, Weininger seems to ascribe a higher moral position to the prostitute, who is at least honest about the basis of her existence; the mother, conversely, may be more reprehensible precisely because she produces new life and thus perpetuates the cycle of reproduction, death, and decay (Heckmann, 90–91). Like Nietzsche, Weininger argues that while man embodies intellect, consciousness and soul, woman is soulless matter; furthermore, as "Sklavin des Sexuellen im Manne" (slave to the sexual in man; quoted in Heckmann, 95) she is dependent on man even for her sexual power.

Weininger's work is a response to the gender anxiety of his day in the wake of women's demands for access to education, work, and civil rights. Like the Expressionists, Weininger is dismayed by changes in conventional social roles; his solution is to transcend gender tensions by eradicating sexual difference and postulating a "utopia" based on pure masculinity in which relations between the sexes have been replaced by the dominance of his ethical ideal M, an isolated and absolute male who, like Nietzsche's *Übermensch,* has foresworn sexuality and procreation. Like many others — August Strindberg, Gustav Klimt, Egon Schiele, Oskar Kokoschka, Frank Wedekind, and Alfred Döblin spring to mind — he fears female sexuality and aims to annihilate it philosophically, if not with a knife.

Weininger shares many convictions with mainstream Expressionism. However, differences also emerge between Weininger's thought and the theoretical positions of Expressionism. Weininger wishes to overcome sexual difference by eradicating sexuality, but this position is too extreme for the Expressionists, who propose instead a kind of quarantine of the sexual within women, who will live exclusively in and through their sexuality so that men may be freed from it — but visit occasionally. Whereas Weininger sees the possibility of women overcoming their own W traits by renouncing their sexuality, this alternative is notable by its absence from Expressionist writings, theoretical or literary. Weininger's views on the impurity of sex put him in the orbit of the German moral purity movement (Anderson, 443), whereas Expressionists, in a spirit of bohemian license, embrace sexual freedom. However, male Expressionists approach sexuality with ambivalence: it is not simply pleasure; rather it represents a struggle that must be played out repeatedly in order to reassert dominance and male identity. Weininger's arguments ultimately lead to a position Expressionists do not share. For him, emancipation is emancipation *from* femaleness for *both* sexes, whereas for Expressionists, emancipation follows distinct gender lines: emancipation for women is emancipation *to* complete identification with their female sexual functions, so that man is free to become an exponent of pure *Geist* (Wright 1987). On balance, Weininger's remedy for the cultural malaise of his era is not identical with the Expressionist solution, but it is clearly a not-so-distant cousin. While Heckmann argues that the close relationship between Georg Trakl's poetry and Weininger's

thought makes Trakl more an exponent of Viennese aestheticism than of Expressionism (14–15), the argument can just as easily be turned around. That is, the presence of Weininger's influence can be taken as a characteristic not merely of Trakl but of Expressionism more generally, especially when comparing the lyric poetry of men and women Expressionists and their differing idioms.

In turning from a discussion of philosophical sources to Expressionist works themselves, it makes sense to ask whether gender-related aspects of that legacy receive different interpretations from male and female authors. But comparisons are difficult, since little of the work of women Expressionists has been collected and published. A pioneering exception is Helmut Vollmer's 1992 volume of women's Expressionist poetry *In roten Schuhen tanzt die Sonne sich zu Tod,* which lends itself to comparison with Kurt Pinthus's *Menschheitsdämmerung,* the ultimately canonical collection of Expressionist poetry that appeared in 1919, sold briskly, and had reached a circulation of 20,000 by the time of its 1922 reprinting (Pinthus, 33).

As "die beste" (the best), "die repräsentativste" (the most representative), and "die klassische Anthologie des Expressionismus" (the classical anthology of Expressionism; Pinthus, 7) *Menschheitsdämmerung* provides a useful comparison to Vollmer's anthology.[12] *Menschheitsdämmerung* includes 276 poems by twenty-three authors. Of these authors, only one, Else Lasker-Schüler, is a woman, and of the 276 poems, fifteen are by her. Pinthus points out in the original introduction that while some may object that two poets, Lasker-Schüler and Theodor Däubler (both born in 1876), do not belong to the young Expressionist generation (with birthdays clustering around 1885), he has included them because they embody core qualities of Expressionism: Lasker-Schüler "läßt als erste den Menschen ganz Herz sein — und dehnt dennoch das Herz bis zu den Sternen" (*MHD*, 25; is the first to allow humans to be all heart — to expand nonetheless the heart up to the stars, *DoH*, 30). In other words, although Lasker-Schüler has been included, the "typical" Expressionists are all men.

*Menschheitsdämmerung* is not organized around particular authors or readily recognized themes. Instead, Pinthus creates four "horizontal" categories: "Sturz und Schrei" (Crash and Cry), "Erweckung des Herzens" (Awakening of the Heart), "Aufruf und Empörung" (Call to Action and Revolt) and "Liebe den Menschen" (Love for Human Beings). Within these divisions, which function like the movements of an orchestral composition, the poems express motifs that intertwine in what Pinthus describes as a dynamic symphony. This poetic symphony is designed to express an inner action, one that moves from outrage in *fortissimo* through the *andante* of doubt and despair and the *furioso* of rebellion, finally resolving with the *moderato* of the awakening heart, the *maestoso* of a loving humanity (*MHD*, 22–23; *DoH*, 28). In the introduction of 1919,

Pinthus emphasizes the Expressionist project to create a new, more noble, more humane human being. He declares famously, "Alle Gedichte dieses Buches entquellen der Klage um die Menschheit, der Sehnsucht nach der Menschheit. Der Mensch schlechthin, nicht seine privaten Angelegenheiten und Gefühle, sondern die Menschheit, das ist das eigentlich unendliche Thema" (*MHD*, 25; All the poems in this book spring from the lament over humanity, the desire for humanity. Simply the human, not [his] private affairs and feelings, but rather humanity, that is actually the infinite theme, *DoH*, 30). Out of the new human being is to emerge a new world (*MHD*, 27; *DoH*, 32), one with kindness, justice, comradeship, and love for all (*MHD*, 28; *DoH*, 33), made possible through the "Macht des menschlichen Geistes, der Idee" (*MHD*, 30; power of the human spirit, the idea, DoH, 35). It is in this context that Lasker-Schüler's poetry of the "heart" sounds its note. Pinthus and other Expressionists reject the scientific rationality of the fathers, but they embrace a new "idea." They scorn the sentimentality of the bourgeoisie but adopt a heroic emotionalism of their own, one that transcends the individual to include all humanity. The goal is a synthesis, an "unisono der Herzen und Gehirne" (*MHD*, 22; harmony of hearts and minds, *DoH*, 28).

Pinthus's use of the metaphor "Humanitätsmelodie" (*MHD*, 14; melody of humanity, *DoH*, 18) for his collection is qualified, however, by the dominant Expressionist practice of distinguishing between *Mensch* — or "human being" — and *Weib* (woman). Pinthus never defines what he means exactly by *Menschheit* (humanity), but it is not difficult to infer that he and the poets of the collection assume a community of men. In the closing passage of the 1919 introduction, Pinthus begins his coda-like charge to younger readers with the words: "Ihr Jünglinge aber, die Ihr in freier Menschheit heranwachsen werdet . . ." (*MHD*, 31; you young men, however, who will grow up in a freer humanity, *DoH*, 37),[13] and there is frequent use of the words *Bruder* (brother) and *Brüderlichkeit* (fraternity) both in the introduction and in the numerous poems that express anguish, hope, rebellion, or a sense of solidarity.

The invocations of *Menschheit* scattered throughout the collection reach a crescendo in the sections "Aufruf und Empörung" and "Liebe den Menschen." As a transition from the section "Erweckung des Herzens," Franz Werfel's "Ich bin ja noch ein Kind" (*MHD*, 208–9; I am still a child, *DoH*, 233–35) lists the suffering of humans and beasts alike but asserts the existence of God coursing through all creation and proclaims "Wir sind" (We are). In this poem women figure as *Hure* (whore), *Weib* (female), *Mutter* (mother), and *Mädchen* (girl) as well as, curiously enough, *Kaiserin* (queen, female Kaiser). As the section "Aufruf und Empörung" opens, the famous Hasenclever poem "Der politische Dichter" (*MHD*, 213–16; The Political Poet, *DoH*, 237–40) depicts the titanic struggle of the poet, the "Freiheitskämpfer" (freedom fighter)

against the "Herrscher" (ruler); of the "Jünglinge" (young men) against the fathers. Women in the role of passive and violated victims form the backdrop for this struggle: "Zerstampfte Frauen hinter Läden weinen" (trampled women cry behind shutters) while "auf weiße Mädchen fällt das nackte Vieh" (the naked beasts fall upon white-faced girls) with obvious sexual implications. Similarly, Karl Otten addresses "die Menschheit," invoking a "Blutorkan" (bloody hurricane) of eroticized suffering and including women as "Sirenen" (sirens)"Gebärende" (birthers) and "Zeugende" (reproducers) before inciting workers to rebel against the inhuman treatment accorded them and "their" women and children (227–30). Paul Zech's "Neue Bergpredigt" (New Sermon on the Mount; 230–33) appeals to fallen women, "Töchter der Magdalena" (daughters of Mary Magdalen; 230), and to "Mütter fruchtbar ohne Sinn" (mothers senselessly fertile; 231), as well as to men.

Johannes R. Becher's "Mensch stehe auf" (*MHD*, 253–58; Human Being Rise, *DoH*, 276–80) exhorts a male audience, with passing references to "Babels Hure und Verfall" (Babylon's whore and ruin) on the one hand, and to "schwangere Eselinnen" (pregnant donkeys) on the other, that may at last find rest when the revolution succeeds. Similarly, Alfred Wolfenstein's "Guter Kampf" (*MHD*, 259–62; The Good Fight, *DoH*, 281–84) will be waged, among other ends, for the sake of the "Mädchen in des Prinzipals Kabinett, an seinen Schoß gefesselt wie ein Brett" (girl tied like a board / To the boss's lap in his private room), for the sake of tired mothers and "der Liebe Frau" (261; lady of love, 284). More eroticized revolutionary violence appears in Becher's "Eroica" (*MHD*, 265–67; *DoH*, 288–91 where "Jäh aus Riesen-Phallus schoß Lava-Samen kataraktisch in mein Blut" (*MHD*, 265; Abruptly out of a gigantic phallus lava-seeds shot like a cataract into my blood, *DoH*, 289), and where he as visionary poet-revolutionary becomes the "Visionenschwangerer Stier" (*MHD*, 266; bull pregnant with visions, *DoH*, 289). Ludwig Rubiner's "Der Mensch" (*MHD*, 273–74; The Human Being, *DoH*, 297–98) is characterized by "das Denken" (*MHD*, 273; thinking, *DoH*, 297) in entirely male terms. The poems in the final section praise *Brüderlichkeit* (fraternity) and *Freundschaft* (friendship), again with women and girls, mothers and prostitutes providing the backdrop and adoring audience for male rescue. In contrast, Else Lasker-Schüler's vision of "Mein Volk" (*MHD*, 269; My People, *DoH*, 293) is completely gender-neutral (269).

In the anthology the most frequent term for women is the derogatory *Weib* (female), followed by *Mädchen* (girl), with the more standard *Frau* running a distant third. References to *Huren* (whores) and *Mütter* (mothers) also occur frequently, and the most frequent female activities are *Gebären* (birthing), suffering, and lamenting. In the majority of poems in which women figure at all, they appear as scenery, part of the stage setting for the poem's message, listed in long enumerations of phenomena that

characterize the metropolis, war, or rebellion.[14] Thus, for example, Wilhelm Klemm describes "Meine Zeit" (*MHD*, 40; My Age, *DoH*, 62–63) as consisting of "Gesang und Riesenstädte, Traumlawinen, / Verblaßte Länder, Pole ohne Ruhm, / Die sündigen Weiber, Not und Heldentum, / Gespenterbrauen, Sturm auf Eisenschienen . . ." (Song and giant cities, dream-avalanches, / Faded lands, poles without glory, / The sinful women, perils and heroism, / Spectral brewings, storm on iron rails);[15] and in "Der Dichter und der Krieg" (The Poet and the War) Albert Ehrenstein sighs "Müde bin ich der trostlosen Furten, / des Überschreitens der Gewässer, Mädchen und Straßen" (*MHD*, 88; I am weary of the bleak fords, / Of the crossing of streams, girls, and streets, *DoH*, 111).[16] Violence perpetrated against women, too, is a matter-of-fact part of this backdrop. Thus, Johannes R. Becher's poem "Berlin" (*MHD*, 43–45; *DoH*, 66–68) mentions not only bright lights, noise, and speeding trains but also the fact that "Auf Winkeltreppe ward ein Mädchen wüst zerstochen" (44; On back stairs a girl was stabbed brutally, 67) while elsewhere loiter "Huren mit den ausgefransten Fressen" (44; whores with frayed mugs, 67). In Jakob van Hoddis's poem "Der Todesengel" (*MHD*, 103–4; Angel of Death, *DoH*, 126–27) a *Mädchen* suffers sacrificial death in the midst of exotic and bloody ceremonies that celebrate the union of the Angel of Death with his unresisting bride. If women are not treated cavalierly, they threaten *Geist*, and as Walter Hasenclever argues in his poem "Kehr Mir Zurück, Mein Geist" (*MHD*, 130; Come Back To Me, My Reason, *DoH*, 152) the connection to *Geist* requires protection at all costs: "Wenn je dich ein Genuß verzehrt, den töte! Verkauf dein Weib, du wirst es überstehn" (Kill what brings you pleasure before it can consume you! / Sell your woman, you will get over it). Similarly, in "D-Zug" (*MHD*, 130–31; Express Train; *DoH*, 152–53) Gottfried Benn underscores the insignificance of women with the comment: "Eine Frau ist etwas für eine Nacht" (*MHD*, 130; A woman is something for one night, *DoH*, 153).

Such casual brutality is not entirely typical, however, and it does not preclude some exceptions. Ernst Stadler, for example, paints a sympathetic picture of poor shop girls pouring into the streets to meet their lovers at closing time (*MHD*, 47–48; Closing Time, *DoH*, 71), and Paul Zech describes the miserable plight of "Sortiermädchen" (*MHD*, 55–56; Sorting Girls, *DoH*, 78–79). Walter Hasenclever has an uncharacteristically tender poem "Auf den Tod einer Frau" (*MHD*, 318; On the Death of a Woman, *DoH*, 344), and Georg Heym's haunting "Ophelia" (*MHD*, 107–8; *DoH*, 130–31) describes a woman's body drifting downstream, past urban and rural landscapes, exhibiting in death a peacefulness that contrasts with the noise and bustle of the city. But Ophelia is a classic victim of male jealously and violence, and the implication may be that the man who killed her has done her a favor. Ivan Goll's magnificent poem "Noemi" (*MHD*, 270–73; *DoH*, 293–97) presents the Biblical figure,

abstracted from her story in the Book of Ruth, as daughter of the Jewish people but beyond that as an Ur-ancestor of all humanity and a symbol of rebirth out of catastrophe. Franz Werfel's "Hekuba" (*MHD*, 134; *DoH*, 157–58) as "elendste der Mütter" (most wretched of all mothers) shares a bond with "Mütter" (mothers) and "junge Weiber" (young women) through the ages. However, relatively few poems in the collection make a female figure the focus of the poem rather than a prop. The reader encounters the first such poem, which is by Else Lasker-Schüler ("Meine Mutter," *MHD*, 103; My Mother, *DoH*, 126), a full 100 pages into the collection.[17]

Most remarkable, perhaps, is Johannes R. Becher's painful tribute to the assassinated Rosa Luxemburg. A Polish-Jewish expatriate who studied in Basel before settling in Germany, Luxemburg was one of the most highly educated women in Europe, a prolific writer on national economy and Marxist theory and a leading activist in the German Socialist movement. She never married or had children, but fellow activist Leo Jogiches and she were lovers for many years. She and Karl Liebknecht were assassinated in January 1919. Becher's tribute (*MHD*, 285–87; Hymn to Rosa Luxemburg, *DoH*, 308–10) addresses Luxemburg in ecstatic but grotesquely incommensurate terms: "Du Heilige! O Weib! —" (285; You holy one! O woman! 308) using such imagery as "dein Kuß" (your kiss), "milde Milch" (mild milk) and "reine jungfrauweiße Taube Glaubens-Saft" (pure virgin-white / Dove faith-sap). In addition to the Christian imagery of Marian virginity and the poet's vision of her violated body being taken "vom Kreuz" (287; from the cross, 310) the poem invokes pagan symbolism of feminine mystery ("sibyllinishe Mütter" 286; sibylline mothers, 309) and fertility ("Acker-Furche bergend sichere Saat," 286; field-furrow sheltering safe seed, 309) and offers a bizarre example of the manner by which the complexity of a real woman's existence is tied to the Procrustean bed of Expressionist abstractions about women.

Compared to theoretical essays in the journals of the movement (Wright 1987), in the poetry of *Menschheitsdämmerung* hostility toward women is muted, but the treatment of women is still characterized by familiar assumptions and clichés. Though expression has mutated into more modern, more starkly abstract, and therefore seemingly new forms, the underlying assumptions remain deeply traditional with regard to women's purposes, roles, and limitations. When Expressionism rebels against such inventions of modernity as science, technology, statistics, trade and industry (*MHD*, 26; *DoH*, 31), feminism, to most Expressionists, is just another item on that list, one of the many manifestations of a society that has lost its grounding in eternal verities such as the *Wesen* (essence) of male and female.[18] Kurt Pinthus describes Expressionism's drive toward abstraction as a quest for "nicht das Individuelle, sondern das allen Menschen Gemeinsame . . . das Einende, nicht die Wirklichkeit, sondern der Geist" (*MHD*, 28; not the individual, bur rather for what is

common to all humanity . . . the unifying, not the reality, but rather the spirit, *DoH*, 33). But in seeking such all-encompassing, abstract universals, Expressionism runs the risk of ignoring the very distinctions and nuances out of which genuine alternatives might evolve. The mere fact that male Expressionists often view the prostitute with sympathy and celebrate her defiance of bourgeois sexual mores, her suffering, and her supposedly authentic sexual instincts (see Schönfeld) does not vitiate the argument that the majority of male Expressionists view woman mainly in terms of sexual function (Wright 1987).

Pinthus's *Menschheitsdämmerung* enjoys singular status as the publication that presented Expressionism in literature to a wider audience and in effect defined the Expressionist canon just as the movement began to wane. With his own anthology of poetry by women authors, *In roten Schuhen tanzt die Sonne sich zu Tod*, Helmut Vollmer has done yeoman's service by creating a kind of companion piece to Pinthus's collection. Vollmer's volume, the first of its kind, includes the work of 39 women poets who wrote and published in the Expressionist style. In the introduction, he argues that the large number of authors represented may surprise readers. Most of these poets are entirely forgotten today, the most basic information about their lives seemingly impossible to reconstruct. Nevertheless, the biographical sketches and bibliographies at the end of the volume provide a significant amount of information and can serve as points of departure for further research. The poems — more than 150 of them — are arranged in five sections reminiscent of *Menschheitsdämmerung*: "Der Mensch ist tot" (Man is dead); "Ich bin das Gelächter der schlaflosen Stadt" (I am the laughter of the sleepless city); "Ich lebe meinen Traum in ewigen Zeiten" (I live my dream in eternal times); "Die Dunkelheit frißt mich mit Raubtierzähnen" (The darkness devours me with predator's teeth) and "Ich sehe dein Herz sternen" (I see your heart star). In each, familiar Expressionist themes intertwine: war, the modern metropolis, dreams, pain, love, and hope for a better world.

As Vollmer points out in the introduction, it was difficult in any case for women writers to establish themselves in the literary market of the early twentieth century, and the Expressionist milieu did not make things any easier. In the day-to-day dramas enacted in artists' cafés, talented women such as Else Lasker-Schüler, Emmy Hennings, and Claire Goll played supporting roles. The biographies of Vollmer's contributors reveal many close ties to male writers of the movement. Thus Else Lasker-Schüler, for example, had relationships with Herwarth Walden, Gottfried Benn, Georg Trakl, Peter Baum, Hans Ehrenbaum-Degele, and others. Henriette Hardenberg was close to Richard Oehring, Alfred Wolfenstein, and Johannes R. Becher. Emmy Hennings was paired at various times with Becher, Ferdinand Hardekopf, and Hugo Ball. Claire and Ivan Goll are one of the movement's best-known couples, and Herwarth Walden married Nell

Walden after divorcing Else Lasker-Schüler. Vollmer reports numerous dedications of works by one partner to another, suggesting that the relationships provided much poetic inspiration. Nevertheless, their literary templates for women "als angebetete und verwunschene Projektionen der Sehnsucht und Verzweiflung, als Muse, Dämonin, Geliebte, Gefährtin, Schwester, Mutter, Heilige und Dirne" (as exalted and execrated projections of desire and despair, as muse, demon, lover, companion, sister, mother, saint and whore, 17) seem more compelling for male Expressionists than their experience with real women colleagues.

Women writers share many of their male colleagues' artistic and political goals. They do not shrink from engagement; they call for an end to bourgeois hypocrisy and the sexual double standard; they are equally committed to a new humanity or *Menschlichkeit*; they too long for love and life, and they share the horror at the death and destruction brought on by the First World War; they condemn the war, and do not see women as blameless. But mixed in with these common themes is also the call for equality and an end to the limitations that society and culture impose on women. Claire Goll is particularly passionate in linking the oppression of women to the horrors of war and showing how women's emancipation and full participation in public life is the world's best hope for an end to the violence of war:

> Der schmachvolle Zusammenbruch der von Männern geführten Völker müßte uns endlich lehren, die Welt unter einem andern Gesichtswinkel als dem männlichen zu sehen . . . Wir . . . die wir nie mitspielen durften auf der Bühne der Welt! Wann werden wir endlich nicht mehr Chor sein, der klagt, sondern einzeln auftreten im Leben? Wie lange wollen wir uns noch zurückdrängen lassen von den eitlen, brutalen Mimen der Gewalt? Wo bleibt *unsere* Revolution? (quoted in Vollmer, 21)[19]

> [The ignominious collapse of societies led by men should teach us at last to see the world from another point of view than the masculine one. . . . We who have never been allowed to play a role on the world's stage! When will we finally no longer be the chorus that laments, but rather individual actors in life? How long will we allow ourselves to be suppressed by the vain and brutal mimes of power? Where is *our* revolution?]

Vollmer argues that the typically Expressionist devices used by male and female poets make it difficult to recognize sex-specific characteristics in this writing. He warns that it is problematic to regard the preference of the women poets for particular themes, motifs, or metaphors as typically feminine, since they can all be found in the works of men as well. A poem from the collection that makes this point emphatically is Erna Kröner's "Der Zug" (The Train, 64), which captures the jarring experience of modern transportation using images of the fragmented body in an ironic and darkly humorous fashion, reminding the reader simultaneously of Jakob van

Hoddis's "Weltende" (*MHD*, 39; End of the World, *DoH*, 61) and Ernst
Stadler's "Fahrt über die Kölner Rheinbrücke bei Nacht" (*MHD*, 179;
Ride across the Cologne Rhine Bridge at Night, *DoH*, 202–3):

> Meine Beine rollen sich geschwind am Rücken hinauf,
> Bis ich hupp, hupp wie ein Ventilator mich um meine
> Ohrmuschel drehe.
> Gott sei Dank! Endlich rennt das Licht hinterher auf den
> Schienen.
> Meine Hüften trennen sich erlöst von den Rippen
>
> Und meine Augen hängen sich an eine starke Telegraphenstange.
> Da trabt ein alter Mann vorbei.
> Über die Schulter zieht ihm der lila Strick
> Ein höhnisch grinsendes Maul in die Jacke.

> [My legs roll rapidly up my back
> Till I turn like a fan hop, hop around my ear conch.
> Thank God! Finally the light runs after me on tracks.
> My hips separate themselves with relief from my ribs.
>
> And my eyes hang onto a strong telegraph pole.
> There goes an old man trotting by.
> A purple cord over his shoulder pulls
> A disdainfully grinning face into his jacket.]

What is truly striking in turning from *Menschheitsdämmerung* to *In
roten Schuhen* is the shift to a female *perspective* that Vollmer notes in his
introduction but does not explain more fully. If we look more closely at the
poems and specify more precisely how these differences in perspective are
manifested, it leads to novel observations about women Expressionists'
views on *Menschheit*, the roles women can play as members of the human
race, and their experience of *Geist* (intellect, spirit), or transcendence. In
short, the female perspective expands and enriches our notion of the extent
and limits of Expressionism.

This shift in perspective appears most dramatically in the treatment of
stock female characters such as the *Dirne* or prostitute. In *Menschheitsdäm-
merung* the prostitute tends to function primarily as a requisite part of the
cityscape, perhaps sinful, demonic and threatening, or diseased and repul-
sive, but in any case merely one element in long enumerations; in the
women's poems the prostitute appears far less frequently and then the por-
trayal is less formulaic and more personalized and empathetic. In Paula
Ludwig's "Die Buhlerin" (Lover), for example, the first-person lyrical
voice identifies with the primitive power of animals: "In meinen Füßen hat
sich die Schlange verbissen / . . . das Herz zwitschernder Vögel / Ich

atme im Stöhnen des Tiers" (the snake has sunk its teeth into my feet / ... the heart of twittering birds / I breathe with the groaning of a beast) and then universalizes her experience to include not just *Menschheit* but all beings: "Es gibt kein Wesen, das sich mir verschlösse / . . . Und ich verströme in allen" (There is no being that is closed to me / . . . and I stream into all; 75). On a related note, in Martina Wied's "Die Dirne" (The Whore) the prostitute serves not as passive backdrop but as active and powerful agent, the made-up face merely a mask behind which lurks a sinuous panther on the prowl for prey. Or the prostitute may be portrayed with sympathy. Emmy Hennings' "Nach dem Cabaret" (After the Cabaret; 59) notes a series of human figures in the early morning hours: children, peasants on their way to market, church-goers, then devotes the culminating lines of the poem to a prostitute who "irrt noch umher, übernächtig und kalt" (still wanders about, unkempt and cold). In Trude Bernhard's "Klage einer Dirne" (Lament of a Whore; 73), the first-person lyrical voice of the prostitute speaks poignantly of her pain: "Hat mir schon einmal einer über die Stirne gestrichen, ohne mir wehe zu tun? . . . Meine Küsse fallen blutend, von der Sichel des Abschieds gemäht" (Has anyone ever stroked my brow without hurting me? . . . My kisses fall bleeding, cut down by the scythe of parting). In Emmy Hennings's "Apachenlied" (Apache-Song) the first-person narrator, "eine von den Oftgeküßten" (one of those often kissed) expresses despair, fear, and resignation while hinting enigmatically at the threat of violence: "Ich flüchtend grauer, wehender Fetzen! / . . . Und Géry soll das Messer wetzen" (I, fleeing, a gray, fluttering tatter! / . . . And Géry is said to whet his knife; 77). Nowhere in the collection is violence against women eroticized.

In contrast to *Menschheitsdämmerung*, here the word *Weib* appears only two or three times. Berta Lask's poem "Das Weib" (The Woman; 179) uses the word in the sense not of a real human being or even of a philosophical category called Woman but as a powerful mythic figure — and one with a soul. The poem opens with the line "Alle hundert Jahr wach' ich auf aus dem Lebensschlaf" (Every hundred years I awake out of my dormant existence), echoing the opening line of Georg Heym's "Der Krieg" (The War). The mythic "Weib" stumbles forth, blinded and with bound feet, a child in her womb, into a world of blossoms and sunshine, blood and horror, before posing a question: "Wer hört meiner Seele schlafschweres Aufschreien? / Wird das Kind einst hellere Sonnen und Sterne schauen?" (Who hears the sleep-heavy cry of my soul? / Will my child ever see brighter suns and stars?). The Expressionist *Schrei* in anguish at the present and in the longing for a utopian future issues here from the *Weib*, who, according to much (male) Expressionist theory, constitutes precisely the obstacle to that future.

When painted *Weiber* appear, they are paired with equally repugnant male counterparts: "blöde Kerle" (stupid jerks), as for example in Franziska

Stoecklin's "De Profundis," 63) or most strikingly, in Lili von Braun-behrens's "Stadtnacht" (City Night; 72). There, a male customer reduced to a grotesquely "torkelnde, widrige Wampe" (reeling, repellent beer belly) waddles into "des Teufels Residenz" (the devil's domicile). While men at the bar disappear in a cloud of "Schnapsgeist" (alcoholic vapors) a prostitute sidles over to solicit a potential john with "verzückter Fratze" (ecstatic grimace) only to discover that he is the devil: "der Mann mit dem Pferde-fuß" (the man with the cloven hoof). In a more prosaic café setting, complete with *Dirnen* (whores) as well as "Bürgerfrauen" (middle-class women) and an effeminate "Garçonne," Sylvia von Harden's description of a male-female interaction is less dramatic but equally telling: "Lu greift zagend nach einem Kavalier./ Streckt sich in ihn./ Er zerfällt pathetisch / In sich" (Lou reaches hesitantly for a cavalier. / Leans into him. / He collapses pathetically / Into himself; 76). In short, from the female perspective, the unsavory prostitute is still less repugnant than her male partners. These are not heroes struggling in a metaphysical agon.

The treatment of the mother figure also differs radically. Male Expressionists tend to portray both the birthing mother and the bereaved mother mourning her child one-dimensionally as figures of suffering, and most often as part of the background rather than the focus of a poem. Vollmer's collection includes poems that also function this way, but many go beyond those limits. Marie Pukl's "Mütterlichkeit" (Motherliness; 130), for example, never uses the word "Mutter" (mother) at all; instead *Mütterlichkeit* becomes synonymous with the abstract principle of dynamic *Werden* (becoming), the bridge between metaphysical heights and the physical earth with its herds of grazing animals, its "sanft geböschten Tiefen" (soft hilly depths). Similarly, Henriette Hardenberg writes a "Requiem" for her mother in which she calls upon birds and blossoms to cover her in "Liebes-erde" (love-earth), a neologism that spans the gap between "love," a lofty sentiment frequently invoked by Expressionists, and the earth. Else Lasker-Schüler's tender tribute, the second of her poems in *Menschheitsdäm-merung*, accomplishes a similar bridging of heaven and earth when the poet refers to her mother as "Der große Engel, der neben mir ging" (*MHD*, 103; The great angel who walked beside me, *DoH*, 126). These poems with their tenderness toward the mother provide an interesting contrast to the male Expressionists' much ballyhooed anger toward the father; in this collection of women's poems, at least, anger at the father is simply absent. Equally noteworthy is the series of poems by Lola Landau describing pregnancy, birth, and contemplation of the child. In "Geburt" (Birth; 178) she portrays the "martyrdom" of labor in highly Expressionistic imagery. The delivery reaches its climax in the moment when "da bricht ein Schrei als Fackel aus meinem Munde / Und legt Brand an die festliche Stunde" (then like a torch a cry breaks out of my mouth / And sets fire to the festive hour) soon joined by the "flackernde Schrei meines Kindes"

(flickering cry of my child) and closes with an experience of divinity: "und ich höre, wie Gott mir leibhaftig entgegenlacht" (and I hear how god incarnate laughs with me). Here, the purifying flame of divinity replaces the flesh and filth more typically associated with birth, and the once metaphorical and metaphysical *Schrei* now signals as well real birth and physical, indeed obstetric, labor.

Another important component of the female perspective is the perception of inequality in power relations between men and women. Berta Lask, for example (40–41) takes herself and women to task for suppressing their "Weibes Wissen / Aus Scheu vor der Mannmacht" (Women's knowledge / Out of timidity before male power; 40). In a poem entitled "Die Fahne" (The Flag), Erna Kröner melds images of the modern city and allusions to patriotism with violent collapse: "Gewimmer, Gestöhn und krachende Knochen. / Die Kraft hat das Recht / Und schüttelt die blutigen Locken, / An der sich die Schwachheit zerschneidet" (Whimpering, groaning and cracking of bones. / Might makes right / And shakes its bloody locks, / on which weakness is cut to ribbons; 60). Yet at the same time, women also possess power and passion. Elsabeth Meinhard's poem "Mädchen" (Girl; 134) uses the image of a hooded falcon — more conventionally used in medieval poetry to describe the freedom, skill, and courage of the knight — to convey the confinement and frustration of girls who long for the day when a "Sturmwind" (stormy wind) will shatter their chains and "ein Blitz aus der Menschheit" (a bolt of lightning from humankind) will tear them into "des Alls lebendiges Mark" (the living marrow of the universe).

These poets implicitly reject the male Expressionist juxtaposition of male *Mensch* to female *Weib* and the notion of a male monopoly on *Geist*. Instead, in countless examples, the women include themselves in the circle of *Menschen*. This means sharing in the guilt for what has occurred (see Franziska Stoecklin, "O wie haben wir Menschen die Erde entstellt"; O How We Humans Have Disfigured The Earth; 39) and the suffering that has ensued (see Henriette Hardenberg's "Abend im Kriege"; Evening in Wartime; 38), as well as helping to build a new world. In "Der Mensch ist tot" (The Human Being is Dead) Claire Goll describes how "we" with "our" hands and "our" hearts will create that better world (44). Charlotte Wohlmuth, in a poem that could have been written by Ludwig Rubiner, writes of "Wir Utopisten" (We Utopians; 53) in whom the fire glows, who envision "Ziele" (goals) and "Wirken" (works) that will carry one and all "In die ersten Menschlichkeiten!" (Into primal humanity). And Berta Lask has a vision of "erwachende Frauen" (awakening women; 55) at last finding their voice, a voice of divine inspiration: "Mund des Herzens, / Verklebt und verwachsen, / Laßt herein / Gottes Sturm!" (Heart's mouth, / Stuck shut and misshapen, / Let in God's storm!). Negative variations exist as well. Margarete Kubicka begins her poem "Die Mutter" with a pietà-like image but then indicts this mother who kept her distance

from "Geist" (intellect/spirit) cursing her "die nichts verstand" (who understood nothing) for failing both her son and other women (45). Other poems simply criticize male *Geist*. In "Kriegsausbruch" (Outbreak of War; 31–33), Lulu Lazard accuses "Kadaver Wissenschaft" (dead academic knowledge), "hohle Kunst" (hollow artistry), and "Tat" (action) of leading to war. Trude Bernhard cynically dismisses fevered *Hirn* (brain), *Wille* (will), and self-professed activism: "Zerlumpt entfällt der Tag kraftlosem Hirn . . . / Nachts werden Willen heiß wie Schöpfer wach / Und stumpfen hin an kleinverstreuten Lüsten, / Dann wird die Hand, die handeln wollte, schwach . . ." (A ragged day falls from a feeble brain . . . / By night wills awaken hot as creators / And grow dull in trivial enjoyments, / Then the hand that wished to act gets weak" ("Leben," 91). From this female perspective, the dawn of a new humanity or *Menschheitsdämmerung* seems almost to require as a precondition the dissipation of male privilege, its fading into a sort of long overdue Twilight of the Men or *Männerdämmerung*.

The women poets do not subordinate female creation through birth to male creation through art, positing instead equality and reciprocity. Thus Lola Landau's poem "Wiedergeburt" (Rebirth; 206) presents a dynamic and mutual process of creation and recreation: "Mein Schöpfer warst du" (You were my creator) she acknowledges, but now "Dein Eingang bin ich . . . / Dein Ausgang, aus dem du entstürzt, Kind mit gespültem Gesicht" (I am your entrance . . . / Your exit, from which you descended, child with fresh-rinsed face). In the final strophe of the poem, in an interesting contrast to the male tendency to identify women with primitive being, Landau presents woman as the very agent through whom one is "carried" — note the double entendre — from the most primitive levels of being to the promise of full humanity:

So wächst du ins Urherz zurück, in Pflanze und Schleim.
Ich trage dich zärtlich als Alge und Fisch durch die endlosen
Wehn,
Bis du gekrümmt in mir hockst, ein Mensch mit lächelnden Zehn,
Wie der Weise sinnend gebückt, du umschauerter Keim.

[Thus you grow back into primal heart, into plant and mud.
I carry you tenderly as algae and fish through endless labor pains,
Until you crouch coiled within me, a human with smiling toes,
As a wise man bent pondering, you awesome seed.]

In a juxtaposed poem on the opposite page (207), Paula Ludwig reverses the conventional associations (that is, female equals earth equals death, male equals Apollonian fire equals spiritual life) as she identifies the touch of a lover with deathly paralysis. She writes "Ich muß durch die Erde

gehen / Und ihre Gluten einlassen in mein Herz, / Daß ich nicht werde wie der Tod, / Wenn du mich anrührst" (I must go through the earth / And let her fires into my heart, / That I may not become like death, / When you touch me). As an earth mother or an earth lover, the speaker draws chthonic strength, like Anteus, from touching the earth, not her lover, in order to ward off the predations of the male.

The language of women Expressionists is as innovative, bold, and often grotesque as the language of the (male) *Menschheitsdämmerung*. However, in contrast to the male practice of seeing the city as "the Whore of Babylon," personified in the prostitutes who populate the scene, women Expressionists see the city primarily in terms of death, loneliness, and pain. Thus, for example, Martina Wied's poem "Das Gespenst der großen Stadt" (The Ghost of the Metropolis; 71) notes the requisite prostitutes, but features the dominant image of a "nackten Schädel übereist von Schorf" (a naked skull iced over with scab) atop a swaying, ghostly figure that stalks through stinking city streets. In Else Lasker-Schüler's "Weltende" (End of the World, a poem which incidentally does not appear in *Menschheitsdämmerung*, though the theme is well-represented, particularly by the epoch-making van Hoddis poem that opens the collection), the end of the world appears not in terms of violence or physical destruction but through an image of lovers seeking emotional comfort from the heavy shadows of death: "Komm, wir wollen uns näher verbergen . . . / Das Leben liegt in aller Herzen/ Wie in Särgen. / Du! Wir wollen uns tiefer küssen — / Es pocht eine Sehnsucht an die Welt, / An der wir sterben müssen" (Come, let us hide closer to one another . . . / Life lies in all hearts / As in coffins. / You! Let us kiss more deeply — / Yearning pounds upon the world, / And we must die of it; 29).

Even a cursory comparison of *Menschheitsdämmerung* and *In roten Schuhen* has suggested some key differences between male and female Expressionists, particularly in their treatment of female figures and gendered topics. Arguably, the work of these women poets is more successful than that of their male colleagues in achieving a synthesis of *Herz* and *Gehirn* (see Pinthus, 22) and envisioning a truly new *Mensch*. Though they write about many of the same stock problems or themes, the women's poetry shows more variability and less predictability. In contrast to the stark yet conventional dualisms of male poets, the women's treatment of similar subject matter is more nuanced, demonstrating its innovativeness through genuine reinterpretation of received categories and a synthesis of seemingly irreconcilable dichotomies. To some extent the women Expressionist poets embrace the same traditional roles that male Expressionists ascribe to them: mothers, lovers. But they imbue these roles with an unfamiliar passion, strength, and significance in the struggle for the utopian new world of Expressionist longing.

In contrast, one can say that *Menschheitsdämmerung* is not so much hostile to women as simply oblivious to them, apart from a limited number

of categories of human experience with which women are readily and stereotypically identified. Through the comparison with *In roten Schuhen* it becomes more obvious how, on a fundamental level, old male-female divisions of cultural labor remain intact in the Expressionist avant-garde, and women remain largely marginalized in the work of male poets. Would the same be true in other Expressionist genres? At the conclusion of his introduction to *In roten Schuhen* Vollmer calls for additional research, particularly on the large body of fiction by women Expressionists. He has since published his own collection of women's short stories, *Die rote Perücke: Prosa expressionistischer Dichterinnen* (The Red Wig: Prose of Expressionist Women Writers, 1996). Together with little-known single-authored collections such as Claire Goll's *Die Frauen erwachen* (Women Awake, 1918), Vollmer's short stories could be compared, for example, with Fritz Martini's *Prosa des Expressionismus* (Prose of Expressionism, 1970) or Karl Otten's collections, particularly *Ego und Eros: Meistererzählungen des Expressionismus* (Ego and Eros: Masterpieces of Expressionist Narrative, 1963).[20] There is, to my knowledge, no collection of women's dramas that could be compared with, say, Horst Denkler's *Einakter und kleine Dramen des Expressionismus* (One-Act Plays and Short Dramas of Expressionism, 1968), though dramatic works by women may similarly await discovery. Vollmer's collection also raises questions about period, challenging literary scholarship to rethink its tendency to consider the prewar years from 1910 to 1914 as the peak of the movement's creativity and brilliance and the standard against which later Expressionist works are judged, often negatively. As Vollmer notes, the women poets do not reach the height of their output until somewhat later, after the war, after male politicians have failed catastrophically.

Among male Expressionists, a progressive minority always championed equal rights and a role in public life for women. The very first issue of Franz Pfemfert's *Die Aktion* (Action, 1911) includes an essay by Hedwig Dohm criticizing the conventional sexual morality expected of women and calling for a reform of the relationship between the sexes, along with eradication of the notion that women are intellectually inferior to men. Subsequent issues of *Die Aktion* contain numerous essays in which the feminist philosopher Grete Meisel-Hess argues for women's sexual emancipation — though her critique of Nietzsche's views on women, her rebuttal of Otto Weininger, and her calls for a "new man" to share in child-rearing and domestic chores with the new, emancipated woman do not appear.[21] Eight years later, in her volume of "lyrical" essays titled *Das Ergebnis* (The Outcome, 1919), Nadja Strasser writes that for too long women have been regarded as "dolls," treated like dolls. No struggle, she asserts, is "größer und bedeutungsvoller als der Kampf der Frau um Geist" (greater and more significant than the fight of women for intellectual recognition; quoted in Vollmer, 19). An investigation into women Expressionists' relationship to

the German women's movement of the day might reveal that more progressive views are dominant among Expressionist women, thus shifting the movement's philosophical center of gravity on the woman question. Given scholarship that has attempted to analyze Expressionism's relationship to the avant-garde, modernity, or post-modernity, it is worth asking how those arguments might be modified if the potentially even more destabilizing perspectives of women Expressionists were included.[22] Finally, the contention surrounding male and female Expressionists' views of women, and their humanity, capacities, and real or potential roles, anticipates the even greater divide that will open in the twenties, as the New Woman — in theory at least, economically independent, politically empowered, and sexually emancipated — encounters the "lost generation" of young men (Wright 1994).[23]

# Notes

[1] See, for example, the collections by Otto Best or Thomas Anz and Michael Stark.

[2] See also Sherwin Simmons' discussion of "Ornament, Gender, and Interiority in Viennese Expressionism." Simmons traces the development of Egon Schiele and Oskar Kokoschka from the ornamental aesthetic associated with the Wiener Werkstätte to Expressionist depth and interiority. Documenting the association of women artists with ornamental superficiality, Simmons argues that in their anxiety over gender roles, "male expressionist artists struggled to separate themselves from the growing presence of women in the Viennese art world" (271).

[3] Thomas Anz is aware of Vollmer's work on women Expressionists and refers to it in his *Literatur des Expressionismus* (34) while making the point that an analysis of Expressionism from the perspective of gender is yet to be done. Indeed, the Swiss press published the second edition of Raabe's *Expressionismus. Der Kampf um eine literarische Bewegung* in 1987. Inexplicably, however, despite both Vollmer's and the Arche Verlag's scholarly credentials, Vollmer's publications are not listed in the MLA bibliography.

[4] A glance at the number of references to these three writers in the MLA bibliography provides an interesting indicator of the problem. References to Lasker-Schüler spike at 144, then fall off rapidly with 25 for Goll and 2 for Hennings. Grete Meisel-Hess, a theorist and novelist who appeared regularly in the pages of *Die Aktion*, gets one.

[5] Richard Brinkmann found nothing on the subject of women Expressionists to report in his first survey, *Expressionismus. Forschungs-Probleme 1952–1960*; nor does he in his second review of the literature (1980) foresee potential for future scholarship in the area of women Expressionists, despite the emerging significance at the time of women's studies and feminist scholarship. The impression of a movement lacking women representatives is also perpetuated by introductions to German literary history designed for upper-level high school and college students. See for example the Metzler *Deutsche Literaturgeschichte* or Thomas Anz's contribution,

"Expressionismus," in *Moderne Literatur in Grundbegriffen*. The discussions in Nürnberger's *Geschichte der deutschen Literatur* (Bayrischer Schulbuch-Verlag) or Knapp's *Literatur des deutschen Expressionismus (Beck'sche Elementarbücher)* include only Lasker-Schüler. The same applies to the ambitious 1990 volume of *Der Deutschunterricht* devoted to Expressionism.

[6] We do, however, have a volume dedicated to another well-known couple, Ivan and Claire Goll. In the introduction to their volume, editors Eric Robertson and Robert Villain discuss the lack of critical interest in both authors' works and factors that contributed to it, including exile, bilingualism, and the difficulty of fitting either writer into any neat category. On a related note, Bernhardt Blumenthal laments that Claire Goll has been regarded by literary critics primarily as translator and editor of her husband's works but neglected as a prose author in her own right.

[7] I am not the first to draw attention to the basically conventional view of women held by most male Expressionists. However, Wolfgang Paulsen, the author of *Expressionismus und Aktivismus*, and I draw different conclusions from the same observation. Writing a generation ago, Paulsen observed that Expressionists "elevated the prostitute to a pedestal" (6), intending to shock the bourgeoisie. But "the social intent revealed itself as utterly trite. . . . We would hardly call these 'loose women' emancipated: they remained totally subservient to the men in their lives . . . Indeed, the question of women's emancipation never arises anywhere in Expressionism . . . Man remains the center of its universe, and a self-centered universe it is! Women are but supporting characters, sentimentalized, glorified, but at times also brutalized. In no way did German Expressionist writers even attempt to change the traditional role of women in German society." Paulsen goes on to argue that male Expressionists' conservatism was fully shared by the women in their circles, with the single exception of Else Lasker-Schüler (6–8). I appreciate the candor of Paulsen's remarks but take exception on two counts: first, one *can* find discussion of the women's movement, admittedly not in traditional literary texts but certainly in the movement's numerous socio-political essays, manifestos, and reviews; and second, it is rash to conclude on the basis of a few examples that women Expressionists as a whole were conservative in their views, when so little is known about those women and their work to begin with.

[8] For an interesting discussion of the Expressionist appropriation of subjectivity and hysteria, traditionally viewed as feminine characteristics, see Richard Murphy's "The Poetics of Hysteria. Expressionist Drama and the Melodramatic Imagination."

[9] See the new biography on George, *Secret Germany: Stefan George and his Circle*, by Robert Edward Norton, Ithaca, NY: Cornell UP, 2002.

[10] In his book *Primitive Renaissance (2001)*, David Pan makes a persuasive case for Expressionism as a primitivist critique of modernity. Though he does not touch on women or gender issues directly, he does include "mythic violence" and the inevitability of conflict between humans and nature as essential elements of primitivism, thus implying the necessity of struggle between men and women, if woman is viewed not as human subject but as part of the object world of nature.

[11] See Peter Burgard's collection of essays, *Nietzsche and the Feminine*, for a systematic review of the topic along with pertinent current theoretical meditations.

[12] Kurt Pinthus, ed., *Menschheitsdämmerung: Symphonie jüngster Dichtung* (Berlin: Rowohlt, 1920; Hamburg: Rowohlt Taschenbuch Verlag, 1959, 1976, 1993). Unless otherwise indicated, all quotations from this anthology are designated by the abbreviation *MHD* and page number, and English translations are taken (though modified by the present author in some cases) from *Menschheitsdämmerung / Dawn of Humanity: A Document of Expressionism*, trans. Joanna M. Ratych, Ralph Ley, Robert C. Conard (Camden House, 1994) and designated by the abbreviation *DoH* and page number.

[13] Though perhaps intended to some degree as a more general, inclusive form of address to a whole generation, as indicated by the translation "young people," the word Pinthus uses (Jüngling) refers specifically only to young men and is, to that same extent, specifically exclusive of women.

[14] As an additional illustration of this argument, see for example Kasimir Edschmid's definition of Expressionism, quoted in Anz's "Expressionismus" essay: "Nun gibt es nicht mehr die Kette der Tatsachen: Fabriken, Häuser, Krankheit, Huren, Geschrei und Hunger. Nun gibt es die Vision davon. Die Tatsachen haben Bedeutung nur soweit, als durch sie hindurchgreifend die Hand des Künstlers nach dem greift, was hinter ihnen steht" (144).

[15] See Neil H. Donahue's reading of this poem in the introduction to this volume.

[16] On a related note, in his article "Grossstadt in der Malerei des Expressionismus am Beispiel E. L. Kirchners," Franz Matsche juxtaposes a cast of erotically ambiguous, siren-like women to the male bonvivants who populate Kirchner's cityscapes.

[17] Jürgen Froehlich's *Liebe im Expressionismus* offers a wide-ranging and detailed analysis of poems published by male Expressionists between 1910 and 1914 in *Die Aktion* and *Der Sturm*. Froehlich contends that the poems bridge familiar dualisms and shatter stereotypes; however, they also illustrate the pervasiveness of those stereotypes and the fragility of such syntheses.

[18] For an informative discussion of the ideological ebb and flow of the German women's movement and its relationship to Expressionism, see Marion Adams's "Der Expressionismus und die Krise der deutschen Frauenbewegung."

[19] See Margaret Littler's "Madness, Misogyny and the Feminine in Aesthetic Modernism: Unica Zürn and Claire Goll," in which the author examines the tension between Goll's political activism as a young woman and anti-feminist statements in her later autobiography, *Ich verzeihe keinem* (1976).

[20] It could be fruitful, for example, to take Richard Sheppard's analytical approach to short stories by Döblin, Heym, and Jung and use it comparatively on fiction by female as well as male authors.

[21] Meisel-Hess's four novels, referred to only fleetingly by Ellinor Melander in her article on Meisel-Hess's philosophy, could provide additional insight into the relationship of women writers to the Expressionist movement.

[22] Richard Murphy, for example, examines Expressionist "defamiliarization techniques" aimed at the "dismantling of the real" (**1999, 260**); however, he does not address the Expressionist reinforcement of traditional notions of what women "really" are. Aldo Venturelli positions Expressionism at the border between modernism and post-modernism and argues that the Expressionist mission "einer

umfassenden Emanzipation" fails for lack of an ability to turn ideas into political action and to reconcile art and society, intellectual elites, and mass culture, or public life and the private sphere. Yet these are the very areas in which the women of Expressionism may have suggested alternatives. In his discussion of Berlin, Thomas Anz distinguishes between "zivilisatorische Moderne" and "ästhetische Moderne"; using Anz's distinction as an analytical tool, research on women in Expressionist literature and women authors could offer new insights into women's position as a point of contact — and friction — between these two. Similarly, Walter Erhart describes the New Man as an "artificial product of artistic autonomy" (308) on the boundary between modernism and postmodernism, unable to integrate the "sublime" and life; attention to *das Weib* and women's writings could modify his diagnosis.

[23] The New Woman of the twenties is another topic that cries out for attention from scholars of German Studies. The overwhelming majority of publications to date deal with examples from British and American literature. Notable exceptions include Katharina von Ankum's edited volume *Women in the Metropolis,* along with a handful of dissertations and individual articles by her and a small number of others.

# Works Cited

Adams, Marion. "Der Expressionismus und die Krise der deutschen Frauenbewegung." In *Expressionismus und Kulturkrise,* ed. Bernd Hüppauf, 105–30. Heidelberg: Carl Winter, 1983.

Anderson, Susan C. "Otto Weininger's Masculine Utopia." *German Studies Review* 19, 3 (1996): 433–53.

Ankum, Katharina von, ed. *Women in the Metropolis: Gender and Modernity in Weimar Culture.* Berkeley, Los Angeles, London: U of California P, 1997.

Anz, Thomas. "Berlin, Hauptstadt der Moderne: Expressionismus und Dadaismus im Prozeß der Zivilisation." In *Das poetische Berlin: Metropolenkultur zwischen Gründerzeit und Nationalsozialismus.* ed. Klaus Siebenhaar, 85–104. Wiesbaden: Deutscher Universitätsverlag, 1992.

———. "Expressionismus." In *Moderne Literatur in Grundbegriffen,* ed. Dieter Borchmeyer and Viktor Žmegač, 142–52. Tübingen: Niemeyer, 1994.

———. *Literatur des Expressionismus.* Stuttgart and Weimar: Metzler, 2002.

———, and Michael Stark, eds. *Expressionismus: Manifeste und Dokumente zur deutschen Literatur, 1910–1920.* Stuttgart: Metzler, 1982.

Bachofen, Johann Jakob. *Das Mutterrecht: Eine Untersuchung über die Gynaikokratie der alten Welt nach ihrer religiösen und Rechtlichen Natur.* Basel: B. Schwabe, 1897.

———. *Myth, Religion, and Mother Right: Selected Writings of J. J. Bachofen.* Trans. Ralph Manheim, preface by George Boas and introduction by Joseph Campbell. Princeton, NJ: Princeton UP, 1992.

Best, Otto, ed. *Theorie des Expressionismus.* Stuttgart: Reclam, 1976.

Beutin, Wolfgang, Klaus Ehlert, Wolfgang Emmerich, Helmut Hoffacker, Bernd Lutz, Volker Meid, Ralf Schnell, Peter Stern, and Inge Stephan. *Deutsche Literaturgeschichte von den Anfängen bis zur Gegenwart.* Stuttgart: Metzler, 1984.

Blumenthal, Bernhardt. "Claire Goll's Prose." *Monatshefte* 75, 4 (1983): 358–68.

Brinker-Gabler, Gisela, ed. *Deutsche Literatur von Frauen.* Munich: Beck, 1988.

Brinkmann, Richard. *Expressionismus: Forschungs-Probleme, 1952–1960.* Stuttgart: J. B. Metzler, 1961.

———. *Expressionismus: Internationale Forschung zu einem internationalen Phänomen.* Stuttgart: 1980.

Burgard, Peter J., ed. *Nietzsche and the Feminine.* Charlottesville, VA: U of Virginia P, 1994.

Denkler, Horst, ed. *Einakter und kleine Dramen des Expressionismus.* Stuttgart: Reclam, 1968.

Eichmann-Leutenegger, Beatrice. "Henriette Hardenberg — Lyrikerin des Expressionismus." *Neue Züricher Zeitung,* December 13, 1988, quoted in Vollmer, *In roten Schuhen,* 15.

Erhart, Walter. "Facing Modernism — German Expressionism: Fulfillment or Escape?" In *The Turn of the Century: Modernism and Modernity in Literature and the Arts,* ed. Christian Berg, Frank Durieux, and Geert Lernout, 302–16. Berlin and New York: de Gruyter, 1995.

Froehlich, Jürgen. *Liebe im Expressionismus: Eine Untersuchung der Lyrik in den Zeitschriften "Die Aktion" und "Der Sturm" von 1910–1914.* Frankfurt am Main: Peter Lang, 1990.

Garré, Roy, as reported in the *1995/96 Jahresbericht of the Institut für Philosophie der Universität Bern,* http://www.philosophie.ch/pgb/jb9596.htm.

Goll [Studer], Claire. *Die Frauen erwachen: Novellen.* Frauenfeld: Huber, 1918.

Heckmann, Ursula. *Das verfluchte Geschlecht: Motive der Philosophie Otto Weiningers im Werk Georg Trakls.* Frankfurt am Main: Peter Lang, 1992.

Hoffmann-Curtius, Kathrin. "Frauenbilder Oskar Kokoschkas." In *Frauen-Bilder, Männer-Mythen: Historische Beiträge,* ed. Ilsebill Barta, Zita Breu, Daniela Hammer-Tugendhat, Ulrike Jenni, Irene Hierhaus, and Judith Schöbel, 148–78. Berlin: Reimer, 1987.

Knapp, Gerhard P. *Die Literatur des deutschen Expressionismus.* Munich: Beck, 1979.

Lewis, Beth Irwin, *George Grosz: Art and Politics in the Weimar Republic.* Princeton, NJ: Princeton UP, 1991.

———. "*Lustmord*: Inside the Windows of the Metropolis." In von Ankum, ed. *Women in the Metropolis: Gender and Modernity in Weimar Culture,* 202–32.

Littler, Margaret. "Madness, Misogyny and the Feminine in Aesthetic Modernism: Unica Zürn and Claire Goll." In Robertson and Villain, *Yvan Goll — Claire: Texts and Contexts*, 175–88.

Martini, Fritz, ed. *Prosa des Expressionismus*. Stuttgart: Reclam, 1970.

Matsche, Franz. "Grossstadt in der Malerei des Expressionismus am Beispiel E. L. Kirchners." In *Die Modernität des Expressionismus*, ed. Thomas Anz and Michael Stark, 95–119. Stuttgart: Metzler, 1994.

Melander, Ellinor. "Toward the Sexual and Economic Emancipation of Women: The Philosophy of Grete Meisel-Hess." *History of European Ideas* 14, 5 (1991): 695–713.

Murphy, Richard. "The Poetics of Hysteria: Expressionist Drama and the Melodramatic Imagination." *Germanisch-Romanische Monatsschrift* 40, 2 (1990): 156–70.

———. *Theorizing the Avant-Garde: Modernism, Expressionism, and the Problem of Postmodernity*. Cambridge: Cambridge UP, 1999.

Norton, Robert Edward. *Secret Germany: Stefan George and His Circle*. Ithaca, NY: Cornell UP, 2002.

Nürnberger, Helmuth. *Geschichte der deutschen Literatur*. Munich: Bayrischer Schulbuch-Verlag, 1992.

Otten, Karl, ed. *Ego und Eros: Meistererzählungen des Expressionismus*. Stuttgart: Goverts, 1963.

Pan, David. *Primitive Renaissance: Rethinking German Expressionism*. Lincoln and London: U of Nebraska P, 2002.

Paulsen, Wolfgang. "Expressionism and the Tradition of Revolt." In *Expressionism Reconsidered: Relationships and Affinities*, ed. Gertrud Bauer Pickar and Karl Eugene Webb, 1–8. Munich: Wilhelm Fink, 1979.

———. *Expressionismus und Aktivismus*. Bern and Leipzig: Gotthelf, 1935.

Pinthus, Kurt. *Menschheitsdämmerung: Ein Dokument des Expressionismus*. Berlin: Rowohlt, 1959, 1993. In English: *Menschheitsdämmerung / Dawn of Humanity: A Document of Expressionism*. Trans. Joanna M. Ratych, Ralph Ley, and Robert C. Conard. Columbia, SC: Camden House, 1994.

Raabe, Paul, ed. *Expressionismus: Der Kampf um eine literarische Bewegung*. Zurich: Arche, 1987.

———, ed. *Index Expressionismus: Bibliographie der Beiträge in den Zeitschriften und Jahrbüchern des literarischen Expressionismus, 1910–1925*. Neudeln, Liechtenstein: Kraus-Thomson Organization, 1972.

Ritchie, J. M. "Richard Brinkmann's Expressionismus." *German Life and Letters* 34, 4 (1980–81): 453–68.

Robertson, Eric, and Robert Villain, eds. *Yvan Goll — Claire: Texts and Contexts*. Amsterdam and Atlanta: Rodopi, 1997.

Schönfeld, Christiane. *Dialektik und Utopie: Die Prostituierte im deutschen Expressionismus*. Würzburg: Konigshausen & Neumann, 1996.

———. "The Urbanization of the Body: Prostitutes, Dialectics, and Utopia in German Expressionism." *German Studies Review*. 20, 1 (1997): 49–62.

Studer, Claire. *Die Frauen erwachen: Novellen.* Frauenfeld: Huber, 1918.

Sheppard, Richard. "Insanity, Violence and Cultural Criticism: Some Further Thoughts on Four Expressionist Short Stories." *Forum for Modern Language Studies* 30, 2 (1994): 152–62.

Simmons, Sherwin. "Ornament, Gender, and Interiority in Viennese Expressionism." *Modernism/Modernity* 8, 2 (2001): 245–76.

Tatar, Maria. *Lustmord: Sexual Murder in Weimar Germany.* Princeton, NJ: Princeton UP, 1995.

Toller, Ursula. "Ausgrenzung der Frauen." Review of Hartmut Vollmer, ed., *Die rote Perücke: Prosa expressionistischer Dichterinnen.* http://www.oekonet.de/virginia/frueh97/vollmer.htm.

Tönnies, Ferdinand. *Gemeinschaft und Gesellschaft: Grundbegriffe der reinen Soziologie.* Berlin: K. Curtius, 1920.

Venturelli, Aldo. "Avantgarde und Postmoderne: Beobachtungen zur Krise des Expressionismus." *Recherches Germaniques* 22 (1992): 103–21.

Vollmer, Hartmut, ed. *"In roten Schuhen tanzt die Sonne sich zu Tod": Lyrik expressionistischer Dichterinnen.* Zurich: Arche, 1993.

———, ed. *Die rote Perücke: Prosa expressionistischer Dichterinnen.* Paderborn: Igel, 1996.

Wotschke, Jean. *From the Home Fires to the Battlefield: Mothers in German Expressionist Drama.* Frankfurt am Main: Peter Lang, 1998.

Wright, Barbara. "'New Man,' Eternal Woman: Expressionist Responses to German Feminism." *German Quarterly* 60, 4 (1987): 582–99.

———. "The New Woman of the Twenties: *Hoppla! That's Life!* and *The Merry Vineyard.*" In *Playing for Stakes: German Language Drama in Social Context; Essays in Honor of Herbert Lederer,* ed. Anna K. Kuhn and Barbara D. Wright, 119–38. Oxford and Providence: Berg, 1994.

# 11: Expressionism and Cinema: Reflections on a Phantasmagoria of Film History

*Sabine Hake*

NO OTHER FILM IN WORLD CINEMA is as closely identified with a particular movement or style as *Das Kabinett des Dr. Caligari* (The Cabinet of Dr. Caligari, 1920) is with Expressionism. Similarly, no other film has been invoked so frequently to make sense of Weimar culture and society and, even more problematically, to shed light on the mass appeal of National Socialism. *Caligari's* almost mythical status continues in competing accounts of its production and reception, contradictory claims about its relevance to the evolution of form and meaning in silent cinema, and highly speculative assertions about its place in German film history (Budd 1990). In the same way that *Caligari* denies the comforts of closure, the Expressionist film in general also resists easy definition. However, its elusiveness in terms of critical category has not precluded its continuing resonance in film history and cultural criticism, as well as in later filmic and multi-media practices. As regards the study of Weimar culture, the inevitable slippages in meaning can be seen most clearly in the two "imaginaries" identified with "Weimar cinema" and "Expressionist film" (Elsaesser 2000, 34) and their respective contribution to the historical, theoretical, and filmic reconstruction of German modernity.

Designed by Walter Röhrig, Hermann Warm, and Walter Reimann, *Caligari* is known best for its painted backdrops, false perspectives, skewed angles, dramatic lighting, and graphic effects (Robinson 1997). As told by screenwriters Hans Janowitz and Carl Mayer, the story follows the mysterious Dr. Caligari, who arrives at the fairground of a small town with the somnambulist Cesare. A series of murders strikes fear among the townspeople and has a devastating effect on three young friends caught in a love triangle, with one of the men, Allan, killed and the woman, Jane, abducted by the somnambulist. The framing story, which places the man's best friend Francis in an insane asylum, leaves it open whether he is the victim of a mad doctor or his own delusions. Recent findings suggest that the film's complicated narrative structure was the product of a series of deliberate artistic and economic decisions. For that reason, *Caligari* cannot be

reduced to an expression of authoritarian tendencies in German society, and even less can it be viewed as a premonition of Hitler. In presenting the dramatic events in a highly stylized setting, director Robert Wiene and producer Erich Pommer of the Decla studio sought to achieve two things: to distinguish their product from the majority of genre films produced during the period and, furthermore, to strengthen film's ties to the other arts by emphasizing its aesthetic qualities. And indeed, as the history of Weimar cinema shows, the references to Expressionism gave the art films made after *Caligari* a clear advantage in domestic and foreign markets and contributed to the subsequent transformation of cinema into a legitimate middle-class diversion.

But what is specifically Expressionist about *Caligari*? In narrative terms, the story translates the anxieties and resentments of the war and postwar years into specific melodramatic constellations. The appearance of a stranger destroys the appearance of harmony and order. At the same time, the otherness embodied by Dr. Caligari and his medium facilitates moments of transgression, including erotic ones. Thematically, these disruptions are articulated through the fascination with madness as both an alternative state of being and a metaphor of disintegration. Whereas the first refers back to German Romanticism and its critique of rationality, the second gives rise to a fundamentally modern critique of authoritarianism (Donahue 1994). Similarly, the film's rejection of conventional definitions of reality can be interpreted as liberating or traumatizing, either leading to an expansion of the visible world toward the fantastic and the imaginary or announcing the total disintegration of traditional distinctions between subject and object. The deep ambivalence toward modernity culminates around the central figure of Caligari, whose double role as savior and tyrant articulates the precarious relationship between knowledge and power and the disturbing similarities between magic/sorcery and cinema that must be considered central to the Expressionist imagination.

Not surprisingly, the new technologies of vision play a key role in what can be described as the driving forces behind Expressionism in the cinema: its tendency toward stylization, its exploration of ambiguities, and its fascination with vision as the founding site of modern identities. The foregrounding of visuality and its destabilizing effect on traditional notions of identity is most evident in its departure from one-point perspective, with its ordered, stable worldview, and in its heavy reliance on scenarios of looking: Caligari's dark glasses, Cesare's large eyes, and Jane's hypnotized stare. Through the attractions of the fairground, *Caligari* comments on the mass appeal of early cinema and the dangers of spectatorship. The film's self-identification with the traditions of the variety show is underscored by the melodramatic acting style and the deliberately theatrical settings. Yet through its uniquely filmic effects, including animation, *Caligari* also demonstrates the new pleasures to be gained through spectatorial

constellations modeled after the unconscious, a reference obviously to the affinities between early cinema and psychoanalysis. The introduction of an unreliable narrator has prompted some scholars to explore the connection between narrative ambiguity and the profound crisis of meaning after the loss of the war and the collapse of the empire (Murphy). Yet the addition of a framing story has also convinced others to read the film as a reassertion of the legacies of Romanticism against the fundamental ruptures brought about by mass culture and modernity (Kasten 1990, 39–51).

These positions are symptomatic of the divided critical reception that has linked *Caligari*, and the Expressionist cinema as a whole, to the history of Weimar cinema and the competing views of film as a reflection of social reality or an expression of artistic processes. They are identified with two influential studies, Siegfried Kracauer's *From Caligari to Hitler* (1947) and Lotte Eisner's *The Haunted Screen* (1952). In his socio-psychological study of Weimar cinema, Kracauer relied heavily on Expressionist themes and motifs in uncovering the "psychological dispositions or tendencies that prevail within a nation at a certain stage of its development" (6) — in this case, Germany after the First World War. Without access to *Caligari's* original script, Kracauer interpreted the addition of the framing story as symptomatic of broader tendencies in German society to suppress all challenges to its authoritarian structures and social hierarchies. Expressionism's characteristic wavering between rebellion and submission, in turn, allowed him to detect pre-fascist tendencies behind what he saw as Weimar cinema's preoccupation with father-son conflicts and its uncanny fixation on madmen and tyrants. The result: a succession of tyrants and despots from *Caligari* to *Mabuse*, with Hitler as their final real-life reincarnation. Coming from art history, Eisner chose a formalist approach and focused primarily on thematic and stylistic characteristics; hence her conclusion that "der phantastische deutsche Stummfilm dieser Zeit im Grunde oft nur als eine Art von Weiterentwicklung romantischer Visionen erscheint und daß eine moderne Technik den Imaginationen einer Traumwelt lediglich neue plastische Form verliehen hat" (the German cinema is a development of German Romanticism, and that modern technique merely lends visible form to Romantic fancies; 106). Both critics saw the Expressionist film less as a product of its times than as a manifestation of German identity and its inherent dilemmas, with Eisner underscoring the centrality of the *Dämonische* (in the Goethean sense) to the national imagination and with Kracauer constructing a teleology that implicates the national unconscious in the rise of National Socialism. Recent challenges to Kracauer's and Eisner's histories of Weimar cinema have shifted attention to international connections and popular traditions, a development that has also opened up new perspectives on the Expressionist film.

The coupling of film and Expressionism has always been problematic, with some scholars characterizing most films from the Weimar period as

Expressionist (Courtade), with many others limiting the term to the first half of the decade (Cooke), and with a few questioning the validity of the term, except in the case of *Caligari* and its less successful imitations (Salt). Some read the Expressionist film primarily as a response to social problems, while others emphasize its aesthetic qualities (Scheunemann). Some see these films as the culmination of the artistic innovations of Wilhelminian cinema, whereas others emphasize their haunting presence within Weimar cinema. And there is still little agreement whether Expressionism is analyzed best through the categories of ideology critique or film aesthetics. An overview of the scholarship is therefore bound to produce more questions than answers. Major points of contestation include: Is Expressionism in the cinema a style, a movement, or a period? A style or a Rieglian *Kunstwollen* (will to style)? An aesthetics or an epistemology? A textual quality or a spectatorial effect? A set of narrative themes and motifs or the result of particular visual and imaginary constellations? The self-representation of an epoch through visual means or the manifestation of national character in narrative form? An artistic rebellion against cultural and social conventions or a calculated response to the demands of product differentiation? An active participant in blurring the boundaries between high and low culture or the direct manifestation of intense conflicts and contradictions within Weimar society? A departure from the medium's inherent realism, as suggested by its photographic nature, or the first phase in the development of new technologies of illusion, simulation, and virtual reality? The German contribution to the European film avant-garde or the product of a cinematic *Sonderweg* (special path) that separates German cinema from other national cinemas?

*Caligari*'s phenomenal success paved the way for a number of art films distinguishable above all by their artificial settings, strange characters, and bizarre story lines. What many of these films shared was their heavy reliance on atmosphere, or *Stimmung*, as the unifying force that synthesized disparate literary motifs, visual traditions, perceptual modes, emotional dispositions, and cultural sensibilities. The preference for chiaroscuro, or *clair-obscur*, lighting represents only the most obvious manifestation of this highly symptomatic function of *Stimmung*. While Expressionist elements appeared in a number of genres and oeuvres, only a few films aimed at a radical transformation of the visible world by projecting extreme psychological states onto highly constructed interiors and exteriors.

Most of the Expressionist films were produced between 1920 and 1923. These years of great political and economic instability brought failed revolutionary uprisings and military putsches, mass unemployment and hyperinflation, and widespread poverty and disorientation, and finally, the stabilization of the currency in 1924. Often associated with the end of Expressionism, the so-called stabilization period gave rise to the optimistic,

pragmatic, detached, and occasionally cynical views on technological progress and social change that found expression in the realistic styles associated with *Neue Sachlichkeit*, a term usually translated as New Sobriety or New Objectivity (McCormick, 15–37).

Among the films typically identified as Expressionist, only a few present a unified new worldview; many more incorporate Expressionist elements into existing generic traditions and filmic styles. In a narrow sense, the label "Expressionist" can be applied to all films that move beyond conventional notions of reality, as established by realist and naturalist traditions, and seek to create more powerful reality effects based on perceptions, emotions, and sensations. These films include Karl Heinz Martin's never released *Von morgens bis mitternachts* (From Morn to Midnight, 1920), an adaptation of the acclaimed Georg Kaiser play, and his lost *Das Haus zum Mond* (The House to the Moon, 1920), about a mysterious house and its eccentric inhabitants; Hans Werckmeister's rediscovered science fiction film *Algol* (1920); and a relatively unknown rural melodrama, *Torgus* (1921), directed by Hanns Kobe. Other films often cited in this group are *Genuine* (1920), *Raskolnikow* (1923), and *Orlacs Hände* (The Hands of Orlac, 1924), three Wiene films that enjoyed modest commercial success. As for the better-known classics, Lupu Pick's *Scherben* (Shards, 1921) and *Sylvester* (New Year's Eve, 1924) are frequently described as Expressionist because of their symbolically charged interiors. But a strong emphasis on psychological motivation also links these films to the emerging genre of the so-called *Kammerspielfilm* (chamberplay film), an important part of Weimar cinema, and its critical investigation of familial structures and social milieus. *Schatten* (Warning Shadows, 1923), Arthur Robison's exploration of the affinities between film and dream, and *Das Wachsfigurenkabinett* (Waxworks, 1924), Paul Leni's first directorial success after years of working as a set designer, share the Expressionist preference for episodic narratives, spatial metaphors, and visual tropes. Yet these films are equally indebted to the techniques of the fantastic that were cultivated first by pre-cinematic diversions like the shadow-play and the curio show.

The difficulty of establishing a corpus of Expressionist films should not distract from the considerable influence of the Expressionist movement, which revolutionized theater, literature, and the visual arts during the 1910s, on a wide range of filmic practices during the early 1920s. Perhaps even more important, the elusiveness of the term "Expressionism" does not necessarily contradict its usefulness as a heuristic device in bringing together often contradictory aesthetic and cultural influences and in reconstructing the changing alliances between avant-garde movements and popular tastes since the late nineteenth century. Historically, the Expressionist movement must be described as an artistic response to a fundamental crisis in the institutions of power and the organization of culture, a crisis that

had culminated in the bloodshed of the First World War and contributed to the fall of the monarchy and that would continue to haunt the Weimar Republic and its tentative attempts to establish parliamentarian processes and defend democratic principles. Expressionists during the 1910s set out to measure the shock of modernity through the experience of the big city, the crisis in the institutions of power, the dramatic changes in class and gender relations, the transformation of marriage and family life, and so forth. The trauma of the war profoundly affected these visions of modernity by introducing a more anxious, troubled, pessimistic tone. Thus where Expressionist artists and writers had conjured up radical social utopias and dreams of individual liberation, the filmmakers used the Expressionist provocation primarily to reflect on the limits and failures of self-realization.

As an aesthetic phenomenon, Expressionism allowed Weimar filmmakers to respond to the gradual codification of classical narrative with an emphatic validation of the art film. Situated between an early "cinema of attractions" (Tom Gunning) and the cinema of narrative integration, *Caligari* exhibited many of the traits that had characterized German film culture during the 1910s, including the tradition of the fantastic identified with names like Henrik Galeen and Paul Wegener and the demands for artistic quality associated with the *Autorenfilm* (authors' film), a type of film associated with particular literary authors or screenwriters. The fact that the Expressionist style developed its distinctive characteristics (for example, the emphasis on frame composition, the attention to set design) based on an incomplete articulation of the rules governing classical narrative has prompted some critics to describe early German cinema as backward or retarded by international standards (Salt). However, it might also be argued that these differences allowed Weimar film artists to utilize the conventions of early cinema for the formal concerns of the avant-garde and to address contemporary problems through subjective perspectives and imaginary worlds unencumbered by the laws of classical narrative. Thus the combination of retardation and innovation produced a quintessential modern vision of cinema and a profoundly filmic vision of modernity that, to add to the contradictions, was often achieved through the deceptively antimodern stories and images identified with Expressionism.

From an economic perspective, the Expressionist film responded to the studios' need to reach new audiences through the production of films advertised as innovative, creative, and provocative in form as well as content. Especially at Decla Bioscop, the company responsible for *Caligari* and several other Wiene films, these new art films became an important aspect of product differentiation. The references to Expressionism in reviews and advertisements invested the act of moviegoing with an aura of cultural relevance, a strategy that proved highly effective in a conservative middle-class society still ruled by sharp distinctions between high and low

culture. Introduced during a period of rapid consolidation in the film industry, the label "art film" also gave German productions a unique identity on foreign markets. *Caligari* sparked an artistic trend known as *Caligarisme* in France, energized the cine-club movements in Great Britain, and caused some concerns about "a German invasion" among the Hollywood majors. Together with Ernst Lubitsch's *Madame Dubarry* (1919; released in the U.S. as *Passion*) and Paul Wegener's *Der Golem: Wie er in die Welt kam* (1920; released in the U.S. as *The Golem*), the famous Wiene film became part of a package of German films sold for U.S. distribution in the early 1920s. In the United States, these films established favorable conditions for the first wave of migration to Hollywood by those — Lubitsch, Murnau, Jannings, and Pommer — responsible for the international success of the German art film.

The precarious balancing act between film as art and film as commodity is nowhere more apparent than in the Expressionist movie posters. They were part of elaborate advertising campaigns that in the case of *Caligari* included a spectacular Berlin premiere on the elegant Kurfürstendamm, extensive commentary in art journals and literary magazines, and the appearance throughout the city of mysterious banners proclaiming "Du mußt Caligari werden!" (You Must Become Caligari!). The posters for two famous Decla productions (reproduced in this volume), *Das Kabinett des Dr. Caligari* and *Genuine*, illustrate well the close connection, central to the Expressionist film as a whole, between the eclectic use of heterogeneous forms, styles, and traditions and the direct address to both the core group of enthusiastic moviegoers and the more hesitant educated middle classes. For the *Caligari* poster, the graphic-design firm of Ledl Bernhard used the flat surfaces, simple shapes, and intense colors (for example, the orange sky, the blue footpath) known from Lucien Bernard's famous *Sachplakate* (object-based posters) advertising AEG light bulbs and Bosch sparkplugs. In evoking the orientalist world of *Genuine*, the influential graphic artist Josef Fenneker combined the elongated forms of *Jugendstil* and *art nouveau* with the graphic look favored by the painters of the Viennese Secession. Both posters present erotic fantasies that thrive on the affinities between passion and madness, obsession and violence, excess and degeneration. While making some use of the diagonal lines, sharp angles, and stark contrasts typically identified with Expressionism, Bernard and Fenneker take most of their thematic and stylistic elements from the rich tradition of nineteenth-century exoticism. This is especially apparent in the juxtaposition of white woman and dark man, the preference for phallic forms and organic shapes, the fusion of animate and inanimate world, and the symbolic investment in sexual desire as a transgressive but also potentially deadly experience.

The Expressionist film must be examined as an aesthetic *and* economic phenomenon, and similarly its main representatives must be evaluated

within the changed conditions of filmmaking during the early 1920s. In many smaller companies, but also at Ufa (Universum Film AG) studio's independent producer units, a guild model based on teamwork prevailed over traditional notions of individual creativity. Accordingly, the signature style of *Caligari* arose less from a lack of materials, as the myth would have it, than from an excess of creative talent. The close identification of the Expressionist film with highly stylized settings confirms the formative influence of set designers like Röhrig, Herlth, and Warm, who, often with no more than plaster, paper, cardboard, and paint, constructed what might alternatively be called a mise-en-scène of the modern uncanny, the historical unconscious, or the national imagination. Famous for translating the rather conventional stories of fear and desire, longing and renunciation, revolt and subordination, into uniquely filmic effects, Mayer wrote the scenarios for classics like *Caligari, Genuine, Scherben,* and *Sylvester* (Kasten 1994, Frankfurter). Considered the unifying force behind the Expressionist vision in its various fantastic, naturalist, and realist manifestations, Mayer remains best known for his collaboration with Friedrich Wilhelm Murnau. Meanwhile, Wiene emerged as the director most closely identified with Expressionism in the narrow sense. After the phenomenal success of *Caligari*, he directed *Genuine*, a lurid orientalist melodrama about a blood-thirsty femme fatale, and continued with an adaptation of Dostoyevsky's *Crime and Punishment, Raskolnikow,* and the Dr. Jekyll and Mr. Hyde story of *Orlacs Hände*. In these films, Wiene developed further the main themes of the Expressionist canon: the crisis of masculinity and the threat of female sexuality, the power of the unconscious and the dissociation of the self, and the social pathology of evil and violence (Jung and Schatzberg).

Famous directors such as Ernst Lubitsch, Friedrich Wilhelm Murnau, Georg Wilhelm Pabst, and Fritz Lang played only a minor role in the creation of an Expressionist vision for the screen, a fact that makes them well-suited to illuminate its presentation of fantasy, desire, and identity from the margins. For instance, on the level of set design, the confectionery-style decor in Lubitsch's *Die Bergkatze* (The Mountain Cat, 1921) can be said to introduce a humorous, and decidedly female, alternative to the Expressionist preoccupation with a masculinity in crisis. Similarly, Murnau's *Nosferatu* (1922) dissolves the perceptual uncertainties and psychological ambiguities of Expressionism into a pure poetics of the image indebted equally to nineteenth-century Romantic painting and twentieth-century photographic realism. *Der Schatz* (The Treasure, 1923), directed by Pabst, explores the symbolic currencies of light and shadow in the rural melodrama, a genre far removed from the big-city settings preferred by Expressionist drama and poetry. Finally, in *Dr. Mabuse, der Spieler* (Dr. Mabuse, the Gambler, 1922) Lang takes advantage of Expressionism's dependency on trivial literature, including its preoccupation with sex, crime, and

violence, and simultaneously responds to the movement's grand gestures of innovation with the famous quip about Expressionism as a mere game.

The most ambitious attempt to define the Expressionist film during the time of its ascendancy was made by Rudolf Kurtz, the editor of the influential trade paper *Lichtbild-Bühne*. In *Expressionismus und Film* (1926), Kurtz welcomed the convergence of a modern mass medium and a new art movement as an essential and integral part of the modernist imagination. For him, the Expressionist film was simultaneously a product of aesthetic modernism and a response to the growing disenchantment with modernity. Like futurism, cubism, constructivism, and surrealism, Kurtz argued, Expressionism mediates between art and technology and seeks transcendence through an aestheticization of physical reality. However, these processes require the presence of a true film artist who transforms the images into visions. His advocacy of individual creativity reveals the strong influence of Alois Riegl's above-mentioned notion of *Kunstwollen*, a Nietzschean will to artistic expression that Kurtz considers more important than any considerations of form or style. Resisting film's mimetic tendencies and its false promises of immediacy, Expressionism provides a "Hilfsmittel, um Wirkungen, die jenseits des Photographierbaren liegen, optisch zu beschwören" (important means of conjuring up optical effects that lie beyond the realm accessible to photography; Kurtz, 84), but only as long as filmmakers acknowledge the metaphysical dimension of the filmic image. By enlisting Expressionism in the advancement of film as art, Kurtz betrayed typical middle-class prejudices against film as "mühelose Apperzeption" (effortless perception; 126), a cheap entertainment for the masses. Yet at the same time, he relied on the most advanced technical means to enlist the new medium in a re-enchantment of the world. Instead of reducing the Expressionist film to certain formal devices, he extolled its spiritual dimensions. But as a pragmatist, he also defended the need for economic compromises; being fully aware that "was die Zustimmung dieser Massen nicht erzwingt, ist für die deutsche Filmindustrie schädlich" (what does not win the approval of the masses is detrimental to the German film industry; 129).

On the basis of these preliminary remarks, is it at all possible to give a working definition of Expressionist film? To begin with formal categories, *Caligari* and its successors might be defined best through their highly original approach to mise-en-scène, lighting, and camerawork and their equally distinctive narrative structure and treatment of images, figures, and symbols. The Expressionist films break with filmic conventions in two equally significant ways: by transforming, rather than merely recording, the visible world and by combining the representational paradigms of showing and telling. The underlying assumptions about reality as a construction are repeatedly thematized through the characters' dreams, delusions, and hallucinations, through optical tricks and devices (for example,

keyholes, shadows, mirrors), and through the extensive use of masking and iris-in/ iris-out in creating focus and sustaining continuity. This pervasive uncertainty surrounding the act of vision continues on the narrative level in the preference of Expressionist films for framing stories and episodic structures, flashbacks and ellipses, unreliable narrators, and self-reflexive comments on the act of storytelling.

In addressing this aesthetic tension between subjective and objective reality and in contemplating its broader implications for modern mass society, the Expressionist film relies heavily on narrative themes and motifs taken from German Romanticism, beginning with the figure of the *Doppelgänger* (double). Important sources of inspiration include early nineteenth-century painting (Friedrich, Spitzweg) and literature (Hölderlin, Novalis, E. T. A. Hoffmann); yet the sensationalist styles of the Gothic novel and the moral messages of the fairytale must be considered equally relevant to the production of Expressionist *Stimmung* (Schütz). As noted earlier, these heterogeneous influences are usually processed through the turn-of-the-century sensibilities associated with symbolism, aestheticism, and *Jugendstil*. Of course, the Expressionist film also shares a number of characteristics with the Expressionist drama, such as its preoccupation with the crisis of masculinity and the dangers of female sexuality, its preference for social and ethnic types rather than psychologically developed characters, its fascination with madness, violence, and degeneracy, and its above-mentioned vacillation between rebellion and submission (von Cossart). Finally, the connections between Expressionist theater and film are most evident in the theatrical staging conventions, the frontal acting of the characters, the highly stylized costumes, and the general preference for exaggerated gestures, movements, and physiognomies. These eclectic tendencies and hybrid influences make the Expressionist film an integral part of the new alliance between mass culture and modernity and a privileged medium for articulating the hopes and desires generated by this momentous encounter. Not surprisingly, the extensive references to the other arts established the Expressionist film as an important model of intertextuality for all of Weimar culture (Hoesterey). The scenarists who applied these integrative principles most successfully — Hanns Heinz Ewers, best known for *Der Student von Prag* (The Student of Prague, 1913 and 1926) and *Alraune* (Mandrake, 1928 and 1930), and Thea von Harbou, the author of several Lang films, most notably *Metropolis* (1927) — were also the ones with extensive commitments in literature, theater, and, most problematically, politics.

Contributing to what might be called a reenactment of the modern uncanny, the Expressionist film appears above all as an experiential or perceptual phenomenon, defined less by certain visual styles than by uncertain visual effects. For that reason, the films always also comment on the status of cinema as a technique of illusionism and a technology of light (Guerin).

Internal conflicts and desires are projected onto an external world that has become foreign and strange. This process finds expression in the destabilization of the subject at the center of the narrative. References to spectatorship and its dangers are ubiquitous, whether in the form of dreams and hallucinations, voyeuristic and exhibitionistic tendencies, or instances of discovery, surveillance, and observation. These self-reflexive references are sustained by the conceptual tension between vision as illusion and revelation and the contested status of visuality as the foundation of knowledge or ignorance, blindness or insight. Both definitions of vision expand the boundaries of the real beyond the traditional subject-object divide; hence the strong affinities with the fantastic, the grotesque, the occult, and the supernatural.

Many Expressionist films create a fantasy space that foregrounds the medium's affinity with psychological processes such as projection, introjection and condensation. This derealization of space extends from buildings to objects of everyday use and includes a theatricalization of performance through exaggerated gestures and facial expressions and highly choreographed body movements. The fact that modern techniques are turned into tools for escaping into pre-industrial, pre-modern worlds only underscores the precarious position of the Expressionist film in relation to tradition, modernity, and myth. The resultant fantasy effects attest to the power of the Expressionist vision to articulate and overcome the discursive divisions (for example, subject vs. object, interior vs. exterior) that give rise to its contradictory nature. Because of these qualities, the films must be described as simultaneously subversive and normative, original and derivative, and populist and elitist. Of course, this essentially antagonistic structure and the available strategies of reconciliation made Expressionism ideally suited to the articulation of a widespread ambivalence, shared by Weimar filmmakers and their audiences, toward modern mass culture.

Translated into the creative process, the encounter between film and Expressionism took essentially two directions: on the one hand, novelists, poets, and dramatists felt compelled by the cinema into reflecting on the future of literature in the age of modern mass media; on the other, filmmakers incorporated elements from the other arts in order to distinguish their own work from conventional films. Since the prewar years, the literary responses to the cinema had been closely associated with the Expressionist movement (Vietta; Žmegač). Known as the *Kinodebatte* (cinema debate), these polemical writings on the cinema investigated the artistic qualities of the silent film and the social rituals of movie-going (Hake, 61–88). Yet the heated arguments also served to hide deeper concerns, not only about the intense competition over audiences between literature and film but also about the radical transformation of the bourgeois public sphere through new visual sensibilities and popular entertainments. In the *Kientopp* (nickleodeon), writers and intellectuals had to confront the

specter of social leveling and cultural decline — and they did so by simultaneously extolling the powers of visual pleasure and projecting their own fears about a decline of high culture onto the movie audience, which they saw as an embodiment of modern mass society. Thus Alfred Döblin declared that "man nehme dem Volk und der Jugend nicht die Schundliteratur noch den Kientopp; sie brauchen die sehr blutige Kost ohne die breite Mehlpampe der volkstümlichen Literatur und die wässerigen Aufgüsse der Moral. Der Höhergebildete aber verläßt das Lokal, vor allem froh, daß das Kinema — schweigt" (one shouldn't deprive the masses of trashy novels and films. They need this bloody diet more than the indigestible gruel of folk literature and the watery brew created under the pretense of moral uplift. But the better-educated will leave the premises, most of all happy that the movies — are silent; Kaes 1978, 38).

Meanwhile, a number of Expressionist writers rediscovered in the cinema key features of literary modernity, including an affinity for the big city with its dangers and attractions. In the cult of movement, the acceptance of fragmentation, and the emphasis on vision, the new medium already seemed to practice what these writers sought to capture in their poems and plays — namely, the essence of modernity. Thus Jakob van Hoddis and Alfred Lichtenstein introduced the possibilities of montage into lyric poetry, creating a style alternately referred to as "three-second style," "telegram style," or "cinema style" (*Kinostil*). Prose authors like René Schickele enlisted the camera as a model of narration capable of addressing the problem of alienation through its detached perspective. Dramatists like Ernst Toller and Georg Kaiser thematized the drama of the modern mass individual through filmic scenarios of looking, with Kaiser's neologism *Kinoismus* validating film as a model for new aesthetic experiences.

However, when it came to writing scenarios for the film industry, most authors remained unwilling to abandon their initial hopes about film's re-enchantment of the world in favor of the anti-naturalist and anti-impressionist tendencies that had given rise to the Expressionist movement during the 1910s. Thus the tension between "Abstraktion und Einfühlung" (abstraction and empathy), to cite the title of the influential 1908 art-historical study by Wilhelm Worringer (discussed in greater detail in the introduction by Neil H. Donahue), yielded very different results in Expressionist theater and film. The drama of interiority liberated the modern stage from the constraints of convention; on the screen, the same approach often looked forced and derivative. Only *Das Kinobuch* (The Cinema Book, 1913) allowed for a more creative involvement with the filmic medium. Following a suggestion by Kurt Pinthus, several young writers, including Walter Hasenclever, Else Lasker-Schüler, Max Brod, and Arnold Höllriegel, contributed their scenarios to his anthology, convinced that "wir können das Kino (trotzdem es ein Feind der höheren Kunst ist) nicht bekämpfen" (we must not fight the cinema [even though it is the

enemy of high art]; Pinthus, 24). In exploring alternatives to the static film drama, many of these writers called for more fast-paced stories and fantastic visual effects. For them, the artistic potential of film hinged entirely on the creative possibilities of movement and speed; the difference from actual Expressionist films could not have been greater.

While the early literary responses to the cinema are inseparable from the larger social and cultural debates of the Wilhelminian period, the filmic appropriation of Expressionism reflects above all the intense economic pressures on film studios during the Weimar years. Institutional concerns stood behind both the popularization of Expressionist drama during a prolonged crisis in bourgeois theater and the promotion of art film at a crucial point in the embourgeoisement of cinema. However, its relationship to the Expressionist drama cannot be reduced to simple patterns of influence but must be explained through more complicated processes of incorporation and transformation. A direct transfer from stage to screen occurred only once, in *Von morgens bis mitternachts*, the adaptation of the famous Kaiser play by theater director Karlheinz Martin. Clear patterns of influence remained limited to the kind of thematic concerns shared by Kaiser's *Gas I* and *Gas II* and *Metropolis*. The Expressionist film's debt to the Expressionist drama remained most pronounced in the preference for emotional archetypes (for example, the Son, the Father, the Woman) but rarely extended to the latter's vitalist tendencies. The representation of the crisis of male subjectivity through the allure of the big city, the threat of female sexuality, and the oppressive nature of family life owed much to Expressionist drama but also found plenty of inspiration in naturalism and its strong emphasis on milieu as a determining factor in identity formation.

However, the influence of modern theatre productions on the staging conventions and acting styles of the Expressionist film was indeed considerable and can be traced quite easily. Innovative directors achieved a radical expansion of the proscenium stage through two equally important strategies: greater abstraction (for example, dark backdrops and flat spaces, highly symbolic use of objects, graphic approach to sets and costumes) and greater expressiveness (for example, through exaggerated gestures and movements). Many of these experiments were first tested in Berlin, the center of the German film industry and theatrical world. Two stage producers, Max Reinhardt of the Deutsche Theater and Leopold Jessner of the Staatstheater, exerted a strong influence on Expressionist filmmakers through their approach to lighting and set design, their emphasis on good acting, and their own, perhaps less noteworthy, directorial efforts. After *Hintertreppe* (Backstairs, 1921), a naturalistic milieu study with Henny Porten, Jessner directed *Erdgeist* (Earth Spirit, 1923), a disappointing adaptation of the famous Wedekind play despite the casting of Asta Nielsen in the title role. Reinhardt, who tried directing several times, had a much

more lasting effect through his work with famous actors like Werner Krauß, Fritz Kortner, and Emil Jannings. Known for their intensely physical style, they performed the much-discussed crisis of male subjectivity through a double strategy of externalization and internalization that proved equally effective on the stage and the screen. Their masculine physiognomies, body types, gestural codes, and performance styles confirmed their close ties to the Expressionist movement of the prewar years. But as evident in the screen personas of younger actors like Ernst Deutsch, Conradt Veidt, and, later, Peter Lorre, the Expressionist film also provided a space for a more contemporary body consciousness articulated in the aesthetic registers of indeterminacy and ambiguity.

The emphasis on the body as the site of an ongoing struggle for authenticity and truth distinguishes the performance style of Expressionism's leading actors from the more realistic styles of their contemporaries and draws attention to the productive influence of the modern dance movement on the conventions of dramatic acting during the 1920s. These influences harked back to early stage experiments with stage pantomime (for example, by Reinhardt). Additional impulses came from the modern dance movement as personified by dancer/teacher Mary Wigman, the main representative of German *Ausdruckstanz* (expressive dance). Such widespread interest in the ritualistic aspects of performance resonated in the anti-psychological styles that distinguished the leading Expressionist actors from the popular film stars appearing in conventional comedies and melodramas. More problematic applications of that difference surfaced in what might be called Expressionism's fascination with the gestural code of Germanness and its utilization in the representation of German national identity and its Others (for example, in the allusions to Jewishness).

The relationship between Expressionist film and architecture must be approached through a similar distinction between direct influences and general affinities. A few architects associated with the Expressionist movement developed an active interest in the cinema, most notably Hans Poelzig, who built the cavernous spaces of Berlin's Große Schauspielhaus in 1919 and who worked on the 1920 production of *Der Golem* (Reichmann 1997a). Set designer Paul Leni came to the cinema under the influence of Expressionist art and, in his later films, focused on mise-en-scène as a primary site of aesthetic experimentation (Bock). Eschewing the more radical aspects of Expressionist architecture, film architects preferred to work in a highly eclectic manner, combining the typical organic shapes and forms with select elements taken from *Jugendstil* and *Werkbund* design as well as *Gründerzeit* historicism. These heterogeneous influences found a perfect model of integration in a conception of filmic space that resisted established notions of verisimilitude and, instead, made productive use of the oscillation between the real and the imagined, the filmic and the theatrical, and the painterly and the architectural (Kessler).

Similar factors account for the lack of a discernible connection between Expressionist painting and film. All three set designers working on *Caligari* had a background in painting. Yet the career of Walter Reimann suggests closer affinities between Expressionist set design and late nineteenth-century painting (Reichmann 1997b). Often-cited elements of Expressionist filmmaking such as oblique angles, false perspectives, graphic distortions, and the selective addition of color (for example, in the choice of tints) bear only a superficial resemblance to the signature style of, say, Lionel Feininger or George Grosz. Yet despite their different formal strategies, painters and filmmakers were responding to the same dramatic transformation of space, place, and identity as a result of the new technologies of mass transportation and mass communication and the accelerated processes of modernization, industrialization, and urbanization. But whereas Expressionist painters embraced fragmentation and abstraction as an integral part of the modern condition, for instance by celebrating simultaneity and contingency, filmmakers used the technical possibilities of film to diagnose the crisis of modern subjectivity through a nineteenth-century tradition of the fantastic and the daemonic.

In a similar way, Weimar's leading cinematographers relied on pre-cinematic technologies of vision (for example, camera obscura, shadow play, panorama) as well as new advances in camera design and technology (for example, Karl Freund's "unleashed camera"). Aside from Freund, who worked on several Murnau films, this highly qualified group included Carl Hoffmann (*Von morgens bis mitternachts* and *Dr. Mabuse, der Spieler*), Fritz Arno Wagner (*Schatten*), and Guido Seeber (*Sylvester*). Many film histories credit the Expressionist film for cultivating the art of chiaroscuro lighting, which distinguishes foreground and background and highlights figures and objects, and, in so doing, animates and mobilizes narrative space. The dramatic interplay of light and darkness is often used to establish conceptual pairs such as conscious vs. unconscious, spiritual vs. physical, and, rather predictably, good vs. evil. All of these oppositions infuse the thematic preoccupations of the Expressionist film with heightened psychological relevance (Franklin). Of course, similar lighting techniques had appeared already in the Danish melodramas, as well as in the fantastic films by Wegener and Galeen. Yet the enlistment of lighting in the creation of highly artistic and, by extension, self-reflexive effects must be considered unique to the Expressionist film.

In the Expressionist cinema, the camera performed two equally important functions. Working against the spatial divisions established by the theater, cinematographers sought to incorporate the painted backdrops into the uniquely filmic mise-en-scènes created through unusual framing, high- and low-angle shots, and extreme close-ups. Aided by sophisticated editing techniques (for example, iris-in/out, superimposition, associative montage), skilled practitioners like Freund and Hoffmann achieved the radical

expansion of narrative space through greater camera movement. The actors were integrated into the artificial settings through shadows and silhouettes that emphasized their bodies' visual rather than corporeal qualities. Cinematographers often turned to the fantastic, with its many references to visions, nightmares, and hallucinations and its acute awareness of narrative ambiguity and visual uncertainty in order to bring together the incompatible forces that constituted the larger field of vision in the Expressionist film.

All of these patterns of influence came together in the three film genres usually mentioned in conjunction with Expressionism's thematic preferences: the fantastic film, the chamberplay film, and the street film. All genres played a key role in the self-presentation of German cinema as a national cinema and an art cinema, and all participated equally in the transition from the dramatic conventions of the 1910s to the narrative conventions of the 1920s. The origins of the fantastic film reached back to the wave of *Autorenfilme* started by Max Mack's *Der Andere* (The Other, 1912), an adaptation of Paul Lindau's famous *Doppelgänger* play. While the fascination with split consciousness in the fantastic film confirmed the close affinities between Romanticism and Expressionism, the visual representation of doubling more frequently resembled the sensationalist styles of the trivial novel. This mixture of high and low culture forms was perfected in several contributions that explored the supernatural, the miraculous, the fantastic, and the uncanny through the visual and narrative conventions of Gothic horror, folklore, and mythology; here the debt to the literary fairytale cannot be underestimated (Jörg). To give only a few examples, the motif of the double was central to Stellan Rye's 1913 adaptation of *Der Student von Prag*, with Wegener in the title role, and to the eponymous 1926 version by Galeen starring Veidt. The mythical Jewish figure of the Golem inspired the early *Golem* films (1914 and 1917) and the famous 1920 remake by Galeen and Wegener. An interest in questions of artificial life first inspired Otto Rippert's six-part serial *Homunculus* (1916) and returned, more elaborately, in *Orlacs Hände* and the various *Alraune* adaptations. Finally, the problem of modern technology linked a virtually unknown work like *Algol* to the most famous film of the period, *Metropolis*, and thus established the conditions for all later transfers between the fantastic and the science fiction film.

Continuing in the tradition of early melodrama, the chamberplay films used extreme limitations of time, place, and characters to address the problem of modern subjectivity from the perspective of the domestic sphere (Risholm). But again the Expressionist fascination with oedipal scenarios was mediated through a wide range of other influences. Inspired by the psycho-sexual explorations of August Strindberg and Frank Wedekind, *Genuine* used the figure of the femme fatale to evoke a morbid turn-of-the-century atmosphere of wealth, luxury, and degeneracy. Naturalist

theories of milieu prevailed in the claustrophobic petty-bourgeois interiors of *Scherben*, which depicts the disintegration of a mother-father-daughter triad after the arrival of a stranger, and *Sylvester*, which narrates the self-destruction of a young man caught between his wife and mother. A more critical approach to the excesses of the imagination distinguishes the episodic narratives of *Schatten*, an exploration of unconscious desires in the format of a shadow play, and *Das Wachsfigurenkabinett*, a reflection on madness and tyranny inspired by the popular cabinet of horrors. Expressionist staging and lighting conventions prevail whenever the problem of sexuality assumes center stage: namely, as the main problem in the patriarchal family and, by extension, in traditional society and as a powerful cipher for the irrational forces threatening the rule of reason in modern civilization. However, to what degree the chamberplay genre constructs its psychological interiors irrespective of any formal considerations can be seen in borderline cases such as Arthur von Gerlach's *Die Chronik von Grieshuus* (The Chronicle of Grieshuus, 1925) with its unique combination of Naturalist, Symbolist, and Expressionist elements.

Whereas the chamberplay films used Expressionist elements in formal reflections on the powers of the private sphere, the street films built on the tradition of social critique begun by Naturalist dramas to explore the connection between the spaces of the modern metropolis and the changing topographies of gender and class. The simultaneous shift from the classical Expressionism embodied by *Caligari* to what Eisner calls "stylized naturalism" started with *Hintertreppe*, which presents a female servant's romantic delusions with an acute awareness of the oppressive living conditions of the urban poor and without the comparative social typology found in the earlier *Vordertreppe — Hintertreppe* (Front Stairs, Backstairs, 1915). The spatial division between public and private spheres and the equation of the big city with dangerous sexualities (for example, in the figure of the prostitute) still prevailed in early street films like *Die Straße* (The Street, 1923), directed by Karl Grune. Later street films took a more critical approach to the Expressionist topos of the big city as "whore Babylon" and, as evident in Pabst's *Die freudlose Gasse* (Joyless Street, 1925), paid greater attention to social problems such as unemployment, poverty, crime, and exploitation. This trend toward social realism culminated in the city symphonies of the late 1920s and continued in the few examples of working-class filmmaking from the early 1930s.

With the rise of the sound film, the Expressionist vision in the cinema lost its aesthetic, social, and economic relevance and, finally, became part of world cinema. This process began with the first wave of emigration during the 1920s that, among others, brought Paul Leni to Hollywood to turn *The Cat and the Canary* (1927) into an Expressionist murder mystery. The work of Edgar Ulmer on *The Black Cat* (1935) and other classics of the horror genre contributed to the subsequent association of

Expressionism with the underside of mainstream society and the dark world of drives and instincts. The second wave of emigration after 1933 completed the transfer of Expressionist elements into established Hollywood genres and, during the 1940s and 1950s, gave rise to the pessimistic, cynical, and often intensely violent visions of modern life later categorized as "film noir." Famous exiled directors working in the noir mode included Fritz Lang, who obsessively mapped the urban scene of violence, power, and destiny from *Ministry of Fear* (1945) to *While the City Sleeps* (1956), and Robert Siodmak, who staged claustrophobic interiors of fear and desire in *The Dark Mirror* (1946) and *The Spiral Staircase* (1945).

The trajectory from Expressionist film to film noir continues to be a subject of scholarly controversy (Elsaesser 1996a). Some scholars have emphasized the contribution of German directors, actors, and cinematographers to the thematic and stylistic concerns of the American film noir, including its preoccupation with a dangerous female sexuality (Wager, 19–69). Others have used the exile experience to link Expressionism and film noir through their shared reenactment of the sense of dissociation and displacement inherent in the condition of modernity. Such approaches have generated sweeping historical overviews that give Weimar cinema a central place in the genealogy of the horror film (Prawer, 165–200) and find an Expressionist influence whenever there is some degree of distortion in the field of vision (Barlow). Equally ambitious has been the supposition of certain affective affinities, via the trope of modernity as horror, between the silent cinema of Expressionism and the aesthetics of silence in the expressive modernism of Orson Welles, Ingmar Bergman, and others (Coates). No matter how problematic these readings may be, it cannot be denied that the label "Expressionist" has become ubiquitous in descriptions of films that cultivate the aesthetics of alienation without necessarily partaking in the discourses that initially gave form to these stylistic features. But this is a question both of historical reception or, rather, receptions and of the contemporary re-readings produced with different intentions by audiences, critics, and filmmakers.

It is as part of these international patterns of reception that the Expressionist film continues to function as an important reference point in the ongoing transformations of German cinema since the postwar years. As far back as the early rubble films and antifascist films produced by the East German DEFA studio, filmmakers repeatedly used chiaroscuro lighting and object symbolism to reconnect to the legacies of Weimar culture, including its utopian vision of a progressive mass culture. Later, in the context of New German Cinema, Werner Herzog paid homage to Murnau with *Nosferatu, Phantom der Nacht* (1978, released in the U.S. as *Nosferatu*) and, in so doing, expanded the possibilities of the new *Autorenfilm* toward the Romantic traditions of the sublime. Again with very different intentions, gay activist filmmaker Rosa von

Praunheim presented, in *Anita, Tänze des Lasters* (Anita, Dances of Vice, 1987), a persiflage of the *Caligari* style that celebrated Expressionism as one of the filmic styles most easily adaptable to postmodern strategies of citation and simulation. All of these examples — the number of films with a vaguely expressionistic sensibility is much larger and would include recent work by Oskar Roehler — confirm that the historical encounter between film and Expressionism still resists easy explanations. But it also shows that the Expressionist vision in the cinema continues to provide a space of textual ambiguity that raises provocative questions about the limits of representation and interpretation and the limitlessness of desire and the imagination.

# Works Cited

Barlow, John D. *German Expressionist Film*. Boston: Twayne, 1982.

Bock, Hans-Michael, ed. *Paul Leni: Grafik, Theater, Film*. Frankfurt am Main: Deutsches Filmmuseum, 1986.

Budd, Michael, ed. *The Cabinet of Dr. Caligari: Texts, Contexts, Histories*. New Brunswick, NJ: Rutgers UP, 1990.

Coates, Paul. *The Gorgon's Gaze: German Cinema, Expressionism, and the Image of Horror*. Cambridge: Cambridge UP, 1991.

Cooke, Paul. *German Expressionist Films*. Harpenden: Pocket Essentials, 2002.

Cossart, Axel von. *Kino-Theater des Expressionismus: Das literarische Resümee einer Besonderheit*. Essen: Die blaue Eule, 1985.

Courtade, Francis. *Cinéma expressioniste*. Paris: Henri Veyrier, 1984.

Donahue, Neil H. "Unjustly Framed: Politics and Art in *Das Cabinet des Dr. Caligari*." *German Politics & Society* 32 (Summer 1994): 76–88.

Eisner, Lotte. *The Haunted Screen*. Trans. Roger Greaves. Berkeley: U of California P, 1977. Originally published as *L'Ecran Démoniaque*. Paris: Le Terrain Vague, 1952. In German: *Die dämonische Leinwand*. Frankfurt am Main: Fischer, 1975.

Elsaesser, Thomas. "A German Ancestry to Film Noir? Film History and its Imaginary." *Iris* 21 (1996a): 129–51.

———. *Weimar Cinema and After: Germany's Historical Imaginary*. London: Routledge, 2000.

———, ed. *Early German Cinema: The First Two Decades*. Amsterdam: U of Amsterdam P, 1996b.

Frankfurter, Bernhard, ed. *Carl Mayer: Im Spiegelkabinett des Dr. Caligari: Der Kampf zwischen Licht und Dunkel*. Vienna: Promedia, 1977.

Franklin, James C. "Metamorphosis of a Metaphor: The Shadow in Early German Film." *German Quarterly* 54, 2 (March 1980): 176–88.

Galeen, Henrik. *Das Wachsfigurenkabinett: Drehbuch von Henrik Galeen zu Paul Lenis Film von 1923.* With an essay by Thomas Koebner and materials by Hans-Michael Bock. Munich: text + kritik, 1994.

Guerin, Francis. *In a Culture of Light: Cinema and Technology in 1920s Germany,* Minneapolis: U of Minnesota P, 2005.

Hake, Sabine. *The Cinema's Third Machine: German Writings on Film, 1907–1933.* Lincoln and London: U of Nebraska P, 1993.

Hoesterey, Ingeborg. "Intertextuality of Film and other Visual Arts in Weimar Culture." *Kodikas/ Code Ars Semeiotica* 14, 1/2 (1991): 163–75.

Jörg, Holger. *Die sagen- und märchenhafte Leinwand: Erzählstoffe, Motive und narrative Strukturen der Volksprosa im "klassischen" deutschen Stummfilm (1910–1930).* Sinzheim: Pro Universitate, 1994.

Jung, Uli, and Walter Schatzberg. *Beyond Caligari: The Films of Robert Wiene.* New York and Oxford: Berghahn, 1999.

Kaes, Anton, ed. *Kino-Debatte: Texte zum Verhältnis von Literatur und Film, 1909–1929.* Munich and Tübingen: Niemeyer, 1978.

Kasten, Jürgen. *Carl Mayer: Filmpoet; Ein Drehbuchautor schreibt Filmgeschichte.* Berlin: VISTAS, 1994.

Kasten, Jürgen. *Der expressionistische Film: Abgefilmtes Theater oder avantgardistisches Erzählkino? Eine stil-, produktions- und rezeptionsgeschichtliche Untersuchung.* Münster: MAKS, 1990.

Kessler, Frank. "Les architectes-peintres du cinéma allemand muet." *Iris* 12 (1991): 47–54.

Kracauer, Siegfried. *From Caligari to Hitler: A Psychological History of the German Film.* Princeton, NJ: Princeton UP, 1974.

Kurtz, Rudolf. *Expressionismus und Film.* Berlin: Verlag der Lichtbild-Bühne, 1926.

Mayer, Carl. *Das Cabinet des Dr. Caligari: Drehbuch von Carl Mayer und Hans Janowitz zu Robert Wienes Film von 1919/20.* With an essay by Siegbert S. Prawer and materials by Uli Jung and Walter Schatzberg. Munich: text + kritik, 1995. For an English translation of the film script, see Robert Wiene, *The Cabinet of Dr. Caligari,* trans. R. V. Adkinson. London: Lorrimer, 1997.

McCormick, Richard W. *Gender and Sexuality in Weimar Modernity: Film, Literature, and "New Objectivity."* New York: Palgrave, 2001.

Murphy, Richard. "Carnival Desire and the Sideshow of Fantasy: Dream, Duplicity and Representational Instability in *The Cabinet of Dr. Caligari.*" *Germanic Review* 66, 1 (1991): 48–56.

Pinthus, Kurt. *Das Kinobuch.* Frankfurt am Main: Fischer, 1983.

Prawer, S. S. *Caligari's Children: The Film as Tale of Horror.* Oxford: Oxford UP, 1980.

Reichmann, Hans-Peter, ed. *Hans Poelzig: Bauten für den Film.* Frankfurt am Main: Deutsches Filmmuseum, 1997a.

Reichmann, Hans-Peter, ed. *Walter Reimann: Maler und Filmarchitekt.* Frankfurt am Main: Deutsches Filmmuseum, 1997b.

Risholm, Ellen. "Formations of the Chamber: A Reading of *Backstairs.*" In *Peripheral Visions: the Hidden Stages of Weimar Cinema,* ed. Kenneth S. Calhoon, 121–43. Detroit: Wayne State UP, 2001.

Robinson, David. *Das Cabinet des Dr. Caligari.* London: British Film Institute, 1997.

Salt, Barry. "From *Caligari* to Who?" *Sight and Sound* 48, 2 (1979): 119–23.

Scheunemann, Dietrich. "Activating the Difference: Expressionist Film and Early Weimar Cinema." In *Expressionist Film: New Perspectives,* 1–32. Rochester, NY: Camden House, 2003.

Schütz, Miriam. "Phantastische Romantik im deutschen Stummfilm." In *"Wahlverwandtschaften": Kunst, Musik und Literatur im europäischen Film,* ed. Walter Stock, 7–50. Frankfurt am Main: Bundesverband Jugend und Film e.V., 1992.

Vietta, Silvio. "Expressionistische Literatur und Film: Einige Thesen zum wechselseitigen Einfluß ihrer Darstellung und Wirkung." *Mannheimer Beiträge aus Forschung und Lehre* 10 (1975): 294–99.

Wager, Jans B. *Dangerous Dames: Women and Representation in the Weimar Street Film and Film Noir.* Athens: Ohio UP, 1999.

Žmegač Victor. "Exkurs über den Film im Umkreis des Expressionismus." *Sprache im technischen Zeitalter* 53 (1970): 243–57.

# Select Bibliography

## Anthologies of Primary Documents

Anz, Thomas. *Phantasien über den Wahnsinn: Expressionistische Texte.* Munich: Hanser, 1980.

Anz, Thomas, and Michael Stark, eds. *Expressionismus: Manifeste und Dokumente zur deutschen Literatur, 1910–1920.* Stuttgart: Metzler, 1982.

Benn, Gottfried. "Einleitung." In *Lyrik des expressionistischen Jahrzehnts: Von den Wegbereitern bis zum Dada.* Munich: dtv, 1962.

Best, Otto, ed. *Theorie des Expressionismus.* Stuttgart: Reclam, 1976.

Bode, Dietrich. *Gedichte des Expressionismus.* Stuttgart: Reclam, 1966.

Brinker-Gabler, Gisela, ed. *Deutsche Literatur von Frauen.* Munich: Beck, 1988.

Denkler, Horst, ed. *Einakter und kleine Dramen des Expressionismus.* Stuttgart: Reclam, 1968.

Edschmid, Kasimir. *Frühe Manifeste: Epochen des Expressionismus.* Darmstadt: Luchterhand, 1960.

Geerken, Hartmut, ed. *Märchen des Expressionismus.* Frankfurt am Main: Fischer, 1979.

Gordon, Mel, ed. *Expressionist Texts.* New York: PAJ Publications, 1986.

Green, Malcolm, ed. and trans. *The Golden Bomb: Phantastic German Expressionist Stories.* Edinburgh: Polygon, 1993.

Kaes, Anton, ed. *Kino-Debatte: Texte zum Verhältnis von Literatur und Film, 1909–1929.* Munich and Tübingen: Max Niemeyer, 1978.

Kandinsky, Wassily. *Kandinsky: Complete Writing on Art.* Eds. Kenneth C. Lindsay and Peter Vergo. Boston, MA: G. K. Hall, 1982.

Kandinsky, Wassily, and Franz Marc, eds. *Der blaue Reiter.* Munich: Piper, 1912.

Martini, Fritz, ed. *Prosa des Expressionismus.* Stuttgart: Reclam, 1970.

Otten, Karl, ed. *Ego und Eros: Meistererzählungen des Expressionismus.* Stuttgart: Goverts, 1963.

———, ed. *Schrei und Bekenntnis: Expressionistisches Theater.* Neuwied am Rhein: Luchterhand, 1959.

Pinthus, Kurt, ed. *Menschheitsdämmerung: Ein Dokument des Expressionismus.* Berlin: Rowohlt, 1993. In English: *Menschheitsdämmerung / Dawn of Humanity: A Document of Expressionism.* Trans. Joanna M. Ratych, Ralph Ley, and Robert C. Conard. Columbia, SC: Camden House, 1994.

Pörtner, Paul. *Literatur-Revolution, 1910–1925: Dokumente, Manifeste, Programme.* Neuwied am Rhein: Luchterhand, 1961.

Raabe, Paul, and H. L. Greve, eds. *Expressionismus, Literatur und Kunst, 1910–1923: Eine Ausstellung des deutschen Literaturarchivs im Schiller-Nationalmuseum vom 8. Mai bis 31. Oktober 1960.* Stuttgart: Turmhaus-Druckerei, 1960.

———. *Index Expressionismus: Bibliographie der Beiträge in den Zeitschriften und Jahrbüchern des literarischen Expressionismus, 1910–1923.* Nendeln, Liechtenstein: Kraus-Thomson, 1972.

———. *Die Zeitschriften und Sammlungen des literarischen Expressionismus: Repertorium der Zeitschriften, Jahrbücher, Anthologien, Sammelwerke, Schriftenreihen und Almanache, 1910–1921.* Stuttgart: Metzler, 1964.

Rietszchel, Thomas. *Sekunde durchs Hirn: 21 expressionistische Erzähler.* Leipzig: Reclam, 1982.

Rigby, Ida Katherine. *An alle Künstler! War — Revolution — Weimar: German Expressionist Prints, Drawings, Posters, and Periodicals from the Robert Gore Rifkind Foundation.* San Diego, CA: San Diego State UP, 1983.

Ritchie, J. M., ed. *Vision and Aftermath: Four Expressionist War Plays.* London: Calder and Boyars, 1969.

Schmitt, Hans-Jürgen, ed. *Die Expressionismusdebatte: Materialien zu einer marxistischen Realismuskonzeption.* Frankfurt am Main: Suhrkamp, 1973.

Schürer, Ernst, ed. *German Expressionist Plays.* New York: Continuum, 1996.

Vietta, Silvio, ed. *Lyrik des Expressionismus.* Munich: dtv, 1976; Tübingen: Niemeyer, 1976.

Vollmer, Hartmut, ed. *"In roten Schuhen tanzt die Sonne sich zu Tod": Lyrik expressionistischer Dichterinnen.* Zürich: Arche, 1993.

———. *Die rote Perücke: Prosa expressionistischer Dichterinnen.* Igel: Paderborn, 1996.

Washton-Long, Rose-Carol, ed. *German Expressionism: Documents from the End of the Wilhelmine Empire to the Rise of National Socialism.* New York: G. K. Hall, 1993.

## Secondary Sources

Adams, Marion. "Der Expressionismus und die Krise der deutschen Frauenbewegung." In Hüppauf, *Expressionismus und Kulturkrise,* 105–30.

Allen, Roy F. *German Expressionist Poetry.* Boston: Twayne, 1979.

Allen, Roy F. *Literary Life in German Expressionism and the Berlin Circles.* Ann Arbor: UMI Research P, 1972.

Anz, Thomas. *Literatur der Existenz: Literarische Psychopathographie und ihre soziale Bedeutung im Frühexpressionismus.* Stuttgart: Metzler, 1977.

———. *Literatur des Expressionismus.* Stuttgart: Metzler, 2002.

———, ed. *Phantasien über den Wahnsinn: Expressionistische Texte.* Munich: Hanser, 1980.

Anz, Thomas, and Michael Stark, eds. *Expressionismus: Manifeste und Dokumente zur deutschen Literature, 1910–1920.* Stuttgart: Metzler, 1982.

———, eds. *Die Modernität des Expressionismus.* Stuttgart and Weimar: Metzler, 1994.

Arnold, Armin. *Die Literatur des Expressionismus: Sprachliche und thematische Quellen.* Stuttgart: Kohlhammer, 1966.

———. *Prosa des Expressionismus: Herkunft, Analyse, Inventar.* Stuttgart: Kohlhammer, 1972.

Aschheim, Steven E. *The Nietzsche Legacy in Germany, 1890–1990.* Berkeley and London: U of California P, 1992.

Bahr, Hermann. *Expressionismus.* Munich: Delphin, 1916. In English: *Expressionism.* Trans. R. T. Gribble. London: Frank Henderson, 1925.

Barlow, John D. *German Expressionist Film.* Boston: Twayne, 1982.

Barron, Stephanie, ed. *Degenerate Art: The Fate of the Avant-garde in Nazi Germany.* Los Angeles: Los Angeles County Museum of Art, 1991.

———, ed. *German Expressionism, 1915–1925: The Second Generation.* Los Angeles: Los Angeles County Museum of Art, 1988.

Barron, Stephanie, and Wolf-Dieter Dube, eds. *German Expressionism: Art and Society.* Milan: Bompiani, 1997.

Bathrick, David R. "Moderne Kunst und Klassenkampf: Die Expressionismus-Debatte in der Exilzeitschrift *Das Wort.*" In *Exil und innere Emigration: The Third Wisconsin Workshop*, ed. Jost Hermand and Reinhold Grimm, 89–109. Frankfurt am Main: Athenäum, 1972.

Behr, Shulamith. *Expressionism.* Cambridge, UK: Cambridge UP, 1999.

———. *Women Expressionists.* New York: Rizzoli, 1988.

Behr, Shulamith, David Fanning, and Douglas Jarman, eds. *Expressionism Reassessed.* Manchester: Manchester UP, 1993.

Benson, Renate. *German Expressionist Drama: Ernst Toller and Georg Kaiser.* London: Methuen, 1984; New York: Grove Press, 1984.

Berman, Russell. "German Primitivism / Primitive Germany: The Case of Emil Nolde." In *Fascism, Aesthetics, and Culture*, ed. Richard J. Golsan, 56–66. Hannover, NH and London: U of New England P, 1992.

Best, Otto F. "Einleitung." In *Theorie des Expressionismus,* 5–25.

———, ed. *Theorie des Expressionismus.* Stuttgart: Reclam, 1976.

Bridgwater, Patrick. *Poet of Expressionist Berlin: The Life and Work of Georg Heym*. London: Libris, 1991.

Brinkmann, Richard. *Expressionismus: Forschungsprobleme, 1952–1960*. Stuttgart: Metzler, 1961.

———. *Expressionismus: Internationale Forschung zu einem internationalen Phänomen*. Stuttgart: Metzler, 1980.

Bronner, Stephen, and Douglas Kellner, eds. *Passion and Rebellion: The Expressionist Heritage*. South Hadley, MA: Bergin, 1983; New York: Columbia UP, 1988.

Budd, Michael, ed. *The Cabinet of Dr. Caligari: Texts, Contexts, Histories*. New Brunswick, NJ: Rutgers UP, 1990.

Bushart, Magdalena. "Changing Times, Changing Styles: Wilhelm Worringer and the Art of his Epoch." In Donahue, *Invisible Cathedrals: The Expressionist Art History of Wilhelm Worringer*, 69–85.

———. *Der Geist der Gotik und die expressionistische Kunst: Kunstgeschichte und Kunsttheorie, 1911–1925*. Munich: Schreiber, 1990.

Coates, Paul. *The Gorgon's Gaze: German Cinema, Expressionism, and the Image of Horror*. Cambridge: Cambridge UP, 1991.

Connelly, Frances S. "Primitivism." In Kelly, *Encyclopedia of Aesthetics*, 88–92.

Cooke, Paul. *German Expressionist Films*. Harpenden: Pocket Essentials, 2002.

Corngold, Stanley. "Kafka as Expressionist." In *Franz Kafka: The Necessity of Form*, 250–88. Ithaca, NY: Cornell UP, 1988.

Cosentino, Christine. *Tierbilder in der Lyrik des Expressionismus*. Bonn: Bouvier, 1972.

Cossart, Axel von. *Kino-Theater des Expressionismus: Das literarische Resümee einer Besonderheit*. Essen: Die blaue Eule, 1985.

Courtade, Francis. *Cinéma expressioniste*. Paris: Henri Veyrier, 1984.

Crockett, Dennis. *German Post-Expressionism: The Art of the Great Disorder 1918–1924*. University Park, PA: Pennsylvania State UP, 1999.

Denkler, Horst. *Drama des Expressionismus: Programm — Spieltext — Theater*. Munich: Fink, 1967.

———, ed. *Einakter und kleine Dramen des Expressionismus*. Stuttgart: Reclam, 1968.

———, ed. *Gedichte der "Menschheitsdämmerung": Interpretationen expressionistischer Lyrik*. Munich: Fink, 1971.

Diebold, Bernhard. *Anarchie im Drama*. Frankfurt: Frankfurter Verlagsanstalt, 1921.

Diereck, Augustinus P. *German Expressionist Prose: Theory and Practice*. Toronto: U of Toronto P, 1987.

Donahue, Neil H. "The Fall of Wallenstein, or the Collapse of Narration? The Paradox of Epic Intensity in Alfred Döblin's *Wallenstein* (1920)." In *A Companion to Alfred Döblin*, ed. Roland Dollinger, Heidi Thomann

Tewarson, and Wulf Koepke, 75–92. Rochester, NY: Camden House, 2003.

———. *Forms of Disruption: Abstraction in Modern German Prose*. Ann Arbor: U of Michigan P, 1993.

———. Review of *Menschheitsdämmerung / Dawn of Humanity: A Document of Expressionism*, ed. Kurt Pinthus. *German Quarterly* 68, 4 (1995): 471–72.

———. "Unjustly Framed: Politics and Art in *Das Cabinet des Dr. Caligari*." *German Politics and Society* 32 (1994): 76–88.

———. "Wilhelm Worringer." In Kelly, *Encyclopedia of Aesthetics*, 4:482–83.

———, ed. *Invisible Cathedrals: The Expressionist Art History of Wilhelm Worringer*. University Park, PA: Penn State P, 1995.

Dube, Wolf-Dieter. *Expressionists and Expressionism*. Geneva: Skira, 1983.

Edschmid, Kasimir. *Frühe Manifeste: Epochen des Expressionismus*. Darmstadt / Neuwied am Rhein / Berlin-Spandau: Luchterhand, 1960.

———. *Lebendiger Expressionismus*. Munich: Desch, 1961.

———. *Über den Expressionismus in der Literatur und die neue Dichtung*. Berlin: Reiss, 1919.

Eisner, Lotte. *The Haunted Screen: Expressionism in German Cinema and the Influence of Max Reinhardt*. Orig. 1952. Berkeley, CA: U of California P, 1973.

Eliel, Carol. *The Apocalyptic Landscapes of Ludwig Meidner*. Los Angeles: Los Angeles County Museum of Art; Munich: Prestel, 1989.

Elsaesser, Thomas. "A German Ancestry to Film Noir? Film History and its Imaginary." *Iris* 21 (1996): 129–51.

———. "Social Mobility and the Fantastic: German Silent Film." *Wide Angle* 5, 2 (1982): 14–25.

———. *Weimar Cinema and After: Germany's Historical Imaginary*. London: Routledge, 2000.

———, ed. *Early German Cinema: The First Two Decades*. Amsterdam: U of Amsterdam P, 1996.

Eykman, Christoph. *Denk- und Stilformen des Expressionismus*. Munich: Francke, 1974.

Fähnders, Walter, ed. *Expressionistische Prosa*. Bielefeld: Aisthesis, 2001.

Fechter, Paul. *Der Expressionismus*. Munich: Piper, 1914.

Fischer, Robert. *Das Cabinet des Dr. Caligari*. Stuttgart: Focus, 1985.

Foster, Jr., John Burt. *Heirs to Dionysus: A Nietzschean Current in Literary Modernism*. Princeton: Princeton UP, 1981.

Franklin, James C. "Metamorphosis of a Metaphor: The Shadow in Early German Film." *German Quarterly* 54, 2 (March 1980): 176–88.

Friedmann, Hermann, and Otto Mann, eds. *Expressionismus: Gestalten einer literarischen Bewegung*. Heidelberg: Wolfgang Rothe, 1956.

Froehlich, Jürgen. *Liebe im Expressionismus: Eine Untersuchung der Lyrik in den Zeitschriften "Die Aktion" und "Der Sturm" von 1910–1914.* Frankfurt am Main: Peter Lang, 1990.

Furness, R. S. *Expressionism.* London: Methuen, 1973.

Gordon, Donald E. *Expressionism: Art and Idea.* New Haven and London: Yale UP, 1987.

———. "On the Origin of the Word 'Expressionism.'" *Journal of the Warburg and Courtauld Institutes* 29 (1966): 368–85.

Grace, Sherrill E. *Regression and Apocalypse: Studies in North American Literary Expressionism.* Toronto: U of Toronto P, 1989.

Hake, Sabine. *The Cinema's Third Machine: German Writings on Film, 1907–1933.* Lincoln and London: U of Nebraska P, 1993.

Haxthausen, Charles W. "A Critical Illusion: 'Expressionism' in the Writings of Wilhelm Hausenstein." In Rumold and Werckmeister, *The Ideological Crisis of Expressionism: The Literary and Artistic German War Colony in Belgium 1914–1918*, 169–91.

———. "Modern Art after 'The End of Expressionism': Worringer in the 1920s." In Donahue, *Invisible Cathedrals: The Expressionist Art History of Wilhelm Worringer*, 119–34.

Heckmann, Ursula, *Das verfluchte Geschlecht: Motive der Philosophie Otto Weiningers im Werk Georg Trakls.* Frankfurt am Main: Peter Lang, 1992.

Heller, Reinhold. "Expressionism." In Kelly, *Encyclopedia of Aesthetics*, 135–39.

Heselhaus, Clemens. *Lyrik des Expressionismus: Voraussetzungen, Ergebnisse und Grenzen, Nachwirkungen.* Tübingen: Niemeyer, 1956.

Hoesterey, Ingeborg. "Intertextuality of Film and Other Visual Arts in Weimar Culture." *Kodikas/ Code Ars Semeiotica* 14, 1/2 (1991): 163–75.

Hoffmann-Curtius, Kathrin. "Frauenbilder Oskar Kokoschkas." In *Frauen-Bilder, Männer-Mythen: Historische Beiträge*, ed. Ilsebill Barta, Zita Breu, Daniela Hammer-Tugendhat, Ulrike Jenni, Irene Hierhaus, and Judith Schöbel, 148–78. Berlin: Reimer, 1987.

Hohendahl, Peter Uwe. *Das Bild der bürgerlichen Welt im expressionistischen Drama.* Heidelberg: Carl Winter, 1971.

Hüppauf, Bernd. "Zwischen revolutionärem und sozialem Prozeß: Bemerkungen über den Ort des Expressionismus in der Literaturgeschichte." In Hüppauf, *Expressionismus und Kulturkrise*, 55–83.

———, ed. *Expressionismus und Kulturkrise.* Heidelberg: Carl Winter, 1983.

Huyssen, Andreas, and David Bathrick, eds. *Modernity and the Text: Revisions of German Modernism.* New York: Columbia UP, 1989.

Ihekweazu, Edith. *Verzerrte Utopie: Bedeutung und Funktion des Wahnsinns in expressionistischer Prosa.* Frankfurt am Main: Peter Lang, 1982. Repr. in Jost and Schmidt-Bergmann, *Im Dialog mit der Moderne.*

Jelavich, Peter. "Wedekind's Spring Awakening: The Path to Expressionist Drama." In Bronner and Kellner, *Passion and Rebellion: The Expressionist Heritage*, 129–50.

Jens, Inge. *Studien zur Entwicklung der expressionistischen Novelle*. Diss., Tübingen, 1953.

Jones, M. S. *Der Sturm: A Focus of Expressionism*. Columbia, SC: Camden House, 1984.

Jost, Roland, and Hansgeorg Schmidt-Bergmann. *Im Dialog mit der Moderne: Zur deutschsprachigen Literatur von der Gründerzeit bis zur Gegenwart*. Frankfurt am Main: Athenäum, 1986.

Jung, Uli, and Walter Schatzberg. *Beyond Caligari: The Films of Robert Wiene*. New York and Oxford: Berghahn, 1999.

Kaes, Anton. "The Expressionist Vision in Theater and Cinema." In *Expressionism Reconsidered: Affinities and Relationships*, ed. Gertrud Bauer Pickar and Karl Eugen Francke, 89–98. Munich: Fink, 1979.

———, ed. *Kino-Debatte: Texte zum Verhältnis von Literatur und Film, 1909–1929*. Munich and Tübingen: Max Niemeyer, 1978.

Kahler, Erich von. "Die Prosa des Expressionismus." In Steffen, *Der deutsche Expressionismus: Formen und Gestalten*, 157–78.

Kandinsky, Wassily. *Über das Geistige in der Kunst*. Munich: Piper, 1912; Bern: Benteli, 1952.

Kandinsky, Wassily, and Franz Marc, eds. *Der blaue Reiter*. Munich: Piper, 1912.

Kanzog, Klaus. "Alfred Döblin und die Anfänge des expressionistischen Prosastils." *Jahrbuch der deutschen Schillergesellschaft* 17 (1973): 63–83.

Kasten, Jürgen. *Carl Mayer: Filmpoet: Ein Drehbuchautor schreibt Filmgeschichte*. Berlin: VISTAS, 1994.

———. *Der expressionistische Film: Abgefilmtes Theater oder avantgardistisches Erzählkino? Eine stil-, produktions- und rezeptionsgeschichtliche Untersuchung*. Münster: MAKS, 1990.

Kellner, Douglas. "Expressionist Literature and the Dream of the 'New Man.'" In Bronner and Kellner, *Passion and Rebellion: The Expressionist Heritage*, 166–200.

Kelly, Michael, ed. *Encyclopedia of Aesthetics*. New York: Oxford UP, 1998.

Kemper, Hans-Georg. *Vom Expressionismus zum Dadaismus: Eine Einführung in die dadaistische Literatur*. Kronberg/Taunus: Scriptor, 1974.

Klarmann, Adolf. "Expressionism in German Literature: A Retrospective of a Half Century." *Modern Language Quarterly* 36, 1 (1965): 62–92.

Knapp, Gerhard P. *Die Literatur des deutschen Expressionismus*. Munich: Beck, 1979.

Kolinsky, Eva. *Engagierter Expressionismus: Politik und Literatur zwischen Weltkrieg und Weimarer Republik; Eine Analyse expressionistischer Zeitschriften*. Stuttgart: Metzler, 1970.

Korte, Hermann. *Krieg in der Lyrik des Expressionismus: Studien zur Evolution eines literarischen Themas*. Bonn: Bouvier, 1981.

Kracauer, Siegfried. *From Caligari to Hitler: A Psychological History of German Film*. Princeton: Princeton UP, 1947. 5th paperback edition, 1974.

Krispyn, Egbert. *Style and Society in German Literary Expressionism*. Gainesville, FL: U of Florida P, 1964.

Krull, Wilhelm. *Prosa des Expressionismus*. Stuttgart: Metzler, 1984.

Kuhns, David F. *German Expressionist Theatre: The Actor and the Stage*. Cambridge: Cambridge UP, 1997.

Kurtz, Rudolf. *Expressionismus und Film*. Berlin: Verlag der Lichtbild-Bühne, 1926; Zurich: Rohr, 1965.

Lang, Lothar. *Expressionistische Buchillustration in Deutschland, 1907–1927*. Frankfurt am Main: 1975. 2nd edition, Leipzig: Ed. Leipzig, 1993.

Lewis, Beth Irwin. *George Grosz: Art and Politics in the Weimar Republic*. Princeton, NJ: Princeton UP, 1991.

———. "*Lustmord*: Inside the Windows of the Metropolis." In *Women in the Metropolis: Gender and Modernity in Weimar Culture*, ed. Katharina von Ankum, 202–32. Berkeley, CA and London: U of California P, 1997.

Lloyd, Jill. *German Expressionism: Primitivism and Modernity*. New Haven and London: Yale UP, 1991.

Lukács, Georg. " 'Größe und Verfall' des Expressionismus" (1934). In *Essays über Realismus*, vol. 4 of *Werke: Probleme des Realismus 1*, 109–49. Neuwied and Berlin: Luchterhand, 1971.

Luther, Gisela. *Barocker Expressionismus? Zur Problematik der Beziehung zwischen der Bildlichkeit expressionistischer und barocker Lyrik*. The Hague: Mouton, 1969.

Manheim, Ralph. "Expressionismus: Zur Entstehung eines kunsthistorischen Stil- und Periodenbegriffes." *Zeitschrift für Kunstgeschichte* 49, 1 (1986): 73–91.

———. "*Im Kampf um die Kunst*": *Die Diskussion von 1911 über zeitgenössische Kunst in Deutschland*. Hamburg: Sautter & Lackmann, 1987.

———. "Kunst und Nation im spätwilhelminischen Deutschland: Eine Kunst-Debatte im Jahre 1911." In *Die deutsche Nation: Geschichte — Probleme — Perspektiven*, 71–82. Hamburg: SH-Verlag, 1994.

Martens, Günter. "Nietzsches Wirkung im Expressionismus." In *Forschungsergebnisse: Nietzsche und die deutsche Literatur*, ed. Bruno Hillebrand, 35–82. Tübingen: Niemeyer / DTV, 1978.

———. *Vitalismus und Expressionismus: Ein Beitrag zur Genese und Deutung expressionistischer Stilstrukturen und Motive*. Stuttgart: Kohlhammer, 1971.

Martini, Fritz. "Georg Heym: Die Sektion." In *Das Wagnis der Sprache*, 256–86. Stuttgart: Klett, 1954.

———, ed. Introduction to *Prosa des Expressionismus*, 3–48. Stuttgart: Reclam, 1970.

Marzynski, Georg. *Die Methode des Expressionismus: Studien zu seiner Psychologie.* Leipzig: Klinkhardt & Biermann, 1921.

Matsche, Franz. "Großstadt in der Malerei des Expressionismus am Beispiel E. L. Kirchners." In Anz and Stark, *Die Modernität des Expressionismus,* 95–119.

McClintick, Christopher. "The Anthologist Function: *Menschheitsdämmerung* from 1919 to 1994." *Michigan Germanic Studies* 19 (1993): 141–58.

McCormick, Richard W. *Gender and Sexuality in Weimar Modernity: Film, Literature, and "New Objectivity."* New York: Palgrave, 2001.

Meixner, Horst, and Silvio Vietta, eds. *Expressionismus: Sozialer Wandel und künstlerische Erfahrung; Mannheimer Kolloquium.* Munich: Fink, 1982.

Michalski, Sergiusz. *New Objectivity: Painting, Graphic Art and Photography in Weimar Germany, 1919–1933.* Cologne: Taschen, 1994.

Miesel, Victor, ed. *Voices of German Expressionism.* Englewood Cliffs, NJ: Prentice Hall, 1970.

Mitzman, Arthur. "Anarchism, Expressionism and Psychoanalysis." In Bronner and Kellner, *Passion and Rebellion: The Expressionist Heritage,* 55–81.

Murphy, Richard. "The Poetics of Hysteria: Expressionist Drama and the Melodramatic Imagination." *Germanisch-Romanische Monatsschrift* 40, 2 (1990): 156–70.

———. *Theorizing the Avant-Garde: Modernism, Expressionism, and the Problem of Postmodernity.* Cambridge, UK: Cambridge UP, 1999.

Muschg, Walter. *Von Trakl zu Brecht: Dichter des Expressionismus.* Munich: Piper, 1961.

Newton, Robert P. *Form in the "Menschheitsdämmerung": A Study of Prosodic Elements and Style in German Expressionist Poetry.* The Hague and Paris: Mouton, 1971.

Oehm, Heidemarie. *Subjektivität und Gattungsform im Expressionismus.* Munich: Wilhelm Fink, 1993.

Pan, David. *Primitive Renaissance: Rethinking German Expressionism.* Lincoln and London: U of Nebraska P, 2001.

Paret, Peter. *The Berlin Secession: Modernism and its Enemies in Imperial Germany.* Cambridge MA: Belknap P of Harvard U, 1980.

Pascal, Roy. *From Naturalism to Expressionism: German Literature and Society, 1880–1918.* New York: Basic Books, 1973.

Paulsen, Wolfgang. *Deutsche Literatur des Expressionismus.* Bern: Peter Lang, 1983.

———. *Expressionismus und Aktivismus: Eine typologische Untersuchung.* Strasbourg: Heitz, 1935.

———, ed. *Aspekte des Expressionismus: Periodisierung — Stil — Gedankenwelt.* Heidelberg: Lothar Stiehm, 1968.

Perkins, Geoffrey. *Contemporary Theory of Expressionism.* Bern and Frankfurt: Herbert Lang, 1974.

Petro, Patrice. *Joyless Streets: Women and Melodramatic Representation in Weimar Germany.* Princeton, NJ: Princeton UP, 1989.

Petropoulos, Jonathan. *Art as Politics in the Third Reich.* Chapel Hill and London: The U of North Carolina P, 1996.

Pickar, Gertrud Bauer, and Karl Eugene Webb, eds. *Expressionism Reconsidered.* Munich: Fink, 1979.

Pinthus, Kurt. *Das Kinobuch.* Frankfurt am Main: Fischer, 1983.

Prawer, S. S. *Caligari's Children: The Film as Tale of Horror.* Oxford: Oxford UP, 1980.

Raabe, Paul. *Der Ausgang des Expressionismus.* Biberach an der Riss: Wege und Gestalten, 1966.

———. *Die Autoren und Bücher des literarischen Expressionismus.* Stuttgart: Metzler, 1985.

———. "On the Rediscovery of Expressionism as a European Movement." *Michigan German Studies* 2 (1976): 196–210.

———, ed. *Expressionismus: Aufzeichnungen und Erinnerungen der Zeitgenossen.* Olten: Walter, 1965. In English: *The Era of German Expressionism.* Trans. J. M. Ritchie. London: Calder & Boyers, 1974; Dallas: Riverrun Press, 1980.

———, ed. *Der Kampf um eine literarische Bewegung.* Zurich: Arche, 1987.

———, ed. *Die Zeitschriften und Sammlungen des literarischen Expressionismus: Repertorium der Zeitschriften, Jahrbücher, Anthologien, Sammelwerke, Schriftenreihen und Almanache, 1910–1921.* Stuttgart: Metzler, 1964.

Richard, Lionel. *Phaidon Encyclopedia of Expressionism: Painting and the Graphic Arts, Sculpture, Architecture, Literature, Drama, the Expressionist Stage, Cinema, Music.* Trans. Stephen Tint. Oxford: Phaidon; New York: Dutton, 1978.

Rigby, Ida Katherine. *An alle Künstler! War — Revolution — Weimar: German Expressionist Prints, Drawings, Posters, and Periodicals from the Robert Gore Rifkind Foundation.* San Diego, CA: San Diego State UP, 1983.

Ritchie, James MacPherson. *German Expressionist Drama.* Boston: G. K. Hall/Twayne, 1976.

Robinson, David. *Das Cabinet des Dr. Caligari.* London: British Film Institute, 1997.

Rolleston, James. "Expressionism and Modern Poetics." *Nietzsche-Studien* 9 (1980): 285–301.

———. *Narratives of Ecstasy: Romantic Temporality in Modern German Poetry.* Detroit: Wayne State UP, 1987.

Rothe, Wolfgang, ed. *Expressionismus als Literatur: Gesammelte Studien.* Bern: Francke, 1969.

Rötzer, Hans Gerd, ed. *Begriffsbestimmung des literarischen Expressionismus.* Darmstadt: Wissenschaftliche Buchgesellschaft, 1976.

Rumold, Rainer. *Janus Face of the German Avant-garde: From Expressionism to Postmodernism.* Evanston, IL: Northwestern UP, 2002.

Rumold, Rainer, and O. K. Werckmeister, eds. *The Ideological Crisis of Expressionism: The Literary and Artistic German War Colony in Belgium, 1914–1918.* Columbia, SC: Camden House, 1990.

Salt, Barry. "From *Caligari* to Who?" *Sight and Sound* 48, 2 (1979): 119–23.

Salter, Ronald. *Georg Heyms Lyrik: Ein Vergleich von Wortkunst und Bildkunst.* Munich: Wilhelm Fink, 1972.

Schearier, Stephen. *Das junge Deutschland 1917–1920: Expressionist Theater in Berlin.* Bern / Frankfurt: Lang, 1988.

Scheunemann, Dietrich. *Expressionist Film — New Perspectives.* Rochester, NY: Camden House, 2003.

Schmitt, Hans-Jürgen, ed. *Die Expressionismusdebatte: Materialien zu einer marxistischen Realismuskozeption.* Frankfurt am Main: Suhrkamp, 1973.

Schneider, Karl Ludwig. *Der bildhafte Ausdruck in den Dichtungen Georg Heyms, Georg Trakls und Ernst Stadlers: Studien zum lyrischen Sprachstil des deutschen Expressionismus.* Heidelberg: Carl Winter, 1954.

Schönfeld, Christiane. *Dialektik und Utopie: Die Prostituierte im deutschen Expressionismus.* Würzburg: Königshausen & Neumann, 1996.

———. "The Urbanization of the Body: Prostitutes, Dialectics, and Utopia in German Expressionism." *German Studies Review* 20, 1 (1997): 49–62.

Schultz, H. Stefan. "German Expressionism: 1905–1925." *Chicago Review* 13 (1959): 8–24.

Schürer, Ernst. *Georg Kaiser.* New York, Twayne, 1971.

———. "Überlegungen zur Bildsprache im Drama des Expressionismus: Herkunft — Funktion — Wirkung." In Jost and Schmidt-Bergmann, *Im Dialog mit der Moderne,* 221–45.

———, ed. *Der Bettler: Eine dramatische Sendung,* by Reinhard Sorge. Stuttgart: Reclam, 1985.

———, ed. Introduction to *German Expressionist Plays.* New York: Continuum, 1996, vii-xxi.

Schütz, Miriam. "Phantastische Romantik im deutschen Stummfilm." In *Wahlverwandtschaften: Kunst, Musik und Literatur im europäischen Film,* ed. Walter Stock, 7–50. Frankfurt am Main: Bundesverband Jugend und Film e.V., 1992.

Selz, Peter. *German Expressionist Painting.* Berkeley: U of California P, 1957; repr. 1974.

Sharp, Francis Michael. *The Poet's Madness: A Reading of Georg Trakl.* Ithaca: Cornell UP, 1981.

Shearier, Stephen. *Das junge Deutschland 1917–1920: Expressionist Theater in Berlin.* Bern: Peter Lang, 1988.

Silberman, Marc. "Industry, Text and Ideology in Expressionist Film." In Bronner and Kellner, *Passion and Rebellion: The Expressionist Heritage*, 374–83.

Soergel, Albert, and Curt Hohoff. *Dichtung und Dichter der Zeit: Neue Folge; Im Banne des Expressionismus*. Leipzig: R. Voigtländers, 1925.

Sokel, Walter. "Dialogführung und Dialog im expressionistischen Drama: Ein Beitrag zur Bestimmung des Begriffs 'expressionistisch' im deutschen Drama." In Paulsen, *Aspekte des Expressionismus: Periodisierung-Stil-Gedankenwelt*, 59–84.

———. "Die Prosa des Expressionismus." In Rothe, *Expressionismus als Literatur: Gesammelte Studien*, 153–70.

———. *The Writer in Extremis: Expressionism in Twentieth-Century German Literature*. Stanford: Stanford UP, 1959.

———, ed. *Anthology of German Expressionist Drama: A Prelude to the Absurd*. Ithaca and London: Cornell UP, 1984. Originally published Garden City, NY: Doubleday Anchor, 1963.

Spreizer, Christa. *From Expressionism to Exile: The Works of Walter Hasenclever (1890–1940)*. Rochester, NY: Camden House, 1999.

Stark, Michael. *Für und Wider den Expressionismus: Die Entstehung der Intellektuellendebatte in der Literaturgeschichte*. Stuttgart: Metzler, 1982.

Steffen, Hans, ed. *Der deutsche Expressionismus: Formen und Gestalten*. Göttingen: Vandenhoeck & Ruprecht, 1965.

Steinlein, Rüdiger. *Theaterkritische Rezeption des expressionistischen Dramas: Ästhetische und politische Grundpositionen*. Kronberg an der Taunus: Scriptor, 1974.

Strathausen, Carsten. *The Look of Things: Poetry and Vision around 1900*. Chapel Hill and London: The U of North Carolina P, 2003.

Stücheli, Peter. *Poetisches Pathos: Eine Idee bei Friedrich Nietzsche und im deutschen Expressionismus*. Bern: Peter Lang, 1999.

Stuyver, Wilhelmina. *Deutsche expressionistische Dichtung im Lichte der Philosophie der Gegenwart*. Amsterdam: H. J. Paris, 1939.

Taylor, Ronald. *Literature and Society in Germany, 1918–1945*. Brighton, Sussex: Harvester Press; Totowa, NJ: Barnes & Noble, 1980.

Taylor, Seth. *Left-Wing Nietzscheans: The Politics of German Expressionism, 1910–1920*. Monographien und Texte zur Nietzsche-Forschung, vol. 22. Berlin: De Gruyter, 1990.

Thomke, Hellmut. *Hymnische Dichtung im Expressionismus*. Bern and Munich: Francke, 1972.

Titford, J. S. "Object-Subject Relationships in German Expressionist Cinema." *Cinema Journal* 13.1 (1973): 17–24.

Utitz, Emil. *Die Überwindung des Expressionismus: Charakterologische Studien zur Kultur der Gegenwart*. Stuttgart: Enke, 1927.

Vietta, Silvio. "Expressionistische Literatur und Film: Einige Thesen zum wechselseitigen Einfluß ihrer Darstellung und Wirkung." *Mannheimer Beiträge aus Forschung und Lehre* 10 (1975): 294–99.

———. "Großstadtwahrnehmung und ihre literarische Darstellung: Expressionistischer Reihungsstil und Collage." *Deutsche Vierteljahrsschrift für Literaturwissenschaft und Geistesgeschichte* 48 (1974): 354–73.

———. "Zweideutigkeit der Moderne: Nietzsches Kulturkritik, Expressionismus und literarische Moderne." In Anz and Stark, *Die Modernität des Expressionismus*, 9–20.

Vietta, Silvio, and Hans-Georg Kemper. *Expressionismus*. Munich: Wilhelm Fink, 1975.

Vogt, Paul. Introduction to *Expressionism: A German Intuition, 1905–1920*. New York: Solomon R. Guggenheim Museum, 1980.

Wager, Jans B. *Dangerous Dames: Women and Representation in the Weimar Street Film and Film Noir*. Athens, OH: Ohio UP, 1999.

Waller, Christopher. *Expressionist Poetry and its Critics*. Leeds: W. S. Maney, 1986.

Weinstein, Joan. *The End of Expressionism: Art and the November Revolution in Germany, 1918–1919*. Chicago: U of Chicago P, 1990.

Weissenberger, Klaus. " 'Ein Mensch der Liebe kann nur auferstehen!' Else Lasker-Schülers Lyrik im Kontext von Liebesthematik und deren poetischer Konkretisation." In *Else Lasker-Schüler*, ed. Ernst Schürer and Sonja Hedgepeth, 91–117. Tübingen: Francke, 1999.

Weisstein, Ulrich. *Expressionism as an International Literary Phenomenon*. Paris: Didier, 1973.

———. "German Literary Expressionism: An Anatomy." *German Quarterly* 54, 3 (1981): 262–83.

Werenskiold, Marit. *The Concept of Expressionism: Origin and Metamorphoses*. Oslo: Universitetsforlaget; New York: Columbia UP, 1984.

Williams, Eric B. *The Mirror and the Word: Modernism, Literary Theory and Georg Trakl*. Lincoln, NE: U of Nebraska P, 1993.

Williams, Rhys W. *Carl Sternheim: A Critical Study*. Bern and Frankfurt am Main: Peter Lang, 1982.

———. "Culture and Anarchy in Expressionist Drama." In Behr, Fanning, and Jarman, *Expressionism Reassessed*, 201–12.

———. "Primitivism in the Works of Carl Einstein, Carl Sternheim and Gottfried Benn." *Journal of European Studies* 13 (1983): 247–67.

Wirtz, Ursula. *Die Sprachstruktur Gottfried Benns: Ein Vergleich mit Nietzsche*. Göppingen: Kümmerle, 1971.

Worringer, Wilhelm. *Abstraktion und Einfühlung: Ein Beitrag zur Stilpsychologie*. Munich: Piper, 1908. In English: *Abstraction and Empathy: A Contribution to the Psychology of Style,* trans. Michael Bullock. New York: International UP, 1953.

Worringer. "Entwicklungsgeschichtliches zur modernsten Kunst." In *Im Kampf um die Kunst: Die Antwort auf den "Protest deutscher Künstler,"* 92–99. Munich: Piper, 1911. Reprinted as "Zur Entwicklungsgeschichte der modernsten Malerei." *Sturm* 75 (1911): 597–98.

———. *Formprobleme der Gotik.* Munich: Piper, 1911. In English: *Form as Gothic,* later as *Form Problems of the Gothic,* trans. Herbert Read. London: Putnam's Sons, 1927.

———. *Fragen und Gegenfragen: Schriften zum Kunstproblem.* Munich: Piper, 1956.

———. "Kritische Gedanken zur neuen Kunst." *Genius* 1 (1919): 221–36. Repr. in *Fragen und Gegenfragen: Schriften zum Kunstproblem,* 86–105.

———. *Künstlerische Zeitfragen.* Munich: Bruckmann, 1921. Lecture (19 October 1920) für the Ortsgruppe München der deutschen Goethe-Gesellschaft. Repr. in *Fragen und Gegenfragen: Schriften zum Kunstproblem,* 106–29.

Wotschke, Jean. *From the Home Fires to the Battlefield: Mothers in German Expressionist Drama.* New York: Peter Lang, 1998.

Wright, Barbara. " 'New Man,' Eternal Woman: Expressionist Responses to German Feminism." *German Quarterly* 60, 4 (1987): 582–99.

———. "The New Woman of the Twenties: *Hoppla! That's Life!* and *The Merry Vineyard.*" In *Playing for Stakes: German Language Drama in Social Context; Essays in Honor of Herbert Lederer,* ed. Anna K. Kuhn and Barbara D. Wright, 119–38. Oxford, UK and Providence, RI: Berg, 1994.

———. "Sublime Ambition: Art, Politics and Ethical Idealism in the Cultural Journals of German Expressionism." In Bronner and Kellner, *Passion and Rebellion: The Expressionist Heritage,* 82–112.

Zeller, Bernhard, ed. *Expressionismus — Literatur und Kunst, 1910–1923: Eine Ausstellung des deutschen Literaturarchivs im Schiller-Nationalmuseum vom 8. Mai bis 31 Oktober 1960.* Marbach: Deutsches Literaturarchiv, 1960.

Žmegač, Victor. "Exkurs über den Film im Umkreis des Expressionismus." *Sprache im technischen Zeitalter* 53 (1970): 243–57.

# Contributors

NEIL H. DONAHUE is Professor of German and Comparative Literature at Hofstra University, where he has taught since 1988. Besides numerous articles, he is the author of *Forms of Disruption: Abstraction in Modern German Prose* (1993), *Voice and Void: The Poetry of Gerhard Falkner* (1998), and most recently, *Karl Krolow and the Poetics of Amnesia in Postwar Germany* (2002). He is editor of *Invisible Cathedrals: The Expressionist Art History of Wilhelm Worringer* (1995) and, with Doris Kirchner, of *Flight of Fantasy: New Perspectives on Inner Emigration in German Literature, 1933–1945* (2003). He has been the recipient of grants from the German Academic Exchange Service (DAAD), the National Endowment for the Humanities (NEH), the Fulbright Program, and the Alexander von Humboldt Foundation.

RICHARD T. GRAY is Byron W. and Alice L. Lockwood Professor in the Humanities at the University of Washington, where he teaches in the Department of Germanics. His broad area of research is German literature and intellectual history from the Enlightenment to the early twentieth century. He is the author of *About Face: German Physiognomic Thought from Lavater to Auschwitz* (2004) and *Stations of the Divided Subject: Contestation and Ideological Legitimation in German Bourgeois Literature, 1770–1912* (1995). He has also worked as a translator, most recently publishing two volumes of Nietzsche's early works for the critical North American Nietzsche edition, *Unfashionable Observations I-IV* (1995) and *Unpublished Fragments: From the Period of Unfashionable Observations* (1999). He is currently working on a book with the working title "Money Matters," which explores the influence of economic thought on the German cultural imagination from 1770 to 1871.

SABINE HAKE is Texas Chair of German Literature and Culture in the Department of Germanic Studies at the University of Texas at Austin. She is the author of four books: *German National Cinema* (2002, published in German in 2004 as *Film in Deutschland: Geschichte und Geschichte ab 1895*), *Popular Cinema of the Third Reich* (2001), *The Cinema's Third Machine: German Writings on Film 1907–1933* (1993), and *Passions and Deceptions: The Early Films of Ernst Lubitsch* (1992), as well as numerous articles on German film and Weimar culture. Her current

research project deals with urban architecture and mass utopia in Weimar Berlin.

JAMES ROLLESTON is Professor in the Department of German at Duke University and has written widely on topics in modern German literature. He is the author of *Narratives of Ecstasy: Romantic Temporality in Modern German Poetry* (1987) and, most recently, he has edited *A Companion to the Works of Franz Kafka*, published by Camden House in 2002.

ERNST SCHÜRER is Professor Emeritus of German in the Department of Germanic and Slavic Languages at The Pennsylvania State University, where he taught from 1978 to 2003. Before that he taught at Yale University (1963–73) and the University of Florida (1973–78). He is the author of *Georg Kaiser* (1971), *Georg Kaiser und Bertolt Brecht* (1971), and *Georg Kaiser: Von morgens bis mitternachts: Erläuterungen und Dokumente* (1975), and has edited or co-edited *Lebendige Form: Interpretationen zur deutschen Literatur* (1970), *B. Traven: Life and Work* (1987), *Franz Jung: Leben und Werk eines Rebellen* (1994), *The Berlin Wall: Representations and Perspectives* (1996), *German Expressionist Plays* (1997), and *Else Lasker-Schüler: Ansichten und Perspektiven / Views and Reviews* (1999), as well as plays by Georg Kaiser, Carl Sternheim, Ernst Toller, and Reinhard Sorge.

FRANCIS MICHAEL SHARP is Professor of German at the University of the Pacific. He earned his PhD at the University of California at Berkeley and taught at Princeton University before returning to California. He is the author of a book and several articles on Georg Trakl and has a longstanding interest in German Expressionism. He is also the author of several essays on contemporary German-language writers including Max Frisch, Peter Handke, Thomas Bernhard, Martin Walser, and Barbara Frischmuth.

WALTER H. SOKEL is Commonwealth Professor Emeritus of German Literature at the University of Virginia, where he taught from 1973 to 1994, after having taught at Columbia and Stanford universities; he has also had guest professorships at Harvard and Rutgers as well as abroad in Hamburg, Freiburg, and Graz. He is one of the most prominent and accomplished Germanists of the last half century, beginning with his groundbreaking study of Expressionism *The Writer in Extremis: Expressionism in Twentieth-Century German Literature* in 1959. His accomplishments as editor are also considerable: his *Anthology of German Expressionist Drama: Prelude to the Absurd* in 1963 introduced that body of work to an American audience. His work on literary Expressionism established its historical and literary significance alongside the more well-known movement in the arts. But he is most widely known for his work on Franz Kafka: his monumental study *Franz Kafka: Tragik und Ironie* (1964) has been a touchstone for all subsequent Kafka scholarship. His *The Myth of Power and the Self: Essays on Franz Kafka* (2002) brings together his work on Kafka since then to the present. As an

NOTES ON THE CONTRIBUTORS ♦ 359

intellectual historian and critic of twentieth-century German literature, his numerous scholarly articles — not just on Kafka but also on many other figures — have demonstrated the intellectual, philosophical, and socio-historical roots of twentieth-century German literature and the significance of its literary formulation, and have given insight and impetus to further research: for that reason, his seminal essay on German Expressionist prose is included here for the first time in English translation.

CHRISTA SPREIZER has taught at The Graduate Center/CUNY, Queens College/CUNY and the University of Pennsylvania, where she received her doctorate in 1994. Her book *From Expressionism to Exile: The Works of Walter Hasenclever (1890–1940)* appeared in 1999 with Camden House. Her research areas include the integration of media in the language and literature classroom, as well as German Expressionism and the history of science (*Wissenschaftsgeschichte*). She is currently researching the cultural milieu in Leipzig during the late Wilhelminian period.

KLAUS WEISSENBERGER is Professor of German in the Department of German & Slavic Studies at Rice University in Houston, Texas, where he has taught since 1971. He is the author of *Formen der Elegie von Goethe bis Celan* (1969), *Die Elegie bei Paul Celan* (1969), and *Zwischen Stein und Stern: Mystische Formgebung bei Else Lasker-Schüler, Nelly Sachs und Paul Celan* (1976). He has edited the volumes *Die deutsche Lyrik von 1945 bis 1975: Zwischen Botschaft und Spiel* (1981) and *Prosakunst ohne Erzählen: Die Gattungen der nicht-fiktionalen Kunstprosa* (1985) and the edition of Wilhelm Lehmann, *Band 4: Romane III: Der Provinzlärm* (1986). In his articles of the last two decades, he has concentrated on non-fictional prose works written by modern German authors, mainly during their exile from Nazi Germany.

RHYS W. WILLIAMS is Professor of German and Pro-Vice-Chancellor at the University of Wales, Swansea. He has published on German Expressionism (Sternheim, Benn, Einstein, Kaiser, and Toller) and on post-Second World War literature (Andersch, Böll, Siegfried Lenz, and Martin Walser). Currently he is general editor of the *Contemporary German Writers* series and has written articles for the volumes on Sarah Kirsch, Peter Schneider, Jurek Becker, Uwe Timm, and Hans-Ulrich Treichel.

PERRY WILLETT is a librarian at the University of Michigan and has published articles in the field of librarianship. He also has an MA in Comparative Literature and a long-standing research interest in Expressionism and in the genre of the graphic novel, in particular those of Frans Masereel.

BARBARA WRIGHT taught German language, literature, and culture courses from 1973 until her retirement from the University of Connecticut in 2001. She received her Ph.D. from the University of California at Berkeley

with a dissertation on the political philosophy of German Expressionists, and several pioneering articles over the years have illuminated the role of women in the Expressionist movement. She has been active since 2001 as a consultant to institutions on issues related to curricular reform, outcomes assessment, general education, foreign language instruction, and international education. In 2005 she became an associate director of the Western Association of Schools and Colleges in Alameda, CA.

# Index